DATE DUE FOR RETURN

This book may be recalled before the above date.

Methods in Cell Biology

VOLUME 72

Digital Microscopy: A Second Edition of Video Microscopy

Series Editors

Leslie Wilson
Department of Biological Sciences
University of California
Santa Barbara, California

Paul Matsudaira
Whitehead Institute for Biomedical Research
Department of Biology
Massachusetts Institute of Technology
Cambridge, Massachusetts

Methods in Cell Biology

Prepared under the auspices of the American Society for Cell Biology

VOLUME 72

Digital Microscopy: A Second Edition of Video Microscopy

Edited by

Greenfield Sluder

Department of Cell Biology
University of Massachusetts Medical School
Worcester, Massachusetts

David E. Wolf

Sensor Technologies LLC
Shrewsbury, Massachusetts

ELSEVIER
ACADEMIC
PRESS

AMSTERDAM • BOSTON • HEIDELBERG • LONDON
NEW YORK • OXFORD • PARIS • SAN DIEGO
SAN FRANCISCO • SINGAPORE • SYDNEY • TOKYO

Academic Press is an imprint of Elsevier

Elsevier Academic Press.
525 B Street, Suite 1900, San Diego, California 92101-4495, USA
84 Theobald's Road, London WC1X 8RR, UK
http://www.academicpress.com

International Standard Book Number: 0-12-564169-9 (Case)
International Standard Book Number: 0-12-649161-5 (Paperpack)

PRINTED IN THE UNITED STATES OF AMERICA
03 04 05 06 07 08 9 8 7 6 5 4 3 2 1

CONTENTS

9. Fundamentals of Fluorescence and Fluorescence Microscopy

David E. Wolf

10. A High-Resolution Multimode Digital Microscope System

E. D. Salmon, Sidney L. Shaw, Jennifer Waters, Clare M. Waterman-Storer, Paul S. Maddox, Elaine Yeh, and Kerry Bloom

11. Fundamentals of Image Processing in Light Microscopy

Richard A. Cardullo

12. Techniques for Optimizing Microscopy and Analysis through Digital Image Processing

Ted Inoué and Neal Gliksman

13. The Use and Manipulation of Digital Image Files in Light Microscopy

Edward H. Hinchcliffe

CONTRIBUTORS

Numbers in parentheses indicate the pages on which the authors' contributions begin.

Keith Berland (103, 431), Physics Department, Emory University, Atlanta, Georgia 30322

Kerry Bloom (185), Department of Biology, University of North Carolina, Chapel Hill, North Carolina 27599

C. Buehler (431), Laboratory for Fluorescence Dynamics, Department of Physics, University of Illinois at Urbana-Champaign, Urbana, Illinois 61801

Dylan A. Bulseco (465), Sensor Technologies LLC, Shrewsbury, Massachusetts 01545

Richard A. Cardullo (217, 415), Department of Biology, The University of California, Riverside, California 92521

Chen Y. Dong (431), Laboratory for Fluorescence Dynamics, Department of Physics, University of Illinois at Urbana-Champaign, Urbana, Illinois 61801

Kenneth Dunn (389), Department of Medicine, Indiana University Medical Center, Indianapolis, Indiana 46202-5116

Todd French (103, 431), Molecular Devices Corporation, Sunnyvale, California 94089

Neal Gliksman (243), Universal Imaging Corporation, West Chester, Pennsylvania 19380

Enrico Gratton (431), Laboratory for Fluorescence Dynamics, Department of Physics, University of Illinois at Urbana-Champaign, Urbana, Illinois 61801

Edward H. Hinchcliffe (65, 271), Department of Biological Science, University of Notre Dame, Notre Dame, Indiana 46556

Jan Hinsch (57), Leica Microsystems, Inc., Allendale, New Jersey 07401

Ted Inoué (243), Universal Imaging Corporation, West Chester, Pennsylvania 19380

Ken Jacobson (103), Physics Department, Emory University, Atlanta, Georgia 30322; Lineberger Comprehensive Cancer Center; Department of Cell and Developmental Biology, University of North Carolina at Chapel Hill, Chapel Hill, North Carolina 27599

H. Ernst Keller (45), Carl Zeiss Microimaging, Inc., Thornwood, New York 10594

Paul S. Maddox (185), Department of Biology, University of North Carolina, Chapel Hill, North Carolina 27599

Frederick R. Maxfield (389), Department of Biochemistry, Weill Medical College of Cornell University, New York, New York 10021

Butch Moomaw (133), Hamamatsu Photonic Systems, Division of Hamamatsu Corporation, Bridgewater, New Jersey 08807

Joshua J. Nordberg (1), Department of Cell Biology, University of Massachusetts Medical School, Worcester, Massachusetts 01605

Masafumi Oshiro (133), Hamamatsu Photonic Systems, Division of Hamamatsu Corporation, Bridgewater, New Jersey 08807

Vladimir Parpura (415), Department of Cell Biology and Neuroscience, The University of California, Riverside, California 92521

Zenon Rajfur (103), Department of Cell and Developmental Biology, University of North Carolina, Chapel Hill, North Carolina 27599

E. D. Salmon (185, 289), Department of Biology, University of North Carolina, Chapel Hill, North Carolina 27599

Sidney L. Shaw (185), Department of Biology, University of North Carolina, Chapel Hill, North Carolina 27599

Randi B. Silver (269), Department of Physiology and Biophysics, Weill Medical College of Cornell University, New York, New York 10021

Greenfield Sluder (1, 65), Department of Cell Biology, University of Massachusetts Medical School, Worcester, Massachusetts 01605

Peter T.C. So (431), Laboratory for Fluorescence Dynamics, Department of Physics, University of Illinois at Urbana-Champaign, Urbana, Illinois 61801

Kenneth R. Spring (87), Laboratory of Kidney and Electrolyte Metabolism, National Heart, Lung, and Blood Institute, National Institutes of Health, Bethesda, Maryland 20892-1603

Jason R. Swedlow (349), Division of Gene Regulation and Expression, University of Dundee, Dundee DD1 5EH, Scotland, United Kingdom

Phong Tran (289), Department of Biology, University of North Carolina, Chapel Hill, North Carolina 27599

Yu-li Wang (337), Department of Physiology, University of Massachusetts Medical School, Worcester, Massachusetts 01605

Clare M. Waterman-Storer (185), Department of Biology, University of North Carolina, Chapel Hill, North Carolina 27599

Jennifer Waters (185), Department of Biology, University of North Carolina, Chapel Hill, North Carolina 27599

David E. Wolf (11, 157, 319, 465), Sensor Technologies LLC, Shrewsbury, Massachusetts 01545

Elaine Yeh (185), Department of Biology, University of North Carolina, Chapel Hill, North Carolina 27599

PREFACE

In our introduction to Video Microscopy, the forerunner to this volume, we commented upon the marvelous images then coming in from the Mars Pathfinder in the summer of 1997: "The opening of a previously inaccessible world to our view is what we have come to expect from video imaging. In the past three decades, video imaging has taken us to the outer planets, to the edge of the universe, to the bottom of the ocean, into the depths of the human body, and to the interior of living cells. It can reveal not only the forces that created and altered other planets but also the forces of life on earth." This continues to reflect what must be the ever sanguine view of scientists about their world, their work, and the use of technology to promote the pursuit of pure knowledge.

That said, we recognize that the world has changed enormously in the intervening six years. Our choice of the title Digital Microscopy, as opposed to the earlier volume's Video Microscopy, reflects the profound change that the past six years have brought. For the most part, true video detectors are gone from the arsenal of microscopy and are replaced by a new generation of digital cameras. This is more than a vogue; it represents how microscopy, by becoming more and more specialized, is constantly evolving in the nature of the information that it can provide us. This book follows a similar organization of material to that of Video Microscopy, with the notable caveat that we now focus on issues related to digital microscopy. The organization of this book is loosely tripartite. The first group of chapters presents some of the optical fundamentals needed to provide a quality image to the digital camera. Specifically, it covers the fundamental geometric optics of finite- and infinite-corrected microscopes, develops the concepts of physical optics and Abbe's theory of the microscope, presents the principles of Kohler illumination, and finally reviews the fundamentals of fluorescence and fluorescence microscopy. The second group of chapters deals with digital and video fundamentals: how digital and video cameras work, how to coordinate cameras with microscopes, how to deal with digital data, the fundamentals of image processing, and low light level cameras. The third group of chapters address some specialized areas of microscopy. Since quantitative microscopy is at the heart of these topics, we begin with a discussion of some critical issues of quantitative microscopy and then move on to ratio imaging of cellular analytes, fluorescence resonance energy transfer, high-resolution differential interference microscopy, lifetime imaging, and fluorescence correlation spectroscopy. It is in this last category that the field of microscopy is now most dynamic.

We have chosen here to confine our discussion to wide-field microscopy. This is because the area of confocal microscopy merits a volume onto itself and, indeed, has been covered extensively elsewhere. That said, our discussions of the critical issues involved in quantitative microscopy are directly applicable and extremely germane to laser scanning confocal microscopy.

As we put the final touches on this book, we have just completed the twenty-third Analytical and Quantitative Light Microscopy (AQLM) course, started by Shinya Inoué, which we now direct at the Marine Biological Laboratories at Woods Hole, Massachusetts. Beyond a doubt, this book is a direct outgrowth of AQLM and differences between this book and its forerunner, Video Microscopy, published in 1998, reflect not only changes in the field, but changes in the course as well. In beginning to write and to involve (or was it to coerce?) others to help write this book, we were keenly aware that we were fast approaching the twenty-fifth anniversary of AQLM. We therefore asked Shinya Inoue to comment on the first AQLM course:

On April 27–May 3, 1980, at the suggestion of Mort Maser, Associate Director in charge of education and research at the Marine Biological Laboratory, we offered the first course on "Analytical and Quantitative Light Microscopy" (AQLM). I was joined by Gordon Ellis and Ted Salmon from the University of Pennsylvania Program in Biophysical Cytology, by Lance Taylor, a past student with Bob Allen and then at Harvard, and by several others, including commercial faculty that Mort Maser and I had recruited from Zeiss, Leitz, Nikon, Olympus, Eastman Kodak, Hamamatsu Photonics, Colorado Video, Venus Scientific, Crimson Tech, and Sony. These manufacturers also provided the needed equipment, supplies, and technical personnel as they had for Bob's course.

For the early offerings of the AQLM course, we concentrated two days on polarized light microscopy, including the interaction of polarized light with matter, after an introduction to the principles of microscope image formation and the phase contrast principle. We reasoned that, early in the course, we should deal thoroughly with the basic nature of the probe used in light microscopy—the light wave—and how it interacts with the optical components, as well as the electronic structure of the molecules that make up the specimen. Then, after a day and a half exploring further details of image formation and other modes of contrast generation, we spent the final day and a half examining the principles and application of fluorescence microscopy. Throughout the course, interspersed with discussions on microscope optics, image interpretation, and analysis, we reviewed some advanced applications of microscopy in cellular and molecular biology.

As has pretty much become the tradition for our course, from 9 a.m. to noon each day we held lectures and demonstrations on the subject matters, with afternoons and evenings mostly devoted to laboratory experiences, sometimes lasting until past midnight. As a major innovation for this course, every pair of students was provided with an up-to-date research microscope together with video and digital processing equipment and received personal attention from both commercial and academic faculty. The intensive, hands-on laboratory gave

the participants an opportunity for total immersion, with the students, academic faculty, and commercial representatives all interacting with each other to try out well-tested, as well as never-tried-before, novel ideas and observations.

One early finding in both of the MBL microscopy courses was that the video devices that were attached to the microscopes, mainly to allow a large group of participants to watch the events taking place under the microscope, behaved, in fact, incredibly better than had been anticipated. The cameras and monitors would enhance the image contrast beyond expectation, and simple digital processors would allow the unwanted background to be subtracted away, or noise to be integrated so effectively that a totally new world appeared under the microscope. For example, images that were totally invisible or undetectable before, including faint DIC diffraction images of molecular filaments (whose diameters were far below the microscope's limit of resolution) and weakly birefringent or fluorescent minute specimen regions, could now be recorded or displayed on the video monitor with incredible clarity.

As has often happened at the MBL courses, the combination of (a) students and faculty with varied backgrounds but a strong, shared interest in making pioneering contributions, (b) total immersion in the course and laboratory experience away from the daily distractions at their home institutions, and (c) hands-on availability of contemporary equipment and specimens (thanks to the generosity of the participating vendors) led to synergy and interactions that opened up new technology and new fields of study.

Not only was the new field of video microscopy born at the early MBL microscopy courses, but soon after attending the AQLM course, some of the students began to develop even more powerful approaches, including those that finally allowed the tracking of specific individual molecules directly under the microscope. At the same time, the friendships developed at the courses opened up new channels of communication between users of microscopes, between users and manufacturers, and among manufacturers themselves. In fact, several improvements that we see today in microscopes and their novel uses arose from discussions, interactions, or insights gained in these courses. Owing in part to the success and impact of the MBL microscopy courses, light microscopy has undergone a virtual renaissance in the last two decades.

We must, at the outset, express the enormous debt that we and the field of microscopy owe to Shinya Inoué, Lans Taylor, Ted Salmon, and Gordon Ellis. We would be remiss if we did not also mention Bob and Nina Allen's parallel and simultaneous endeavours with the fall course, Optical Microscopy. These people set the standard for AQLM and established its dual essence. It is at once a course for students in the basics of light microscopy and also a meeting for faculty, both academic and commercial, to develop new methods and applications. We owe a tremendous debt to our faculty, many of whom have participated in the course from its beginning and contributed to this volume. Most of all, we owe a tremendous debt to our students, who each year bring this course alive, bring us out of our offices, and rekindle in us the love of

microscopy. Together, these people make AQLM what it is—an extremely exciting environment in which to study and explore microscopy.

A lot may be said about the genesis of AQLM and, in parallel, about the metamorphosis of the field of optical microscopy. Shinya, we know, laments the fact that the need to cover ever more advanced topics has forced us to shorten our sections on polarized light and the fundamental issue of how light interacts with matter. During our fourteen years directing AQLM, we have seen an alarming trend in cell biology to misuse microscopy, particularly in the quantitative analysis of fluorescence images. We have increasingly seen our role to try, in the few days that the course affords us, to seek to raise an awareness in our students minds of the complexities involved in image quantification and give them some of the tools needed for its proper use. The response of our students and faculty has been truly remarkable. This is, of course, a reflection of the high quality of students and their dedication to microscopy and good science in general.

The preparation of a book of this sort cannot be done in isolation, and many people have contributed both directly and indirectly to this volume. First, we thank our contributors for taking the time to write articles covering the basics and practical aspects of digital microscopy. Although this may be less glamorous than describing the latest and greatest aspects of their work, their efforts will provide a valuable service to the microscopy community. We also thank the members of the commercial faculty of AQLM for their years of patient, inspired teaching of both students and us. Through their interaction with students, these people, principals in the video and microscopy industries, have defined how the material covered in this book is best presented for use by researchers in biology. We are grateful that some of them have taken the time from their busy schedules to write chapters for this book. Several people must be thanked for their help in preparing the manuscript of this book—Cathy Warren, Roxanne Wellman, Josh Nordberg, Kathryn Sears, and Leya Berguist. In addition, we would be nowhere without the unflagging help and cheerful patience of our editor at Elsevier, Mica Haley. The job of editing a book like this is a dubious honor, and after a season of arm twisting, we can only hope that we have as many friends at the end of the process as we had at the beginning. Our gratitude also goes out to the many individuals who administer the educational programs at the Marine Biological Laboratory, especially Lenny Dawidowicz, Kelly Holzworth, Carol Hamel, and Dori Chrysler-Mebane. We pray that the Marine Biological Laboratory will never lose sight of its singular role in science education. Five generations of scientists are indebted to this remarkable institution.

In recognition of the contributions of the many past students of AQLM, the commercial faculty, and the instrument manufacturers, we respectfully dedicated this volume to them all.

<div align="right">

Greenfield Sluder
David E. Wolf

</div>

CHAPTER 1

Microscope Basics

Greenfield Sluder and Joshua J. Nordberg

Department of Cell Biology
University of Massachusetts Medical School
Worcester, Massachusetts 01605

I. Introduction

The first part of this chapter provides basic background information on how microscopes work and some of the microscope issues to be considered in using a video camera on the microscope. In this we do not intend to reiterate the material covered in the chapters by Ernst Keller on microscope alignment and by Jan Hinsch on mating cameras to the microscope; the material outlined here is intended to provide an introduction to these more detailed presentations.

II. How Microscopes Work

There are two types of microscopes in use today for research in cell biology: the older finite tube length (typically 160 mm mechanical tube length) microscopes and the infinity optics microscopes that are now produced.

A. The Finite Tube-Length Microscope

The objective lens forms a magnified, real image of the specimen at a specific distance from the objective known as the intermediate image plane (Fig. 1A). All objectives are designed to be used with the specimen at a defined distance from the front lens element of the objective (the working distance) so that the image formed (the intermediate image) is located at a specific location in the microscope. The working distance varies with the objective and is typically greater for lower-power objectives, but the location of the intermediate image in the microscope is fixed by design. The intermediate image is located at the front focal plane of the ocular, another sophisticated magnifying lens. Because the intermediate image is located at the focal length of the ocular, the image, now further magnified, is projected to infinity (Fig. 1B). The human eye takes the image projected to infinity and forms a real image on the retina. In practice, this means that one can observe the specimen as if it is at infinity and the eye is relaxed. If one makes the mistake of trying to use one's eye to accommodate for focus, eye strain and a headache are likely to occur. The combination of the objective lens and the ocular lens is shown in Fig. 1C; this is the basic layout of the microscope.

The photo-detecting surface of the digital or video camera must be located at the intermediate image plane or a projection of the intermediate image. Modern microscopes are designed to accept a variety of accessories and consequently have multiple light paths and relay lenses that project the intermediate image to a number of locations as outlined below and shown for an upright microscope in Fig. 2. In the path to the eye, the intermediate image plane is by convention located 10 mm toward the objective from the shoulder of the eyepiece tube into which the ocular is inserted. In other words, if one removes an ocular, the intermediate image will be 10 mm down in the tube. This holds true whether the microscope is relatively small and simple or is large with a long optical train leading to the oculars. In the latter case, the manufacturer uses relay optics to project the intermediate image to the front focal plane of the ocular. For older microscopes with a long thin camera tube on the trinocular head, the intermediate image plane is located 10 mm from the tip of the tube or shoulder into which one mounts a projection ocular that is used in conjunction with a 35-mm camera. If one has a video camera tube with a C mount thread on the trinocular head, the intermediate image plane is above the C mount at the intended position of the photo-detecting surface. For camera ports on the sides or front of inverted microscopes, the location of the intermediate image plane (or its projected image)

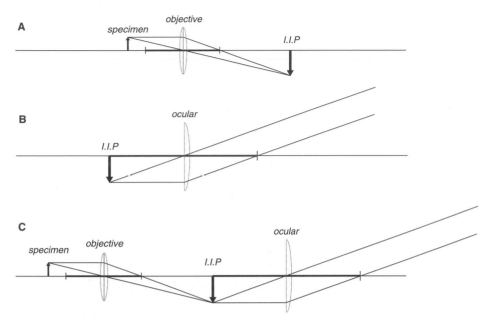

Fig. 1 Geometric optics of the compound microscope of finite tube length design. (A) Objective lens. The specimen (small arrow on left) is located outside the focal length of the objective lens, and a real magnified image (large inverted arrow) is formed at the intermediate image plane (IIP). (B) Ocular lens. The image of the specimen at the IIP is located at the focal length of the ocular lens, and light from every point on the intermediate image is projected to infinity. Shown here is the ray path for the light coming from a point at the tip of the arrow image. (C) The layout of the compound microscope. The specimen is imaged at the IIP, and this image is projected to infinity by the ocular. The eye takes the light coming from the ocular and forms a real image on the retina. The dark bars along the optic axis denote the focal lengths of the lenses.

is located at the intended location of the photo-detecting surface, be it a 35-mm film camera or a digital or video camera.

For research-grade microscopes that are designed to accommodate optical accessories for specialized contrast modes, such as differential interference contrast, polarization microscopy, or epifluorescence, the manufacturer puts a color-corrected negative lens (often called a "telan" lens) in the nosepiece to project the image of the specimen to infinity and adds an additional lens in the body of the microscope (the tube lens) to form a real image of the specimen at the intermediate image plane (Fig. 3A, upper, for a specimen point off the optical axis; and Fig. 3A, lower, for a point on the optical axis). This is done because these optical accessories work properly only with light projected to infinity, and additional space is needed to accommodate these optical components.

The total magnification of the specimen image is, in the simplest case, the product of the magnification of the objective and that of the ocular. If the microscope has an auxiliary magnification changer with fixed values (say

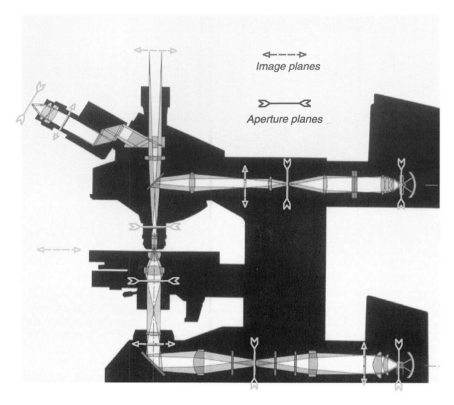

Fig. 2 Diagrammatic cross section of a modern upright microscope equipped for transmitted and epi-illumination. For both the illumination and imaging pathways, the conjugate image planes are shown by the dashed arrows with outward-facing arrowheads. The conjugate aperture planes are shown by the solid arrows with inward-facing arrowheads. For this particular microscope, the photosensitive surface of the digital or video camera would be placed at the image plane located above the trinocular head. Diagram of microscope kindly provided by R. Rottenfusser of Carl Zeiss Corporation.

$1\times$, $1.5\times$, and $2\times$), this magnification value must also be multiplied times the magnification of the objective and ocular. In the case of camera couplers, the magnification of the coupler (if any) should be substituted for the ocular magnification, and the size of the charge-coupled device (CCD) chip in the camera should be taken into account when calculating the magnification of the image on the monitor: The smaller the chip, the greater the magnification of the image on the monitor and the smaller the field of view (Hinsch, 1999).

B. Infinity Optics Microscopes

These microscopes differ from the finite tube–length microscopes in that the objectives are designed to project the image of the specimen to infinity and do not, on their own, form a real image of the specimen (Fig. 3B, upper, for a specimen

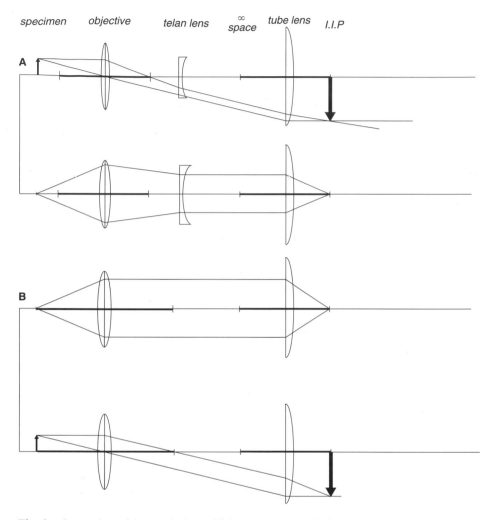

specimen objective telan lens ∞ space tube lens I.I.P

Fig. 3 Comparison of the practical use of finite tube-length and infinity-corrected microscope optics. (A) Finite tube length optics. A "telan" lens (negative lens) is put in the nosepiece of the microscope to project to infinity the light coming from every point on the specimen. Further up the microscope body, the tube lens forms a real image of the specimen at the IIP. The upper diagram shows the ray paths for light coming from an off-axis point on the specimen. The lower diagram shows the same for light coming from an on-axis point on the specimen. (B) Infinity-corrected optics. The objective takes light from every point on the specimen and projects it to infinity. Farther up the microscope body, the tube lens forms a real image of the specimen at the intermediate image plane (IIP). The upper diagram shows the ray paths for light coming from an on-axis point on the specimen. The lower diagram shows the same for light coming from an off-axis point on the specimen. The dark bars along the optic axis denote the focal lengths of the lenses.

point on axis; Fig. 3B, lower, for a specimen point off axis). A real image of the specimen is formed at the intermediate image plane by a tube lens mounted in the body of the microscope. By convention, the intermediate image plane is located 10 mm toward the objective from the shoulder of the tubes that hold the oculars (see Fig. 2). As for the finite tube-length microscopes, the intermediate image is located at the focal length of the ocular, and the specimen image is projected to infinity. In practice, the use of infinity-corrected optics means that the manufacturers do not need to put a "telan" lens in the nosepiece of the microscope to provide the "infinity space" for optical accessories for specialized contrast modes.

Because different manufacturers use tube lenses of different focal lengths and use different strategies to correct for lateral chromatic aberration of the objectives, it is no longer practical to use objectives of one manufacturer on the microscope of another even though all modern objectives are infinity corrected. In addition, Leica and Nikon no longer use the Royal Microscopical Society thread on their objectives, and consequently, other objectives will not physically fit on their microscopes.

III. Objective Basics

A. Types of Objectives

Three types of objectives are in common use today: plan achromats, plan apochromats, and plan fluorite lenses. The first, plan achromats, are color corrected for two wavelengths—red (656 nm) and blue (486 nm)—and are corrected for spherical aberration in the green (546 nm). The term "plan" refers to correction for flatness of field so that a thin specimen will be in focus across the entire field not just in the center (or at the margins of the field at a different focus setting). Plan achromats have a number of good features, particularly for monochromatic applications. They cost less than other types of objectives, and they have fewer lens elements. This latter characteristic can be important for polarization and differential interference contrast microscopy, in which one wants strain-free optics to optimize contrast. With fewer lens elements, there is often less birefringent retardation associated with the lens.

Plan apochromats are the most highly corrected objectives available. They are corrected for four wavelengths (red, green, blue, and violet 405 nm), and the chromatic aberration is relatively well corrected for other wavelengths between those that are fully corrected. These objectives are are also corrected for spherical aberration at four wavelengths and have a high degree of flatfield correction. These corrections are optimized for most of the field of view, with some loss of correction at the margins of the field. These lenses are put together by hand to exacting specifications and are expensive. Great care should be used in handling them because a mechanical shock or temperature shock can irreversibly degrade

their optical performance. In addition, they contain many more lens elements than achromats, and consequently, they often are not as well suited for polarization or differential interference applications as achromats in monochromatic applications. For white light or polychromatic applications, however, these lenses excel.

In regard to optical performance and cost, fluorite lenses (or semiapochromats) occupy a niche between the achromats and the apochromats. They are corrected for chromatic and spherical aberrations at three wavelengths (blue, green, and red).

It should also be mentioned that any objective, no matter how well it is designed or built, is engineered to work within a defined region of the visible spectrum. In specialized applications, such as the use of the near ultraviolet or near infrared, the optical performance of the lens may degrade substantially. Not only will the chromatic and spherical aberration corrections fail but also the transmission characteristics may suffer because the antireflection coatings are not designed to work outside a given range of wavelengths. This is also part of the reason why it is important to have an efficient infrared blocking filter in the illumination pathway when one is using transmitted light in normal applications or in fluorescence when working with red emission. If the video camera is sensitive to infrared, one may superimpose a poorly corrected infrared image on the image one is recording. For near ultraviolet and near infrared applications, one should seek objectives that are specifically designed for these specialized uses.

B. "Mixing and Matching" Objectives

For finite (160 mm) mechanical tube-length microscopes one can use objectives of one manufacturer on the microscopes made by others, particularly in applications where only one wavelength of light is to be used. For critical applications in which more than one illumination wavelength is used, one should bear in mind that 160-mm tube-length Olympus and Nikon objectives are "chrome free"; that is, the objective provides complete color correction for the intermediate image. Zeiss and Leica objectives are designed to be used with compensating eyepieces to correct for defined residual chromatic aberration. Mismatching objectives and oculars can produce color fringing, particularly at the margins of the field, when a specimen is observed with white light. In fluorescence microscopy, when two different wavelengths are used, one will obtain slightly different sized images at the two wavelengths. Leica objectives designed for 170-mm mechanical tube length should not be used on stands of other manufacturers if optimal image quality is desired.

It is important to note that one should not use infinity-corrected optics on finite tube-length microscopes. Infinity-corrected objectives are not designed to produce a real image; even if one can obtain an image, it will be of extremely poor quality. The only time one can use infinity-corrected objective lenses on a microscope designed for finite tube-length optics is in conjunction with specialized objective lens adapters, which are available from all the microscope manufacturers. Similarly, one should not try to use 160-mm tube-length lenses on a stand

designed for infinity-corrected objectives without an adapter designed for this purpose. One can tell whether the objective in hand is designed for a finite tube-length or infinity-corrected microscope by simple inspection of the engraved numbers on the barrel of the objective. Finite tube-length objectives typically have the number 160 followed by a slash and 0.17, the thickness in millimeters of the coverslip for which the lens is designed. Infinity-corrected objectives have an infinity symbol followed by a slash and the coverslip thickness.

C. Coverslip Selection

All objectives, be they finite tube length or infinity corrected, are designed to be used with number 1.5 coverglasses that are 0.17 mm thick. This holds true even for oil, glycerol, and water immersion objectives. A coverslip that is too thin or too thick will introduce spherical aberration that will noticeably degrade image contrast. For example, if one images tiny fluorescent beads with a coverslip of inappropriate thickness, there is a pronounced halo of diffuse light around each bead, and one cannot find a point at which the bead is in perfect focus. This is particularly evident with objectives with a numerical aperture greater than 0.4. The exceptions to this rule are special dipping objectives that are designed to be used without a coverslip and objectives that have a correction collar that allows the use of a range of coverslip thicknesses.

IV. Mounting Video Cameras on the Microscope

A. Basic Considerations

Typically the video camera is mounted directly on a C mount thread without screwing an imaging lens into the camera. In such a case, the photo-detecting surface, be it a tube or a CCD chip, must be located at either the intermediate image plane or the projected image of the intermediate image plane. If the detecting surface is located at some other plane, one will notice that the focus for the specimen in the oculars will be different from the focus needed to obtain an image on the monitor. This represents more than just an inconvenience; the image quality as seen by the camera will be less than optimal, because the objective corrections are designed for an image that is projected to the design distance of the intermediate image plane. This means that one should purchase video adapter tubes that are designed to be used on the particular microscope one is using.

In addition, one should be aware that the degree of lateral chromatic correction at the intermediate image plane will depend on the objective design. For finite tube-length microscopes, Olympus and Nikon objectives manufactured within the last 20 years provide complete color correction for the image at the intermediate image plane. Older Zeiss and Leica objectives were designed to have some residual chromatic aberration that was corrected by compensating

eyepieces. This is not a practical problem when using just one wavelength of light to image a specimen, but it is a factor to consider when imaging with white light or when seeking to superimpose images taken sequentially at two wavelengths, as is often done when producing multicolor images of fluorescent specimens, using a monochrome video camera. One may find that images formed by shorter wavelengths will be slightly larger than images formed by longer wavelengths of light. To deal with this problem, one should use camera tubes (even if they are $1\times$) that have optics that compensate for lateral chromatic aberration. When using CCD cameras with $\frac{1}{3}$- or $\frac{1}{2}$-inch chips, residual lateral chromatic aberration may not be a practical problem for noncritical applications because one is imaging only the center of the field. For infinity corrected systems, the intermediate image is fully color corrected in all microscopes.

Although not commonly used, a second way to mount a camera is to use a projecting ocular to form a real image of the specimen on the detecting surface of the camera. In such cases, it is important to use a projecting ocular because a conventional ocular will not produce a real image of the specimen on the photo-detecting surface unless the camera is put at a grossly inappropriate location. If one is to use a conventional ocular, an imaging lens, such as one used to image outdoor scenes, must be mounted on the camera. The camera is put on a rail or stand close to the ocular with a light-absorbing sleeve between the ocular and the camera lens to block stray light. In such a case, the camera lens should be set at infinity so that slight changes in the distance between the ocular and the camera lens will not change the focus of the image on the photo-detecting surface. This is a practical concern when one is using a microscope in which the whole head moves when one changes focus.

B. Empty Magnification

For higher numerical aperture lenses, the resolution provided by the objective at the intermediate image plane is often higher than the resolution provided by the photo-detecting surface. That is, the detector undersamples the image, and consequently, the image on the monitor or the image recorded digitally on the hard drive of a computer is limited by the pixel spacing of the camera, not the optical resolution of the objective. Thus, it is often of great importance to introduce additional magnification or "empty magnification" to the image formed on the photo-detecting surface. This is normally done with the auxiliary magnification wheel found on most modern microscopes or magnification in the phototube that holds the camera. The extent of empty magnification needed depends on the resolution or magnification of the objective lens and the physical pixel dimensions of the camera. To fully capture the resolution provided by the objective, the camera should oversample the image so that the most closely spaced line pair imaged by the objective will be separated by at least one and preferably two rows of unstimulated detector pixels. However, in introducing empty magnification, one should bear in mind that increases in magnification will reduce

image intensity per unit area by a factor of the magnification squared and reduce the field of view.

C. Camera Pixel Number and Resolution

It is tempting to think that cameras with large pixel arrays (say 1000×1000) will produce higher-resolution images than cameras with smaller pixel arrays (say 500×500). This is not strictly true, because empty magnification can always be used with a small-pixel array camera to capture the full resolution offered by the objective lens. The advantage of larger-array cameras is that one can image a larger field at a magnification that matches camera pixel spacing with the objective resolution. Put another way, at a given specimen field size, the larger-array cameras will capture an image with greater resolution.

Reference

Hinsch, J. (1999). *Meth. Cell Biol.* **56,** 147–152.

CHAPTER 2

The Optics of Microscope Image Formation

David E. Wolf

Sensor Technologies LLC
Shrewsbury, MA 01545

The nature of light is a subject of no material
importance to the concerns of life or to the
practice of the arts, but it is in many other respects extremely interesting.

Thomas Young[1] (1773–1829)
(M. Shamos, 1987)

[1] There is a coincidental connection between the lives of Jean Baptiste Fourier and Thomas Young that transcends optics. In 1798 Fourier joined Napoleon's army during the invasion of Egypt. Word of the French Expeditionary Force had reached Admiral Nelson, who unsuccessfully chased the French

I. Introduction

Although geometric optics gives us a good understanding of how the microscope works, it fails in one critical area: explaining the origin of microscope resolution. Why is it that one objective will resolve a structure whereas another will not? This is the question we will examine in this chapter. To accomplish this, we must consider the microscope from the viewpoint of physical optics. Useful further references are Inoué and Spring (1997), Jenkins and White (1957), Sommerfeld (1949a), and Born and Wolf (1980) for the optics of microscope image formation.

II. Physical Optics—The Superposition of Waves

Let us consider a simple type of wave, namely, a sine or cosine wave, such as that illustrated in Fig. 1. Mathematically the equation of the wave shown in Fig. 1 (dotted line) is

$$y(t) = y_0 \sin(\omega t). \tag{1}$$

Here we are considering the abstract concept of a wave in general. However, a clear example of a wave is the light wave. Light is a wave in both space and time. The equation for its electric field vector, E, takes the form

$$E(x, t) = E_0 \sin(kx - \omega t), \tag{2}$$

where ω (the frequency in radians per second) is related to the frequency of the light, v, in by the relation $\omega = 2\pi v$, and k is the wave number, which is related to the wavelength, λ, by the relation $k = 2\pi/\lambda = 2\pi v/c$, where c is the speed of light; *and* E_o is the amplitude. In Appendix I, we show that Eq. (2) represents the unique solution of the wave equation, which governs optics. Two additional points are worth mentioning here: First, that the intensity of light is the square of the electric

fleet across the Mediterranean. On August 1, his luck changed. The French fleet was anchored in a wide crescent at the bay at Aboukir, 37 km east of Alexandria. Secure on their shoreward side, the French had moved all of their cannons to the seaward side. At 5:40 PM Nelson began the assault. British Men-of-War *Goliath* and *Zealous* managed to wedge their way between the French and the shore. It was a bold move that led to the destruction of the French fleet and stranded the French Expeditionary Force in Egypt, among them Fourier (www.discovery.ca/napoleon/battle.cfm). The French expeditionary force is perhaps most famous for its discovery in 1799 by Dhautpol and Pierre-Francois Bouchard of the Rosetta stone near the town of Rosetta in the Nile delta. Translation of the Rosetta stone represented one of the great intellectual challenges of time and, similar to the work of Young and Fourier in physics and mathematics, respectively, it expanded humanity's worldview. Thomas Young was a brilliant linguist and was the first to recognize that some of the hieroglyphics on the Rosetta stone were alphabetic characters. Young's work was the critical starting point that ultimately enabled Jean Francois Champollion to complete the translation of the Rosetta stone (www.rosetta.com/RosettaStone.html).

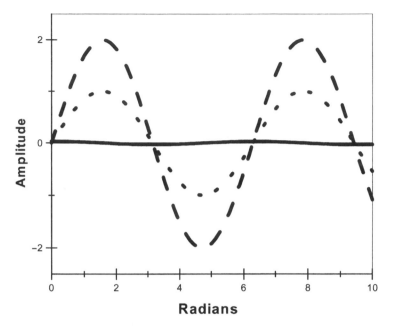

Fig. 1 Superposition of sine waves: *dotted line*, sin (x); *dashed line*, the condition of constructive interference sin (x) + sin $(2\pi + \phi)$; *solid line*, the condition of destructive interference sin (x) + sin $(x + \pi - \phi)$ where $\phi \ll 1$.

field vector; second, that the spatial and temporal components of the light wave can be separated.[1] As a result, you can view light as being a spatial sine or cosine wave moving through space with time.

Now let us suppose that we have two simultaneous waves with the same frequency,

$$y(t) = y_0 \sin(\omega t) + y_1 \sin(\omega t + \phi), \tag{3}$$

but that are phase shifted with respect to one another with a phase shift ϕ. The composite wave is determined by pointwise addition of the individual waves, a principle known as the superposition theorem. When the two waves are completely in phase, (i.e., $\phi = 0$), we have the condition of constructive interference shown in Fig. 1 (dashed line). When the two waves are 180° out of phase, we have the condition of destructive interference shown in Fig. 1 (solid line).

This can be most readily shown by adopting the exponential form of the wave:

$$E(x, t) = E_0 \ \mathbf{Re} \ \{e^{-i(kx - \omega t)}\},$$
$$E(x, t) = E_0 \ \mathbf{Re} \ \{e^{-ikx} \ e^{+i\omega t}\}.$$

III. Huygens' Principle

In 1678 the Dutch physicist Christiaan Huygens (1629–1695) evolved a theory of wave propagation that remains useful in understanding such phenomena as reflection, refraction, interference, and diffraction. Huygens's principle is that,

> All points on a wave front act as point sources for the production of spherical wavelets. At a later time the composite wave front is the surface which is tangential to all of these wavelets.

(Halliday and Resnick, 1970)

In Fig. 2, we illustrate how Huygens' principle or construction can be used to explain the propagation of a plane wave. We have chosen this example because it seems otherwise counterintuitive that one can construct a plane out of a set of finite radius spheres.

Expressed in this way, Huygens' principle is an empirical construct that will not explain all aspects and phenomena of light. Clearly, a complete description requires the application of James Clerk Maxwell's (1831–1879) wave equation and the boundary conditions of his electromagnetic theory. In Appendix I, we demonstrate that Eq. (2) is, indeed, a solution to Maxwell's wave equation. Gustav Kirchoff (1824–1887) has developed a more robust form of Huygens's principle that incorporates electromagnetic theory. In Appendix II, we develop the rudiments of Kirchoff's approach. Subsequently, in Appendix III, we use Kirchoff's solution to develop a mathematical treatment of the Airy disk. The reader is referred to Sommerfeld (1868–1951) (Sommerfield, 1949a) for an excellent description of diffraction theory.

Fig. 2 Huygens' construct illustrating how a plane wave front at time $t = 0$ propagates as a plane wave front at time t.

======= # IV. Young's Experiment—Two-Slit Interference

One usually sees Huygens' principle described using the quotation above. In practice however, it is more often applied by considering a wave surface and then asking what the field will be on at some point, P, away from the surface. The composite field will be given by the sum of spherical wavelets reaching this point at a given time. Because the distances between points on the surface and point P vary, it must be the case that for them to arrive simultaneously, they must have been generated at different points in the past. In this context, Huygens' principle is really an expression of the superposition theorem.

This was the approach taken by Thomas Young (1773–1829) in 1801 in explaining interference phenomena. Young's now classic experiments demonstrated the fundamental wave nature of light and brought Young into conflict with Sir Isaac Newton (1643–1727) and his Corpuscular Theory of Light. Young's experiment is illustrated in Fig. 3. Young used a slit at A to convert sunlight to a coherent spherical wave (Huygens's wavelet). Two slits are symmetrically positioned on B relative to the slit at A. Huygens's wavelets propagate from the two slits and will, at various points, constructively and destructively interfere with one another. Fig. 4 considers some arbitrary point P a distance y from the center of the surface C, which is a distance D from B. If the distance between the slits is d, the path length difference between the two wavelets at P will be $d \sin(\theta)$ and intensity maxima caused by constructive interference will occur when

$$d \sin(\theta) = m\lambda, \tag{4}$$

where $m = 0$, 1, 2, 3, and so forth. The pattern that Young saw is shown in Fig. 5 and is referred to as the double-slit interference pattern. One clearly observes the alternating intensity maxima and minima. The maxima correspond to the angles θ given by Eq. (4).

It is worthwhile to examine this problem more closely and to determine the actual intensity profile of the pattern in Fig. 5. Huygens's principle promises us that it derives from the superposition theorem. If the time-dependent wave from slit 2 is $E_2 = E_0 \sin \omega t$ and the wave from the first slit is $E_1 = E_0 \sin(\omega t + \phi)$, then the time-dependent wave at point P is

$$E = E_1 + E_2 = E_0(\sin \omega t + \sin [\omega t + \phi]), \tag{5}$$

where again $\phi = $ a $\sin \theta$. Eq. (5) may be algebraically manipulated as follows:

$$E = E_0(\sin \omega t + \sin \omega t \cos \phi + \cos \omega t \sin \phi)$$
$$= E_0(\sin \omega t(1 + \cos \phi) + \cos \omega t \sin \phi). \tag{6}$$

The intensity is given by E^2, therefore,

$$I = E_0^2(\sin^2 \omega t(1 + \cos \phi)^2 + \cos^2 \omega t \sin^2 \phi$$
$$+ 2 \sin \omega t \cos \omega t \sin \phi[1 + \cos \phi]). \tag{7}$$

Fig. 3 Young's double-slit experiment in terms of Huygens's construct.

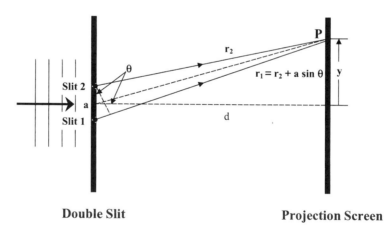

Double Slit **Projection Screen**

Fig. 4 Young's double-slit experiment showing the source of the phase shift geometrically.

What we observe physically is the time-averaged intensity, I_{AV}. Recalling that the time average of $\sin^2 \omega t$ and $\cos^2 \omega t$ is 1/2 whereas that of $2 \sin \omega t \cos \omega t = \sin 2\, \omega t = 0$, we obtain

$$I_{\mathrm{AV}} = \frac{E_0^2}{2}([1 + \cos\phi]^2 + \sin^2\phi) \tag{8}$$

Fig. 5 Young's double-slit interference pattern.

$$= \frac{E_0^2}{2}(1 + 2\cos\phi + \cos^2\phi + \sin^2\phi)$$
$$= E_0^2(1 + \cos\phi) \tag{9}$$
$$= 2E_0^2\cos^2\frac{\phi}{2}.$$

Considering Fig. 4, because the angle θ is small,

$$\phi = a\sin\overset{\simeq}{\theta}\, a\tan\theta = \frac{ay}{d}, \tag{10}$$

and therefore,

$$I_{AV} = 2E_0^2\cos^2\left(\frac{ay}{2d}\right). \tag{11}$$

In deriving Eq. (11) we have ignored the $1/r^2$ fall off of intensity. To allow for this, one would have to replace E in Eq. (5) by E/r. That is, we assume a spherical rather than a plane wave. This, of course, causes the intensity of the bands to fall off with increasing y.

In this derivation, one sees the fundamental application of the superposition theorem to derive the composite wave. In this case, the application is relatively straightforward as the wave at P is the superposition of only two waves. In other cases, such as the single-slit diffraction example that follows, the composite is a

superposition of an infinite number of waves, and the summation becomes an integration. In Appendix II, we consider Kirchoff's generalization of this problem to a scalar theory of diffraction.

V. Diffraction from a Single Slit

The double-slit interference experiment is an example of Huygens's principle of superposition where we have only two generating sites. A related interference phenomenon is that of single-slit diffraction, which is illustrated in Fig. 6. Here, we envision a plane wave impinging on a narrow slit of width a. We imagine the slit divided into infinitesimally narrow slits separated by distance dx, each of which acts as a site that generates a Huygens's wavelet. Two neighboring wavelets generate parallel wavelets. A lens collects these wavelets and brings them to a focus at the focal plane. We consider two wavelets from neighboring regions of the slit, which ultimately converge on point P of the focal plane. The path difference will be $dx \sin(\theta)$. Calculation of the resulting interference pattern referred to as single-slit Fraunhoffer (we define in the appendices what we mean by Fraunhoffer diffraction) diffraction requires summing or integrating over the entire surface of the slit and is illustrated in Fig. 7. Effectively, the single slit acts as an infinite set of slits. Indeed, you are probably more familiar with diffraction

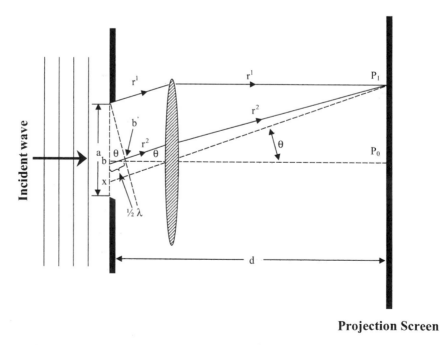

Fig. 6 The single-slit experiment showing the source of the phase shifts geometrically.

Fig. 7 The single-slit diffraction pattern.

produced by a grating, which is an infinite set of equally spaced slits separated by some fixed distance.

VI. The Airy Disk and the Issue of Microscope Resolution

We are now in a position to turn our attention to how interference affects microscope images: How does a microscope treat a point source of light? You might ask, Why do we care? We care because ultimately all objects can be represented as the sum of an infinite set of point sources. If we know how the microscope treats (distorts, if you will) a point object, we know how it treats any object. This is the concept of the point-spread function, because a point of light is confused or spread out by both the optical and the electronic system of the digital or video microscope system. We will encounter this concept progressively throughout this volume. This spreading is an example of what mathematicians refer to as convolution. In Chapter 11, we will be introduced to the concept of convolution. Unfortunately, the reverse process, which we might refer to as deconvolution, is not mathematically trivial. Later in this chapter we will introduce the concept of Fourier series and transforms, both as an introduction to the idea of spatial frequencies and to provide the mathematical tools necessary to understand deconvolution. The

concept of deconvolution using Fourier transforms will finally be considered in the Chapters 16 and 17.

In Fig. 8, we illustrate how a microscope views a point source of light. One expects from consideration of geometric optics that a point of light at A will be focused by the objective to a point on the image plane. However, Huygens teaches us that the two points on the wavefront act as generation sites for Huygens's wavelets. Although most of the light goes to the center-point on the image plane, where it constructively interferes to produce a bright spot, some of it also goes to other points. At the second point shown in the figure, the two waves will be phase shifted. The result is an interference pattern on the image plane. Rather than focusing the point source to a spot, the actual image shown in Fig. 9 is known as the Airy disk, after George Biddell Airy (1801–1892). The ability of the microscope to resolve two spots as two ultimately relates to how sharply the Airy disks are defined (see Fig. 10). For self-luminous point sources, such as the ones obtained in fluorescence microscopy, the Airy disks are independent and do not interfere with one another.

An empirical criterion for resolution for such self-luminous objects that is related to the separation where the primary maximum of the second Airy disk coincides with the primary minimum of the first is

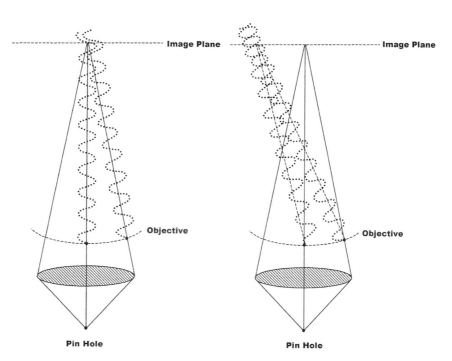

Fig. 8 A point of light viewed in the microscope showing how interference leads to the Airy disk pattern.

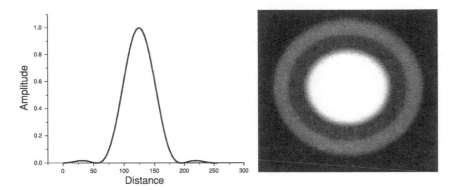

Fig. 9 The Airy disk: Notice how the intensity of the secondary ring is only about 2% of the intensity of the primary maximum. The ability to see this ring in the microscope offers an empirical test of noise rejection in the microscope.

$$r = 1.22\lambda_0/(2\mathrm{NA_{obj}}) \tag{12}$$

and is known as Rayleigh's criterion. The NA (numerical aperture) of an objective is related to the collection angle θ and is given by

$$\mathrm{NA} = n \sin(\theta) \tag{13}$$

where n is the index of refraction. For bright field images, the point sources will be partially coherent, and the resolution will also be dependent on the NA of the condenser. Thus, for bright field point sources, resolution is given by

$$r = 1.22\lambda_0/(\mathrm{NA_{obj}} + \mathrm{NA_{cond}}). \tag{14}$$

In a modern context, it is important to recognize that Rayleigh's criterion is empirical and ultimately based on the human eye's ability to resolve intensity differences. It asks the question, or more accurately, states the answer to the question, What is the minimum intensity dip between the two maxima required for the human eye to resolve them as two Airy disks? With modern image detectors and image processing, it is possible to push these limits. We will explore this issue further in subsequent chapters.

On deeper consideration of Fig. 8, the reader may be tempted to cry foul. There is a point at which the spherical wavelets emitted from the two points destructively interfere, but what about wavelets from all of the other generating centers between these points? In reality, we must consider and superimpose all of the wavelets to generate the composite field at any point P. In Appendix II, we will discuss Kirchoff's approach to this problem, and in Appendix III, we will apply the approach to the problem of the Airy disk.

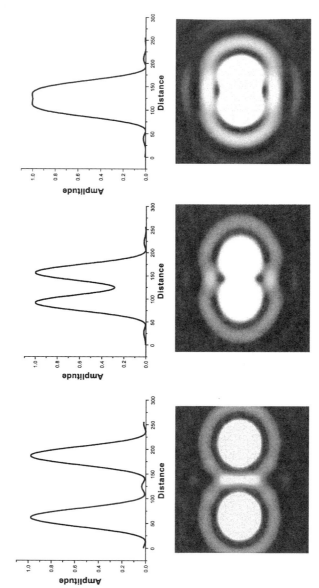

Fig. 10 Defining resolutions as the ability to distinguish two Airy disks: As the disks come closer, the intensity dip between them becomes smaller. Resolution definitions such as Rayleigh's criteria set are based on the ability of the human eye to detect this dip. Other criteria may be more appropriate for digital systems.

VII. Fourier or Reciprocal Space—The Concept of Spatial Frequencies

The issue of resolution also relates to the amount of contrast (the difference between light and dark) and the sharpness of edges. To understand these questions, we must take a detour into what may at first appear to be a strictly mathematical domain. This is the concept of Fourier, or reciprocal, space. This concept is fundamental to understanding the optics of microscope image formation.

We must begin with the concept of a spatial frequency. Consider, for instance, the picture in Fig. 11A. When we look at this, or any, scene our first inclination is to say that the sizes of the objects are random. On closer examination, we realize that this is not really the case. Every scene has certain characteristic spacings in it. We have drawn some of these characteristic frequencies as $sine^2$ waves over the figure. Mathematically, these spacings are referred to as spatial frequencies. (More accurately, we might refer to spatial wavelengths, L, and define the spatial frequencies as $2\pi/L$.) In every scene, certain spatial frequencies dominate over others. This concept may seem very abstract at first. When you think about it, one point that you will probably recognize is that fine detail is described by high spatial frequencies. So in some sense, the highest spatial frequency, which we can detect, must be related to the resolution limit of our optical system. If you take a magnifying glass and examine Fig. 11A closely, you will see dots. What this tells us is that there is a cutoff, a highest spatial frequency, beyond which the printer did not need to go to accurately portray the photograph. This is very clear in digital photography. When you look at a high-resolution digital photograph, it is nice and sharp; as you zoom in, however, you will eventually see the pixels. The maximum spatial frequency used in the photograph, is 2π divided by the interpixel distance.

One might think that although light waves can be represented by sine waves, or more accurately a sum of sine waves, this might not be the case for all waves. Let's phrase this differently: Can we put this abstract concept of spatial frequencies into a coherent mathematical context? To approach this problem, let us simplify it a bit. Suppose that rather than dealing with the two-dimensional image of Fig. 11A, we scan one horizontal line across this image and look at the intensity as a function of position. Such a line is shown in Fig. 11B. Again, the information is not random. We can clearly see characteristic spatial frequencies.

Jean-Baptiste Fourier (1768–1830), in the early nineteenth century, demonstrated the remarkable fact that any wave or function could be described as a sum of sine waves (actually, sine + cosine waves). Rather than work with the scan of Fig. 11B, let us consider a simpler but more challenging pattern, namely, that of a step function, as illustrated below in Fig. 12A—a step function that is an alternating pattern of white and black bands. One might think that nothing is farther from a sine wave.

Fig. 11 (A) Every object or image has characteristic spatial frequencies. (B) A linescan across the books in Fig. 11.

However, think about it a little more closely. If we draw a sine wave with the same spacing, it approximates the step function (Fig. 12A). This is the lowest spatial frequency, $2\pi/L$. We next try to fill in the gaps by adding some amount of a sine wave with spatial frequency $3 \times (2\pi/L)$ (Fig. 12B). As one successively adds sine waves of shorter and shorter wavelength (spatial frequencies $m \times (2\pi/L)$, where m is odd) (Fig. 12C–F) in the appropriate proportions, the resulting sum looks more and more like a step function. To achieve perfect match, one has to use an infinite number of sine waves. However, as the amplitudes of the waves decreases rapidly and monotonically, any given degree of approximation can be achieved with a finite number of sine functions. It is significant to note that when one cuts off the summation at a finite number of sine waves, the resultant wave shows oscillations or "ringing," which is most apparent at the edge of the step (Fig. 12F). As we will see, the optical ringing at the edges of objects in the light microscope is caused by incomplete reconstruction of Fourier series. Indeed, microscopes always act as low-pass filters with some maximum spatial frequency making it through, and as we shall see, is the basis of resolution in the microscope.

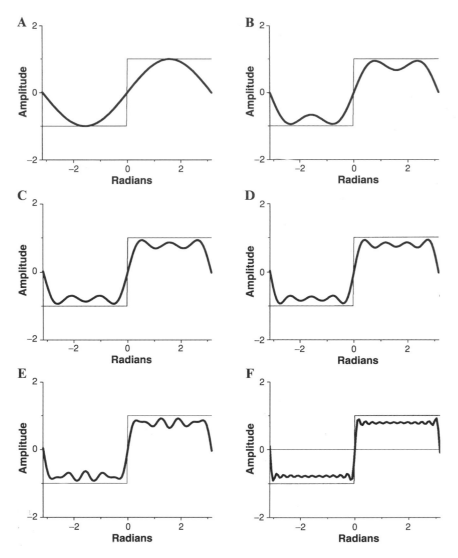

Fig. 12 Fourier's construction of a step from a composite of sine waves: (A) sin x, (B) sin $x +$ 1/3 sin 3x, (C) sin $x +$ 1/3 sin 3$x +$ 1/5 sin 5x, (D) sin $x +$ 1/3 sin 3$x +$ 1/5 sin 5$x +$ 1/7 sin 7x, (E) sin $x +$ 1/3 sin 3$x +$ 1/5 sin 5$x +$ 1/7 sin 7$x +$ 1/9 sin 9x, (F) up to the term 1/23 sin 23x. Notice that even in (F) there is ringing of the intensity pattern.

In Fig. 13, we show the amplitudes of the spatial frequencies of the step function. Such a plot is referred to as the Fourier transform of the original function. Note that in the case of the step function, the function is not continuous but rather discrete. That is, only those spatial frequencies, that are odd numbers have nonzero amplitude. In fact, for a spatial frequency m, the amplitude is 1/m.

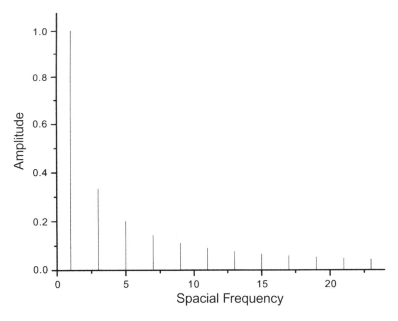

Fig. 13 The amplitudes of the frequency terms: This is the so-called Fourier transform of the step function.

In Fig. 14, we use the Fourier series to recreate the step function as an image. In Fig. 14A, we have generated an image with a sinusoidally varying intensity. We can get a sense of the bars of the step function, but the edges are very fuzzy. In Fig. 14B–E we progressively add the sin $3\times$, sin $5\times$, sin $7\times$, sin $9\times$ terms. With the addition of each higher-order spatial frequency, the edges become more and more distinct. However, in each case we can see ringing at the edges because we lack higher-order terms.

Next we ask the question, What will happen if we eliminate the first term in the series? This is shown in Fig. 14F. What happens is that we now have a perfectly reasonable looking step function, only its bars are now twice as close as before.

In this discussion, we have considered a one-dimensional Fourier series. One can also perform Fourier transforms on two-dimensional patterns (i.e., images) or even three-dimensional patterns such as a z-stack of images. In Appendix I, we develop the mathematics of Fourier series and transforms. Reducing a wave to a Fourier series is derived, following Carl Friedrich Gauss (1777–1855), as being essentially equivalent to a problem in nonlinear least squares curve fitting: The solution of the step function is derived explicitly, the integral form is developed, and finally, the application of Fourier transforms to solving the wave equation of electrodynamics and optics is discussed.

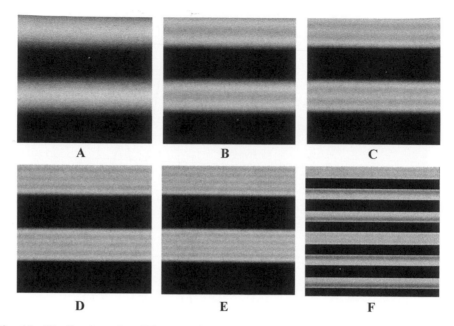

Fig. 14 The Fourier series of Figure 13 shown as an image; (A) to (E) correspond to Fig. 13. In (F) we have removed the sin x term, which causes a doubling of the frequency pattern.

VIII. Resolution of the Microscope

Physical systems, such as microscopes, tend to pass only a certain set of spatial frequencies. In a sense, the highest frequency passed becomes a measure of resolution. An object such as diffraction grating, which is essentially the step wave shown in Fig. 14, requires all spatial frequencies to see it correctly. How a microscope treats such an object is illustrated in Fig. 15. When the grating is illuminated with a bundle of planar light, say at the center, the zeroth-order undiffracted light propagates straight through as one bundle, whereas higher orders are diffracted and propagate as parallel bundles at appropriate angles. Because all of these bundles are parallel, they will be focused by the objective at the back focal plane, with higher orders appropriately displaced from the center. A Fourier transform of the image forms at the back focal plane. These bundles recombine at the image plane to form a real image of the diffraction grating. You can see the problem immediately: Not all of the orders will make it through the objective. There is a cutoff, and higher orders fail to enter the objective. The larger the collection angle (the NA) of the objective, the higher the cutoff and the higher the resolution. So far, we have discussed what's going on at the center of the object. The situation becomes more complex as one moves away from the center. The cutoff frequency on the two sides becomes asymmetric. The resolution limit is effectively defined by the highest spatial frequency that enters the objective.

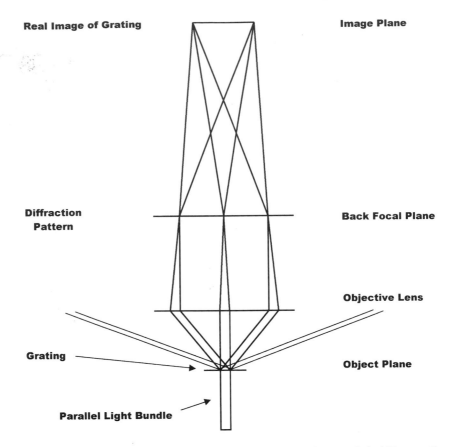

Real Image of Grating

Image Plane

Diffraction Pattern

Back Focal Plane

Objective Lens

Grating

Object Plane

Parallel Light Bundle

Fig. 15 In the microscope, the resolution limit results from the microscope's inability to collect all spatial frequencies. Objects act as diffraction gratings and Fourier transform of the object forms at the back focal plane.

In Fig. 16 we image the back focal plane for Fourier transform of biological specimens. We have chosen specimens with some well defined structure. Figure 16A shows a diatom and Fig. 16B a muscle section. For comparison we also show the specimens viewed in the image plane.

IX. Resolution and Contrast

We have previously seen how resolution can be defined in terms of our ability to distinguish between two Airy disks. As the disks come closer and closer, which corresponds to trying a higher and higher spatial frequency, the contrast between

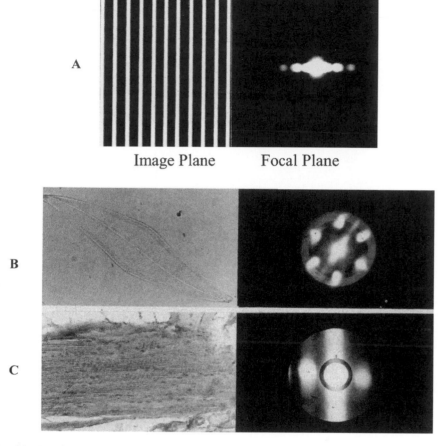

Image Plane Focal Plane

Fig. 16 Fourier patterns at the back focal plane of the objective for (A) a Ronchi ruling, (B) a diatom, (C) a muscle fiber. Courtesy Greenfield Sluder.

the two disks decreases. The resolution limit is reached when the contrast between the two points becomes sufficiently small that they can no longer be distinguished as two separate points. We see that image contrast and resolution become highly intertwined factors. This is illustrated in Fig. 17, where sine waves of increasing spatial frequency (left to right) and increasing contrast (bottom to top) are displayed as an image; the higher the contrast the higher the detectable spatial frequency. In Fig. 18 we show this same fact for hypothetical microscope objectives. Resolution (highest collected spatial frequency) clearly increases with increasing numerical aperture. However, for a given objective, the greater the contrast the greater the resolution.

Modulation Transfer Function

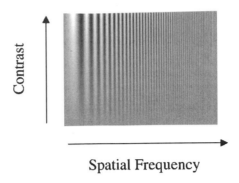

Fig. 17 Increasing contrast increases resolution (the highest detectable spatial resolution).

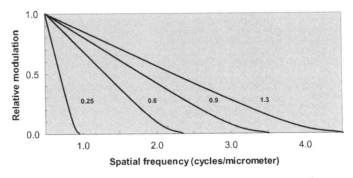

Fig. 18 The relationship between contrast (relative modulation) and resolution (highest discernable spatial frequency) for objectives with $NA = 0.25$, 0.6, 0.9, and 1.3.

X. Conclusions

In this chapter we have described Abbe's Theory of the Microscope relating resolution to the highest spatial frequency that a microscope can collect. We have shown that this limit increases with increasing numerical aperture. As a corollary to this, resolution increases with decreasing wavelength because of how NA depends upon wavelength. The resolution is higher for blue light than for red light. Finally, we see that resolution is dependent on contrast and that the higher the contrast, the higher the resolution.

Ultimately, this last point relates to issues of signal-to-noise and dynamic range. The use of video and new digital cameras has necessitated redefining classical limits such as those of Rayleigh's criterion. In subsequent chapters, we will further explore these critical issues.

XI. Appendix I

A. Fourier Series

In the chapter we indicated that a light wave could be represented by the equation

$$E(x_1 t) = E_0 e^{-i(kx-wt)}. \tag{1}$$

One might ask, Where this comes from? We know that the mathematical form of the wave must satisfy Maxwell's wave equation, and we can, indeed, show that it is a solution of this equation. Yet we may still ask to what extent is it the only solution? It was considerations such as these that led to the development of Fourier series and transforms. At the end of this appendix we will see why. We begin by exploring briefly the concept of the Fourier series and their importance in optics. For a more extensive discussion the reader is referred to the elegant treatment by Arnold Sommerfeld in his book *Partial Differential Equations in Physics* (Sommerfield, 1949b). Suppose that one has an arbitrary function, a wave form, $f(x)$, which is defined over the interval of $-\pi$ to π. (By suitable rescaling, any interval $-L/2$ to $L/2$ can be redefined to meet this criterion.) We next suppose that this function can be approximated by a function $S_n(x)$, which is the sum of a series of n sine waves and n cosine waves with coefficients A_m and B_m plus a constant A_0. That is,

$$S_n(x) = A_0 + \sum_{m=1}^{n} \{A_m \sin(mx) + B_m \cos(mx)\}. \tag{2}$$

The problem, then, is to determine the $2n + 1$ coefficients A_m and B_m that define the $S_n(x)$. This problem, is equivalent to the problem of fitting experimental data to a curve or mathematical function. As in the curve-fitting problem, we recognize that for every value of x there is a deviation or difference $\delta(x)$ between the approximation $S_n(x)$ and the function $f(x)$. That is,

$$f(x) = S_n(x) + \delta(x). \tag{3}$$

The goal is to minimize the square of the deviation over the entire interval $-\pi$ to π. That is, we seek to minimize χ^2, where

$$\chi^2 = \frac{1}{2\pi} \int_{-\pi}^{+\pi} \delta_n^2(x) dx. \tag{4}$$

Minimization requires that all of the partial derivatives of χ^2 with respect to the A_m's and the B_m's be simultaneously equal to 0. For an arbitrary value of m, we have that,

$$-\frac{\partial \chi^2}{\partial A_m^2} = \frac{1}{\pi} \int_{-\pi}^{+\pi} \{f(x) - S_n(x)\} \cos(mx)dx = 0, \text{ and}$$

$$-\frac{\partial \chi^2}{\partial B_m^2} = \frac{1}{\pi} \int_{-\pi}^{+\pi} \{f(x) - S_n(x)\} \sin(mx)dx = 0.$$

(5)

One can then solve Eq. (5) for the $2n + 1$ coefficients by putting Eq. (2) into Eq. (5) and making use of the orthogonal properties of the sine and cosine functions, namely, that:

$$\frac{1}{\pi} \int_{-\pi}^{+\pi} \cos(px) \sin(qx)dx = 0 \qquad \text{for (all values of } p \text{ and } q) \qquad (6a)$$

$$\frac{1}{\pi} \int_{-\pi}^{+\pi} \cos(px) \cos(qx)dx = 0 \qquad \text{for } (p \neq q),$$

$$= 1 \qquad \text{for } (p = q),$$

(6b)

$$\frac{1}{\pi} \int_{-\pi}^{+\pi} \cos(px) \cos(qx)dx = 0 \qquad \text{for } (p \neq q),$$

$$= 1 \qquad \text{for } (p = q),$$

(6c)

$$\frac{1}{\pi} \int_{-\pi}^{+\pi} \sin(px) \sin(qx)dx = 0 \qquad \text{for } (p \neq q),$$

$$= 1 \qquad \text{for } (p = q).$$

(6d)

Substituting the conditions of Eq. (6) as well as the trivial condition that

$$\frac{1}{2\pi} \int_{-\pi}^{+\pi} dx = 1$$

(7)

we find that

$$A_m = \frac{1}{\pi} \int_{-\pi}^{+\pi} f(x) \cos(mx) \, dx,$$

(8a)

$$B_m = \frac{1}{\pi} \int\limits_{-\pi}^{+\pi} f(x) \sin(mx)dx, \tag{8b}$$

$$A_0 = \frac{1}{2\pi} \int\limits_{-\pi}^{+\pi} f(x)dx. \tag{8c}$$

The $2n+1$ coefficients can be determined by means of Eq. (8).

A rigorous mathematical treatment (Sommerfeld, 1949a) must demonstrate three critical points: that as n $\rightarrow \infty$, that χ^2, indeed $\delta(x)$ for all values of x, goes to 0; that a solution exists; and that the solution is unique. Here, we will assume these three points and go on to examine the problem of the step function.

The step function is given by

$$\begin{aligned} f(x) &= -1 \qquad \text{for } -\pi < x < 0 \\ f(x) &= +1 \qquad \text{for } 0 < x < +\pi. \end{aligned} \tag{9}$$

Before applying Eq. (7) and (8) we recognize that, as we are centering the step function around a DC level of 0, that $A_0 = 0$. Furthermore, we recognize that as the function must have a node at $-\pi$, 0, and $+\pi$, the function is a series in sines with odd coefficients, m. This last condition means that all of the B_m's equal 0 and that all A_m's $= 0$ where m is even. Inserting Eq. (9) into Eq. (8a) gives us the Fourier series for the step function, namely,

$$f(x) = \sum_{m=0}^{\infty} \left(\frac{1}{2m+1} \right) \sin[(2m+1)x]. \tag{10}$$

Related to the Fourier series is the concept of the Fourier transform. The function in real space is described by $f(x)$. We alternatively speak of the function being described in frequency or reciprocal space. This frequency space description is referred to as the Fourier transform, $\Im(\nu) = \Im\{f(x)\}$, of the function. For the step functions, $\Im(\nu) = 0$ except for $\nu = 2m+1$, where $\Im(\nu) = \frac{1}{2m+1}$ and m is an integer. For completeness we also speak of the inverse Fourier transform \Im^{-1}. This leads to the trivial identity that

$$\Im^{-1}[\Im\{f(x)\}] = f(x). \tag{11}$$

The requirement that the function have nodes at $-\pi$, 0, and $+\pi$, or more generally the requirement that the function is defined over a finite interval with specific boundary values, leads to series like that of Eq. (9) wherein the series contains only a subset of all possible sine waves defined by the eigen values m. In the more general case, all possible sine and cosine waves represent possibilities, and the summation in the equation is replaced by an integral. In such cases, it is

more convenient to use the exponential form of the wave, e^{ikx}. The connection between this representation and the sine/cosine representation is contained in the trigonometric identities

$$\sin(kx) = \frac{e^{ikx} - e^{-ikx}}{2i},$$ (12a)

$$\cos(kx) = \frac{e^{ikx} + e^{-ikx}}{2i}.$$ (12b)

We may then define the Fourier transform of the function $f(x)$ as

$$\Im(s) = \frac{1}{\sqrt{2\pi}} \int_{-\infty}^{+\infty} f(x)e^{-isx}dx,$$ (13a)

and the inverse Fourier transform by

$$\Im^{-1}(x) = \frac{1}{\sqrt{2\pi}} \int_{-\infty}^{+\infty} \Im(s)e^{isx}ds.$$ (13b)

We have here derived the concept of Fourier series and Fourier transforms as a means of introducing the fact that the diffraction pattern is the Fourier transform of the object and that the diffraction pattern may be observed at the back focal plane of the microscope objective. As the reader will see in subsequent chapters (11, 16, and 17) the Fourier transform becomes a powerful tool in digital deconvolution techniques to remove out-of-focus fluorescence. Ultimately, this results from the fact that the Fourier transform of the object is the diffraction pattern observed at the back focal plane of the objective. Indeed, some laboratories have created Fourier filters of the image not by digital transformation but by physically masking specific frequencies at the back focal plane (Hui and Parsons, 1975).

Fourier transforms also are very powerful tools for solving partial differential equations such as the wave equations. Let us suppose, as an example, that we have an electromagnetic wave, which is propagating in the x direction and polarized so that it is confined to the z direction. Then we can write the wave equation for the electric field as:

$$\frac{\partial^2 E}{\partial t^2} = c^2 \frac{\partial^2 E}{\partial z^2}.$$ (14)

We next Fourier transform both sides of Eq. (14). If we reverse the order of integration and differentiation, we obtain

$$\frac{d^2\Im(E)}{dt^2} = -s^2 c^2 \Im(E).$$ (15)

Note that this is a simple rather than a partial differential equation. We can then write,

$$\Im(E) = \Im_0(E)e^{-isct}. \tag{16}$$

All that remains to be done to determine E is to inverse Fourier transform Eq. (14). Let us assume that $E(x) = E_0 e^{ikx}$. Fourier has already taught us that this is not a big assumption, as even if it is not true, it will be the case that the wave can be represented as a sum or distribution of terms $E_0 e^{ikx}$. Then the Fourier transform is determined by putting Eq. (11) in to Eq. (14):

$$\Im(E) = E_0 e^{-isct} \frac{1}{\sqrt{2\pi}} \int_{-\infty}^{+\infty} e^{i(k-s)x} dx. \tag{17}$$

The integral m Eq. (17) is the Dirac Delta Function given by

$$\delta(k-s) = \frac{1}{\sqrt{2\pi}} \int_{-\infty}^{+\infty} e^{i(k-s)x} dx, \tag{18}$$

then

$$\Im(E) = E_0 e^{-isct} \delta(k-s). \tag{19}$$

The critical property of the Dirac Delta Function is that it is 0 for all values of s except for $s = k$, where the function has the value of 1.
We next inverse Fourier transform Eq. (19)

$$E = E_0 \int e^{-i(sct-sx)} \delta(k-s) ds. \tag{20}$$

The properties of the Dirac Delta Function lead us to

$$E = E_0 e^{i(kx-kct)}, \tag{21}$$

remembering that

$$k = \frac{2\pi}{\lambda} = \frac{2\pi\upsilon}{c} = \frac{\omega}{c}. \tag{22}$$

We obtain

$$E = E_0 e^{i(kx-\omega t)}. \tag{23}$$

We have now come full circle. We have shown that e^{ikx} is a solution to the spatial part of the wave equation. We have further shown that any solution can be represented as a Fourier sum or distribution of such solutions. Finally, we have used the Fourier transform to demonstrate that given the form e^{ikx} of the spatial dependence, e^{-iwt} must be the solution of the temporal dependence.

XII. Appendix II

A. Kirchoff's Scalar Theory of Diffraction: Recasting Huygens's Principle in an Electrodynamic Context

Our goal in this appendix is to describe Kirchoff's formulation of Huygens' principle in terms of electrodynamic field theory. Here we will follow the derivation of Sommerfield in his book *Optics, Lectures on Theoretical Physics* (Sommerfield, 1949a). We present an outline of the theory, and the reader is referred to the original for more details. Other texts with excellent discussions of this problem and the problem of the diffraction pattern from a circular aperture are *An Introduction to Fourier Optics* (Goodman, 1968) and *Electrodynamics* (Jackson, 1975). The latter is particularly valuable as it treats the full vectorial solution rather than the scalar approximation. The reader is further referred to *Principles of Optics* (Born and Wolf, 1980).

B. Generalizing the Problem

Figure A1 represents a generalized view of diffraction problems. We have a point P and a surface. The surface consists of an opaque region, $\bar{\sigma}$, and an aperture region, σ. The basic question how the field at P relates to the field in the aperture, σ.

For mathematical purposes we define an exterior and an interior to the surface and we create a second infinitesimally small spherical surface K around the point P. This serves to isolate the singularity at P and to create a closed surface for purposes of investigation. In the figure, dn represents the normal to the surface at any point r.

Fig. A1 The generalized condition of an opaque surface $\bar{\sigma}$ with an aperture σ.

C. Scalar Spherical Waves

In the chapter we have dealt with plane waves of the form e^{ikx}, which depend only on the coordinate x. Here we must deal with a scalar spherical wave, which depends only on the radial value r. Such waves must, in general, be solutions of the equation

$$\frac{1}{r} \cdot \frac{\partial^2 (ru)}{\partial r^2} + k^2 u = 0. \tag{1}$$

Eq. (1) is the wave equation in spherical coordinates assuming spherical symmetry; that is, no angular dependence.

The so-called principal solution of Eq. (1) has the form

$$u = \frac{1}{r} e^{ikr}. \tag{2}$$

D. Green's Theorem

Here we need to integrate over the surface σ to find our solution. This is accomplished using Green's function, G, to find the solution, which we call V_p for the field at P. In general, Green's theorem tells us that

$$\int \left\{ G\frac{1}{r}\left(\frac{d^2 rv}{dr^2}\right) - v\frac{1}{r} \times \frac{d^2 rG}{dr^2} \right\} d\tau = \int \left(G\frac{\partial v}{\partial n} - v\frac{\partial G}{\partial n} \right) d\sigma, \tag{3}$$

where $d\tau$ represents the volume element within the surface and $d\sigma$ represents the surface element.

The use of $G = u$ leads to contradictions because of the requirement that $v = 0$ and $\frac{\partial v}{\partial n} = 0$ everywhere on the surface $\bar{\sigma}$. Instead, we define G by the conditions that

$$\frac{1}{r} \times \frac{\partial^2 rG}{\partial r} + k^2 G = 0 \quad \text{within the volume;} \tag{4a}$$

$$G = 0 \text{ on } \sigma; \tag{4b}$$

$$G \to u \text{ as } r \to 0; \tag{4c}$$

$$r\left(\frac{\partial G}{\partial n} - ikG\right) \to 0 \text{ as } r \to \infty. \tag{4d}$$

It is Eq. (4d) that enables the boundary conditions on v without contradiction. If we define the volume as the exterior exclusive of the volume surrounding P by K, then the left side of Eq. (3) vanishes. Integration of the right-hand side over K leads to $-4\pi v_p$. Thus Eq. (3) reduces to

$$4\pi v_p = \int_\sigma \left\{ \frac{\partial v}{\partial n} G - v \frac{\partial G}{\partial n} \right\} d\sigma. \tag{5}$$

Applying the condition $\dfrac{\partial v}{\partial n} = 0$ on σ, Eq. (5) becomes

$$4\pi v_p = \int_\sigma -v \frac{\partial G}{\partial n} \delta\sigma. \tag{6}$$

The boundary conditions on v are

$$v = 0 \text{ on } \bar\sigma; \tag{7a}$$

$$v = \frac{A \exp ikr'}{r'} \text{ on } \sigma. \tag{7b}$$

E. Solution for a Plane

This problem simplifies where the screen or surface is a plane. In that case, Green's function can be conveniently expressed by the method of images (to satisfy the condition in Eq. (4b) that $G = 0$ on σ). Referring to Fig. A2 if the point P is at arbitrary coordinate (x, y, z), then the image point is at coordinates $(x, y, -z)$. For an arbitrary point Q with coordinates (ξ, η, ζ), we have

$$G = \frac{e^{ikr_1}}{r_1} - \frac{e^{ikr_2}}{r_2}, \tag{8a}$$

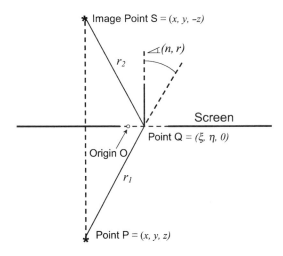

Fig. 2 Method of images applied to the generalizable diffraction problem.

$$\text{where } r_1^2 = (\xi - x)^2 + (\eta - y)^2 + (\zeta - z)^2 \tag{8b}$$

$$\text{and } r_2^2 = (\xi - x)^2 + (\eta - y)^2 + (\xi + z)^2. \tag{8c}$$

We next calculate

$$\frac{\partial G}{\delta \zeta} = \frac{d}{dr_1}\left(\frac{e^{ikr_1}}{r_1}\right)\frac{\partial r_1}{\partial \zeta} - \frac{d}{dr_1}\left(\frac{e^{ikr_1}}{r_1}\right)\frac{\partial r_2}{\partial \zeta}; \tag{9}$$

$$\frac{\partial G}{\partial n} = \frac{-\partial G}{\partial \zeta} = 2\frac{\partial}{\partial r}\left(\frac{e^{ikr}}{r}\right)\cos(n, r). \tag{10}$$

We than have that

$$\frac{\partial}{\partial r}\left(\frac{e^{ikr}}{r}\right) = \frac{ike^{ikr}}{r} - \frac{1}{r^2}e^{ikr} \\ = \frac{ike^{ikr}}{r}\left(1 - \frac{1}{ikr}\right). \tag{11}$$

In the limit of large r we have that $kr = \frac{2\pi r}{\lambda} \gg 1$ and

$$\frac{\partial}{\partial}\left(\frac{e^{ikr}}{r}\right) \sim \frac{2\pi i}{\lambda}\frac{e^{ikr}}{r}. \tag{12}$$

Putting Eq. (12) into Eq. (10), and that into Eq. (6), we can solve for v_p.

$$i\lambda v_p = \int_\sigma \frac{e^{ikr}}{r}\cos(n, r)v d\sigma. \tag{13}$$

F. Huygens' Principle

Equation (13) is mathematically equivalent to Huygens's Principle. A light wave falling on the aperture σ propagates as if every element $\delta\sigma$ emitted a spherical wave, the amplitude and phase of which are given by that of the incident wave v.

If we assume point source illumination, then

$$v = \frac{Ae^{ikr'}}{r'}, \tag{14}$$

in which case,

$$i\lambda v_p = A\int e^{ik(r+r')}\frac{\cos(n, r)\delta\sigma}{rr'}. \tag{15}$$

XIII. Appendix III

A. Diffraction by a Circular Aperture from which the Airy Disk Comes

Our next goal is to understand the origin of the Airy Disk in the context of Kirchoff's formulation of Huygens' principle. We again follow Sommerfeld in this discussion. If we take as our starting point Eq. (15) of Appendix II and further assume that dimensions of the aperture are small compared to the distance r_1 and r_2, then the term $\cos(n,r)/r_1 r_2$ varies little within the opening. Hence, that term may be taken outside of the integral. Replacing r and r' with R and R', their respective values at the center of the aperture, Eq. (15) becomes

$$i\lambda v_p = \frac{A}{RR'}\cos(n,r)\int e^{ik(r+r')}\delta\eta\delta\xi, \tag{1}$$

where η and ξ have the same meaning as in Appendix II. Now,

$$r = \sqrt{(x-\xi)^2 + (y-n)^2 + z^2}. \tag{2}$$

Because $R^2 = x^2 + y^2 + z^2$,

$$\begin{aligned}
r &= \sqrt{R^2 - 2(x\xi + y\eta) + \xi^2 + \eta^2} \\
&\cong R - \frac{x}{R}\xi - \frac{y}{R}\eta + \frac{\xi^2 + \eta^2}{2R} - \frac{(x\xi + y\eta)^2}{2R^2} \\
&= R - \alpha\xi - \beta\eta + \frac{\xi^2 + \eta^2 - (\alpha\xi + \beta\eta)^2}{2R},
\end{aligned} \tag{3}$$

to second order in ξ and η.

Where α and β are respectively the directional cosines of the diffracted ray $O \rightarrow P'$,

$$r' = R' + \alpha_0\xi + \beta_0\eta + \frac{\xi^2 + \eta^2 - (\alpha_0\xi + \beta_0\eta)^2}{2R'}. \tag{4}$$

It then follows that

$$e^{ik(r+r')} = e^{ik(R+R')}e^{-ik\Phi}, \tag{5}$$

where

$$\Phi = (\alpha - \alpha_0)\xi + (\beta - \beta_0)\eta - \left(\frac{1}{R} + \frac{1}{R'}\right)\frac{\xi^2 + \eta^2}{2} + \frac{(\alpha\xi + \beta\eta)^2}{2R} + \frac{(\alpha_0\xi + \beta_0\eta)^2}{2R'}. \tag{6}$$

With these modifications Eq. (1) becomes

$$i\lambda v_p = \frac{A}{RR'}\cos(n,R)e^{ik(R+R^1)}\int e^{-ik\Phi}\delta\xi\delta\eta. \tag{7}$$

We have, as they say, reached the proverbial end of the tunnel. For the microscope, both R and R' are large in comparison to the dimensions of the aperture. This is the important condition of Fraunhoffer diffraction. In this limit, Φ becomes linear in ξ and η:

$$\Phi \cong (\alpha - \alpha_0)\xi + (\beta - \beta_0)\eta. \tag{8}$$

We define

$$a = \alpha - \alpha_0, \tag{9a}$$

and

$$b = \beta - \beta_0, \tag{9b}$$

in which case,

$$\Phi \cong a\xi + b\eta. \tag{10}$$

Considering the problem of a small circular aperture in the microscope, we recognize that in the Fraunhoffer limit RR' and $\cos(n, r)$ vary very little. Because $|\exp ik(R + R')\,\xi| = 1$ and A is a constant, we may rewrite Eq. (7) as

$$v_p = C \int e^{ik\Phi}\,\delta\xi\delta\eta, \tag{11}$$

where C is a constant.

If we replace the coordinates (ξ, η) and the directional cosines (a, b) with polar coordinates, that is,

$$\xi = r \cos \varphi; \tag{12a}$$

$$\eta = r \sin \varphi; \tag{12b}$$

$$a = s \cos \psi, \tag{12c}$$

$$b = s \sin \psi, \tag{12d}$$

where r is the distance from the center of the opening, and s is the sine of the deflection angle between the diffracted ray and the perpendicular incident ray (the undiffracted ray), thus we may rewrite Eq. 11 as

$$v_p = Ck \int_0^{d/2} r\,dr \int_{-\pi}^{\pi} e^{-ikrs\cos(\varphi - \psi)}\,d\varphi. \tag{13}$$

We recognize the φ integral to be the cylindrical Bessel function:

$$J_0(\rho) = \frac{1}{2\pi} \int\limits_{-\pi}^{+\pi} e^{+i\rho \cos \alpha} d\alpha. \tag{14}$$

Thus,

$$v_p = 2\pi Ck \int\limits_{0}^{d/2} J_0(krs) r dr \tag{15}$$

$$= \frac{2\pi Ck}{k^2 s^2} \int\limits_{0}^{ksd/2} J_0(\rho') \rho' d\rho', \tag{16}$$

where $\rho \equiv ikrs$. Then,

$$v_p = \frac{\pi Cd}{s} J_1\left(ks\frac{d}{2}\right). \tag{17}$$

What we actually observe is not v_p but $|v_p|^2$. If we also normalize this by dividing by the intensity squared at $s = 0$, we obtain

$$\frac{v_p^2}{v_{p_0}^2} = \frac{J_1^2\left(ks\frac{d}{2}\right)}{J_1^2(0)}. \tag{18}$$

This is the equation of the Airy disk observed in the microscope for a point source of light.

Acknowledgments

I thank Ryan and Kathryn Sears, Leya Bergquist, Dylan Bulseco, and Roxanne Wellman for help in the preparation of this manuscript and Robin G. Jordan, professor of physics at Florida Atlantic University for the quotation by Thomas Young at the beginning of this chapter. I also acknowledge support through the National Institutes of Health grants RO1-NS28760 and R44-DK57347.

References

Born, M., and Wolf, E. (1980). "Principles of Optics: Electromagnetic Theory of Propagation Interference and Diffraction of Light." 6th Ed. Pergamon Press, New York.

Goodman, J. W. (1968). "Introduction to Fourier Optics." McGraw-Hill Book Company, New York.

Halliday, D., and Resnick, R. (1970). "Fundamentals of Physics." John Wiley & Sons, New York.

Hui, S. W., and Parsons, D. (1975). Direct observation of domains in wet lipid bilayers. *Science* **190**, 383.

Inoué, S., and Spring, K. R. (1997). "Video Microscopy." 2nd Ed., Plenum Publishing, New York.

Jackson, J. D. (1975). "Classical Electrodynamics." 2nd Ed., John Wiley & Sons, New York.

Jenkins, F. A., and White, H. E. (1957). "Fundamentals of Optics." 3rd Ed. McGraw-Hill Book Company, New York.

Shamos, M. (1987). "Great Experiments in Physics." Dover Publications, New York.

Sommerfeld, A. ed. (1949a). Optics: Lectures on Theoretical Physics, vol. 4. Academic Press, New York.

Sommerfeld, A. ed. (1949b). "Physics: Partial Differential Equations," vol. 6. Academic Press, New York.

Young, T. (1801). Lecture 39, "Course of Lectures on Natural Philosophy and the Mechanical Arts." Press of the Royal Institution, London.

CHAPTER 3

Proper Alignment of the Microscope

H. Ernst Keller

Carl Zeiss Microimaging, Inc.
Thornwood, New York 10594

The light microscope, in many of its configurations, is a somewhat complex tool with many adjustable components. Good alignment is essential for good image quality, especially for quantitative studies. In this chapter we will try to provide a few simple guidelines for the best alignment of all those components of the light microscope that can be focused or centered. A better understanding of the function of these components and how their control influences the image has become even more critical for electronic imaging. Although analog or digital image processing can, to a small extent, compensate for poor mechanical and optical alignment, the best end result, free of artifacts, is derived from the best

possible optical image. When all the microscope's controls are routinely set correctly, the video image will be at its best.

I. Key Components of Every Light Microscope

Before we discuss the alignment of the microscope, let us follow the light path through the microscope from source to detector, look at the main components, learn the terminology, and understand their functions. Those familiar with the light microscope can proceed directly to the section of this chapter that discusses Koehler illumination (Fig. 1).

First a few words about the basic stand: Whether the microscope is upright or inverted, the stand is designed to provide the stability essential for high-resolution microscopy and to rigidly hold all components such that they can be ergonomically controlled. The stand incorporates functions like coaxial and bilateral focus for stage, substage, or sometimes nosepiece; control of diaphragms; and often switching of filters and diffusers. Furthermore, many stands provide receptacles for neutral density, color or polarizing filters, waveplates or so-called compensators, and special sliders for contrast enhancement.

A. Light Source

The lamp is either mounted inside the stand or in an external lamp house for better heat dissipation, particularly for higher-intensity sources. Most modern microscopes are equipped with a low-voltage tungsten-halogen illuminator, either 6 or 12 V, ranging in power consumption from 10 to 100 W. Either an adjustable lamp socket or a lamp house control provides for precise centration and focus; sometimes the bulb has its own precentered socket. The shape of the tightly woven flat filament of the bulb can be rectangular or square, and this, in turn, mandates the best lamp alignment, taking into account a reflector behind the bulb, which is part of most lamp housings. Frequently, in modern microscopes, the power supply for the illumination is integrated into the stand.

More demanding is the mounting and alignment of gas discharge sources such as mercury or xenon lamps, commonly used for fluorescence microscopy or when an exceptionally bright source is required for specimens or techniques that absorb large amounts of light. Be sure to follow the manufacturer's instructions and warnings closely when installing and aligning high-pressure discharge lamps. Because many of these lamps are under high pressure, wearing safety goggles is essential. Because these lamps emit large amounts of ultraviolet (UV) radiation, UV-protective eyewear must be worn in the presence of an unshielded arc lamp. Discharge lamps usually require special lamp collectors to optimally image the small, bright arc source into the condenser or objective aperture.

Tungsten-halogen sources have a continuous spectral emission over the visible and near-infrared (IR) ranges with a color temperature of between 2800 and

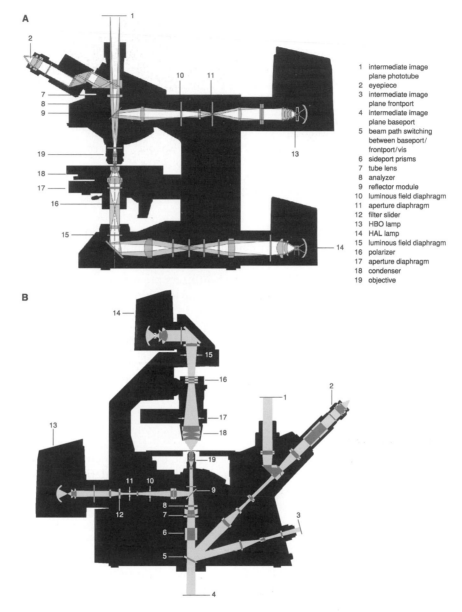

1 intermediate image
 plane phototube
2 eyepiece
3 intermediate image
 plane frontport
4 intermediate image
 plane baseport
5 beam path switching
 between baseport/
 frontport/vis
6 sideport prisms
7 tube lens
8 analyzer
9 reflector module
10 luminous field diaphragm
11 aperture diaphragm
12 filter slider
13 HBO lamp
14 HAL lamp
15 luminous field diaphragm
16 polarizer
17 aperture diaphragm
18 condenser
19 objective

Fig. 1 Components and light path of (A) an upright microscope. (B) An inverted microscope.

3200 °K. Xenon lamps are a somewhat continuous spectral emitter with a color temperature of 5500 °K; mercury lamps have very discrete emission peaks from the UV through the visible spectral ranges and cannot provide good color balance.

B. Lamp Collector

As the name implies, the collector captures as much light as possible from the source and relays this light to the condenser, which is the objective in incident light applications such as fluorescence microscopy. Either the collector is focusable or the lamp can be axially moved to ensure focus of the source in the front focal plane (aperture) of the condenser or the focal plane of the objective for even, uniform illumination. The focal length, the aperture, and the degree of the optical correction of the collector lens directly influence the light flux and the uniformity of illumination at the specimen. Special quartz collectors are available and recommended for UV microscopy or for fluorescence excitation in UV.

C. Diffusers and Filters

In transmitted or incident light illumination, diffusers are often used to more evenly distribute the nonuniform illumination of a filament or arc. Special low-angle diffusers accomplish this with a negligible loss of overall light intensity; conventional ground-glass diffusers are not recommended. Filters serve a variety of functions, including correcting the color balance, contrast enhancement, neutral light attenuation, and aiding in the selection of specific spectral regions for fluorescence excitation and for improved chromatic correction in black and white video microscopy or photomicrography. The use of IR blocking filters is especially important because objectives are not well corrected for these wavelengths, yet video cameras are sensitive to this light. As a consequence, image quality is degraded if IR-blocking filters are not used.

D. Field Diaphragm

Imaged into the specimen plane by the condenser (transmitted light) or by the objective (incident light) and epifluorescence it defines the circular field illuminated, aids focus and centration of the illumination.

E. Condensers

In transmitted light, the condenser's important function is to provide even, bright illumination of the specimen field for a wide range of different magnifications. Its numerical aperture, or cone angle of illumination, directly influences resolution, contrast, and depth of field. Condensers come in a range of optical corrections, achromatic and aplanatic, offer different numerical apertures and specimen field diameters, and sometimes are fitted with turrets to provide for special contrasting techniques such as phase contrast, modulation contrast, or differential interference contrast.

As indicated earlier, in incident-light applications the objective is also the condenser. Being one and the same, alignment between condenser and objective is

always perfect, greatly facilitating the set-up of epifluorescence or other incident light methods.

F. Aperture Diaphragm

Usually built into the condenser and located at it's front focal plane, the aperture diaphragm controls the illuminating color light and thereby influences resolution, contrast and depth of field. In incident light illumination it is the diaphragm closure the source in the epi light path and optically conjugate to the objective's exit (entrance) pupil. In fluorescence, it can also be used for light attenuation.

G. Condenser Carrier or Substage

On an upright microscope, the condenser carrier is usually attached to the stage carrier and moves with the stage focus. The inverted microscope has a separate condenser carrier attached to the transmitted-light illumination column. In both cases the condenser carrier not only holds the condenser but also allows for its focus and centration.

H. The Specimen Stage

The control knobs on the stage move the specimen in the x and y planes. Depending on the application, the specimen stage can come in a variety of configurations. Some stages offer rotation of the specimen.

I. The Objective

This component is most instrumental to a quality image. Its parameters and its degree of optical correction largely determine not only the magnification ratio but, more importantly, the resolution, the contrast, the image brightness the spectral throughput, the depth of focus, the sharpness from center to edge, and the color rendition. From Achromats and Planapochromats through a variety of very specialized lenscs, the microscope objective needs to be carefully selected according to budget and application. Keep in mind, however, that the best performance of an objective is only attainable if everything else is perfectly aligned.

J. Revolving Nosepiece

Precisely machined turrets with receptacles for four to seven objectives allow for fast changing between magnifications and help maintain focus (parfocality) and registration of specimen field (parcentration).

K. Infinity Space

Most modern microscopes have infinity-corrected objectives providing this space, which can readily accept a variety of accessories like reflectors, filters, and so on, which, as long as they are plane parallel, have no negative effect on focus, alignment, or image quality. A tube lens at the far end of this infinity space focuses the infinite conjugate rays into the intermediate image plane, frequently the location where electronic detectors are directly mounted.

A brief warning may be in order here: Different manufacturers use different design concepts for the full correction of the intermediate image; also, the focal length of the tube lens varies, and the parfocal distance (objective shoulders to specimen plane) may not be the standard 45 mm. This means that switching objectives between different manufacturers is not as easy today as it was in the past with finite optics, where some standards prevailed.

L. Tube, Eyepiece, and Video Adapters

Comfortable viewing of the image with a fully relaxed eye is the function of tube and eyepiece, with the latter enlarging the real intermediate image formed by the objective to such an extent (usually around 10X) that all detail resolved by the objective can also be resolved by the eye. Video and camera adapters serve the same purpose and must be carefully chosen depending on the pixel resolution of the detector (see Chapter 8).

II. Koehler Illumination

Koehler illumination is one of the oldest and, today, most universally used techniques to provide even illumination over the specimen field and to allow for control over resolution, contrast, and depth of field. The technique was first described in 1893 by August Koehler, then a young assistant professor at the University in Giessen, Germany, who later joined the Zeiss Works in Jena to head up their microscopy development. It took almost 50 years for Koehler illumination to gain universal acceptance. Today, practically every microscope provides the necessary controls for its implementation.

Figure 2 shows on the left the image forming ray path, on the right the illumination or pupil beam path. Geometric optic rays depicting respectively one off axis specimen point and one off axis source point clearly show the 4 directly related conjugate planes at every crossover in both paths.

The *light source* is imaged by the collector into the front focal plane of the condenser, where we usually have an adjustable diaphragm, the *condenser* or *aperture* diaphragm. From here the source image is projected by the condenser into infinity, traversing the specimen as a parallel pencil of light for each source point

imaged in the condenser aperture and uniformly distributing each source point's intensity over the full field. The objective receives these parallel pencils and forms a second image of the light source in its *back focal plane*. A third image of the source appears in the *exit pupil* of the eyepiece, also called eyepoint, which is usually approximately 15 mm above the eyepiece. If we include the source itself, we have four source-conjugated planes in the microscope.

The imaging-beam-path conjugate planes begin with the *field diaphragm*, which with a properly focused condenser, will be imaged into the *specimen plane*. From here the objective images specimen plus field diaphragm into infinity, while the tube lens forms the *real intermediate image*, which lies near the front focal plane of the eyepiece. The eyepiece projects the image to infinity, and the lens of the eye focuses the *final image* on the retina. Again, four image-conjugated planes can be found, or three if the imaging detector receives the intermediate image directly.

In incident-light Koehler illumination there is one additional source-conjugated plane to allow for aperture control of the illumination independent from the observation or objective aperture. All else is identical to transmitted light, only the condenser and objective are one and the same.

Understanding illumination and imaging ray paths will greatly facilitate an optimal alignment and can be very useful in finding image artifacts or dust particles in the optical system, and so forth.

A. Aligning the Microscope for Koehler Illumination

Follow these simple steps:

1. Center and focus the light source (unless precentered) following the manufacturers instructions. With the condenser and diffuser removed, place a piece of paper into the light path at the level of the condenser carrier. An image of the lamp filament should be visible, and controls on lamp housing or socket permit focus and centration of this filament image in the circular area representing the condenser aperture.

2. Insert condenser and diffuser (if present). Place a specimen on the stage, and use a medium power objective (10×, 20×, or 40×) to focus on any specimen feature. If not enough light is available, open the field and aperture diaphragms fully. Too much light may saturate the camera and may require rheostat control of the light source or the placement of neutral density filters in the light path. Do not use the condenser aperture as a means to control light intensity.

3. Once specimen focus is obtained, close the field diaphragm and focus (usually raise) the condenser until the field diaphragm comes into sharp focus with the specimen.

4. Center the condenser to align the image of the field diaphragm concentric with the circular field of view.

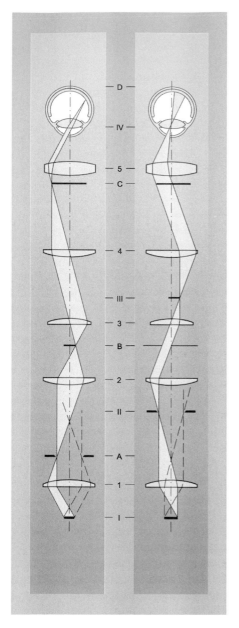

Left: The image-forming beam path
- A = Luminous-field diaphragm
- B = Specimen plane
- C = Intermediate image
- D = Retina of the observer's eye

Right: The pupil beam path
- I = Lamp filament
- II = Aperture diaphragm
- III = Objective pupil
- IV = Pupil of the observer's eye

The main imaging components are:
1. Collector
2. Condenser
3. Objective
4. Tube lens
5. Eyepiece

Fig. 2 Light path in transmitted light Koehler illumination.

5. Open the field diaphragm just beyond the field of the objective used. For videomicroscopy do not open the diaphragm beyond the field of the sensor, which is always less than the visual field. Also, when using a video camera do not close the image of the field diaphragm into the field of the sensor for reasons outlined in Chapter 5 by Sluder and Hinchcliffe.

6. Slowly close the condenser aperture diaphragm until the desired image contrast is achieved. Be sure to never use this diaphragm to control image brightness. Both contrast and resolution are directly affected. An open aperture stop usually gives poor contrast. Closing it partially enhances contrast, but at the expense of resolution. Setting the condenser aperture for best balance between resolution and contrast is what sets the expert microscopist apart from the novice and is very much a function of the specimen itself.

A centering telescope or Bertrand lens lets us focus on the condenser aperture diaphragm to verify its setting and centration. When using such a lens, set the condenser aperture to just impinge on, or become visable, in the objective lens aperture.

Contrary to transmitted light Koehler illumination, in epifluorescence microscopy the aperture diaphragm, if available, can be used to control the excitation intensity, often useful to obtain a flare-free, high-contrast image. Not all epifluorescence systems provide an aperture iris, however, and light attenuation by neutral density filters or arc control can be used to reduce excitation intensity if desired. A good test specimen to set up Koehler illumination in epifluorescence is a H & E–stained tissue section, which will fluoresce with almost any filter combination and display minimum bleaching.

B. What Are the Benefits of Koehler Illumination?

By limiting the imaging-ray bundles to the field covered by a given objective/ eyepiece or detector combination, less stray light or internal "noise" is generated in the microscope. With the exceptional sensitivity of electronic detectors, "hot spots" may occur unless the field diaphragm is closed to the edges of the detector's field.

Even, uniform illumination of the specimen is achieved by distributing each source point's energy over the full field. Thus, minimal shading correction is required by the video electronics.

Full control over the illumination (condenser) aperture allows for the best compromise between resolution and contrast and for some effect on the depth of field.

C. Resolution and Contrast

Because the theory of image formation, the diffraction limits of resolution, and contrast generation have all been described in books and articles, it would go beyond the scope of this practical guide to repeat Abbe's theory and wave optical

imaging. However, the reader is well advised to gain some understanding of these concepts to better appreciate good alignment and optimal setting of controls and diaphragms.

Here is just a very brief summary of the basic concepts, taking into account the electromagnetic wave nature of light; its wavelength, λ; and the interaction of wavefronts with the specimen's structures. Ernst Abbe was the pioneer who developed the theory of image formation through the microscope. He differentiated between two types of specimens: the self-luminous object (light sources, luminescence, fluorescence), which follow the Rayleigh criterion for resolution, which is based on diffraction in the objective. Here the minimum point-to-point spacing resolution (d) is given by:

$$d(\mu\text{m}) = \frac{0.61\lambda}{\text{NA (objective)}}.$$

In the case of an illuminated object, the Abbe criterion for resolution is

$$d(\mu\text{m}) = \frac{\lambda}{\text{NA (objective)} + \text{NA (condenser)}},$$

where λ is the wavelength of the emitted or illuminating light and NA is the numerical aperture of objective or condenser, given by the sine of half its collection angle times the refractive index of the medium between specimen and objective. Note that this formula provides the reason why one does not want to close the condenser diaphragm simply to control light intensity or to enhance contrast. The penalty is lost resolution. Also, note that increasing the condenser NA to a value greater than that of the objective, though in principle may provide increased resolution, is not recommended for brightfield applications. The problem is that under such conditions, one is adding a darkfield image to the brightfield image; consequently, image contrast is severely compromised.

With the self-luminous object, it is diffraction in the objective itself, that causes the smallest image point to expand into an "airy disk" (Fig. 3), the diameter of which becomes

$$D_{(\mu\text{m})} = \frac{1.22\lambda}{\text{NA (objective)}}.$$

In Fig. 3 (left), W' indicates a spherical surface in the optical path that is equidistant from the center of the image plane O'. All wavefronts from this surface follow equidistant paths to O' and arrive there in phase. This leads to a bright central maximum at O'. At other points along the image plane we can have either constructive or destructive interference or some combination of both. This results in the Airy disk profile in the image plane (Fig. 3, right). The Airy disk and point-spread functions in general will be further discussed in Chapters 6 and 15.

In the illuminated object, diffraction is generated by the specimen's structural features and their spacing. The diffraction angle (α) is determined by the wavelength (λ) and the spacing or distance (d) between features:

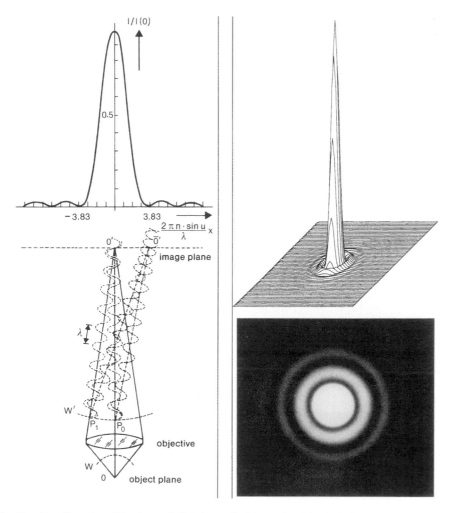

Fig. 3 Airy disc of a self-luminous, infinitely small object point. The dark rings around the central disc are zones of destructive interference between wavefronts diffracted on the objective's internal aperture.

$$\sin \alpha = \frac{\lambda}{d}.$$

The numerical aperture of an objective (NA $= \sin \alpha \times n$) is a direct measure for the diffraction angle it is capable of collecting. Abbe was able to prove that for a given structural spacing to be resolved, at least two adjacent orders of diffracted light produced by this spacing need to participate in the image formation. It is interference between diffracted and nondiffracted wavefronts in the intermediate image plane that resolves structural detail and determines the contrast at which the image is rendered.

CHAPTER 4

Mating Cameras to Microscopes

Jan Hinsch

Leica Microsystems, Inc.
Allendale, New Jersey 07401

I. Introduction
II. Optical Considerations

I. Introduction

The compound microscope forms images in two stages. The objective (first stage) projects a real image of the specimen into the intermediate image plane (IIP) of the microscope at a ratio magnification (M). The resolution in the IIP is typically between 40 and 100 line pairs per millimeter (lp/mm). Because the resolution of the human eye is of the order of 5 lp/mm, additional, virtual magnification (V) by the eyepiece (second stage) is necessary to match the resolution of the eye to that of the microscope. The total microscope magnification (V_{total}) is the product of $M \times V$. The designation V_{total} is used because the eye views a virtual image in the microscope.

The diameter, in millimeters, of that part of the intermediate image that is used by the eyepiece is called the field of view number (FOV). Depending on the numerical aperture (NA) and magnification of the objective and the FOV number of the eyepiece, microscope images may contain up to five million image elements, referred to as pixels.

Video cameras can resolve only a fraction of this available information because of the inherent resolution limits of the camera detectors. Thus, when mating video cameras to microscopes, choices need to be made whether to sacrifice some of the field of view in the interest of matched resolution or vice versa. This chapter discusses how best to mate video cameras to microscopes at magnifications that preserve specimen image resolution when necessary. This chapter will also

58 Jan Hinsch

consider what needs to be done to maintain the optical corrections of the objective and eyepiece in the video image.

The microscope's resolution (r) depends on the NA of the objective. It is commonly calculated at

$$r = \frac{1.22 \times \lambda}{NA_{obj} + NA_{cond}},$$

where r is the minimum spacing of specimen detail, λ is the wavelength of the illuminating light, and NA_{obj} and NA_{cond} are the numerical apertures of objective and condenser, respectively. In the case of green light (λ 0.55 μm) and a condenser numerical aperture equal to that of the objective, one can state the resolution simply as

$$r(\mu m) \simeq \frac{1}{3 \times NA},$$

or, converted to line pairs per millimeter,

$$r(lp/mm) = NA \times 3000.$$

Resolution usually refers to distances in the object plane. In the context of this chapter, the term circle of confusion (Z) is sometimes used to signify resolution in planes other than the object plane; for example, the IIP, where a point source appears as a confused circle of radius $Z = M \times r$.

Magnification is a means of diluting the density of the image information to suit the limited resolution of the sensing structure of the receiver. The human eye, for example, typically has a resolution of 0.2 mm at a viewing distance of 25 cm, the so-called conventional viewing distance. At a magnification $V_{total} = NA \times 600$, $Z = V_{total} \times r$ and becomes 0.2 mm; thus, the instrument and the eye are matched in regard to resolution. A somewhat broader range of magnifications from $V_{total} = NA \times 500$ to $V_{total} = NA \times 1000$ are considered reasonable if the eye is to appreciate all the spatial information an objective produces. This is called the range of useful magnifications. At $V_{total} < NA \times 500$, there is information overload, and the eye cannot detect the finest specimen detail resolved by the microscope. At $V_{total} > NA \times 1000$, no information is revealed that was not already apparent at lower magnifications; we have entered the zone of empty magnification (see Table 1).

$Z = r \times V_{total}$, where $r(\mu m) = 1/3NA$, $lp/mm = NA \times 3000$, and $w =$ the angle subtended by two image points spaced by the distance Z ($\tan w = Z/CVD$).

$$N \text{ image elements} = \frac{lp/mm \times FOV \text{ no.}^2}{(2 \times M \text{ IIP})} \times \pi.$$

In mating video cameras to microscopes, the resolution limits of a video system need to be taken into account just as do those of the human eye. In fact, we have to concern ourselves with both. First we have to determine at what magnification,

Table I
Range of Useful Microscope Magnifications for the Human Eye

Z (μm) at CVD of 25 cm	Z (lp/mm)	Angle	Product (NA \times V_{total})	Pixels in millions at field of view number 25	
100	10.0	1′23″	300	4.91	?
112	8.9	1′32″	336	3.91	Zone of
125	8.0	1′43″	375	3.14	lost
140	7.1	1′56″	420	2.50	information
160	6.3	2′12″	480	1.92	?
175	5.7	2′24″	525	1.60	?
200	5.0	2′45″	600	1.23	Range of useful
220	4.5	3′02″	660	1.01	Magnifications
250	4.0	3′26″	750	0.79	(nA \times 500 to
280	3.6	3′51″	840	0.63	nA \times 1000)
320	3.1	4′24″	960	0.48	?
350	2.9	4′49″	1050	0.40	Zone of empty
400	2.5	5′30″	1200	0.31	Magnification
440	2.3	6′30″	1320	0.25	?

expressed in multiples of the aperture, we need to project the image onto the faceplate of the video camera to resolve specimen detail on the monitor screen. Next, we need to consider the maximum permissible viewing distance from the screen at which our eye can still fully appreciate all the displayed information.

The answer to the first part of the question can be worked out reliably in an empirical way: A test object close to the resolution limit of the lens is chosen, such as the diatom *Pleurosigma angulatum* in the case of an objective of 40× magnification with an NA of 0.65 (40/0.65). This diatom shows a periodic structure of dots spaced by 0.65 μm in hexagonal arrangement. Our objective will just comfortably resolve this structure. If the dots are clearly resolved on the screen, the video system takes full advantage of the resolution available from the microscope.

Elsewhere in this book (Chapter 2), a different approach is hinted at for determining the camera resolution. It is of interest to the micoscopist because it makes the resolution test with diatoms more absolute. An optically well-resolved test diatom is imaged into the target plane, and its magnification is systematically varied (Vario-eyepiece, etc.) to just the point at which resolution is achieved. Then the minimum NA necessary to achieve resolution is calculated and the magnification in the plane of the chip that just yielded reliable resolution of the screen image is determined. The ratio of M_{chip}/NA then is universally applicable to any NA.

Calculation of the minimum NA to resolve a test object with pitch r:

$$NA_{objective} + NA_{condenser} = \frac{1.22 \times \lambda}{r}.$$

For Pleurosigma (dot spacing of $0.66\,\mu m$), one will find that theoretically an NA of only 0.5 should be needed, which is 30% short of the observed value of NA 0.65. This discrepancy is related to the complexity of the diatom structure in the z-direction. In incident light microscopy, resolution is indeed achieved at NA 0.5.

Typically, an undistinguished color video camera, with a 2/3-inch tube requires a minimum magnification in the target plane of $NA \times 200$. Thus, between the IIP and the target plane of the video camera, additional magnification of 3.25:1 is needed in the case of the 40/0.65 objective. How much of the field of view will be captured under these conditions? Division of the target diagonal (11 mm) by the magnification occurring between the IIP and the TV target (3.25:1) yields 3.4 mm. Of the 25-mm field of view customary in today's microscopes, 98% of the area had to be sacrificed to fully demonstrate the resolving power of the lens. This is the worst-case scenario, but even with the best television-based video technology, we'd be lucky to keep the lost area below 80%. More recently, digital cameras with several megapixel sensors have become available, and capturing the entire field of view at full resolution is a realistic possibility.

Multimegapixel sensors produce big image files and long processing times. To reconcile the demand for imaging large fields for surveying purposes at one time and small fields to preserve resolution at other times with \sim1-Mpixel cameras, the use of a pancratic (zoom) eyepiece is helpful. A magnification range of 1:5 will comfortably cope with both extremes, and lesser ranges may be perfectly adequate. The magnification changers built into many microscopes serve the same purpose. It is worth remembering that the light intensity changes inversely to the square of the magnification, and sometimes (fluorescence) higher intensity may have to be given priority over resolution.

Now to the second part of the question. A structure, clearly resolved on the screen, must be viewed from the proper distance. If we move too close to the screen, the television lines become annoyingly apparent. That tends to happen at viewing distances of less than five television screen diagonals. If we move too far away, the eye's resolution may become the limiting factor. To address this concern in a rational way, we return to the earlier statement that the range of useful magnifications lies somewhere between the extremes of $NA \times 500$ and $NA \times 1000$. This rule holds for the television screen as well. How do we calculate the magnification? Before we get to the answer, two paragraphs defining the difference between magnification and ratio of magnification are added here.

The magnification of real images such as the intermediate image in the microscope tube or the image on the television screen can be measured with a ruler or a scale if the dimensions of the object are known. This we call the ratio of magnification. To distinguish it from virtual magnification, we say "ten to one"

and write 10:1. In this chapter the letter M was used to signify the ratio of magnification.

Virtual images, in contrast, are formed, for example, by magnifying glasses (simple microscopes). The image exists only in the plane of our retina; it is inaccessible to measurement. We define the magnification of such images by relating the retinal image size to what it would have been if the object were viewed from a distance of 25 cm without any optical aids. This reference distance of 25 cm is, by agreement, the closest accommodation distance of the average human eye and is called the conventional viewing distance. From a distance of 25 cm, we see things at one times (written 1 ×) magnification. A magnifying glass of $f = 12.5$ cm permits the infinity accommodated eye to cut the conventional viewing distance effectively in half; therefore, the magnification, being reciprocal, is called two times, written 2×.

$$V = \frac{25 \text{ cm}}{\text{fcm}}.$$

The ratio of magnification on the monitor screen is the product of several factors:

$$M_{\text{objective}} \times M_{\text{magnification changer}} \times \text{M television adapter}$$
$$\times \text{ electronic magnification} = M \text{ screen.}$$

"Electronic magnification" is the ratio of the screen diagonal over the target diagonal. For a 15-inch screen and a 2/3-inch television tube, the electronic magnification is 35:1.

An objective 40/0.65, an eyepiece 10×, a camera lens 0.32×, and electronic magnification of 35:1 produces a total screen magnification of $M = 4480$:1. If viewed from a distance of 25 cm, we also have a magnification of $V = 4480×$. From a viewing distance of 50 cm or 100 cm, the magnification shrinks to 2240× or 1120×, respectively, or generally,

$$V = \frac{M_{\text{screen}} \times 25 \text{ cm}}{d};$$

$$d = \frac{M_{\text{screen}} \times 25 \text{ cm}}{V},$$

where d is the distance, in centimeters, from the screen to the observer.

For V to be in the range of useful magnifications of 500 to 1000 times the NA, we calculate the minimum and maximum distances for an NA of 0.65:

$$d_{\text{min}} = \frac{M_{\text{screen}} \times 25 \text{ cm}}{\text{NA} \times 500} \quad \frac{112{,}000 \text{ cm}}{325} = 345 \text{ cm};$$

$$d_{\text{max}} = d_{\text{min}} \times 2 \qquad = 690 \text{ cm.}$$

Within a range of viewing distances from 345 to 690 cm, we will be able to appreciate the full resolution of the optics. Had we chosen a lesser M_{screen}, then d_{min} soon would become less than five screen diagonals, and some of the information would literally fall through the cracks of the screen's line raster.

II. Optical Considerations

Classification of microscope objectives into achromats, fluorites, and apochromats refers to their color and spherical corrections. In a perfect objective, the image does not change its axial location with wavelength. It may, however, change in size. A lateral chromatic difference of magnification of 1% across the extremes of the visible spectrum is not unusual. Color fringes, increasingly apparent the larger the FOV number, result from this condition if left uncorrected. Chromatic difference of magnification is successfully eliminated by the use of compensating eyepieces. Some of these eyepieces additionally contribute to improved flatness of field.

C-mount adapters connect cameras with standardized C-mounts to the photo tube of the microscope. The simplest kind of C-mount adapters just place the camera target into the IIP and then have 1 × magnification. With a 2/3-inch camera, 11 mm of the field are utilised and the effects of chromatic difference of magnification across such small fields are negligible.

The shrinking size of camera chips requires proportionally reduced magnifications for C-mount adapters. Magnifications of 0.63:1, 0.5:1, and so forth demand appropriate optics inside the C-mount adapter with properties similar to the compensating eyepieces.

Three-chip color cameras employ a complex prism that splits the spectrum in three bands centered at red, green, and blue by the use of chromatic beam splitter/reflectors. Similar to all interference coatings, their characteristics change with the angle of incidence, which can lead to color shading across the field. C-mount adapters of telecentric optical design, which is signified by parallelism of the principal rays, will eliminate such problems.

Even one-chip sensors that use mosaic color filters directly laminated to the chip are not immune to shading problems. Typically, each pixel is topped by a lens that collects light that would otherwise fall on the space separating adjacent cells. It makes a difference in efficiency if light strikes the lens perpendicularly or obliquely. The chip manufacturers often take that into account by slanting the lenses' axes increasingly far with the pixels' distance from the center of the chip. That slant may or may not agree with the optical parameters of the microscope and its camera adapter. Usually, but not always, a telecentric path of rays is more satisfactory.

Amateur-type digital cameras with permanently built-in zoom lenses are attractive on account of their price and easy portability from one microscope to another. The images, if intended for illustrative purposes only, are not to be

despised. This style of camera typically has a permanently attached zoom lens of a design that avoids shading problems. Yet the pupil positions of many zoom lenses are not so well matched to the pupil of the eyepiece so that images free of vignetting are possible over only a fraction of the lens' range of focal lengths, if at all. Several microscope manufacturers offer special adapters to attach such cameras to either the straight phototube or one of the binocular viewing eyepieces.

The expectation that an electronic camera will be mated sooner or later to any microscope has profoundly affected the design of contemporary instruments. The C-mount adapter flange has been moved closer to the objective and so intercepts the imaging path in a plane well ahead of the intermediate image. That makes possible the design of couplers that do not compromise optical performance or, in the case of zoom adapters, reduce light transmission significantly. Some adapters are made both in converging and telecentric design. In any case, the couplers deserve as much attention as any component in the imaging path of the microscope.

CHAPTER 5

"Do Not (Mis-)Adjust Your Set": Maintaining Specimen Detail in the Video Microscope

Edward H. Hinchcliffe[1] and Greenfield Sluder[2]

[1]Department of Biological Science
University of Notre Dame
Notre Dame, Indiana 46556

[2]Department of Cell Biology
University of Massachusetts Medical Center
Worcester, Massachusetts 01605

I. Introduction

To maximize the amount of specimen information that is displayed on the video monitor or recorded in electronic format, all components of the video microscopy imaging system must be optimized: microscope, camera coupling to the microscope, camera, image processing system, and monitor. Failure to properly control any of these links in the integrated imaging system inevitably leads to the

loss of specimen detail. In this chapter we discuss the practical aspects of adjusting the video camera and the monitor to prevent the loss of specimen image gray-level information. These issues are relevant not only to those who use analog video equipment but also to those using modern digital systems.

The problem one faces in coordinating camera and monitor adjustments is that there are too many interacting variables and no standard against which to evaluate the performance of the system. One can vary the intensity of the optical image on the photosensitive surface of the camera, camera settings (which are often controlled by a computer), and monitor settings. All three appear interactive and can to some extent be used individually to seemingly optimize the quality of the image. When done in a haphazard fashion, empirical "knob twiddling" opens the real possibility of losing specimen information, typically in the brightest or darkest portions of the image. Also, when recording the results of an experiment, one can find that the quality of the recorded image is not as good as the image one saw on the monitor. This discovery is often made after the experiment is over and it is too late to remedy the situation.

The information presented in sections I–IV of this chapter deals with the adjustment and optimization of the image contrast generated by analog video cameras. However, although these are analog images, the image-contrast optimization concepts presented here are directly applicable to the manipulation and use of digital charge-coupled device (CCD) cameras ("digital imaging"), which in recent years have largely replaced analog detectors. Monitoring the output of the digital camera is dealt with in section V at the end of the chapter.

II. The Black and White Video Signal

Here we review, in a simplified fashion, a few aspects of the monochrome composite video signal, produced by analog tube-type cameras and conventional analog CCD cameras. For a complete description of the composite video signal and how it is displayed on the monitor, the reader is referred to Video Microscopy (Inoué and Spring, 1997). The camera converts the optical image on its photosensitive surface, or faceplate, into a sequence of electrical signals, which comprise the video signal. For cameras using the North American format, the image at the camera faceplate is sampled from top to bottom in 525 horizontal scan lines every 1/30th of a second. Within each scan line, the faceplate light levels are converted into a voltage that is proportional, within limits, to light intensity. Shown in Fig. 1A is a schematic representation of a number of scan lines through the image of a "cell" that is darker than the background. Figure 1B shows the voltage output of the camera as a function of position along each of these representative scan lines. When displayed one above the other in sequence, as occurs in the monitor, the scans recreate the two-dimensional intensity profile of the specimen image. In reality/each frame (one complete image) is not scanned sequentially in 525 lines. Rather, every other scan line (together forming a "field")

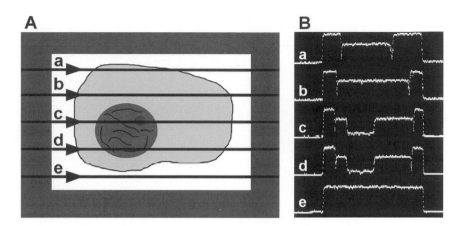

Fig. 1 Video signals corresponding to scan lines through the image of a "cell." (A) A schematic drawing of a cell with rectangular black border as imaged on the faceplate of the video camera. The horizontal black lines labeled A–E are representative scan lines through the image, with the scans going from left to right and progressing from top to bottom. (B) Actual camera output for the scan lines showing camera output voltages as a function of position along the scan lines.

is transmitted in 1/60th of a second, and then the remaining scan lines are transmitted in the next 1/60th of a second. This is known as the "interlace," and it serves to eliminate an annoying vertical sweeping of the image. Figure 2 shows a portion of the signal coming from the camera; in this case, two scan lines represent a specimen image that is brighter in the center of the image than at the periphery. Starting at the left is the H sync pulse of negative voltage, which serves to coordinate the monitor scan with that of the camera. The voltage then returns to 0 volts (part of the blanking pulse that blanks the signal while the electron beam in the camera returns from the end of one scan line to the start of the next scan). The voltage then rises to 0.05–0.075 volts, which is the "setup" or "pedestal" that is the picture black level. Thereafter, the voltage rises and falls in relation to the image intensity along the scan line. At the end of the active picture portion of the scan, the voltage returns to the pedestal value and then drops to 0 volts at the beginning of the H blanking pulse, on which is superimposed the negative H sync pulse. The full range of signal amplitude for specimen image light intensities is encoded in slightly less than 0.7 volts. Figure 3 (lower portion of the figure) shows the step grayscale test target or "specimen" that will be used for the rest of this chapter. In this and subsequent figures, the grayscale specimen is viewed by a camera, and the resulting image on the monitor is shown in the lower portion of the figure. The upper part of the figure shows the camera output voltages for a scan line running across the grayscale as displayed by a Dage MTI Inc. RasterScope device. The camera output voltage rises in a stepwise fashion from just above 0 volts for the black band to just under 0.7 volts for the white band, with a proportionate increase in camera output voltage for each step in

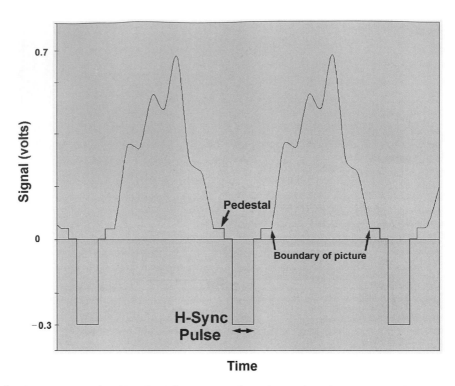

Fig. 2 The composite video signal for two scan lines of a specimen image that is brighter in the center of the image than at the periphery. The active picture portion of the signal is indicated for the second scan, and the pedestal voltage is indicated at the end of the first scan. Between scans is the H blanking pulse (0 volts), on which is superimposed the H sync pulse (negative voltage). The full range of signal amplitude for specimen image light intensities is encoded in slightly less than 0.7 volts.

image intensity. We have not used quite the full 0.7 volt range of camera output to display the first and last steps. With the monitor properly adjusted, all intensity values in the specimen are represented in the monitor image. The purpose in using this grayscale is that one can easily identify the loss of grayscale information when either the camera or the monitor is adjusted improperly.

III. Adjusting the Camera and Video Monitor

To set up the video system one must do two things. First, the camera is adjusted so that all image intensity values are represented in its output signal using the full 0.7-volt camera output to include the highest and lowest image intensity values. Second, the monitor is adjusted to display the gray values present in the camera output. Proper adjustment of the camera is of paramount importance, because loss of information at the camera level cannot be later restored. Also, note that

Fig. 3 Grayscale test specimen and camera output. The test specimen used throughout this chapter consists of a step grayscale running from black on the left to white on the right. In this and subsequent figures, the grayscale specimen is viewed by a camera, and the resulting image on the monitor is shown in the lower portion of the figure. The upper part of the figure shows the camera output voltages for a scan line running across the grayscale as displayed by a Dage MTI Inc. RasterScope device. Black is represented by a voltage just above 0 volts, and white is represented by just under 0.7 volts. Here the camera response is linear; for each increase in specimen image intensity, there is an equal increase in camera output voltage (gamma = 1).

image-recording devices record just what the camera provides, not the optimized image on the monitor screen. What do the camera/monitor controls mean, how does one rationally use them, and what are the consequences of their improper use?

A. Camera Controls

1. Gain

Camera gain is an amplifier setting that modifies the amplitude of the camera output voltage for any given intensity of light input. Sometimes this control is labeled as "contrast." Shown in Fig. 4B is a scan line through our grayscale specimen; the darkest specimen detail (black) is just above 0 volts, and the brightest specimen detail (white) is 0.7 volts. The corresponding image on a properly adjusted monitor is shown immediately below. When the gain is set too high, as shown in Fig. 4A, the camera output for each step is relatively larger but the lighter grays in the specimen are driven to the full 0.7 volts and become saturated at white. Thus, the practical consequences of too high a gain setting are improved contrast between the darker-gray steps and the complete loss of the specimen information contained in the lighter-gray values. Obviously, monitor adjustment or image processing cannot restore this lost information.

When the gain is lowered below the proper setting (Fig. 4C), the output of the camera is reduced for each step of specimen image intensity. The black value remains essentially 0 volts and the white portion of the specimen is represented by a

Fig. 4 Camera gain. In panel B the camera and monitor are adjusted to capture and display, respectively, all grayscale values. Panel A shows the results of raising the camera gain while leaving the monitor settings constant. For the camera output trace, note that the black level remains at 0 volts, the height of each step is increased, and the lighter-gray values in the specimen image are driven to 0.7 volts. The monitor image shown below shows that the lighter gray values are saturated, resulting in an irretrievable loss of highlight information. Also note that the contrast between the darker-gray values is increased. Panel C shows the results of lowering the camera gain. Black remains at 0 volts, the step size between gray levels is reduced, and the white portion of the specimen is represented by less than 0.7 volts. Although the monitor representation of the specimen contains all grayscale information, the contrast between the graylevel steps is low.

voltage less than the full 0.7 volts. When viewed on the monitor, the black band of the target remains black, whereas the white band is represented as a gray. The practical consequence of too little gain is, therefore, a low-contrast image. Although this image in principle retains all the gray-level information, small differences in specimen image intensity are drowned out in the noise and can be effectively lost.

2. Linearity of Camera Gain: Gamma

The gamma of a camera is the slope of the light-transfer characteristics curve, plotted as log signal output as a function of log luminance at the faceplate. The gamma (k), the slope of the curve, is the exponent of the relationship of faceplate luminance to signal output: $I/I_{D^k} = i/i_{D^k}$ where I is the luminance, i the signal current, and I_D the luminance that would give a signal current equal to the dark current i_D (Inoué and Spring, 1986). The discussion thus far has been predicated on the assumption that the camera gain is the same for all specimen image intensities and the gamma is 1.0 (Fig. 5A). For cameras that allow control of gamma, the linearity of the amplifier response can be adjusted to accentuate contrast in desired ranges of specimen image brightness. For example, setting gamma to less than 1 causes a greater amplification of the lower specimen intensities relative to the higher ones (Fig. 5B), resulting in the accentuation of contrast in the dimmer portions of the specimen. Conversely, setting gamma to greater than 1 amplifies the brighter values more than the dimmer ones (Fig. 5C). The result is the selective enhancement of contrast in the brighter regions of the specimen image. In using the gamma control of a camera we must bear in mind, however, that one is effectively suppressing the specimen information contained in the gray values that are less amplified. For a more complete description of the use of the gamma function to selectively manipulate contrast see Inoué (1986).

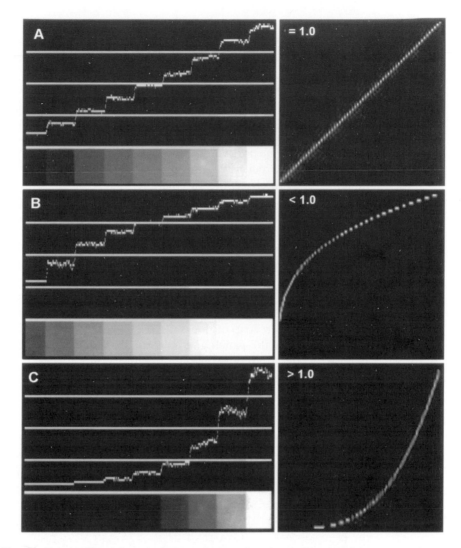

Fig. 5 Gamma. Shown here are the consequences of varying the linearity of the camera gain; that is, varying gamma. For each of the three panels, the left side shows the camera output and the monitor image of the specimen. The right side shows the camera output (ordinate) as a function of light input abscissa. When the camera gamma is 1.0 (A), the camera gain is equal for all light intensities in the specimen image. When the camera gamma is set less than one (B), the gain is higher for the lower light intensities. All grayscale values are captured and displayed, but there is higher contrast between the darker-gray levels than between the lighter ones. (C) Camera gamma set higher than one; the gain is higher for the brighter specimen intensities. Although all grayscale values, in principle, are represented in the camera output, the contrast between the brighter specimen gray values is greater than that for the darker gray steps. Here the loss of the darker-gray values in the monitor representation of the specimen is an artifact.

3. Automatic Gain

Often cameras have an automatic gain feature to accommodate varying specimens and specimen illumination intensities. For many cameras, this feature can be turned on and off deliberately. For some cameras, the automatic gain, when engaged, partially modulates the manual gain setting. In its simplest incarnation, the automatic gain circuit raises or lowers the highest voltage in the image signal and sets it to 0.7 volts. In theory, the very brightest portion of the specimen image would serve as the reference even if it corresponded to a minute bright spot in some portion of the image. In practice, however, the response of the automatic gain circuit is damped to an extent that varies with camera model and manufacturer. In effect, the automatic camera gain responds to a percentage of the image that has bright features. As a consequence, caution should be exercised in using the automatic gain feature in certain applications such as fluorescence microscopy, where a small percentage of the image area comprises high-intensity values on a dark or black background. The large amount of dark area leads to a rise in the camera gain, which can cause the brighter values in the light-emitting portion of the specimen to become saturated. To best differentiate between brightness level within the fluorescent specimen one should manually adjust the camera gain. A demonstration of this phenomenon is shown in Fig. 6. Here we have put a narrow strip of the grayscale on a neutral gray background (Fig. 6A, lower portion of the panel) and adjusted the camera so that all specimen image intensity values are represented in the camera output (Fig. 6A, upper). When the neutral gray background is replaced with a black surround, the camera gain automatically increases (Fig. 6B, upper), thereby driving the lighter-gray values to

Fig. 6 Auto gain and average image intensity. Panel (A) lower portion shows the monitor display of the specimen used; a strip of grayscale on a surround of neutral gray. The white horizontal line through the grayscale shows the scan line for which the camera output voltages are shown immediately above. (B) With the camera in the auto gain mode, the gray surround is replaced with a black surround, leaving camera and monitor adjustments constant. The large area of black in the specimen leads the auto gain circuit to increase the camera gain, causing a loss of lighter-gray specimen detail, albeit with an increase in contrast between the darker-gray values of the specimen.

Fig. 7 Auto gain and field stop position. (A) Lower portion shows a field of cells with the horizontal white cursor line. The camera output voltage profile along this line is shown in the upper portion of this panel; no attempt was made to use the full 0.7-volt camera output. (B) and (C) As the image of the microscope field stop is increasingly brought into the field seen by the camera, the auto gain circuit increases the camera gain. As a consequence, lighter-gray values are driven to white, and specimen information is lost.

white (Fig. 6B, lower). Note that the black level remains unchanged and the contrast between the darker-gray steps is enhanced.

Figure 7 shows how bringing the image of the microscope field stop into the image area can lead to the same sort of problem. Shown here is a low-contrast specimen (cultured cells through which we have positioned the cursor or horizontal sampling line) with the image of the microscope field stop lying outside of the field of view (Fig. 7A, lower). When the field stop is closed down, the automatic increase in camera gain drives the lighter specimen grays toward saturation, and information can consequently be lost (Fig. 7B, C).

The use of the automatic gain feature is also not indicated for quantitative applications with specimens whose intensity varies with time. For example, when measuring the bleaching of a fluorescent specimen, the automatic gain circuit will attempt to compensate for loss of specimen intensity, leading to a progressively noisier but constant-intensity image.

4. Specimen Illumination Intensity

To optimize the amount of specimen gray level information included in the camera output, attention must be paid to the intensity of the specimen image projected on the camera faceplate. When the camera is used in the automatic gain mode, this may not be critical in that the camera can deal with a range of light intensities. However, information can be lost if the average image intensity is close to the limits that the camera can accommodate. Clearly insufficient image intensity will, in the extreme, produce no signal from the camera compared to noise. At the other extreme, an image that is too bright will saturate the faceplate of the camera, and again no image will be transmitted from the camera. Typically,

Fig. 8 Specimen image intensity and camera response with fixed gain. Camera and monitor are adjusted to capture and display all gray levels. (A) With camera and monitor settings held constant, specimen illumination is increased. The result is the saturation of the light-gray values and an increase in the contrast between darker-gray values. (B) Camera output voltage profile and monitor image of the grayscale specimen at adequate illumination. (C) A decrease in specimen illumination intensity results in smaller changes in camera output for each step of the grayscale; the specimen white is represented by a relatively low camera output voltage. Thus, the image of the grayscale on the monitor is of low contrast, ranging from black to dark gray.

one has enough control over the intensity of the specimen image to avoid such gross problems. An overly bright image is most easily controlled either by reducing the output of the microscope illuminator or by introducing neutral density filters into the illumination pathway. However, in some applications, such as polarization or high–extinction differential interference contrast microscopy, one may be forced to work at the low end of intensities that the camera can use.

Figure 8 shows the loss of specimen gray-level information when the intensity of the specimen image on the camera faceplate is raised or lowered. Although this demonstration was conducted with the camera in the fixed gain mode, the phenomena shown here can occur when the specimen image intensity exceeds the range of values that the automatic gain control can accommodate. At proper specimen image intensity (Fig. 8B), all gray levels are represented in the camera output. At inappropriately high specimen image intensity (Fig. 8A), the lighter-gray values become saturated and are thus displayed as white. There is some increase in contrast between the darker-gray values. At inappropriately low specimen image intensity (Fig. 8C), the contrast between specimen gray values is reduced and the darker-gray values go to black. The white portion of the specimen is displayed as gray. Although we fixed the camera gain for this demonstration, the same results can be obtained when the image intensity is outside the range the automatic camera gain can accommodate.

5. Black Level

For each scan line of the video signal (Fig. 2), the black level is at a voltage that is slightly higher than the 0 volt blanking level. This 0.05–0.075-volt offset is called the setup or pedestal. For cameras that have black level control, this offset can be varied so that one can manually control what lower image intensity is represented by no camera output (i.e., black). Sometimes this camera control is labeled "brightness."

Figure 9A shows the step grayscale specimen with the camera gain and black level set properly. Figure 9B and C show the results of two increased levels of the black level control with the gain fixed. As the black level is increased, more of the darker-gray level steps are set to 0 volts. The whole output curve for the camera is shifted downward to lower voltages, with the step size (gain) remaining the same. As a result, the lower gray values are lost and the white value is reduced to gray. In practice, this means that the indiscriminate use of the black level control can lead to the loss of specimen detail.

Some cameras have an automatic black level option that, in principle, sets the lowest signal voltage of the image to the setup or pedestal level (0.05–0.075 volts). In practice, however, auto black circuits typically do not detect just the very lowest voltage in the field because insignificant objects such as small black granules in the specimen and imaged dirt particles would serve as the reference for the black level. As with the auto gain function, the auto black circuit is damped so that it monitors the lowest voltages in a percentage of the field or responds to dark objects of some threshold size. The extent to which the auto black circuit is damped can vary with camera model and manufacturer. Also, the degree of averaging may not be the same for auto gain and auto black. For demanding applications it may be best to use the manual black level control, because small areas of dark-gray specimen detail can be driven to black and the information lost when the camera is used in the auto black mode.

Obviously one would not want to indiscriminately use the black level control for images that have true blacks, because one could lose the darker specimen detail. However, the great value of this control becomes apparent when working with low-contrast specimens that are represented (under conditions of adequate illumination) only by lighter-gray values. By setting the black level we can make the darkest gray become black and then raise the gain to amplify the lightest gray to white. What started as a low-contrast image, represented by only higher camera output voltages, now is represented by the full 0.7 volts range of the camera output. In effect we have enhanced the contrast of the image, retaining

Fig. 9 Black-level control. (A) Monitor representation of the grayscale and the camera output voltages for a scan line through the grayscale. Leaving camera gain and the monitor settings constant, the black level control for the camera is increased in (B) and (C). As this control is progressively increased, more of the lighter-gray values are set to black. Note that the contrast between remaining steps does not change and that the white specimen step is progressively brought to lower camera output voltages; hence the white portion of the specimen is displayed as gray on the monitor.

Fig. 10 Use of black level and gain controls to enhance contrast. (A) Camera output voltages and the monitor representation of the grayscale when the camera and monitor are set to display all gray levels. The gray levels are numbered for reference. For (B), the black-level control was increased to set gray level 4 to almost black, and the gain was increased to set gray level 7 to almost white. The result is a marked increase in the contrast between gray levels 4–7. (C) Direct comparison between gray levels 4–7 taken from (A) and (B). The use of black level and gain controls in this fashion is useful when one has a low-contrast specimen or when one wishes to selectively enhance the contrast for desired portions of the specimen image.

all relevant gray level information. This operation is illustrated in Fig. 10A–C, in which we have sought to increase the contrast between several of the midlevel gray steps (of course remaining mindful of the irretrievable loss of higher and lower specimen image intensities). Figure 10A shows the camera set to display all gray levels. For Fig. 10B we have increased the black level to drop gray level 4 to black and then raised the gain to display gray level 7 as white. The contrast enhancement for gray levels 4–7 is shown in Fig. 10C.

This strategy can be implemented deliberately with the use of manual black level and gain controls, especially when one is working with a demanding specimen or is interested in optimizing the visualization of only a subset of the specimen detail. For routine work or for specimens that are of relatively uniform intensity across the field of the microscope, the use of auto black in combination with auto gain may perform this operation satisfactorily. However, note that when the camera is used with both auto black and auto gain, bringing the image of the microscope field stop into the field seen by the camera can lead to a marked loss of specimen contrast. The camera black level control will take the image of the field stop to be the darkest specimen value, leaving the real specimen values at light grays. In addition, the presence of a large area of black may lead to an automatic increase in gain, which can drive the light-gray values to white.

B. Monitor Control

Black and white monitors typically have "brightness" and "contrast" knobs to modify the displayed image characteristics. We emphasize that these controls modify just the monitor response to the signal from the camera and, thus, exert no control over the characteristics of the image being captured by a recording device. This means that monitor controls should be used to optimize the display only after the camera is properly adjusted.

1. Brightness Control

This varies the current of the electron beam that scans the phosphor surface at the face of the picture tube. At the minimal setting, the screen may be black and show no image. At maximum setting, portions of the image representing zero camera input appear gray, and the brighter-gray values may be represented with low contrast. Figure 11 shows the consequences of setting the monitor brightness control either a bit too low or a bit too high in relation to the proper setting. Figure 11B shows the grayscale with the monitor properly adjusted and the camera output trace showing that all specimen intensity values are represented in the camera signal. Figure 11A and C show the results of setting the brightness control too high and too low, respectively, without any change in camera output. When set too high, blacks become gray and the lighter-gray values are driven to white. When set too low, the white value goes to gray and the dark-gray values are shown as black. In both cases, information that is present in the camera output is functionally lost in the image displayed on the monitor.

2. Contrast Control

This is a gain control that varies the change in electron beam current relative to changes in the input voltages from the camera. The higher the "contrast" setting, the more the camera signal is amplified. Shown in Fig. 12B is the grayscale with the monitor properly adjusted and the camera output trace showing that all specimen intensity values are represented in the camera signal. Fig. 12A and C show the results of setting the contrast control too high and too low, respectively, with no change in camera output. At monitor gain that is too high, the blacks stay black and the light-gray values are driven to white. With a real specimen on the microscope, this sometimes leads to "blooming" of the highlights. Lower-than-proper monitor

Fig. 11 Monitor settings: brightness. For this exercise, the camera was properly adjusted to capture all gray levels in the specimen, as is shown in the camera voltage output profiles in all panels. With the monitor properly adjusted (B), all gray levels are displayed on the face of the monitor. When the brightness control is set too high (A), the black step is displayed as a gray, and the lighter-gray values are saturated and, thus, white. When the brightness control is set too low (C), the darker-gray values become black, and the lighter-gray values become darker. In both cases, the improper adjustment of monitor brightness leads to the functional loss of specimen information that is present in the camera signal.

Fig. 12 Monitor settings: contrast. For this exercise, the camera and monitor were properly adjusted to capture and display all gray values, as shown in (B). When monitor contrast (gain) is increased (A), the lighter-gray values are driven to saturation and become white; displayed contrast between the remaining gray levels is increased. In the monitor display there is a loss of specimen information present in the camera signal (upper portion of this panel). When monitor contrast is lowered (C), the grayscale displayed is of low contrast without true black or true white.

contrast settings yield an image of low contrast with the white value going to gray, and at the extreme, no image is shown on the monitor screen.

3. Monitor Response and Contrast Enhancement

Because monitors typically have a gamma between 2.2 and 2.8, the brightness of the image on the monitor is not linearly proportional to the input voltage from the camera. The contrast between lighter-gray values is greater than between the darker-gray values because the lighter values are amplified to a greater extent. Although this high gamma compensates for the low gamma of some tube-type cameras, it can distort the rendition of the image produced by linear cameras such as CCDs. This can be controlled with an image processor that allows one to manipulate the gamma of the camera output signal (see Fig. 5).

IV. Practical Aspects of Coordinately Adjusting Camera and Monitor

When examining a specimen that has known gray level characteristics, such as the grayscale we have used as a test target, adjusting the camera and monitor is relatively straightforward because we know what specimen information needs to appear on the monitor image. However, when working with a real microscope image, we obviously do not have the luxury of knowing what to look for. The difficulty is that the camera and monitor controls appear interactive, and we have no good reference from which to work. How, then, does one properly adjust the camera and the monitor to ensure that we do not inadvertently lose specimen information?

Unfortunately, there is no simple answer to this question, nor any foolproof protocol in the absence of a means to evaluate camera output independent of the monitor response. An added complication is that some, but not all, cameras have

features that allow the operator to monitor their output to some extent. Thus, the particulars of coordinately adjusting camera and monitor controls will depend on the specific instrumentation available to the operator. Nevertheless, the principles of coordinately adjusting the camera and monitor are discussed below.

As mentioned earlier, one must first ensure that the camera output contains the specimen gray levels that are relevant and adjust the signal so that these gray levels are represented over as much of the 0.7-volt camera output as possible. The only way to do this knowledgeably and effectively is to have the capability of measuring the camera signal output independent of the monitor response. Without such capability, we have found that it is virtually impossible to precisely or repeatedly optimize the output of the camera. Given the cost of a scientific grade video system and the importance of maximizing the amount of specimen information that can be captured, the relatively low cost of obtaining some means of monitoring camera output is a good investment.

Traditionally, the way of monitoring camera output has been to use an oscilloscope to examine the waveform of the live composite video signal as illumination intensity, gain, and black level controls are manipulated. This works well if one has an appropriate oscilloscope that can be dedicated for use with the video equipment and one becomes adept at displaying the waveform for the portion of the specimen that is of interest. Given that many researchers do not have an easy familiarity with the use of oscilloscopes and that these instruments are bulky, there is a great temptation not to use them. As an alternative, some image processors offer the ability to set a cursor line through the image of a specimen and then quantify the pixel values along that line. By positioning the cursor through the brightest and darkest portions of the image, one can determine the characteristics of the camera output. This works best if the processor allows one to use a live image rather than a static captured image; the live image enables one to immediately see the results of camera control manipulations. For the figures shown in this chapter, we used a Rasterscope made by the Dage MTI Corporation. This easy-to-use device, hooked up between the camera and the monitor, displays the camera output profile for a positional cursor line through the live image of the specimen. The graphic representation of the camera output is superimposed on the image of the specimen. Once the camera is properly adjusted, the image of the camera output can be turned off.

For digital cameras, the image intensities can be represented on the computer screen by an image-intensity histogram, which is often included as part of image-analysis software programs. This will be dealt with in greater detail in section V of this chapter.

If one has the means to monitor camera output, the coordinate adjustment of camera and monitor is relatively easy. First set the camera and monitor controls to their "home" or neutral settings. Adjust specimen illumination so that a reasonable image appears on the monitor. With the camera in manual or automatic gain modes, reduce the camera black level control (sometimes called brightness) until the darkest portion (of interest) of the specimen along the cursor

line is set to just above 0 volts. Then the gain control is raised until the brightest portion (of interest) of the specimen is set at just 0.7 volts. If the specimen illumination is a bit too low, one will not be able to raise the highlights to the full 0.7 volts. If this is the one, repeat this sequence with increased illumination. Once these adjustments are made, one can be assured that all the specimen gray levels of interest are included in the output of the camera and that the contrast is maximized.

To adjust the monitor, first set the monitor to underscan the video signal, thereby providing a reference background outside the image field. Then set monitor brightness at maximum and back this control off until the portions of the field outside the scanned area are just black. The monitor contrast control is then adjusted so that the lightest values are white with no blooming, or spreading of the whites into adjacent areas.

If one does not have the means to assess camera output independent of the monitor image, there is no way to reliably ensure that the camera is optimally adjusted. Nevertheless, the empirically derived protocol that seems to work best for us is described below. Although this sequence can be used with the camera set in manual or automatic gain, the latter setting may be helpful.

First set the camera and monitor controls to their "home" or neutral settings. Then adjust the monitor brightness control so that the areas outside the scanned field just become black. Next adjust the camera black level control until the darkest portion of interest in the specimen image appears black. Readjust the monitor brightness control, if necessary, to reestablish a true black for the monitor. Then adjust the camera gain control until the lightest portions of the specimen image are just under saturation, using blooming of the whites as an indication of overdriving the camera. It is all right if the whites appear as a light gray on the monitor at this point. Next adjust the monitor gain control until the lightest values are just white without any blooming into adjacent areas. If the image on the monitor seems to be of unusually low contrast and is noisy when the camera gain is set to its highest value, try raising the illumination intensity for the specimen and repeating the set-up procedure.

When we evaluated the results of our empirical camera adjustments with the Rasterscope, we found that we sometimes set the black level slightly too low, leading to a loss of the very darkest grays. Also, the camera gain was often not set high enough, so we were not using maximum possible camera output for the brightest features of the specimen image. As a consequence, we often set the monitor gain a bit too high. In addition, we were not readily able to tell when the specimen illumination was slightly too low; under such conditions, we were not using quite the full output of the camera and compensating for this with monitor gain. In conclusion, these exercises revealed that we were consistently able to obtain better images of the specimen on the monitor when we had a means to directly evaluate the camera output. The implications of these findings for the use of image recording devices should be evident.

====== ## V. Digital Imaging

Thus far, this chapter has dealt with imaging generated by analog video equipment. However, many of the current detectors used in video microscopy are digital; the analog voltage generated on the camera faceplate is converted to a numerical value that represents each picture element (pixel) by an analog–digital converter (A–D converter, or "digitizer"; see article by Ken Spring in this issue of *Methods in Cell Biology*). This conversion occurs in the camera itself, and the image information is transferred to a computer as a stream of numbers; the graphical information is then displayed as a grid of discrete pixels in an image file known as a raster image or bitmap image. In addition to its position within the bitmap, each pixel also has a bit depth, often referred to as the grayscale resolution or gray level of the image. This is the number of bits of information used to represent the intensity of each pixel. Each binary bit will have one of two values: either a zero or a one. Therefore, an image that is said to have a bit depth of 8 has the potential of 2^8 distinct gray levels (0–255).

The intensity values for each individual pixel contained within a bitmap can be represented graphically, usually as a feature in commercial imaging software packages. These graphs show the number of pixels (frequency) for each intensity value found in a particular image. For an 8-bit image, there are 256 potential values (0–255), which range from pure black (0) to pure white (255). This information is displayed as an image-intensity histogram. These histograms are usually updated on the computer screen along with the image display as the camera image refreshes; the histogram can be used to dynamically analyze image intensities when there is a change in gain, black level, or specimen illumination. In Fig. 13A–C, a tissue culture cell imaged with DIC optics is shown as a test specimen. The image in panel A has low contrast, and this can be confirmed by the image intensity histogram: A narrow range of intensities clustered between 96 and 144 (roughly middle gray; Fig. 13D) represent the image. Because the cell occupies only a small portion of the frame, the image intensities are heavily weighted toward background.

In digital imaging, contrast can be manipulated by changing the gain and black level, just as in analog video. The rules demonstrated in section III of this chapter pertain to digital imaging as well as analog cameras. It is important to remember that changing any parameter (i.e., gain, black level, specimen illumination) permanently changes the contrast of image that is saved in the final image file in the computer. Inappropriate manipulation of contrast can drive the pixels in the brightest or darkest portion of the specimen to pure white or pure black, and the potential exists to lose key specimen detail in these regions of the image. This lost detail cannot be restored by image processing.

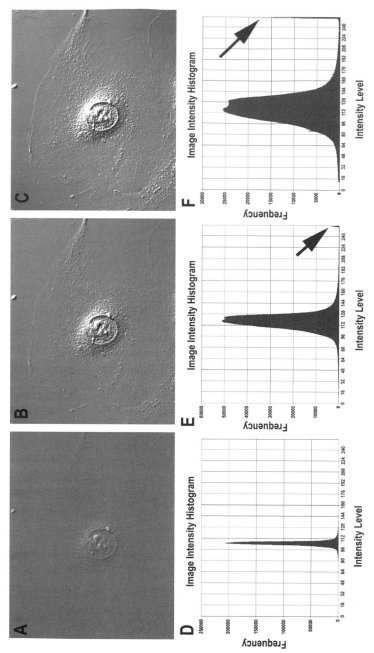

Fig. 13 Digital image contrast stretch. For this exercise, the test specimen is a cultured cell, imaged using DIC optics, and corresponding image-intensity histograms. (A) and (B) show the cell and intensity histogram when the camera is set to just below the middle gray. For (B), the black-level control was decreased, and the gain was increased so that the brightest pixel intensities were driven to pure white (i.e., saturated; *arrow* in panel E). The result is a marked increase in the contrast in peripheral regions of the cell and a broadening of the intensity histogram. (C) The effect of further increasing gain and decreasing black level. Here, details in the cytoplasm are revealed, with the tradeoff that the brightest intensities in the perinuclear region become saturated (*arrow* in panel F). The use of black-level and gain controls in this fashion is useful when one has a low-contrast specimen or when one wishes to selectively enhance the contrast for desired portions of the specimen image.

A. Contrast Manipulation—Camera Controls

1. Digital Gain

Gain (increase in camera output) is altered in the digital image by moving the "gain slider" in the image-capture window of imaging software. When the gain slider is moved in the plus direction (i.e, gain is increased), the peak of image intensities shifts to the right (toward the brightest intensities). If the contrast is raised too far, pixels will be driven to an intensity of 255 (white), and grayscale information can be lost (see Fig. 13E, F, arrows). Similarly, when the gain slider is moved in the minus direction (i.e., lowered), the image intensity peak shifts to the left, and the distribution narrows, decreasing the contrast of the specimen. If gain is lowered too far, the pixels can be driven to 0, and information in these pixels is lost and cannot be retrieved, even by digital enhancement (not shown).

2. Digital Black Level

The black level can also be used to manipulate the contrast in digital images. Often, the black-level slider is set to zero, and contrast manipulation depends on lowering this level using a slider in the software. When the black-level slider is lowered, the peak shifts to lower intensities. Just as in analog imaging, lowering the black level has the potential of irretrievably obscuring image detail in the lowest pixel intensities.

B. Contrast Manipulation—Contrast Stretch

Increasing the gain alone broadens the distribution of image intensities but shifts the peak intensity towards white. To increase contrast in the specimen while maintaining the peak intensity around middle gray, a contrast stretch is performed. Here, the gain is increased, and the black level is decreased (Fig. 13B, E and C, F), as is done with analog cameras (see Fig. 10). In Fig. 13 panels A and D, the initial image has a narrow intensity distribution and is fairly low contrast (middle gray). When the black level is decreased and the gain increased, the peak stays in roughly the same place, but the distribution becomes broader, and the image has more contrast (Fig. 13B, E). Note that there are some pixels that have been driven to pure white (an intensity level of 255; arrow in Fig. 13E). In Fig. 13C and F, the black level has been further decreased, and the gain further increased. This has the effect of further broadening the intensity distribution, resulting in an image that has higher contrast. The effect is to drive more pixels in the nuclear region of the cell to an intensity level of 255 (Fig. 13F, arrow). Although information is lost in the brightest regions of the cell, the overall result is increased contrast and the ability to detect details in the peripheral regions of the cell.

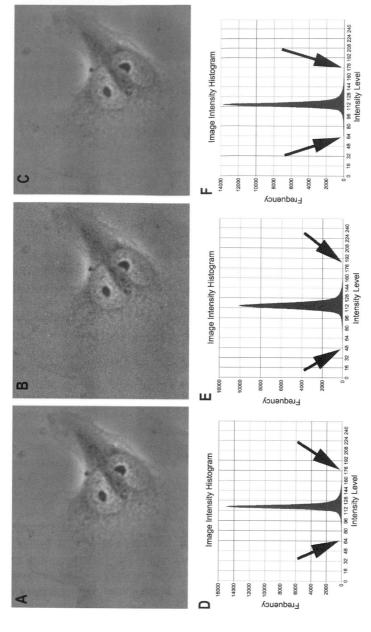

Fig. 14 Digital image-intensity histograms. For this exercise, the test specimen consists of cultured cells imaged with phase contrast (A–C). (D–F) Image-intensity histogram for the corresponding image. (A) Contrast is set to center around middle gray (peak in [D]). (B) Specimen illumination was decreased. To compensate for this, the camera gain was increased tenfold, yielding an image with roughly the same contrast as in (A). The consequence of increasing gain is an increase in noise. The image in (C) was captured with the same settings used in (B), the noise was reduced by introducing a four-frame average. Arrows represent the limits of the range of intensities in each particular image.

C. Contrast Manipulation—Specimen Illumination

Changing the intensity of specimen illumination will also shift the distribution of pixel intensities. Increasing illumination shifts the peak to the right, toward the higher values; decreasing illumination shifts the peak to the left, toward the lower values. As before, the intensity histogram can be used to monitor whether or not any pixels are driven to pure white or black.

Understanding the effects of specimen illumination can be important. Too much light can induce photo damage in living cells (Rieder and Cole, 1999) and can cause fluorescent molecules to become photobleached. Thus, for many applications, specimen illumination must be kept to a bare minimum. For situations in which specimen illumination must be restricted, increase in gain can be used to compensate for loss of pixel intensities. An example of this is shown in Fig. 14. In panel A, the gain setting is set to the minimum, and the illumination is raised to a level sufficient to detect the cells in the field. The image histogram (Fig. 14D) shows that there is a fairly narrow distribution of image intensities centered near the middle of the range (\sim120). Note that the range of intensities in this image extends from \sim64 up to 176 (Fig. 14D arrows). In panel B, the specimen illumination has been reduced to 1/10 that used in panel A. To compensate for this, the gain has been increased. The image histogram (Fig. 14E) shows a similar narrow range. Thus, the images shown in Fig. 14A and B look very similar. A major difference is the amount of noise in the image, seen in Fig. 14C. This noise can be detected by careful examination of the image-intensity histogram in panel E. Here, the range of intensities extends from a low of 48 to a high of \sim185 (compared to the range of 64–176 seen in panel D). These pixels, along with those in the major peak represent random noise throughout the image. To eliminate this noise (which is stochastic), the image can be frame averaged. Here, the pixel intensities do not extend below 64 or above 175 (arrows in Fig. 14F).

Acknowledgments

We thank Paul Thomas and Dean Porterfield for the kind loan of a Rasterscope during the preparation of this chapter, and Al McGrath for providing valuable input on interpreting image intensity histograms. Work in Ted Hinchcliffe's lab is supported by a Research Scholar Award from the American Cancer Society and by a grant from the Department of Defense Congressionally Directed Medical Research Program awarded to the Walther Institute for Cancer Research at the University of Notre Dame. Work in Kip Sluder's lab is supported by grants from the National Institutes of Health and the Worcester Foundation for Biomedical Research.

References

Inoué, S. (1986). "Video Microscopy." Plenum, New York.
Inoué, S., and Spring, K. R. (1997). Video Microscopy: The Fundamentals. Plenum, New York.
Rieder, C. L., and Cole, R. (1999). *J. Cell Biol.* **148,** 333–666.

CHAPTER 6

Cameras for Digital Microscopy

Kenneth R. Spring

Laboratory of Kidney and Electrolyte Metabolism
National Heart, Lung, and Blood Institute
National Institutes of Health
Bethesda, Maryland 20892-1603

I. Overview

The image in the present-day light microscope is usually acquired with a charge-coupled device (CCD) camera. The CCD is composed of a large matrix of photosensitive elements (often referred to as "pixels" shorthand for "picture elements") that simultaneously capture an image over the entire detector surface. The light-intensity information for each pixel is stored as electronic charge and is

converted to an analog voltage by a readout amplifier. This analog voltage is subsequently converted to a numerical value by a digitizer situated on the CCD chip, or very close to it. In this chapter, I will review the fundamental characteristics of CCDs and related detectors, point out the relevant parameters for their use in microscopy, and consider promising recent developments in the technology of detectors.

II. Basic Principles

Electronic imaging with a CCD involves three stages: interaction of a photon with the photosensitive surface, storage of the liberated charge, readout or measurement of the stored charge. The CCDs in modern cooled and intensified cameras contain large arrays of silicon photoconductors, typically 1200 (H) × 1000 (V), incorporating surface channels for transfer of the signal to the output amplifier. An individual pixel absorbs a photon in a specialized region known as the depletion layer, resulting in the liberation of an electron and the formation of a corresponding positively charged hole in the silicon crystal lattice. External voltages are applied to the individual pixels to control the storage and movement of the generated charges. Initially, the pixels act as "wells," storing the charge for a given time interval; the amount of stored charge is linearly proportional to the light flux incident on the pixel up to the capacity of the well. After the charges are collected, a series of voltage steps are applied to shift the charge along the transfer channels to the readout amplifier, where the signal is converted to a voltage. Virtually all CCDs used at present accumulate holes rather than electrons—so-called "HAD" or hole-accumulator-diode CCDs. HAD technology has dominated because there is more electronic noise associated with the storage and transfer of electrons than of holes. However, for convenience I will refer to all charges as electrons.

The charge storage capacity of a potential well in a CCD is largely a function of the physical size of the individual pixel. Most pixels are square in present-day CCDs, and the charge storage capacity of the potential well may be approximated by the area of the pixel in microns multiplied by 1000. Thus, a $4\,\mu$-square pixel will have a charge storage capacity of about 16,000 electrons. This full-well capacity (FWC) determines the maximum signal that can be sensed in the pixel.

A. Sources of Noise

The minimum detectable signal is determined by both the photon statistical noise and the electronic noise of the CCD. Conservatively, a signal can only be discriminated from noise when it exceeds the noise by a factor of \sim2.7; that is, a signal/noise (S/N) ratio = 2.7. How low a signal will yield a S/N ratio of 2.7? Even with an ideal noiseless detector there is inherent noise associated with the signal because of random variations of the photon flux. This photon statistical noise is

equal to the square root of the number of photons. Therefore, the maximum achievable S/N for a perfect detector is given by S/\sqrt{S}, equal to \sqrt{S}; a light flux of 8 photons will be required to achieve a S/N of 2.7.

Real cameras add electrical noise from two sources—dark noise and readout amplifier noise—to the photon statistical noise. Dark noise is the random fluctuation in the amount of electronic charge that is accumulated in a potential well when the detector is in total darkness. Dark charge accumulation is a consequence of thermal excitations of the CCD that liberate electrons or holes. Dark noise cannot simply be subtracted, as it represents the uncertainty in the magnitude of the dark charge accumulation in a given time interval. Dark noise has been drastically reduced by the storage of holes rather than electrons, as there is a far greater likelihood of thermal generation of electrons than holes. CCDs for scientific applications are usually cooled because the accumulation of dark charge is reduced by an order of magnitude for every $20\,°C$ temperature decrease. Cooling to $-30\,°C$, or even to $0\,°C$, reduces dark noise to a negligible quantity in most microscopy applications.

Readout amplifier noise is the other major electronic noise source in a cooled CCD. Readout noise may be thought of as the price that must be paid for converting the accumulated charge into a voltage. Because it is noise, its magnitude cannot be precisely determined but only approximated by an average value. Readout noise increases with the speed of measurement of the accumulated charge in each pixel. Higher readout speeds require greater amplifier bandwidths, and inevitably, increased amplifier bandwidth is associated with greater noise. Cooling the CCD helps to reduce readout amplifier noise, but there is a temperature below which readout amplifier performance is reduced.

An alternative strategy for achieving high-speed readout with lower noise is equipping the CCD with multiple output taps, so that four or more readout amplifiers are used to extract the image information. The image information is then obtained in the form of adjoining blocks that are later stitched together by processing software.

An additional benefit of cooling the CCD is an improvement in the charge transfer efficiency (CTE). Each time a packet of charge is shifted along the transfer channels there is a possibility of leaving some behind. When this occurs, the image is less crisp because the charge from adjacent pixels is inadvertently admixed leading to blurring. The large format of modern CCDs necessitates a very high CTE to prevent the loss of a significant magnitude of the charge from pixels that are far from the readout amplifier. The pixel farthest from the readout amplifier undergoes thousands more transfer steps than the pixel closest to the amplifier. When CTE values in a cooled CCD are 0.9999 or greater, charge loss is negligible. However, when the CTE is lower than 0.999, such loss occurs and the region farthest from the output amplifier appears dimmer than that near it; then the camera is said to exhibit "shading."

Shading may be compensated for in two different ways: with software or with hardware. When the software correction method is used, an image of uniform

intensity is captured and a pixel-by-pixel gain correction map is generated. This map can then be used to correct the intensity values in all subsequent images. This approach is satisfactory as long as the magnitude of the correction factors is not greater than 10%–20%. The hardware method involves sampling the intensities of dark or blank pixels in five to six reference columns at the end of each row of the CCD. These reference columns are outside of the image area and serve as controls for charge loss during the transfer. Large corrections, up to three- to fivefold, can then be made by adjusting the gain factors for an individual row. The voltage readout from each row of pixels in the image are multiplied by the correction factor for that row. When the multiplication factors are large, as in the most distant regions of a video-rate CCD, the noise is also substantially increased. Although the signal does not appear to be reduced by this correction process and the shading is gone, the S/N is not uniform over the entire image.

B. Quantum Efficiency

Quantum efficiency (QE) is a major determinant of the minimum detectable signal in a CCD camera, particularly in low-light-level applications. QE is a measure of the likelihood that a photon of a particular wavelength (and therefore energy) will be captured in the detector. If the photon is not detected because it never reaches the depletion layer or passes completely through it, no signal is generated. CCDs typically used in fluorescence microscopy can detect photons with wavelengths between 400 and 1100 nm. Most CCDs used in scientific imaging are interline transfer devices, described in detail below. Only about 25% of the surface area of these devices is photosensitive because the remainder is covered by the opaque charge transfer channels. A decade ago, manufacturing techniques were developed to bond microscopic lenses onto the surface of each pixel in register with the photosensitive regions. The lenses extend over the charge transfer channels and act to direct the incident photons to the sensitive area, increasing their effective surface area threefold.

The latest-generation CCD sensors have a QE of 70% in the green, so seven out of every 10 incident photons are detected in this range of the visible spectrum. If the readout noise is relatively high, the charge generated by a detected photon cannot be discriminated from the amplifier noise, and the signal is obscured. Assuming a detectable signal must be about 2.7 times larger than the noise, a CCD camera that has a readout noise of 10 electrons/pixel plus signal-dependent noise given by \sqrt{S} requires a minimum detectable signal of 35 electrons. Because present-day CCD cameras use unity gain readout amplifiers, each photon that is detected results in liberation of a single electron or hole. If the QE is 70%, 50 photons must impinge on a single pixel before a signal can be identified with certainty. If a video-rate CCD camera is used, the readout noise is much higher, ~150 electrons/pixel, and the minimum detectable signal is then –450 electrons/pixel.

Additional strategies are occasionally used to further improve QE in both the visible and ultraviolet wavelength ranges. The charge transfer gates that lie on the surface of the CCD sensor are not perfectly transparent and absorb or reflect blue or ultraviolet light. The transparency of these gates has been increased in recent years by the use of indium-tin oxide in place of aluminum. When even higher QE is deemed necessary, a back-illuminated CCD may be employed. In the back-illuminated CCD sensor, the detector is flipped over so that light is incident on the back surface after the CCD has been substantially thinned by etching. A QE as high as 90% can be achieved in such back-thinned detectors, but these devices are delicate and relatively costly. Performance of back-thinned CCDs in the ultraviolet wavelengths may be further improved by the addition of special antireflection coatings.

Coatings of wavelength conversion phosphors to the front face of conventionally oriented CCD sensors have also been used to enhance sensitivity to wavelengths outside of the normal spectral range of an unmodified CCD. Such conversion phosphors absorb light energy in the spectral region of interest and emit at a wavelength compatible with the spectral sensitivity of the CCD. For example, CCD sensitivity at ~ 200 nm is very low, even in a back-thinned CCD, but conversion phosphors are available that efficiently absorb light at 200 nm and emit at 560 nm.

C. Dynamic Range

Dynamic range is the extent of signal variation that can be quantified by a detector. It is typically expressed in units of 2^n, where n is the dynamic range in bits; a detector that can support $2^8 = 256$ discrimination levels (i.e., gray levels) has a dynamic range of 8 bits. Most CCD camera manufacturers specify the dynamic range of the camera as the ratio of the FWC to the readout noise. Thus, a camera with a 16,000 electron FWC and a readout noise of 10 electrons would have a dynamic range of 1600, or between 10- and 11-bit resolution. This specification is not a realistic measure of the useful dynamic range; rather, it represents the maximum dynamic range within a scene in which some regions are just at saturation and others are lost in the noise. The useful dynamic range is smaller both because the CCD becomes nonlinear when the wells are about 90% full and because a signal equal to the readout noise is unacceptable visually and of virtually no use quantitatively. For our hypothetical camera, the useful dynamic range can be calculated as the ratio of 90% of 16,000 (the FWC) or 14,400 electrons divided by 27 electrons (the signal needed to achieve a S/N of 2.7 with a readout noise of 10 electrons). The ratio is 533, or a little better than 9 bits. Thus, a more realistic dynamic range designation of such a camera would be 10-bit resolution or 1024 gray levels. Each gray level would then correspond to about 14–16 stored charges; this relationship is often denoted as $\sim 14 e^-$/A.D.U. (analog to digital unit).

The maximum dynamic range is not equivalent to the maximum achievable S/N, a parameter that is also a function of FWC. Because the FWC represents the maximum signal that can be accumulated, the associated photon statistical noise

is the square root of the FWC, or 126.5 electrons for a FWC of 16,000 electrons. The maximum S/N is given by the signal, 16,000 electrons, divided by the noise, 126.5 electrons, and is equal to 126.5, the square root of the signal itself. Electronic noise, as well as stray light, will decrease the maximum achievable S/N to values below the 126.5 in our example, as they both diminish the effective FWC by filling the wells with charge that is not signal.

D. Image Integration

When the light flux incident on the CCD is low, as is the case in fluorescence microscopy, the period of image integration before read out may be lengthened to accumulate more charges in each well. Image integration on the sensor (on-chip integration) is essential for most applications of CCD cameras, cooled or room temperature, under low-light-level conditions. The maximum integration period is a function both of the sensor FWC and of the rate of dark charge accumulation. Ideally, the integration period should be sufficiently long to nearly fill the wells of the pixels in the brightest regions. Most microscopy applications do not require integration periods longer than 30 seconds, and dark charge is still a very small fraction of FWC for such a time interval.

Careful examination of the image from a room-temperature CCD obtained after a long integration period in total darkness often reveals a small number of white spots that represent "hot" pixels. These are individual sensors with abnormally high rates of dark charge accumulation that saturate long before the neighboring pixels exhibit significant signal. The usual practice is to discard the information from the hot pixels by subtraction of a "spot mask" or background image.

Accumulation of charge beyond the FWC may result in "blooming," a situation in which the excess charge spills out into adjacent pixels and contaminates their wells. Most CCDs are equipped with antiblooming capabilities, where the excess charge is siphoned off and discarded instead of being allowed to spread to nearby pixels. In either case, the remaining charge fails to faithfully represent the incident light flux, and the upper limit of the dynamic range of the detector is exceeded. The pixel is saturated and the stored intensity information is compromised.

E. CCD Architecture

There are three basic designs for a CCD—full frame, frame transfer, and interline transfer—as shown in Fig. 1. The full-frame device has virtually no dead space between the photosensitive regions and requires the incorporation of a mechanical shutter. The charge accumulated while the shutter is open is transferred and read out while the shutter is closed. Full-frame devices have the largest photosensitive area of all the CCDs, but their operation is limited by the speed of the mechanical shutter and the charge-transfer and readout steps. They

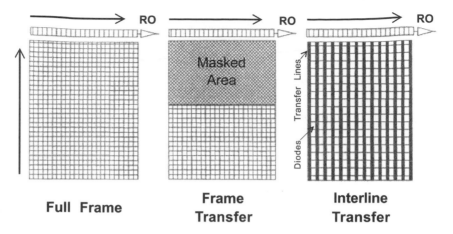

Fig. 1 Designs for CCD detectors. See text for details.

have proven most useful in applications involving long exposure times—several seconds to hours—in which speed is not a concern.

Frame-transfer CCDs resemble a full-frame CCD in which the sensor has been subdivided vertically into two equal regions. The lower region is photosensitive, and the upper is covered by an opaque metal mask. Charge, accumulated in the photosensitive pixels during the integration period, is rapidly shifted vertically to the masked region at the end of the integration period. The stored charge in the masked region is then systematically shifted and read out at a slower rate to ensure efficiency while the next image is simultaneously being integrated on the photosensitive portion of the sensor.

The interline-transfer CCD has a charge-transfer channel adjacent to each photosensitive region. Stored charge need only be shifted horizontally once by a small distance to move into the masked transfer channels. The interline-transfer CCD allows very short integration periods and enables electronic control of exposure or "electronic shuttering." Once the charge has been shifted to the transfer channels, it moves vertically to the serial register for readout. As discussed above, the area of the sensor occupied by the transfer channels is substantial, amounting to 75% of the surface, so the use of adherent microlenses is essential. Interline transfer CCDs may also be electronically shuttered, or made effectively light insensitive, by discarding the accumulated charge instead of shifting it to the transfer channel.

When CCDs were first developed, they were in competition with vidicon tube cameras and were required to produce an electronic output that conformed to the prevailing standards for video (see Chapter 5). This history is relevant today because it has dictated the geometry of the CCD and its numerical description. As illustrated in Fig. 2, CCDs are available in a number of rectangular sizes that are

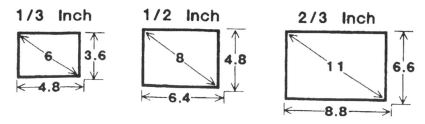

Fig. 2 Geometry of commonly used CCD sensors. All dimensions are in millimeters.

designated in inches. Careful examination of Fig. 2 reveals that none of the dimensions listed correspond to their designations in inches. The notation arose because the rectangles represented the size of the rectangular scanned area in the corresponding round vidicon tube. Thus, a "one-inch" CCD has a sensor size of 9.6×12.8 mm, with a diagonal of 16 mm, as this was the scanned area of a 1-inch tube with a 25.4-mm outside diameter and an ~18-mm-diameter input window.

F. Scan Formats

Because early CCDs were designed for video standards such as RS-170 and NTSC, they were required to produce an interlaced scan output. Interlaced scanning was an engineering solution to the speed limitations of early video equipment. It entailed the assembly of each image from two lower-resolution images known as "fields" taken 16 msec apart so that the final picture was a composite of the two fields in which the odd and even horizontal scan lines were obtained at different times. These speed limitations are no longer a concern, and modern CCDs use a "progressive scan" output in which the sensor is read progressively from top to bottom so that each image contains the simultaneously acquired stored information of all the rows of the sensor. In video-rate devices, the charge transfer and readout steps are accelerated so that the entire image is produced in the requisite 33 msec. The speed increase results in greater noise and reduced charge transfer efficiency, as described above.

G. Binning

When the incident light flux is very low, the process of binning may substantially improve the S/N of a CCD camera. Binning is an operation by which the signals from several adjacent pixels are pooled and treated as if they came from a single larger sensor (superpixel). Binning involves shifting the charge from a number of adjacent pixels into the output node and delaying the readout until the signal from all of the selected pixels has accumulated in the node. Binning trades off spatial resolution for sensitivity. The improvement in S/N

comes from the fact that the pooled signal from several pixels is read out only once. The relative contribution of the readout amplifier noise is reduced in proportion to the number of pixels that are binned. When 3×3 binning is employed, the signal is increased ninefold, whereas the noise is 1/9th of the noise obtained on sampling each of the nine pixels individually. The only physical limitation to the number of pixels that can be combined is the charge storage capacity of the serial register and output node of the CCD, both of which are typically two to three times larger than the FWC of a single pixel. This is not usually a significant concern because binning is employed when the signal is weak and the amount of stored charge does not approach the FWC. The associated reduction in spatial resolution is often a more important limitation to the extent of binning.

H. Color

There are three strategies for producing color images with CCD sensors: 1) cover each pixel of the CCD with a mask containing either red, green, or blue filters (RGB) usually arranged in the Bayer mosaic pattern; 2) divide the incident light with a beam-splitting prism and attached filters into three components (R, G, B) and three CCDs to capture the relevant images; 3) use a liquid crystal filter or rotating filter wheel to capture the R, G, and B images in succession (frame-sequential color). Although each approach has its strengths and weaknesses, all color cameras are less sensitive than their monochrome counterparts because of unavoidable losses associated with the color filters or other optical components.

When a Bayer mosaic filter is used, the color information is distributed over four pixels, one red, one blue, and two green (Fig. 3). The emphasis on green in

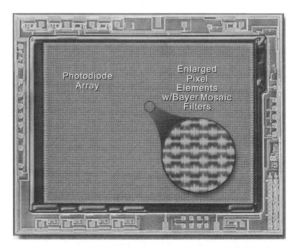

Fig. 3 A Bayer mosaic filter CCD for color imaging. (See Color Insert.)

the filter distribution pattern accomplishes good color fidelity with human vision and has only modest decreases in spatial resolution. Spatial resolution is largely determined by the luminance portion of a color image—that part associated with the monochrome signal. Each pixel, regardless of the color of the filter, contains considerable luminance information, so the resolution is not diminished in proportion to the number of pixels that constitute a sensor unit. Our visual system requires that only rather coarse color information be admixed with the monochrome structural information to produce a visually satisfying image. Some single-CCD color cameras improve the spatial resolution by shifting the CCD small amounts between a series of images and then interpolating between the images. This approach slows acquisition considerably because of the mechanical repositioning between frames. The single-chip CCD with an adherent color filter is the most widely used color camera in light microscopy.

The three-CCD color camera combines rapid image acquisition with high spatial resolution (Fig. 4). Spatial resolution may be greater than that of the individual CCD sensors, as each CCD may be slightly offset by a subpixel amount. Thus, the RGB images all represent slightly different samples and can be combined in software to produce a higher-resolution image. Commercial broadcast television cameras are all of the three-CCD variety, and many scientific applications that require high-resolution color and good temporal resolution employ these devices. They are often used in microscopy, particularly in applications involving histology or pathology.

Frame-sequential color cameras equipped with a liquid crystal filter are widely used in light microscopy (Fig. 5). Because the same sensor is used for all three colors, image registration is not an issue. The acquisition of three frames in succession slows the process considerably. Proper color balance often requires

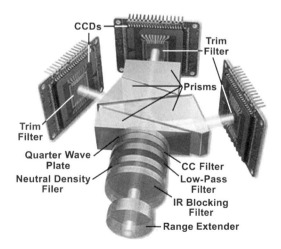

Fig. 4 A three-CCD color camera. (See Color Insert.)

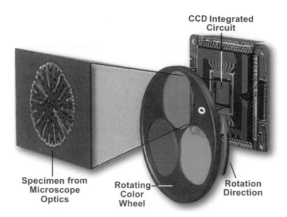

Fig. 5 A frame-sequential color camera using a filter wheel. (See Color Insert.)

longer integration times for one color than for another. In addition, the transmission of the liquid crystal or color filter is not the same for the three wavelengths, so the integration time must be adjusted accordingly. When a rotating filter wheel is used, more than three colors may be acquired. In remote sensing applications, up to 10 different wavelengths are captured in succession. A readily visible problem with such multiwavelength systems is image registration. Small positional shifts occur because the filter surfaces are not absolutely flat or the filters are not mounted perfectly. These artifacts can be corrected by postprocessing, but the acquisition time is further lengthened.

Liquid crystal filters have a lower transmission than the colored glass or interference filters used in the filter wheel systems. Liquid crystal filters only transmit one polarization, so half of randomly polarized incident light is lost. Additional losses in the filters themselves reduce transmission to about 40%. The polarization sensitivity of the liquid crystal filters also can distort the colors of objects imaged under polarized light. In fact, the analyzer can be removed in some cases as the filter fulfills that role.

Finally, some new technologies are on the horizon that may become relevant to the light microscopist. As discussed earlier, the depth of penetration of a photon into the silicon of a CCD depends on its energy and, hence, its wavelength. A new sensor exploits this property by layering the sensing regions and determining the "color" of an incident photon from its depth of penetration.

I. Image-Intensified CCD Camera

Image intensification is a widely used alternative to prolonged on-chip integration and binning when the image must be obtained in a short time period. Image intensifiers are an integral part of many low-light-level cameras, particularly video-rate devices. When the intensifier is coupled to a CCD camera,

the device is designated an ICCD (intensified CCD). Image intensifiers are three-stage devices: The first stage is photon detection by a photocathode and the liberation of photoelectrons, the second stage is an electron accelerator or multiplier, and the third stage is conversion of the electron beam to visible light or a detectable electronic signal.

Photons impinge on the front surface of a photocathode that absorbs their energy and releases an electron from its back surface. The released electron is accelerated by a substantial voltage and strikes the wall of a microscopic capillary in a microchannel plate (MCP) electron multiplier. The impact of the electron on the capillary surface results in the release of a cloud of electrons that cascade through the capillary driven by a voltage gradient along its length. The capillary is slightly tilted so that subsequent additional impacts with the capillary wall occur and result in a large increase in the number of electrons that emerge from the end of the channel in the MCP. A high voltage accelerates the electron cloud across a small gap to impact on a screen coated with a phosphor that converts the electron energy to light. The process results in an overall light gain of as high as 10^6, although 10^5 is more commonly achieved. Thus, a single detected photon at the input of the intensifier may result in an emission at the output of tens or hundreds of thousands of photons. This output light flux is usually relayed to the CCD sensor by a tapered fiber optic coupler that is designed to collect as much of the emitted light as possible.

The gain of image intensifiers is controlled by variation in the voltage across the MCP and can usually be adjusted over about a 1000-fold range. MCP gain can be adjusted very rapidly (within a few milliseconds) and reproducibly so that frequent gain alteration is an integral part of many quantitative imaging systems using an ICCD. When the gain of the MCP is fixed, image intensifiers have a limited dynamic range within a scene compared to a CCD camera. The dynamic range is largely determined by the maximum current that can flow through a region of the MCP. Well-designed ICCD cameras exhibit a 1000-fold dynamic range within a scene and, therefore, just achieve 10-bit resolution. When the gain of the intensifier is adjusted, a much larger intensity range can be accommodated, but the limitations still apply for the dynamic range within a scene. Because each detected photon results in the generation of thousands of photons at the output window of the image intensifier, the potential wells in the CCD sensor to which the intensifier is coupled may quickly fill to overflowing with charge. Therefore, unless the CCD employed has very large pixels, dynamic range limitations will also arise in the CCD itself. Thus, just a few frames of integration on the CCD sensor may saturate regions of interest and preclude the accurate measurement of their intensity. Often when integration is performed with an ICCD, the gain of the intensifier is substantially reduced to prevent such regional saturation.

Spatial resolution of an ICCD is always less than that of the CCD alone. The intensification process tends to blur the signal from individual photons and obscure fine image details. The extent of the resolution loss is a function of the size of the MCP capillaries, the geometry of the fiber optic coupling, and the pixel

size and number of the CCD sensor. The latest designs use 6-μm diameter MCP capillaries, tapered fiber optic couplers, and CCDs with array sizes of 1000×1000 or greater. The spatial resolution achieved is about 75% of that of the CCD alone.

J. Gating of the ICCD

The photocathode of the image intensifier can be rapidly turned off or on (gated) by altering its voltage from negative to positive. Gating effectively shutters the intensifier, eliminating the need for a mechanical shutter and allowing the intensified camera to tolerate much higher-input light intensities. When the input light intensity is overly bright, gating can be used to reduce the "on" time to as little as a few nanoseconds. Gated intensified CCD cameras are used in spectroscopy and high-speed imaging for sampling the photon fluxes that are obtained during such brief exposures.

K. Electron-Bombarded CCD

The first intensified video camera, the silicon intensifier target or SIT, used a photocathode and large accelerating voltage to generate energetic photoelectrons that impacted directly on the target of a silicon diode vidicon tube. Because of the high energy of the electrons, each electron impact generated many charge pairs in the silicon diode target. The SIT differed from the image-intensified cameras that followed because the electrons were not used to generate photons by impacting on an output phosphor but instead acted directly on the detector surface. The electron bombarded (EEB) CCD is the modern-day, solid-state embodiment of the SIT. The photosensitive surface is a photocathode as in the SIT and image intensifiers, and the photoelectrons are accelerated by a large voltage, but they impact onto a back-thinned CCD, where they liberate a large number of charge carriers.

The EBCCD has several advantages over the old SIT, including faster response, lower geometric distortion, and better uniformity of sensitivity across the detector surface. The spatial resolution of the EBCCD is generally higher than that of a comparable ICCD, but the EBCCD has substantially smaller dynamic range than a cooled CCD with the same size pixels. Each detected photon generates hundreds of charges, so the potential wells of the CCD fill very quickly. As with the ICCD, this limitation can be partially overcome by using a CCD with larger pixels.

L. On-Chip Multiplication

Two recent developments in CCD sensor technology are useful to light microscopists. As discussed above, the readout amplifier in a conventional CCD has unity gain, and each detected photon liberates a single electronic charge. Conventional CCD cameras incorporate subsequent amplification stages that allow multiplication of the output of the readout amplifier. This mode of

amplification has the disadvantage of increasing both the signal and the readout noise to the same extent. Ideally, the readout amplifier itself should have variable gain, so that the signal can be increased without any amplification of the readout amplifier noise. Recently, two new designs were announced for a low-noise, on-chip charge multiplication stage interposed between the sensors and the readout amplifier of a CCD.

In one version, the serial register pixels are modified to enable voltage-controlled avalanche multiplication of the charge stored in that pixel. Thus, as each row of a 512×512 array CCD is transferred to the serial register, the corresponding 512 pixels in the serial register allow variable multiplication of the stored charge before read-out. Because the serial register pixels are twice as large as the sensor pixels and the output node pixel is three times as large, there are limits to the maximum multiplication that can occur. Usually, however, multiplication is used when the signals are small and the stored charge in the pixels is nowhere near FWC. Avalanche multiplication occurs when the bias voltages of the serial register pixels are substantially increased, a process that also results in an increase in noise.

In the second version, the stored charges are transferred as usual to a modified serial register that contains a long, specialized region in which a variable number of impact ionization steps may occur. Each of these steps leads to charge carrier multiplication with little increase in noise, much as in the dynode chain of a photomultiplier tube. Thus, the signal that reaches the readout amplifier may be increased up to 50-fold depending on the gain that is selected, whereas the read-out amplifier noise is unaffected. A single electronic charge resulting from the detection of one photon could result in as many as 50 charges at the output node. For a CCD with a readout noise of 10 electrons, the S/N would be 5 for a single photon event.

Low noise amplification of the stored charge before read out is preferable to the amplification of the incident light flux that occurs in ICCD cameras or to the electron multiplication that occurs in the EBCCD. In both of these devices, amplification of the signal substantially reduces the dynamic range because the charge storage wells are filled at a rate that is directly related to the amplification factor.

III. Application of CCD Cameras in Fluorescence Microscopy

Although fluorescence microscopy is considered a "low-light-level" technique, the emitted light flux may vary over several orders of magnitude. In the past, low-light level referred to conditions in which a video-rate camera is incapable of capturing an image. The weakest light flux that can be detected by a tube or solid-state video-rate camera is about 10^{-2} lux (or 10^{-3} foot candles), equivalent to the nighttime incident light of a full moon or to the levels observed in polarized light microscopy near extinction. The most demanding applications

in fluorescence microscopy may require as much as four orders of magnitude greater sensitivity.

In addition to the physical limits of fluorescence, the need for sensitive detectors is driven by the low collection efficiency of conventional wide-field microscopes. The geometric constraints imposed by the numerical aperture of the objective lens as well as the inevitable losses in the optical train of the microscope lead to a loss of 80% or more of the original fluorescence signal. Depending on the properties of the detector, the resultant electronic signal may represent as little as 3% or as much as 16% of the fluorescence emission.

When a veteran video camera company representative was once asked about the basis for deciding between a cooled or intensified CCD camera for fluorescence microscopy, he replied, "It's all a matter of time." Indeed, given sufficient time for integration, a cooled CCD camera will always outperform an ICCD with a comparable sensor (see also chapter by Moomaw Deu). However, some biological events occur on such fast time scales and yield so few photons that a useful image cannot be obtained with a cooled CCD camera. The recent emphasis on the application of fluorescence microscopy to study the dynamics of living cells results in many such situations. The high illumination intensities or prolonged integration periods needed to capture an image using a cooled CCD camera may produce such serious photodynamic damage. How does one decide which detector to use?

The ICCD has the strengths of high speed and sensitivity but the weaknesses of limited dynamic range and resolution, both bit depth and spatial. The cooled CCD has the virtues of high quantum efficiency, large dynamic range, virtually perfect linearity, and excellent spatial resolution. These strengths come at the price of limited speed, both in the period of integration required to capture an image with acceptable S/N and in the time taken to read that image out. In many cases, the EBCCD and the On-Chip Multiplication CCD cameras offer an attractive compromise between the extremes of the cooled and ICCD cameras. The break-even point is determined by the experimental requirements, particularly the speed/sensitivity concern.

A rule of thumb for minimization of photodynamic damage during live cell imaging by reducing the excitation light intensity can be summarized as follows: 'If you can see the fluorescence through the eyepieces, the excitation light is too bright.' The limiting sensitivity of the dark-adapted human eye is about 10^{-4} lux or 10^{-5} foot candles, a light level that requires an integration time of about 200 ms on a cooled CCD camera to produce an acceptable S/N. If the biological event of interest occurs in less than this time, an ICCD, EBCCD or On-Chip Multiplication CCD is the appropriate detector. In many fluorescence microscopy applications to the study of living cells, the concentration of fluorophore in the cell or organelle may be limited either by loading limitations or by interaction of the probe with the process of interest, such as the undesired calcium buffering by the calcium indicator dye. Under these conditions the signal may be so weak that a longer integration time is required for a cooled CCD or EBCCD to capture a

useful image, even when binning is employed. Again, the ICCD or On-Chip Multiplication CCD may prove more appropriate under these circumstances because the gain may be increased to compensate for the weak signal while maintaining the requisite sampling speed.

It is important to note that the dynamic range limitations of the ICCD and EBCCD can make it difficult to capture events that exhibit large variations in brightness, as in specimens containing both thick and thin regions. When imaging Ca^{++} in neurons, for example, the cell body may be 40 times thicker than the dendrites, which requires a minimum of 12-bit resolution to simultaneously monitor the fluorescence from both sites. Because ICCDs generally have at most 10-bit dynamic range, one would have to capture several images at different gain settings with an ICCD. High gain could be used to visualize the small structures, and low gain to capture the image of the thick cell body. With a cooled CCD or On-Chip Multiplication CCD, however, it would be possible to effectively image both sites at once.

IV. Future Developments in Imaging Detectors

A promising development is the recently improved performance of the CMOS (complementary metal oxide semiconductor) sensors. These devices have large charge storage capacity, very fast readout of regions of interest, and extremely large dynamic range. Several (three to six) amplifiers are required for each pixel, and to date, uniform images with a homogeneous background have been a problem because of the inherent difficulties of balancing the gain in all of the amplifiers. CMOS sensors also exhibit relatively high noise associated with the requisite high-speed switching. Both of these deficiencies are being addressed, and sensor performance is nearing that required for scientific imaging.

References

Inoué, S., and Spring, K. R. (1997). Video Microscopy: The Fundamentals. Plenum, New York.

Murphy, D. B. (2001) "Fundamentals of Light Microscopy and Electronic Imaging." Wiley-Liss, New York.

Sluder, G., and Wolf, D. E. (1998). "Methods in Cell Biology," Volume 56, "Video Microscopy." Academic Press, San Diego.

CHAPTER 7

Electronic Cameras for Low-Light Microscopy

Keith Berland,[1] Ken Jacobson,[1,2,3] Todd French,[4] and Zenon Rajfur[3]

[1]Physics Department
Emory University
Atlanta, Georgia 30322

[2]Lineberger Comprehensive Cancer Center

[3]Department of Cell and Developmental Biology
University of North Carolina
Chapel Hill, North Carolina 27599

[4]Molecular Devices Corporation
Sunnyvale, California 94089

METHODS IN CELL BIOLOGY, VOL. 72
Copyright 2003, Elsevier Inc. All rights reserved.
0091-679X/03 $35.00

I. Introduction

A. Low-Light Imaging in Biology

The demand for low-light-level cameras in biological microscopy is mainly for fluorescence imaging. Modern low-light-level cameras provide much better technological solutions than even just a few years ago, and continuing improvements in sensitivity and ease of use are facilitating their integration into a wide variety of biological applications, ranging from imaging rapid changes in ion concentration in live cells to the distribution of labeled molecules in fixed specimens (Wang and Taylor, 1989; Arndt-Jovin *et al.*, 1985; Shotton, 1995; Bastiaens and Squire, 1999; Brownlee, 2000). Sensitive cameras allow observation of cells labeled with a variety of fluorescent probes at illumination levels that cause insignificant perturbation of cellular function over extended periods, providing a means to study real-time changes in structure, function, and concentration (Taylor *et al.*, 2001). Detection with low illumination levels can also help reduce photobleaching or "fading" of fluorescent probes to manageable levels. Moreover, low-light electronic cameras have replaced the traditional role of film cameras for microscopic imaging.

There are many different types of electronic cameras, and a wide variety of requirements in biological imaging. Thus, it can be difficult to determine which cameras best fit a particular application. The aim of this chapter is to provide an introduction to electronic cameras, including a discussion of the parameters most important in evaluating their performance, and some of the key features of different camera formats. This chapter does not present a comprehensive list of all available devices, a difficult task given the rapid and continuous changes in camera technology. The best sources of up-to-date product information and explanatory materials are the camera manufactures.[1] Rather, it is hoped that this chapter will provide the reader with a basic understanding of how electronic cameras function and how these properties can be exploited to optimize image quality under low light conditions.

B. The Importance of Proper Optical Imaging

Broadly speaking, most fluorescence imaging can be characterized as "low light," and highly sensitive cameras are invaluable for recording quality images. However, one should not overlook the microscope itself, as the actual image intensity that must be measured by the camera depends critically on the microscope and imaging optics. The goal in light-limited imaging will be to optimize the collection efficiency of the microscope; that is, to get as much light as possible from a luminescent specimen to the camera. Choosing appropriate optical components for each application, such as objectives, filters, and dichroic mirrors, is thus very important. This may require some extra work, but is easy to do and well worth the effort, as poor optical design can result in significant light loss. Using a high-quality microscope together with the proper optical components should result in substantially higher light levels reaching the camera. More light translates into better images, even for the most sensitive cameras.

There are several important factors that determine the collection efficiency of a microscope. First, the fraction of fluorescence emission that can be collected by the objective lens is determined by its numerical aperture (NA). Higher-NA lenses collect more light. A second factor is the throughput (transmission) of the objective, which varies for different lens designs and is also dependent on lens materials and coatings (Keller, 1995). Manufacturers can be consulted regarding which lenses have higher throughput. Filters and dichroic mirrors also reduce the collection efficiency, although they are necessary to attenuate the illumination relative to the fluorescence emission. These elements should be carefully chosen to optimize the signal relative to the background, based on the excitation and emission spectra of the particular fluorescent molecule to be imaged. Finally, microscopes often have multiple mirrors, lenses, and windows between the back aperture of the objective and the camera, resulting in light loss. Microscopes with multiple camera ports do not usually send the same amount of light to each port, and one should determine which port receives the most light. When low-light imaging is a priority, it may prove fruitful to upgrade the microscope itself, as many designs now have a direct optical path from the back of the objective to the camera, which can improve throughput substantially (Herman and Tanke, 1998).

Table I shows the total fluorescence detection efficiency for two different cameras and highly optimized optics. The total collection efficiency of about 10% represents an optimistic upper limit on the collection efficiency. Although it may be difficult to actually reach 10% with any given microscope or fluorescent probe molecule, it should be possible to get reasonably close, say within a factor of two

[1]Although there are more camera manufacturers than we can list here, there are a few with very good materials that explain the underlying technology, such as Andor Technology (www.andor-tech.com), Apogee Instruments (www.ccd.com), Hamamatsu Photonics (www.hamamatsu.com), and Roper Scientific (www.roperscientific.com).

Table I

Factors which determine the efficiency of a fluorescence microscope. The total collection efficiency is given by the product of the different factors shown. Some of the values shown will be difficult to achieve, as described in the text. The total detection efficiency represents the percentage of emitted photons detected by the camera.

Microscope Elements	Optimized Collection Efficiency
Objective Lens: Numerical Aperture[†]	.3
Objective Lens: Transmission	.9
Dichroic Mirror	.8
Microscope Throughput[‡]	.8
Filters[†‡]	.6
Total Collection Efficiency	~10%
Total Detection Efficiency (Camera = 50% Quantum Efficiency)	5%
Total Detection Efficiency (Camera = 10% Quantum Efficiency)	1%

[†]Represents the fraction of emitted light that is collected by the objective.
[‡]The light transfer efficiency from the objective to the camera, excluding other listed elements.
[†‡]Filter transmission can be higher if excitation and emission wavelengths are well separated.

to 10. However, it is also not uncommon to collect much less light than the numbers shown in the table. For example, use of low-NA objectives, or a camera port that receives, for example, 50% (or less) of the light, will both reduce the efficiency. Other potential sources of light loss include the use of too many or inappropriate filters; use of DIC microscopes without the slider or analyzer removed; dirty optics, perhaps covered with dust or immersion oil; and optical misalignment. Without proper attention to optical imaging, the total collection efficiency could easily be much less than 1%, or even less than 0.1%, throwing away much-needed light.

C. Detection of Low Light

The total detection efficiency can be used to estimate the camera signal amplitude for various applications, beginning with a single fluorescent molecule. If we estimate that with moderate illumination a single probe will emit about 10^5 photons per second, the microscope and two cameras from Table 1 would detect 10,000 and 1000 photons, respectively, for a 1-second exposure (neglecting photobleaching; So *et al.*, 1995; Tsien and Waggoner, 1995; Harms *et al.*, 2001).[2]

[2]This photoemission rate can vary greatly depending on the photophysics of the specific probe and the illumination level, but 10^5 is a reasonable estimate for this illustration. In fact, this number can realistically, in some cases, be 10 to 1000 times larger, or as low as desired if illumination is reduced. Photobleaching will normally limit the total number of photons emitted, as fluorescent molecules often will photobleach after 10^3–10^5 excitations. Thus, the rates of 10^5 or higher may not be sustainable, depending on the exposure time. If long or multiple exposures were needed, one would often use

In contrast, a shorter exposure, say one video frame (1/30th second exposure) would detect 330 and 33 photons, respectively. A very important point one should notice from these numbers is that it is possible to measure reasonably large numbers of photons, especially with a high-efficiency camera, even from a single fluorophore, provided it does not photobleach too rapidly (Funatsu *et al.*, 1995; Schmidt *et al.*, 1995). The microscope magnification and camera pixel size will determine across how many pixels the image from a single fluorophore will be spread, as discussed later. In any case, the technology is available to reliably measure fluorescence even from only a small number of probe molecules, particularly when the optical collection efficiency is also optimized. The remainder of this chapter is devoted to the discussion of electronic camera technology.

II. Parameters Characterizing Imaging Devices

The fundamental purpose of any electronic camera is to generate an electrical signal that encodes the optical image projected on its surface. When the light intensity is reasonably high, there are a number of cameras that perform very well. As the image intensity declines, it becomes increasingly more difficult to obtain high-quality images. Applications with the lowest light levels generally require some compromises between spatial resolution, temporal resolution, and signal-to-noise levels. However, as cameras become more sophisticated the required compromises are less severe. Ideally, a camera would record the arrival of every photon with high spatial and temporal precision, without introducing any extraneous signal, or noise. Of course, ideal detectors are hard to come by, and it is thus important to understand how real detectors perform. In the following section we discuss the key parameters that determine a camera's characteristic response.

Although there are many types of cameras available for microscopy, it seems the most relied on type is the CCD (charge-coupled device) camera (Hiraoka *et al.*, 1987; Aikens *et al.*, 1989). The other common type of camera, the CMOS (complementary metal-oxide semiconductor) camera, is mainly used for consumer devices, as it can be made very inexpensively. There are CMOS cameras appropriate for microscopy, yet it would appear that CMOS cameras are destined for the low-cost market, whereas CCD technology will remain preferred for high-performance systems.

Hence we will concentrate on CCD camera performance, although the basic ideas are generally valid for any camera type. There are many excellent references available for readers interested in more details about vacuum tube–based cameras, as well as solid state cameras and microscopy in general (Tsay *et al.*, 1990; Inoué and Spring, 1997; Sluder and Wolf, 1998; Miura, 2001; Periasamy and APS, 2001).[3]

lower-intensity illumination to limit photobleaching. One might also use lower illumination to limit perturbation of live-cell preparations.

A. Sensitivity and Quantum Efficiency

Camera sensitivity refers to the response of the camera to a given light level. A convenient measure of this quantity is the quantum efficiency (QE), which refers to the fraction of photons incident on the detector surface that generate a response (photoelectrons). Different CCD materials and designs can have vastly different quantum efficiencies, from a few percent to above 90% in some devices. The higher–quantum efficiency cameras are generally more sensitive, although a camera's minimum noise level must also be considered to determine how "sensitive" it is. Camera sensitivity is thus sometimes expressed in terms of the minimum amount of light that can be reliably measured, often called the noise equivalent floor. In this case, a lower sensitivity rating means the camera can detect dimmer light (i.e., is more sensitive). To be completely clear, it is best to specify the signal to noise ratio (see below) that can be achieved for a given light level. The use of different definitions in reporting the sensitivity can lead to confusion, and the manufacturer should be consulted when data sheets are unclear.

1. Spectral Response

The quantum efficiency of an image detector is wavelength dependent. This property is called the spectral response and is the result of the nonuniform response of the device materials to different colors of light. Some typical curves of quantum efficiency versus wavelength are shown in Fig. 1 for three different CCDs. The spectral response is dominated by the material response (silicon) but is modified by how the CCD is manufactured. Most CCDs have their peak response in the visible wavelengths and are normally more sensitive to red light than to blue. The sensitivity can be enhanced for particular applications by tuning the thickness of the photoactive region (blue or red enhancement), adding antireflective coatings (enhancing the peak light acceptance), or down-conversion coatings (improving the UV response), for example. Other enhancements such as changing the design of overlying control structures (e.g., open electrode or ITO electrode designs) offer a double enhancement of improving the light gathering of the sensor (less blocked light, see Fill Factor below) and shifting the peak spectral response more toward the blue. No matter what enhancements are offered, it is most important to verify that a camera has reasonably high sensitivity to the wavelengths of light that are to be imaged in your particular experiment.

2. Units

Camera sensitivity is also often reported in units of radiant sensitivity, which is equivalent to the QE, but expressed in units of amps/watt rather than electrons/photon. One can easily switch between quantum efficiency and radiant sensitivity using

[3]For an example of an on-line resource see http://bsir.bio.fsu.edu.

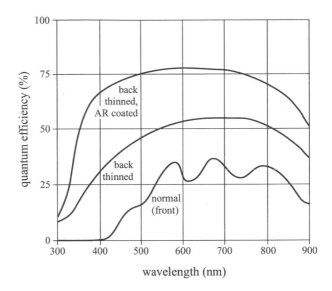

Fig. 1 Quantum efficiency of a CCD as a function of wavelength, showing typical curves for three devices—normal (front face), back thinned, and back thinned with antireflective (AR) coating.

$$QE = 1240 \frac{R_s}{\lambda},$$

where R_S is the radiant sensitivity in amps/watt and λ is the wavelength in nanometers. Both quantum efficiency and radiant sensitivity are radiometric units.

When the sensitivity is reported as the smallest resolvable signal, as mentioned above, it is usually expressed in photometric units, such as lux, lumen, or candela. Quoting sensitivity in lux is ambiguous unless the light spectrum is specified. Photometric units are adjusted for the response of the average human eye to different colors of light, and thus differ from radiometric units such as energy or number of photons. The integrated product of the radiant quantity and the efficiency of the eye yields the corresponding photometric (sometimes called luminous) quantity. The luminous efficiency function of the eye is called the CIE $V(\lambda)$ curve (CIE publication, 1990). Note that one lumen is equivalent to $1/683\,W$ (about 1.5 mw) of monochromatic light whose frequency is $540 \times 10^{12}\,Hz$ (a wavelength of about 555 nm in air). Figure 2 shows the conversion between radiometric and photometric units as a function of wavelength for monochromatic light.

3. Fill Factor (CCD Format)

The sensitivity of a CCD detector is also affected by its geometry. Not all the light reaching the CCD falls on photoactive areas (the pixels), as some of the surface may be obstructed as part of the device design for transferring stored

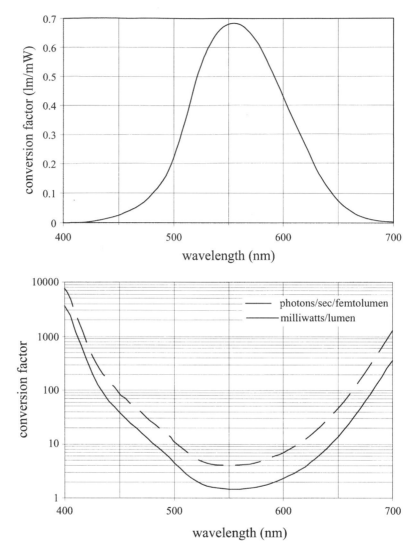

Fig. 2 Factors for converting between radiant flux (milliwatts or photons/second) and luminous flux (lumens) for monochromatic light. The two panels are shown for reader convenience, although they contain the same information.

photoelectrons. The surface electrodes obscure some incoming light. Interline transfer CCDs (see section "Slow-Scan CCD Cameras" for different CCD formats), for example, have inactive space between each row of pixels for charge transfer, resulting in reduced collection efficiency. The fill factor refers to the

fraction of the detector that is active, determined mainly by the surface area of the pixels. For interline transfer CCDs, the fill factor can be as low as 25%. This loss can be diminished by positioning microlenses over each pixel to refract light that would be blocked by the control structure into the active pixel area, thus increasing the effective collection area on an active pixel. Current microlens techniques (sometimes two layers of lenses) along with improvements in pixel design (e.g., Sony's hole accumulation diode, HAD, design) can achieve fill factors of more than 70% for interline transfer devices. Other CCD formats, such as frame-transfer CCDs, do not have masked areas between pixels and have higher fill factors, 70%–90%. Devices that are prepared for backside illumination have no obscuring control structures and thus are normally quoted as 100% fill factor devices, although some light may still be lost to buried pixel control structures such as antiblooming schemes. Note also that some CCD manufacturers combine the effect of the quantum efficiency and the fill factor and just report the product as the quantum efficiency. The quantum efficiency in this sense is that of the whole device, whereas the quantum efficiency we defined above is for the active area. The net result is the same, but the terminology can be confusing.

B. Camera Noise and the Signal-to-Noise Ratio

Electronic imaging is complicated by the presence of noise, which degrades image quality. If the response of a camera to a given light level is below the noise level, the image will not be resolved. The most important measure of a camera's response is therefore not the sensitivity itself but, rather, the signal-to-noise ratio, which can be achieved for a given light level reaching the detector. The signal-to-noise ratio (S/N) is defined as the signal level generated by the camera's response to light, divided by the average noise level. The higher the signal to noise ratio is, the better the image quality. The signal-to-noise ratio is often expressed in equivalent forms, decibels (dB), or bits. To convert the signal-to-noise ratio to decibels, the following formula is used:

$$(S/N)_{dB} = 20\log(S/N)$$

The equivalent number of bits can be found by calculating the base 2 logarithm of the signal to noise ratio (S/N) or dividing $(S/N)_{dB}$ by six, as one bit is equivalent to 6 dB.

Noise plays an important role in determining the performance of imaging devices, particularly in low-light-level imaging, where the signal is small by definition (see section "Intensified Cameras" for techniques to amplify the signal). To achieve a good signal-to-noise ratio, therefore, requires a camera that has very low noise. Knowledge of noise sources and how their effects can be minimized is thus valuable in understanding how various cameras are designed and in determining which camera types are most appropriate for a given application.

1. Shot Noise

Using an electronic camera to detect an image is essentially an experiment in counting the number of photoelectrons stored in the pixel wells. The electron counting is a random process and will follow Poisson statistics. The uncertainty in the measured result, called shot noise or photon noise, will be the familiar "square root of N," where N, in this case, is the number of electrons collected in each pixel. Shot noise is intrinsic to the photon statistics of the image and cannot be reduced. As the light level increases, the shot noise increases, eventually exceeding the level of other noise sources (this is a good thing). When shot noise is the dominant noise source for an image, the signal-to-noise grows as the square root of the number of photons measured at any pixel. This condition is the best obtainable; that is, the signal-to-noise ratio cannot exceed the shot noise limit. The signal-to-noise ratio will vary between applications depending on whether the camera noise sources are most important or are insignificant when compared with shot noise.

2. Readout Noise

Intimately coupled to the design of image detectors is the method they use to transfer the recorded image from the detector to a useable electronic format. This process, called readout, will introduce noise to the signal. The main source of readout noise in CCDs is an on-chip preamplifier required before digitization. The noise level is independent of the amount of light reaching the camera, and high readout noise will reduce the signal-to-noise ratio, particularly for low-light images. The readout noise level is highly dependent on the readout rate, increasing approximately as the square root of the readout rate. Thus, cameras with lower readout rates will have better signal-to-noise ratios than cameras with higher readout rates, other things equal. The cost of a lower readout rate is a reduced frame rate. For high-end video CCDs, readout noise can be as low as 5 electrons per pixel, increasing to several hundred electrons per pixel for lower-end devices. The readout noise level is determined by the electronics of each device, but some typical numbers for high-performance electronics are 3 electrons per pixel at 50 kHz, 10 electrons at 1 MHz, and 20 electrons at 20 MHz readout rates. Although there are no other systematic ways to reduce the readout noise, it can be effectively reduced by a new type of CCD that multiplies the number of photoelectrons before the read out occurs, thus applying gain to the signal without affecting the readout noise (see "On-Chip Multiplication Gain").

3. Background and Noise

There are a number of sources of background signal in electronic imaging. Thermally generated electrons get collected in the same pixels as the photoelectrons. These electrons, called dark charge, are generated even when the CCD is not

illuminated.[4] The associated noise, called dark noise, will grow as the square root of the dark charge, as does shot noise. Other factors, such as Rayleigh and Raman scattered illumination or stray light leaking through to the camera can also contribute to the background signal, again contributing to the noise as the square root of the number of electrons generated. The background level ultimately lowers the dynamic range (discussed below) of the camera and raises the noise. With image processing, the average background level can be subtracted from an image, although this subtraction will not reduce the noise. Although it is valuable to understand the various noise sources, there is no need in actual experiments to distinguish between shot noise and various other background noise sources. Rather, the total noise (excluding readout noise) can be calculated directly as the square root of the total number of electrons collected in any pixel.

In general, for video rate applications, the dark noise is not as important as readout and shot noise. In contrast, for longer image acquisition times, dark noise can be significant at room temperature. By cooling the camera with thermoelectric coolers or liquid nitrogen, dark charge, and thus dark noise, can be drastically reduced. High-quality cooled scientific cameras can achieve extremely low dark charge levels of less than a single electron per pixel per hour. This is in contrast to the dark charge of a few hundred electrons per pixel per second for standard, uncooled cameras.

Cooling is not the only strategy used to reduce dark charge. Some camera chips have multipinned phasing (MPP), which helps reduce collection of surface electrons on the CCD chip during image integration. MPP devices can reduce dark charge several hundred times. The major drawback of MPP is that it usually results in a reduction of pixel well capacity, and thus limits the dynamic range.

4. Example Calculation

Assume a cooled slow-scan CCD camera has quantum efficiency of 50%, read noise of $N_r = 10$ electrons per pixel, and is cooled such that much less than one thermal electron is generated per pixel during a 1-second exposure. What will be the signal-to-noise ratio when the number of photons per pixel per second reaching the camera is 100, 1000, and 10,000? First, the number of electrons generated is given by the number of photons multiplied by the quantum efficiency, or 50, 500, and 5000. The shot noise, N_S is then 7, 22, and 71 respectively. The total noise is given by $N = \sqrt{N_r^2 + N_s^2 + N_d^2}$, where the dark noise, N_d, is negligible for this example. Total noise is thus 12, 24, and 71 electrons, with corresponding signal-to-noise ratio of 4, 19, and 70, respectively, or 12, 26, and 37 dB.

[4]Camera data sheets often specify a dark current, in amperes per centimeter squared, rather than dark charge, in electrons per second per pixel. The conversion between the two is determined by the size of each pixel, and the charge of the electron, which is 1.6×10^{-19} Coulombs.

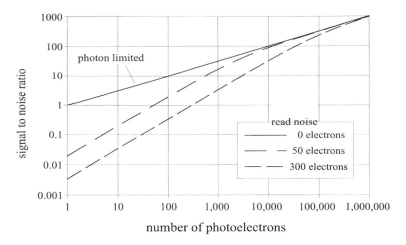

Fig. 3 The signal-to-noise ratio as a function of image intensity, assuming negligible dark noise. The three curves correspond to three different values for the read noise.

How would the signal-to-noise ratio be changed using a 1-second or 1-minute exposure if the same camera is illuminated by 1000 photons per pixel per second and also has dark charge of 50 electrons per pixel per second? The total number of photons reaching the detector would be 1000, or 60,000 for the long exposure, generating 500 or 30,000 electrons, respectively. The total dark charge for the two integration times is 50 or 3000 electrons, respectively. The combination of dark noise and shot noise would then be 23 or 182, respectively. Adding in read noise results in noise of 25 or 182 electrons. The signal-to-noise ratio is then 20 (26 dB), or 165 (44 dB). Note that the shot noise limit for these two cases is a signal-to-noise ratio of 22 (27 dB) for the 1-second exposure and 173 (45 dB) for the 1-minute exposure. The signal-to-noise ratio can, of course, be calculated in one step rather than the two shown, but this method nicely illustrates how read noise becomes less significant for long exposures. Figure 3 further illustrates this point with plots of the signal-to-noise ratio as a function of signal intensity for three different values of the read noise.

C. Spatial Resolution

Electronic cameras form images by sampling the optical image in discrete pixels, as shown in Fig. 4. The spatial resolution of a camera system is determined by the pixel spacing and is independent of the optical resolution of the microscope, although limited by it (Castleman, 1993). To resolve image features of a given spatial frequency, the camera must sample the image with at least twice that frequency. This requirement can be roughly understood as simply stating that image details will be resolved only when the pixel spacing is smaller than the scale

Specimen Microscope Magnified image
 magnification projected onto the
 camera

Fig. 4 Spatial resolution in electronic cameras is determined by the pixel size as described in the text. The magnified image is projected onto the camera, where it is sampled in discrete pixels. Image features that change over distance scales smaller than two pixels are not resolved in the electronic image. A real camera would have many more pixels than this cartoon.

over which image features change. As an extreme but intuitive example, one can imagine a "camera" with only a single large pixel, for example, a photomultiplier tube, that can measure light intensity, but that has no spatial resolution. By dividing the detector into pixels, the image will begin to be resolved, and as the number of pixels is increased, higher levels of detail will become apparent, up to the diffraction-limited resolution of the microscope optics. CCDs generally have a pixel spacing from about 2 to 40 μm. The smallest resolvable details in the magnified image on the detector's active area are therefore about 4–80 μm in size, because of the sampling requirements stated above.

Most image detectors are physically small devices, typically 1 inch square for image tubes and even less for many CCD chips. Choosing how much an image is expanded or compressed in projecting the image on the device will involve a trade-off between the resolution and the field of view. Image magnification also involves a trade-off between spatial resolution and image brightness—the more an image is magnified, the more the light from each fluorophore is spread out, reducing the signal in any given pixel and, thus, the signal-to-noise ratio (Shotton, 1993).

1. Example

The size of a microscope image is governed by the object size and the microscope magnification, the smallest size being limited by the point spread function of the microscope (diffraction-limited resolution). The spatial resolution of an imaging system can easily be calculated if the camera pixel size and magnification are known. Consider a CCD camera with 10 × 10-μm square pixels

on a microscope with a 63 × objective (NA = 1.4) and no further magnification. For each dimension of the camera chip, the 10-μm pixel at the camera corresponds to 159 nm (10 μm/63 magnification) in the specimen plane. This camera/lens combination would thus correctly sample image details down to 318 nm (2 × 159). This would not, however, fully exploit all the available image detail. The Rayleigh criteria for the optical resolution limit is given by 0.61λ/NA, which specifies the minimum separation at which two point objects can be resolved (Castleman, 1993). Assuming we have 500 nm light, this limit is 218 nm for a 1.4-NA objective. To correctly recover all the available image detail would require sampling at 109 nm (218/2) pixel spacing. This could in fact be achieved with additional magnification of approximately 1.5×, which would sample the image every 106 nm. This extra magnification can be added to the microscope, or sometimes to the camera itself.

D. Linearity and Uniformity

In general, cameras are designed to be linear, meaning the detector has a linear relation between input signal intensity and output signal. This feature is essential for quantitative imaging and must be verified for each camera. A CCD is a linear detector, although linearity is lost if the detector is overexposed. In this case, photoelectrons from adjacent pixels overflow into neighboring wells, causing blooming. Antiblooming circuitry and the improved design of modern CCDs reduce this problem. Also, the camera response across the detector surface is not always uniform and leads to image distortion, or shading. The camera response is not the only source of this problem, as the illumination itself is often not uniform over the entire field of view. Shading (flat field) correction can be added to some cameras to electronically correct their response, or the image may be corrected at a later time using image processing provided that the necessary correction is known from imaging a uniform sample.

Sometimes, video cameras are intentionally coupled to an output stage that is not linear. Two common sources of nonlinearity built into a video CCD camera are automatic brightness control and gamma correction. Automatic brightness control automatically changes the output preamplifier's gain when the number of stored charges in a pixel becomes too large. This change in gain is not normally under the camera operator's control and is therefore difficult to compensate for in quantitative imaging. The best solution is to turn off automatic brightness control. Many cameras (especially video CCD cameras) also have gamma-compensated output. Gamma correction is useful to properly transfer an image from the detector to a video monitor but is generally harmful to quantitative analysis. Monitors have a nonlinear response to the voltage applied to them. If monitor brightness is M_B and monitor voltage is M_v, M_ν, then this nonlinearity is closely modeled by a power function:

$$M_B = M_v^\gamma, \tag{1}$$

where the exponent gamma (γ) is about 2.5. Then the words "the signal, S" and the second equation become

$$M_v = S^{1/\gamma}. \tag{2}$$

Cameras that perform gamma correction convert the linear CCD signal into a gamma-corrected one (using Eq. [2]). This means a digitizer will quantize the data at nonlinear intensity levels. The advantage is that the first digitization controls the precision in the signal, and there is no further loss of precision when using a digital-to-analog converter for the video signal sent to the monitor. The disadvantage is that to make quantitative comparisons in the linear space of the original CCD signal, some of the original signal precision may be lost.

E. Time Response

Cameras do not always respond immediately to a change in input intensity, introducing lag and a decrease in temporal resolution. Lag can be introduced in several ways, including the time response of the phosphor screen in image intensifiers, and the incomplete readout of all accumulated charge in any one frame of tube cameras. Lag is not significant in CCD cameras. If fast time resolution is of interest, it is very important to make sure the camera lag does not affect the measurement. For example, ratio imaging will likely contain artifacts if performed using a camera with lag, such as a SIT camera.

F. Dynamic Range

There are a finite number of intensity levels, or gray levels, that can be detected by a given device, which can limit the detection of fine details. The range of levels is called the dynamic range. High dynamic range is important whenever there is a wide range of signal levels that must be recorded for a given imaging application. Dynamic range may be specified both within one frame (intrascene) and between frames (interscene). The dynamic range is determined by two factors; the overall operating range, or pixel well depth in the case of CCDs, and the average noise level and is calculated by dividing the maximum signal level (for each pixel) by the minimum average noise level (excluding shot noise).

For example, a CCD with pixel capacity of 200,000 electrons and an average noise floor of 50 electrons has a dynamic range of 4000:1. Normally, similar to the signal-to-noise ratio, the dynamic range is expressed in either dB or the equivalent number of bits. For this example, 4000 gray levels are equivalent to 72 dB, or 12 bits.

Another way to think about dynamic range is that it specifies the smallest difference in signal level that can be resolved when the camera is operating at full range; i.e., the smallest difference in image brightness that can be observed on top of a bright background. Although this second definition is technically not quite

correct, it is useful in as much as it gives some intuitive feeling for what the dynamic range is. The signal-to-noise ratio and dynamic range should not be confused. Whereas the dynamic range describes the camera's ability to respond over a range of signal levels, the signal-to-noise ratio is dependent on the conditions for each image acquired, comparing actual signal levels and camera noise. The signal-to-noise ratio is always less than the dynamic range.

The dynamic range of a camera can be limited by the choice of digitizer. For most video-grade CCDs this is not a problem, as they often have a dynamic range of only 40 dB or less, which is less than a dynamic range of an 8-bit digitizer (256:1). In contrast, scientific-grade CCDs may have a dynamic range of greater than 100 dB (16 bit, or 66,000:1). In this case, a digitizer with equivalent precision is required, or digitization of the camera signal will reduce the dynamic range.

G. Gain

Gain refers to signal amplification by the camera to create an electrical signal that can be accurately measured. Although sensitivity describes the input response of the device, gain determines the total output response. Gain stages can only increase the noise, but some gain is normally necessary to transmit a signal that can be reliably read by the digitizing electronics. If the digitization is performed in close proximity to the detector, the gain requirements are less. Not all gain is provided by an electronic amplifier. Sometimes it is an inherent part of the photodetector, as in SIT cameras and image intensifiers, although these devices still have electronic gain as well.

When gain can be changed between frames, the camera can accommodate an interscene dynamic range that may be several orders of magnitude larger than the intrascene dynamic range. However, the response characteristics of a camera are normally not precisely known for different gain settings. For example, altering the gain may affect the slope of the camera's linear response or may even result in a nonlinear response. These differences must be measured and calibrated to use the detector with multiple gain settings. Without precise knowledge of the response of the detector at different gain settings, it is impossible to make quantitative measurements that can be compared. Therefore, when the gain response is not well known, it is important that all the images of a time sequence, for example, use the same gain setting for proper quantitative analysis. Unfortunately, some images may have points that exceed the normal intrascene dynamic range. However, without changing the gain there is nothing that can be done, and the detector gain should be set to the best compromise. One exception is the gain of the output preamplifier of CCD cameras, which does not normally affect the response of the detector. However the effect of the system gain must be measured to verify linearity.

H. Frame Rate and Speed

Different applications require image acquisition at varying speeds, or frame rates. The frame rate is determined by the pixel read rate and the number of pixels in the image. For a fixed number of pixels, the main drawback to higher frame rates is increased noise caused by higher readout rates (faster readout also has less light per pixel per frame). Digitization is normally the rate-limiting step in image readout. For a certain level of noise and digitization depth (number of bits), the maximum digitization rate is consistent across all manufacturers. The frame rate is then determined by the number of pixels. Most video cameras have a fixed frame rate of 30 frames per second. Scientific cameras and other specialized systems can offer variable frame rates. If a camera contains many pixels (one million or more), the frame rate will in almost all cases be lower than video rate, particularly for low-light applications. This is because the high read noise associated with fast readout would overwhelm the small signal levels inherent to low-light imaging, resulting in poor signal to noise ratios.

I. Resolution, Sensitivity, and Imaging Rate

A properly operated electronic camera is essentially an array of independent photodetectors. When the signal-to-noise ratio is reasonably high for most pixels, the result will be high-quality images. Various camera design choices employ different strategies to maximize signal-to-noise ratios, usually involving some compromise between spatial resolution, frame rate, and the signal-to-noise ratio. For example, when the signal per pixel is small compared with readout noise, one can simply acquire an image for a long time, provided the camera has low dark noise, to build up the required signal level. This describes the basic design of slow-scan CCD detectors, which increase the signal-to-noise ratio at the expense of time resolution. Another strategy is to use a camera with fewer (larger) pixels, effectively increasing the amount of signal per pixel. This will also increase the signal-to-noise ratio at the expense of spatial resolution. Conversely, for a given light level reaching the camera, increasing spatial resolution (more, but smaller, pixels) will lead to a decrease in the signal-to-noise ratio, as will increasing the frame rate. The required resolution and the image characteristics (intensity, spatial and temporal frequency) will determine which strategy and suitable camera design to employ for a given application.

Sometimes, when spatial resolution can be sacrificed, a technique called binning can be used to optimize the signal-to-noise ratio or the frame rate for a given application. Binning is an electronic technique, available only on certain camera models, that combines the stored charges of adjacent pixels on the CCD chip. Binning is effectively equivalent to using a camera with a smaller number of larger pixels than the actual camera in use—there is essentially no time loss associated with binning, as combining electrons from multiple pixels can be completed much faster than pixel readout. There are several reasons one might choose to use

binning. One is that there will be fewer pixels to digitize per frame, which will allow for higher frame rates. Another reason is to increase the signal level by increasing the active area of each effective pixel. This is especially useful for low-light situations in which the number of photoelectrons collected by each single pixel is low compared to the readout noise. Getting more light to each pixel can also be accomplished using lower optical magnification, but electronic binning, when it is available, is certainly more convenient than changing optical hardware. The obvious drawback in either case is reduced spatial resolution. Another drawback of binning is that the full-well capacity cannot always be used without saturation, as binning transfers all of the charge from multiple wells into one well before readout. This should not be a problem in most low-light imaging applications, as the pixels are generally nearly empty rather than full, and binning is used to increase the number of electrons to measurable levels.

III. Specific Imaging Detectors and Features

There are currently many options available in choosing electronic cameras, and devices with improved performance characteristics are constantly being released. More cameras are being manufactured with application-specific designs, resulting in exciting possibilities for biological imaging. In this section, we present some of the basic camera types that are commonly available and highlight the major features. For up-to-date information on the latest product specifications, one should consult camera manufacturers. In choosing a camera for special applications, it is wise to evaluate several models, on a trial basis, to compare their performance and image quality using an investigator's actual samples.

A. Video CCD Cameras

Monochrome video CCDs are the most commonly available and least expensive CCD-based cameras for microscopy. These are not considered low-light cameras, as they do not have particularly high quantum efficiency (10%–20%). The typical minimum sensitivity of low-end devices is 0.5 lux (noise equivalent), which is barely low enough for microscopy. High-end video CCD cameras can have sensitivity as low as 0.01 lux, which can be used for fluorescence imaging of brightly labeled specimens. Readout noise is the main noise source since dark noise is usually minimal for video rate acquisition. The high readout noise and relatively low pixel capacity (36,000 to 100,000 electrons) limit the dynamic range. In the highest quality video CCDs, the dynamic range can be as high as 8 bits, although noise often limits the true dynamic range of many video CCDs to around 6 bits. Typical spatial resolution is approximately 700 × 500 pixels (interlaced), on a 1/4- to 2/3-inch chip. Video CCDs have a fixed frame rate of 30 Hz. These basic cameras have little flexibility, but they are easy to use and are compatible with standard video equipment.

Some video CCD cameras have been modified to enhance performance and increase flexibility. Circuits have been added that allow variable "on chip" integration time, from a short 100 s (300 times less than video rate exposures), up to several hundred seconds. Long integration times are very useful for low-light applications, increasing the total amount of light reaching the detector before it is read. On-chip integration has a major advantage over frame-averaging standard video camera output, as on-chip integration incurs read noise only once, rather than each time the image is read for averaging. Variable–frame rate video CCDs incorporate cooling to reduce dark charge, which is important for the longer exposure times. These modified video CCDs are much more powerful and flexible than standard video cameras and provide an economical option for low-to-moderate-light-level imaging.

B. Slow-Scan CCD Cameras

Slow-scan, or scientific, CCDs are designed specifically for low-light applications, with the ideal attributes of both very high sensitivity and low noise. Slow-scan CCDs are currently the best available low-light cameras, provided fast time resolution is not required. These cameras are substantially more flexible than video cameras, and this flexibility can be exploited to achieve superior image quality for many applications. They come in many different formats, and the particular CCD chip will determine the camera performance. The quantum efficiency of scientific CCDs ranges from 20% to above 90% significantly better than video devices. The highest quantum efficiency is found in back-illuminated CCDs, which collect the image from the back surface of the chip rather than the front, to reduce light losses incurred in passing through the electrodes and protective layers on the front surface of the chip. Applying antireflective coatings can also help achieve maximum quantum efficiency. Back-thinned CCDs are more expensive than other scientific CCDs, and the application will determine whether this added sensitivity is required and worth the investment.

In addition to high sensitivity, scientific CCD cameras also have very high spatial resolution, which is achieved by using CCDs with more pixels. Arrays may contain upwards of 5000 × 5000 pixels. Some devices are built such that they can be placed side by side to create even larger pixel arrays. The growth in the number of pixels results in longer read times and, thus, slower frame rates. This should not pose a major problem unless fast time resolution is required, in which case the highest spatial resolution may be too much to hope for at present, at least for low-light applications. If only a small number of images are required, frame-transfer CCDs can be used to acquire several images rapidly, with the images stored on inactive areas of the CCD and read out later at slow readout rates. This approach works because charge transfer to the inactive regions of the CCD chip can be completed much faster than the actual readout. As mentioned above, binning can also be employed to increase the frame rate.

Slow-scan cameras have very low background, and hence low noise, allowing for long image acquisition times. The readout and thermal noise are minimized through slow readout rates and cooling or multipinned phasing. Readout noise as low as 5 electrons per pixel is common, and dark charge can be reduced to just a few electrons per pixel per hour. This results in the potential for very high signal-to-noise ratios in high light conditions, or with long integration times for low light levels. Basically, using slow-scan CCDs, low-light images can be integrated (on-chip integration) for whatever time is necessary to achieve a reasonable signal to noise ratio, provided the sample is stable. The low noise also makes it possible to exploit the full dynamic range of each pixel. The electron well capacity of scientific CCDs is generally at least several hundred thousand electrons per pixel, with some devices holding over one million electrons per pixel. The dynamic range of scientific cameras is 10–16 bits (1000:1–66,000:1), much greater than the 8-bit (maximum) video CCD.

An important factor in determining camera quality is the image transfer method. Because scanning pixels in the vertical direction limits the speed of the camera, the CCD manufacturers developed different scan procedures to speed up this process. Some CCDs transfer pairs of pixels in adjacent horizontal rows. The rows are scanned in one single sweep, and their charge is added together. This procedure diminishes the vertical resolution, resulting in an image with a poorer resolution than the actual number of pixels in one direction. An alternative method is interlaced transfer, in which odd-numbered rows are read in one step and even-numbered rows in the next one. The result is the loss of scan synchronicity. Both methods are not suitable for precise measurements, though there are software algorithms, that can deinterlace the image, basically splitting it into two separate images (with half the perpendicular resolution). Recent advances in CCD chip design, especially improvements in the vertical electron transfer rate, allowed development of progressive interline scanning. In this method, every single pixel is read in one scan, preserving full vertical resolution and synchronicity.

Aside from electronic methods to transfer the image, CCDs employ physical structures that enable specific types of image transfer. Frame-transfer devices are the most basic sort, where the image is formed on the active area and then read out directly from the active area. The image is shifted across the active area, one column at a time, for a total time that is slightly greater than the number of pixels divided by the readout rate. For example, a 1000 × 1000 pixel camera read at 20 MHz will require 50 ms to shift the image and read it out. In frame-transfer cameras, it is important that the transfer time is a small fraction of the total integration time, or the image may smear as more photons fall on the active area while the image is shifted out to the readout register. Alternatively, shutters are used to block light during readout. Another more complicated camera is based on full-frame-transfer devices. In these systems, the CCD size is essentially doubled. The excess area (frame storage area) is storage for a single image during readout. It is typically the same size and material as the active area except that it has a

masking layer that blocks incoming light. When an image is ready to be read, the collected charge is rapidly moved to the frame storage area and then read out at the normal rate. The transfer time to the storage area is normally the number of columns divided by the readout rate. For the same example, the transfer time would be 50 µs. Readout still occurs in the original 50 ms except that while one frame is being read, the next can be accumulated. A simple alternative to this design is the split-frame-transfer device, where the frame storage area is split into multiple regions for multiple readout registers. A final type of camera is based on interline transfer devices. In these devices, the CCD is also about double the required photoactive area, except that the masked regions are interspersed every other row. The transfer of the image from the active to the storage area moves all rows in parallel. This takes one charge-transfer cycle, significantly faster than the other alternatives. Again, with the same example, that would mean it would take 50 ns to transfer the entire image. As with the full-frame-transfer devices, the next image can be accumulated while the first is being read. Although possessing a clear advantage in image transfer time, the interline transfer devices do suffer from poor fill factor as discussed earlier.

C. Fast-Scan CCDs

When experiments require greater time resolution than slow-scan CCDs provide, fast-scan CCDs are another option. These are integrating cameras, like the slow-scan CCD, but they have faster readout to achieve higher frame rates. Unfortunately, high readout rates result in increased noise, and the specimen must by fairly bright to acquire good images with these cameras. Fast-scan cameras generally sacrifice noise, dynamic range, or resolution for the higher frame rates. The advantage of the fast-scan camera over an intensified video camera (see following) is greater resolution, higher dynamic range, and ease of use (Ramm, 1994). These features can both be important if signal levels are highly variable. The fast-scan camera also features variable integration times, providing flexibility for different applications. The high readout noise limits the dynamic range to 8–12 bits, compared to the 10–16-bit resolution of comparable slow-scan cameras.

D. Intensified Cameras

In some imaging applications, the amount of light reaching the detector may be too low to acquire high-quality images in the requisite amount of time. Image intensifiers are designed to overcome this limitation by amplifying the amount of light reaching the camera. Figure 5 presents a schematic of an intensified CCD camera setup. In the nonintensified camera, the poor image quality is the result of the low signal-to-noise ratio; that is, the low light levels do not result in a signal level sufficiently above the noise. Image intensifiers can increase the signal level substantially without a corresponding increase in dark noise or readout noise, resulting in better signal-to-noise ratios. Image intensifiers do not reduce the shot

electron image intensified light

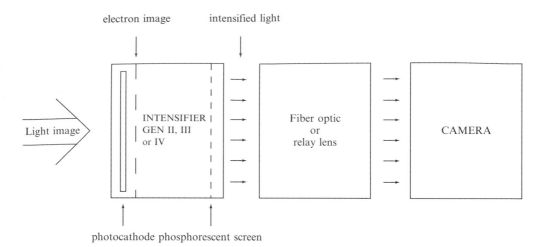

Light image

INTENSIFIER
GEN II, III
or IV

Fiber optic
or
relay lens

CAMERA

photocathode phosphorescent screen

Fig. 5 Schematic of an intensified CCD camera. Light reaching the photocathode generates an electron image, which generates an intensified light image on striking the phosphorescent screen. The image on the screen is then projected to the camera.

noise inherent in the image and actually add some noise of their own to the system. If there were no dark noise or readout noise, the image intensifier would be of no help. The increase in signal-to-noise ratio without the need for long integration times, as with slow-scan cameras, makes intensified cameras very useful for low-light applications where fast time resolution is required, such as measuring the kinetics of rapid calcium changes.

A second major application of image intensifiers is to achieve very high time resolution through gating. Intensifiers can normally be turned on and off very rapidly, for some devices in less than 1 nanosecond. Thus, light can be collected from very short time windows to record transient events. Another application of high-frequency gating is fluorescence lifetime imaging (Lakowicz and Berndt, 1991; Marriott *et al.*, 1991; Verveer *et al.*, 2000).

1. Intensifier Formats

There are several different types of image intensifiers. Gen I intensifiers employ vacuum tubes similar to standard tube-type cameras. Electrons generated at the photocathode (each by a single photon) are accelerated onto a phosphorescent screen. The electrons striking the screen produce multiple photons in proportion to the electron energy, thus amplifying the signal. The image produced on the phosphor screen is then viewed by a suitable camera. Typical gain for a Gen I intensifier may be as high as several hundred times. The quantum efficiency of the cathode is generally about 10%.

Gen II, Gen III, and Gen IV intensifiers employ a microchannel plate, which is a collection of small glass tubes, with metal surface coatings on the inside walls. Electrons collide with the surfaces as they are accelerated through the tubes, resulting in a cascade of electrons reaching the phosphorescent screen. The gain can be very high, up to 1,000,000 times. This method of amplification has very low thermally induced dark noise. The main differences between Gen II, III, IV intensifiers are the efficiency of the cathode material and the method of construction. These intensifiers can have respectable quantum efficiencies, reaching 30%–50% in high-quality devices.

Although intensifiers can greatly increase sensitivity, there are some drawbacks. First, their spatial resolution may be limited, depending on the size and spacing of the glass capillaries and the phosphor material. Although in some cases the intensifier may have comparable resolution to the camera itself, it is probably best not to use an intensifier if very high spatial resolution is required. The second drawback is that intensifiers often exhibit some nonuniformity and, therefore, require flat field correction. Intensifiers also often produce images with a lot of "snow," caused by thermally generated background noise. Finally, the phosphor screen may introduce lag, caused by long-lived phosphorescence. Proper choice of phosphor material can reduce lag at the cost of image intensity. If very fast time resolution is important in a particular application, the intensifier and phosphor material must be chosen appropriately.

Image intensifiers must be coupled to the camera in some manner. The two main methods are lens coupling and fiber optic coupling. The principle difference is in the coupling efficiency. Lens coupling is easy, but the transfer efficiency from the phosphor screen to the camera is typically less than 10%. Fiber coupling, however, results in 50%–60% transfer efficiency. Lens coupling of image intensifiers is more convenient if the intensifier and camera need to be separated; for example, if either component fails or to use the camera alone, without an intensifier.

2. Cameras for Image Intensifiers

All the camera types described above can be coupled to image intensifiers, although it is rare to couple them to slow-scan scientific cameras. Intensified video CCDs are very popular and are reasonably affordable low-light cameras. The main drawbacks are high noise and low dynamic range (less than 8 bits). The low dynamic range may cause difficulty in trying to find the proper gain settings or may not be sufficient to resolve the details of images with wide variations in signal level. Fixed frame rate and lack of flexibility are limitations, just as with the nonintensified video CCDs. An expensive but attractive option is to couple an image intensifier to a fast-scan scientific CCD. The major advantage of this pairing is the much larger dynamic range of 8–12 bits, which is useful when using high-end intensifiers. This configuration is most commonly seen in high-speed (faster than video rate) applications.

E. Internal Image Amplification Cameras

The progress in the field of low-light microscopy is inherently connected with the development of more sensitive, fast, and accurate image sensors. Until recently, the use of image intensifiers was the primary choice for low-light-level/ high-speed event applications, but recent technological advances in CCD technology are challenging this dogma. The main problem with the use of CCDs in these applications is the increase of read noise with the pixel readout rate (which effectively sets the detection limits) or the need for long exposure times (which limits the time resolution). Intensifiers overcome these limitations by amplifying the signal above the noise level with minimal introduction of additional noise.

1. On-Chip Multiplication Gain

CCD chips with internal image amplification have been introduced by Texas Instruments and Marconi Applied Technology. These new devices use an "on-chip multiplication gain" technology that allows boosting the photon-generated electron signal directly on the CCD chip. The signal amplification is performed in an additional part of the readout register (inserted before the output amplifier). Electrons collected from each pixel in the CCD are transferred to the extended readout register (also called a gain or multiplication register), where a much higher transfer voltage is applied than is necessary to transfer electrons alone. The electrons are accelerated from pixel to pixel, causing generation of secondary electrons by impact ionization, thereby amplifying the original signal. The generation of secondary electrons is a stochastic process, causing statistical variation in the level of signal amplification. That is, there is gain noise, typically expressed as the noise factor. The noise factor is reported to be from 1.0 to 1.4 (Jarram *et al.*, 2001). It is the multiplier (NF) of the signal (S) in the modified shot noise calculation (shot noise, $N_s = \sqrt{NF \times S}$). The gain of one transfer within the gain register is small (1%–1.5%), but with enough pixels in the gain register, the gain can become significant. Gains of several hundred can be achieved, and they are dependent on the applied voltage, the temperature, and the number of pixels in the gain register. Gain increases with the applied voltage and number of pixels in the gain register and decreases with the operating temperature. Thus, it is very important to cool the CCD chip, which also fortuitously reduces dark current and dark noise. Although the signal is amplified, the net effect of the gain is to reduce the effect of the read noise. The read noise relative to the amplified signal is decreased. The other most common noise source, the dark current, is amplified with the signal. The net reduction of the read noise, however, cannot be arbitrarily low, as there is another unusual noise source lurking called spurious charge. Spurious charge is generated during the charge transfer process. Usually it is much smaller than the read noise. However, spurious charge effects will add an extra electron to every 10–100 transfers depending on conditions (Jarram *et al.*, 2001).

This new on-chip multiplication gain technology should have a considerable utility in applications that demand high readout rate and low incident light, as, for example, in single-molecule fluorescence measurements, though image intensifiers will remain superior in applications requiring very high time resolution. Note, however, that these nonintensified-light amplifying cameras do not carry the risk of chip damage from exposure to high light levels that is a constant threat with traditional external image intensified cameras.

2. Electron Bombardment Cameras

A different approach to the problem of internal image amplification is provided in electron bombardment cameras. In a conventional image-intensified camera, electrons produced by photons striking a photocathode are subsequently multiplied by the intensifier and converted back to photons by the phosphorescent screen at the back of the intensifier. The intensified image is optically transferred to the camera by a lens or a fiber-optic coupling (Fig. 5). The electron-bombardment technique eliminates the image intensifier (and two-stage conversion of incident light to electrons and electrons back to light) and the optical coupling to the CCD camera. In the electron-bombardment camera, the incident light is converted to electrons on the photocathode. These photoelectrons are accelerated directly into a back-thinned CCD by applying a high voltage between photocathode and CCD chip. These accelerated electrons "bombard" the CCD chip and generate multiple electron-hole pairs on the impact that amplifies the initial signal. This process yields gains of over 1000. As a result, the initial image is amplified with similar gain as in the traditional intensifier, but with very much reduced noise (the CCD chip and photocathode are both in a cooled, high-vacuum compartment). The amplified image is also distortion free (because of the relative close proximity of the photocathode and CCD chip). In short, this technique has advantages of the traditional intensified cameras but eliminates drawbacks introduced by external image intensifiers. In the past, the use of this technique was severely limited by the short life span of the CCD chip when bombarded by the strong electron beam. However, the new Hamamatsu cameras now have a life span comparable to that of normal CCDs. Even though at this stage of development, electron-bombardment cameras are expensive, prices should fall as the market develops.

F. Color Video Cameras

Color cameras, designed primarily for the commercial and surveillance markets, are mass manufactured (found in the family camcorder or Webcam) and are often optimized to reproduce the response of the human eye to different colors of light. They are less sensitive than their monochrome counterparts because they must split the incoming light into its different colors, and the extra optics cause some light loss. Normally the light is sent through red, green, and blue filters or, on high-end systems, multiple beamsplitters or prisms to separate

the color components. Each component is then imaged on a different region of a CCD, or sometimes on three different CCDs. An alternate, less attractive strategy is to image the three colors sequentially, using a filter wheel, and then combine the three images to form a single color image.

Although color video cameras are also not sensitive enough for ultra-low-light-level microscopy, they can sometimes be used with good results for conventional immunofluorescence and FISH. The best models have a minimum sensitivity reaching below 0.1 lux (some advertised even as 0 lux). Although most color cameras have fixed video format (30 Hz frame rate), some offer flexible exposure times, similar to the modified video cameras discussed above. These cameras are cooled to accommodate longer exposure times and may, therefore, prove quite useful in low- to moderate-light applications. The noise and dynamic range are comparable to monochrome video, as color video cameras use the same types of CCDs. The resolution is therefore also comparable (up to about 700 × 500 pixels), although a few higher-resolution models are available. Color cameras are easy to use and normally couple directly to monitors and video recording equipment.[5] Some also offer digital output that can be directly sent to a computer. The color separation schemes used in color cameras are not always optimal for fluorescence microscopy with various fluorescent probes. If multiple indicators must be imaged simultaneously, color cameras may be convenient, but for quantitative fluorescence imaging, it is often better to use monochrome cameras with customized filters.

G. Digital Still Cameras

A new alternative for capturing still images is the digital still camera. These cameras are almost always color cameras and are intended to replace traditional photographic cameras. They incorporate a CCD camera into a convenient camera body, often the same body as for film-based SLR cameras. Still cameras are easy to operate, commonly have high resolution (usually > 1000 × 1000 pixels), reasonable dynamic range (12 bits typical), and may collect up to several images per minute. The high-sensitivity color versions may just be acceptable for fluorescence microscopy. These cameras were very expensive not long ago, but their commercial popularity has now made their price quite attractive.

H. SIT Cameras

Silicon intensified-target (SIT) cameras are built around an image tube rather than a solid state detector. Photons striking a photocathode create photoelectrons, which are accelerated onto a silicon target. The accelerated electrons generate many electron-hole pairs in the target, resulting in the signal

[5]Standard video recording equipment has much lower resolution and dynamic range than the camera itself; except for professional video equipment.

amplification of the SIT camera. Charges stored in the target are read out with a scanning electron beam, as in other television tube cameras.

These cameras have significant lag caused by incomplete charge readout of each frame, which effectively results in some degree of on-chip integration or image averaging between frames. This results in visually pleasing images, although it can also be a drawback if high time resolution is needed, such as in ratiometric calcium imaging, where lag produces significant artifacts. When a SIT camera is coupled to a Gen I intensifier, it is called an ISIT camera. This type of camera has very high gain and is suitable for low-light-level video, but as with the SIT camera, the ISIT has little flexibility and significant lag SIT cameras were fairly popular for video microscopy not long ago and are still available, although for most fluorescence applications they are not competitive with CCD-based devices.

I. CMOS Imagers

The promise of CMOS imaging devices is a single integrated imaging sensor with on-chip processing and control; that is, no external electronics. These devices are similar to CCDs but are far less commonly used in microscopy. The first CMOS imagers were charge-injection devices (CID). The CID has an array of pixels, each independently addressed, and differs from CCDs in that electrons in each pixel are not removed by the readout process. The ability to randomly address pixels could be useful for imaging a small area of interest at higher rates. In addition, pixels of the CID can have different image integration times. This allows CID detectors the possibility of obtaining the maximum signal-to-noise ratio for each pixel, even though there may be large differences in light intensity for various pixels. For example, pixels with low light levels can be averaged on-chip for a longer time, whereas reading out bright pixels before overflow leads to blooming. CIDs have promising characteristics, although they often have high readout and dark noise. The high noise makes them difficult to use for low-light-level imaging.

Another CMOS imager is the active pixel device, developed primarily to overcome the high readout noise of CIDs. An active pixel sensor is a CID with an amplifier at each pixel. These active pixel sensors bring the readout noise to levels comparable to high-quality CCDs (about 10 electrons per pixel). However, an active pixel sensor still has a large dark current (\sim5000 electrons per pixel per second), making it difficult to use for microscopy except for high-speed imaging. These devices have low power consumption and are cheap to produce. In many respects (dynamic range, resolution, addressability), CMOS imagers are comparable to or better than CCDs (Golden and Ligler, 2002). However, the current sensors are not well suited to low-light-level imaging. As stated earlier, current development of CMOS sensors is driven by the consumer market, which has different needs than biological microscopy; thus making it difficult to expect optimized low-light performance from the ubiquitous handheld cameras.

J. Image Acquisition

Electronic cameras do not all have the same output format, and evaluating the image acquisition system is an important part of choosing a camera. The basic objective is to get an image into digital format and read into a computer. For many cameras, such as slow-scan CCDs, cameras with variable integration modes, and cameras with other unique designs (multiple outputs, very high speeds), the manufacturer incorporates a dedicated digitizer as part of the camera system. This is the most desirable performance choice, and it should normally be easy to get the digital image into a computer for whatever processing is necessary. Video cameras, however, usually have an output that can be directly sent to standard equipment such as videocassette recorders. When it is necessary to digitize the signal and import it into a computer for further processing, a frame grabber can be used. Frame grabbers can often be customized to capture analog signals from many different cameras (almost always fast-scan cameras).

There are numerous ways of processing an image once it is stored in digital format. Some basic capabilities can prove useful, such as flat field correction and background subtraction. Flat field correction accommodates nonuniform response in an image. It is normally required even for cameras with uniform response because the illumination or collection may not be uniform. Sometimes additional processing is required just to visualize the data. For example, high–bit depth images do not typically display directly on monitors. They must be rescaled for the normal 8-bit (grayscale) display. Note that this is true even for a 24-bit display because there are 8 bits each devoted to the red, green, and blue channels, thus leaving only 256 possible gray levels displayable. Finally, the most useful data is not always the initial intensity images but rather a combination of images as in ratio imaging, or fluorescence lifetime imaging. Although basic image processing and storage is usually straightforward, it can become quite complicated if interfacing electronics and camera components are not correctly matched. It is therefore sensible to discuss output formats and image handling with manufacturers to avoid headaches after the camera is delivered.

IV. Conclusions

The requirements for electronic camera performance are as varied as its diverse applications, particularly those of fluorescence microscopy. The information presented in this chapter will hopefully aid the reader in understanding how to appropriately apply the available technology to suit their imaging requirements. A good place to start when evaluating cameras for a particular biological application is to address the following questions: What time resolution and frame rate are required? Is high spatial resolution a priority? How bright is a typical sample?

The answers to these questions can narrow down the appropriate choices considerably. For example, if time resolution and frame rate are of no concern,

slow-scan CCDs certainly offer the best available performance, both in terms of the signal-to-noise ratio and their spatial resolution. Slow-scan cameras are thus the first choice for experiments using fixed specimens, such as measurements using immunofluorescence and fluorescence in situ hybridization. However, if video rate imaging is required, one need not evaluate slow-scan CCD cameras. A very basic video CCD may suffice if samples are heavily labeled or are not perturbed by high-intensity illumination. When video rate imaging is required for very dim specimens, an intensified CCD camera is probably most appropriate. The variable-integration-time video cameras are a very attractive option if one needs to acquire images at video rate acquisition as well as with longer integration times for less bright samples. This flexibility can facilitate many diverse applications with highly varied light levels. Whichever camera type is chosen, it is always best to evaluate the camera performance in the lab before making a purchase.

Finally, we reiterate that obtaining quality fluorescence images requires not only a good camera but also optimal optical imaging. By maximizing the microscope light collection efficiency, one can substantially increase the amount of light reaching the camera. This is an important consideration that can greatly benefit any application using fluorescence microscopy.

Acknowledgments

This update was supported by National Institutes of Health grant GM 35325, the Cell Migration Consortium IK54GM64346, by P60-DE13079 from the National Institute for Dental and Cranial Research, and by American Heart Association 0335178NCKB.

References

Aikens, R. S., Agard, D. A., and Sedat, J. W. (1989). Solid-state imagers for microscopy. *In* "Fluorescence Microscopy of Living Cells in Culture." Part A. Fluorescent Analogs, Labeling Cells, and Basic Microscopy" (Y. L. Wang and D. L. Taylor, eds.), pp. 291–313. Academic Press, New York.

Arndt-Jovin, D. J., Robert-Nicoud, M., Kaufman, S. J., and Jovin, T. M. (1985). Fluorescence digital imaging microscopy in cell biology. *Science* **230**, 247–256.

Bastiaens, P. I. H., and Squire, A. (1999). Fluorescence imaging microscopy: spatial resolution of biochemical processes in the cell. *Trends in Cell Biol.* **9**, 48–52.

Brownlee, C. (2000). Cellular calcium imaging: so, what's new? *Trends in Cell Biol.* **10**, 451–457.

Castleman, K. R. (1993). Resolution and sampling requirements for digital image processing, analysis, and display. *In* "Electronic Light Microscopy" (D. Shotton, ed.), pp. 71–94. Wiley-Liss, New York.

Funatsu, T., Harada, Y., Tokunaga, M., Saito, K., and Yanagida, T (1995). Imaging of single fluorescent molecules and individual ATP turnovers by single myosin molecules in aqueous solution. *Nature* **374**, 555–559.

Golden, J. P., and Ligler, F. S. (2002). A comparison of imaging methods for use in an array biosensor. *Biosensors Bioelectronics* **17**, 719–725.

Harms, G. S., Cognet, L., Lommerse, P. H. M., Blab, G., and Schmidt, T. (2001). Autofluorescence proteins in single-molecule research: applications to live cell imaging microscopy. *Biophys. J.* **80**, 2396–2408.

Herman, B., and Tanke, H. J. (1998). "Fluorescence Microscopy." Bios Scientific Publishers, Oxfordshire, UK.

Hiraoka, Y., Sedat, J. W., and Agard, D. A. (1987). The use of a charge-coupled device for quantitative optical microscopy of biological structures. *Science* **238,** 36–41.

Inoué, S., and Spring, K. R. (1997). Video microscopy: the fundamentals. Kluwer Academic Publishers, New York, NY.

Jarram, P., Pool, P. J., Bell, R., Burt, D. J., Bowring, S., Spencer, S., Hazelwood, M., Moody, I., Catlett, N., and Heyes, P. S. (2001). The LLCCD: low light imaging without the need for an intensifier. *Proc. SPIE* **4306,** 178–186.

Keller, E. H. (1995). Objective lenses for confocal microscopy. *In* "Handbook of Biological Confocal Microscopy" (J. B. Pawley, ed.), 2nd ed., pp. 111–126. Plenum, New York.

Lakowicz, J. R., and Berndt, K. W. (1991). Lifetime-selective fluorescence imaging using an RF phase-sensitive camera. *Rev. Sci. Instrum.* **62,** 1727–1734.

Marriott, G., Clegg, R. M., Arndt-Jovin, D. J., and Jovin, T. M. (1991). Time resolved imaging microscopy. *Biophys. J.* **60,** 1374–1387.

Miura, K. (2001). Imaging and detection technologies for image analysis in electrophoresis. *Electrophoresis* **22,** 801–813.

Periasamy, A. (ed.) and American Physiological Society (2001). "Methods in Cellular Imaging." Oxford University Press, Oxford.

Ramm, P. (1994). Advanced image analysis systems in cell, molecular, and neurobiology applications. *J. Neurosci. Meth.* **54,** 131–149.

Schmidt, T., Schutz, G. J., Baumgartner, W., Gruber, H. J., and Schindler, H. (1995). Characterization of photophysics and mobility of single molecules in a fluid lipid membrane. *J. Phys. Chem.* **99,** 17662–17668.

Shotton, D. (1993). An introduction to the electronic acquisition of light microscope images. *In* "Electronic Light Microscopy" (D. Shotton, ed.), pp. 1–38. Wiley-Liss, New York.

Shotton, D. M. (1995). Electronic light microscopy: present capabilities and future prospects. *Histochem. Cell Biol.* **104,** 97–137.

Sluder, G., and Wolf, D. E. (eds.) (1998). "Video Microscopy." Morgan Kaufmann, San Francisco.

So, P. T. C., French, T., Yu, W. M., Berland, K. M., Dong, C. Y., and Gratton, E. (1995). Time-resolved fluorescence microscopy using two-photon excitation. *Bioimaging* **3,** 49–63.

Spectral luminous efficiency function for photopic vision. CIE publication 86, (1990).

Taylor, L. D., Woo, E. S., and Giuliano, K. A. (2001). Real-time molecular and cellular analysis: the new frontier of drug discovery. *Curr. Opinion Biotech.* **12,** 75–81.

Tsay, T. T., Inman, R., Wray, B., Herman, B., and Jacobson, K. (1990). Characterization of low-light-level cameras for digitized video microscopy. *J. Microscopy* **160,** 141–159.

Tsien, R. Y., and Waggoner, A. (1995). Fluorophores for confocal microscopy. *In* "Handbook of Biological Confocal Microscopy" (J. B. Pawley, ed.), pp. 267–279. Plenum, New York.

Verveer, P. J., Wouters, F. S., Reynolds, A. R., and Bastiaens, P. I. H. (2000). Quantitative imaging of lateral ErbB1 receptor signal propagation in the plasma membrane. *Science* **290,** 1567–1570.

Wang, Y. L., and Taylor, D. L. (eds.) (1989). "Fluorescence Microscopy of Living Cells in Culture. Part A. Fluorescent Analogs, Labeling Cells, and Basic Microscopy" Academic Press, New York.

CHAPTER 8

Cooled vs. Intensified vs. Electron Bombardment CCD Cameras— Applications and Relative Advantages

Masafumi Oshiro and Butch Moomaw

Hamamatsu Photonic Systems
Division of Hamamatsu Corporation
Bridgewater, New Jersey 08807

METHODS IN CELL BIOLOGY, VOL. 72
Copyright 1998, Elsevier Inc. All rights reserved.
0091-679X/03 $35.00

I. Introduction

Electronic imaging has become an important tool in the area of biological sciences as a result of the many advantages of modern detectors compared with the human eye. The following advantages offer great benefits to scientists and researchers.

- The flexibility of imaging detectors enables one to observe objects that are too dark or too bright to be seen by the unaided human eye.
- The spectral sensitivity of the human eye is limited from 400 to 700 nm. The spectral sensitivity range of imaging detectors is wider, offering observation and acquisition of images over the range from x-ray to infrared wavelengths.
- The intrascene dynamic range of the human eye is narrow (about 20 gray levels) compared to that of a camera. CCD detectors can achieve up to a 16-bit (64,000 gray levels) intrascene dynamic range.
- The human eye cannot follow an object if it moves too fast or too slow. Modern detectors can capture images in time ranges from femtoseconds to hours and compress or expand real-time events into a time scale that is meaningful for human observation.
- Images can be analyzed using image processors to characterize the objects.
- Images can be stored in electronic formats for future reference and quantitative analysis.
- Images can be modified using image processors, and the processed images can reveal information that cannot be observed with the human eye.

To respond to the requirements of modern science, a variety of imaging detectors are available. A CCD (charge coupled device) camera is the most popular imaging detector for high light applications but CID (charge injection device) and CMOS (complementary metal oxide) detectors are also finding uses for special applications. This discussion does not address these technologies but rather concentrates on low-light CCD detectors.

Special methods of imaging are needed when the available light intensity at the sample decreases to a level that approaches the average noise of the detection system. The ratio of the amount of signal collected to the amount of noise in the system is called the signal-to-noise ratio (SNR). A suitable SNR is the goal of all low-light cameras, and many methods and technologies are available for this purpose.

For low-light applications, there are four types of CCD cameras available:

1. Intensified CCD (ICCD)
2. Integrating cooled CCD (CCCD)
3. Electron bombardment CCD (EBCCD)
4. Electron multiplication CCD (EMCCD)

The first three of these are briefly summarized here.

The ICCD camera uses an image intensifier (II) coupled to a CCD camera (Fig. 1). The II converts incoming photons into electrons, multiplies the electrons, reconverts them to photons, and then projects this on to a CCD camera through a relay lens or fiber plate. This enables one to observe a low-light image by amplifying the original signal to a great extent (tens of thousands of times are possible) compared with the noise of the camera. These features enable rapid imaging at low-light levels but with limited intrascene dynamic range.

The CCCD camera uses a CCD chip, similar to a high light level camera (Fig. 2). In this device, exposure integration is used to increase the signal, and cooling of the CCD is used to reduce the thermal noise in the detector during the extended exposure time. After the exposure is complete, special circuits are used to read out the information from the CCD to further reduce the noise in the camera. These features combine to produce an image with a good SNR and good intrascene dynamic range if given enough time.

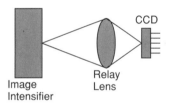

Fig. 1 Intensified CCD.

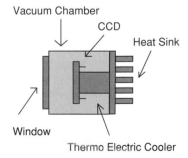

Fig. 2 Cooled CCD.

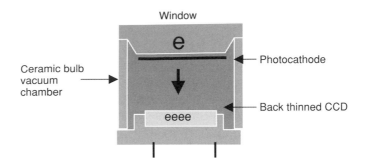

Fig. 3 Electron bombardment CCD.

The electron bombardment CCD combines the intensifier approach with some of the features of the CCCD system (Fig. 3). Incoming photons are converted to electrons and accelerated by a high voltage directly into a special CCD chip. This chip has been reversed and thinned to a degree that enables the incoming high velocity electrons to generate multiple electrons directly in the device. This direct signal amplification can be combined with CCD cooling and special circuits for readout to produce a good SNR and intrascene dynamic range at reasonable frame rates.

Even though the main goal of these cameras is higher sensitivity (better SNRs), there are different characteristics that may be seen as both advantages and disadvantages when they are used in low-light applications. We are often asked which camera is better; there is no simple answer. It is often necessary to look at the application, construct a prioritized list of requirements, and make a comparison to the benefits of each type of camera. In this manner, it is possible to make an educated choice from the large selection of cameras available.

II. Sensitivity

Sensitivity is one of the most important characteristics for low-light cameras. We use the word *sensitivity* to describe how sensitive cameras are for low-light imaging. However, there are often some misunderstandings about which factors generate "high sensitivity."

A. What Does "High Sensitivity" Mean?

A brighter image on the monitor? We naturally think that a highly sensitive camera generates a brighter image compared with a less sensitive camera. Brightness of the image on a monitor screen is an important factor for the human eye to recognize the image; however, it is not an accurate way to judge sensitivity. For example, if the image is buried in noise the human eye cannot recognize the image, regardless of how bright.

Table I

Camera (FWC)	Bit Depth (gray levels)	Electrons/ gray level	No. gray levels at 100 ms exp.	Electrons collected
A (20,000)	12 bit (4096)	4.88	3000	14,640
B (15,000)	12 bit (4096)	3.66	4000	14,640

A larger gray level value in the image captured? The logical conclusion that a larger number in the gray level scale means more sensitivity in the detector is a common misunderstanding. The gray level number is a calculation based on the number of photons detected and then divided up by the digitizer into some number of gray levels. It is possible for one gray level to represent any number of actual photons, so it is important to multiply the gray levels in an image by the photon/gray level conversion number. (In CCDs, one photon in the signal is represented by one electron in the CCD, but the digitizer is set-up to use some specific number of photons to equal one gray level in the output. This number is referred to as the "electron count" or "digitizer count.") A lower gray level number may actually represent more real signal collected when comparing "sensitivity" in this manner.

For example, compare two cameras using the same sample and same illumination level. If the two cameras have the same field of view, or the optics are adjusted to provide the same field of view to both cameras, then the light level at the detector will be equal for both cameras. Camera A has 20,000 electrons full-well capacity (FWC) and Camera B has 15,000 electrons FWC. Both cameras are using 12-bit digitizers and provide 4096 gray levels.

As illustrated in Table I, the sensitivity of both cameras is the same. Each collected the same number of photons, but the displayed gray level is different. Camera B, with fewer electrons per count will make more gray levels in the same time than Camera A. The accuracy of the gray levels will be better with Camera A (more signal in each gray level), and the maximum amount of signal will be greater with Camera A.

A better signal to noise ratio? If an image consists of signal and noise, a signal cannot be recognized that is smaller than the noise. Suppose sensitivity is compared between two cameras; one generates higher signal than noise and the other generates lower signal than noise. In this case, the former camera is more sensitive than the latter. In other words, the ratio of signal to noise indicates "sensitivity."

B. What is Signal-to-Noise Ratio (SNR)?

1. Signal-to-Noise Ratio (SNR)

SNR is expressed by a simple formula: Divide the signal detected by the detector measured in electrons (**S** electrons) by the total noise (**N** electrons).

$$SNR = \frac{S}{N} \tag{1}$$

2. Signal (S)

S (electron) is calculated by multiplying the input light level: I (photon/sec), the quantum efficiency: QE (electron/photon) of the detector, and the integration time: T (sec).

$$S = I \bullet QE \bullet T \tag{2}$$

3. Noise (N)

The noise is not only generated by detectors but also generated by the signal itself. The combination of both types of noise becomes the total noise (N).

4. Signal Shot Noise (N_{shot})

The minimum unit of light is a photon, and the distribution of photons is considered to be a Poisson distribution. In this case, statistical noise, signal shot noise: N_{shot} (electron) of the signal: S (electron) is calculated using equation (3).

$$N_{shot} = \sqrt{S} \tag{3}$$

5. Camera Noise (N_{camera})

There are two major sources of camera noise. One is camera read noise: N_{read} (electron) that appears when the signal is read from a detector and converted to a voltage signal. The other is camera dark noise: N_{dark} (electron), which is the fluctuation of the dark current: D (electron/sec) generated by environmental heat around the detector. The total dark current is the function of the integration time: T (sec) and it can be subtracted; however, the statistical noise of the dark current remains.

$$N_{dark} = \sqrt{D \bullet T} \tag{4}$$

The camera noise: N_{camera} (electron) is calculated using Equation (5).

$$N_{camera} = \sqrt{N_{read}^2 + N_{dark}^2} \tag{5}$$

6. Total Noise (N)

Noise is the combination of signal shot noise: N_{shot} (electron) and camera noise: N_{camera} (electron). Noise is calculated using equation (6).

$$N = \sqrt{N_{shot}^2 + N_{camera}^2} \tag{6}$$

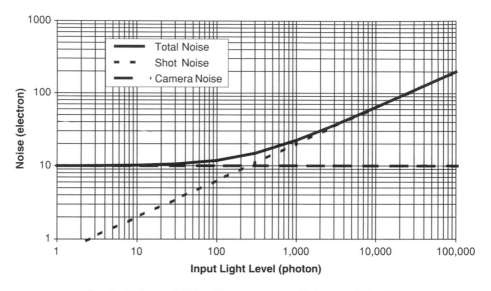

Fig. 4 Noise vs. light level (camera noise = 10 electron, QE = 0.4).

C. How Are Noise and Light Level Related?

Figure 4 shows the camera noise, signal shot noise, and total noise based on light level. Camera noise stays the same at all light levels, but signal shot noise increases relative to the light level increase. In lower light levels, camera noise is higher than signal shot noise and total noise is determined primarily by camera noise. In higher light levels, signal shot noise is higher than camera noise and total noise is determined primarily by signal shot noise. In other words, the camera noise is an important factor in achieving higher SNR only in low-light situations. If you know the properties of any camera, it is easy to construct a similar graph for that camera at a particular wavelength.

D. Achieving "High Sensitivity"

Considering that a higher SNR equates to higher sensitivity in low light situations, increasing the signal and/or lowering the noise will yield "high sensitivity."

1. Methods for Increasing Signal

a. Higher QE (More Electrons)

Imaging detectors convert incoming photons into electrons. This conversion rate is known as quantum efficiency (QE). Higher QE generates more electrons and results in a higher signal. Figure 5 shows the SNR for different QE. In brighter light levels, the difference of SNR is not as significant since the signal noise becomes dominant. In lower light levels, the difference of SNR becomes more important and is proportional to the QE difference.

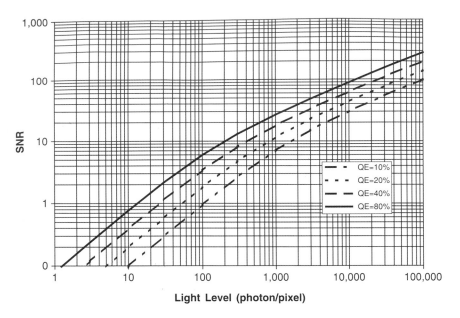

Fig. 5 SNR vs. QE (camera noise = 10 electrons).

There are several basic designs for CCD chips and each has different characteristics, including the quantum efficiency. A standard front illuminated full frame CCD has about 40% to 50% QE at peak wavelength, while a back-thinned CCD has about 80% QE at peak wavelength. New interline transfer CCDs with micro lenses approach 75% QE. The higher QE helps to increase the signal and results in higher sensitivity.

Notice the change in slope in the lines in Fig. 5 as the dominant noise changes from camera noise on the left to signal shot noise on the right at different QE values.

b. Signal Integration (Temporal/Spatial)

The signal can be integrated temporally and/or spatially. Temporal integration will yield increased signal at the expense of exposure time but not affect the spatial resolution of the image. Spatial integration, also called binning, will increase the signal and improve the frame rate at the expense of spatial resolution in the image. In some cases, spatial integration can also improve the dynamic range of a camera by increasing the maximum signal level (FWC).

Signal integration of multiple images in a computer is also possible, but since the noise of the readout is already included, it is not the same as integration on the CCD. Averaging of images in a computer also can benefit the SNR because the noise values of both the signal shot noise and the camera noise will be reduced. SNR will improve by the square root of the number of averages.

A video rate integrating CCD (VICCD) is developed for applications that require a detector that has reasonable image quality in both high light and low light levels. The CCD chip used for the VICCD is designed to have lower dark noise and higher light collection efficiency. The VICCD uses standard video format such as RS-170 and CCIR; then the image is updated in real time for high light level imaging. For low-light level imaging, the signal is integrated on the CCD chip for a certain number of frames and read out. In this case the image is not updated in real time but in the cycle of integrating frames. This integration improves the sensitivity by the factor of the integrated number of frames since the main noise source of a VICCD is the camera read noise; refer to Equation (8). A VICCD is not as sensitive as a Cooled CCD, but the VICCD has advantages such as compatibility to VCRs, real-time high light imaging, and lower cost.

The *binning* process sums the signals of adjacent pixels in a specified array (example: 2×2) to create a larger signal that is read out as if it were one pixel. This means the signal increases by the factor of the number of binned pixels (example: $2 \times 2 = 4$ times increase in signal) without increasing the read noise. This works best with cameras that have low dark noise since dark noise is summed as well. This method creates higher sensitivity at the expense of spatial resolution.

c. Increase Detector Area (Macro Applications)

When the imaging object is considered as a point light source, the light collection efficiency of the detector is determined by the diameter of the lens and the distance between the imaging target and the lens. The distance is proportional to the imaging object size and the inverse factor of detector size. The larger detector shortens the distance, and it results in a higher signal level due to the increased collection angle on the object side of the lens (Fig. 6).

d. Selection of Microscope Objectives and Magnification Factors

The relationship between the magnification and numerical aperture (NA) of a microscope objective is a key to the brightness of an image in microscopy. Increasing NA is one of the most effective methods of increasing signal.

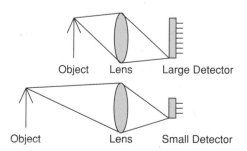

Fig. 6 Larger detector shortens the distance and results in higher light collection efficiency. Drawing by M. Oshiro.

In transmitted light, intensity increases by the square of the change in NA. In reflected light fluorescence, intensity increases by the fourth power of the change in NA. A seemingly small increase in the NA of an objective can make a considerable difference in the signal level.

Similarly, the intensity in an image is inversely proportional to the magnification, again by a factor of 2. As magnification is reduced, the intensity at the detector increases by the square of such change.

This leads to the following useful equation for evaluating the relative brightness of two objectives or finding the resulting brightness difference in a contemplated objective change between objective "a" and objective "b."

$$\text{Relative Brightness (fluorescence)} = \frac{1}{\left(\frac{NA_a}{NA_b}\right)^4 \times \left(\frac{MAG_b}{MAG_a}\right)^2}$$

2. Methods for Reducing Noise

a. Signal Intensification

Signal intensification is one way to "reduce noise" by multiplying the original signal level to a higher value before the actual camera detects the signal. In this manner, the noise of the camera becomes relatively low compared with the amplified signal. An image intensifier converts incoming photons into electrons at the photocathode. Each electron can be intensified (multiplied) by acceleration and/or by a microchannel plate, by tens of thousands of times. In this process, the signal shot noise also increases proportionally to the increase of the signal. Therefore, the intensification of the signal is not equivalent to increasing the signal. However the intensification of the signal is relatively equivalent to reducing the camera noise because the camera noise is not intensified. This type of system basically separates the signal from the noise by amplifying the signal but not the camera noise. Figure 7 shows the relative noise for various gains of the image intensifier based on the condition that the CCD camera noise is 150 electrons and the relay lens coupling efficiency is 0.045.

b. Intensified Cameras (ICCD, SIT, EB-CCD)

Historically, standard CCD and tube cameras did not have enough sensitivity for low-light applications because of high camera noise. The combination of a Signal Intensifier and CCD or tube camera, such as intensified CCD (ICCD), silicon intensified target (SIT), and EB-CCD, makes the camera noise relatively small compared to the increased brightness of the signal. This type of technology makes it possible to image low light level images at rapid rates. This is one kind of sensitivity and is still useful in some applications where speed is needed and intrascene dynamic range is not high. Availability of SIT cameras is decreasing rapidly due to scarcity of some of the tube circuit electronics so this device may disappear as an option in the near future. The newer EB-CCD technology is a good replacement for the older SIT technology.

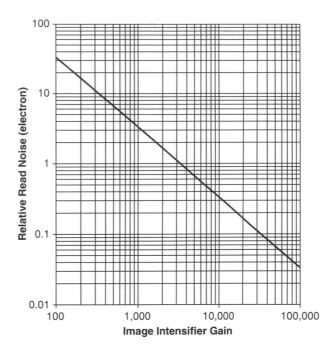

Fig. 7 Relative read noise of intensified CCD.

Modern intensified CCD cameras incorporate improved intensifiers with higher QE, photocathode materials, better microchannel plate technology for higher spatial resolution, and efficient fiber coupling to a wide variety of low noise CCD cameras. These improvements have extended the usefulness of the ICCD camera and improved the image quality and intrascene dynamic range of this technology. The presence of the microchannel plate still limits the resolution compared to a plain CCD and requires careful attention to light levels to prevent damage to this very sensitive device.

A special type of ICCD is called a photon counting camera and is designed to have enough signal intensification for single photons to exceed the noise of the camera. This enables real-time discrimination and rejection of camera noise to reveal single-photon interaction at the detector. Photon counting is used to detect weak light such as luminescence.

In high-light levels, multiple photons arrive together and the light level can be measured as a function of signal intensity. In other words, higher signals yield higher gray levels and lower signals yield lower gray levels. In low-light levels, individual photons arrive at the detector at discrete intervals. At this light level, signal intensity has no relation to light level. The signal only means the arrival of a single photon. Therefore, light intensity can be measured as a function of the number of photon pulses per unit of time, which corresponds to the arrival of

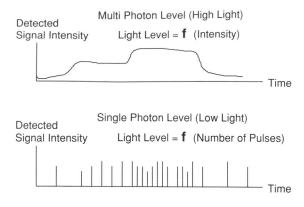

Fig. 8 Multiphoton and single photon.

photons. In other words, higher number of pulses within a certain time means higher light, and lower number of pulses means lower light (Fig. 8).

A photon counting intensified camera amplifies each detected photon to an intensity level that is so far above the camera noise that the pulse from the photon is easily discriminated from camera noise and converted to binary data count of 1 (Fig. 9). Each time the camera is read out, this binary data is added to a memory array and displayed as a gray level equal to the number of pulses accumulated at that point in the image. Gray levels in this case are simply the numbers of pulses detected at each pixel in the image over the total accumulation time.

This method eliminates camera noise almost completely, and the only noise sources are the signal shot noise and some small noise from the dark current of the photocathode in the intensifier. Normally the photon counting detector is designed to have minimum noise and high signal gain. The limiting factor to this technology is the readout rate of the camera because each pixel can count only one photon in each readout period. If the photons arrive in a single pixel at a faster rate than they can be read, then the camera looses count of the photons in that pixel for that readout period.

Intensified photon counting cameras are most useful at low-light levels and in situations where some kinetic information is required over the course of a long integration time. The ability to read out the camera information at rapid rates and still maintain an accurate photon count over long periods can offset the disadvantage of relatively low overall quantum efficiency and resolution when compared with cooled slow scan cameras.

Cooled slow scan cameras take advantage of the very high quantum efficiency of CCD chips and recent improvements in reducing total camera noise. Manufacturing of modern CCDs has greatly decreased the inherent dark current of silicon-based devices, and when combined with very deep cooling, the dark noise of a CCD can be low enough to recognize individual photon events. Special

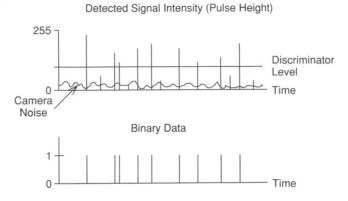

Fig. 9 Photon counting (discrimination).

readout methods can be employed to read this information from the CCD so the total camera noise can be only a few electrons. Because one photon produces one electron in the CCD, this is a favorable ratio for signal-to-noise when the number of incoming photons exceeds the camera noise.

The advantages of cooled slow scan cameras over the intensified type are the increase in spatial resolution and versatility when the total photon count is high but there is no ability to see kinetic events within the total exposure time.

c. Lower Camera Noise

Camera noise is comprised of the dark noise (fluctuation of the dark current) and the read noise (noise generated in the readout process). In most modern cameras, the dark noise has become so low it is not a factor in biological imaging. For ultra low–light applications, it still needs to be considered. Camera read noise is the primary source of camera noise in most applications.

The dark current of the detector is primarily generated by environmental heat. Figure 10 is an example that shows the camera noise for various dark current levels. It is significant that the dark current is most critical in low-light situations or anytime when longer integration is required.

Normal CCD cameras are limited in their low-light abilities primarily by the readout noise of the camera at short exposure times and by the dark noise as exposure time increases. For low light applications CCDs are designed with some additional features to improve the ratio of the signals to the camera noise.

E. Required Levels of SNR

Applications determine the level of **SNR** required. The images in Fig. 11(A–E) are taken with a photon-counting camera. Longer integration gives better **SNR** and results in higher resolution and higher dynamic range.

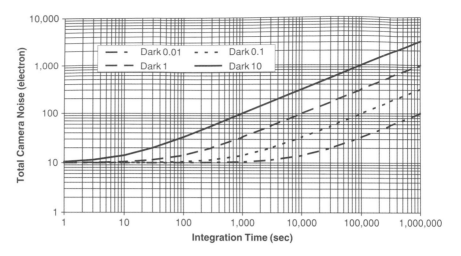

Fig. 10 Total camera noise vs. dark current (read noise = 10 electrons).

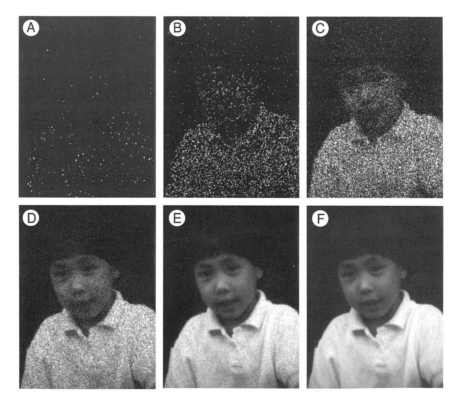

Fig. 11 (A) 1/30 sec: Photon counting. (B) 1 sec: Photon counting. (C) 10 sec: Photon counting. (D) 100 sec: Photon counting. (E) 1000 sec: Photon counting. (F) High light image.

If the application requires the recognition of detail in the image or the measurement of gray levels in the image, higher image quality (SNR) such as Fig. 11(E) is required. If the application requires one to simply recognize the rough shape of the image, it does not require high image quality and Fig. 11(C) will be sufficient. If the application requires one to detect the existence of an object, Fig. 11(A) will be sufficient. It is important to determine the required image quality (SNR) from the application and choose the best detector to accomplish this requirement.

F. Sensitivity Comparison

Intensified cameras, such as ICCD and SIT, and cooled CCD are used for low-light applications. There is no easy answer to determine which is more sensitive. Earlier observations on signal and noise (see Equations 1, 3, and 6) show that SNR is

$$ \text{SNR} = \frac{S}{\sqrt{N_{shot}^2 + N_{camera}^2}} = \frac{S}{\sqrt{S + N_{camera}^2}} \tag{7} $$

In the situation of very low light level, Signal (S) is smaller than N_{camera}^2, then Signal Shot Noise (N_{shot}) is negligible.

$$ \text{SNR} \cong \frac{S}{\sqrt{N_{camera}^2}} = \frac{S}{N_{camera}} \tag{8} $$

From Fig. 7, read noise of the Intensified CCD (less than 0.1 electron at 100,000 gain) is much smaller than that of the Cooled CCD (5 to 10 electron). In this light level, the Intensified CCD will generate higher SNR because of lower read noise.

In the situation of relatively higher light levels, N_{camera}^2 is smaller than Signal (S), then N_{camera} is negligible.

$$ \text{SNR} \cong \frac{S}{\sqrt{S}} = \sqrt{S} \tag{9} $$

From Equation (2), the signal is the function of QE, and higher QE generates higher SNR (higher sensitivity). Normally a CCD has higher QE compared to the photocathode of an image intensifier; therefore the Cooled CCD will generate higher SNR in this light level.

Figure 12 shows the SNR difference of intensified CCD and cooled CCD in various light levels.

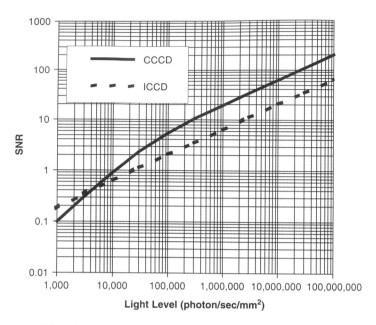

Fig. 12 **SNR** based on light level (integration time = 1 sec).

Figures 12 and 13 are mathematically generated using the following parameters:

Intensified CCD (ICCD)
QE of photocathode: 50 (%)
Dark current of photocathode: 0.05 (electron/pixel)
Microchannel plate open area ratio: 60 (%)
Noise figure of image intensifier: 2
Image intensifier photon gain: 50,000 (photon/photon)
Relay lens coupling efficiency: 4.5 (%)
QE of CCD (interline) camera including open area ratio: 56 (%)
Read noise of CCD camera: 150 (electron)
Pixel size: 24 × 24 (μm^2)

Cooled CCD (CCCD)
QE of CCD: 80 (%)
Dark current: 0.001 (electron/pixel)
Read noise: 5 (electron)
Pixel size: 24 × 24 (μm^2)

III. Dynamic Range (DR) and Detectable Signal (DS) Change

Dynamic range (DR) is one of the most important characteristics for low light cameras. DR indicates the ratio of the brightest to the darkest signal that can be detected in the same scene.

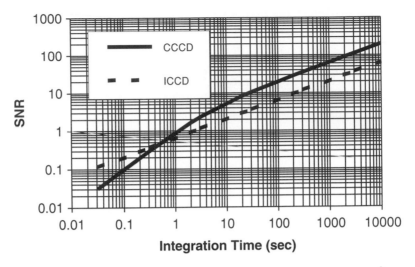

Fig. 13 **SNR** based on integration time (light level: 10,000 photon/sec/mm^2).

A. Definition of DR for a Camera

The DR of a CCD camera is defined by the ratio of camera noise: N_{camera}, which is equivalent to the lowest signal detectable, and saturation: **SAT**, which is equivalent to the FWC and represents the highest signal detectable.

$$DR = \frac{SAT}{N_{camera}} \qquad (10)$$

In the case of a "digital" camera, the DR is a ratio of the electrons of signal to the electrons of camera noise. The signal is assumed to equal the FWC (saturation level) of the CCD.

The term *dynamic range* is often confused with the number of gray levels in the digitizer, but these are not equivalent. A digitizer can divide the dynamic range up into as many gray levels as desired, but the dynamic range is not altered. As more gray levels are created from the same number of electrons, the accuracy of each gray level is diminished, but the dynamic range is not affected.

For example, 8-bit conversion gives 256 gray levels and 12-bit conversion gives 4096 gray levels. However, the original dynamic range is unchanged, just divided into a different number of gray levels. If this done with the same FWC, then each gray level represents fewer and fewer electrons as bit depth is increased.

The DR defined by equation (10) is useful information when the application requires one to image bright and dark objects in the same scene. However, if the application requires one to see a small signal on top of a bright background or measure a small fluctuation in a bright signal, equation (10) will not provide an accurate value for the detectable signal change.

B. Definition of Detectable Signal Change

Because a signal generates noise (signal shot noise), this noise often exceeds the camera noise as in equation (9). Once the image information is in this range the DS change is defined by the ratio of the signal level to the noise of the signal. In the case of saturation: **SAT,** which is equivalent to the highest signal detectable and the noise at saturation level: N_{SAT}.

$$DS = \frac{SAT}{N_{SAT}} = \frac{SAT}{\sqrt{SAT}} = \sqrt{SAT} \tag{11}$$

The DS is equivalent to SNR at saturation level. DS can be calculated from the number of electrons at the saturation level. In the cases where the signal level is below the saturation level of the camera but above the camera noise, then the DS is calculated using just the number of electrons in the signal divided by the noise of that signal.

This calculation provides a good idea of the minimum detectable signal change that is possible at that level of signal.

Example

$N_{camera} = 10$ (electron) **SAT** $= 100,000$ (electron)

$$DS = \frac{SAT}{N_{camera}} = 10,000 \tag{12}$$

$$DS = \sqrt{SAT} = 316 \tag{13}$$

In this case, it is only possible to detect a signal change of one part in 316 (0.3%) compared to the DR of 10,000:1.

C. Approach for Higher DR and DS Change

The DR can be improved by lowering noise and/or increasing saturation level but the DS change can only be improved by increasing the signal level. Improved detectors are one way to overcome these limitations, but it is also possible use integration of the signal temporally or spatially after digitization. Using temporal integration provides improvement of the DR by the function of the integration time: **N**.

$$DR,_N = \frac{N \bullet SAT}{\sqrt{N} \bullet N_{camera}} = \sqrt{N} \bullet DR \tag{14}$$

$$DS,_N = \sqrt{N \bullet SAT} = \sqrt{N} \bullet DS \tag{15}$$

The DR of real-time video cameras, such as ICCDs, is normally limited to 256:1. This is referred to as 8 bits. However, if the signal is integrated in a frame grabber that has a higher number of bits, such as 16 bits, the DR will be improved. For example, when the signal is integrated for 256 frames, the DR will be improved at the factor of 16 to 4096:1.

$$DR_1 \cong 256$$

$$DR_{1,256} \cong \sqrt{256} \times 256 = 4096:1$$

IV. Spatial Resolution Limits

One limit to detector spatial resolution is the number of pixels or the number of scanning lines. In intensified cameras, the size of the spot produced from intensification of one photon at the photocathode into larger number of photons at the phosphor output is a major limitation for resolution. In all cameras, resolution is limited by the amount of light (photons). In other words, the possible resolution of any detector may not be fully utilized in low-light situations. This is illustrated in Fig. 11 in the photon-counting illustration.

A. Intensified Camera

An intensified camera, such as the ICCD, is made up of an image intensifier and a CCD camera with relay optics. The resolution of an image intensifier is expressed as 1 p/mm (number of black and white line pairs in 1 millimeter of the photocathode that can be resolved).

Normally the resolution of the image intensifier exceeds that of a video rate CCD. Since the number of scanning lines is a defined video standard such as RS-170 and CCIR, all video-rate CCD cameras have the same vertical resolution, about 350 TV lines.

The horizontal resolution of a video rate CCD is expressed as horizontal TV lines (number of vertical black and white lines in the horizontal direction that can be resolved). The standard aspect ratio of 4:3 generally leads to rectangular pixel shapes that lead to complications when trying to make calibrations for spatial measurements. In the case of horizontal resolution, there is no standard to limit the number of pixels. As a result, the resolution in the horizontal direction exceeds that in the vertical direction.

For non-video rate ICCDs, the size of the pixels and the size of the projected image from the intensifier must be compared because there are no standards for these combinations.

Another limitation of the resolution comes from the frame grabbers. If the number of pixels of the frame grabber is smaller than that of the CCD camera, the resolution will be lower than the original resolution of the CCD camera.

B. Cooled CCD

A cooled CCD normally has square pixels and gives the same resolution in both vertical and horizontal directions. Because there is no standard to define the number of vertical lines in the cooled CCD, the resolution of the cooled CCD is expressed as the size and number of pixels in both horizontal and vertical directions.

To match the resolution of the CCD chip to the resolution of a microscope, it is necessary to divide the pixel dimension by the required resolution in the image. This will indicate the minimum magnification required between the object and the CCD. This value will provide the minimum magnification for detection. For maximum resolution in the image, it is necessary for the smallest image dimension to cover two to three pixels on the CCD so two to three times the minimum magnification is required. This condition will lead to small fields of view due to the small size of CCD chips compared to the eyepiece field of view. It will also lead to low-light levels. Remember, both field of view and intensity are reduced by the change in magnification *squared*. If you double the magnification at a fixed NA, the field of view and the intensity are reduced by four times. For example, camera with 10 micron square pixels and required image resolution of 0.5 microns: $10 \mu/0.5 \mu = 20$ times magnification for detection and 40 to 60 times magnification for good resolution.

C. EB-CCD

Resolution of the EB-CCD camera is a compromise between the ICCD and the cooled CCD. Because there is no microchannel plate and no coupling lens, the resolution is determined by the size of the pixels in the CCD and the amount of "spread" during the electron acceleration. Even if several photons strike the same spot on the photocathode, they may be accelerated into an area of several pixels, producing some distribution of "spread" around a central pixel.

Compared with the size of the electron cloud from a microchannel plate, this is better resolution but compared with a single pixel in a CCD, it can be lower.

V. Temporal Resolution

Temporal resolution is limited by the frame rate of the camera when the exposure time is very short. An ICCD with a video rate CCD camera has 30 frames per second frame rate due to the RS-170 video specification and the fixed exposure time.

The frame rate for a cooled CCD depends on the design of the CCD. For frame transfer and interline CCDs, it is calculated from the total number of pixels and read out speed. For example, a cooled CCD that has 1000 by 1000 pixels with 1 MHz read out speed has 1 frame per second as the fastest frame rate. This always

assumes the exposure time is very short. If the exposure time is longer than the readout time, the two have to be added together, except for interline transfer CCDs. When a full frame CCD chip is used in the Cooled CCDs, it is necessary to add the readout time, to the exposure time and then add the time required to open and close the mechanical shutter. The frame rate will then be slower than just the exposure and readout time.

In the case of an ICCD, there is another limitation of temporal resolution; decay lag of the phosphor screen of the image intensifier. Normally the decay lag of the phosphor screen is fast enough when the intensifier is used with a video rate CCD (30Hz). This concern has to be addressed when an image intensifier is used with higher frame rate cameras.

VI. Geometric Distortion

Intensified cameras have 2% to 3% geometric distortion. This is caused by the image intensifier itself and relay optics. Normally the inverter type image intensifier has higher distortion compared to the proximity type image intensifier. A cooled CCD has no geometric distortion because the signal of each pixel is handled independently and there is no distortion in EB-CCD cameras since there are no microchannel plates or coupling systems.

VII. Shading

Intensified cameras have up to 20% shading. This is caused by the image intensifier itself and the type of coupling to the CCD. In the intensifier, normally the center of view is brighter than the corner. A fiber optic coupling generally has less shading than a lens coupling.

A cooled CCD does not have shading like intensified cameras; however, there is a pixel sensitivity difference but this is a small percentage. EB-CCDs can have some shading due to the photocathode and internal masks.

VIII. Usability

It is important to understand basic advantages and limitations in practical use when considering the different technologies.

A. Intensified Camera

Standard interface (RS-170, CCIR) for video rate cameras: The standard video format makes it easy to use video peripherals such as video recorders, image processors and image processing software.

Fast frame rate (30Hz for RS-170, 25Hz for CCIR Video Rate cameras): The frame rate is fast enough for most real time applications and focusing.

Usable in only low light level: The intensified camera can be used for high light applications, such as DIC and phase contrast, if the light source level is adjusted low enough for the detector. However, the image quality is not as good as that of high light detectors. The Image Intensifier also has a risk for burn-in when excessive light is applied. The damage will be minimized with the tube protection circuit, however special caution is required.

B. Cooled CCD

Low light to high light: In both high and low light levels, cooled CCDs can generate similar image quality if given time, and there is no risk of detector burn in high light.

Pixel manipulation (binning, sub array): Binning combines the pixels and handles multiple pixels as one pixel. This improves sensitivity and reduces the data size at the expense of spatial resolution. This is useful for low-light imaging and for applications that require high frame rates.

The sub array feature allows only a specified area of an image to be transferred from the CCD. This maintains the original resolution in that area and reduces data size. This is useful for applications that require high frame rates.

Flexible interface: CCD cameras generally have digital interfaces. In addition to standard interfaces like RS-422, RS-644, IEEE1394, and SCSI, there are a number of manufacturer specific interfaces. This makes it possible to interface with many peripheral storage devices and a broad line of computer/software packages but care needs to be taken to assure what possibilities and limitations are imposed in each case.

Cooling required for low light: CCDs are normally cooled with a thermoelectric cooler. This cooler requires some additional method to remove the heat. Convection, fans and water circulation are common ways of handling this.

Slow frame rate can make focusing difficult: Because of slow read out, or the existence of a mechanical shutter, or the sheer number of pixels, the frame rate of a Cooled CCD can be slow. This limits the temporal resolution and makes focusing difficult under low light conditions. Frame transfer CCDs and Interline CCDs usually generate faster frame rates.

C. Electron Bombardment CCD

Low light use only: EB-CCDs may be used at moderate light levels, but image quality is not the same as a normal CCD due to the "spread" of electrons after conversion at the photocathode. Damage to the photocathode may occur from long-term exposure to fixed image patterns, leaving an "image burn," but this is rare since it would take a thousand hours or more of continuous irradiation.

When compared to ICCDs with microchannel plates that can be damaged in a few minutes, this could be an advantage for some applications.

Pixel manipulation (binning, sub array) on some models: Binning combines the pixels and handles multiple pixels as one pixel. This improves sensitivity and reduces the data size at the expense of spatial resolution. This is useful for very low light imaging and for applications that require high frame rates.

The Sub Array feature allows only a specified area of an image to be transferred from the CCD. This maintains the original resolution in that area and reduces data size. This is useful for applications that require high frame rates.

Flexible interface: EB-CCD cameras offer both RS-170 (standard video) and/or digital interfaces. This makes it possible to interface with many peripheral storage devices and a broad line of computer/software packages.

Cooling may be required: For the slow scan digital type EB-CCDs, cooling is normally a thermoelectric cooler at the CCD. This cooler requires some additional method to remove the heat. Convection, fans or water circulation are common ways of handling this. For ultimate sensitivity, even the photocathode may be cooled. No cooling is required for video rate versions.

Slow frame rates can make focusing difficult: Some models of the EB-CCD have slow readout to minimize noise. This limits the temporal resolution, but binning or subarray can improve focusing under low-light conditions. Video rate models offer 30 frames per second so this is not a problem.

IX. Advanced Technology

Imaging technology is improving every day and it is important to have up to date information about this in a modern research setting. Dramatic improvements are leading to higher sensitivity, higher spatial resolution and higher temporal resolution at increasingly shorter intervals.

A. High Sensitivity

The QE of an image intensifier is lower than that of a cooled CCD, but new photocathodes with more than 50% QE and broader spectral ranges have been developed to reduce the gap between cooled CCDs and image intensifiers.

Improvements in micro lens technology have lead to interline cameras with nearly the same QE as back-thinned type CCDs. Spectral sensitivity limits are being expanded at the same time. It is not unusual to find good QE numbers over the range of ultra-violet to near IR.

B. High-Spatial Resolution

The spatial resolution of ICCDs is improving due to new photocathode materials and microchannel plates with finer spacing and less shading. Better

coupling methods to newer style CCDs have eliminated many of the older video rate CCD camera limitations.

New, larger scale CCDs with as many as 4000 × 4000 pixels are available though they require a slow frame rate and large image storage capacity.

EB-CCDs offer better resolution at moderate to low-light intensities but may lack the overall intensity gain or speed of ICCDs but faster exposures than CCDs.

C. High–Temporal Resolution

Using one of the latest high QE photocathodes, cameras with no mechanical shutter and pixel clock speeds of 10 MHz to 30 MHz, efficient fiber coupling, and new computer interfaces, it is now possible to achieve frame rates in the range of several hundred per second at low light levels.

D. Convenience

Using an advanced imaging detector is becoming easier due to increasing standardization of interface protocols. These new detectors place additional burdens on the user to understand the technology, design experiments with tighter controls and know the limitations of each piece of equipment used in the experiment. With increasing sensitivity comes an increasing demand for optical cleanliness, microscope alignment and bench skills.

It is very popular to use image processing software to analyze and/or modify images. In this case, the imaging detector has to be physically connected to the computer and the control of the imaging detector has to be linked to the image processing software. Hardware standards, such as IEEE1394, Camera Link, and AIA (RS-422 & RS-644), are common. It is now possible to run more than one camera on the same computer and image processing software can combine this data for advanced applications. With a bit of study we can now choose the best system for the application from a variety of combinations.

Acknowledgments

The editor gratefully acknowledges the work of Mr. Masafumi Oshiro of Hamamatsu Photonics K.K. Japan, who wrote the original chapter on which this edition is based, and Dr. Ken Spring for his ideas and experience in teaching these subjects in a clear manner. Additional thanks are due to Mr. T. Maruno, Mr. H. Iida, and Mr. T. Hayakawa of Hamamatsu Photonics K.K. Japan for their helpful discussions and advice over many years.

CHAPTER 9

Fundamentals of Fluorescence and Fluorescence Microscopy

David E. Wolf

Sensor Technologies LLC
Shrewsbury, Massachusetts 01545

METHODS IN CELL BIOLOGY, VOL. 72

I. Introduction

The application of fluorescence to microscopy represents an important transition in the development of microscopy, particularly as it applies to biology. It was the transition from asking the question, What are the structures of a cell to asking the question, Where are specific molecules located within the cell? Combined with immunofluorescence techniques and later with polynucleic acid technology, biologists could now answer this question for essentially any molecule within the cell, including the location of specific genes within a chromosome. Fluorescence does more than answer this qualitative question of molecular localization. It enables us to quantitate the amounts of specific molecules within a cell, to determine whether molecules are complexing on a molecular level, to measure changes in ionic concentrations within cells and organelles, and to measure molecular dynamics. A recurring theme throughout this book is how to accurately extract quantitative information from microscope images, particularly from fluorescence images. The reason is that in an age of dramatic pseudocolor images, it is easy to mislead first oneself and then, in turn, others. The accurate application of correct quantitative technique in fluorescence microscopy requires careful attention to detail. Sadly, the custom is as Hamlet expressed it:

> "But to my mind, though I am native here
> And to the manner born, it is a custom
> More honour'd in the breach than the observance."
> *William Shakespeare*, Hamlet the Prince of Denmark
> *Act I, Scene IV, lines 16–19*

Our goals in this chapter are fourfold. First, we will consider the fundamental physics of fluorescence. Second, we will begin to look at some of the issues important to quantitative measurement of fluorescence. Although quantitative measurement presents many pitfalls to the beginner, it also presents significant opportunities to one skilled in the art. Third, we will examine how fluorescence is measured in the steady state and time domain. Finally, we will examine how fluorescence is applied in the modern epifluorescence microscope. Because the scope of this article is broad, we must apologize at the outset, as we can only begin to examine these issues. For a more complete discussion of fluorescence and fluorescence microscopy, the reader is referred to several excellent texts on these subjects (Parker, 1968; Becker, 1969; Guibault, 1973; Mavrodineanu *et al.*, 1973; Cundall and Dale, 1980; Demas, 1983; Lakowicz, 1986; Haugland, 1996).

II. Light Absorption and Beer's Law

In considering the phenomenon of fluorescence emission, it is useful to take a step back and consider the absorption of light by a solute in solution. Many substances, such as multiring organic molecules, are colored, which is to say they

Fig. 1 Schematic of an absorbance measurement. A cuvette of thickness I is shown in cross section. The intensity at $x = 0$ is I_0 and at $x = I$ is I_1. At some arbitrary point x within the volume, the intensity is $I(x)$ and at some Δx later is $I(x + \Delta x)$.

absorb light at specific visible wavelengths. Let us consider (see Fig. 1) a solution of some absorbing solute of concentration C, molecules per cubic centimeter, in a cuvette. We shine a light of intensity I_0, photons per centimeter squared per second, on the front surface of this cuvette. What we would like to know is the output intensity at the other side of the cuvette. Let us call the thickness of the cuvette 1, and the cross sectional area A. Let us generalize the question a bit. If we define the front surface to be at a position $x = 0$ and the back surface at $x = 1$, then we can consider an infinitesimal slab at some x inside the cuvette of thickness dx. If we know $I(x)$, what is $I(x + dx)$? $dI = I(x + dx) - I(x)$ is the number of photons absorbed per unit area per second, and the total number of photons absorbed within the slab per second is AdI. Now, if you think of the photons as being a shower of bullets blasting into clay spheres (the solute molecules), then you predict that the number of photons absorbed by the slab will be proportional to the number of bullets, $I(x)$, times the number of clay spheres, Cdx. If we let ε' be the constant of proportionality, we have

$$dI = -\varepsilon' C I dx. \tag{1}$$

A little rearranging gives us

$$dI/I = -\varepsilon' C dx, \tag{2}$$

which is a differential equation that, on integration, gives us

$$\ln(I/I_0) = -\varepsilon' C x, \tag{3}$$

or, equivalently,

$$I = I_0 \exp(-\varepsilon' C x). \tag{5}$$

This is known as Beer's law.

We can bring this into a more familiar form if we consider the logarithmic form of the equation at $x = 1$. The fraction of light transmitted through the cuvette is $I(1)/I_0$; call it T. Then,

$$\ln(T) = -\varepsilon' C 1.$$

Let us then change over to base 10 logarithms:

$$\log(T) = 2.303 \ln(T) = -2.303\,\varepsilon' C 1;$$

$$\log(1/T) = 2.303\,\varepsilon' C 1.$$

Log ($1/T$) is known as the optical density of the sample, OD, and if we define $\varepsilon = 2.303\varepsilon'$, we come to the familiar form of Beer's law

$$\text{OD} = \varepsilon C 1, \tag{6}$$

where ε is the molar extinction coefficient and has units $M^{-1}\,\text{cm}^{-1}$.

Filters used to reduce light intensity in fluorescence microscopy are typically designated by their optical density. An optical density of one will attenuate light tenfold, of two, 100-fold, and so forth.

ε, of course, is wavelength dependent. Typical values for ε are $5 \times 10^4\,M^{-1}$ $1\,\text{cm}^{-1}$ for organic molecules. This puts us in a position to estimate the sensitivity of adsorbance measurements. Let us assume that we can measure ODs as low as .01. Then, if we are using a standard 1-cm path-length cuvette, the lowest concentration we can reliably detect or measure will be

$$C = \text{OD}/\varepsilon 1 = .01/(5 \times 10^4)(1) = .2\mu M.$$

Thus, the detection limit of a standard adsorbance measurement is a few tenths of a micromolar. In contrast, the detection limit for fluorescence samples can be as low as a picomolar. As a solution assay method, if one uses 100-μL cuvettes, this translates to being able to detect an atto, 10^{-18}, moles of a fluorescent substance. In the fluorescence microscope, one can readily see surface concentrations on the order of 100 molecules/μ^2. Recognize, also, that this concentration refers to fluorophore density. Thus, if necessary, one can multilabel a probe to push this limit. Webb's group, for instance, has succeeded in visualizing the surface dynamics of individual LDL receptors by preparing LDL labeled with 100 C_{16}dil molecules/LDL molecule (Barak and Webb, 1982).

All of this I offer as a rationale for turning our attention to the phenomenon of fluorescence.

III. Atomic Fluorescence

Figure 2 is meant to illustrate the energy levels of some atom. This kind of energy level diagram is referred to as a Jablonski diagram. The energy levels are labeled S_n, where n is the principal quantum number. E_0 is, of course, the ground

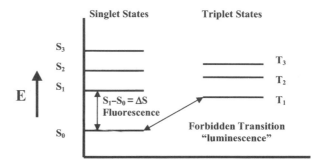

Fig. 2 Jablonski diagram showing the energy levels of a hypothetical atom. The energy levels and therefore the spectral lines that occur are very discrete. A set of triplet states parallels the set of singlet states at slightly reduced energy. Transition between triplet and singlet states violate conservation of angular momentum and is said to be forbidden.

state of the atom. We can get the atom into some excited state E_n by shining light of energy $E_n - E_0$ on it. The frequency, ν, and wavelength, λ, of this light can be determined by the Planck's radiation law, namely,

$$E_n - E_0 = h\nu = hc/\lambda, \tag{7}$$

where h is Planck's constant. Once in the excited state, the molecule will stay there for a while and then decay back to the ground state by emitting light of identical wavelength. Thus, atomic adsorbance and emission spectra are identical, very sharp, and very boring from our point of view.

It should also be noted that one can excite atomic fluorescence by other forms of energy. If you sprinkle salt crystals onto a candle's flame, you excite the sodium ions with heat and they then emit yellow light. Similarly, we can excite with electrical energy. Figure 3 shows the so-called plasma glow of a helium neon laser. Here electrons bombard the atoms of gas, stripping off their electrons. The atoms then emit at very precise wavelengths corresponding according to Eq. (7) to transitions between the various energy levels.

You may also remember that the principal quantum number does not tell the whole story. Electronic orbitals are also defined by whether they have an angular momentum. The ground state cannot have angular momentum and is known as a singlet state. In Fig. 2, we have shown the other singlet; that is no angular momentum levels for the nonzero quantum numbers. For $n > 0$, we have a set of parallel states that have angular momentum. Because angular momentum can be in any of three possible directions, these states are threefold degenerate and are known as triplet states. They have energy levels slightly less than the corresponding singlet states. Angular momentum must be conserved. As a result, a transition from a triplet state to a singlet state, such as T_1 to S_0, or vice versa, is forbidden. In quantum mechanics, we can never say never. Forbidden transitions are not absolutely forbidden, just very unlikely. Thus, if one can trick an atom

Fig. 3 Atomic fluorescence spectrum of a HeNe gas showing the discrete nature of the spectral lines. Excitation and emission occur at the same wavelengths.

into T_1, it will stay there for a very long time. For organic molecules, we have fast fluorescence with excited state lifetimes on the order of nanoseconds and slow fluorescence, or luminescence, with lifetimes that can be as long as several seconds.

IV. Organic Molecular Fluorescence

When we consider organic molecules, we are considering the molecular orbitals as shown in Fig. 4. The critical difference is that by virtue of the many vibrational states of organic molecules, the energy levels become bands. This causes the absorbance and emission spectra to broaden, as shown in Fig. 5. In a typical scenario, a molecule is sitting in the lowest energy level of the ground state. It can absorb light of a variety of wavelengths, bringing it to some vibrational level of, say, the first singlet excited state. It then decays nonradiatively to the lowest level of the excited state, where it sits for a while and then decays to any of the vibrational levels of the ground state. Finally, it gives up energy nonradiatively to return to the lowest vibrational level of the ground state. In addition to broadening the spectra, these vibrational levels result in several other interesting phenomena. First of all, we see that the energy of emission is less than that of excitation. Thus, the emitted light is redder; it has a longer wavelength than the exciting light. This is known as the Stoke's shift after the father of fluorescence. Second, and almost counterintuitively, the excitation spectrum's shape reflects the distribution of excited state vibrational levels, whereas the emission spectrum's shape reflects the distribution of ground state energy levels. Third, it can happen,

Molecular Spectra

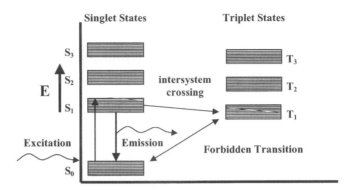

Fig. 4 Jablonski diagram showing the energy levels of a hypothetical organic molecule. In contrast to atomic energy levels, the energy levels are broadened because the molecule can exist in a large number of vibrational states.

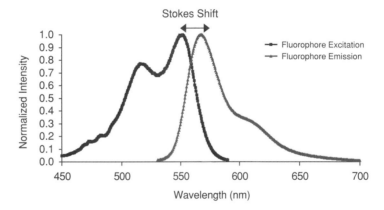

Fig. 5 Molecular fluorescence spectrum illustrating the broadening of the spectral lines because of vibrational energy levels and the Stoke's Shift between the excitation and emission maxima.

as illustrated in Fig. 4, that the vibrational levels of the triplet states can overlap the vibrational levels of the singlet states. This affords the molecule a way of nonradiatively going from a singlet state into the corresponding triplet state, a phenomenon known as intersystem crossing.

Now, one would assume, from our discussion so far, that the excitation spectrum corresponds to the absorbance spectrum. This is not always the case and

typically means that nonfluorescent spectroscopic species, such as dimers, are forming.

V. Excited–State Lifetime and Fluorescence Quantum Efficiency

Up to this point, we have spoken in very vague terms about the excited-state lifetime, τ_0. It is, of course, the case that not every molecule spends exactly time τ_0 in the excited state. In reality, τ_0 defines the probability, $p(t)$, that a fluorophore that is in the excited state a time 0 will still be there at time t. $p(t)$ is given by

$$p(t) = p_0 \exp\left(-t/\tau_0\right), \tag{8}$$

where p_0 is a normalization constant. We have expressed this equation in terms of the language of physics. Recognize, however, that we can think of an experiment in which we flash a cuvette with light and then watch the decay of fluorescence following the flash.

It is often convenient to think in terms of a rate of decay of the excited state, $k = 1/\tau_0$. Then

$$p(t) = p_0 \exp\left(-kt\right). \tag{9}$$

Of course, decay can occur by processes that compete with fluorescence. It is useful then to separate out a radiative k_r, and nonradiative, k_{nr}, part. Then,

$$k = k_r + k_{nr}. \tag{10}$$

We can then define the fluorescence quantum efficiency (QE) as the fraction of radiative decay. That is,

$$QE = k_r/(k_r + k_{nr}). \tag{11}$$

If we define a hypothetical excited-state lifetime in which there would be no nonradiative decay and call this τ_0, we can express QE in terms of the excited-state lifetimes:

$$QE = \tau/\tau_0. \tag{12}$$

This last equation supports one's intuitive feeling that if one adds a nonradiative decay mechanism to a system, one shortens its excited-state lifetime and makes it less fluorescent.

An analogy may be drawn to a bucket full of water. A pump fills the bucket at a constant rate. A hole in the bucket represents radiative decay. Poking a new hole (nonradiative decay) decreases both the amount of water in the bucket (fluorescence intensity) and the average time that any given water molecule spends in the bucket (excited state lifetime).

VI. Excited–State Saturation

We can state this last point differently: Fluorescence intensity is proportional to the number of fluorophores in the excited state. Suppose that we have a very simple system of fluorophores at a total concentration C_T, which we excite with light of intensity I_0. Suppose that the system is driven up into its first excited singlet state, S_1, with a forward rate constant k_f and then comes back down with a reverse rate constant of k_r. Then, at equilibrium, we will have

$$k_f I_0 (C_T - [S_1]) = k_r [S_1]. \tag{13}$$

Equation (13) can be rearranged to obtain

$$[S_1] = \frac{k_f I_0 C_T}{k_r + k_f I_0}. \tag{14}$$

Equation (14) illustrates two important points. First, that for a constant illumination intensity, $[S_1]$ and therefore fluorescence intensity, is proportional to the total concentration of the fluorophore. Second, fluorescence intensity is not proportional to illumination intensity. Doubling input intensity does not necessarily double output intensity. Rather, the excited state and the fluorescence intensity saturates with increasing illumination intensity. If you try to define quantum efficiency, not as we have above, but as (power out)/(power in), you paradoxically get an intensity-dependent quantum efficiency. This phenomenon of saturation is particularly important when dealing with laser illumination; for instance, in the confocal microscope.

VII. Nonradiative Decay Mechanisms

There is, of course, a whole battery of nonradiative decay mechanisms. Many of these mechanisms can be developed into tools, providing valuable information in biological experiments. Fundamentally, fluorescence is sensitive to molecular environment. Environmental changes such as ion concentrations, hydrophobicity, and pH can alter not only quantum efficiency but also the actual spectra of fluorophores. Now-classic examples are the Ca^{++} and pH-sensitive fluorophores (Haugland, 1996). Using a membrane impermeable fluorescence-quenching agent, our laboratory has been able to determine the distribution of a fluorophore across a biological membrane (Wolf, 1985).

Excited states are chemically unstable. This is particularly true of triplet states. The familiar phenomenon of fluorescence photobleaching on prolonged illumination is typically caused by chemical reactions of the triplet state, often with oxygen (Lakowicz, 1986). For fixed samples, one can slow photobleaching by using agents that inhibit such reactions. Photobleaching also has enabled us to develop the technique of fluorescence recovery after photobleaching (FRAP) to measure lateral diffusion (Axelrod et al., 1976).

VIII. Fluorescence Resonance Energy

An important example of a nonradiative decay mechanism is nonradiative fluorescence resonance energy transfer (FRET). FRET provides a "spectroscopic ruler" enabling one to measure distances of the order of 1–5 nm (Förster, 1948; Stryer and Haugland, 1967). The principle of FRET is illustrated in Figs. 6 and 7. FRET-based systems use two fluorophores, referred to as the donor–acceptor pair. Figure 6 shows the fluorescence excitation and emission spectra of a well-matched donor–acceptor pair. For the case shown, if the system is illuminated with light at approximately 480 nm, the donor will be excited and fluoresce, but the acceptor will not. Because the emission spectrum of the donor overlaps the absorbance spectrum of the acceptor, it is theoretically possible that light emitted by the donor would be reabsorbed by the acceptor and subsequently emitted by the acceptor in the red region of the spectrum at wavelengths >650 nm. In fact, such radiative energy transfer does not occur at typical biological concentrations <1 μM. Significantly, however, a different form of energy transfer, FRET, can occur when the two fluorophores are in close proximity. As shown in Fig. 7, if one has the donor alone and excites it with blue 480 nm light, the donor molecule absorbs the light and is driven into an excited state. Because these excited states typically have asymmetric molecular orbitals, we have illustrated them as dipoles. Organic fluorophores remain in this state for a time, referred to as the excited-state lifetime, that it typically ∼10 ns, before they decay back to the ground state by emitting light, in this case, green light at a longer wavelength. However, if an acceptor molecule is in close proximity to the donor molecule, the donor's dipole can induce the acceptor molecule into its own dipolar-excited state. The acceptor can then decay to its own ground state, emitting red light with a wavelength >650 nm. FRET manifests itself in four major ways: (1) a decrease of donor fluorescence, (2) an increase in sensitized acceptor fluorescence, (3) a decrease in

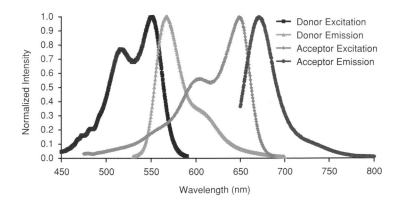

Fig. 6 Spectral overlap between donor emission and acceptor excitation spectra in fluorescence resonance energy transfer.

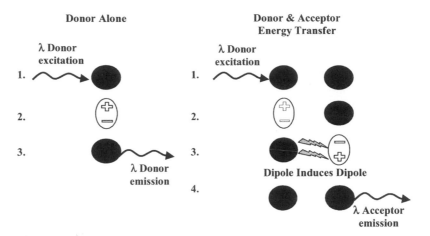

Fig. 7 Schematic of the mechanism of fluorescence resonance energy transfer.

donor excite-state lifetime, and 4) a depolarization of donor fluorescence relative to its excitation.

As described, FRET represents a dipole-induced dipole interaction. Therefore, the efficiency of this transfer falls off as the reciprocal of the sixth power of the intermolecular distance. Because the laws of quantum mechanics govern these processes, an individual donor molecule cannot give away part of its energy. It must give all of it or none of it to an acceptor. Furthermore, transfer can only occur if the energy levels overlap. That is, there must be spectral overlap of the donor emission and acceptor absorbance spectra, as shown in Fig. 6. For transfer between a single donor and acceptor molecule, the efficiency of transfer, E_T, is given by

$$E_r = \frac{R_0^6}{R^6 + R_0^6},\tag{15}$$

where R is the intermolecular distance, and R_0 is the distance where E_T is 50%. In the case where the donor is proximal to more than one acceptor, the relationship is more complex. Typically, R_0 is \sim50 Å. However, with careful choice of the donor and acceptor pair, it can easily be manipulated between \sim30 and 75 Å. The R^{-6} dependence of FRET makes it exquisitely sensitive to intermolecular distance. FRET only occurs when the donor and acceptor are in extremely close proximity to one another.

There is an important caveat to mention here, mainly the assumption of an R^{-6} dependence of the transfer efficiency. Earlier experimenters in this field were very rigorous in proving the validity of this assumption (Stryer and Haugland 1967). We will not quote Hamlet again, but if one is going to use FRET quantitatively, it is important that the R^{-6} assumption hold. This assumption is equivalent to assuming singlet–singlet transfer. There are a number of cases in which the assumption is not valid. Also, it is quite often the case that FRET is not between a

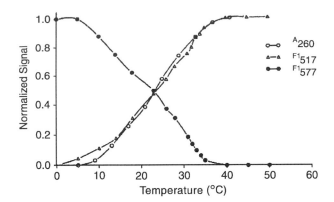

Fig. 8 Oligonucleotide hybridization detected by FRET. The 5' termini of a complementary oligonucleotide are labeled respectively with fluorescein and rhodamine. When hybridization occurs, there is FRET between the fluorescein and rhodamine. As the hybridization is melted, FRET is lost, as shown by the loss of sensitized rhodamine fluorescence, Fl_{577}, and the increase (dequenching) of fluorescein fluorescence, Fl_{517}. The later may be compared to the hyperchromicity as measured by absorbance at 260 nm, A_{260} (Cardullo et al., 1988).

single donor–acceptor pair, but between a donor and a distribution of acceptors, in which case Eq. (15) does not apply (Fung and Stryer, 1978; Dewey and Hammes 1980; Wolf et al., 1992).

An example of FRET is shown in Fig. 8 (Cardullo et al., 1988). Here the 5' ends of complementary oligonucleotides were labeled with fluorescein and rhodamine. Hybridization results in FRET between the two fluorophores. As the hybridization is melted by increased temperature, FRET is lost, as observed in a loss of sensitized rhodamine fluorescence and an increase or "dequenching" of the fluorocein fluorescence. The later is seen to parallel the absorbance at 260 nm, the hyperchromicity.

IX. Fluorescence Depolarization

Polarization, as applied to fluorescence, can also yield useful information about biological systems (Weber, 1952). Figure 9 shows a cuvette in an L-format fluorimeter illuminated with polarized light. If one uses vertically polarized light, then one can measure an intensity parallel to the illumination polarization, I_\parallel, and an intensity perpendicular to the illumination polarization, I_\perp. You can think of a fluorophore as being an antenna. Those antennae parallel to the light's electric field vector become excited. If the molecules are not free to rotate, they stay in their initial orientation, so that when they emit light, the fluorescence is polarized parallel to the illumination. However, if the molecules are completely free to randomize their orientation before emitting light, they are just as likely to

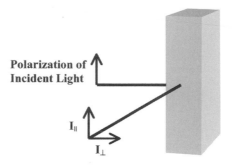

Fig. 9 Schematic of a fluorescence polarization measurement.

emit perpendicular as parallel to the exciting light, and the fluorescence is completely depolarized. In a real situation, the critical question is how much rotation occurs within the excited state lifetime. We can define the polarization

$$p = (I_\parallel - I_\perp)/(I_\parallel + I_\perp), \qquad (16)$$

or the anisotropy

$$r = (I_\parallel - I_\perp)/(I_\parallel + 2I_\perp). \qquad (17)$$

Then, for totally fluid medium, p and $r = 0$, whereas for totally rigid medium, p and $r = 1$.

A practical complication is that p and r are dependent not just on the rate of rotation but also on the excited state lifetime. Factors changing the rotation rate tend to also change the lifetime. Thus, from steady-state measurements alone, one can never be sure what is changing. What one really needs to measure is the decay of fluorescence polarization using a fluorescence lifetime instrument. It often proves to be the case, particularly with membrane systems, that changes in fluorescence depolarization reflect not changes in the rates of molecular rotation, but changes in the limits of the rotation envelope.

Fluorescence polarization can also be used to answer such questions as how a given fluorophore orients itself in a membrane. Classic examples of this are papers from Webb's and Axelrod's groups studying the orientation of cyanine dyes in artificial and red blood cell membranes, respectively (Dragsten and Webb, 1978; Axelrod, 1979).

X. Measuring Fluorescence in the Steady State

Fluorescence is typically measured by an instrument called a spectrofluorimeter. Figure 10 illustrates the design of a spectrofluorimeter. Light from a xenon or mercury lamp is sent through a monochromator, which selects light

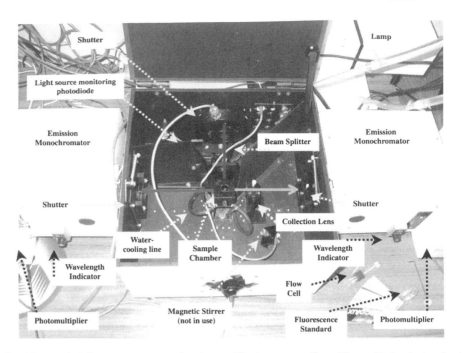

Fig. 10 Typical fluorescence spectrofluorimeter. The instrument (from Photon Technologies, Inc.) shown is set up in the so-called "T configuration," where there is a single excitation monochromator and two emission monochromators. (See Color Insert.)

from a narrow band of wavelengths. This light is sent through the sample. Fluorescence is typically measured perpendicular to the direction of illumination, the so-called L configuration. Emitted light is collected into a second monochromator, which selects the particular band of wavelengths to be measured. This light is then sent to a photomultiplier tube, which measures the fluorescence intensity. Typical photomultiplier tubes have quantum efficiencies of 10%–15%. The monochromators of a fluorimeter can be driven individually, so as to produce either excitation or emission spectra.

Spectrofluorimeters are more complicated devices than spectrophotometers in that they must correct for a number of factors: First, illumination intensities change with time. To correct for such fluctuations, a second light detector is often employed to measure the illumination intensity, and the photomultiplier output is divided by this intensity. Second, lamps do not produce the same intensity at all wavelengths. Third, photomultipliers are not equally sensitive to all wavelengths.

The second and third factors must be corrected for if one needs to obtain absolute rather than relative spectra. Similar issues, as well as spatial corrections, must be applied to video detectors on microscopes if one wants to obtain quantitative spectral information.

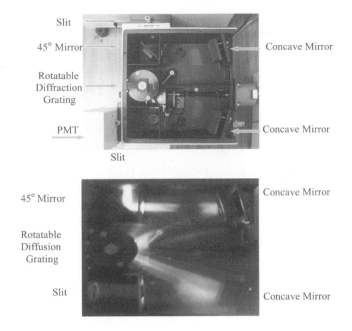

Fig. 11 Design of a monochromator for fluorescence spectroscopy (from Photon Technology Inc.). (See Color Insert.)

XI. Construction of a Monochromator

Figure 11 illustrates the construction of a monochromator, which is a device that selects for a light of a narrow band of wavelengths. A typical spectro-fluorimeter has two monochromators, one at the excitation and one at the emission end. Let us consider the excitation monochromator in the figure. Light from a xenon arc lamp strikes a concave mirror directing the light to a diffraction grating. The grating in turn separates the light into its spectral components. This spectrum is then focused by a second concave mirror onto a surface. A slit selects the wavelengths that one wishes to use or measure. A lens in the fluorimeter focuses the light to the center of the sample cuvette. You will notice the drive mechanism coupled by universal joints that rotates the diffraction grating. This moves the spectrum at the slit and thereby changes the wavelength.

XII. Construction of a Photomultiplier Tube

The detector in most spectrofluorimeters, as well as microscope photometry systems including confocal microscopes, is a photomultiplier tube (PMT) (see Fig. 12). PMTs are highly sensitive linear devices for light detection. Light strikes

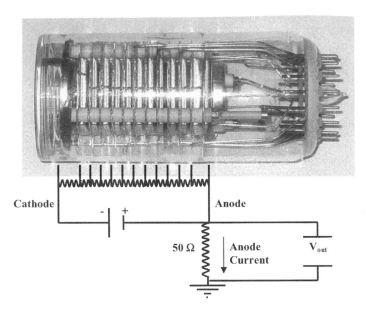

Fig. 12 End-window photomultiplier tube.

a photosensitive photocathode held at voltage V_c. In response to light, the photocathode emits electrons on its back surface. These electrons are accelerated by voltage difference, $V_1 - V_c$, toward the first dynode. Because of the acceleration, an electron striking the dynode's front surface causes multiple electrons to be emitted from the dynode's back surface. These emitted electrons are then accelerated toward the second dynode by the voltage difference $V_2 - V_1$. The process continues down the dynode chain (typical photomultipliers today have as many as 11 dynodes) until a considerable current is generated by this multiplication process at the PMTs anode.

XIII. Measuring Fluorescence in the Time Domain

Considerable information about the environment of a fluorophore can be obtained by measuring the excited-state lifetime or, inversely, the rate of fluorescence decay, see Eq. (9). Solvated molecules are in equilibrium with their environments, and driving them into excited states alters this equilibrium. The solvent environment must adjust to the new charge distribution presented by the excited state. As a result, lifetime can be very sensitive to the local environment. Although similar information is contained in the quantum efficiency and spectrum,

these parameters represent an average over the ensemble of fluorophores. Lifetime measurement offers the possibility of heterogeneity analysis in which the populations emitting at different lifetimes can be mathematical or physically distinguished.

The measurement of fluorescence excited-state lifetimes is a very complex field, and we can only touch on some of the critical issues. The reader is referred to several standard texts on this subject (Cundall and Dale, 1980; Demas, 1983; Lakowicz, 1986), as well as to Chapter 21 on lifetime imaging in the microscope.

We have already described, in Section V, the concept of flashing with a pulse of light and measuring the decay of fluorescence. In Eq. (9), we spoke about a single exponential decay. Here we will generalize this slightly, allowing for two exponential decay times τ_1 and τ_2 with fractions f_1 and f_2, respectively. Then Eq. (9) becomes

$$p(t) = p_0\{f_1(\exp(-t/\tau_1) + (1-f_1)(\exp(-t/\tau_2)\}, \tag{18}$$

where we have recognized that $f_2 = 1 - f_1$. Of course, we can generalize this even further to, say, N decay times:

$$p(t) = p_0\left\{\sum_i^N F_i \exp\left(-\frac{t}{\tau_2}\right)\right\}, \tag{19}$$

where

$$\sum_i^N f_i = 1. \tag{20}$$

In reality, although some systems can be treated as one or two exponential decay times, many fluorescent systems are best treated as a continuum distribution of lifetimes.

Although the conceptual experiment of flashing with a pulse and measuring the decay of fluorescence can be done in some cases, in most instances it proves difficult for two reasons. First, as most organic lifetimes are in the nanosecond time scale, to be effectively an impulse, the light pulse must have a picosecond or faster width. This can only be achieved with relatively high-cost pulsed laser systems. Second, the response of the detector limits our ability to measure fluorescence decay as illustrated ideally in Fig. 13. Here we have illuminated with an impulse. The first photon locks up the detector for some dead-time, and this dead-time is followed by a ringing in the detector. As a result, the simple experiment of pulse and measure continuously is difficult.

A number of strategies have been developed to overcome these problems. We will here focus on four of them: boxcar-gated detection, streak cameras, photon correlation, and phase modulation.

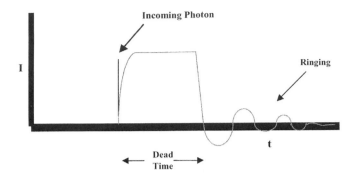

Fig. 13 Schematic of the response of a photomultiplier to an incoming photon illustrating rise time, dead time, and after-pulsing or ringing.

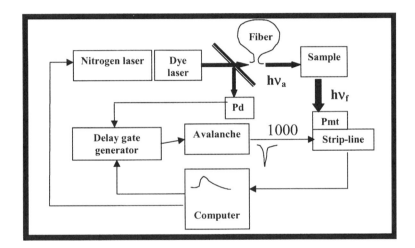

Fig. 14 Boxcar-gated detection measurement of fluorescence excited-state lifetimes (from Photon Technologies, Inc.). PMT, photo multiplier tube.

A. Boxcar-Gated Detection Method

The concept of boxcar-gated detection is illustrated in Fig. 14 for Photon Technology Incorporated's (PTI's) fluorescence lifetime system. Here a nitrogen laser pulses a dye laser that is coupled to the sample chamber with a fiber-optic. A beam splitter carries some of the pulse to a photodiode, which triggers a delay gate generator. This causes a pulse delay relative to the input pulse. This pulse is used to trigger a PMT. The PMT only measures during this delayed pulse. As a result, current is only measured by the PMT during the delayed pulse. By systematically sweeping the delay time, one can, over the course of many pulses, build up a measurement of the decay process.

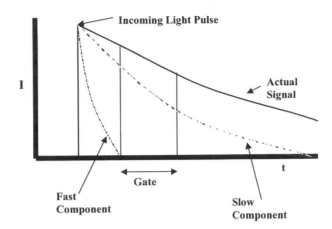

Fig. 15 Schematic of how gating can be used to suppress a fast lifetime component.

An interesting feature of this approach is illustrated in Fig. 15. Suppose that one has a double exponential decay with a relatively fast and a relatively slow lifetime component. By judicious choice of the delay, one can effectively "tune out" the fast lifetime component. As discussed in Chapter 21, this can be effectively exploited in lifetime imaging analysis.

As we have already discussed, one must often correct for the finite pulse width of the light source. Effectively, the light pulse, $I_{ex}(t')$ can be divided into an infinite number of infinitely narrow slices each occurring at its own time t'. Each slice will elicit an exponential decay:

$$I(t) = \int_0^\infty I_{ex}(t')e^{\frac{-(t-t')}{\tau}}\,dt'. \tag{21}$$

This can, of course, be generalized to multiple exponential decay. An example of such an analysis made on the PTI instrument is shown in Fig. 16. One sees the incident light pulse, the fluorescence response, the fit of the fluorescence response assuming the pulse width, and the exponential decay correcting for this finite width of the incident pulse.

B. Streak–Camera Method

Streak cameras measure fluorescence lifetimes by translating a temporal difference into a spatial difference. Figure 17 illustrates how this is accomplished in the Hamamatsu streak camera. In the figure, the incident light has been split along the horizontal axis into different wavelengths using, for instance, a diffraction grating. A horizontal slit is placed immediately behind the photocathode. The electrons are accelerated toward a microchannel plate. Vertical electrodes are used to rapidly sweep the electron beam along the vertical

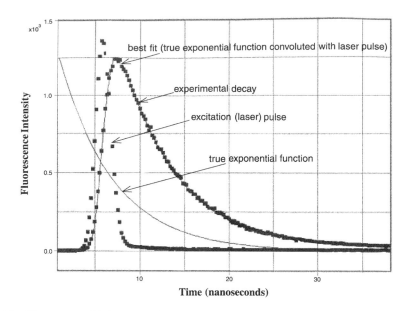

Fig. 16 Fluorescence lifetime data from the Photon Technology, Inc., gated-boxcar detection system. Note that because the illumination is not a perfect pulse, the pulse must be deconvolved from the emission signal to obtain the "true" exponential decay.

OPERATING PRINCIPLE, FUNCTIONS AND PERFORMANCE

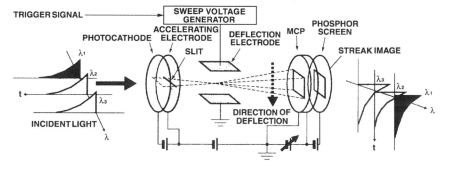

Fig. 17 Operating principle of measurement of fluorescence lifetimes using a streak camera (from Hamamatsu Photonics).

axis as electrons accelerate toward the microchannel plate. As a result, the vertical axis becomes time and the horizontal axis is wavelength. A phosphor screen at the anode end of the microchannel plate converts this image back to light, which can then be examined using a video camera. The signal from the camera is integrated over multiple pulses. Data obtained from the streak camera give not only the

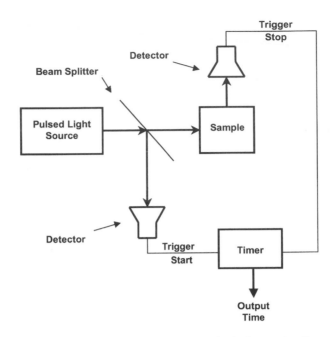

Fig. 18 Schematic diagram of the photon correlation method of measuring fluorescence lifetimes.

fluorescence decay with time but also the wavelength dependence of this decay. As the solvent surrounding the fluorophores adjusts to the altered electronic distribution of the excited state, the energy levels and, therefore, the lifetimes change. Time-resolved spectra provide a further level of information about the molecular milieu.

C. Photon Correlation Method

The decays $p(t)$ in Eqs. (18) and (19) represent the probability that a molecule in the excited state at time 0 is still in the excited state at some later time t. This probability is equivalent to the distribution of times between absorption of a photon by the fluorophores and emission of a photon of fluorescence. The photon correlation method seeks to directly measure that distribution function. The instrumentation is shown schematically in Fig. 18. Here a photodetector detects the illuminating light pulse and initiates a timing circuit. The timing circuit is turned off by the detection of the fluorescence by the photomultiplier. As a result, the circuit measures the time between excitation and emission. By repeating this measurement many times, one obtains the probability distribution of times between excitation and emission. The advantage here is that it is a low-light-level technique, as the goal is to measure only one photon per pulse.

D. Note on the Process of "Deconvolution"

As is the case in the boxcar method, one must "deconvolve" the shape of the excitation pulse to obtain the true shape of the decay for a pulse of infinitesimal width. The process of "deconvolution" represents starting with $I(t)$ and solving Eq. (21) for the exponential term or, in the more general case, terms. After spending a few moments considering how this might be done, one soon realizes that it is not a trivial problem. The issue of temporal deconvolution of the light pulse directly parallels the issue of spatial deconvolution of out-of-focus fluorescence, which will be discussed in the chapters by YuLi Wang and Jason Swedlow. Indeed, the temporal problem can be solved by very similar Fourier and iterative reconvolution techniques. For a discussion of Fourier Transforms see chapter 2. The reader is referred to Cundall and Dale (1980) and Demas (1983) for a discussion of iterative reconvolution applied to fluorescence lifetime analysis, for a discussion of a different approach known as the method of moments.

E. Phase Modulation Method

In Chapter 2, we discussed the fact that determining the response to an impulse, the so-called point-spread function, defines the systems response to any real distribution of intensities because any real object in the microscope is composed of an infinite number of points. We went on to describe the concept of Fourier transforms, where we consider not the response to a point but to a sine wave in space. We introduced the concept of spatial frequencies and the fact that any object is composed of an infinite number of sine waves or spatial frequencies. We also described the Fourier treatment of a step function and of its first derivative, the impulse. This connected the two treatments by demonstrating that an impulse is composed of an infinite number, which is all of the spatial frequencies.

Let us now consider Fig. 19, which shows a conventional spectrofluorimeter that is modified by introducing modulators of the incident light intensity and the detector sensitivity. For the input side, this modulation is readily accomplished with an acousto-optical modulator. Suppose that we modulate the incident light sinusoidally, as shown in Fig. 20A. Now suppose that the sample is fluorescent and has a single exponential decay rate. We can then determine the systems response by application of Eq. (21) in which $I_{ex}(t') = \sin(\omega t)$, where ω is the frequency in radians/second. In Fig. 20B, we have applied Eq. (21) numerically to the sine wave of Fig. 20A. Conceptually, this involves dividing the sine wave into an infinite number of slices. Each slice causes an exponential decay, and the composite effect is the sum of this infinite number of exponentials. We observe that this convolution has two effects. First, the resultant wave is shifted in time or phase relative to the excitation wave, and second, it is filled in or modulated in intensity. For a single exponential decay, the fluorescence lifetime can be calculated from the phase shift, ϕ, from

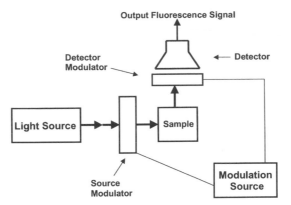

Fig. 19 Schematic diagram of a phase modulation spectrofluorimeter. The light source and the detector can be independently modulated. This is typically done either at the same frequency as a phase shift (homodyne detection) or at different frequencies (heterodyne detection).

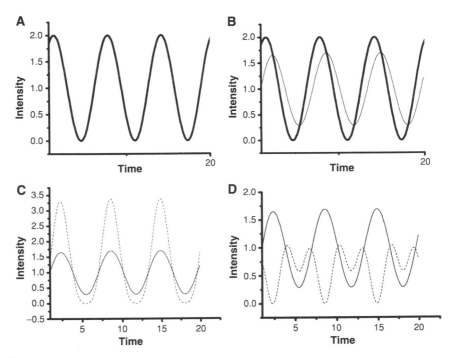

Fig. 20 Phase modulation spectrofluorimetry (homodyne detection). (A) The illuminating light source is modulated sinusoidally (—). (B) In response to this modulation, and as a result of the probabilistic nature of emission, the fluorescence shows a phase shift and demodulation of the signal amplitude (—). (C) Modulating the detector in phase with the illumination modulation enhances the fluorescence (----). (D) Modulating the detector 180° out of phase with the illumination modulation suppresses the fluorescence (----).

the equation (Lakowicz, 1986):

$$\tau = \frac{\arctan(\phi)}{\omega},$$ (22)

or from the demodulation of the sine wave, m:

$$\tau = \frac{m^2 - 1}{\omega^2}.$$ (23)

For the single exponential decay, the phase and demodulation lifetimes are the same. The two become different for multiple exponential decay. For a more complete discussion of this important aspect of fluorescence spectroscopy, the reader is referred to several excellent texts (Cundall and Dale, 1980; Demas, 1983; Lakowicz, 1986).

Now suppose that we modulate the detector as well as the excitation light. In the case of photomultiplier tubes, this is accomplished by modulating the cathode to anode voltage. Suppose that we modulate the detector at the same frequency as the excitation, a condition referred to as homodyne detection. If we introduce an adjustable phase shift between the excitation and detector modulations, then what will happen is that the range or modulation of the detector signal will be maximized when the phase shift $= \phi$ as shown in Fig. 20C, and will be a minimum when the phase shift $= \phi + 180°$, as shown in Fig. 20D. Effectively one can tune in or out a signal based on its fluorescence lifetime.

Because typical lifetimes are on the order of nanoseconds, modulation frequencies need to be on the order of 100 MHz, which also requires measurement of the sine wave at this time scale as well. This problem can be overcome by modulating the detector at a slightly different frequency. The resultant signal is then a "beat" signal of frequency equal to the difference between the two modulation frequencies. This is a condition known as heterodyne detection.

In Chapter 21, Gratton shows how both pulse and phase modulation techniques can be applied to microscopy. Examples of data obtained through a microscope with both techniques are illustrated.

XIV. Filters for the Selection of Wavelength

Wavelength selection for fluorescence microscopy is usually accomplished with filters rather than monochromators. Given that fluorescence signals are typically 10^6-fold less than the incident exciting light, the design specifications of such filters are demanding. We will confine our discussion here to the types of filters typically available on fluorescence microscopes. The top panel in Fig. 21 shows the percentage transmission of a short-pass, band-pass, and long-pass filter. The lower panel shows a fluorescence emission spectrum of a fluorescent dye; first in the absence of any filter and second through the short-pass, band-pass, and

Fig. 21 Filters for wavelength detection. (Top) The percentage transmission of a short-pass, long-pass, and band-pass filter. (Bottom) Fluorescence emission spectrum unaltered and subjected to these filters.

long-pass filters of the top panel. There are, in addition, multipass filters that allow more than one band or region to pass.

Most of the filters encountered in fluorescence microscopy are either absorbing glass filters or interference filters made by depositing a set of thin films on the glass. The distinction is important. Unlike absorbing glass filters, thin-film filters respond differently to the different components of plane polarization and, additionally, are designed for a particular incident angle, usually either 0° or 45°.

One can, in fact, shift the wavelength selection properties of such filters by rotating them around either of the axes, which are perpendicular to the direction of light propagation.

XV. The Fluorescence Microscope

The fundamental design of the epiillumination fluorescence microscope is illustrated in Fig. 22. One will immediately recognize that this design is essentially a folded form of Kohler illumination (see the chapter by Greenfield Sluder). The folded epiillumination design enables one to use the objective simultaneously as the condenser. Note that the light source is typically a mercury or xenon lamp. In most systems, the lamp is parallel to a parabolic mirror, which is adjusted so that the reflection of the lamp is focused back on the source. In a different design, an elliptical mirror, pioneered by Photon Technologies, Inc., is used and the lamp penetrates and is perpendicular to the mirror. The lamp is situated at a focus of the ellipse. As described in Chapter 1, the lamp is focused to and, therefore, conjugates with the back focal plane of the objective. The specimen plane forms a real image at and is therefore conjugate with the intermediate image plane. Combining these two terminologies, we say that the intermediate image plane is a conjugate image plane to the specimen or object plane. Significantly, in fluorescence microscope, there is a second intermediate image plane, which falls at the field diaphragm of the illuminator. This can usually be located because there is a diaphragm or aperture, the field stop, at this position. This intermediate image

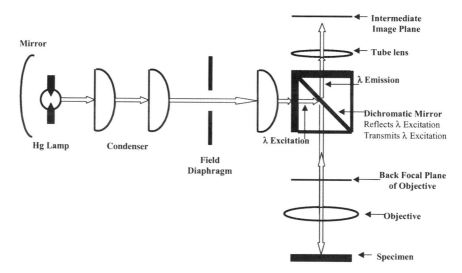

Fig. 22 Schematic diagram of the epiIllumination optics of a fluorescence microscope.

plane is significant to people who wish to focus a laser onto the sample. A beam focused at the image plane is focused on the sample. To minimize the beam at the object plane, one often needs to expand it so that it fills the back focal plane of the objective. For more on coupling lasers to microscopes either directly or with fiber optics see Chapter 22.

Incident light from the lamp passes through the fluorescence filter cube. The excitation filter, usually a low-pass or band-pass filter, selects the excitation wavelengths. Further selection is accomplished by a second filter, referred to as the dichromatic mirror, which typically is a long-pass filter that reflects the excitation light into the objective. The fluorescence light returns through the objective. However, its longer wavelengths are transmitted by the dichromatic mirror. Further selection of fluorescence wavelengths is effected by the emission filter, typically a long- or band-pass filter, which selects wavelengths for observation. Most modern fluorescence microscopes have multiple filter cubes and a slider or turret for choosing between these cubes.

XVI. The Power of Fluorescence Microscopy

We began this chapter with a discussion of physical advantages of fluorescence as a molecular detection technique. It is perhaps fitting to end with the biological advantages. The real power of the fluorescence spectroscopy and microscopy as tools of modern biology and biochemistry results not only from the exquisite sensitivity of fluorescence to detect down to even single molecules but also from our ability to selectively label specific biomolecules of interest. This began with the use of antibodies to localize specific molecules within a cell, but today has broadened to include a wide and ever-growing variety of molecular probes (Haugland, 1996). The various properties of the phenomenon of fluorescence have opened windows to explore the environments within cells and to study the dynamics of molecules. It is easy to fall into the trap of becoming seduced and enamored of "pretty pictures," and it is the responsibility of investigators to learn to properly treat quantitative data obtained with the fluorescence microscope.

In this chapter, we have tried to introduce and provide a basis for understanding some of these issues. Several further chapters, particularly those concerned with detectors, image processing, ratio-imaging, FRET, deconvolution, fluorescence correlation spectroscopy, and lifetime imaging, follow up on this quintessential theme. I am tempted to paraphrase Shakespeare, again, and say that, "The fault, dear reader, is not in our fluorescence microscopes, but in ourselves that we are underlings." However, I prefer to end more positively and point out that if one takes the time and effort to understand the proper use of the tools one is using, then one has heeded the advice of Lady Macbeth when asked what happens if we fail:

"We fail! But screw your courage to the sticking place, and we'll not fail."
William Shakespeare, Macbeth
Act I, Scene VII, lines 60-70

Acknowledgments

I thank Kathryn Sears, Leya Bergquist, Dylan Bulseco, Kip Sluder, and Roxanne Wellman for help in the preparation of this manuscript. I acknowledge support through the National Institutes of Health grants RO1-NS28760 and R44-DK57347.

References

Axelrod, D. (1979). Carbocyanine dye orientation in red cell membrane studied by fluorescence polarization. *Biophys. J.* **26,** 557–574.

Axelrod, D., Koppel, D. E., Schlessinger, J., Elson, E. L., and Webb, W. W. (1976). Mobility measurement by analysis of fluorescence photobleaching kinetics. *Biophys. J.* **16,** 1055–1069.

Barak, L. S., and Webb, W. W. (1982). Diffusion of low density lipoprotein-receptor complex on human fibroblasts. *J. Cell. Biol.* **95,** 846–852.

Becker, R. (1969). "Theory and Interpretation of Fluorescence and Phosphorescence." John Wiley-Interscience, New York.

Cardullo, R. A., Agrawal, S., Flores, C., Zamecnik, P., and Wolf, D. E. (1988). Detection of oligonucleotide hybridization by nonradiative fluorescence resonance energy transfer. *Proc. Natl. Acad. Sci. (USA)* **85,** 8790–8794.

Cundall, R. B., and Dale, R. E. (1980). "Time-Resolved Fluorescence Spectroscopy in Biochemistry and Biology." Plenum Press, New York.

Demas, J. N. (1983). "Excites State Lifetime Measurements." Academic Press, New York.

Dewey, T. G., and Hammes, G. G. (1980). Calculation of fluorescence resonance energy transfer on surfaces. *Biophys. J.* **32,** 1023–1035.

Dragsten, P., and Webb, W. W. (1978). Mechanism of the membrane potential sensitivity of the fluorescent membrane probe merocyanine 540. *Biochemistry* **17,** 5228–5240.

Förster, T. (1948). Intermolecular energy migration and fluorescence. *Ann. Phys. (Leipzig)* **2,** 55–75.

Fung, B. K. K., and Stryer, L. (1978). Surface density determination in membranes by fluorescence energy transfer. *Biochemistry* **17,** 5241–5248.

Guibault, G. G. (1973). "Practical Fluorescence Theory, Methods, and Techniques." Marcel Dekker, New York.

Haugland, R. (1996). "Handbook of Fluorescent Probes and Research Chemicals." Molecular Probes, Eugene, OR.

Lakowicz, J. R. (1986). "Principles of Fluorescence Spectroscopy." Plenum Press, New York.

Mavrodineanu, R., Shultz, J. I., and Menis, O. (1973). "Accuracy in Spectrophotometry and Luminescence Measurements." U. S. Department of Commerce, NBS, Washington, DC.

Parker, C. A. (1968). "Photoluminescence of Solutions." Elsevier, Amsterdam.

Stryer, L., and Haugland, R. P. (1967). Energy transfer: a spectroscopic ruler. *Proc. Natl. Acad. Sci. (USA)* **58,** 719–726.

Weber, G. (1952). Polarization of the fluorescence of macromolecules I. Theory and experimental method. *Biochem. J.* **51,** 145–155.

Wolf, D. E. (1985). Determination of the sidedness of carbocyanine dye labelling of membranes. *Biochemistry* **24,** 582–586.

Wolf, D. E., Winiski, A. P., Ting, A. E., Bocian, K. M., and Pagano, R. E. (1992). Determination of the transbilayer distribution of fluorescent lipid analogues by nonradiative fluorescence resonance energy transfer. *Biochemistry* **31,** 2865–2873.

CHAPTER 10

A High-Resolution Multimode Digital Microscope System

E. D. Salmon, Sidney L. Shaw, Jennifer Waters, Clare M. Waterman–Storer, Paul S. Maddox, Elaine Yeh, and Kerry Bloom

Department of Biology
University of North Carolina
Chapel Hill, North Carolina 27599

I. Introduction

In this chapter we describe the development of a high-resolution, multimode digital imaging system based on a wide-field epifluorescent and transmitted light microscope and a cooled charge-coupled device (CCD) camera. Taylor and colleagues (Taylor *et al.*, 1992; Farkas *et al.*, 1993) have reviewed the advantages of using multiple optical modes to obtain quantitative information about cellular processes and described instrumentation they have developed for multimode digital imaging. The instrument described here is somewhat specialized for our microtubule and mitosis studies, but it is also applicable to a variety of problems in cellular imaging including tracking proteins fused to the green fluorescent protein (GFP) in live cells (Cubitt *et al.*, 1995; Olson *et al.*, 1995; Heim and Tsien, 1996). For example, the instrument has been valuable for correlating the assembly dynamics of individual cytoplasmic microtubules (labeled by conjugating X-rhodamine to tubulin) with the dynamics of membranes of the endoplasmic reticulum (ER, labeled with $DiOC_6$) and the dynamics of the cell cortex [by differential interference contrast (DIC)] in migrating vertebrate epithelial cells (Waterman-Storer and Salmon, 1997). The instrument has also been important in the analysis of mitotic mutants in the powerful yeast genetic system *Saccharomyces cerevisiae*. Yeast cells are a major challenge for high-resolution imaging of nuclear or microtubule dynamics because the preanaphase nucleus is only about 2 μm wide in a cell about 6 μm wide. We have developed methods for visualizing nuclear and spindle dynamics during the cell cycle using high-resolution digitally enhanced DIC (DE-DIC) imaging (Yeh *et al.*, 1995; Yang *et al.*, 1997). Using genetic and molecular techniques, Bloom and coworkers (Shaw *et al.*, 1997a,b) have been able to label the cytoplasmic astral microtubules in dividing yeast cells by expression of cytoplasmic dynein fused to GFP. Overlays of GFP and DIC images of dividing cells have provided the opportunity to see for the first time the dynamics of cytoplasmic microtubules in live yeast cells and how these dynamics and microtubule interactions with the cell cortex change with mitotic cell cycle events in wild-type and in mutant strains (Shaw *et al.*, 1997a,b).

Our high-resolution multimode digital imaging system is shown in Fig. 1 and diagrammed in Fig. 2. The legend to Fig. 2 provides model numbers and sources

Fig. 1 Photograph of the multimode digital imaging system including the Nikon FXA upright microscope sitting on an air table (Newport Corp., Irvine, CA, VW-3660 with 4-inch-high tabletop). Images are captured with a Hamamatsu C4880 cooled CCD camera. Image acquisition, storage, processing, analysis, and display are controlled by MetaMorph Digital Imaging software in a Pentium-based computer.

of the key components of the instrument. There are three main parts to the system: a Nikon FXA microscope, a Hamamatsu C4880 cooled CCD camera, and a MetaMorph digital imaging system. First we will consider our design criteria for the instrument, then consider separately the major features of the microscope components, the cooled CCD camera, and the MetaMorph digital imaging system. The reader is referred to other sources for general aspects of microscope optics (Spencer, 1982; Inoué and Oldenbourg, 1993; Keller, 1995); DIC microscopy (Salmon, 1998); fluorescence microscopy (Taylor and Salmon, 1989); video cameras, slow-scan cameras, and video microscopy (Inoué, 1986; Aikens *et al.*, 1989; Shotten, 1995; CLMIB staff, 1995; Inoué and Spring, 1997); and 3D imaging methods (Hiroka *et al.*, 1991; Carrington *et al.*, 1995; Pawley, 1995).

II. Design Criteria

A. Fluorescence Considerations

When we began building our instrument 4 years ago, our primary objective was to obtain quantitative time-lapse records of spindle microtubule dynamics and

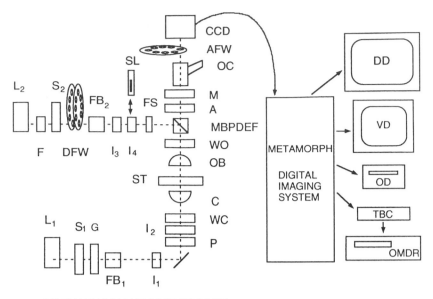

NIKON FXA LIGHT MICROSCOPE

Fig. 2 Component parts are L1, 100-watt quartz halogen lamp; S1, Uniblitz shutter (No. 225L2A1Z523398, Vincent Associates, Rochester, NY); G, ground glass diffuser; FB1, manual filter changers including KG4 heat cut and green interference filters; I_1, field iris diaphragm; I_2, condenser iris diaphragm; P and A, high transmission Nikon polaroid polarizer and removable analyzer; WC, and WO, Wollaston prisms for condenser and objective: C. Nikon NA = 1.4 CON A. Achr-Apl condenser; ST, rotatable stage with focus position controlled by z-axis stepper motor (Mac2000, Ludl Electronic Products, LTD., Hawthorne, NY); OB, 20X/NA = .75 or 60X/NA = 1.4 Nikon objectives; MBPDEF, epifilter block with multiple bandpass dichromatic mirror and emission filter (Nos. 83101 and 83100. Chroma Technology Corp., Brattleboro, VT); L2, 100-watt HBO mercury lamp; F, KG4 heat cut filter; S2 shutter; DFW, dual 8-position filter wheel (Metaltek, Raleigh, NC), one wheel containing neutral density filters (No. FNQ011, Melles Griot, Irvine, CA) and the other a series of narrow bandpass excitation filters (Nos. 83360, 83490, and 83570, Chroma Technology Corp.); FB₂, manual filter changer; I_3, epicondenser iris diaphragm; I_4, epifield diaphragm slider; SL, slit (25 μm width, No. 04PAS004, Melles Griot, Irvine, CA) cemented to Nikon pinhole slider (No. 84060) for photoactivation; FS, filter slider; M, optivar magnification changer, 1–2× OC, oculars; AFW, 4-position filter wheel (Biopoint filter wheel No. 99B100, Ludl Electronic Products, LTD., Hawthorne, NY) with one position containing a Nikon high transmission polarizer for the analyzer and another position an optical glass flat of the same thickness as the analyzer; CCD, cooled CCD camera (No. C4880, Hamamatsu Photonics, Bridgewater, NJ); DD, 1024 × 768-pixel, 20-inch digital graphics display monitor (No. 2082, Viewsonic); VD, RGB video display monitor (No. PVM1271Q, Sony); MetaMorph digital imaging system (Universal Imaging Corp., West Chester, PA) with a 166-MHz Pentium computer having both EISA and PCI bus. 128-MByte RAM memory, Imaging Technology AFG digital and video image processing card, Hamamatsu C4880 CCD controller card, Matrox MGA Melenimum 4-M RAM graphics display card, SVGA graphics display to S-VHS converter card (Hyperconverter, PC Video Conversion Corp., San Jose, CA), 1.4-MByte floppy drive, 2-GByte hard drive, 1-Gbyte Iomega Jaz drive, Hewlett Packard SureStore CD Writer 40201, ethernet card, and parallel port cards for controlling shutter S1 and driving laser printer; 8–serial port card for controlling MetalTek filter wheel, Ludl z-axis stepper, CCD camera, and OMDR; OD, Pinnacle Micro 1.3-GByte optical drive; TBC, time-base corrector; OMDR, Panasonic 2028 Optical Memory Disk Recorder. Video is also recorded on a Panasonic AG-1980P S-VHS recorder and a Panasonic AG-6750A time-lapse S-VHS recorder. Modified from Salmon *et al.* (1994).

chromosome movements for mitosis in live tissue culture cells and in *in vitro* assembled spindles in *Xenopus* egg extracts. Fluorescence optical components were chosen, in part, based on the fluorophores that were available for labeling microtubules, chromosomes, and other microtubule- or spindle-associated components. Microtubules could be fluorescently labeled along their lengths by incorporating X-rhodamine-labeled tubulin into the cytoplasmic tubulin pool (Fig. 3; Salmon *et al.*, 1994; Murray *et al.*, 1996). In addition, we needed to use fluorescence photoactivation methods to produce local marks on spindle microtubules to study the dynamics of their assembly (Mitchison and Salmon, 1993; Waters *et al.*, 1996). This is accomplished by the addition of a caged-fluorescein-labeled tubulin to the cytoplasmic pool and fluorescence photoactivation with a 360-nm microbeam as described by Mitchison and coworkers

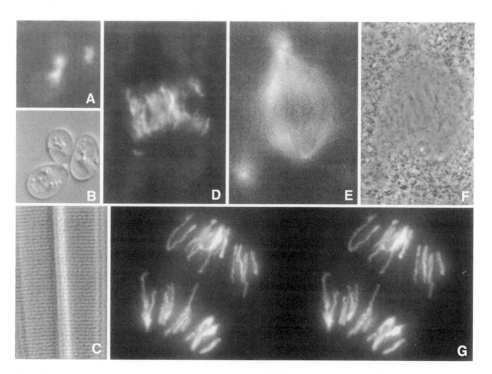

Fig. 3 Views of a living, dividing yeast, *Saccharomyces cerevisiae*, by (A) fluorescence of GFP protein bound to nuclear histones and (B) DIC.* (C) Images in DIC of the 0.24-μm spacing between rows of surface pores of the diatom *Amphipleura* illuminated with green light.* Images of a spindle undergoing *in vitro* anaphase in *Xenopus* cytoplasmic egg extracts: (D) DAPI-stained chromosomes, (E) X-rhodamine-tubulin-labeled spindle and aster microtubules, and (F) phase contrast (Nikon 20X/NA = 0.75 Fluar Phase 3 objective). See Murray *et al.* (1996) for details. Stereo-pair images (G) of DAPI-stained chromosomes generated from a stack of 0.5-μm optical sections through a *Xenopus* spindle fixed in the extracts in midanaphase.* (*, Nikon 60X/NA = 1.4 Plan Apo DIC objective and NA = 1.4 condenser illumination for DIC.) With permission from Salmon *et al.* (1994).

(Mitchison, 1989; Sawin and Mitchison, 1991; Sawin *et al.*, 1992). In extracts and some living cells, chromosomes can be vitally stained with the DNA intercalating dyes DAPI or Hoescht 33342 (Sawin and Mitchison, 1991; Murray *et al.*, 1996). Thus, in fluorescence modes, we needed to be able to obtain images in a "red channel" for X-rhodamine microtubules, a "green channel" for photoactivated fluorescein marks, and a "blue channel" for chromosomes.

B. Live Cell Considerations

Photobleaching and photodamage are a major concern during time-lapse imaging of fluorescently tagged molecules in live cells or in *in vitro* extracts. Minimizing these problems requires that the specimen be illuminated by light shuttered between camera exposures, that the imaging optics have high transmission efficiencies, that the camera detectors have high quantum efficiency at the imaging wavelengths, and that light can be integrated on the detector to reduce illumination intensity and allow longer imaging sessions without photodamage. This later point is true not only for epifluorescence but also for transmitted light (phase-contrast or DIC) imaging. In our studies, the detector also needed a high dynamic range (12 bits = 4096 gray levels), as we wanted to be able to quantitate the fluorescence of a single microtubule or the whole mitotic spindle, which could have 1000 or more microtubules. In addition, the red, green, and blue images needed to be in focus at the same position on the detector so that the fluorophores within the specimen could be accurately correlated.

C. Phase Contrast and DIC Imaging

Phase contrast or DIC-transmitted light images allow the localization of fluorescently tagged molecules in the cells to be correlated with overall cell structure or the positions of the chromosomes, nucleus, cell cortex, and so on (Fig. 3). DIC has much better resolution than phase contrast (Inoué and Oldenbourg, 1993) and excellent optical sectioning abilities (Inoué, 1989), but unlike phase contrast, an analyzer must be placed in the light path after the objective. Conventional analyzers typically transmit 35% or less of incident unpolarized light, and thus for sensitive fluorescence methods, the analyzer must be removed from the light path for fluorescence imaging and inserted for DIC imaging.

D. The Need for Optical Sections

In some of our studies, three dimensional images from "*z*-axis" series of images or four dimensional microscopy where a *z*-axis image series is recorded at each time point in a time-lapse series have been required. For example, proteins localized to the kinetochore of one chromosome may be 5 μm out of focus with the kinetochore of another chromosome in the same cell. To see all of the kinetochores

in the cell, several focal planes are acquired along the z-axis and projected into a single two dimensional representation of the three dimensional data.

III. Microscope Design

The Nikon FXA upright microscope (Figs. 1 and 2) can produce high-resolution images for both epifluorescent and transmitted light illumination without switching the objective or moving the specimen. The functional aspects of the microscope set-up can be considered in terms of the imaging optics, the epiillumination optics, the transillumination optics, the focus control, and the vibration isolation table.

A. Imaging Optics

Light collected by the objective passes through the body tube, the filter cube holder of the epifluorescence illuminator, a magnification changer, then either straight to the camera or by a prism into the binocular tube for viewing by eye. The cooled CCD camera is mounted at the primary image plane of the microscope.

1. Objectives and Matching Condenser

In epifluorescence microscopy, the intensity of the image varies as the fourth power of objective numerical aperture (NA) and inversely with the square of the magnification (M) between the objective and the detector (Taylor and Salmon, 1989):

$$I_{sp} = I_{il}NA_{obj}^4/M^2, \tag{1}$$

where I_{il} is the intensity of the epiillumination light entering the objective aperture. For high-resolution work, we typically use the highest NA possible (NA = 1.4) to maximize fluorescence intensity. Most of our specimens are less than 10 μm thick, so that lower-NA objectives or water-immersion objectives that have better performance for thicker specimens (Keller, 1995) have not been necessary. For high-resolution work, we use a Nikon 60X/NA = 1.4 Plan-Apochromatic objective, either the one designed for phase-contrast or the one designed for DIC. The specimen is illuminated in the transmitted light mode through a Nikon NA = 1.4 condenser containing a turret for selecting matching phase annulus or DIC Nomarski prism and a polarizer for DIC. For the highest-resolution work, immersion oil must be used with the condenser as well as the objective. For lower-resolution work and magnification, we have also found the

Nikon Fluar 20X/NA = 0.6 and 40X/NA = 1.3 to be very useful lenses. The Fluar lenses have better transmission efficiency, at 360 nm, in comparison to the PlanApochromat lenses, so they are better for photoactivation experiments.

2. Magnification

The magnification changer is an important feature of the imaging path because the camera is fixed in position at the primary image plane above the objective, and different specimens often require different magnifications. It provides 1.0, 1.25, 1.5, and 2.0× selectable intermediate magnifications to the camera detector. The body tube above the objective provides additional magnification of 1.25×. Therefore, for the 60X objective, the final possible magnifications to the detector are 75, 93.75, 112.5, and 150×.

How much magnification is necessary so that resolution is not limited by the pixel size of the cooled CCD detector? As discussed below, the Hamamatsu cooled CCD detector uses a chip with a pixel size of $12 \times 12\,\mu$m. To resolve two adjacent specimen points as distinct points, their images at the detector must be at least two pixel elements apart, or $24\,\mu$m (Fig. 4). With the specimen points separated by three pixel elements, or $36\,\mu$m, the problem of aliasing (Inoué and Spring, 1997) is avoided. The diffraction limited lateral resolution, r, of two adjacent points in the specimen for the Nikon 60X/NA = 1.4 objective is about:

$$r = 0.61\lambda/\mathrm{NA_{obj}} = 0.24\mu\mathrm{m} \qquad (2)$$

for $\lambda = 550$ nm green light. The magnifications needed so that $0.24\,\mu$m in the specimen is magnified to 24 or $36\,\mu$m on the detector is $24/.24 = 100\times$ or $36/.24 = 150\times$. Thus, for resolution limited by the objective and not the detector

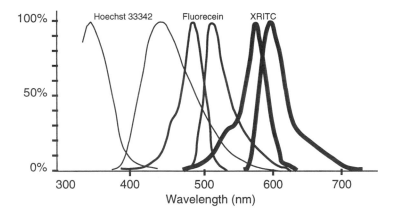

Fig. 4 Excitation and emission spectra for the blue, green, and red fluorophores we commonly use. The excitation and emission spectra for S65TGFP is similar to the fluorescein spectrum and we have had great success using the multiband pass filter (Fig. 5) and the fluorescein excitation filter.

we must use at least the 1.5× setting of the magnification changer and the 2× setting for the best resolution. Magnifications less than 100× produces brighter images as predicted by Eq. (1), but resolution in these images is limited by the resolution of the detector.

3. Determining Focus

We have found that an effective way to focus the specimen image on the camera is with dark-adapted eyes. Adjustments are available on the FXA microscope so that the oculars can be made parfocal with the camera. During an experiment, the specimen is viewed by eye and quickly brought into focus. Then the light is switched to the camera for recording. The Hamamatsu C4880 camera has a fast-scan mode that can produce displayed video images as fast as 10 Hz. We have also used this camera feature for achieving focus, but for most situations, we have found that achieving focus with the dark-adapted eye is quicker than switching the camera's mode of operation back and forth between the fast-scan mode of focusing and the slow-scan mode for image recording.

4. Phase Contrast

When phase images are recorded along with fluorescent images, we use the phase objective and the matching phase annulus on the condenser turret. The DIC objective Nomarski prism and the DIC analyzers are removed from the imaging path. The phase ring in the back aperture of the objective produces some loss of fluorescent image brightness, but it has not proven significant.

5. DIC and the Analyzer Filter Wheel

For DIC, a Normarski prism is inserted just above the objective, and the condenser turret is switched to the Nomarski prism that matches the objective. The Nikon polarizer beneath the condenser uses high-transmission (35%) Polaroid materials mounted between optical glass flats.

For focusing by eye, a high-transmission DIC analyzer is slid temporarily into the light just above the objective Normarski prism. For the best DIC image contrast, the bias retardation of the objective Nomarski prism is typically adjusted to about 1/15th to 1/10th the wavelength of light (see Salmon *et al.*, 1998) by the following procedure. First, the prism is adjusted to extinguish the background light. Then it is translated further, brightening the background and making one side of the structure of interest maximally dark. At this position, this side of the structure will be darker than the background whereas the other side of the structure will be brighter than the background, producing the "shadowed" appearance of the DIC image (Fig. 3).

For DIC image recording, the focusing analyzer is removed from the light path. A filter wheel just beneath the camera (Fig. 2) is used to insert a high-transmission

DIC analyzer into the light path. For fluorescence imaging, the filter wheel is rotated to an adjacent position that contains an optical glass flat of equivalent optical thickness to the analyzer. The Ludl filter wheel was chosen in part because it was sufficiently thin to fit between the top of the microscope and the camera without changing the position of focus of the primary image on the detector. It was also selected because it can change filter positions without inducing noticeable vibration of the objective. This filter wheel is relatively slow, requiring about 1 second to change filter positions; a time that has not proven a problem for our applications. Finally, the filter wheel is rotated by a stepping motor. There are 4000 steps between adjacent filter positions, and the ability of the filter wheel to repeatedly bring the analyzer back to the exact same position (crossed with the polarizer) is excellent.

B. Epiillumination Optics

There are a number of important features of the epiillumination pathway for our multimode microscope, including the mercury lamp housing, dual filter wheel, condenser, condenser diaphragm, field stop (diaphragm or slit), optical flat slider, and filter cubes.

1. Mercury Lamp and Housing

The lamp housing contains a mirror in the back so that both the direct light from the arc and the reflected light from the mirror pass through the lamp collector lens and become projected into the objective aperture by the epillumination optics. The mirror image helps obtain a more intense and even illumination of the objective aperture.

2. Heat Reflection Filter

This filter prevents harmful infrared light from heating the shutters, filters, or the specimen. Many conventional fluorescence filter sets do not block infrared light, which shows up as a hot spot on cameras though it is invisible to the eye.

3. Köhler Illumination

Nikon has a mirror within an objective mount that can be used for focusing and aligning the images of the arc lamp centered and in focus at the position of the objective back aperture. This is the procedure for Köhler illumination, the alignment that gives the most even illumination of the specimen. See the microscope manual for detailed alignment procedures.

4. Dual Filter Wheel and Epishutter

There are two eight-position filter wheels mounted near the lamp collector lens where the illumination light is out of focus. The wheels hold 1-inch-diameter filters. The filter wheel assembly includes a 1-inch electronic shutter. The sides of the blades facing the lamp are silvered to reflect the light when the shutter is closed and to prevent overheating of the shutter mechanism. The filter wheel position and the shutter are under computer control.

The first wheel has a series of neutral density filters including 0, 0.3, 0.5, 1.0, 1.3, 2.0, 2.3, and 3.0 O.D. The second filter wheel has one open position, and the rest contain a series of band-pass filters. The open position is used with conventional filter cubes. Three of the band-pass filters are excitation filters used to excite the blue, green, and red fluorophores (Fig. 4) through a multiple band-pass dichromatic filter cube (Fig. 5). These have central wavelengths of 360, 480, and 570 nm. Other filter positions contain filters for 340, 408, and 546 nm.

5. Condenser Diaphragm

The epiillumination condenser diaphragm is often useful for making manual "on-the-fly" adjustments of illumination intensity. Closing this diaphragm can reduce illumination intensity by about 1 O.D.

6. Field Stops

We use two field stops. One is a diaphragm that is used during fluorescence imaging to restrict the field of illumination to only the region of interest. As this diaphragm is closed down, the amount of fluorescent scattered light from the specimen decreases, which can significantly enhance the contrast in fluorescence images. Thus, we take care to adjust this diaphragm for each specimen.

The other field stop that can be exchanged easily for the diaphragm is a strip of slits and spots that we use for fluorescence photoactivation. There are translation screws for centering the position of the field stops.

7. Correction for Longitudinal Chromatic Aberration

Between the field stop and the filter cube holder is a slider for 1.5-cm filters. For fluorescence imaging we use an open position. For photoactivation at 360 nm, we insert a 3-mm-thick optical glass flat to make the 360-nm excitation light image of the field spot or slit parfocal with the green or red light images we use for focusing the slit on the specimen, as described in the following photoactivation section.

8. Filter Cube Turret

The Nikon FXA epiilluminator has four positions for filter cubes. These filters must be rotated into position by hand. We usually leave one of these positions

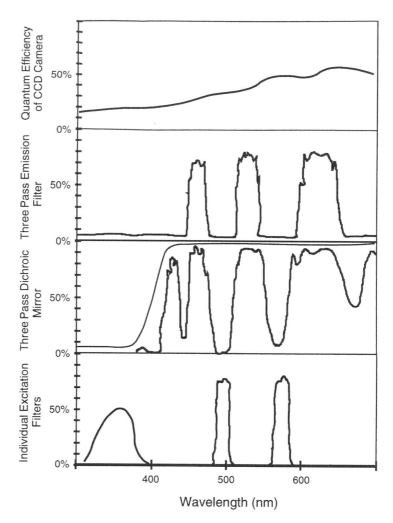

Fig. 5 The quantum efficiency of the TC-215 CCD chip in the Hamamatsu C4880 camera compared to the spectra of the Chroma excitation filters, multiple band pass dichromatic mirror, and multiple band pass emission filter. For the filters, the *y*-axis is percentage transmission. The thin line in the curves for the three-pass dichromatic mirror is produced by a coating on the backside for reflecting 360-nm excitation light.

open for the highest-resolution DIC imaging when fluorescence images are not required. We use conventional filter cubes, or specialized cubes, in the other positions.

We initially tried to use a motor-controlled filter turret to select different filters. However, when different filter cubes were used, they had slightly different optical properties (tilted optical elements, nonparallel surfaces, etc.) so that the

different-colored images were deflected to different positions on the CCD detector. Their alignment was often not repeatable each time a particular filter was rotated into place. Taylor and colleagues have had better repeatable position accuracy using a linear filter slider (Taylor *et al.*, 1992; Farkus *et al.*, 1993); however, this does not eliminate the problem of image registration on the detector.

9. Multiple Band-Pass Dichromatic Mirror and Emission Filter

This problem was solved by using a multiple band-pass dichromatic mirror and emission filter set manufactured by Chroma similar to one described by Sawin *et al.* (1992). In combination with the appropriate excitation filters, these have excitation and emission spectra similar to DAPI or Hoescht DNA intercalating dyes (360 ex/450 em), fluorescein and GFP (480 ex/510–530 em), and X-rhodamine (570 ex/620–650 em) (Fig. 5). This has been an important filter cube for our work because the image for the three different fluorophores project to the same focus on the detector. This is because they all use the same dichromatic mirror and emission filter.

Another important aspect of the Chroma filter set is the high transmission efficiency within each bandpass (Fig. 5). This is important for maximizing sensitivity and minimizing the effects of photobleaching and photodamage. The same principle applies to the selection of any filter cube for live-cell experiments.

C. Transillumination Optics

1. Quartz–Halogen Lamp and Housing

The 100-watt quartz-halogen lamp is mounted in a housing that contains a rear mirror. The combination of the primary filament image with the mirror filament image produces more even illumination of the condenser aperture than occurs for the primary image of the filament alone.

2. Heat–Reflecting Filter

As described for the epiillumination pathway, it is important to remove infrared light from the illumination beam. A 1.5-inch-diameter heat-reflecting filter is inserted in front of the lamp collector lens.

3. Thermal Isolation

We initially had considerable trouble with the stage drifting downward over time. Stage drift is a significant problem in time-lapse recording because the specimen continually goes out of focus. Stage drift was reduced substantially for the FXA stand by isolating the heat of the lamp from the base of the stand using a ceramic connector between the lamp housing and the base of the microscope stand.

4. Köhler Illumination and the Ground–Glass Diffuser

To achieve the highest resolution in DIC, it is essential that the objective aperture be uniformly illuminated (Inoué, 1989; Inoué and Oldenbourg, 1993), and the procedures outlined below are designed to achieve that goal:

1. Initially, the slide is oiled to the condenser (without air bubbles) and viewed with a low-power (10× or 20×) objective.

2. The condenser focus and horizontal position screws are adjusted so that the image of the field diaphragm in the transillumination light path is in focus and centered on the specimen when the specimen is in focus to the eye.

3. The objective is moved away and a small drop of oil (without air bubbles) is placed on the coverslip.

4. The 60X objective is rotated into place. The specimen is focused and the centration of focus of the field diaphragm readjusted. For best contrast, the field diaphragm should be closed till it just surrounds the specimen of interest.

5. The telescope (Bertrand lens) in the magnification changer is then used to focus on the objective back aperture. In that position the condenser diaphragm plane is also in focus. The condenser diaphragm is opened all the way, the ground-glass diffuser is removed from the light path, and the position controls for the bulb and the mirror are adjusted so that the primary and mirror filament images sit side by side in focus at the condenser diaphragm plane. The condenser diaphragm is adjusted to just be visible at the periphery of the objective aperture.

6. The ground-glass diffuser is then placed in the light path to produce more uniform illumination of the 1.4-NA condenser aperture.

5. Band–Pass Filters

The base of the FXA stand contains a filter changer. For live-cell illumination we use a wide-band (40-nm) green 546-nm band-pass filter.

6. Transshutter

Transillumination of the specimen is controlled by a 1-inch Vincent electronic shutter that is under computer control. The shutter sits on top of the base of the microscope underneath the condenser carrier.

D. Focus Control

Z-axis focus is controlled by a Ludl stepping motor attachment to the fine-focus knob. Coarse focus can be done by hand using the inner focus ring on the microscope. The stepping motor has a manual focus knob with three sensitivity positions: coarse, medium, and fine. The sensitivity is selected with a toggle switch on the knob box. We use the coarse setting for focusing at low magnification and the fine setting for focusing at the highest resolution.

During image recording, focus can be controlled by the computer system to yield a stack of images at equal z-axis steps through the specimen (0.1-μm steps are possible, but we typically use either 0.5- or 1-μm intervals).

We also use the stepping motor to correct for the shift in focus as the stage drifts. Often stage drift occurs at a uniform rate in one direction. During time-lapse recordings, focus is stepped at each recording interval to compensate for the stage drift.

E. Vibration Isolation

To prevent vibration from destroying image fine structural detail, the FXA microscope is mounted on a Newport vibration isolation table (Fig. 1). An attractive feature of this table is that it provides arm rests and shelves for computer monitors and other equipment, which are supported independent of the air table.

IV. Cooled CCD Camera

A. Camera Features

Our current camera is a Hamamatsu C4880 dual mode cooled CCD. The CCD detector is a rectilinear array of photodetectors (photodiodes) deposited on a silicon substrate. When the shutter is opened, incoming photons at each photodiode are converted to electrons that are accumulated in potential wells created by an electrode array on the surface of the chip. Thermal motion also knocks electrons into the potential well, and the C4880 is cooled by a Peltier device to about $-30°C$ to reduce "thermal noise." At the end of a light exposure, the shutter is closed. The C4880 camera uses a Texas Instrument TC-215 CCD chip, which has a 1024 × 1024-pixel array in which each pixel element is $12 \times 12\,\mu$m in size. The well capacity is 60,000 electrons; beyond this number, the electrons will flow into adjacent wells. CCD detectors are graded for quality and defects. A grade 1 chip like the one in the C4880 camera has few defective pixel elements and few "hot pixels."

Both photons and thermally accumulated electrons in the rows and columns of the CCD array are "read out" by a combination of parallel and serial transfers of charge to a readout amplifier and analog-to-digital (AD) converter. The C4880 uses two readout amplifiers to increase readout speed. "Readout noise" depends on rate; the slower the better, and the C4880 uses a 500-KHz rate to readout pixel values in its precision slow-scan mode. The C4880 also has a fast-scan mode (7 frames/second), which is much (about 5×) noisier but is useful for imaging brighter light sources and for focusing.

The C4880 is not a conventional video-rate camera equipped with a Peltier cooler. Video-rate CCD chips readout at 30 frames/second, and the CCD chips are

constructed differently from full-frame, slow-scan CCD chips like the TC-215 in the C4880 camera (CLMIB staff, 1995; Shaw *et al.*, 1995; Inoué and Spring, 1997).

We use the slow-scan mode of the C4880 for most of our applications, and several significant features of its operation are described in more depth next. Details on the construction and properties of CCD chip cameras, including the various ways of obtaining images from slow-scan CCDs, are available elsewhere (Aikens *et al.*, 1989; Inoué and Spring, 1997).

B. Quantum Efficiency

Quantum efficiency measures the percentage of incident photons that yield measurable photoelectrons in a pixel well. Quantum efficiency depends on wavelengths, as shown in Figs. 5 and 6D. The TC-215 chip has a peak quantum efficiency of 55% at 650 nm, the emission wavelength for the X-rhodamine fluorescence for our labeled microtubules in living cells. At 510 nm, the emission wavelengths for fluorescein and GFP, the quantum efficiency is about 35%. In general, CCD chips are more quantum efficient toward red and infrared wavelengths and significantly less toward the blue and violet wavelengths (Fig. 6D). Our chip has been coated with a fluorophore, which enhances the sensitivity in the blue-to-ultraviolet region of the spectrum (Fig. 6D).

The quantum efficiency of the TC-215 CCD is 1.5 to 2 times better than most slow-scan, full-frame readout CCDs in the visible wavelengths and much better than conventional interline video-rate CCD cameras (Fig. 6D). In full-frame readout CCD arrays such as the T1215, the potential wells are illuminated through the metal electrode array, which reduces the quantum efficiency. Back-thinned, rear-illuminated CCD chips are much harder to manufacture, but they have become available for almost reasonable prices. These chips can have quantum efficiencies as high as 80% (Fig. 6D).

Video-rate CCD cameras that allow "on-chip integration" are very economical ($800–$2000) and useful for bright fluorescence applications like immunofluorescence, as reviewed by Shaw *et al.* (1995). Compared to the full-frame readout chips, the quantum efficiency of conventional interline transfer chips is poor (15% peak) in part because half of the chip is masked (Fig. 6D). Sony has developed more sensitive chips by fabricating microlenses over each pixel element that collect light hitting the masked regions and direct it into a pixel element. This technique was developed for the "hyperhad" or HAD (hole accumulation diode) video-rate CCD chips by Sony. The quantum efficiency is still only 30% for most of these chips, and the readout noise is much higher than slow-scan, cooled CCD chips. A new Sony HAD chip exhibits 55% quantum efficiency near 510 nm (HAD ICX-061 in Fig. 6D), the peak emission wavelength for GFP fluorescence imaging. For longer-wavelength probes, these chips are much less sensitive than the conventional full-frame transfer chips. Because it is an interline chip, the Sony supports video or near-video readout rates and does not need a shutter. The pixel

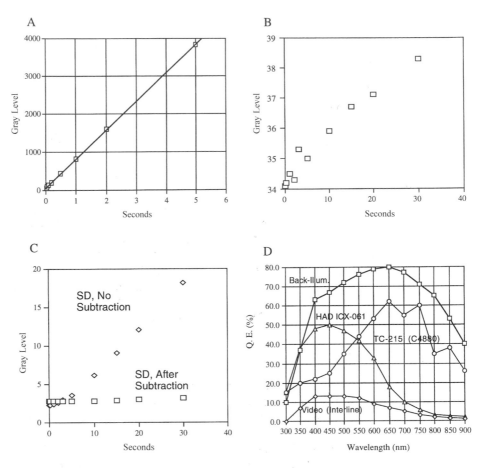

Fig. 6 Performance of the C4880 cooled camera with TC-215 CCD. (A) Measured linearity where 1 gray-level count equals 5 electrons read from the CCD. Light intensity was held constant, and integration time (sec) varied. (B) Measured average values of "dark" gray-level verses integration time (seconds) when the camera shutter is closed. The offset in converting electrons to gray-level is the intercept at zero time. (C) Measured values for camera noise obtained from the standard deviations (SDs) of the dark signal versus integration time (open diamonds) and the SD after pairs of images taken for the same time were subtracted from each other to remove the "hot pixel" contributions (open squares). (D) Comparison of the quantum efficiency of the TC-215 CCD to other types of detectors. Data taken from manufacturer's specifications.

detectors are about 9 μm in size with a well capacity of 15,000 electrons. The readout and thermal noise are remarkably low and comparable to the high-quality slow-scan full-frame transfer devices. Hence, the gap between slow-scan "scientific-grade" cameras and more commercial-grade videorate cameras continues to narrow.

C. Readout

The C4880 has two readout modes: slow scan and fast scan. In either mode, a shutter is used to control light exposure to the CCD chip. We mainly use the slow-scan mode because it has much better signal-to-noise and higher dynamic range (4096 versus 1024 gray levels). Potentially, the fast-scan mode is useful for focusing, as it can run as fast as 10 frames/second. In practice, however, we have found it easier to focus using the dark-adapted eye as described earlier. The following describes the operation of the camera in the slow-scan mode.

1. AD Conversion

The number of accumulated electrons generates a voltage that is scaled and converted into a digital signal. The analog-to-digital converter is 12 bits or 4096 gray levels, and the pixel value is transferred and stored in the computer as a 16-bit or 2-byte (1 byte = 8 bits) value. There are three gain factors (GFs) selectable with this camera. One gray level equals 25, 5, and 1 accumulated electrons at low, high, and super-high values of GF, respectively. We use the high gain setting normally because $5 \times 4096 = 20,480$, about a third of the full-well capacity for the TI-215 detector.

2. Transfer Time

It takes about 4.5 seconds after the chip is exposed to transfer a 1024×1024-pixel image into the computer display. About 4 seconds is the time of the slow-scan readout from the chip at a rate of 500,000 bytes/sec. The other 0.5 seconds is the time required to move the image from the frame buffer in the Imaging Technology AFG card in the computer to the computer's own RAM memory. This later delay can now be greatly eliminated using PCI bus adapter cards. Transfer time can be substantially shortened by reducing image size, now the time needed depends on the number of pixels in the image.

3. Size

In most of our applications, we do not need the full-chip image. The time taken for image acquisition depends on the size of the image transferred, and this time can be substantially reduced by transferring a smaller region of the chip. For example, we often use a 300×300-pixel image size in our mitosis studies. The total number of pixels for these images is about 1/10th the number for the full chip, and the rate of transfer is proportionately faster.

The other big advantage of smaller-sized images is that they take less memory in RAM or disk recording. For example, a 300×300-pixel image requires 1/10th the storage capacity as the full-chip image. We often record 500 images or more in time lapse. A 300×300-pixel image requires 90,000 pixels \times 2 bytes = 0.18 Mbytes

of memory or disk space. A full-chip image requires 1,048,576 pixels × 2 bytes = 2.1 Mbytes of storage, 23 times more than the 300 × 300-pixel image.

4. Binning

During readout, the C4880 camera controller can combine adjacent pixel values into one value. This "binning" increases the sensitivity of the camera and reduces the image size in proportion to the number of binned pixels. Binning of 2 × 2, 4 × 4, or 8 × 8 produces increases in sensitivity and reduces image size by factors of 4-, 16-, or 64-fold, respectively. The enhanced sensitivity is shown in Fig. 7 for a field of immunofluorescently stained microtubules, where the excitation light intensity is reduced by insertion of neutral density filters as binning is increased. Note that binning also reduces resolution in proportion to the binned pixels in each direction. We often use 2 × 2 or 4 × 4 binning in our fluorescence applications where resolution is limited not by optical limitations, but by too few photons. The 4- or 16-fold gain in sensitivity by binning can make substantial improvements in image quality.

D. Linearity, Noise Sources, and the Advantages of Cooling

CCD detectors are ideal for quantitative two-dimensional intensity measurements and position measurements because the signal (S) for each pixel is proportional to light intensity over a wide range and there is no geometrical distortion. Fig. 6A shows the output linearity of the C4880 camera measured for a region of a fluorescent specimen in which the light intensity was held constant, but the exposure time was varied from 20 ms to 5 seconds.

Essentially, the CCD detector is a geometrical array of pixel detectors, where the pixel gray-level value (0–4096 gray levels for 12-bit digitization) acquired by the computer, $P_{i,j}$, for a single readout of the chip is:

$$P_{i,j} = (I_{i,j} \, Q_{i,j} \, t + N_{T_{i,j}} \, t + N_{R_{i,j}})\mathrm{GF}, \tag{3}$$

where $I_{i,j}$ is the light intensity, $Q_{i,j}$ is the quantum efficiency, $N_{T_{i,j}}$ is the thermally generated electrons/second, t is the exposure time, $N_{R_{i,j}}$ is the electron equivalent error in the readout process, and GF is the gain factor in the conversion of accumulated electrons to gray level.

Thermal noise N_T is usually specified as the number of electrons per second at a given temperature. This number decreases by about 50% for each 8° of cooling (Fig. 8). So, for example, if a detector element accumulates 400 thermal electrons/second at 20 °C (about room temperature), there will be only 6 at −28 °C. Our C4880 camera has a specified average value of $N_T = .1$ electrons/pixel/per second at −40 °C (Fig. 6B). Some pixel elements on the chip are much worse than most, and these are termed "hot" pixels. For a chip cooled to −30 °C these hot pixels only become apparent for exposures longer than several seconds, as seen in Fig. 8. For uncooled chips, these hot pixels are not apparent at video

BINNED (*N* x *N*) BINNED AND
 ZOOMED (*N* x *N*) (*N* x *N*)

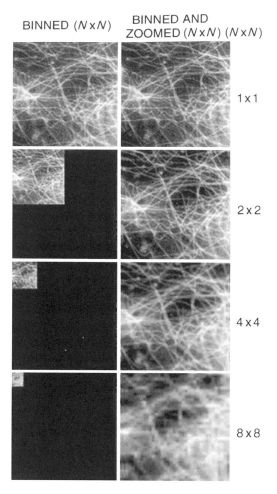

1 x 1

2 x 2

4 x 4

8 x 8

Fig. 7 Binning increases sensitivity, reduces image size, and reduces resolution. Images of a field of microtubules in a cell fixed and stained with fluorescent antibodies to tubulin. Images were taken with $N \times N$ binning at constant integration time and excitation light intensity. Image brightness increased as N^2. The final images were scaled to the same maximum brightness in the print.

rates (1/30-second exposures), but they can become very apparent even for exposures of .1 to 1 second (Shaw *et al.*, 1995). The new HAD Sony chips, however, have remarkably low thermal noise and few hot pixels.

The other major source of noise is readout noise, N_R. Unlike the photon and thermal noise, it does not depend on integration time, but occurs once when the chip is readout to the computer. N_R depends on how fast and on the way readout is achieved (Aikens *et al.*, 1989; Inoué and Spring, 1997).

We measured the thermal and readout noises by measuring the standard deviations (SDs) of "dark" images obtained by capping the camera and recording

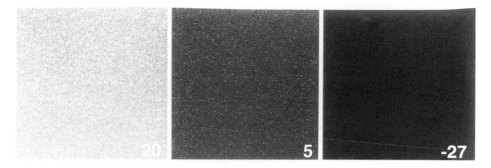

Fig. 8 Dark images from the C4880 camera as a function of temperature of the CCD chip. Exposures were for 5 seconds, and temperature in degrees centigrade is indicated on each frame.

for durations between 20 ms to 40 second when the camera was cooled to $-30\,^\circ$C (Fig. 6B). Both thermal and readout noise are governed by random number statistics, where SD is a measure of their noise contributions. For exposures less than 5 seconds, readout noise dominates (Fig. 6C). Readout noise is constant, independent of exposure time, at $N_R = 2.6$ gray levels or 5 (electrons per gray level) \times 2.6 = 11.3 electrons. Thermal noise increases with exposure time and begins to be more significant than readout noise for exposures longer than 5 seconds, mainly because of the "hot pixels."

E. Dark and Background Reference Image Subtraction

The average values of the contributions of thermal and readout noise can be subtracted from a specimen image by subtracting a "dark" reference image. The dark reference image is obtained by blocking light to the camera for the same exposure time t used for the specimen image, and their difference is given from Eq. (3) by:

$$
\begin{aligned}
P_{i,j} = {} & \text{specimen image} - \text{dark reference image} \\
= {} & \Big[I_{i,j}\, Q_{i,j}\, t + (N_T \pm \Delta N_T)_{i,j} + (N_R \pm \Delta N_R)_{i,j} \Big] \text{GF} \\
& - \Big[(N_T \pm \Delta N_T)_{i,j} + (N_R \pm \Delta N_R)_{i,j} \Big] \text{GF} \\
P_{i,j} = {} & (I_{i,j}\, Q_{i,j}\, t + N_{T_{i,j}} \pm \Delta N_{R_{i,j}}) \text{GF},
\end{aligned}
\tag{4}
$$

where $\Delta N_{T_{i,j}}$ and $\Delta N_{R_{i,j}}$ represent the random noise in the thermal and readout contributions. For bright specimens, these noise values are small and insignificant. For low-intensity specimens near the "noise floor" of the camera, these values are significant and generate poor image quality and large uncertainty in image measurements. Dark image subtraction reduces substantially the

dark image noise from hot pixels (Fig. 6C), and this subtraction is essential for good image quality for weakly fluorescent specimens.

There are other sources of noise from the microscope, including out-of-focus fluorescence, reflections from the coverslip and optical components, and fluorescence from the optical components. The average values of these contributions to the specimen image can be subtracted out by obtaining a "reference" image from a region of the slide lacking the specimen or by focusing up or down so the specimen is out of focus.

F. Shading

Quantum efficiency is remarkably constant between different pixel elements for the highest-quality CCD chips and does not have to be corrected except in the most critical applications. Variation in sensitivity between different pixels is termed "shading." This shading can be corrected for any signal by multiplying each pixel value with a scaling factor ($SF_{i,j}$). $SF_{i,j}$ is obtained by acquiring a bright image (B) with constant light intensity (I) across the detector and acquiring a dark image (D) with the shutter closed on the camera. In the computer, the average values for all the pixels in the bright image (B_{avg}) and the dark image (D_{avg}) are calculated, and the scale factor for each pixel ($SF_{i,j}$) is obtained from the ratio

$$SF_{i,j} = (B_{avg} - D_{avg})/(B_{i,j} - D_{i,j}). \tag{5}$$

G. Signal-to-Noise

The ratio of signal (S) to noise (N) is a measure of image quality, and the reciprocal (N/S) represents the uncertainty in making an image measurement. After background subtraction and shading correction, the ability to see image detail and the uncertainty of intensity measurement depends on random sources of noise in the integrated signal ($I_{i,j} Q_{i,j} t$) as well as from thermal noise (ΔN_T) and readout noise (ΔN_R). Noise in the specimen signal (called photon noise or shot noise) depends on random-number statistics just as do the other sources of noise in the camera. For S photon-produced electrons, the SD (ΔS) is a measure of the noise of S, just as the SDs are a measure of thermal and readout noise. For example, if the other sources of noise are neglected and the average number of signal electrons recorded for one pixel is 100, then the ΔS is the square root of 100, or 10. $S/N = 10$, and the uncertainty in measurement = 10%. There is a 63% chance of measuring $S \pm$ square root of S electrons in a subsequent measurement made the same way.

In general, the more photoelectrons accumulated by photon absorption by silicon in the CCD chip the better the image quality. This is shown in Fig. 9. An image of a fluorescent specimen was acquired for 20-, 200-, and 2000-ms exposure time at constant illumination intensity then scaled to the same peak brightness for

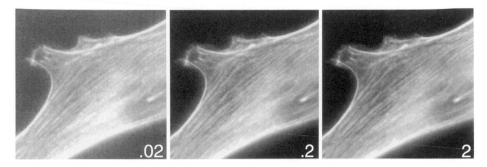

Fig. 9 Images of actin filaments in a cell that was fixed and stained with rhodamine-labeled phaloidin, taken at the same illumination light intensity but different integration times, as indicated in seconds on each frame. Too few photons makes a noisy image.

printing. At 20-ms exposure, the image is very "grainy," and the fluorescent actin filament bundles in the cell are indistinct and poorly resolved because of too few photons. The image is much better at 200 ms and beautiful at 2 seconds. Quantitatively, signal-to-noise in the camera is given by:

$$S/N = S/(\Delta S^2 + \Delta N_T^2 + \Delta N_R^2)^5. \qquad (6)$$

Note from Fig. 6B that at short exposure times (less than 2 seconds), thermal noise is insignificant in the C4880 camera and image quality is determined by photon statistics and readout noise.

V. Digital Imaging System

A. Microscope Automation and Camera Control

1. Computer Control of the Microscope

Essential to using the multimode microscope system is a flexible software package that allows control of the microscope components. Commercial software packages operating on Windows, Macintosh, and UNIX platforms are now available. We have selected the MetaMorph software package from Universal Imaging Corporation running under Windows95 for the majority of our image acquisition and processing. Figure 2 details the hardware components that run the software to control the illumination, focus, and camera.

The software contains instructions (drivers) for controlling auxiliary devices attached to the microscope. As an example, a driver within MetaMorph controls the dual eight-position filter wheels containing O.D. and fluorescence excitation filters. An excitation wavelength and light intensity can be selected from a pull-down menu for a dim rhodamine-labeled specimen and a second set of filters chosen for brighter DAPI staining. The two sets of selections are saved as preset

filter combinations and are automatically selected during time-lapse experiments when rhodamine and DAPI images are taken sequentially. In addition to filter wheels, the MetaMorph software contains drivers for controlling the focusing motor, epi- and transillumination shutters, and output to devices such as an optical memory disk recorder.

The MetaMorph camera driver allows us to take advantage of several properties specific to the Hamamatsu C4880 CCD camera. The time of exposure, area of CCD chip readout, binning of pixels, and camera gain and offset can all be saved as a preset file. Having these variables saved affords us the ability to obtain images of a specimen brightly illuminated for DIC or dimly illuminated for fluorescence without manually reconfiguring the camera.

Critical to our use of the software is a scripting language (or journaling) for customized control of the parameters, sequence, and timing of image acquisition. Journals are a sequence of instructions to the MetaMorph imaging software generated by recording a sequence of selections from the program menus. For example, to take phase contrast, DAPI, and rhodamine images of the same spindle in time lapse, journals are recorded that control image acquisition for each optical mode. For phase contrast, the transmitted shutter is opened and the CCD camera instructed to open its shutter for 600 ms, close the camera shutter, and then transfer the 12-bit image to computer memory. Similarly, journals are written to control image acquisition for DAPI and rhodamine epifluorescence that specify the exposure time of the camera, the neutral density filter, the excitation filter, and the opening and closing of the epifluorescence light shutter. A time-lapse journal then calls the phase contrast, DAPI, and rhodamine journals in sequence at a specified time interval.

2. Image Processing and Analysis

In addition to automated control of the microscope, the software contains routines for manipulating the size, scale, and contrast of images and allows handling of multiimage stacks. Image stacks are created in circumstances such as multimode time-lapse experiments where all DAPI images in a series remain in the DAPI stack and all rhodamine or DIC images remain in their respective stack. The ability to perform contrast enhancements or arithmetic (such as background image subtraction) on all images in a stack rather than performing the function on each image individually saves tremendous amounts of labor. Our camera and digital-to-analog converter generate images with greater than 4000 gray levels (12 bits). The MetaMorph software has tools for linear and nonlinear modification of image contrast as well as scaling from 12 bits to 10- or 8-bit images. The contrast enhancement allows presentation of very bright specimen information in the same image as very dim information, as is often the case when microtubules in a spindle are shown next to astral microtubules (Fig. 3E).

The software has excellent routines for creating 24-bit RGB image stacks and for overlaying fluorescent colors onto grayscale DIC or phase-contrast images.

For example, an RGB stack can be easily obtained from three stacks taken in a time-lapse series where one stack is the rhodamine image, another a fluorescein or GFP image, and the third a DAPI or DIC or phase-contrast image. Separate gain and contrast adjustment controls are available for each channel of the RGB image. The RGB image stack can be treated like any other image stack and displayed by a movie player.

Many of our experiments require quantitative analysis of images for relative fluorescence intensity or for motion. Analysis is helped tremendously by the use of calibration files. The MetaMorph software package contains routines for saving distance measurements, made from images of a stage micrometer, and intensity measurements from florescence standards. These measurements can be called on to provide calibrated values instantly. The time and date of image acquisition are contained in the header of all MetaMorph image files, allowing accurate rates to be calculated from distance measurements of time-lapsed images. The ability to couple image processing with analysis greatly increases the quantity and variety of measurements available. The journaling language described above for automating image acquisition can also be applied to image-processing routines to automatically link repetitive processes.

B. Other Useful Software and Devices

We have found several other software packages useful for image presentation and production of movies. These include Adobe Photoshop for making complicated montages of images generated in MetaMorph and saved as TIFF-formatted files and Adobe Premiere for making digital movies in .mov or .avi file formats. For making slides and labeling prints, images are copied into Microsoft PowerPoint, where lettering and annotation of images is convenient. Black-and-white draft prints of images are obtained with a Hewlett Packard Laser Jet 4M printer, and photographic-quality prints are generated with a Tektronics Phaser SDXII Dye Sublimation printer. Other ways of image processing and presentation are described by Shaw *et al.* (1995) in a paper concerning a low-cost method of digital photography using NIH-Image software and a Macintosh computer.

VI. Example Applications

A. DE-DIC

Our DE-DIC images are recorded typically with 600-ms on-chip integration. The standard test specimen for high resolution in the light microscope is the frustrule pore lattice of the diatom *Amphipleura*. These pores in the silica shell are aligned with about 0.19-μm separation along rows and 0.25-μm separation between rows. As seen in Fig. 3C, the rows of pores are clearly resolved by our DE-DIC system, and the individual pores are almost resolvable with green

light illumination. A major advantage of this system for living cells is the low illumination intensity and the computer control of shutter, which illuminates the specimen only during camera exposure. As a result, cells are viable for long periods of time-lapse recording.

Using this system we have obtained high-resolution real-time images of yeast nuclear motion in the cell division cycle. In one series of experiments (Salmon *et al.*, 1994), GFP histones were expressed to visualize the nucleus (Fig. 3A) and cellular structural detail recorded by DIC (Fig. 3B). The native GFP fluorescence excited at 490 nm was photoactivated using a several-second pulse of 360-nm light, then images were recorded using the fluorescein channel and excitation filter. In other studies (Yeh *et al.*, 1995; Yang *et al.*, 1997), we discovered that the cooled CCD camera produces high-contrast and high-resolution DE-DIC images, such that the positions of the spindle pole bodies and the anaphase elongation of the mitotic spindle within the 2-μm diameter preanaphase nucleus can be clearly seen (Fig. 10). To achieve the images shown in Fig. 10, it is necessary to reduce the refractive index mismatch between the cell wall and the media. This is achieved by embedding the cells in 25% gelatin-containing LPD yeast growth medium (Yeh *et al.*, 1995). Slides are prepared with a 10-μm-thin film of the 25% gelatin, a 5-μL drop of cell suspension is added, a number 1.5 22 × 22-mm coverslip is pressed down on the preparation, and the preparations are then sealed with VALAP (1:1:1 vasoline, lanolin, and paraffin).

B. Multimode Imaging of Anaphase *in vitro*

The multimode microscope system has also been particularly useful for recording anaphase spindle dynamics and chromosome segregation for the first time *in vitro* (Salmon *et al.*, 1994; Murray *et al.*, 1996) by reconstituting mitosis in a test tube from sperm nuclei and cytoplasmic extracts prepared from *Xenopus* eggs (Shamu and Murray, 1992; Holloway *et al.*, 1993) (Fig. 3D–F). Here phase DAPI fluorescence image stacks record chromosome movements while X-rhodamine-labeled tubulin fluorescence shows spindle microtubule assembly dynamics. The spindles in cytoplasmic extracts are held in a chamber between a slide and a coverslip separated by 12-μm latex beads and sealed with halocarbon oil and VALAP. For time lapse, sequential 600-ms exposures of rhodamine and DAPI or phase images are recorded to their respective image stacks at either 30- or 60-second intervals. The *Xenopus* egg cytoplasm is very optically dense, making the rhodamine and DAPI fluorescent images the most useful for recording spindle and chromosome dynamics. Three-dimensional images derived from a single time-point stack of optical sections have also proved very useful for determining the behavior of all of the chromosomes and their kinetochore regions within the spindle (Salmon *et al.*, 1994; Murray *et al.*, 1996) (Fig. 3G). Figure 11 shows frames from an RGB digital movie of *in vitro* anaphase in which the DAPI blue chromosome images are overlaid on the rhodamine tubulin red image of the spindle microtubules (Murray *et al.*, 1996).

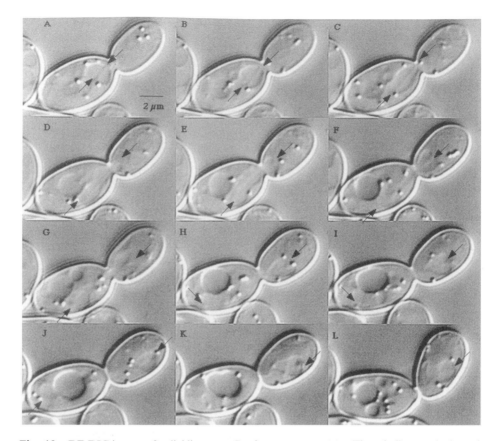

Fig. 10 DE-DIC images of a dividing yeast *Saccharomyces cerevisiae*. The spindle extends through the center of the nucleus and is formed from an overlapping bundle of microtubules extending from opposite spindle pole bodies (arrows). (A) Preanaphase. (B–K) Anaphase. (L) Cytokines. The preanaphase nucleuse in A is about 2.5 μm in diameter. Modified from Yeh *et al.* (1995).

Fig. 11 Anaphase recorded for mitotic spindles assembled in the test tube from *Xenopus* egg extracts as described (Murray *et al.*, 1996). At 30-second intervals, an X-rhodamine-tubulin image and a DA PI-stained chromosome image were recorded. Red and blue image stacks were overlaid with MetaMorph and printed in Adobe Photoshop. Time in minutes is indicated on each frame taken from the time-lapse sequence. (See Color Insert.)

C. Fluorescence Photoactivation

Another application of our multimode system has been in the analysis of the dynamics of kinetochore microtubules within mitotic tissue cells using fluorescence photoactivation methods (Mitchison and Salmon, 1993; Waters *et al.*, 1996). Figure 12 shows a metaphase newt lung epithelial cell that has been microinjected with X-rhodamine-labeled tubulin to label all the spindle microtubules and C2CF caged-fluorescein-labeled tubulin for photoactivation of tubulins within the spindle fiber microtubules as developed by Mitchison (1989). For photoactivation, the field diaphragm in the epiilluminator is replaced with a 25-μm slit cemented to a Nikon pinhole slider (Fig. 2). The spindle is marked with 350-nm illumination for 2 seconds using the Chroma DAPI exciter filter within the excitation filter wheel and no neutral density filters. Image stacks for rhodamine, fluorescein, and phase are acquired at 30-second intervals. The exposures are 600 ms, using two OD-neutral filters in front of the 100-watt Hg lamp and using a 2 × 2-pixel binning of pixels in the Hamamatsu Cooled CCD detector. The 2 × 2-pixel binning reduces the 300 × 300 central image capture area to 150 × 150 pixels and increases image sensitivity fourfold. This has proven to be important in allowing lower excitation light intensity, which reduces photobleaching and has not significantly reduced useful resolution in these low-light-level images. The images in Fig. 12 show that photoactivated marks on the kinetochore fibers flux poleward, demonstrating that at metaphase, the kinetochore microtubules that connect the chromosomes to the poles have a net addition of tubulin subunits at their kinetochore ends and a net disassembly of subunits at their polar ends. In anaphase, this poleward flux of kinetochore

Fig. 12 Multimode imaging and local fluorescence photoactivation to see the dynamics of kinetochore fiber microtubules in metaphase newt lung epithelial cells. Cells were injected in early mitosis with X-rhodamine-labeled tubulin and C2CF caged-fluorescein-labeled tubulin. At each time point, a phase image showed chromosome position, an X-rhodamine image showed spindle microtubule assembly, and the C2CF fluorescein image recorded the poleward flux and turnover of photoactivated fluorescent tubulin within the kinetochore fiber microtubules. In the color frames, the green photoactivated C2CF fluorescein fluorescence is overlaid on the red image of the X-rhodamine tubulin in the spindle fiber microtubules. Time is given in minutes after photoactivation. See Waters *et al.* (1996) for details. Scale = 10 μm. (See Color Insert.)

microtubules persists as chromosomes move poleward (Mitchison and Salmon, 1993; Zhai *et al.*, 1995; Waters *et al.*, 1996). Photoactivation has also been used to show that poleward flux of spindle microtubules occurs in other cell types (Sawin and Mitchison, 1991). This has important implications for how kinetochore microtubule dynamics are coupled to force generation-for-chromosome movement and proper alignment of the chromosomes for accurate segregation during mitosis (Mitchison and Salmon, 1993; Waters *et al.*, 1996).

D. Microtubule and ER Dynamics in Migrating Tissue Cells

The sensitivity of the imaging system has made it possible to track with great clarity the assembly dynamics of individual microtubules and ER in migrating epithelial cells (Waterman-Storer and Salmon, 1997). Microtubules are fluorescently labeled red by microinjecting X-rhodamine-labeled tubulin into cells. Endoplasmic reticulum is fluorescently labeled green using the membrane-intercalating dye $DiOC_6$ (Waterman-Storer *et al.*, 1993), and the leading edge lamellopodia and the lamella of the cell are recorded by DIC. Sets of image stacks are recorded every 7 seconds. Figure 13A–C show a pair of images, one from the rhodamine channel showing the microtubules and the other by DIC showing the leading edge of the lamella. Figure 13D–F show a pair of images, one from the rhodamine channel and the other from the $DiOC_6$ channel. One significant advance in the prevention of photobleaching in a sealed slide–coverslip preparation is the oxygen-scavenging enzyme system Oxyrase (Waterman-Storer *et al.*, 1993), used in these experiments.

E. GFP-Dynein-Labeled Microtubules in Yeast

Shaw *et al.* (1997a), imaged the dynamics and organization of the cytoplasmic microtubules in live budding yeast (Fig. 14). GFP dynein expressed in yeast binds all along the lengths of the cytoplasmic but not the nuclear microtubules. The fluorescence is barely detectable with the dark-adapted eye with no attenuation of the Hg illumination to the specimen. Images with distinct astral microtubules are recorded using exposures of 3 seconds, 1 OD illumination attenuation, and the field diaphragm closed down around the specimen to reduce the out-of-focus fluorescence from the gelatin layer that holds the yeast against the coverslip surface. We found that a single optical section was not sufficient to see the organization of astral microtubules in these small cells, which are about 5 μm in diameter. As a result, we developed an image acquisition procedure where for each time-lapse point (1-minute intervals), a series of five fluorescent optical sections is taken through the yeast at 1-μm intervals along the z-axis (Shaw *et al.*, 1997b). In the position of the middle section, a DIC image is taken by inserting the analyzer before the camera with the emission filter controller described earlier. After the completion of the time lapse over the yeast cell cycle of about 90 minutes, the fluorescent image stack is processed so that at each time interval, the

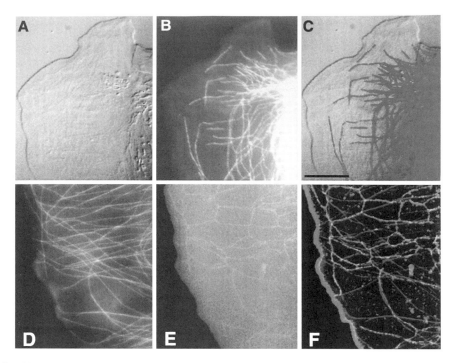

Fig. 13 Microtubules in the lamella of a live migrating newt lung epithelial cell. Microtubules are fluorescently labeled by microinjection of X-rhodamine-labeled tubulin into the cytoplasm and ER-labeled with $DiOC_6$. (A) DIC image of leading edge of lamella. (B) X-rhodamine microtubule image. (C) RGB color overlay of A and B. (D) X-rhodamine tubulin image of another cell. (E) $DiOC_6$ image of the ER. (F) RGB color overlay of E and F. See text for details. (See Color Insert.)

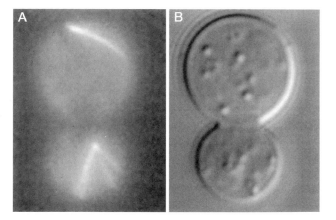

Fig. 14 (A) Fluorescent image of GFP-dynein bound to astral microtubules and (B) the corresponding DIC image of an anaphase yeast *Saccharomyces cerevisiae*. The elongated nucleus is mostly out of focus in the DIC image. See text for details.

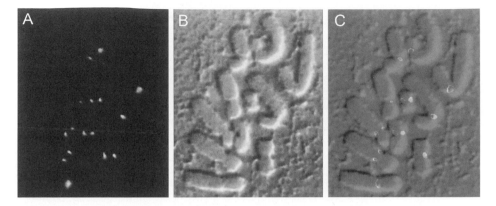

Fig. 15 The mitotic arrest protein MAD2 localizes to kinetochores on chromosomes in mitotic PtK1 cells when they are unattached from spindle microtubules. The cell was treated with nocodazole to induce spindle microtubule disassembly and then lysed and fixed for immunofluorescence staining with antibodies to the MAD2 protein (Chen *et al.*, 1996). (A) A single optical fluorescence section. (B) The corresponding DIC image. (C) The fluorescent MAD2 image and the DIC image combined in an RGB image to show the localization of MAD2 on either side of the centomeric constriction of the chromosomes where the sister kinetochore are located. Some kinetochores are above or below the plane of focus and not visible. (See Color Insert.)

fluorescent microtubule images in each five-plane stack are projected onto one plane. This projected image can then be displayed side by side or overlaid with the corresponding DIC image (Fig. 14). Movies of these images show the organization and dynamics of astral microtubules relative to the cell nucleus and other structural features of the cell visible by DIC.

F. Immunofluorescent Specimens

We have found that the cooled CCD image acquisition system produces images of immunofluorescent-stained specimens with great clarity. Often our specimens do not have high levels of out-of-focus fluorescence, and the advantages of confocal imaging are not required. Figure 15 shows an example where mammalian PtK1 tissue cells are stained with antibodies for a protein implicated in the control of the anaphase onset during mitosis, MAD2 (Chen *et al.*, 1996). The hypothesis is that when bound to kinetochores, MAD2 signals the cell to "stop" the cell cycle. When kinetochores become properly attached to microtubules emanating from opposite poles, MAD2 antibody staining of kinetochores disappears (all the "red stop lights" are off) and the cell enters anaphase.

References

Aikens, R. S., Agard, D., and Sedat, J. W. (1989). "*Methods in Cell Biology,*" Vol. **29**, pp. 292–313. Academic Press, San Diego.

Carrington, W. A., Lynch, R. M., Moore, E. D. W., Isenberg, G., Forarty, K. E., and Fay, E. S. (1995). *Science* **268**, 1483–1487.

Chen, R. H., Waters, J. C., Salmon, E. D., and Murray, A. W. (1996). *Science* **274**, 242–246.

CLMIB staff (1995). *Am. Lab.* April, 25–40.

Cubitt, A. B., Heim, R., Adams, S. R., Boyd, A. E., Gross, L. A., and Tsien, R. Y. (1995). *Trends Biochem. Sci.* **20**, 448–455.

Farkas, D., Baxter, G., DeBiasio, R., Gough, A., Nederlof, M., Pane, D., Pane, J., Patek, D., Ryan, K., and Taylor, D. (1993). *Annu. Rev. Phys.* **55**, 785.

Heim, R., and Tsien, R. (1996). *Curr. Biol.* **6**, 178–182.

Hiroka, Y., Sedlow, J. R., Paddy, M. R., Agard, D., and Sedat, J. W. (1991). *Semin. Cell Biol.* **2**, 153–165.

Holloway, S. L., Glotzer, M., King, R. W., and Murray, A. W. (1993). *Cell* **73**, 1393.

Inoué, S. (1986). "VideoMicroscopy," Plenum, New York.

Inoué, S. (1989) *"Methods in Cell Biology,"* Vol. **30**, pp. 112. Academic Press, San Diego.

Inoué, S., Oldenbourg, R. (1993). *In* "Handbook of Optics," (Optical Society of America, eds.) 2nd ed. McGraw-Hill, New York.

Inoué, S., and Salmon, E. D. (1995). *Mol. Biol. Cell* **6**, 1619–1640.

Inoué, S., and Spring, K. (1997). "Video Microscopy," 2nd ed. Plenum, New York.

Keller, H. E. (1995). *In* "Handbook of Biological Confocal Microscopy," (J. B. Pawley, ed.) pp. 111–126. Plenum, New York.

Mitchison, T. J. (1989). *J. Cell Biol.* **109**, 637.

Mitchison, T. J., and Salmon, E. D. (1993). *J. Cell Biol.* **119**, 569.

Murray, A. W., Desai, A., and Salmon, E. D. (1996). *Proc. Nat. Acad. Sci. USA* **93**, 12327–12332.

Olson, K., McIntosh, J. R., and Olmsted, J. B. (1995). *J. Cell Biol.* **130**, 639.

Pawley, J. (ed.) (1995). "Handbook of Biological Confocal Microscopy," 2nd ed. Plenum, New York.

Salmon, E. D., Inoué, T., Desai, A., and Murray, A. W. (1994). *Biol Bull.* **187**, 231–232.

Sawin, K. E., Theriot, J. A., and Mitchison, T. J. (1992). *In* "Fluorescent Probes for Biological Activity in Living Cells." Academic Press, San Diego.

Sawin, K. E., and Mitchison, T. J. (1991). *J. Cell Biol.* **112**, 941.

Schotten, D. (1993). "Electronic Light Microscopy," Wiley-Liss, New York.

Shamu, C. E., and Murray, A. W. (1992). *J. Cell Biol.* **117**, 921.

Shaw, S. L., Salmon, E. D., and Quatrano, R. S. (1995). *BioTechniques* **19**, 946–955.

Shaw, S. L., Yeh, E., Maddox, P., Salman, E. D., and Bloom, K. (1997a). *J. Cell Biol.* **139**.

Shaw, S. L., Yeh, E., Bloom, K., and Salman, E. D. (1997b). *Curr. Biol.* **7**, 701–704.

Shotten, D. M. (1995). *Histochem. Cell Biol.* **104**, 97–137.

Spencer, M. (1982). "Fundamentals of Light Microscopy," Cambridge University Press, London.

Taylor, D. L., and Salmon, E. D. (1989). *"Methods in Cell Biology,"* Vol. **29**, pp. 207–237. Academic Press, San Diego.

Taylor, D. L., Nederhof, M., Lanni, F., and Waggoner, A. S. (1992). *Am. Sci.* **80**, 322–335.

Waterman-Storer, C. M., and Salmon, E. D. (1997). *J. Cell Biol.* **139**, 417–434.

Waterman-Storer, C. M., Sanger, J. W., and Sanger, J. M. (1993). *Cell Motil. Cytoskel.* **26**, 19.

Waters, J. C., Mitchison, T. J., Rieder, C. L., and Salmon, E. D. (1996). *Molec. Biol. Cell.* **7**, 1547–1558.

Yang, S. S., Yeh, E., Salmon, E. D., and Bloom, K. (1997). *J. Cell Biol.* **136**, 1–10.

Yeh, E., Skibbens, R. V., Cheng, J. W., Salmon, E. D., and Bloom, K. (1995). *J. Cell Biol.* **130**, 687–700.

Zhai, Y., Kronebusch, P., and Borisy, G. (1995). *J. Cell Biol.* **131**, 721.

CHAPTER 11

Fundamentals of Image Processing in Light Microscopy

Richard A. Cardullo

Department of Biology
The University of California
Riverside, California 92521

I. Introduction

Image processing is now routinely used by a wide range of individuals who have access to digital cameras and computers. With a minimum investment, one can readily enhance contrast, detect edges, quantify intensity, and apply a variety of mathematical operations to images. Although these techniques can be extremely powerful, the average user often digitally manipulates images with abandon, seldom understanding the most basic principles behind the simplest image-processing routines. Although this may be acceptable to some individuals, it often leads to an image that is significantly degraded and does not achieve the results

METHODS IN CELL BIOLOGY, VOL. 72

that would be possible with some knowledge of the basic operation of an image-processing system.

The theoretical basis of image processing, along with its applications, is an extensive topic that cannot be adequately covered here but that has been presented in a number of texts dedicated exclusively to this topic (Cardullo, 1999; Castleman, 1979; Chellappa and Sawchuck, 1985; Gonzalez and Wintz, 1987; Jahne, 1991; Pratt, 1978; Russ, 1994). In this chapter the basic principles of image processing used routinely by microscopists will be presented. Because image processing allows the investigator to convert the microscope/detector system into a quantitative device, a number of considerations must be taken into account to ensure that information can be extracted in a meaningful way. This chapter will focus on three basic problems: (1) reducing "noise," (2) enhancing contrast, and (3) quantifying the intensity of an image. These techniques can then be applied to a number of different methodologies such as video-enhanced differential interference microscopy, nanovid microscopy, fluorescence recovery after photobleaching, fluorescence correlation spectroscopy, fluorescence resonance energy transfer, and fluorescence ratio imaging. In all cases, knowledge of the basic principles of microscopy, image formation, and image-processing routines is absolutely required to convert the microscope into a device capable of pushing the limits of resolution and contrast.

II. Digitization of Images

An image must first be digitized before an arithmetic or logical operation can be performed on it. For this discussion, a digital image is a discrete representation of light intensity in space (Fig. 1). A particular scene can be viewed as being continuous in both space and light intensity, and the process of digitization converts these to discrete values. The discrete representations of intensity are commonly referred to as gray values, whereas the discrete representation of position is given as picture elements, or pixels. Therefore, each pixel has a corresponding gray value that is related to light intensity [e.g., at each coordinate (x,y) there is a corresponding gray value designated as $GV(x,y)$]. The key to digitizing an image is to provide enough pixels and grayscale values to adequately describe the original image.

Clearly, the fidelity of reproduction between the true image and the digitized image depends on both the spacing between the pixels (e.g., the number of bins that map the image) and the number of gray values used to describe the intensity of that image. Figure 1 shows a theoretical one-dimensional scan across a portion of an image. Note that the more pixels used to describe, or sample, an image, the better the digitized image reflects the true nature of the original. Conversely, as the number of pixels is progressively reduced, the true nature of the original image is lost. When choosing the digitizing device for a microscope, particular attention must be paid to matching the resolution limit of the microscope (\sim0.2 μm for visible light) to the resolution limit of the digitizer. A digitizing array that has an effective separation of 0.05 μm per pixel is, at best, using four pixels to describe

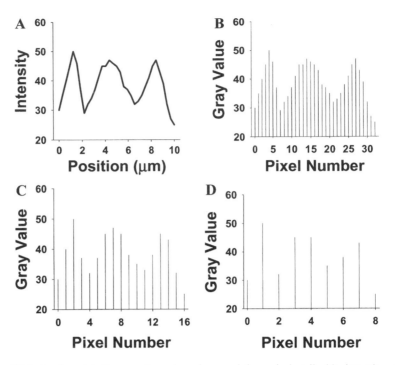

Fig. 1 (A) A densitometric line scan through a microscopic image is described by intensity values on the *y*-axis and its position along the *x*-axis. (B) A 6-bit digitized representation (64 gray values) of the object in (A), with 32 bins used to describe the position across 10 microns. The digital representation captures the major details of the original object, but some finer detail is lost. Note that the image is degraded further when the position is described by only (C) 16 bins or (D) 8 bins.

resolvable objects in a microscope, resulting in a highly digitized representation of the original image. (Note: this is most clearly seen when using the digitized zoom feature of many imaging devices, which results in a "boxy" image representation.) In contrast, a digitizer that has pixel elements separated by 1 μm effectively averages gray values five times above the resolution limit of the microscope, resulting in a degraded representation of the original image.

In addition to assigning the number of pixels for an image, it is also important to know the number of gray values needed to faithfully represent the intensity of that image. In Fig. 1B, the original image has been digitized at 6-bit resolution (6 bits $= 2^6 = 64$ gray values from 0 to 63). The image could be better described by more gray values (e.g., 8 bits $= 256$ gray levels) but would be poorly described by fewer gray values (e.g., 2 bits $= 4$ gray values).

The decision on how many pixels and gray values are needed to describe an image is dictated by the properties of the original image. Figure 1 represents a moderately low-contrast, high-resolution image that needs many gray levels and pixels to adequately describe it. However, some images are by their very nature high contrast and low resolution and require fewer pixels and gray values to

describe it (e.g., a line drawing may require only one bit of gray-level depth: black or white). Ultimately, the trade-off is one in contrast, resolution, and speed of processing. The more descriptors used to represent an image, the slower the processing routines will be performed. In general, an image should be described by as few pixels and gray values as needed so that speed of processing can be optimized. For many applications, the user can select a narrower window, or region of interest (ROI), within the image to speed up processing.

III. Using Gray Values to Quantify Intensity in the Microscope

A useful feature shared by all image processors is that they allow the microscopist to quantify image intensity values into some meaningful parameter. In standard light microscopy, light intensity, and therefore its digitized gray value, is related to the optical density that is proportional to the log of the relative light intensity. In dilute solutions (i.e., in the absence of significant light scattering) the optical density is proportional to the concentration of absorbers, C, the molar absorptivity, ε, and the pathlength, 1, through the vessel containing the absorbers. In such a situation, the optical density (O.D.) is related to these parameters using Beer's Law:

$$O.D. = \log(I_0/I) = \varepsilon Cl,$$

where I and I_0 are the intensity of light in the presence and absence of absorber respectively. Within dilute solutions, it therefore might be possible to equate a change in O.D. with changes in molar absorptivity, pathlength, or concentration. However, with objects as complex as cells, all three parameters can vary tremendously, and the utility of using O.D. to measure a change in any one parameter is uninformative. (See chapter on fluorescence microscopy for a further discussion and derivation of Beer's law.)

Although difficult to interpret in cells, measuring changes in digitized gray values in an optical density wedge offers the investigator a good way to calibrate an entire microscope system coupled to an image processor. Figure 2 shows such a calibration using a brightfield microscope coupled to a charge-coupled device (CCD) camera and an image processor using a wedge that had 0.15-O.D. increments. The camera/image processor unit was digitized to 8 bits (0–255 gray values), and the median gray value was recorded for a 100×100-pixel array (the ROI) in each step of the wedge. In this calibration, the black level of the camera was adjusted so that the highest optical density corresponded to a gray value of 5. At the other end of the scale (the lowest optical density used), the relative intensity was normalized so that I/I_0 was equal to 1 and the corresponding gray value was ~95% of the maximum gray value (~243). As seen in Fig. 2, as the step wedge is moved through the microscope, the median value of the GV increased as the log of I/I_0. In addition to acting as a useful calibration, this figure shows that an 8-bit processor can reliably quantify changes in light intensity over two orders of magnitude.

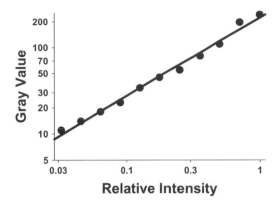

Fig. 2 Calibration of a detector using an image processor. The light intensity varied incrementally using an optical density step wedge (0.15-O.D. increments), and the gray value was plotted as a function of the normalized intensity. In this instance the camera/image-processor system was able to quantify differences in light intensity over a 40-fold range.

IV. Noise Reduction

The previous sections have assumed that the object being imaged is relatively free of noise and is of sufficient contrast to generate a usable image. Although this may be true in some instances, the ultimate challenge in many applications is to obtain reliable quantitative information from objects that produce a low-contrast, noisy signal. This is particularly true in cell physiological measurements using specialized modes of microscopy such as video-enhanced differential interference contrast, fluorescence ratio imaging, and nanovid microscopy. There are different ways to reduce noise, and the methods of noise reduction chosen depend on many different factors including the source of the noise, the type of camera employed for a particular application, and the contrast of the specimen. For the purposes of this chapter we shall distinguish between temporal techniques and spatial techniques to increase the signal-to-noise ratio (SNR) of an image.

A. Temporal Averaging

In most low-light-level applications there is a considerable amount of shot noise associated with the signal. If quantitation is needed, it is often necessary to reduce the amount of shot noise to improve the SNR. Because this type of noise reduction requires averaging over a number of frames (≥ 2 frames) this method can only be used when static objects are used. Clearly, temporal averaging would not be appropriate if one were interested in optimizing contrast for dynamic processes such as cell movement, detecting rapid changes in intracellular ion concentrations over time, quantifying molecular motions using fluorescence recovery after photobleaching, or single-particle tracking.

Assume that at any given time, t, within a given pixel, i, a signal, $S_i(t)$ represents both the true image, I, and some source of noise, $N_i(t)$. Because the noise is stochastic in nature, $N_i(t)$ will vary in time, taking on both positive and negative values, and the signal, $S_i(t)$, will vary about some mean value. For each frame, the signal is therefore just:

$$S_i(t) = I + N_i(t).$$

As the signal is averaged over M frames, an average value for $S_i(t)$ and $N_i(t)$ is obtained:

$$< S_i >_M = I + < N_i >_M,$$

where $<S_i>_M$ and $<N_i>_M$ represent the average value of $S_i(t)$ and $N_i(t)$ over M frames. As the number of frames, M, goes to infinity, the average value of N_i goes to zero, and therefore,

$$< S_i >_{M \to \infty} = I.$$

The problem facing the microscopist is to determine how large M should be so that the SNR is acceptable. This depends on a number of factors including the magnitude of the original signal, the amount of noise, and the degree of precision required by the particular quantitative measurement. A quantitative measure of noise reduction can be obtained by looking at the standard deviation of the noise, which decreases inversely as the square root of the number of frames ($\sigma_M = \sigma_o / \sqrt{M}$). Therefore, averaging a field for 4 frames will give a two-fold improvement in the SNR, averaging for 16 frames yields a fourfold improvement, and averaging for 256 frames yields a 16-fold improvement. At some point, the user obviously reaches a point of diminishing returns where the noise level is below the resolution limit of the digitizer and any improvement in SNR is minimal (Fig. 3).

Although frame-averaging techniques are not appropriate for moving objects, it is possible to apply a running average where the resulting image is a weighted sum of all previous frames. Because the image is constantly updated on a frame-by-frame basis, these types of recursive techniques are useful for following moving objects, but improvement in SNR is always less than that obtained with the simple averaging technique outlined in the previous paragraph (Erasmus, 1982). Additional recursive filters are possible that optimize the SNR, but these are typically not available on commercial image processors.

B. Spatial Methods

A number of spatial techniques are available that allow the user to reduce noise on a pixel-by-pixel basis. The simplest of these techniques generally use basic arithmetic operations within a single frame or, alternatively, between two different frames. In general, these types of routines involve either image subtraction or division from a background image or the calculation of a mean or median value around the neighborhood of a particular pixel. More

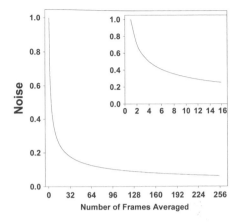

Fig. 3 Reduction in noise as a function of the numbers of frames averaged. The noise is reduced inversely as the square root of the number of frames averaged. In this instance, the noise was normalized to the average value obtained for a single frame. The major gain in noise reduction is obtained after averaging very few frames (inset), and averaging for more than 64 frames leads to only minor gains in the signal to noise ratio.

sophisticated methods use groups of pixels (known as masks, kernels, or filters), which perform higher-order functions to extract particular features from an image. These types of techniques will be discussed separately in Section VI.

1. Arithmetic Operations between an Object and a Background Image

If one has an image that has a constant noise component in a given pixel in each frame, the noise component can be removed by performing a simple subtraction that removes the noise and optimizes the SNR. Although SNR is improved, subtraction methods can also significantly decrease the dynamic range if background intensities are significant compared to the image signal. However, these problems can generally be avoided when the microscope and camera systems are adjusted so that the background is minimized before any processing routines are performed.

Any constant noise component can be removed by subtraction, and in general, it is always best to subtract the noise component from a uniform background image (Fig. 4). Thus, if a pixel within an image has a gray value of, say, 242, with the background having a gray value of 22 in that same pixel, then a simple subtraction would yield a resultant value of 220. Image subtraction therefore preserves the majority of the signal, and the subtracted image can then be processed further using other routines. To reduce temporal noise, both images can be first averaged as described in the previous section. It is important to perform noise-reduction procedures before performing additional arithmetic routines, as performing even simple procedures, especially division (as in ratio imaging), on noisy images will significantly decrease the SNR.

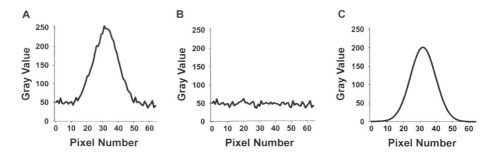

Fig. 4 Subtracting noise from an image. (A) Line scan across an object and the surrounding background (B) Line scan across the background alone reveals variations in intensity that may be caused by uneven light intensity across the field, camera defects, dirt on the optics, and so forth. (C) Image in (A) subtracted from image in (B). The result is a "cleaner" image with a higher sound-to-noise ratio in the processed image compared to the original in (A).

2. Concept of a Digital Mask

A number of mathematical manipulations of images involve using an array (or a digital mask) around a neighborhood of a particular pixel. These digital masks can be used either to select particular pixels from the neighborhood (as in averaging or median filtering, discussed in the next section) or, alternatively, can be used to apply some mathematical weighting function to an image on a pixel-by-pixel basis to extract particular features from that image (discussed in detail in Section VI). When the mask is overlaid on an image, the particular mathematical operation is performed, the resultant value is placed into the same array position, and the operation is performed repeatedly until the entire image has been transformed. Although a digital mask can take on any shape, the most routinely used masks are square, with the center pixel being the particular pixel being operated on at any given time (Fig. 5). The most common masks are 3×3 or 5×5 arrays, so that only the nearest neighbors will have an effect on the pixel being operated on. A further, larger array will greatly increase the number of computations that need to be performed, which can significantly slow down the rate of processing a particular image.

3. Averaging versus Median Filters

When an image contains random and infrequent intensity spikes with particular pixels, a digital mask can be used around each pixel to remove them. Two common ways to remove these intensity spikes is to calculate either the average value or the median value within the neighborhood and to assign that value to the center pixel in the processed image (Fig. 6). The choice of filter used will depend on the type of processed image that is desired. Although both types of filters will degrade an image, the median filter preserves edges better than the averaging

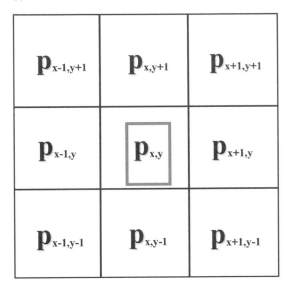

Fig. 5 Generalized structure of a digital mask used for computing means, averages, and higher-order mathematical operations, especially convolutions. In the case of the median and average filters, the mask is overlaid over each pixel in the image and the resultant value is calculated and placed into the identical pixel location in a new image buffer.

filter, since all values with the digital mask are used to compute the mean. Further, averaging filters are seldom used to remove intensity spikes because the spikes themselves contribute to the new intensity value in the processed image and, therefore, the resultant image is blurred (Fig. 6).

The median filter is more desirable for removing infrequent intensity spikes from an image because those intensity values are always removed from the processed image once the median is computed. In this case, any spike is replaced with the median value within the digital mask, which gives a more uniform appearance to the processed image. Hence a uniform background that contains infrequent intensity spikes will look absolutely uniform in the processed image. Because the median filter preserves edges (a sharpening filter), it is often used for high-contrast images.

V. Contrast Enhancement

One of the most common uses of image processing is to digitally enhance the contrast of the image using a number of different methods. In brightfield modes such as phase contrast or differential interference contrast, the addition of a camera and an image processor can significantly enhance the contrast so that specimens with inherent low contrast can be observed. In addition, contrast

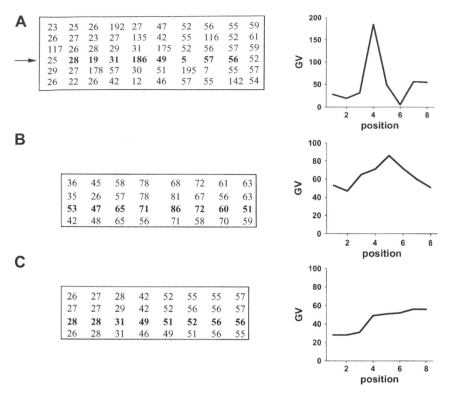

Fig. 6 Comparison of 3 × 3 averaging and median filters to reduce noise. (A) Digital representation of an image displaying gray values at different pixel locations. In general, the object possesses a boundary that is detected as a line scan from left to right. However, the image has a number of intensity spikes that significantly mask the true boundary. A line scan across a particular row (row denoted by arrow, scan is on the right hand side) reveals both high- and low-intensity values that greatly distort the image. (B) When a 3 × 3 averaging filter is applied to the image, the extreme intensity values are significantly reduced but the image is smoothed in the vicinity of the boundary. (C) In contrast, a 3 × 3 median filter both removes the extreme intensity values and preserves the true nature of the boundary.

routines can be used to enhance an image in a particular region, which may allow the investigator to quantify structures or events not possible with the microscope alone. This is the basis for video-enhanced differential interference contrast (DIC), which allows, for example, the motion of low-contrast specimens such as microtubules or chromosomes to be quantified.

To optimize contrast enhancement digitally, it is imperative that the microscope optics and the camera be adjusted so that the full dynamic range of the system is used. The gray values of the image and background can then be displayed as a histogram (Fig. 7), and the user is then able to adjust the brightness and contrast within a particular region of the image. Within a particular gray-value range, the

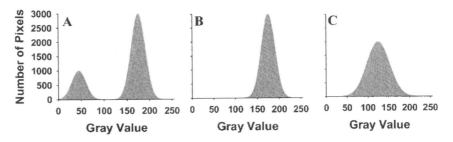

Fig. 7 Histogram representation of gray values for an entire image. (A) The image contains two distributions of intensity over the entire gray value range (0–255). (B) The lower distribution can be removed either through subtraction (if lower values are the result of a uniform background) or by applying the appropriate image transfer function, assigns a value of 0 to all input pixels having a gray value less than 100. The resulting distribution contains only information from input pixels with a value greater than 100. (C) The histogram of the higher distribution can be stretched to fill the lower gray values, resulting in a lower mean value than the original.

user can stretch the histogram so that values within that range are spread out over a different and broader range in the processed image. Although this type of contrast enhancement is artificial, it allows the user to discriminate features that otherwise may not have been detectable by eye in the original image.

Stretching gray values over a particular range in an image is one type of mathematical manipulation that can be performed on a pixel-by-pixel basis. In general, any digital image can be mathematically manipulated to produce an image with different gray values. The user-defined function that transforms the original function is known as the image transfer function (ITF), which specifies the value and the mathematical operation that will be performed on the original image. This type of operation is a point operation, which means that the output gray value of the ITF is dependent only on the gray value of the input gray value on a pixel-by-pixel basis. The gray values of the processed image, I_2, are therefore transformed at every pixel location relative to the original image using the same ITF. Hence, every gray value in the processed image is transformed according to the generalized relationship:

$$GV_2 = f(GV_1),$$

where GV_2 is the gray value at every pixel location in the processed image, GV_1 is the input gray value of the original image, and $f(GV_1)$ is the ITF acting on the original image.

The simplest type of ITF is a linear equation of slope m and intercept b:

$$GV_2 = mGV_1 + b.$$

In this case, the digital contrast of the processed image is linearly transformed, with the brightness and contrast determined by both the chosen value of the slope and the intercept. In the most trivial case, choosing values of $m = 1$ and $b = 0$

would leave all gray values of the processed image identical to the original image (Fig. 8A). Raising the value of the intercept while leaving the slope unchanged would have the effect of increasing all gray values by some fixed value (identical to increasing the DC or black-level control on a camera). Similarly, decreasing the value of the intercept will produce a darker image than the original. The value of the slope is known as the contrast enhancement factor, and changes in the value of m will have significant effects on how the gray values are distributed in an image. A value of $m > 1$ will have the effect of spreading out the gray values over a wider range in the processed image relative to the original image. Conversely, values of $m < 1$ will reduce the number of gray values used to describe a processed

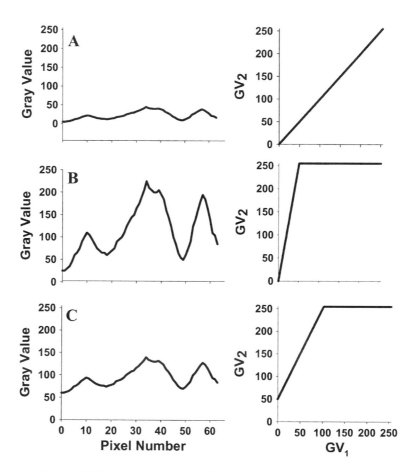

Fig. 8 Application of different linear image transfer functions to a low-intensity, low-contrast image. (A) Intensity line scan through an object that is described by few gray values. Applying a linear ITF with $m = 1$ and $b = 0$ (right) will result in no change from the initial image. (B) Applying a linear ITF with $m = 5$ and $b = 0$ (right) leads to significant improvement in contrast. (C) Applying a linear ITF with $m = 2$ and $b = 50$ (right) slightly improves contrast and increases the brightness of the entire image.

image relative to the original (Fig. 8). As noted by Inoué (1986), although linear ITFs can be useful, the same effects can be best achieved by properly adjusting the camera's black levels and gain controls. However, this may not always be practical if conditions under the microscope are constantly changing or if this type of contrast enhancement is needed after the original images are stored.

The ITF is obviously not restricted to linear functions, and nonlinear ITFs can be extremely useful for enhancing particular features of an image while eliminating or reducing others (Fig. 9). Nonlinear ITFs are also useful for correcting sources of nonlinear response in an optical system or to calibrate the light response of an optical system (Inoué, 1986). The actual form of the ITF, being linear or nonlinear, is generally application dependent and user defined. For example, nonlinear ITFs that are sigmoidal in shape are useful for enhancing images that compress the contrast in the center of the histogram and increase contrast in the tail regions of the histogram. This type of enhancement would be useful for images in which most of the information about the image is in the tails of the histogram, whereas the central portion of the histogram contains mostly background information. One type of nonlinear ITF, which is sigmoidal in shape and will enhance an 8-bit image of this type, is given by the equation

$$GV_2 = \frac{128}{(b-c)^a}[(b-c)^a - (b - GV_1)^a + (GV_1 + c)^a],$$

where b and c are the maximum and minimum gray values for the input image, respectively, and a is an arbitrary contrast enhancement factor (Inoué, 1986). For values of $a = 1$, this normally sigmoidal ITF becomes linear with a slope of 256/$(b - c)$. As a increases beyond 1, the ITF becomes more sigmoidal in nature, with greater compression occurring at the middle gray values.

In practice, ITFs are generally calculated in memory using a look-up table, or LUT. A LUT represents the transformation that is performed on each pixel on the basis of that intensity value (Figs. 10 and 11). In addition to LUTs that perform particular ITFs, LUTs are also useful for pseudocoloring images where particular user-defined colors represent gray values in particular ranges (Fig. 11). This is particularly useful in techniques such as ration imaging, where color LUTs are used to represent concentrations of Ca^{2+}, pH, or other ions, when various indicator dyes are employed within cells.

VI. Transforms, Convolutions, and Further Uses for Digital Masks

In the previous sections the most frequently used methods for enhancing contrast and reducing noise using temporal methods, simple arithmetic operations, and LUTS were described. However, more advanced methods are often needed to extract particular features from an image that may not be

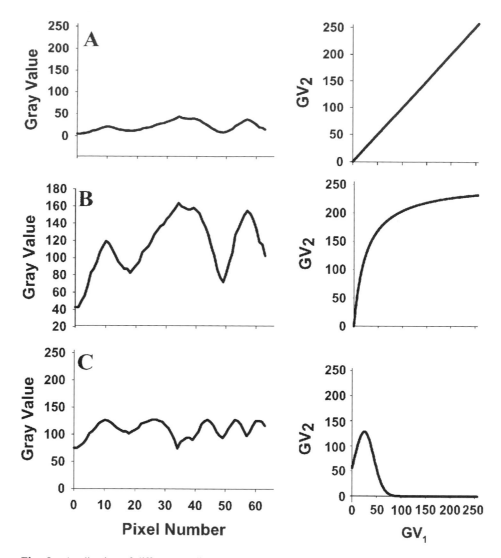

Fig. 9 Application of different nonlinear image transfer functions to the same low-intensity, low-contrast image in Fig. 8. (A) Initial image and image transfer function (right), resulting in no change. (B) Application of a hyperbolic ITF (right) to the image results in amplification of lower input values and only slightly increases the gray values for higher input values. (C) Application of a Gaussian ITF (right) to the image results in amplification of low values, with an offset, and minimizes input values beyond 75.

advisible when only using these simple methods. In this section, some of the concepts and applications associated with transforms and convolutions will be introduced.

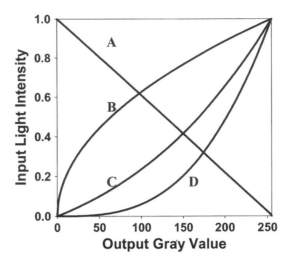

Fig. 10 Some different gray value LUTs used to alter contrast in images. (A) Inverse LUT, (B) logarithmic LUT, (C) square LUT, and (D) exponential LUT. Pseudocolor LUTS would assign different colors instead of gray values.

A. Transforms

Transforms take an image from one space to another. Probably the most used transform is the Fourier transform, which takes one from coordinate space to spatial frequency space. (See the physical optics chapter for a discussion of Fourier Transforms.) In general, a transform of a function in one dimension has the form:

$$T(u) = \sum_x f(x)g(x,u),$$

where $T(u)$ is the transform of $f(x)$ and $g(x,u)$ is known as the forward transformation kernel. Similarly, the inverse transform is given by the relation

$$f(x) = \sum_u T(u)h(x,u),$$

where $h(x,u)$ is the inverse transformation kernel. In two dimensions, these transformation pairs simply become

$$T(u,v) = \sum_x \sum_y f(x,y)g(x,y,u,v)$$

$$f(x,y) = \sum_u \sum_v T(u,v)h(x,y,u,v).$$

It is the kernel functions that provide the link that brings a function from one space to another. The discrete forms shown above suggest that these operations

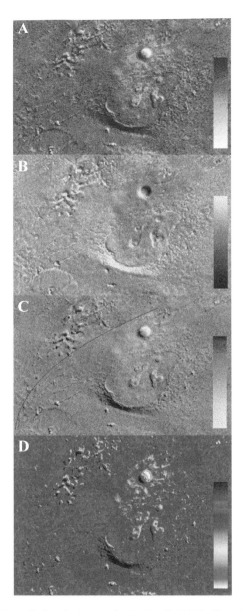

Fig. 11 Different LUTs applied to the image of a cheek cell. (A) No filter, (B) reverse contrast LUT, (C) square root LUT, and (D) pseudocolor LUT. (See Color Insert.)

can be performed on a pixel-by-pixel basis, and some transforms in image processing are computed in this manner (known as a discrete Fourier transform, or DFT). However, DFTs are generally approximated using different algorithms to yield a fast Fourier transform, or FFT.

In the Fourier transform, the forward transformation kernel is

$$g(x, u) = \frac{1}{N} e^{-2\pi i u x},$$

and the reverse transformation kernel is

$$f(x, u) = \frac{1}{N} e^{+2\pi i u x}.$$

Hence, a Fourier transform is achieved by multiplying a digitized image whose gray value is given by $f(x,y)$ on a pixel-by-pixel basis by the forward transformation kernel given above. Transforms and, in particular, Fourier transforms, can make certain mathematical manipulations of images considerably easier than if they were performed in coordinate space directly.

One example in which conversion to frequency space using an FFT is useful is in identifying both high- and low-frequency components on an image that allows one to make quantitative choices about information that can be either used or discarded. Sharp edges and many types of noise will contribute to the high-frequency content of an image's Fourier transform. Image smoothing and noise removal can therefore be achieved by attenuating a range of high-frequency components in the transform range. In this case, a filter function, $F(u,v)$, is selected that eliminates the high-frequency components of that transformed image, $I(u,v)$. The ideal filter would simply cut off all frequencies about some threshold value, I_0 (known as the cutoff frequency):

$$F(u, v) = 1 \;\; if \; |I(u, v)| \leq I_0;$$

$$F(u, v) = 0 \;\; if \; |I(u, v)| > I_0.$$

The absolute value brackets refer to the fact that these are zero-phase shift filters because they do not change the phase of the transform. A graphical representation of an ideal lowpass filter is shown in Fig. 12. Just as an image can be blurred by attenuating high-frequency components using a low-pass filter, so can they be sharpened by attenuating low-frequency components (Fig. 12). In analogy to the low-pass filter, an ideal high-pass filter has the following characteristics:

$$F(u, v) = 0 \;\; if \; |I(u, v)| \leq I_0;$$

$$F(u, v) = 1 \;\; if \; |I(u, v)| > I_0.$$

Although useful, Fourier transforms can be computationally intense and are still not routinely used in most microscopic applications of image processing. A mathematically related technique known as convolution, which uses digital masks to select particular features of an image, is the preferred method of microscopists, as many of these operations can be executed at faster rates and the mathematical operations are performed in coordinate space instead of frequency space. These operations are outlined in the following section.

Fig. 12 Frequency domain cutoff filters. The filter function in frequency space, $F(u,v)$, is used to cut off all frequencies above or below some cutoff frequency, I_0, (A) A high-pass filter attenuates all frequencies below I_0, leading to a sharpening of the image. (B) A low-pass filter attenuates all frequencies above I_0, which eliminates high-frequency noise but leads to smoothing or blurring of the image.

B. Convolution

The convolution of two functions, $f(x)$ and $g(x)$, written as $f(x) * g(x)$, is given mathematically by

$$f(x) * g(x) = \int_{-\infty}^{+\infty} f(\alpha)g(x-\alpha)d\alpha,$$

where α is a dummy integration variable. It is easiest to visualize the mechanics of convolution graphically, as demonstrated in Fig. 13, which, for simplicity, shows the convolution for two rectangular pulses. The convolution can be broken down into three simple steps:

1. Before carrying out the integration, reflect $g(\alpha)$ about the origin, yielding $g(-\alpha)$ and then displace it by some distance x to give $g(x - \alpha)$.

2. For all values of x, multiply $f(\alpha)$ by $g(x - \alpha)$. The product will be nonzero at all points where the functions overlap.

3. Integrating this product yields the convolution between $f(x)$ and $g(x)$.

Hence, the properties of the convolution are determined by the independent function $f(x)$ and a function $g(x)$ that selects for certain desired details in the function $f(x)$. The selecting function $g(x)$ is therefore analogous to the forward transformation kernel in frequency space except that it selects for features in coordinate space instead of frequency space. This clearly makes the convolution an important image-processing technique for microscopists who are interested in feature extraction.

One simple application of convolutions is the convolution of a function with an impulse function (commonly known as a delta function, described in the physical optics chapters), $\delta(x - x_0)$ (the delta function is described further in Appendix I to the physical optics chapter):

$$\int_{-\infty}^{+\infty} f(x)\delta(x - x_0)dx = f(x_0).$$

Fig. 13 Graphical representation of one-dimensional convolution. (A) In this simple example, the function, $f(x)$, to be convolved is a square pulse of equal height and width. (B) The convolving function, $g(x)$, is a rectangular pulse that is twice as high as it is wide. The convolving function is then reflected and is then moved from $-\infty$ to $+\infty$. (C) In all areas where there is no overlap, the products of $f(x)$ and $g(x)$ is zero. However, $g(x)$ overlaps $f(x)$ in different amounts from $x = 0$ to $x = 2$ with maximum overlap occurring at $x = 1$. The operation therefore detects the trailing edge of $f(x)$ at $x = 0$, and the convolution results in a triangle that increases in height from 0 to 2 for $0 < x \leq 1$ and decreases in height from 2 to 0 for $1 \leq x < 2$.

For our purposes, $\delta(x - x_0)$ is located at $x = x_0$, and the intensity of the impulse is determined by the value $f(x)$ at $x = x_0$ and is zero everywhere else. In this example, we will let the kernel $g(x)$ represent three impulse functions separated by a period, τ:

$$g(x) = \delta(x + \tau) + \delta(x) + \delta(x - \tau).$$

As shown in Fig. 14, the convolution of the rectangular pulse, $f(x)$, with these three impulses results in a copying of $f(x)$ at the impulse points.

As with Fourier transforms, the actual mechanics of convolution can rapidly become computationally intensive for a large number of points. Fortunately, many complex procedures can be adequately performed using a variety of digital masks, as illustrated in the following section.

C. Digital Masks as Convolution Filters

For many purposes, the appropriate digital mask can be used to extract features from images. The convolution filter, acting as a selection function $g(x)$, can be

Fig. 14 Using a convolution to copy an object. (A) The function $f(x)$ is a rectangular pulse of amplitude, A, with its leading edge at $x = 0$. (B) The convolving functions $g(x)$ are three delta functions at $x = -\tau, x = 0$, and $x = +\tau$. (C) The convolution operation $f(x) * g(x)$ results in copying of the three rectangular pulses at $x = -\tau, x = 0$, and $x = +\tau$.

used to modify images in a particular fashion. Convolution filters reassign intensities by multiplying the gray value of each pixel in the image by the corresponding values in the digital mask and then summing all the values; the resultant is then assigned to the center pixel of the new image and the operation is then repeated for every pixel in the image (Fig. 15). Convolution filters can vary in size (i.e., 3×3, 5×5, 7×7, etc.), depending on the type of filter chosen and the relative weight that is required from neighboring values from the center pixel.

For example, consider a simple 3×3 convolution filter that has the form

1/9	1/9	1/9
1/9	1/9	1/9
1/9	1/9	1/9

applied to a pixel with an intensity of 128 and surrounded by other intensity values as follows:

Fig. 15 Performing convolutions using a digital mask. The convolution mask is applied to each pixel in the original image (represented by white pixels). The value assigned to the central pixel results from multiplying each element in the mask by the gray value in the corresponding image, summing the result, and assigning the value to the corresponding pixel in a new image buffer (represented by shaded pixels). The operation is repeated for every pixel, resulting in the processed image. For different operations, a scalar multiplier or offset may be needed.

123	62	97
237	128	6
19	23	124

The gray value in the processed image at that pixel therefore would have a new value of $1/9 \times (123 + 62 + 97 + 237 + 128 + 6 + 19 + 23 + 124) = 819/9 = 91$. Note that this convolution filter is simply an averaging filter identical to the operation described in Section IV (in contrast, a median filter would have returned a value of 128). A 5×5 averaging filter would simply be a mask that contains 1/25 in each pixel, whereas a 7×7 averaging filter would contain 1/49 in each pixel. Because the speed of processing decreases with the size of the digital mask, the most frequently used filters are 3×3 masks.

In practice, the values found in the digital masks tend to be integer values with a divisor that can vary depending on the desired operation. In addition, because many operations can lead to resultant values that are negative (as the values in the convolution filter can be negative), offset values are often used to prevent this from occurring. In the example of the averaging filter, the values in the kernel would be

1	1	1
1	1	1
1	1	1

with a divisor value of 9 and an offset of zero. In general, for an 8-bit image, divisors and offsets are chosen so that all processed values following the convolution fall between 0 and 255.

Understanding the nature of convolution filters is absolutely necessary when using the microscope as a quantitative tool. User-defined convolution filters can be used to extract information specific for a particular application. When beginning to use these filters it is important to have a set of standards to which the filters can be applied in order to see whether the desired effect has been achieved. In general, the best test objects for convolution filters are simple geometric objects such as squares, grids, isosceles and equilateral triangles, circles, and so forth. Many commercially available graphics packages provide such test objects in a variety of graphics formats. Examples of some widely used convolution masks are given in the following sections.

1. Detection of a Point in a Uniform Field

Assume that an image consists of a series of grains on a constant background (e.g., a darkfield image of a cellular autoradiogram). The following 3×3 mask is designed to detect these points:

−1	−1	−1
−1	+8	−1
−1	−1	−1

When the mask encounters a uniform background, then the gray values in the processed center pixel will be zero. If, however, a value above the constant background is encountered, then its value will be amplified above that background and a high contrast image will result.

2. Detection of a Line in a Uniform Field

Similar to the point mask in the previous example, a number of line masks can be used to detect sharp, orthogonal edges in an image. These line masks can be used alone or in tandem to detect horizontal, vertical, or diagonal edges in an image. Horizontal and vertical line masks are represented as

−1	−1	−1
+2	+2	+2
−1	−1	−1

and

−1	+2	−1
−1	+2	−1
−1	+2	−1

whereas, diagonal line masks are given as

−1	−1	+2
−1	+2	−1
+2	−1	−1

and

+2	−1	−1
−1	+2	−1
−1	−1	+2

In any line mask, the direction of nonpositive values used reflects the direction of the line detected. When choosing the type of line mask to be used, the user must *a priori* know the directions of the edges to be enhanced.

3. Edge-Detection Computing Gradients

Of course, lines and points are seldom encountered in nature, and another method for detecting edges would be desirable. By far, the most useful edge

detection procedure is one that picks up any inflection point in intensity. This is best achieved by using gradient operators that take the first derivative of light intensity in both the x- and y-directions. One type of gradient convolution filter that is often used is a Sobel filter. An example of a Sobel filter that calculates horizontal edges is the Sobel North filter, expressed as the following 3 × 3 kernel:

+1	+2	+1
0	0	0
−1	−2	−1

This filter is generally not used alone, but is instead used along with the Sobel East filter, which is used to detect vertical edges in an image. The 3 × 3 kernel for this filter is

−1	0	+1
−2	0	+2
−1	0	+1

These two Sobel filters can be used to calculate both the angle of edges in an image and the relative steepness of intensity (i.e., the derivative of intensity with respect to position) of that image. The so-called Sobel Angle filter returns the arctangent of the ratio of the resultant Sobel North–filtered pixel value to the Sobel East–filtered pixel value, whereas the Sobel Magnitude filter calculates a resultant value from the square root of the sum of the squares of the Sobel North and Sobel East values.

In addition to Sobel filters, a number of different gradient filters can be used (specifically Prewitt or Roberts gradient filters) depending on the specific application. Figure 16 shows the design and outlines of the basic properties of these filters.

4. Laplacian Filters

Laplacian operators calculate the second derivative of intensity with respect to position and are useful for determining whether a pixel is on the dark side or light side of an edge. Specifically, the Laplace-4 convolution filter, given as

0	−1	0
−1	+4	−1
0	−1	0

Name	Kernels		Uses
Gradient	$\begin{array}{ccc} -1 & +1 & +1 \\ -1 & -2 & +1 \\ -1 & +1 & +1 \end{array}$		Detects the vertical edges of objects in an image.
Sobel	$\begin{array}{ccc} +1 & +2 & +1 \\ 0 & 0 & 0 \\ -1 & -2 & -1 \end{array}$ **North**	$\begin{array}{ccc} -1 & 0 & +1 \\ -2 & 0 & +2 \\ -1 & 0 & +1 \end{array}$ **East**	North detects horizontal edges; East detects vertical edges. North and East used to calculate Sobel Angle and Sobel Magnitude (see test). Filter Should not be used independently. If horizontal or vertical detection desired, use Prewitt.
Prewitt	$\begin{array}{ccc} +1 & +1 & +1 \\ 0 & 0 & 0 \\ -1 & -1 & -1 \end{array}$ **North**	$\begin{array}{ccc} -1 & 0 & +1 \\ -1 & 0 & +1 \\ -1 & 0 & +1 \end{array}$ **East**	North detects horizontal edges; East detects vertical edges.
Roberts	$\begin{array}{cc} 0 & 1 \\ -1 & 0 \end{array}$ **North East**	$\begin{array}{cc} 1 & 0 \\ 0 & -1 \end{array}$ **North West**	North East detects diagonal edges from top-left to bottom-right; North west detects diagonal edges from top-right to bottom-left.

Fig. 16 Different 3×3 gradient filters used in imaging. Shown are four different gradient operators and their common uses in microscopy and imaging.

detects the light and dark sides of an edge in an image. Because of its sensitivity to noise, this convolution mask is seldom used by itself as an edge detector. To keep all values of the processed image within 8 bits and positive, a divisor of 8 and an offset value of 128 are often employed.

The point detection filter shown earlier is also a kind of Laplace filter (known as the Laplace-8 filter). This filter uses a divisor value of 16 and an offset value of 128. Unlike the Laplace-4 filter, which only enhances edges, the Laplace-8 filter enhances edges and other features of the object.

VII. Conclusions

Judicious choice of image-processing routines can greatly enhance an image and can extract features that are not otherwise possible. When applying digital manipulations to an image, it is imperative to understand the routines that are being employed and to make use of well-designed standards when testing them out. With the advent of high-speed digital detectors and computers, near real-time processing involving moderately complicated routines is now possible.

References

Andrews, H. C., and Hunt, B. R. (1977). "Digital Image Restoration." Prentice-Hall, Englewood Cliffs, N. J.

Bates, R. H. T., and McDonnell, M. J. (1986). "Image Restoration and Construction." Oxford University Press, New York.

Cardullo, R. A. (1999). Electronic and computer image enhancement in light microscopy. *In* "Encyclopedia of Life Sciences," Macmillan Press, New York.

Castleman, K. R. (1979). "Digital Image Processing." Prentice-Hall, Englewood Cliffs, NJ.

Chellappa, R., and Sawchuck, A. A. (1985). "Digital Image Processing and Analysis." IEEE Press, New York.

Erasmus, S. J. (1982). Reduction of noise in a TV rate electron microscope image by digital filtering. *J. Microsc.* **127,** 29–37.

Gonzalez, R. C., and Wintz, P. (1987). "Digital Image Processing." Addison-Wesley, Reading, MA.

Green, W. B. (1989). "Digital Image Processing: A Systems Approach." Van Nostrand Reinhold, New York.

Inoué, S. (1986). "Video Microscopy." Plenum, New York.

Inoué, S., and Spring, K. R. (1986). "Video Microscopy." 2nd Ed. Plenum, New York.

Jahne, B. (1991). "Digital Image Processing." Springer-Verlag, New York.

Pratt, W. K. (1978). "Digital Image Processing." Wiley, New York.

Russ, J. C. (1990). "Computer-Assisted Microscopy. The Measurement and Analysis of Images." Plenum, New York.

Russ, J. C. (1994). "The Image Processing Handbook." CRC Press, Ann Arbor, MI.

Shotton, D. (1993). "Electronic Light Microscopy: Techniques in Modern Biomedical Microscopy." Wiley-Liss, New York.

CHAPTER 12

Techniques for Optimizing Microscopy and Analysis through Digital Image Processing

Ted Inoué and Neal Gliksman

Universal Imaging Corporation
West Chester, Pennsylvania 19380

I. Fundamentals of Biological Image Processing

A. Introduction

 The goal of this chapter is to become familiar with the fundamentals of video microscopy and digital image processing to make best use of the powerful computerized techniques now available. The use of digital image processors has greatly enhanced the utility of the optical microscope, permitting entire fields of study that were impossible until just a few years ago. By the end of this chapter,

Table I
Components of a Typical Video Imaging System

Microscope components	Camera components	Imaging system	Other items
Microscope stand	Camera body	Computer	Video printer
Fluorescence illuminator	Image intensifier	Computer monitor	Video cassette recorder
Filter wheel	Camera controller	Camera digitizer	Laser printer
Light path shutters		Video display monitor	
Automated focus control			
Automated stage control			

you will be exposed to the structure of a digital imaging microscope as well as to some of the fundamental techniques that will improve the quantitative as well as qualitative aspects of the using light microscopy. Finally, we will show examples of how and when to apply digital imaging so as to extract the most useful information from one's samples.

It was only 15 years ago that microscopy was a relatively "simple" art—one selected the optics and microscope stand one wanted from a relatively limited group of suppliers and then ordered the appropriate 35-mm camera. Once the system was set up, anybody could come in, install their film, set up the sample, and press a button to take a picture. The camera would then snap a picture of roughly the correct exposure, and all that was left was to get the film processed.

Today, the typical research microscopy set-up often requires a trained technician just to turn on the power and display an image. Consider Table I, an abbreviated list of components used in a video imaging system used for fluorescence microscopy, many of which must be powered up in the right sequence to avoid damage.

With this many components, it is no wonder that most users find video microscopy systems to be very intimidating. The complexity has risen to such a degree that many users avoid such systems entirely, using simpler technologies that may be easier to use, but less optimal for the application.

Those who brave the complexities of video microscopy and thoroughly learn the fundamentals of the technology are acquiring amazing data that they could not gather using previous technologies. An example of one such application is four-dimensional imaging. In four-dimensional imaging, the user rapidly acquires a set of images of a specimen taken at different focal planes. This is then repeated over time. The resulting image data set contains a representation of the three-dimensional structure of the specimen as it changes in time.

This chapter discusses the major components of the typical video microscopy system so that you are able to properly configure and use its features.

B. Conventional Microscopy versus Digital Video Microscopy

Given the complexity and expense of the digital video microscopy system, what are the compelling benefits to the researcher? What are the advantages of digital video microscopy?

Table II
Considerations in the Use of a Conventional Light Microscope for Fluorescent Samples

Interaction with a microscope	Considerations
Look through the eyepieces at a specimen	Peering through eyepieces may produce eyestrain.
	Eyes are not extremely sensitive at low light levels.
	Eyes are not extremely sensitive to all wavelengths.
	Eyes are not extremely sensitive to seeing objects moving at high speeds.
Focus the microscope	Manual focus is difficult to set reproducibly.
	The focus may be different depending on viewer.
Move the stage	It may be difficult to relocate a sample if the stage is moved.
Select a filter set for fluorescence observation	The user must figure out how to change filters.
	Manual handling of filters makes them susceptible to dust and fingerprints.
Take a photograph with a standard camera	Film lacks sensitivity to record fast events at low light levels.
	Quantitative capabilities of film are limited by nonlinear response.
	Long exposures can lead to photodamage of specimen.
	The color balance and contrast of film is highly dependent on processing conditions.
	Film requires processing and printing.
	Pictures must be physically archived and protected.

Consider the common steps in using a microscope to collect fluorescence images. Table II lists a sampling of these steps and some considerations relating to each.

Given these considerations, it should be possible to make microscopy easier for the user. Digital video microscopy provides a solution for many of these considerations, making microscopy far more enjoyable and quantitative.

Starting with the microscope, how does a digital video microscopy system differ from a system designed for conventional visual light microscopy and photography? Overall, the digital video microscope, driven with the proper computer and software, is faster, more precise, and more sensitive than conventional, noncomputerized methods. The computerized system can automate many of the basic tasks of an experiment including changing filters, opening and closing shutters, changing the focus, and moving the stage reproducibly.

Video microscopy systems do not come without a cost. The initial investment is far greater—in both price and time to learn. It can take months to understand the methods and terminology required to use a video microscope system effectively. However, once the investment has been made, the rewards can be tremendous.

C. Pixels and Voxels and How They Represent Images

1. How Do Images Get into a Video Microscope System?

In a video microscope system, a camera takes the place of your eyes as the light detector. On many microscopes there is a slider that is pulled out, or the head of

Fig. 1 Raster scanning of an image.

the microscope is rotated and the light that would have been sent to the eyepieces is sent to a camera port where a camera is attached.

There are two types of cameras used for video microscopy and image processing. The two types, analog and digital, are both discussed in Chapter 6 of this volume.

A digital camera scans the image and generates a numerical output representing the image. The numerical data are then sent to the image processor. The manner in which the image is scanned and the way in which the numerical data are transferred to the image processor is left intentionally vague, as there are several ways in which this procedure occurs.

Video cameras are the most common form of analog cameras used in biomedical science. Nevertheless, some confocal scanning microscopes use an analog detector that could be considered an analog camera for the sake of this discussion. In the analog system, the image is scanned from left to right and top to bottom in a pattern known as a raster scan, as shown in Fig. 1. The scan is shown as a solid arrow facing toward the right. After the device has scanned each line, the scan position returns to the left side of the next line. This continues until the entire image has been scanned.

As the video camera or confocal laser is scanned, a camera/detector detects the brightness at the spot being scanned and sends this as a voltage to the image processor. The image processor will convert this voltage into a numeric value representing the brightness and work with it digitally (discussed later). After the image has been converted into a digital form, the image from a video camera or a digital camera can be treated identically, and all subsequent discussions apply to both.

2. Pixel and Voxel Defined

Once an image from either a digital or analog camera has been received by the image processor and converted into a digital form (in the case of analog cameras),

Fig. 2 A digital image showing individual pixels.

the images are fundamentally broken down into a finite grid of spots called "pixels," as shown in Fig. 2.

The pixel and the voxel are the smallest units that compose an image or a volume (a three-dimensional image). Just as an integer can only represent specific numbers within a range (for example, 2.5, 3.756, and 7.23 are not integers), a pixel and a voxel represent the sampled object at a specific location in space. Every pixel in an image has a unique X and Y coordinate and is assumed to have the same Z coordinate. Each voxel has X, Y, and Z coordinates. For historical reasons, pixels in an image are usually measured from the upper-left corner of the image, starting with position 0,0. Likewise, voxels are measured as a distance away from the viewer, with the upper-left corner in the top plane defining the origin: position 0,0,0. Figure 3 shows samples of a single plane and a volume, each with the associated coordinate system.

A digital image is somewhat analogous to a black-and-white photograph. Every tiny spot in a photograph is made up of a silver grain. Each silver grain in a photograph could be represented by a location and a value (the brightness of that grain). Likewise, each pixel has its own location and a value—its gray value. Typically, a pixel's value is an 8- or 16-bit number that the computer can use to represent 256 or 65,536 distinct brightness levels. Pixels in color digital images typically have a red, green, and blue value. Color images will not be discussed in this chapter.

Fig. 3 (A) A sample pixel grid showing the location of the origin and the direction of increasing pixel *X* and *Y* coordinates. Corner pixel coordinates are shown. (B) A stack of images showing voxels and the associated pixels.

3. Sampling of Images and Volumes

Pixels and voxels are evenly distributed throughout the image or throughout the volume; each is sampled at specific locations, as shown in Fig. 3. Because a pixel has a distinct size, you can think of the pixel value as the average of the values within the area covered by that pixel. A similar analogy is true for a voxel and the volume encompassed by the voxel. This concept critically effects the interpretation of a digital image.

Pixels and voxels are not infinitely small. This can cause artifacts when dealing with images of small objects. Suppose the imaging system is being used to look at a white line on a black background. The sampled image might have the values for black (usually 0) in the background and white (usually 255) in the foreground. This will not always be true. Figure 4 shows a portion of a greatly magnified image with the white line on a black background. The marks below the diagram show the positions of the pixels. The white line is straddling two columns of pixels. Because of the way that the image processor broke the image down into pixels, two pixels cover half background and half white line and the digitized image contains the values 0 and 128 instead of the expected values of 0 and 255. In addition, note that the single line in the real sample, which is only a single pixel wide, appears in the digitized image as a two-pixel-wide line (the right panel of Fig. 4). Depending on the exact alignment of the image with the way the digitizer breaks down the pixels, the resulting image could have pixel values anywhere from 0 to 255.

This artifact is minimized in most video digitizing systems by a filter in the digitizer that reduces its resolution. The filter causes all single-pixel-wide lines, regardless of alignment, to blur across multiple pixels and, hence, to reduce in intensity. This is not true of direct digital change-coupled device (CCD) cameras,

Fig. 4 (A) Expanded view of the original image (nondigitized) consisting of a single-pixel-wide white line on a black background. The thin lines represent the boundaries between pixels being sampled by the digitizer. (B) Expanded view of the digitized sample image in the image processor.

which contain no such filter and will manifest the artifact if image details are on the scale of single pixels.

4. Tips for Visualizing Small Objects

Table III lists some tips for using digital imaging in regard to the size of the objects being represented versus the size of a pixel.

Imagine what would happen in the previous example if the line's width increased relative to the size of the pixels. If the line being imaged crossed a path 10 pixels wide, then the digital representation of the line would be more accurate; the interior pixels would be white and only the edge pixels would have a value that is some fraction of white depending on how much of each pixel was covered by the line. As noted in Table III, the user's first recourse is typically to boost the magnification of the image to the camera to provide more pixels across the finest details in the image.

II. Analog and Digital Processing in Image Processing and Analysis

A. Background

1. Analog and Digital Defined

This section discusses the relative merits of analog and digital cameras and analog and digital processing techniques. For years, the debate has raged about whether analog or digital is better, in fields from high-end audio to imaging. Now that computers are firmly entrenched in our lives, it would seem that digital is better. But is this the case? Both analog and digital cameras and analog and digital processing techniques have strengths and weaknesses.

Analog process: a process that functions over a continuum of values—analog methods represent and manipulate arbitrary values without regard to numerical precision.

Table III
Methods to Improve Results When Imaging Small Objects

Application	Side effect of imaging	Ways to improve the accuracy of results
All imaging applications	Details smaller than one pixel will be represented inaccurately—the brightness measured for such objects will be altered and fine structures lost.	Choose a magnification such that the smallest details in the image are as large as possible relative to the pixel size. Use a higher-resolution camera with smaller pixels.
Measurement of brightness	Objects or portions of objects that cover fractions of pixels will have sampled gray values that are different than those contained in the actual image. Sampled values may be lower or higher depending on the brightness of the detail relative to the areas of the image around the detail.	Do not measure objects or details that contain only a few pixels. Measure the total brightness within an area when measuring the brightness of fluorescent objects.
Measurement of size	The boundaries of objects will blur across pixels, resulting in an ambiguous determination of exactly where the boundary lies. This may result in measurements that are either too large or too small.	Characterize object boundaries at very high magnifications to determine the exact boundary shape. Use this to define how the boundary is characterized at lower magnifications.

Digital process: a process that stores or manipulates values with a finite precision and range. For example, in the case of the 8-bit pixel, gray levels may only take on integer values in the range of 0 to 255.

B. Practical Consideration

1. Comparison of Analog and Digital Devices and Processes

Table IV compares some of the advantages and disadvantages of digital and analog cameras. Table V compares some of the advantages and disadvantages of digital and analog image processing.

2. Matching a Signal's Dynamic Range to the Digitizer's Capacity

The choice between analog and digital processing can make the difference between solid data and useless images. For example, at even the most basic level of image acquisition, the appropriate choice of contrast control can make a critical difference. Figure 5 shows the voltages measured from a video signal from a line scanned through a high-contrast sample. The signal can be manipulated

Table IV
The Relative Merits of Analog and Digital Cameras in Imaging

	Analog (video) cameras	Digital cameras
Advantages	Several standard interfaces RS-170, NTSC, PAL	Potential for high-speed performance
	Relatively high speed	These cameras can acquire images at higher rates than conventional video.
	The most common temporal resolution in the U.S. is 30 frames/second at roughly 640 × 480-pixel resolution.	Higher potential resolution
		Digital cameras exist with resolutions of ~4000 × 4000 pixels, and larger arrays will be created.
	Ease of use	Image quality
	Conventional analog video cameras stream voltages out a coaxial cable. The signal is easily manipulated with analog amplifiers to change the contrast and brightness.	Images are highly immune from electrical noise interference and thus are easier to maintain digitally during transfer from the camera to an image processor.
Disadvantages	Flexibility	Expense
	Standard interfaces limit the flexibility and performance of most video cameras.	Instrumentation-grade digital cameras tend to be more expensive than conventional video cameras.
	Resolution	Ease of use
	Attributes such as vertical resolution and acquisition speed are intrinsically limited by the standard interfaces.	Digital cameras are moderately complex devices with many options. Although they may be used in a "point and click" mode, current models are intrinsically more complicated than video cameras.
	Image quality	Speed
	Video signals are subject to electrical noise and interference from sources such as fluorescent lighting.	Although images can be acquired faster than analog cameras, it often takes much longer to transfer the image into the image processor.

Table V
The Relative Merits of Analog and Digital Image Processing Techniques

	Analog signal manipulation	Digital number crunching
Advantages	Speed	Flexible
	Analog processing of signals, such as adjusting contrast, can be done at the speed of the signal transmission, limited only by the bandwidth of the electronics.	Digital systems are usually programmable, allowing the algorithms to change to suit the application.
Disadvantages	Inflexible	Speed
	Most imaging systems manipulate analog signals through hardwired circuitry.	Digital systems typically manipulate each piece of information using a single processor that serves as a bottleneck.

using only digital methods, but the part of the signal above the analog-to-digital converter's (AD) saturation level (dotted line) is lost, leading to clipping (Fig. 5B). The camera's analog contrast control can be used to reduce the voltage range of the signal so that it falls into the useable range of the AD converter (Fig. 5C), and then the image can be digitized within the useful range of gray values accepted by the imaging system (Fig. 5D).

C. Some Caveats Regarding Video Camera Controllers

Video cameras were originally intended for purely visual purposes, and many cameras include controls or circuitry that allow one to "enhance" the image in ways that make it unsuitable for subsequent quantitation. Table VI lists some of these controls and how they operate. These options should be disabled in all cases in which you may wish to measure the brightness within the image.

As is shown by the previous examples, it is important to know how images are processed as they flow from the camera and through the imaging system. Making adjustments to the digital image when it would be more appropriate to modify it in analog form can lead to poor or incorrect results. The next section covers more of the organization of the image processor, further clarifying the types of processes that should be done while an image is in an analog or digital form.

Fig. 5 (A) Line scan through an image having a dynamic range greater than that of the AD converter. (B) Line scan of the digitized image showing clipping caused by AD saturation. (C) Video signal after analog signal reduction to bring signal within dynamic range of the AD converter. (D) The digitized line scan of the reduced video signal now fits within normal 8-bit digitizer range.

Table VI
Camera Controls That Alter Gray Scale Response

Control name	Effect on video data (desired setting)
Gamma	Makes the camera's grayscale response nonlinear. Gamma should be set to 1.0 for any brightness measurements.
Auto gain	Alters the camera's gain and black level based on the brightness of the image.
Auto black	This feature should be disabled for virtually any use of the camera with an image processor.
Shading correction	Alters the response of the camera in different parts of the image. This feature should be disabled or set to a flat response for quantitation.
Intensifier protection	Reduces the light amplification of the intensifier when presented with bright objects. The protection can take effect too early, modifying the data. If possible, this feature should be disabled while making measurements.[a]

[a]Care must be taken not to overilluminate and damage the image intensifier after the circuits have been disabled.

III. Under the Hood—How an Image Processor Works

The key to video microscopy is the image processor. An image processor is a conceptually simple device that takes in images, converts them into numbers, manipulates and stores the numbers, and converts those altered numbers back into video format for display.

The purpose of this section is to provide a working understanding of digital image-processing hardware. It details each component of the image processor and provides information to guide you through determining the best solution for your imaging needs.

Many questions arise when discussing the details of image processors: How does the computer convert a video signal into numbers? How does it manipulate images? What features do you need? This section begins with the video signal coming from a video camera. The details would be almost identical for a digital camera except that the image processor would not contain an AD converter.

A. The Components of a Digital Image Processor

Figure 6 shows a simplified diagram of a typical video image processor. This type of image processor is also called a pipeline image processor because the image flows through the system as if it were in a pipeline. The left side of the figure shows where the video image is dealt with in the analog domain, whereas the right side shows those portions that manipulate the image digitally.

1. The Analog-to-Digital Converter—Getting the Video Signal into the Computer

How does the output from a video camera—a time-variant voltage signal representing the image—get into an image processor as a digital image?

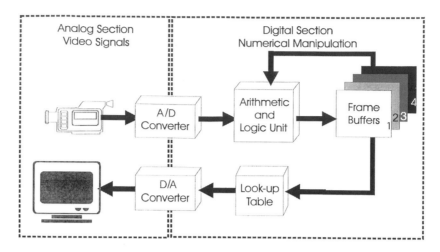

Fig. 6 Video image-processor components and the data path.

The image processor contains a device called an analog-to-digital converter (AD converter), which assigns a numerical value to each voltage level within a given range. (In video, it is most common to have an 8-bit AD converter providing 256 values over a range of 0 to 0.7 volts.) The video signal comes in on a row-by-row basis (see Fig. 1 for a description of the pattern). The AD converter samples the video signal at a set frequency that results in the desired number of samples (pixels) per row of the image. If you were to sample at high frequencies, you would obtain more pixels per row of the image, which would result in higher resolution horizontally. Many manufacturers use AD converters that will produce images with a 640 × 480 resolution. It also happens that an image with 640 columns and 480 lines results in pixels that can be considered square. Once the AD has converted the video signal into numbers, the data pass into another device called an arithmetic and logic unit (ALU).

2. The Arithmetic and Logic Unit—Processing Images at Video Rate

As noted previously, the speed at which a video camera generates images is called the video rate. In the United States and other countries that have adopted a 60-Hertz powerline frequency, video rate is approximately 30 images/second. In other countries that have adopted a 50-Hertz powerline frequency, video rate is 25 images/second. For a typical 640 × 480-pixel resolution image containing 307,200 pixels, this translates to 9,216,000 pixel/second passing through the image processor.

Even with today's fast computers, 9 million pixels is quite a few to process every second. In addition, the computer may experience bottlenecks that slow down the rate at which it can access and process pixels held in the image processor. For this

reason, many modern, video rate image processors use specialized circuitry that is designed specifically for processing video images in real-time (video rate).

ALUs can often perform a number of other operations on and between images. When this occurs, the ALU is a pipeline component—it combines one pixel from each source image to compute a result. Typical computations of an ALU include addition, subtraction, Logical OR, AND, and XOR. Most ALUs also have the capability to multiply or divide an image by a constant.

Many ALUs have two inputs so that the imaging system can combine the newly digitized video image with a stored image. One example of a stored image that is discussed later is the background reference image that is used to correct for background noise.

3. Frame Buffers—Holding the Images for Processing and Display

A frame buffer is memory within the image processor used to store one or more images that have been acquired, processed, or are awaiting subsequent display. Some image-processing systems do not use frame buffers. Image processors without frame buffers grab images from the video camera and store them in the memory built into the computers that control them. However, most of the higher-speed image processors have their own frame buffers built into the image-processing hardware because access to the computer's memory can be much slower than access to a frame buffer.

In addition to access speed, there are other differences between frame buffer memory and the memory in a computer because the demands placed on it are different. For example, in the typical background subtraction application, background reference images must be read from one frame buffer at the same time as result images are written into another frame buffer. In addition, if images are being averaged, there may be other frame buffers being read and written simultaneously. This type of memory is often referred to as multiport memory because of this unique capability.

4. Look-Up Tables—Converting Image Data On-the-Fly

After processing and storage, the digitized image usually passes through a look-up table (LUT). An LUT is simply a table of values, one per gray level in the image, that converts an image value to some other value. LUTs are particularly useful for rapidly modifying the contrast of the image while you view it on the monitor. Table VII demonstrates the use of a LUT to "stretch" the image contrast by a factor of two.

Why are LUTs used? Why not just modify the brightness values of pixels using the computer? Imagine a typical image with dimensions of 640 × 480 pixels and 256 gray levels. The image is composed of over a quarter of a million pixels. If the computer had to manually change pixel values as demonstrated in Table VII, it would require over a quarter of a million multiplications. Because there are only

Table VII
Example of a Look-Up Table Used to
Double the Image Contrast

Image gray value	Table output value
0	0
1	2
2	4
3	6

256 starting gray levels, the computer could calculate the 256 multiplications to fill an LUT. The image processor could then reference the LUT for each pixel value (a fast operation) instead of doing a multiplication (a much slower operation).

LUTs are even more important when performing more complex operations on the pixel intensities. The calculations could be quite complicated, and they could easily reach a point at which the computer could no longer compute the resultant image in a reasonable amount of time if it had to compute values for every pixel. Using a LUT, the computer only performs the computation 256 times, allowing the image processor to apply even the most complex functions as fast as the camera could generate images.

5. The Digital-to-Analog Converter—Displaying the Image Data on a Monitor

The converted values which pass out of the LUT usually enter the digital-to-analog converter (DA converter). This device accepts numerical values and converts them into an analog video signal. The signal can be used by a video monitor to show the resultant image or by a VCR to record the resultant image.

An item that has been omitted from the above diagram is the computer. Often, personal computers control image processors, instructing them to change the function in the ALU, change the LUT, or change data in the frame buffers. For this discussion, you should imagine that the computer is connected to all parts of the digital image processor.

B. Putting the Pieces Together—How Does an Image Processor Work?

1. Introduction

The previous section described the hardware components in a typical image processor. This section covers how the image-processing software puts these components together to perform certain common imaging applications. This chapter addresses the fundamental operations that will handle most of your imaging needs. In addition, the section also covers some less commonly used operations that may be very useful.

2. Contrast Enhancement

Contrast enhancement is perhaps the most common application of image processing in microscopy. Inoué (1981) reported, "The new combination provides clear images with outstanding contrast, resolution, diffraction image quality, and sensitivity." These remarkable results were made possible by a simple box that allowed a high level of contrast manipulation combined with optimal usage of the light microscope.

Contrast enhancement allows you to use the light microscope at the limits of its theoretical performance. Conventionally, microscopists were taught to close the condenser diaphragm to increase image contrast. Unfortunately, closing the condenser diaphragm reduces the resolution of the microscope considerably, making expensive 1.4-NA (numerical aperature) oil objectives perform no better than 0.75-NA objectives. Contrast enhancement allows the microscopist to use the microscope with its condenser diaphragm open so that the microscope has the highest image resolution and thinnest optical section. Clearly, the combination of appropriate microscope adjustments and the effective use of contrast enhancement can be critical to your imaging success.

a. What Is Contrast?

Contrast is the relative difference in brightness of two patches of light. Perceptually, the human visual system compares light intensities in a multiplicative manner—two patches of light, one twice as bright as the other, are perceived as the same contrast regardless of the absolute brightness of the light. Mathematically, this implies that your eyes will perceive increased contrast in an image simply by subtracting a value from it. An example of this is shown in Table VIII. Note how in each example, the second brightness is 50 units less bright than the first. Regardless, the contrast value, defined as the ratio of the two brightnesses, changes dramatically.

b. Computing Values to Enhance Contrast

Contrast can often be improved by multiplying an image by a value greater than 1, then subtracting off a value so that the image does not saturate. Both the multiplication and the subtraction are necessary to improve contrast. If you

Table VIII

Contrast Values for Samples with the Same Absolute Brightness Difference

First brightness	Second brightness	Contrast value
200	150	1.5
100	50	2
75	25	3
51	1	51

multiply the entire image by a value, then the relative brightness remains the same. In addition, if you multiplied by a value greater than 1, you may have increased the pixel values beyond the limited dynamic range of the system and the image will be saturated at the maximum value. Table IX shows an example of how this mathematical procedure could be used by multiplying pixel intensities by 5 and subtracting 100 from the results. Figure 7 shows the results of this operation.

c. How the Image Processor Modifies Contrast

Enhancing contrast with an image processor typically involves using a LUT assigned to the display. All of the data from the frame buffers goes through these LUTs at video rate before being displayed. The advantage of using a LUT for enhancing contrast is that it is fast and it is nondestructive. That is, it does not alter the image data stored in the frame buffers.

The image processor uses the LUT to modify the image contrast as shown in Table IX. The program computes the values for each grayscale element (the numbers 0 through 255) and places those values in the LUT. When the data come through the image-processing pipeline, the value from the image enters the LUT and the converted value comes out of the LUT. The result is an image displayed on the screen that has a modified contrast.

LUTs can be very useful for a variety of contrast manipulations. For example, to reverse the contrast of an image, the LUT would contain the values from white-to-black (255 to 0), instead of black-to-white (0 to 255). Overall, LUTs are easy to

Table IX
Enhanced Contrast Values

Original values	Enhanced values (n. 5–500)
100	0
110	50
120	100
130	150
140	200
150	250

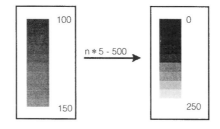

Fig. 7 Gray scale before and after contrast enhancement.

program, operate in real-time, and can perform arbitrary transformations on image data.

3. Image Subtraction

Image subtraction serves a number of purposes in image processing and analysis. These uses range from enhancing images by removing noise from stray light (increasing the accuracy of quantitative brightness measurements), showing the movement of objects within the images over time, and showing the growth or shortening of objects within the images over time (Fig. 8).

a. How Does an Image Processor Subtract a Background Reference Image?

Subtraction of a background reference image from a video image can be used to remove shading and increase the detection of fine structures. Initially, a background reference image is acquired, digitized by the AD converter, and stored in a frame buffer. The live video image is taken in through the AD converter and sent to the ALU at the same time that the frame buffer sends the reference image to the ALU. The ALU "sees" the image as a series of numbers and subtracts the reference image from the live video image. The image processor then stores the result in another frame buffer and or sends it through an LUT to enhance the image contrast. Finally, the DA converter would change the numerical data back into a video image for display on a monitor or recording by a VCR.

In this example, note that two frame buffers are used—one containing the background or reference image and a second for storing the resultant image. The ALU subtracts the background image from the live video, pixel by pixel, and

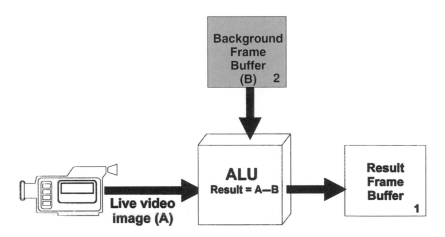

Fig. 8 Flow of data through a pipeline processor configured for background subtraction.

stores the subtracted pixels in the resultant frame buffer at the appropriate location.

b. Enhancing Motion with Subtraction

Image subtraction is an extremely sensitive motion detector that can greatly assist you in determining the presence or absence of any sort of change in a sample. Suppose that you are observing a very complex sample that contains very subtle motion—for example, a single cell moving from one area to another.

Figure 9 shows an image that has been modified to demonstrate what you might see in an image that changes. In this example, one blood cell has moved in the interval from time $t = 1$ to time $t = 2$. Without further processing, it would be very difficult to determine which cell has moved and by how much. However, subtracting the image at $t = 2$ from the image taken at $t = 1$ reveals movement in one cell very clearly (third panel).

4. Image Averaging

Image averaging is used to reduce or eliminate random noise from the image. Random noise has no pattern in the image and is usually caused by photon statistics or noisy electronics. A pixel affected by random noise may be greater in intensity than the actual specimen; however, that same pixel is not likely to be affected by the noise in many other images. Averaging image frames should not affect the image of the specimen; however, averaging should reduce the intensity of a pixel that has been affected by random noise. Averaging more frames should reduce the random noise even further, until it is so minuscule it cannot be distinguished from the specimen.

There are situations in which averaging more image frames can hurt the image. Averaging more image frames exposes the sample to more light and can result in increased photobleaching or phototoxicity. Averaging more image frames can cause the image to blur if the sample is moving or has movement in it. The proper amount of image averaging should be a function of the amount of random noise present, the light stability of the sample, and the motility of the sample.

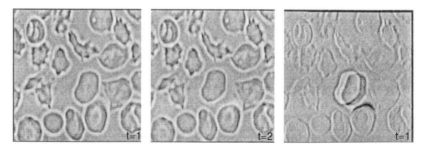

Fig. 9 Sample of images changing over time. Third panel represents subtraction of the previous two images with an offset of 128.

5. Image Integration

Image integration is used when the signal from the sample is extremely weak and close to the level of background noise. This situation often occurs with low-light-level fluorescence or luminescence microscopy. The image is integrated by leaving the shutter open for a longer period of time on the camera so that more photons can accumulate. As with image averaging, as the camera collects more photons, the signal from the sample builds up faster than the random noise in the camera detector, and the signal-to-noise ratio increases.

This technique is more powerful than image averaging. For example, if the sample gives off a photon every 0.1 second and electronic noise within the camera detector is the equivalent of several photons per 0.1 second, the signal from the sample will never be seen even with image averaging if the acquisition time per frame is 0.1 second or less (remember the standard video frame rate in the U.S. is every 0.033 second). If the image is integrated on the camera for several seconds, the camera will record a signal from the sample. There will be a background signal, but because the background is random, it will be less than the signal from the sample.

Image integration is limited by several factors. First is the dynamic range of the camera. The image should not be integrated beyond the point that it saturates the camera. This is a function of the design of the camera detector and the dynamic range. Some cameras accept 8 bits of data—up to 256 gray levels. Other, more expensive, cameras can acquire up to 14 bits of data—16,384 gray levels. Still others can collect further—up to 16 bits of data.

Another consideration for integrating images is time. The longer you integrate an image the more light your sample will be exposed to. This may cause photobleaching or phototoxicity. Longer times will blur any objects in motion just as image averaging would. These considerations should be kept in mind when using this feature.

6. Enhancing Details

Fine details within an image are usually low in contrast and are easily obscured by out-of-focus features or low-frequency noise. A variety of techniques have been developed to enhance the details of an image. Often the goal of enhancing details is to increase the contrast of your details of interest or to reduce the contrast of everything but your details of interest. All of these techniques change pixel brightness depending on the brightness of the surrounding pixels, so care must be used in quantitating intensity information after using these techniques.

One of the most common enhancements is the removal of low-frequency information from an image. In this technique the image is treated as a two-dimensional signal. Brighter pixels are higher signals and darker pixels are lower signals. Fine details in an image would appear as high-spatial-frequency information. Out-of-focus features and shading in the optical system all contribute to lowspatial-frequency information—changes are much more gradual.

Two common techniques for this operation are the fast Fourier transform and the unsharp mask. In general the unsharp mask may require less computation than the fast Fourier transform, but it has problems dealing with the edge of an image. An example of the unsharp masking technique is shown in Fig. 10B.

Another particular type of enhancement is edge enhancement. Edges of objects are usually seen as a pattern of increasing or decreasing brightness within the image. If you are interested in size, shape, or other morphometric information, the edges of objects can be the most important part of the image. Several algorithms have been developed to enhance edges by making the brightness of a pixel a function of its immediate neighbors. This type of methodology is called a convolution and can be executed fairly rapidly by the ALU. An example of the Prewitt edge-detection technique is shown in Fig. 10A.

IV. Acquiring and Analyzing Images—Photography Goes Digital

A. Introduction

The first sections of this chapter covered the principles behind the operation of the digital image processor. This section provides an overview of some techniques and considerations when analyzing images.

B. How Well Does an Image Represent Reality?

How does the image captured by the image processor compare with physical reality? To answer this question, we must start at the light source and examine how the light interacts with the specimen, the microscope optics, the camera, and finally, the image processor.

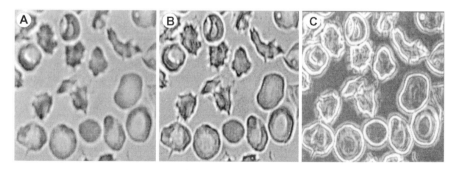

Fig. 10 A sample of detail enhancement. (A) A very detailed image of red blood cells. Many fine details are obscured. (B) Image after unsharp masking using a low-pass filter kernel size of 4 × 4 and scaling factor of 0.75 to decrease the intensity of the low pass image. (C) Image after Prewitt edge detection algorithm. Cell edges and some edges internal to the cells are enhanced.

Ideally, you would like a method to directly extract the desired numerical data from a specimen. For example, if you wanted to measure the calcium in a cell, you would like to be able to directly probe the cell or, better yet, somehow produce an image that directly shows the calcium levels. Unfortunately, under most circumstances, such direct measurements are too invasive, too difficult to make, or simply not possible.

Suppose some optical characteristic of the sample correlated with a parameter that you wished to measure. For example, if the amount of dye uptake per unit volume of a cell correlated with the desired parameter. You should be able to measure the optical density or fluorescence brightness to directly measure that parameter. Unfortunately, it is not that simple. This section covers some of the most important factors to be considered for accurately characterizing cellular parameters using optical imaging.

Returning to the above example, if we assume that the parameter of interest has an effect on the fraction of light that gets through the sample, we can mathematically work backward to calculate and characterize the parameter of interest. A common equation for dealing with parameters that affect the fraction of light that gets through a sample follows. We assume that the fraction of light is linearly proportional to the cell thickness, some parameter of interest, and a calibration factor, ω, characterizing the optical characteristics of the cell:

$$a = 1/(tp\omega),$$

where a is the fraction of light that gets through the sample (the amount of light that gets through the sample/the amount of light illuminating the sample), t is the cell thickness in microns, p is the parameter of interest, and ω is the calibration factor.

Solving for p gives

$$p = 1/(t\omega a).$$

Given this equation, image gray levels could be converted to the parameter p if the exact number of photons impinging on a spot in the sample and the corresponding number of photons coming out of that spot could be measured. Unfortunately, such direct measurements are not practical. The closest measurement is to detect the relative light intensity at a spot using a photodetector; a video camera in this case.

Why isn't the camera image a direct measure of the number of photons coming from the sample? For such measurements to be meaningful, you must understand and compensate for the factors that contribute to the image. The values measured at the camera plane represent some function of the number of photons striking and coming from the sample, the amount of stray light in the room, the transmission characteristics of the optics, the spectral and temporal response of the camera, the amplifiers in the camera and camera control box, and finally, the electronics in the image processor. Some of the most significant factors are shown in Fig. 11, where the light path to the detector (camera) is diagrammed. If you are

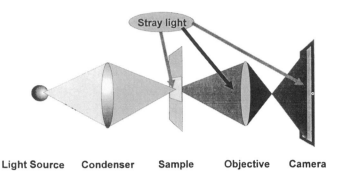

Light Source Condenser Sample Objective Camera

Fig. 11 A diagram of the light path from the source to the image detected at the camera plane.

aware of these corrupting factors, then you may be able to quantify an image in a meaningful fashion.

Table X describes many of the factors that contribute to the gray value measured by an image processor.

Most of the factors listed in Table X can be written into a formula that represents the brightness that the imaging system reports at any given spot in the image. The equation for a simple case of a light source, a sample, lenses (objective and condenser), a video camera, and a digitizer is shown here:

$$R \sim \left\{ [(IaL) + S_c]c_g + c_o + E \right\} d_g d_o,$$

where R is the resultant brightness in the acquired image, I is the intensity of light from the light source, a is the fractional transmission of the sample, L is the transmission characteristic of the lens at this wavelength, S_c is the stray light coming in to the system and making its way to the camera, c_g and c_o are camera gain and offset (black level), E is electronic noise, and d_g and d_o are digitizer gain and offset.

Because of the mix of additive and multiplicative terms in the equation, you cannot adequately characterize the imaging system with random stray light entering at various places in the optical path. Recall that this stray light may be the result of external sources (room light) and internal ones (reflections in the optical system). Problems with external sources of stray light can often be solved by blocking the light leaks or turning off the room lights.

Internal reflections are not easily compensated for in the computer and can be a significant source of error in measurements. The best solution for this problem is to track down the offending optical elements and set up light baffles or to replace the components with units with better antireflective properties.

Electronic noise can indicate a problem with your camera that the manufacturer may be able to fix. Noise can also come from your video cables and can often be reduced by using properly shielded cables. Nonrandom noise may be the result of electrical interference with other electrical equipment in the

Table X
Factors Contributing to the Gray Value Measured for an Image

Item	Description of contribution
Light source	Uniformity of illumination at the specimen is a measure of the relative number of photons that strike a given location in the specimen with another. This parameter may change over time.
Condenser and objective	Lenses absorb some light in a color-dependent manner.
	Lenses contain chromatic aberration, which causes them to shift focus depending on color.
	Lenses can only accept a certain percentage of the light coming from a light source.
	Lenses typically have some loss toward the edge of the field.
	Dust on the lenses can scatter light and cause unevenness.
Sample	The thickness of the sample may vary.
	The amount of dye taken up by a specimen may vary depending on the location within the specimen.
	The specimen has intrinsic spectral characteristics.
	The slide that carries the specimen has its own optical characteristics.
Camera	The camera's response depends on color.
	The camera's sensitivity may vary across the image.
	Gray levels measured depend on the gain and black-level settings of the camera.
	The linearity of response depends on the sensor and the electronics.
	Over long periods of time, some cameras will detect cosmic rays.
Stray light	Room light and light leaks can enter the light path.
	Internal reflections from optical components can also play a role in light transmission.
Electronic noise	Random electronic noise can occur inside the camera or during transfer of the image into the image processor.
	Nonrandom electronic noise can occur because of interference within the electrical system.

building. Try to turn various pieces of equipment off to find the culprit. Working in the evening when less electrical equipment is in use can help. Image integration or image averaging will reduce the effects of random electrical noise.

As is shown by the given equation, the raw image from the microscope and video system is a poor representation of the physical reality of the specimen. Nevertheless, with adequate precautions these factors can be eliminated or minimized.

C. Preparing the Video Image for Analysis

This section continues the analysis detailed in Section B to demonstrate how you can accurately analyze the brightness of objects in a video image.

Assuming that you have eliminated the problems of stray light and electrical noise, the previous formula characterizing the brightness reported by the imaging system can be reduced to a simpler one:

$$R \sim (IaLc_{\mathrm{g}} + c_{\mathrm{o}})d_{\mathrm{g}} + d_{\mathrm{o}}.$$

You can simplify the formula even further by adjusting the camera offset to zero. To do this, follow these instructions:

1. Set the digitizer gain and offset to neutral settings.
2. Block all light to the camera.
3. Adjust the camera offset to produce a digitizer reading of 0.

Note that the default settings for the analog offset contained in the digitizing hardware may not allow a digitizer reading of zero with a given camera. Therefore, it is often necessary to adjust both the camera and digitizer offset to achieve a digitizer reading of zero.

It is tempting to use digital image processing to compensate for the camera's offset. This can be a mistake. Recall that the digitizer has a limited dynamic range. If the camera or digitizer offset is not near zero, then the darkest black in your image will have values greater than zero. For example, if the camera and digitizer offset produce a black level with a gray value of 60 and if you are limited to 256 gray levels (8 bits), the dynamic range of the system has been reduced to only 196 gray levels.

Once the camera and digitizer offset terms have been removed, the formula is reduced further to

$$R \sim IaLc_{\mathrm{g}}d_{\mathrm{g}}.$$

The illumination intensity, the light absorption of the lens, the camera gain, and the digitizer gain can all be characterized and kept relatively constant during an experiment. This simplifies the formula even further:

$$R \sim a\beta.$$

The key is to determine β for the imaging system.

Table XI summarizes the steps necessary before measuring meaningful image brightness data using a digital image-processing system.

1. Characterizing the Optical System

Using the methodology in Table XI, it is quite simple to characterize an optical system in a manner that allows accurate video image analysis. Recall that β represents the illumination intensity, camera gain, digitizer gain, and absorption of light by lenses and does not represent the sample. It is fairly easy to calculate β for the system. First, set the camera and digitizer offsets to produce a gray value of approximately zero. Set the illumination, camera and digitizer gains, and focal plane appropriately for the sample. Move the stage to a blank section of the slide without changing any of the conditions (illumination, camera and digitizer settings, and focal plane) and collect an image. The blank section of the slide represents an image in which the fractional transmission of the sample (a) should be constant. The collected image (R) contains a value of β for every point in the

Table XI
Methods for Increasing the Accuracy of Image Brightness Measurements

Step	Method
Remove external contributions from stray light.	Turn out the room lights or shield the microscope from light.
Remove internal contributions from stray light.	Determine sources of internal reflections and insert light baffles or replace the offending component.
Reduce or eliminate electrical noise from the image.	Use well-shielded cables.
	Turn off all unnecessary electronics and move other electronics as far from your system as possible.
	If using a video camera
	Use image averaging to reduce the time-variant noise contained in the illumination system, the camera electronics, and the digitizing system. Ideally, you want to average for as long as is practical to achieve the best signal-to-noise ratio without blurring your images or causing photobleaching or phototoxicity. In practice, 32 to 64 frames of averaging works quite well.
	If using an integrating camera
	Integrate as long as possible without saturating the detector. This will reduce time variant noise as above.
Set camera and digitizer offsets to zero.	Block all light to the camera and adjust the camera offset until the digitizer produces a gray level of zero.
	It may be necessary to adjust both the camera and digitizer offsets to achieve this condition.
Minimize variations in the illumination intensity.	Use a regulated or battery-driven power supply for the light source. (Voltage fluctuations in the power lines can significantly degrade the reliability of measurements.)

image and is often referred to as the shading reference or white reference image. A more accurate term might be "optical system characterization image."

Once the β for the image has been determined, it can be used to calculate the desired value for the fractional transmission (a) of a real sample:

$$a \sim R/\beta.$$

Thus, to produce an image that contains the corrected fractional transmission of the sample at each pixel, divide the acquired image by the optical system characterization image.

2. Using Shading Correction

Figure 12 shows a dramatic example of this type of image correction used to extract a quantifiable image from a source image that is highly corrupted by shading, dirty optics, and poor camera design. Starting with the original image in the left panel, if analog enhancement is used to raise the contrast of the image, the

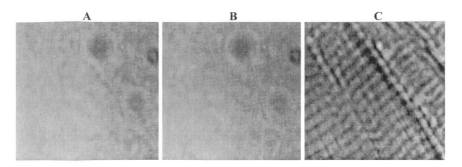

Fig. 12 (A) A very low contrast image of a thin muscle section. Virtually all image details are lost behind camera defects (repeating pattern), shading in the illuminator, and dirt on the optics. (B) Image of a blank section of the slide, used as the optical system characterization image. (C) Corrected image after digital contrast enhancement.

image brightness quickly saturates the digitizer because the dynamic range of the shading pattern is larger than that of the specimen. Although some video camera controllers include a shading compensator that can help to reduce the effects of large, uniform shading, shading compensators would not be able to remove the nonuniform shading in this image, caused by dust in the optical system. The best way to remove the effects of shading involves digital shading correction methods using an optical system characterization image. The optical system characterization image (Fig. 12B) was nearly identical to the original image containing the specimen (Fig. 12A). The resulting shading-corrected image was extremely flat (not shown). Digital contrast enhancement was then applied to increase the dynamic range of the image (Fig. 12A). Table XII contains a list of steps we suggest for collecting and correcting images before measuring image brightness information.

Figure 12 demonstrates the power of proper shading correction and image processing in increasing image accuracy. Note how clearly the muscle banding pattern appears. On first inspection, you may think that this represents a large change in the sample's brightness. However, the line scan in Fig. 13 shows the relative transmission of the sample magnified a 1000-fold. The full scale of the graph represents a tiny 2.5% variation in brightness. Small perturbations in the graph show evidence of brightness changes of less than one-half of a percentage, which is roughly one digitizer gray level at near-saturating brightness.

D. Analyzing Brightness with an Image Processor

Once the optical system has been characterized through shading correction, the brightness of various image features can be measured. Interpretation of the measurements remains the user's responsibility; nevertheless, if you follow the steps listed previously, you can state with a fair degree of certainty that an object

Table XII

Steps for Preprocessing Images before Making Image Brightness Measurements

Recommended preprocessing tips
1. Set camera and digitizer black levels to zero.
2. Set the digitizer gain and camera gain controls to default settings.
3. Examine line scan of the video signal.
4. Adjust the signal amplitude to nearly fill the full range of the digitizer, using the camera controls.
5. Use the analog controls of the digitizer to stretch the signal more if needed.
6. Collect an optical system characterization image and apply shading correction to reduce the effects of shading.
7. Adjust the contrast of the digital image to achieve optimal contrast for visualization and quantitation.

Fig. 13 Line scan showing relative transmission of the corrected image in Fig. 1. Note entire scale represents a relative contrast difference of 2.5%.

with a gray value of 100 has twice the brightness as an object with a gray value of 50. This is a fundamental requirement for a variety of applications including densitometric analysis of electrophoretic gels, quantitation of fluorescence to measure protein concentration, quantitation of luminescence from aequorin or luciferase assays, and so on.

The level of accuracy you can expect to see in your own measurements depends on a number of factors: light levels (the number of photons reaching the camera), how efficiently and accurately the camera detects that light, the electrical noise present in the digitizer and computer system, and the number of samples you can measure to improve the signal relative to random noise. Many other factors contribute to the overall accuracy of your measurements, and a thorough discussion of sampling statistics is beyond the scope of this chapter. For more information, we encourage you to refer to the other references listed for this chapter.

Reference

Inoué, S. (1981). Video image processing greatly enhances contrast, quality, and speed in polarization-based microscopy. *J. Cell Biol.* **89,** 346–356.

Bibliography

Agard, D. A., Hiraoka, Y., Shaw, P., and Sedat, J. W. (1989). Fluorescence microscopy in three dimensions. *In* "Methods in Cell Biology," vol. **30,** pp. 353–377. Academic Press, San Diego.

Allen, R. D., and Allen, N. S. (1983). Video-enhanced microscopy with a computer frame memory. *J. Microscopy* **129,** 3.

Castleman, K. R. (1979). "Digital Image Processing." Prentice Hall, New Jersey.

Gonzalez, R. C., and Wintz, P. (1987). "Digital Image Processing." 2nd ed. Addison Wesley, Reading, MA.

Inoué, S. (1986). "Video Microscopy." Plenum, New York.

Russ, J. C. (1995). "The Image Processing Handbook." 2nd ed. CRC Press, Boca Raton, FL.

CHAPTER 13

The Use and Manipulation of Digital Image Files in Light Microscopy

Edward H. Hinchcliffe

Department of Biological Sciences
University of Notre Dame
Notre Dame, Indiana 46556

I. Introduction

Digital microscopy is the generation of computer-based graphical representations of images as viewed and magnified by the microscope. Like Camera Lucida, photomicrography, and cinemicrography, graphic image files provide a permanent record of observations made in the microscope (Furness, 1997). When combined with a motorized microscope, a through-focus series can be captured, providing a three-dimensional view of the cell. Digital micrography can be used to represent single images of fixed material or to capture motion picture sequences of

living cells. The ultimate expression of the medium is the presentation of time-lapse motion picture sequences of three-dimensional reconstructions (so-called four-dimensional microscopy; see Thomas *et al.*, 1996; Salmon *et al.*, 1998). Although these types of images generate large amounts of digital information, they can be analyzed with relative ease by the current generation of computer software and hardware.

In addition to representing observational information of the cell, digital microscopy image files can also contain quantitative data, either spatial or temporal, relating to the behavior or biochemical events within cells. This is particularly powerful when using sophisticated fluorescent probes to detect and analyze individual molecules *in vivo*. Thus, the "pretty pictures" also contain computational data relating to protein concentration, enzyme kinetics, cellular dynamics, and so forth. To maximize the use of the digital microscope as a quantitative instrument, the temporal and spatial imaging information obtained must be output into a form that can be analyzed, published in journals, displayed on Web sites, and presented at meetings. Mishandling the information contained within digital image files often leads to underrepresentation of data and missed scientific opportunities. Thus, it becomes an important task to generate, manipulate, and store graphics information with as high fidelity as possible.

Unfortunately, most biologists have a limited training in computer science or graphics arts and limited time to acquire such training. Often, the use of computers for biological imaging follows an "oral" tradition based on the experiences of colleagues and collaborators. Although such an approach can propagate useful information, it can also perpetuate misconceptions leading to bad digital habits. In many settings, standard protocols for generating and storing image files—based on information from "the guy down the hall"—are developed without empirically determining which method is best. The result is that digital imaging is not optimized, when it easily could be. The following chapter will deal with image files from the standpoint of a noncomputer scientist/graphics artist. The emphasis here will be on understanding basic concepts and providing the individual biology researcher with the tools to make informed decisions about generating, manipulating, and storing graphics image files.

II. What is an Image File?

An image can be saved as a computer graphics file in one of two broad formats: vector graphics and raster graphics (also called bitmap files; Fig. 1). Vector graphics—commonly generated by drawing or plotting programs—consist of lines, curves, polygons, and other shapes that are specified mathematically to generate an image. Regions of these images are filled with gradations of gray or color (Fig. 1). The advantage of a vector representation is that it exits without a reference scale. To enlarge the image, the computer increases the dimensions of the shape(s), and the image is redrawn. Thus, regardless of final size, the outlines

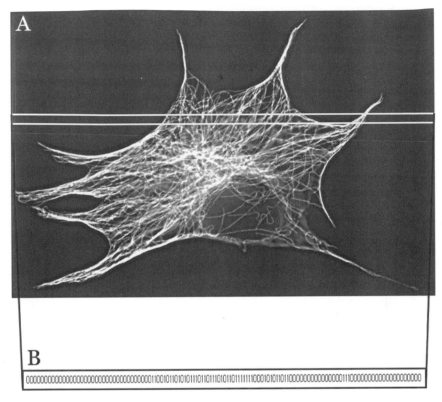

Fig. 1 The raster image. (A) A grayscale image of cytoplasmic microtubules in a Chinese Hamster Ovary (CHO) cell imaged by immunofluorescence. The white box shows how the bitmap (B) is read in a raster pattern of ones and zeros across the image. This bitmap is shown as a 1-bit image (either a zero or a one) for each position. The original 8-bit image would have 256 possible gray levels (0–255).

and discrete tones of the image remain sharp. This type of format is ideal for representing objects such as cartoons, diagrams, and logos. Text, especially enhanced text, does not lose resolution when output in different formats or resized. Resizing a vector image requires that the computer redraw the image, which uses the processor. However, because the image is not composed of a large number of discrete picture elements, the manipulation of vector graphics does not require large amounts of memory. A downside to vector-based graphics is that they are not useful for representing complex images; these types of files cannot yet accurately reproduce the subtle gradations in gray levels found in continuous-tone images (such as a photographic image).

The second major type of graphics file is called raster graphics or bitmap images. Here, the graphical information is displayed as a grid of discrete picture elements (pixels). Because the light intensity values (and color) at each point in the image are assigned to an independent pixel within the grid, bitmaps are an

excellent way to store complex, continuous tone images such as photographs. Because the file stores all the pixel information, viewing raster images does not require much in the way of calculations (i.e., processor power). However, because each pixel is controlled independently, viewing them does require large amounts of memory. When bitmap images are manipulated (i.e., image processing) the computer requires both processor power and memory. Examples of raster file formats include TIFF, PICT, JPEG, GIF, and BMP.

III. Sampling and Resolution

Converting a continuous object—like a micrograph—into a discontinuous, finite graphics image (a bitmap) involves a process called sampling, in which each point in the computer image (a pixel) is made from a sample of the original, infinitely detailed object. This sample depicts the intensity and grayscale/color of the object at each particular point.

A problem arises when there are details in the sampled image that are smaller than the spacing of the sample (pixels). Those details cannot be accurately represented in the resulting image. This is known as aliasing—elements with frequencies too high to be shown in the sampled grid (bitmap) are misrepresented as elements of lower frequency that can be displayed (see Inoué and Spring, 1997). Antialiasing is the process of eliminating the aliasing during the sampling process and is often a feature included in graphics software programs.

When referring to bitmap files, the image is said to have a certain resolution, meaning the final number of points that subdivide the raster image. This resolution is dependent on the pixel dimensions of the bitmap. This is often represented as pixels per line of printed material (usually pixels per inch, or ppi). Thus, an $8'' \times 10''$ image with a resolution of 150 ppi translates into a bitmap of 1200×1500 pixels. As the ppi increases, the size of each pixel gets smaller and vice versa. Remember that this image will initially be displayed on the computer screen. Therefore, to understand how the bitmap will look on the screen, it is useful to define monitor resolution, which is expressed as pixels per unit length of monitor (usually as dots per inch, or dpi). Most current PC monitors have a default screen resolution of 96 dpi (see Inoué and Spring, 1997, for in-depth discussion of monitor resolution).

Unlike vector graphics, raster image files have a fixed size—each pixel (of known dimensions) is mapped to a particular region of the grid. If the image size is increased, the number of pixels that make up the bitmap also has to increase. For example, an initial image with dimensions of $5'' \times 5''$ and having a resolution of 100 ppi, will have a bitmap that is 500×500 pixels. If this image is increased in size to $10'' \times 10''$, the bitmap is now 1000×1000 pixels. If the image size is decreased, the bitmap must also shrink, and the number of pixels decreases. The change of size in a bitmap image changes how the original image is sampled and, thus, is known as resampling the image (Fig. 2). Changing the resolution or ppi of

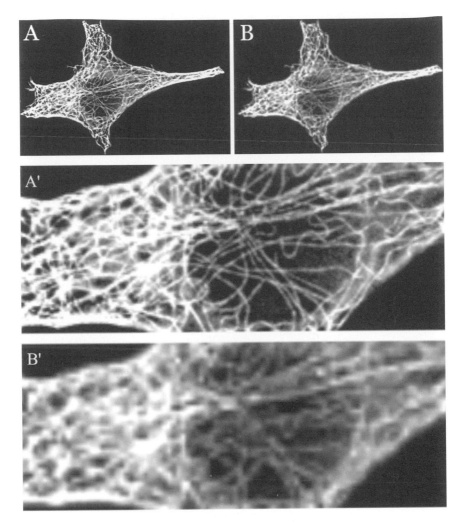

Fig. 2 Resampling and interpolation. (A) Original image of a CHO cell stained with antibodies to α-tubulin. (B) The same image after it has been down-sampled and then resampled to the original size. (A'/B') Blow-ups of selected regions of (A) and B. Note that the microtubules appear jagged, there is pixelation, and the overall quality of the image in (B') is poor. The interpolation routine for this demonstration was deliberately chosen to give poor results; most interpolation methods do much better.

the bitmap will also result in resampling of the image. If an initial 5″ × 5″ image with a resolution of 150 ppi (750 × 750 pixels) is down-sampled to 72 ppi, the bitmap will be 360 × 360 pixels. Remember, this is for the same size image; the pixels will therefore be larger, and the image will appear coarser. If the pixel size becomes too large, they can become visible as individual pixels. Thus, the object is

represented by an insufficient number of pixels and is undersampled, a situation analogous to aliasing.

Because the initial bitmap has a fixed resolution, when the image is resampled, the computer must spread the image over more, smaller pixels (or fewer, larger pixels). How the computer will represent the intensity for these new pixels is called interpolation. There are many different methods available to interpolate the change in bitmap size (see Kay and Levine, 1992). These methods are often integrated into image manipulation software (such as Adobe Photoshop; Adobe Systems Inc. Mountain View, CA). The goal is to re-create—as much as possible—the continuous tones and detail observed in the initial image. To accomplish this, most interpolation methods take into account intensity values from neighboring pixels and try to match tonal gradations. In its extreme, interpolation may not be able to re-create the sharp edges and detail of the original image (see Fig. 2), resulting in a pixilated picture.

IV. Bit Depth

In addition to its position within the bitmap, each pixel also has a bit depth, often referred to as the grayscale resolution or gray level of the image. This is the number of bits of information used to represent the intensity of each pixel. Each binary bit can have one of two values: either a zero or a one. Therefore, an image that is said to have a bit depth of 8 has the potential of 2^8 distinct gray levels (numbered 0–255). Generating image files with increased bit depth per pixel becomes important for quantitative microscopy. As the bit depth increases, so does the ability to represent finer details at each "point" in the image, in relationship to the surrounding pixels. The increase in grayscale resolution also leads to an increased range of light intensity values per pixel. The increase in possible intensity value means that quantitative analysis of the image can be conducted in greater detail. However, the trade-off for this increased detail and intensity is larger file size and slower processing.

In practical terms, files should be generated with as high a bit depth as possible. The bit depth will depend on the AD (analog/digital) converter in the camera or computer. For example, using a modern, cooled change-coupled device (CCD) camera that can generate images at either 8 or 12 bits, it is best to save the images as 12-bit. This will ensure that the full dynamic range of intensities within the image file is available for analysis. Sophisticated image analysis software packages can routinely deal with 12-, 14-, or 16-bit grayscale images, and it is important to conduct image analysis on the original image to obtain accurate quantitative information. Later these files can be converted to 8-bit images for manipulation and printing by mass-market photo programs, such as Photoshop. Remember to save the original image (with the higher bit depth) for future analysis. Think of this original image as a photographic negative. Of course, if intensity values at each pixel are not required for analysis, then lower-bit depth

images work just fine and require less computer resources. For example, if timing data is crucial, time-lapse analysis of a cellular event might not require 12-bit images. As always, there is a trade-off between file size and the need to store information.

V. File Formats

Selecting an image file format depends on several considerations: the purpose of the graphics being represented, the platform used, and the software available to manipulate the images. As mentioned earlier, most if not all digital micrography images are represented using bitmap files. In addition, most of the proprietary imaging formats available are bitmap files (many based on the TIFF format). There are several common bitmap file formats that bear description here. For a more in-depth discussion of file formats (see Kay and Levine, 1992).

Short for Joint Photographic Experts Group, JPEG is a ubiquitous file format for the distribution of digital images (see www.JPEG.org). Its major advantage is in the ability to provide outstanding visual images, particularly photographs, which can be highly compressed. JPEG is designed to exploit the limitations of the human vision: variations in brightness are perceived more than discrete changes in color (or grayscale). JPEG is intended for images that will be viewed by people and is an ideal format to use to present high-quality images with minimal file size (e.g., on a Website or in transferring images back and forth by e-mail or FTP). At its extreme, JPEG can represent an image using around one bit per pixel for storage, yet to the eye, this image looks indistinguishable from the original (see Kay and Levine, 1992). JPEG images are not designed for computer vision: the errors introduced by JPEG—even if they are invisible to the eye—make JPEGs unsuitable for quantitative analysis. This is compounded by the fact that JPEG files lack pixel intensity: The JPEG image looks fine to the eye, but it lacks pixel-by-pixel information necessary for quantitative analysis (see Fig. 3). It is not recommended that image files be archived as JPEGs unless quantitative data is not required.

The Tag Image File Format or TIFF is an excellent choice for saving and manipulating graphics files, particularly when these images will be used by several applications. TIFF images work equally well with grayscale or color images (Kay and Levine, 1992). TIFF files are often the basis for proprietary image file formats found in commercially available image-capture and analysis programs, and most of these programs will output as 8-bit (grayscale), 16-bit (grayscale), or 24-bit (RGB [red, green, and blue]) TIFF images. TIFFs can be saved uncompressed or can use a variety of compression regimes, including LZW compression or JPEG compression (so-called JIFFs). TIFF is an excellent format to archive image data.

Graphics Interchange Format is well suited for exchanging images between different programs, particularly across the Web. Originally designed by CompuServe for this purpose, the GIF format has largely been replaced by the

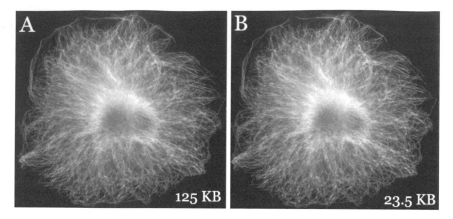

Fig. 3 The effect of JPEG compression on image quality. (A) A CHO cell labeled with anti-α tubulin. The image was reduced to 2.5 inches by 2 inches and saved as an 8-bit, uncompressed TIFF file. With these dimensions, the file was 125 KBytes. (B) The same image, saved as a JPEG, with the quality setting set at medium (i.e., #7). This image is now 23.5 KBytes. There does not appear to be any degradation in the image, despite compressing it to 0.188 its original size.

use of JPEG, particularly in the transfer of photographic images. However, JPEG will not completely replace GIF; for some types of images, GIF is superior in image quality, file size, or both. JPEG is superior to GIF for storing full-color or grayscale images of "realistic" scenes, such as photographs, and continuous-tone images. Subtle variations in color are represented with less space by JPEG than by GIF and yet still provide a faithful representation. In JPEG, sharp edges tend to be blurred unless a high-quality setting is used. GIF is better for images with fewer colors, such as line drawings and simple cartoons that have sharp edges. GIF is only available in 256 color (not true color). Animated GIF images remain the standard for solid-color motion graphics output to the Web.

Microsoft Windows Device Independent Bitmap file are known as BMP files. This is the standard Microsoft Windows raster file format. Although it does not have many features, it can work for moving images around, especially between programs. When this is done, it is best to convert the final image to another format, such as TIFF. Such conversions do not lead to image degradation, similar to that seen when converting a JPEG or GIF to a TIFF. BMP files are also used as the "desktop" image for Microsoft Windows.

VI. Color

It is helpful to understand some basics of color theory to be able to properly manipulate color image files. Colors can be described in terms of their hue, saturation, and intensity (also referred to as luminosity). Hue denotes the color of

an object (technically, hue represents the position on a standard color wheel, expressed in degrees between 0 and 360). Compare the hue of a pair of dark cotton blue jeans with that in a pair of sky blue polyester Ban Lon pants. Saturation is the amount of pure white in the color. For example, the blue in a brand-new pair of jeans is very saturated, whereas the blue in an old pair (or a pair that has been subjected to acid wash) is much less saturated. Intensity or luminosity denotes the brightness of an object: a pair of blue jeans observed in bright sunlight will look different from the same pair of jeans in a dimly lit blues club, around midnight.

There are two common (albeit not exclusive) methods that can be used to represent color in graphic image files. The first method is RGB, which mixes red, green, and blue light together in varying proportions. This is referred to as additive color, because adding all three colors in equal intensities creates white. It is easy to picture an RGB image as the overlaying of three colored transparencies (one red, one green, and one blue); where the colors overlap, they create complementary colors such as cyan, magenta, and yellow. In an RGB image file, each pixel is assigned a specific intensity for each of the three different color channels. If the bit depth for each channel is set to 8, then this image is said to be 24-bit RGB, or 24-bit color (3×8 bits/channel). The result is 16.7 million color variations (often called 24-bit true color). True color has become the standard display mode of most computer monitors. Note that: some color display systems support 32-bit true color display. This is 24-bit RGB plus an 8-bit alpha channel that functions as a mask to specify how an individual pixel's colors should or will be merged when colors are overlaid. This alpha channel is crucial for transparent regions of an image and special effects. Also, as of spring 2003, some new video cards are supporting 32-bit giga color (10 bits per channel RGB, plus a 2-bit alpha channel). This type of color representation is intended to give even more color information per channel, and the expense of transparency (often the alpha channel is only needed for digital "fine" art, where transparent regions of the image are critical).

The second method commonly used to represent color in digital image files is called CMYK (cyan, magenta, yellow, and black; K represents black, so as not to be confused with blue). In CMYK images, the colors are subtractive. This is easiest to understand if thought of as ink printed onto a white piece of paper. Indeed, the use of CMYK inks is the standard mode for commercial color printing —including that for scientific journals—and is called four-color process printing (see below). If all four colors are overlaid in sufficient and equal amounts, then the resulting image is true black. If there is no ink (i.e., no color), then the page is white. In a CMYK image file, each pixel is assigned a percentage value for each of its four different color channels. If the bit depth for each channel is set to 8 (the standard), then this file is said to be 32-bit color (not to be confused with 32-bit true color, mentioned earlier).

VII. Converting RGB to CMYK

The range of colors generated by each method (RGB or CMYK) is referred to as the color gamut of that method (see Inoué and Spring, 1997). Because RGB and CMYK use different methods to reproduce color, the hues in RGB files may be slightly different from those represented in CMYK files. Also, CMYK has a smaller gamut of colors than RGB. The difference in color gamut between an RGB and a CMYK file is often blamed for the disappointing hues/saturation/intensity seen in multicolor digital microscopy images that have been converted from RGB to CMYK for publication in print journals (see Hinchcliffe *et al.*, 1999, 2001, for examples). However, most, if not all, color micrographs are essentially grayscale images that subsequently have been pseudocolored to provide color information. As such, the gradations of red, green, and blue tones in these images are not subtle enough to cause the real problems observed during interconversion from RGB to CMYK. In fact, the interconversion of most digital images from RGB to CMYK does not present color management problems. This can be demonstrated by converting a digital photograph from RGB to CMYK; the result is pleasing and true to the original image. The real problem for digital micrography (and the cause of the less-than-optimal images generated) has its basis in the very nature of multiwavelength fluorescence micrographs.

Fluorescence images are composed of bright regions (where the fluorachrome is present) and a black background (where the fluorachrome is absent). In RGB mode, these types of images overlay very well, resulting in characteristic multichannel fluorescence micrographs. Where there is fluorescence overlap, there is a color shift to a complementary color; this color shift is often used to assay for colocalization of candidate molecules (i.e., red on green produces yellow). Remember that in an RGB image file, black represents the absence of pixel intensity. Therefore, where there is no overlap, the individual fluorochromes are contrasted with the pure black background. When output onto a RGB computer screen, these multicolor RGB fluorescence images are striking: They have deep, saturated colors and are combined with a rich, black background. However, when such an image is converted from RGB to CMYK for printing in a journal, the image becomes weak and sickly. This is the result of the switch from an additive color scheme (RGB) to a subtractive scheme (CMYK). The black background, which in RGB is the absence of intensity (no pixels), is converted to CMYK, which is represented by maximum pixel intensities for these regions (remember, the pure black regions in CMYK images are made up of equal percentages of C, M, Y, and K intensities for each pixel). After conversion, this black "ink" is overlaid onto the position of each fluorachrome present in the other layers. The effect is that the CMYK black regions act like a gray filter over the fluorescent image. The result is that the intensity of each "bright" pixel is diminished; also, the hue and the saturation of each pixel become altered.

To make matters worse, during the conversion from RGB to CMYK, the regions of the image that appear dark may be made up of varying intensities of C, M, Y, or K—they may not be true black. These pixels could be a dark maroon, a hunter green, a midnight blue, or a very deep golden brown. When each of these colors is highly saturated and has a faint intensity, the result is almost black. Thus, differing levels of color—masquerading as black—will be overlaid on the original pseudocolored image and change the hue, saturation and intensity of individual pixels within the image, often in an unpredictable and uncontrollable fashion.

When preparing multicolor fluorescent images for publication, there are several ways to get around the unfortunate situation brought about by the conversion from RGB to CMYK. One way is to start by manipulating each color "layer" as an RGB image until the desired intensities are found. Then the image is "flattened" and the layers are merged together. By flattening the image, the black pixels of the top layer are discarded. Once the image has been flattened, it can be converted from RGB to CMYK. Thus, those pesky "black" pixels from the upper layer are gone, and the image will convert to CMYK with relatively high fidelity. Alternatively, all of the black pixels can be removed from one of the layers in the image before flattening. It is easiest if the layer chosen for this manipulation is the one with the least amount of fluorescence. To perform this, the black pixels are selected as a color range and then deleted *en masse*. The result is that this selected layer contains only the bright pixels representing the fluorescent probe. Because there is no black background at this layer, when overlaid and flattened, this image will convert from RGB to CMYK better. Note that when removing any pixels from an image, it is important to do so judiciously. The danger comes when important information is lost from the image because of manipulation (even that pesky background fluorescence can be important). Select the black color range so that it does not inadvertently remove significant pixel intensities (even slight ones). As always, it is best to reference how the image was generated and manipulated in the materials and methods sections of publications (frank truth will often earn enormous brownie points with editors and reviewers—it never biases good results).

To demonstrate the practical results of these pre-CMYK conversion manipulations, the author conducted a real test by using digital micrographs taken of fluorescent-labeled CHO-K1 cells. For this test, the cells were decorated with a mouse monoclonal antibody to α-tubulin (microtubules) and a rabbit polyclonal antibody to γ-tubulin (the centrosome region). The primary antibodies were subsequently detected with a goat anti-mouse antibody coupled to Alexa 488 (Molecular Probes, Eugene, OR) and goat anti-rabbit antibody coupled to Alexa 594 (Molecular Probes). The samples were analyzed using a Leica DM RXA2 microscope (Leica Microsystems, Deerfield, IL) equipped with the following filter sets: E-GFP and Calcium Crimson (Chroma Inc., Burlington, VT). Images were collected using a Hammamatsu ORCA-ER cooled CCD camera (Hammamatsu Photonics, Bridgewater, NJ) and Simple-PCI Imaging software (Compix, Cranberry Township, PA).

An 8-bit grayscale TIFF image representing each image layer was saved and pseudocolored using Adobe Photoshop. These two layers were then overlain. The bottom layer containing the majority of the pixel intensities (the abundant microtubules) was pseudocolored green, and the top layer—which contained relatively little intensity information (γ-tubulin at the single centrosome)—was pseudocolored red. The resulting overlaid multicolor image was then saved as a 24-bit RGB TIFF file. This RGB image was then converted to a 32-bit CMYK image. For comparison, the conversion to CMYK was carried out both with and without preconversion manipulation. To analyze the color levels of the original RGB image, as well as the resulting CMYK images, the Photoshop color sample tool (the "eyedropper") was used to measure color levels in a specific region of the images.

The following results were found: a region of the image that has only green pixels (microtubules pseudocolored green) had RGB values of 39, 178, and 68, respectively. Before conversion from RGB, the corresponding CMYK values for this image region were $C = 78\%$, $M = 1\%$, $Y = 100\%$, and $K = 1\%$, respectively (Note that for RGB images, Adobe Photoshop 6.0 will measure color output levels in both RGB and CMYK). When this image was directly converted to CMYK (without preflattening), the CMYK values became $C = 59\%$, $M = 5\%$, $Y = 64\%$, and $K = 1\%$, respectively—yielding sickly pale-green microtubules. This was caused by the overlay of "black" pixels on the green microtubules (the Y value dropped from 100% to 64%). However, if the image was first flattened and then converted (no overlying "black" pixels), the values at this region were $C = 77\%$, $M = 1\%$, $Y = 100\%$, and $K = 1\%$, which are very close to the values in the original image. Alternatively, if the black pixels were first removed from the red layer and the image converted from RGB, the levels became $C = 82\%$, $M = 7\%$, $Y = 100\%$, and $K = 0\%$, respectively—also close to the original values of the RGB image. Note that because the original RGB image for this test would first have to be converted to CMYK for publication—thereby negating the critical aspects of the test—these images are not presented here.

VIII. Compression

Because raster graphics require information to be saved for each pixel, bitmap files can be very large. This is particularly true for images that are 1000×1000 pixels or larger (so-called megapixel images). The size of these files also increases as the bit depth increases for each pixel. Large file sizes put stains on computer processing power, memory capacity, and storage (see Bertrand, 2001). One way to deal with the increase in file size is to introduce compression. To compress a file, the computer looks for patterns within the bitmap and tries to represent these patterns with as little information as possible. In addition, movie file formats also can use temporal compression, which looks for similarities between frames.

When a file is compressed, the computer can preserve all the original pixel information and represent this information in the resulting uncompressed image.

This is said to be lossless compression. Alternatively, the computer can discard information deemed irrelevant to be able to represent the final image. This is said to be lossey compression.

For digital microscopy, the use of compression—and the selection of a compression scheme—depends on the requirements of the image and the imaging system. As a rule, it is best to acquire images with as little compression as possible (none at all would be best). Data analysis involving pixel intensities should be done on uncompressed files. These large files can be archived as is. The image can then be converted to a file type that supports compression (Fig. 3). This is convenient for publishing on the Web or transferring via e-mail.

IX. Video Files

To record dynamic changes in living cells, video records can be captured. Frames are captured at a specified interval, and a time-lapse sequence is generated. Such a technique is called time-lapse videomicroscopy. However, video actually refers to analog magnetic tape capture. Thus, it may be more accurate to describe digital motion picture capture from the microscope as digital cinemicrograpy rather than digital video. However, digital videomicroscopy persists as a standard term.

The file format or formats used to store these digital motion picture sequences are in essence a series of raster graphics files, but with significant features. The most important are keyframes and codecs (compression/decompression routines). Features that are common to motion picture (movie) file formats include the ability to change image size, frame rate, bit depth, and codecs. Often file formats are defined by the codec that they use (like MPEG).

Audio Video Interleave (AVI) is considered the video standard for Windows. It is a special case of the RIFF (Resource Interchange File Format). AVI is defined by Microsoft and is the most common format for audio/video data on the PC. AVI is an example of a *de facto* standard. For more info see *http://www.jmcgowan.com/avi.html.*

Quicktime is Apple's video format, but it also works well for PCs.

Motion Picture Experts Group (MPEG) is a version of JPEG for motion picture that allows significant compression of video files. MPEG makes extensive use of compression keyframes and, therefore, requires more processing time. MPEG-1, layer 3 is an audio file format that provides significant compression of audio files. These files are known as MP3. MPEG-4 is becoming a standardized format for large movie files, such as DVDs. This is particularly true for video content using the DivX codec, which is MPEG-4 based (see www.DivX.com).

The **TIFF sequence** gives the ability for TIFF files to play as a motion picture sequence. The quality of TIFF sequences (or TIFF stacks) make them particularly suited for quantitative analysis. However, this does introduce size limitations: the file size of TIFF stacks can be very large.

X. Video CODECs

Because motion picture file formats have the potential to be very large (current video files in our lab are reaching tens of gigabits), there is a great deal of emphasis on compression of the motion picture information. Video files present unique problems when being compressed. The image changes over time. Thus, there must be compression within an individual frame (spatial compression) just as in a conventional graphics file. In addition, the compression routine must have the ability to find similar regions within the images of the series as they change over time (called temporal compression). In digital video, there are three interactive features of compression routines that need to be dealt with: compression of the information, for storage, decompression of the file, to allow viewing of the movie; and compression key frames, signposts placed throughout the video file that allow the program to compare changes from frame to frame and to minimize the amount of data that needs to be stored in the first place.

Codecs can be symmetric or asymmetric. In a symmetric codec, compression and decompression occur at the same rate. Asymmetric codecs take more time to compress than decompress. This has an advantage in playback but requires more time during video production. Central to any codec is the use of compression key frames. In a video sequence in which very little change (such as in many cinemicrography experiments), the computer will use unchanged regions of the image from frame to frame and only have to describe the new (changing) regions. The compression routine references each frame on the previous one. When the scene changes entirely, a new reference frame must be generated. These reference frames are called key frames. Codecs insert keyframes at varying intervals, and some codecs allow key frames to be inserted manually. For the videomicroscopist, key frames only come into play when the scene rapidly changes (a switch to a different imaging contrast mode during the experiment). Otherwise, the keyframes specified by the codec can usually handle subtle changes.

A unique problem arises when video clips from different sources (and clips originally produced with different codecs) are pieced together into a final movie. If the final output is then saved with compression again, the clip is said to be recompressed. This does not provide any savings in file size and usually leads to degradation of the image, often in unpredictable ways. To ensure that video files are not recompressed, it is best to save a image sequence without compression and to only introduce a compression routine when the final movie is constructed.

XI. Choosing a Compression/Decompression Routine (CODEC)

There is a wide variety of video codecs available, and many of them are standard components of the Windows or Apple operating systems. Other codecs are provided as part of commercially available video editing programs, such as Adobe

Premiere or Apple Quicktime. Finally, there are codecs that are designed to work with a specific software application or as part of hardware-based compression. Each of these compression routines is designed for a specific purpose, and there is no one best codec for video use. To optimize the output of digital cinemicrography, it is important to empirically determine which codec will work for a particular application.

What follows is a simple, step-by-step protocol for determining the suitability of a particular codec for an individual application.

1. Identify the program that will be used to play the final sequence (i.e., will this movie be for presentation in Microsoft PowerPoint, for playback from the Web, or as a movie for analysis in the lab?). The final output program will determine which codec will work best.

2. Select a short sample movie to use as a test. This movie should be a clip taken from a candidate sequence of the type to be displayed (i.e., time-lapse of GFP, or phase contrast). Match the bitmap dimensions to the output program (i.e., at least 640 × 480 for videos, 320 × 240 for Web applications). These changes are made in the video editing software (see documentation provided with this software). The test clip should show examples of the type of detail needed in the final movie, but they should be on the order of 10–40 Mbytes (depending on the computer used). The small file size will facilitate rapid compression and playback. It is important that this test clip be made from a sequence that was not previously compressed; otherwise, recompression will occur.

3. Using a video editing program (such as Adobe Premiere or Apple Quicktime), convert the clip to a compressed form using a specific codec. For each codec, compress the clip with a range of compression settings (often referred to as "quality" setting) from best to worst. These setting are often represented as a number from one to 10 (10 being the highest quality and least compression). Alternatively, the quality setting may be a percentage (100% being the best quality and least compression). Start with four separate settings, 100%, 50%, 25%, and 5%. Note the initial file size for the clip and the file size after compression, along with the time it takes to compress the file for each setting.

4. Open the resulting clips in the final output program (such as PowerPoint) and play each clip back as it will be played for the final presentation. Look for pixelation (indicative of too much spatial compression) or jerky play (too much temporal compression). Note the lowest setting that still provides an acceptable image.

5. For each setting, compare the four separate values for compression of this file: (1) degree of compression (change in file size from uncompressed to compressed), (2) time of compression, (3) quality of the image, and (4) quality of the playback.

6. Repeat using another codec. By comparing the four criteria for a range of settings for each codec, the optimal codec and settings for a particular sequence file type can be found (Fig. 4). The trade-off is file size (storage) versus file quality (playback). The time it takes to compress the image is secondary, but it does affect

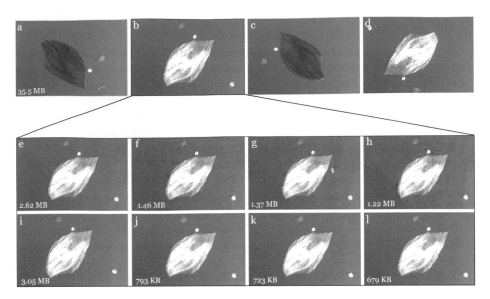

Fig. 4 Selecting the appropriate compression/decompression routine (codec). (a–d) Frames from a movie file of a human cheek cell imaged with polarization microscopy. The specimen is rotated 360° on a rotating stage. The birefringence in the cell appears brighter or darker than the background depending on the orientation of the specimen relative to the compensator. This sequence was saved as an avi file, 1280 × 1024, and 8-bit, giving a file size of 200 MByte. A 640 × 480 subregion of this sequence was saved as an avi without compression, yielding a file size of 35.5 MByte. The file was then saved using two different codecs (see [e–l]) (e–h) a single frame (that corresponds to frame [b]) from a complete image sequence; the movie is described earlier. These movies were saved using Intel Indeo 3.2 codec and a range of compression settings. Compression settings are: (e) 100%; (f) 50%; (g) 25%; and (h) 5%. Resulting file size for the entire compressed movie is shown in the lower left. Note that the image begins to be degraded in (f). This loss of image quality is most apparent when viewed on a computer screen (as the movie file would be). (i–l) same as in (e–h), only with the Indeo Video 5.10 codec. Here, there is little image degradation as the compression increases.

the ability to manipulate the digital motion picture sequences. Remember, different codecs will be optimal for different file types. It is best to empirically determine the best codec for each sequence type (i.e., contrast mode or model system).

Using the protocol outlined above, a real cinemicrography video file was generated and subjected to compression using two separate codecs. For each codec used, four different quality settings were employed. The sample is a human cheek cell (Fig. 4). This cell was imaged using a Leica DM L Pol microscope (Leica Microsystems, Deerfield, IL), equipped with a Brace-Koehler compensator and a 100-W Hg-arc lamp. Images were collected using a Hammamatsu ORCA-100 CCD camera (Hammamatsu Photonics, Bridgewater, NJ) and Simple-PCI Imaging software (Compix, Cranberry Township, PA). The resulting avi file was saved without compression and ended up ~200 Mbyte in size; each frame being

1280 × 1024 pixels, and 8 bit. A region of interest was cropped to 640 × 480 pixels using Adobe Premiere and saved as an uncompressed avi file (final size 35.5 Mbyte). This file was then saved as a new file using either the Intel Indeo 3.2 codec or the Indeo Video 5.10 codec. For each codec, a range was used for the quality settings: 100%, best; 50%, medium; 25%, low; and 5%, really low. The amounts of time it took to compress each movie file were measured: they were all about 1 minute. The movie files were then analyzed for quality. An individual frame from each compression routine used (at each quality setting) is presented in Fig. 4.

For the Intel Indeo 3.2 codec, the 100% setting resulted in a file size of 2.62 Mbyte, which is a compression of 13.5 times over the original cropped movie. However, any further compression with this codec resulted in a degraded image.

Using Indeo Video 5.10, the 100% setting resulted in a file that is 3.05 Mbyte, a compression of 11.6 times the original cropped file. In the case of Indeo Video 5.10, the 50% setting did not result in significant image degradation and yielded a file of 793 KB, a compression of 3.8 times that of the 100% setting. Further compression with this codec to 25% only trimmed 70 KB from the file, and 5% yielded a file size of only 679 KB. Thus, for this movie file, 50% compression with Intel Indeo Video 5.10 is optimal, giving good image quality and a whopping 45× compression. This results in a file size that can easily be used in presentation or on the Web.

XII. Conclusions

With the rebirth of light microscopy as an analytical and quantitative tool, the use and manipulation of digital graphics files has become essential for the cell/molecular biologist. Digital imaging has largely replaced 35-mm photography as a way to record micrographs. The basics of computer imaging can be mastered in little or no time. When used properly, digital image files allow for quantitative measurements of cellular activities. Proper use entails generating files with high bit depth (12 bit) and saving the files uncompressed. Images with lower bit depth (8 bit) can be used for presentation, and these files can be saved with compression to facilitate easy sharing.

Acknowledgments

Thanks to Bill Burnip, Paul Goodwin, Ron Hellenthal, Colin Monks, Sid Shaw, Jason Swedlow, and Kevin Vaughan for providing helpful comments and answering questions relating to various forms of the material presented here. Also thanks to Martha Peterson, Herb Luther and Louie Kerr for making the spring trips to the MBL such a pleasure. Finally, I would like to thank Rich Cardullo, Rick Miller, Mort Abromowitz, Geoff Daniels, Jan Hinsch, Ernst Keller, Butch Moomaw, Dean Porterfield, Paul Thomas, Steve Block, Jeff Gelles, Rudi Rottenfusser, Stan Schwartz, Rick Marlot, Brad Amos, Shinya Inoue, Ted Salmon, Randi Silver, Ken Spring, Yu-Li Wang, David Wolf, and Kip Sluder for introducing me to analytical and quantitative light microscopy during the 1995 AQLM course at the MBL in Woods Hole, MA (and the National Science Foundation for providing me with support to attend the course). EHH is a Research Scholar of the American Cancer Society.

References

Bertrand, C. A. (2001). Color by numbers: Imaging large data. *Science* **293,** 1335–1336.

Furness, P. (1997). The use of digital images in pathology. *J. Pathol.* **183,** 253–263.

Hinchcliffe, E. H., Li, C., Thompson, E. A., Maller, J. L., and Sluder, G. (1999). Requirement of Cdk2–cyclin E activity for repeated centrosome reproduction in *Xenopus* egg extracts. *Science* **283,** 851–854.

Hinchcliffe, E. H., Miller, F. J., Cham, M., Khodjakov, A., and Sluder, G. (2001). Requirement of a centrosomal activity for cell cycle progression through G_1 into S phase. *Science* **291,** 1547–1550.

Inoué, S., and Spring, K. R. (1997). Video Microscopy: The Fundamentals. 2nd Ed., Plenum Press, New York.

Kay, D. C., and Levine, J. R. (1992). "Graphics File Formats." Windcrest/McGraw-Hill, Blue Ridge Summit, PA.

Salmon, E., Shaw, S. L., Waters, J., Waterman-Storer, C. M., Maddox, P. S., Yeh, E., and Bloom, K. (1998). A high-resolution multimode digital microscope system. *Meth. Cell Biol.* **56,** 185–215.

Thomas, C., DeVries, P., Hardin, J., and White, J. (1996). Four-dimensional imaging: computer visualizations of 3D movements in living specimens. *Science* **273,** 603–607.

CHAPTER 14

High-Resolution Video-Enhanced Differential Interference Contrast Light Microscopy

E. D. Salmon and Phong Tran

Department of Biology
University of North Carolina
Chapel Hill, North Carolina 27599

I. Introduction

Differential interference contrast (DIC) light microscopy was an immediate success after its introduction in the 1960s (Allen *et al.*, 1969) because it could produce high-contrast optical images of the edges of objects and fine structural detail within transparent specimens without the confusion induced by the interference fringes typical of phase-contrast microscopy. DIC contrast depends on gradients in optical path (OP $= nd$; refractive index, n, \times thickness, d) and not absolute values of OP. As a result, DIC methods can produce clear optical sections of relatively thick transparent specimens. Resolution in DIC microscopy is also superior to phase contrast. In transmitted light microscopy, lateral resolution, r, depends on the wavelength of light, λ, and the numerical aperture, NA, of both the objective and condenser:

$$r = \lambda/(\mathrm{NA_{obj}} + \mathrm{NA_{cond}}). \tag{1}$$

The best objectives ($\mathrm{NA_{obj}} = 1.4$) potentially can achieve a diffraction limited resolution in green light ($\lambda = 550\,\mathrm{nm}$) of about 200 nm when their aperture is fully and evenly illuminated ($\mathrm{NA_{cond}} = 1.4$). Vertical resolution is approximately two times the lateral resolution (Inoué, 1989; Inoué and Oldenbourg, 1993). In DIC, the NA of the condenser illumination can match the objective NA, and the resolution limit is close to that predicted by Eq. (1) (Inoué and Oldenbourg, 1993). In phase contrast, the annular cone of condenser of illumination is usually only 60% of the objective NA, and the resolution that can be achieved is less than that by DIC.

When viewed by the eye or recorded by conventional photography, fine structural detail near the limit of resolution is often invisible because it has too little contrast. In the early 1980s, Allen, Inoué, and others (Allen *et al.*, 1981a,b; Inoué, 1981, 1989) discovered that the electronic contrast enhancement capabilities of video cameras could make visible the fine structural detail barely resolvable by the DIC microscope and structures such as 25-nm-diameter microtubules (Fig. 1), which are nearly an order of magnitude smaller than the diffraction limit. Both cameras and digital image processors have advanced significantly since the early 1980s (Inoué, 1986; CLMIB Staff, 1995; Inoué and Spring, 1997) and now video-enhanced DIC (VE-DIC) methods are easily implemented (Schnapp, 1986; Salmon *et al.*, 1989; Weiss *et al.*, 1989; Walker *et al.*, 1990; Salmon, 1995).

VE-DIC has been important in many aspects of cell biology including: measuring the assembly dynamics of individual microtubules and force production by microtubule assembly/disassembly (reviewed in Inoué and Salmon, 1995); seeing the motility of bacterial flagella (Block *et al.*, 1991) or the assembly of sickle cell hemoglobin filaments (Samuel *et al.*, 1990); studies of intranuclear spindle dynamics and cell cycle regulation in genetic organisms such as the yeast *Saccharomyces cerevisiae* (Yeh *et al.*, 1995); providing functional assays for the

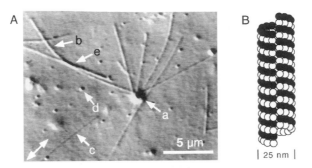

Fig. 1 (A) VE-DIC micrograph of microtubules nucleated from a centrosome (a) in cytoplasmic extracts of sea urchin eggs (Gliksman *et al.*, 1992). The double arrow indicates the DIC shear direction. Contrast is much greater for a microtubule oriented approximately perpendicular (b) to the shear direction in comparison to one oriented in a parallel direction (c). Points in the specimen are imaged in DIC as pairs of overlapping Airy disks of opposite contrast as seen for the tiny particle at d. The separation between Airy disks in a pair is the shear, which is usually chosen to be less than the resolution limit. The width of the Airy disk pair expands the size of objects so that the 25-nm-diameter microtubules (B) appear as 400- to 500-nm-diameter filaments in VE-DIC images (b). Overlapping microtubules are not resolved, but have about twice the contrast as individual microtubules (e). (B) Microtubules are 25-nm-diameter cylindrical polymers of α,β-tubulin dimers (see Inoué and Salmon, 1995).

discovery and function of microtubule motor proteins (reviewed in Salmon, 1995), including the measurement of the stall force and 8-nm step size for the microtubule motor protein kinesin in combination with an optical trap (Kuo and Scheetz, 1993; Svoboda *et al.*, 1993; Svoboda and Block, 1994); assays for membrane dynamics and mechanical properties in combination with optical traps (Kuo and Scheetz, 1992); laser microsurgery (Cole *et al.*, 1995); measurements of dynamic changes in cell volume, organelle transport, cell morphogenesis, and motility (reviewed in Scholey, 1993); and monitoring changes in cellular distributions and cell fate during embryogenesis (Thomas *et al.*, 1996).

The quality of images in VE-DIC microscopy depends critically on both the quality of the image projected onto the camera detector by the microscope as well as on the electronic contrast enhancement capabilities of the camera electronics and the digital image processor (Fig. 2). In this chapter, we will briefly describe the basic concepts of DIC image formation and analog and digital contrast enhancement, the practical aspects of component selection, alignment and specimen chambers for VE-DIC, and several test specimens for measuring microscope and video performance. Further details about DIC, video signals, cameras, recorders, and display devices are beyond the scope of this article and can be found in other sources (Inoué, 1986; Pluta, 1989; Schotten, 1993; CLMIB Staff 1995; Inoué and Spring, 1997).

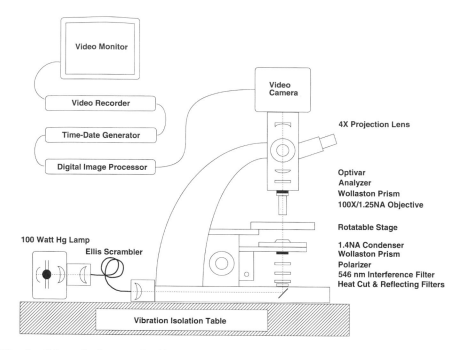

Fig. 2 Schematic diagram of a high-resolution, VE-DIC microscope system. A research polarized light microscope on a vibration isolation table is equipped with an illuminator having a bright 100-watt mercury light source and Ellis fiber-optic light scrambler, heat cut, heat reflection and 546-nm interference filters, efficient polars, rotatable stage, and DIC optics. The Optivar contains a telescope lens for focusing on the objective back focal plane during microtubule alignment. The specimen image is projected at high magnification onto the faceplate of a video camera, enhanced using analog electronics in the camera, then passed through a digital image processor for further enhancement (background substraction, exponential averaging, and contrast improvement). This image is recorded on a videocassette recorder or memory optical disc recorder, and the final image is displayed on a video monitor. See text for details.

II. Basics of DIC Image Formation and Microscope Alignment

A. Microscope Design

A DIC microscope is a "dual beam interferometer" that uses a brightfield polarizing microscope containing polarizer, analyzer, and rotating stage (Figs. 2 and 3). The polarizer is inserted in the light path beneath the condenser. The analyzer is inserted in the light path above the objective in a position where the light from the objective is mainly parallel to the microscope axis. The polarizer is usually aligned with its transmission vibration direction of the light electric field in the E–W direction as you face the microscope and the analyzer is aligned in a N–S direction to extinguish light from the polarizer (Fig. 3, left).

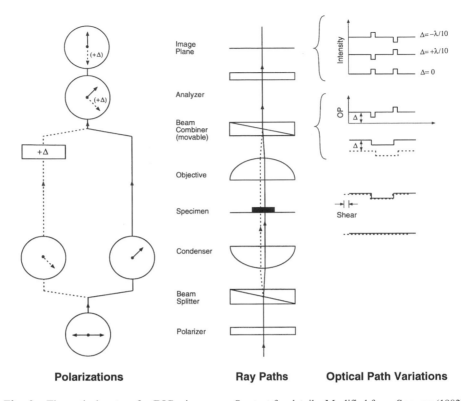

Fig. 3 The optical system for DIC microscopy. See text for details. Modified from Spencer (1982).

In the basic system a prism beam splitter is inserted near the condenser diaphragm plane with its wedge direction at 45° to the polarizer direction (Fig. 3). This birefringent prism splits the light coming from the polarizer into two divergent polarized light waves whose planes of polarization are orthogonal to each other and at ±45° to the initial plane of polarization of the polarizer (Fig. 3). The divergent beams are converted by the condenser into two wavefronts that pass through the specimen separated laterally from each other in the wedge direction (termed the "shear direction," Fig. 3) by a tiny amount, less than the resolution limit for the objective condenser lens combination (Eq. 1). These two wavefronts are recombined by the objective lens and another prism.

In the original system divided by Smith (1955), the beam-splitting prisms are Wollaston prisms, one mounted at the front focal plane of the condenser (the condenser diaphragm plane) and one at the back focal plane of the objective. For medium- and high-power objectives, the back focal plane is usually inside the lens system. Objectives made for Smith DIC contain the Wollaston prism at this position, much like a phase objective with its phase ring, making them unsuitable for other microscopy modes. To avoid this problem, Nomarski (Allen *et al.*, 1969) modified one

wedge of the Wollaston prism so that it could be placed in front of the condenser diaphragm or above the objective (Pluta, 1989). These Nomarski prisms act like Wollaston prisms located at the focal planes of the condenser or objective lenses.

The DIC image contrast depends on the "compensation" or "bias retardation" (Δ_c) between the two wavefronts along the microscope axis (Fig. 3, right). When the objective prism is perfectly aligned with the condenser prism ($\Delta_c = 0$) and the background light is extinguished (Fig. 3, upper right), the edges of objects appear bright in the image, much as seen in darkfield images. When one wavefront is retarded relative to the other, then the background brightens. One edge of the object becomes brighter than the background, whereas the other edge becomes darker than the background. This produces the "shadow-cast" appearance of DIC images (Fig. 1). Reversing the sign of retardation or compensation produces an image of the opposite contrast (Fig. 3, upper right).

Compensators in polarized light microscopes are devices that can add or subtract bias retardation between the two orthogonal beams. In the design in Fig. 3, the objective beam combiner also acts as a compensator when it is translated in the shear direction away from the extinction position. This is done by sliding the prism in the wedge direction (Fig. 3, right). Translation in one direction produces positive bias retardation, whereas translation in the other direction produces negative bias retardation. Some instruments are designed with the objective and condenser prisms aligned and fixed in the extinction position. In these instruments (not shown in Fig. 3), bias retardation between the two wavefronts is typically achieved using a deSenarmount compensator. A deSenarmount compensator uses a quarter-wave retardation waveplate in the extinction position mounted on the prism side of a rotatable polarizer or analyzer. The combination of the quarter waveplate and rotation of the polar induces the bias retardation where $\Delta_c = $ (degrees rotation) $\lambda/180$ (Bennett, 1950).

B. Major Features of a VE-DIC image

There are four major features of a typical DIC image as illustrated by the high-magnification VE-DIC micrograph of the field of microtubules and other small cellular organelles in Fig. 1.

1. Notice that objects appear "shaded," with one side being brighter and the other side darker than the background light intensity. This is easily seen for the 1-μm diameter centrosome (Fig. 1a). Contrast is greater the steeper the gradient in optical path in the shear direction, so that contrast occurs mainly at the edges of objects.

2. DIC image "contrast" is directional and maximum in the "shear" direction—the DIC prism wedge direction in the microscope—and this direction is indicated by the double-headed arrow in Fig. 1. Notice that a microtubule aligned perpendicular to the shear direction has the highest image contrast (Fig. 1b), whereas one in the direction of shear has the least (Fig. 1c). Because contrast is directional, a DIC microscope usually has a rotating stage so that structural detail of interest can be rotated to achieve maximum image contrast.

3. Each point in the specimen is represented in the image by a pair of overlapping "Airy disks." An Airy pattern is the "point spread function" produced by the diffraction of light through the objective aperture. Diffraction by the objective aperture spreads light from each point in the object into an Airy disk in the image. The objective beam-splitting prism in the DIC microscope splits the scattered light from a point in the specimen into two beams, producing overlapping pairs of Airy disks for each point in the specimen. By compensation, one Airy disk image is adjusted to be brighter and the other to be darker than the background light. A line in the plane of the image through the centers of the Airy disk pairs is the shear direction, whereas the distance between the centers of the Airy disks is termed the "shear distance." The overlapping pairs of Airy disks are best seen for tiny particles 50 nm or so in size (Fig. 1d). Images of linear objects such as 25-nm-diameter microtubules are made from a linear series of Airy disk pairs, and objects larger than the resolution limit, such as the centrosome (Fig. 1a), are two-dimensional and three-dimensional arrays of overlapping Airy disk pairs. Their light-dark contrast cancels out except at the edges of the object, so that one side of the object is brighter and the other darker than the background.

4. Image size and resolution in VE-DIC images depends on the size of the Airy disk pair. For the images in Fig. 1, the $NA_{obj} = NA_{cond} = 1.25$, and $\lambda = 546$ nm. In this very high contrast image, each Airy disk appears about 250 nm in diameter, and the pair is about 450 nm wide. The diameter of the central peak intensity of the Airy disk depends on wavelength and, inversely, on NA; the smaller the diameter, the better the resolution as given in Eq. (1). For objects much less in width than the resolution limit, such as the small particles (Fig. 1c) and microtubules (Fig. 1b), they appear in VE-DIC images as objects with a width expanded by the size of the Airy disk pair. This explains why the microtubules in Fig. 1 appear almost 10-fold wider than predicted by their 25-nm diameter and the magnification of the microscope. For objects larger than the resolution limit, the size of the Airy disk becomes less a factor and the object dimension becomes closer to the value predicted from the magnification of the microscope optical system.

A VE-DIC microscope cannot "resolve" a pair of adjacent microtubules, as these are only 25 nm apart, 10-fold less than the resolution limit for the microscope used to make the image in Fig. 1. However, pairs of microtubules have twice the mass and twice the contrast of a single microtubule, as seen in Fig. 1e, where two microtubules cross each other. So as mass increases, contrast increases.

Although resolution is limited to about 200 nm in VE-DIC images, movements of objects can be tracked with subnanometer precision by tracking the centroid of the Airy disk image pair of point sources in the specimen (Gelles *et al.*, 1988; Svoboda *et al.*, 1993; Svoboda and Block, 1994).

C. How Much Bias Retardation Is Best

Intensity in DIC images depends on the difference in optical path between the two beams when they interfere with each other at the analyzer (Fig. 3, right). The

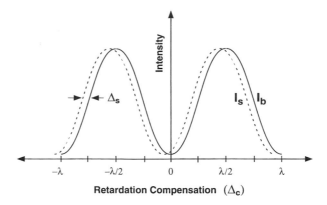

Fig. 4 Plots of intensity verses compensator retardation, Δ_c, for the intensity of the background light, I_b, and for the edge of a specimen, I_s, which exhibits retardation, Δ_s. See text for details.

intensity of light (Fig. 4) at an edge of a specimen, I_s, and a point in the background media, I_b, are given by:

$$I_s = (I_p - I_c)\sin^2\{2\pi[(\Delta_c + \Delta_s)/2]/\lambda\} + I_c, \tag{2}$$

$$I_b = (I_p - I_c)\sin^2[2\pi(\Delta_c/2)/\lambda] + I_c, \tag{3}$$

where I_p is the intensity of light that would leave the analyzer if the analyzer axis were rotated parallel with the polarizer axis of vibration, Δ_c and Δ_s are the retardations induced by the compensator bias retardation and the specimen, respectively (Fig. 3, right), and I_c is the intensity of light with the specimen out of the light path when the analyzer and polarizer are crossed and Δ_c and Δ_s are both zero.

I_c represents the stray light in the system induced by birefringence in the lenses, rotation of the plane of polarization by highly curved lens surfaces (Inoué, 1986; Inoué and Oldenbourg, 1993), and imperfect polarization of light by the polarizer and analyzer. I_c is usually about 1/100th of I_p in a high-resolution (NA = 1.4) DIC microscope system. If I_c is any more than this value, it can be a significant noise factor, interfering with visualization of fine structural detail or objects like microtubules. As seen in Eq. (3) and Fig. 4, when the retardation is $\lambda/2$, the background light is maximum, and when the bias retardation is zero, the only light in the image is produced by the specimen structural detail and the stray light (Fig. 3, upper right).

In practice, the best optical contrast is achieved when bias compensation is adjusted to extinguish the light coming from one edge of the object of interest, the edge of a microtubule, for example, in Fig. 1. This occurs when $\Delta_c = -\Delta_s$. For the edges of organelles and cells, Δ_s corresponds to about 1/10th the wavelength of light or greater, but for microtubules and tiny organelles in cells, Δ_s is very small, less than 1/100th the wavelength of green light. For microtubules, we still

use about 1/15th–1/20th the wavelength bias retardation, so there is sufficient light to the camera. A similar result was found by Schnapp (1986), but Allen and others argue that redardations near 1/4 wavelength are best (Allen *et al.*, 1981; Weiss *et al.*, 1989). Near or at extinction, there is a diffraction anomaly in the Airy pattern produced by the rotation of the plane of polarization at the highly curved surfaces of high-NA lenses (Inoué, 1986; Inoué and Oldenbourg, 1993). This can be corrected by rectifiers, but they are only available for particular lenses. This anomaly disappears with increasing bias retardation (Allen *et al.*, 1981b) and is not apparent in our images (Fig. 1) obtained with about 1/15th wavelength bias retardation.

III. Basics of Video–Enhanced Contrast

A. Video Basics

In video microscopy the image produced by the light microscope is projected onto the detector of the video camera (Fig. 2). Electronics in the video camera scan the detector in a raster pattern, converting variations in light intensity into variations in voltage, which are encoded into a video signal where white is 0.7 volts and black is about .03 volts. The video signal also includes negative horizontal and vertical sync pulses that guide the generation of the raster pattern in the image display (Inoué, 1986). Conventional video cameras produce images at 30 frames/ second for NTSC (the standard television rate in America) and 25 frames/second for PAL (the television rate in Europe). A frame is made by successive scans of two interlaced fields; each field is scanned in 1/60 second. An NTSC image contains 480 active television lines displayed on the video screen. The video signal produced by the camera can be immediately displayed on a video monitor sent to a time-date generator, digital image processor, or recording device (Fig. 2).

Resolution in video is measured by the number of black plus white lines visible in either the horizontal or vertical direction. Horizontal resolution is usually limited by the resolution of the detector, the bandwidth of the analog electronics or the speed of a digitizer, and the number of picture elements ("pixels") in a frame-storage memory buffer. Vertical resolution is limited by the about 480 active television lines in a video frame. A horizontal television resolution of 800 lines means that 800 vertical lines—400 black and 400 white alternating lines—are visible in the video image over width equal to the height of the active picture area.

If a detector or image processor has 800 pixels horizontally, it can't reliably detect 800-television-line resolution because of insufficient pixels and the problem of "aliasing," which occurs when the lines are not centered on the pixel detectors, but centered on the junctions between pixels (Inoué, 1986). At this position, adjacent pixels get average intensities from black and white lines, and they are not resolved. The same aliasing problem occurs in the vertical direction. In general, resolution is given as about $0.7 \times$ number of pixels in either the horizontal or vertical direction. For example, video images with 480 active horizontal lines, have $0.7 \times 480 = 336$

a

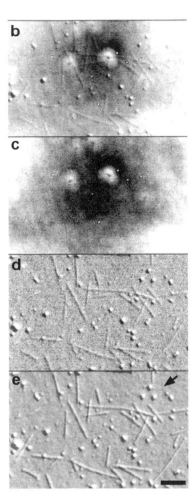

Fig. 5 An example of how individual microtubules can be seen by VE-DIC microscopy because of the enormous gains in contrast that can be achieved by analog and digital image processing. Taxol-stabilized microtubules assembled from pure brain tubulin were bound to the coverslip surface by *Xenopus* egg extracts treated with 5 mM AMPPNP (adenosine 5'-(β,γ-imino)triphosphate). The microtubules were viewed with the vertical optical bench VE-DIC microscope described by Walker *et al.* (1990). Video images were obtained with a Hamamatsu C2400 Newvicon camera and Argus 10 digital image processor (Hamamatsu Photonics Inc.), stored in a MetaMorph image processing system (Universal Imaging, Inc.), and printed on a Tektronics Phaser IISDX dye-sublimation printer. (a) A

television lines of vertical resolution. In contrast, horizontal resolution is often 800 television lines, or almost threefold better than the vertical resolution.

B. Analog Contrast Enhancement

As shown in Fig. 5, a field of microtubules, invisible to the eye in the DIC microscope (Fig. 5a), can be seen with high contrast, using analog and digital contrast enhancement methods. Most video contrast enhancement is produced by analog electronics in the video camera (Fig. 5b and the diagram in Fig. 6). Contrast enhancement is produced by subtracting voltage (black level or pedestal control) from the video signal and amplifying the difference (gain control) for each horizontal line scan of the video raster image.

Increasing the analog contrast enhancement to levels necessary to give distinct images of microtubules induces a new set of technical problems. Image quality becomes limited by noise from several sources, which is amplified as gain is increased. There are two different types of noise. One is stocastic, "shot," or "random" noise that is produced by noise in the video camera and by variations in photon flux between successive frames. This noise makes the image "grainy." The second is "fixed pattern" noise that does not change between successive frames and can obscure weak-contrast objects such as microtubules (Fig. 5b). "Shading" across the image is produced by uneven illumination, birefringence in the lenses, or variations in sensitivity across the detector faceplate. "Mottle" comes from out-of-focus dirt on the lens surfaces. "Dirt" on the faceplate of the detector makes distinct spots.

As gain is increased, the bright and dark regions of the image exceed the dynamic range of the camera, and specimen detail is lost because of "clipping" (Fig. 6). Some high-performance video cameras (e.g., DAGE VE-1000, and Hamamatsu C2400) have analog electronic controls that can be used to flatten out uneven background brightness, thus allowing higher contrast enhancement. These devices are very useful for correcting the unidirectional gradient in background light intensity produced by imperfectly matched DIC prisms. However, the mottle and dirt in the image cannot be removed by this method.

C. Digital Contrast Enhancement

Allen and Allen (1983) were the first to recognize that fixed pattern noise could be eliminated from the video image by subtracting a stored background image using a digital image processor operating at video rates. The background is obtained by defocusing the microscope until the microtubule image just

typical image when viewing by eye through the microscope. (b) The video image after analog contrast enhancement by the video camera electronics. Microtubules are visible, but the image is contaminated by shading, mottle, dirt on the camera detector, and random noise. (c) The background image made by defocusing the microscope. (d) The video image after background substraction from live video, the addition of a bias grey level, and further digital contrast enhancement. (e) An exponential average of four frames substantially reduces the random noise. Scale = 2.5 μm. From Salmon (1995).

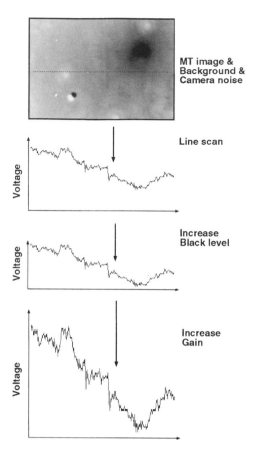

Fig. 6 Analog contrast enhancement. Video cameras with black-level and gain controls can improve image contrast by first subtracting voltage (termed black level or pedestal) from the video signal and then amplifying the difference (using the gain control) to stretch the remaining information in each horizontal scan line. This process also increases the magnitude of uneven background intensity and random noise. Modified from Salmon *et al.* (1989).

disappears. Then a number (usually 128 or 256) of successive frames are averaged and stored in a "background" frame buffer in the image processor (Figs. 5c and 7). The microscope is refocused and the background is continuously subtracted from the live image. A bias gray level is added to the displayed image (usually 128 out of the total of 255 gray levels in an 8-bit digital image) to produce a uniform background gray level. After background subtraction, further contrast enhancement (four- to sixfold) can be achieved by using the output look-up tables of the digital image processor (Figs. 5d and 8).

This method removes much of the fixed pattern noise but does not reduce the random noise in the image from camera noise or variations in photon flux. Averaging of successive frames with the real-time image processor solves this

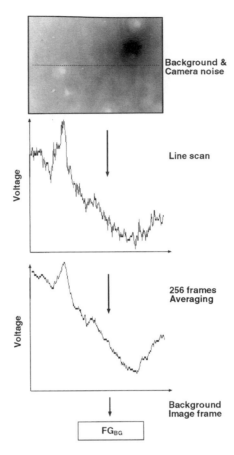

Fig. 7 Background image average and storage. To obtain an image of the fixed pattern noise, such as dirt particles and uneven background in the video image, the microtubule image is slightly defocused and 256 sequential video frames are acquired and averaged to produce a low-noise image, which is saved in a framestore board. Modified from Salmon *et al.* (1989).

problem by sacrificing temporal resolution. The increase in signal-to-noise depends on the square root of the number of averaged frames (N). Too much averaging blurs images of moving objects. The image in Fig. 5e was obtained using a four-frame sliding or exponential average after background subtraction (Fig. 8).

IV. Selection of Microscope and Video Components

A. General Considerations

Achieving high-resolution, high-contrast VE-DIC images requires the highest performance of both the optical and video components of the video microscope system.

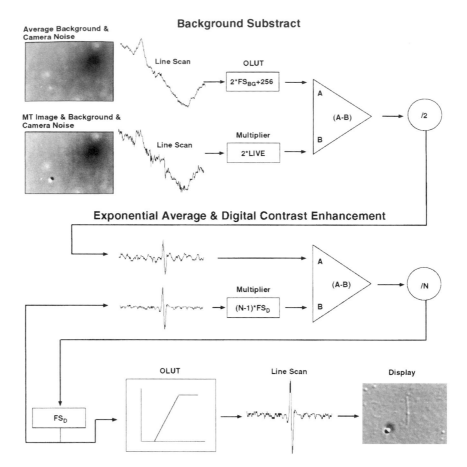

Fig. 8 Flow diagram of a real-time digital image processor. An arithmetic logic unit subtracts a background image (stored in a frame buffer) from each incoming live video frame (every 33 ms) and sets the average background intensity at 128. The resulting frame is then exponentially averaged with a fraction of the previously obtained frame and stored in a display frame buffer, FS_D. For digital contrast enhancement, the image in FS_D is passed through an output look-up table (OLUT), which converts the grayscale values of each pixel according to the function stored in the OLUT. To accomplish these operations in real-time, we use the Argus 10 or Argus 20 digital image processor from Hamamatsu Photonics, Inc. Modified from Salmon *et al.* (1989).

One particularly important design consideration is image light intensity. The image will appear too "noisy" if the image is not bright enough, and this noise is amplified by video contrast enhancement. The standard deviation of photon noise in the image is the square root of the number of photons per second, per picture element (or "pixel"). If only 100 photons are captured per pixel in a video frame, the noise will be equivalent to 10% of the brightness, and the image will appear grainy and resolution poor. If 1000 photons are captured, then the noise will be

only 3.3% of the image brightness and a much higher-quality image is achieved. The video cameras also contribute noise to the image, and it is also important that the image light is sufficiently bright so that the video signal is well above the "noise floor" for the video camera.

A number of factors in the microscope multiply each other to reduce the image light intensity, I_{image} at the camera detector. These include the brightness of the illumination; reduction of light intensity by the DIC optics as described by Eqs. (2) and (3), which can be 100-fold; the need for near-monochromatic illumination; transmission efficiency of the microscope optics including the polarizer, analyzer, filters, and lenses; magnification, M, from the specimen to the camera, which reduces light intensity by $1/M^2$, or about $1/333^2 = 1/10,000$ for the $333\times$ magnification needed in our VE-DIC microscope system to match the optical resolution to the camera detector resolution; camera exposure time, which is 1/30th second at video frame rates.

The reduction of light intensity by the DIC optics and magnification is a property of a VE-DIC microscope system properly aligned for high-resolution, high-contrast imaging. It is important not to have any further losses in light intensity by microscope components because of poor transmission efficiency, and these should be selected carefully.

The brightness of the light source required depends on the exposure time of the camera. At video frame rates, the exposure time is short, 1/30th second, and a very bright light source like a 100-watt mercury lamp with its bright peak at 546 nm is required. If time resolution can be sacrificed, then cameras that allow longer integration times on the detector can be used (Shaw *et al.*, 1995; Cole *et al.*, 1996). The longer the integration time, the less bright must be the light source for the same-quality image (assuming motion is not a problem). For example, a 600-ms exposure on the detector requires about 1/20th the brightness from the light source as is needed for video rates, and the standard 100-watt quartz halogen illuminator is suitable.

B. Microscope Components and Alignment

1. Illumination

The objective aperture must be fully and uniformly illuminated to achieve high-resolution and high-quality images (Inoué, 1989; Salmon *et al.*, 1989; Inoué and Oldenbourg, 1993). It is the high-NA rays of condenser illumination that are important for achieving the maximum resolution predicted by Eq. (2). Uneven illumination causes the image to move obliquely as one focuses through the specimen, reduces depth discrimination, and enhances out-of-focus mottle in the image. The highest-resolution objectives require oil immersion of both the objective and condenser. It is critical that there be no air bubbles in the oil and that sufficient oil is used, particularly for the condenser, so the objective aperture can be fully illuminated.

Finally, it is important the specimen field be illuminated uniformly, as uneven illumination limits the amount of contrast enhancement that can be achieved.

The Köhler method is the standard method in brightfield microscopy to achieve uniform illumination of the specimen. This is the best method for VE-DIC microscopy, and it is usually described in detail in the operating manual for the microscope. Briefly:

1. The image of the field diaphragm is adjusted by moving the condenser to be in focus and centered on the specimen.

2. The field diaphragm is closed down until only the specimen of interest is illuminated, to reduce scattered light from surrounding objects.

3. The condenser diaphragm controls the illumination NA, and the diaphragm is typically opened so that it is just visible at the peripheral edges of the objective back focal plane.

4. The image of the light source is projected in focus and centered onto the condenser diaphragm plane using adjustments of the lamp collection lens or projection optics along the illumination path.

Steps 3 and 4 are usually made using a telescope to view the objective back focal plane, where the image of the condenser diaphragm and light source should be in focus.

The light intensity in the image depends on the bias retardation as given in Eq. (3). For Δ_c near 1/20 the wavelength of green light, 546 nm, $\sin^2[2\pi(\Delta_c/2)/\lambda] = .024$. Because this value is small, and I_p is often 2.5% or less of the light intensity from the illuminator, intense illumination is needed for DIC microscopy of cellular fine structural detail and objects such as individual microtubules, which require high magnification to be resolved by the detector. In addition, monochromatic and not white light gives the highest contrast with DIC because it is an interference contrast method.

We routinely use a 100-watt mercury lamp, which has an intense line at 546 nm wavelength for high-resolution imaging at video rates (Walker *et al.*, 1990). This lamp has a very small arc, about .3 mm when new. The arc is very inhomogeneous with bright spots near the electrode tips. To achieve uniform illumination of the condenser and objective aperture with this arc, we use a fiber-optic light scrambler (Fig. 2) as developed by Ellis (1986) and available from Technical Instruments (Marine Biological Laboratory, Woods Hole, MA). The standard collector in the lamp housing is adjusted to project the light to infinity. The mirror in the back of the light housing is adjusted so the image of the arc it produces is aligned with the primary image produced by the collector lens. A second collector lens focuses this light into the end of a 1-mm-diameter quartz fiber optic. The fiber optic is bent in several 10-cm circles to scramble the light and produce uniform illumination emanating from the other end. A third collector lens at the base of the microscope (Fig. 2) projects an image of the end of the fiber-optic in focus and centered on the

condenser diaphragm. The focal length of this collector lens is selected so that the image of the fiber-optic end matches the size of the wide-open condenser diaphragm and, thus, fully fills the objective aperture when the microscope is properly adjusted for Köhler illumination.

Other intense light sources we have used for VE-DIC include a 200-watt mercury lamp, which has a large arc which can be aligned at 45° along the DIC shear direction and fill the objective aperture in that direction without the need for an optical fiber (Walker *et al.*, 1988; Salmon *et al.*, 1989). However, flickering, promoted by the large electrode separation, substantially interferes with making high-quality VE-DIC video recordings because the background light intensity fluctuates over time. We have also used a 200-watt Metal Halide lamp with a 5-mm-diameter liquid-filled optical fiber made by Nikon (Waterman-Storer *et al.*, 1995). This light source is about one-half the brightness of the 100-watt mercury lamp, but is much more stable and easy to align. Unfortunately, it is not readily available from Nikon. For the finest structural detail, like pure tubulin 25-nm-diameter microtubules (Salmon *et al.*, 1989), 21-nm filaments of sickle cell hemoglobin (Samuel *et al.*, 1990), or 15-nm-diameter bacterial flagella (Block *et al.*, 1991), the high intensity of the 100-watt mercury lamp is needed. The use of lasers as light sources has been inhibited by the mottle and speckle induced in the image by the coherence of the laser light.

For imaging with longer exposures (e.g., 600 ms, Yeh *et al.*, 1995) or lower magnifications (Skibbens *et al.*, 1993), we use a standard 100-watt quartz halogen illuminator that has a mirror housing. This light source is less than 1/10th the brightness of the 100-watt mercury source at green wavelengths. After establishing Köhler illumination, we use the lamp housing controls to position the primary image of the lamp filament on one side of the objective aperture and the mirror image of the filament on the other side, so together they just cover the objective aperture, providing illumination of both the center and the edges of the aperture. Then we slide into the light path a ground-glass filter to diffuse the light and give nearly uniform illumination of the aperture. The ground-glass filters are specially designed by the microscope manufacturer to efficiently diffuse the light without producing a large reduction in light intensity.

The above descriptions assume the Köhler illumination method. There is another method of achieving full and even illumination of the objective aperture with the mercury light source, termed "critical" illumination. By this method, the image of the arc is focused on the specimen. Illuminating light at the condenser diaphragm plane is out of focus and uniform, so the illumination criteria for high resolution [Eq. (2)] is met. However, the uniformity of intensity in the specimen plane depends on the homogeneity of the arc. If only a very small field of view is required, then the center of the arc may be homogeneous enough to work for VE-DIC, as shown by Scholey and coworkers (Scholey, 1993). This method must be applied carefully, because the DIC optics are designed for condenser alignment with illumination using the Köhler method.

2. Filters

We use a combination of Zeiss heat cut and infrared interference reflection filters to remove infrared light from the illumination. This is important for preventing damage to living cells and native preparations.

Green-light wavelengths are typically used for VE-DIC. Resolution is better for shorter wavelengths of light [Eq. (1)], but live cells and native preparations are often damaged by illumination with blue or shorter wavelengths. In addition, light scattering by out-of-focus regions of thicker specimens is much more of a problem for shorter wavelengths of light. The eye is also most sensitive to green light. For these reasons, green-light illumination is a good compromise between the resolution advantages and disadvantages of shorter wavelengths. Narrow-band green interference filters are often used for DIC microscopy to achieve the highest-contrast images. We use an interference filter with a central maximum at 546 nm and half-maximum bandwidth of 20 nm to capture the 546 mercury line (Omega 540DF40). For the quartz-halogen illumination, we use a 540-nm filter with a 40-nm bandwidth. These interference filters have peak transmission efficiencies of 85% or greater.

The heat absorption and green filters are placed in the illumination light path where the light is most parallel to the axis of the microscope. We have placed them either between the two collector lenses in the lamp (Walker *et al.*, 1990) or just before the polarizer (Fig. 2).

3. Polarizer and Analyzer

Polarizers and analyzers are made from materials that polarize light. In either case, polars are required with high transmission of plane polarized light at green wavelengths (85% or greater), a high extinction factor (1000 or greater), and high optical quality and sufficient size to match the physical size of the condenser or objective apertures.

Ideal polars can transmit 100% of incident polarized light when the plane of polarization is aligned parallel to the polarization direction of the prism, and they transmit 50% of incident unpolarized light as plane polarized light.

The extinction factor, EF, measures how well a polarizer produces or an analyzer rejects plane polarized light:

$$\text{EF} = I_c I_p, \tag{4}$$

where I_c is the light transmitted by a pair of "crossed polars" and I_p is the light transmitted when their planes of polarization are parallel.

Optical quality refers to how much the polar interferes with the quality of image formation in the microscope. The polarizer and analyzer are usually placed in positions in the microscope just below the condenser and just above the objective, where the light is more paraxial and imperfections in the polars are out of focus in

the image. The most critical component is the analyzer because its shape, thickness, and imperfections can induce geometrical aberrations that destroy image resolution.

The condenser aperture is typically about 2 cm in diameter for high-resolution ($NA_{cond} = 1.4$) illumination. The objective aperture is typically much smaller, 7 mm or less.

Polars with the highest transmission efficiency are Glan-Thompson prisms (Karl Lambrecht, Chicago, IL), which polarize light by double-refraction in calcite prisms (Inoué, 1986). These prisms can have extinction factors of 10,000 to 100,000 (Inoué, 1986). To match a condenser aperture of 2 cm requires a large prism of about 2.5 cm diameter and 6 cm long and space along the microscope axis before the condenser to insert the prism. On many conventional microscope stands this is difficult, but possible on inverted stands (Schnapp, 1986) and on optical bench stands (Inoué, 1981; Walker *et al.*, 1990). The thickness of the prism requires moving the field diaphragm farther away from the condenser than its normal position without the prism. Glan-Thompson prisms have been successfully used for the analyzer in VE-DIC (Inoué, 1981), but their thickness requires special stigmating lenses and very careful alignment. As a consequence, we use, on our optical bench VE-DIC microscope, a Glan-Thompson prism for the polarizer, but a high-quality polaroid polar for the analyzer (Walker *et al.*, 1990).

Polars made with high-quality polaroid are typically 1–3 cm in diameter and 2–3 mm thick. These polars are made with two dichroic polaroid films about 50 μm or so thick immersed between two thin optical glass flats for high optical quality. A pair of polaroid films are used so that pinholes in one film overlie polarizing material in the other. Polaroid polars with the highest extinction factors (10,000 or greater) usually have poor transmission efficiency, 15% or less of unpolarized light. Polarization contributes 50% of the attenuation whereas absorption of light in the vibration direction contributes 35% of the attenuation. When a polarizer and analyzer made from this material are aligned parallel with their vibration directions, then the maximum intensity is only $0.15 \times 0.65 = 9.8\%$ of the incident light. This reduction in light intensity often makes the light intensity at the camera too low for decent signal-to-noise in the image.

High-transmission polaroid polarizers have reduced extinction factors, 1000 or less. However, a typical extinction factor for one of our VE-DIC microscopes (Waterman-Storer *et al.*, 1995) with a 60X/NA = 1.4 Plan Apochromat objective, and matching condenser illumination is about 100 (because of the rotation of the plane of polarization at the highly curved surfaces of the 1.4-NA objective and condenser lenses; Inoué, 1986; Inoué and Oldenbourg, 1993). Thus, polars with extinction factors of about 1000 are more than sufficient, and we have selected polaroid polarizers with 35% transmission efficiency extinction factors. These are termed "high-transmission" polarizers, and they should be requested from the microscope manufacturer.

4. Objective and Condenser

For high-resolution VE-DIC we have used either (1) Zeiss 100X/1.25 NA Plan Achromat or Nikon 100X/1.4 NA Plan Apochromat objectives and matching Zeiss 1.4 NA oil condenser (Salmon *et al.*, 1989; Walker *et al.*, 1990; Skibbens *et al.*, 1993) or (2) Nikon 60X/1.4 NA Plan Apochromat Objective and matching 1.4-NA oil condenser (Waterman-Storer *et al.*, 1995). In all cases the objectives and condensers were selected to be free of birefringence caused by strain or glues in the lenses. This birefringence produces background noise and mottle, which can obscure fine structural detail no matter how much contrast enhancement is used. The Plan Achromat objectives do not quite have the resolution of the Apochromat objectives, but they have been important for our microtubule and motor protein assays at 37 °C. Heating the optics induces birefringence in the lenses, particularly the objective lenses. Eventually, heating can induce permanent birefringence, which makes the lens unsuitable for VE-DIC of fine structural detail such as individual microtubules. The Plan Achromat lenses are 1/4 the price of the Plan Apochromat lenses and are, thus, less expensive to replace. We have tried to restrict our use of the expensive Plan Apochromat lenses to studies at room temperature.

Most of our specimens we image by VE-DIC are either living cells or isolated organelles in aqueous media, and usually, focus is within $5 \mu m$ of the inner coverslip surface. This is fortunate because for oil-immersion objectives, resolution deteriorates as focus is shifted away from the inner coverslip surface. At $5 \mu m$, depth resolution is noticeably poorer than near the coverslip, and by $20 \mu m$, it is substantially deteriorated. This deteriorization in image quality occurs because of spherical aberration induced by refraction at the glass–water interface, where refraction is greater for the higher aperture rays (Keller, 1995). For specimens thicker than $10 \mu m$, it is better to switch to water-immersion objectives that have correction collars for coverslip thickness and the spherical aberration. Unfortunately, water-immersion objectives with high NAs (NA = 1.3) are expensive.

5. Beam-Splitting DIC Prisms

It is critical for VE-DIC that the effects of the condenser DIC prism be matched by the objective DIC prism. In the Nomarski design as described in Section IIA, the prisms are designed to be mounted at or near the condenser diaphragm plane and just above the objective. The prisms must be oriented correctly, with both their wedge directions at 45° to the polarizer, analyzer vibration directions. When the two prisms are aligned to extinguish the background light, no dark bar should be visible in the center of the prisms when they are viewed by a telescope by focusing on the objective back focal plane. If there is a dark bar, then the prisms are not properly matched. It is important to perform this test for pairs of objective and condenser DIC prisms to ensure that their markings and orientations are correct.

6. Stage Rotation, Centering, and Drift

A rotatable stage is useful for VE-DIC microscopy because DIC contrast is directional. Often ±45° of rotation is sufficient. It is important that either the objectives or stage be centerable so that when the stage is rotated, the specimen stays centered.

Another critical parameter is the stability of the stage. For long-term high-resolution VE-DIC recordings, stage drift should be minimal because z-axis depth-of-focus is often near 300 nm (Inoué, 1989). The stage on our optical bench microscope (Walker *et al.*, 1990), for example, is fixed, and the objective is moved to focus. This is a very stable configuration, and drift is less than 0.3 μm/hour. On our upright microscope stands, the objective is fixed and the stage is moved to focus. Drift has been a major problem, and on one stand, it can be several micrometers per hour. Nevertheless, for VE-DIC it is critical to check that focus is stable for long-term recordings.

7. Compensation Methods

Our microscope stands currently use translation of the objective DIC prism (see Section II,A) to vary retardation and image brightness and contrast. This works fine, but the amount of compensation must always be judged by eye. The preferred method is to use deSenarmont compensation with degrees of rotation of the polar, marked so that the operator can accurately set the amount of retardation.

8. Slides, Coverslips, and Other Specimen Chambers

For dry objectives, number 1.5 coverslips are used because these are near the 0.17-mm thickness specified in objective lens design to correct for geometrical aberrations (Inoué and Oldenbourg, 1993). For oil-immersion objectives, we use number 1 coverslips, which are a bit thinner than number 1.5 coverslips and give the objective more working distance between its front lens element and the coverslip outer surface.

For the best images, coverslips should be cleaned to remove dirt and oil. Coverslips are placed in a beaker full of detergent solution (Alconox, Alconox, Inc., New York, NY), which is in turn placed in an ultrasonic cleaner (Mettler Electronics model ME2.1, Anaheim, CA). After 15 minutes, the coverslips are rinsed for 20 minutes in running tap water. The coverslips are then placed in a specially designed box that holds the coverslips upright and separate so that their surfaces do not touch. This box is placed in the ultrasonic cleaner, agitated for 15 min, and rinsed with five washes of distilled water. The agitation and rinse is repeated twice, and the coverslips are then placed in a beaker of 100% ethanol and returned to the ultrasonic washer for 15 minutes of agitation. Coverslips are then rinsed twice in ethanol and stored one by one in a covered beaker of fresh ethanol. Before use, the coverslips are placed on a custom spinner (Inoué, 1986, p. 143) and

spun dry. Slide surfaces are cleaned by wiping them with Kimwipe soaked in 70% ethanol and then air dried.

We often use Scotch double-sided tape to make perfusion chambers or as spacers in standard slide coverslip preparations. The tape is about 70 μm thick. A razor blade or scissors is used to cut strips that are placed on opposite sides of the slide. The coverslip and preparation are added, and then the coverslip is sealed along the open edges using VALOP (1:1:1 mixture of vasoline, lanolin, and parafin).

A key parameter to consider for specimen chambers for high-resolution VE-DIC is that the optical path through the chamber and specimen must be equivalent to that of a standard slide coverslip preparation. The slide is 1-mm-thick glass of refractive index 1.52, so its optical path, OP, equals 1.52 × 1 mm. Chambers we have used in addition to the double-sided tape chambers include Berg and Block perfusion chamber (Berg and Block, 1984), and a McGee-Russel perfusion and fixation chamber (Waters *et al.*, 1996).

For temperature control we have used either temperature-controlled rooms for temperatures between 20° and 28 °C or placed a large plastic bag around the stage of the microscope, excluding the cameras and illuminators, and warming the stage to 37 °C with an air-curtain incubator (Walker *et al.*, 1989).

9. Magnification to the Camera Detector

The total magnification between the objective and detector in the camera must be sufficient so that resolution is not limited by the detector, video camera, digital image processor, or recording device. Detectors vary in their size and, hence, the size of their pixel elements. For the 1-inch diagonal Newvicon and Chalnicon video detectors, we use a total magnification of 3.5× to 4× produced by the combination of the magnifier in the Optivar in the body tube and a projection adaptor to the C-amount for the camera. For the smaller charge-coupled device (CCD) video detectors, the necessary magnification is less than 4× depending on chip size: Only 2× is needed for the 1/2-inch chip.

Often, however, it is not the camera that is resolution limiting, but the digital image processor or video recorder. Thus, it is essential to test each video system to determine the suitable magnification required using the diatom test plate or cheek cell test specimens described in Section V,A.

Remember, as magnification increases, the field of view decreases as $1/M$ and the intensity decreases as $1/M^2$.

10. Vibration Isolation

Any vibration of the image reduces resolution. Air-tables (Fig. 2, Newport Corp., Irvine CA, Model No. VW-3660 with 4-inch-high table top) or other means of vibration isolation (Salmon *et al.*, 1990) are essential for high-resolution VE-DIC microscopy.

C. Video Components

1. Camera and Analog Processor

Cameras with 800 or more horizontal television-line resolution, low lag, low shading, low geometrical distortion, high image stability, high linearity, and superior signal-to-noise characteristics are desired for VE-DIC microscopy. Such cameras are usually distinct from the intensified video cameras or slow-scan cooled CCD cameras used for low-light-level imaging to render visible images generated by only a few photons (Inoué, 1986). We have found that research-grade cameras using either the Newvicon or Chalnicon tubes (DAGE-MTI model 1000 and Hamamatsu model C2400) give excellent performance and low noise for the very high contrast VE-DIC needed to see single microtubules (Salmon et al., 1989, 1990).

The horizontal resolution of these cameras, 800 television lines, is two- to threefold better than the vertical resolution of a video image with 480 active television lines because of aliasing, as described in Section III,A. To maximize resolution in the video image in the direction of maximum contrast in the DIC image, the camera should be rotated to align the horizontal–line scan direction in the camera with the direction of shear in the DIC image.

Research video-rate CCD cameras (DAGE-MTI model 72 or Hamamatsu model 75i) also give good images with VE-DIC, but their horizontal resolution has not been as good, and their noise level has been somewhat higher than the research-grade Newvicon or Chalnicon tube cameras. Resolution in CCD cameras is determined by the number of detectors in the horizontal and vertical direction, typically 860×480 in the research-grade chips, and horizontal resolution is $0.7 \times 860 = 600$ television lines, somewhat less than the 800 television lines for the tube cameras for the same field of view. New chips with more pixels and better noise characteristics will eventually replace the Newvicon and Chalnicon detectors.

One advantage of the video CCD cameras is that they have much lower lag than the tube cameras, but on-chip integration can be used to improve sensitivity when time resolution can be sacrificed (see Shaw et al., 1995; Cole et al., 1995). This requires some form of computer control either by electronics built into the camera itself (Cole et al., 1995) or by associated image processing systems (Shaw et al., 1995).

The research-grade camera controllers can have several other features useful for VE-DIC. An "idiot" light tells the operator that the video signal is in the right range: not too dim and not so bright that it saturates the detector input amplifier. The analog gain and pedestal controls are easily adjustable to achieve optimum analog contrast. Some controllers also have an automatic gain control to eliminate image flicker resulting from changes in line voltage, lamp flicker, and so on. In addition, controls are available to manually correct for shading at high contrast produced by uneven illumination or by slightly mismatched DIC prisms. We needed to use these shading correctors when we used a Nikon 100X/NA = 1.4

Plan Apochromat objective with Zeiss 100X Plan Achromat DIC optics in our high-resolution studies of kinetochore motility in vertebrate epithelial cells (Skibbens *et al.*, 1993). We called this "Zikon" DIC optics. When this shading is corrected by these analog controllers, then much higher analog contrast enhancement can be achieved before the bright and dark regions of the image exceed the dynamic range of the video electronics (Fig. 8).

2. Digital Image Processor

Initially, we built our own image-processing equipment to perform background subtraction and exponential averaging algorithms (Fig. 8) at video rates (30 frames/second) (Walker *et al.*, 1988; Cassimeris *et al.*, 1989; Salmon *et al.*, 1989). To date there are a number of commercial devices that provide similar functions. These include the Argus 10 and Argus 20 processors from Hamamatsu, DSP2000 from DAGE-MTI, and MetaMorph from Universal Imaging. These real-time processors need to have several frame buffers and at least two arithmetic processors; simple image capture boards or processors with one arithmetic unit will not do the job at video rates. The processors from Hamamatsu and DAGE-MTI do not require computer workstations, but they can output images either by video cable or digital images by SCSI cable to digital-imaging workstations for digital photography (Shaw *et al.*, 1995) or storage to disk. The MetaMorph system resides in a digital-imaging computer workstation, and video images are captured and processed using a plug-in video card and digital imaging software in the computer.

The resolution of the digital image processing depends on the number of pixels per horizontal line in the frame store buffers in the processors. Many processors, such as the Argus 10, generate digital images that are 512×480 pixel images, and the 640×480 processors used in the PC computers have about half the horizontal resolution of video cameras. The Argus 20 has higher horizontal resolution, producing 1000×480 pixel images, so that the digitization process does not reduce image resolution. Images can be transferred to a computer through a SCSI port.

In addition to video contrast enhancement, some of the image processors have numerous other useful features including position, length and area measurement, intensity measurement, and annotation of images.

3. Time-Date Generator

We use a Panasonic model WJ-810 time-date generator to write the date, hour, minute, and second on each image. The size and position in the video frame of the time-date display is adjustable. A stopwatch can also be displayed that shows on each frame the hours, minutes, seconds, and milliseconds from the time the timer is started. The millisecond display allows identification of each frame when recorded video is played back frame-by-frame.

4. VCRs, OMDRs, Monitors, and Video Printers

VE-DIC requires monochrome recording and display devices; color is not required. Standard 1/2-inch VHS cassette recorders have too poor resolution (about 230 television line horizontal resolution) for high-resolution VE-DIC images.

S-VHS divides the video signal during recording into the luminance (monochrome intensity) and chromance (color information) signals. We use the luminance channel for recording and playback. S-VHS 1/2-inch cassette recorders have about 400–450 television lines of horizontal resolution. These are the preferred video recorders in our lab at this time, and we use a Panasonic model AG1980P for real-time recording and a model AG6750A for time-lapse recording.

Previously we used monochrome 3/4-inch U-Matic tape recorders (Sony VO 5800H). These recorders also have about 450–500 television lines of horizontal resolution and somewhat lower noise in the tape recordings (Salmon *et al.*, 1989; 1990). The 3/4-inch video cassettes are much larger and more expensive than the 1/2-inch S-VHS cassettes.

For time-lapse recording, we use an Optical Memory Disk Recorder (OMDR). Ours is an older model, a monochrome device with 450–television line horizontal resolution (Panasonic Model TQ2028). It can store about 16,000 images on one disk at video rates or at any slower speed. It can play back the images at any speed. The OMDR is usually controlled for either recording or playback by a host computer that also controls shutters on the microscope (Shaw *et al.*, 1995). Both Sony and Panasonic offer newer models of OMDRs that use disks that store about 75,000 video images. A PC computer and custom software controls image acquisition and a shutter placed before the filters and polarizer as described by Skibbens *et al.* (1993) and Yeh *et al.* (1995).

OMDRs are very useful for measuring object motility from successive video images either by using a cursor overlaid on the video image and controller by a computer mouse (Walker *et al.*, 1988) or using semiautomatic tracking algorithms and computer processing (Gelles *et al.*, 1988; Skibbens *et al.*, 1993; Yeh *et al.*, 1995).

We routinely use Panasonic WV-5410 B&W video monitors. Video printers capture a video image and produce a print. An inexpensive printer we have used often in analysis of VE-DIC micrographs is the Sony model UP870MD, which produces a thermal print about 4 × 6 in size for $0.01 per print. Other printers are available from a number of companies that produce either larger thermal prints or photographic prints.

5. Digital Storage and Digital Photography

Methods for acquiring and manipulating VE-DIC images for publication are described by Shaw *et al.* (1995).

V. Test Specimens for Microscope and Video Performance

A. Diatom Test Slide

This slide tests the resolution of the microscope and video system. Diatoms have a silica shell shaped like a pillbox. There are pores in the shell arranged in a lattice specific for each species of diatom. Figure 9A shows a low-magnification view of the eight diatoms in the center of the diatom test slide. Number 6, *Pleurosigma angulatum*, has a triangular pore lattice with spacings of 0.61 μm between rows (Fig. 9D). Number 5 is *Surrella gemma*, which has rows of pores where the rows are separated by 0.41 μm (Fig. 9C). Number 8 is *Amphipleura pellucida*, which has horizontal rows of pores. The rows are separated by about 0.25 μm (Fig. 9B), and the pores within rows are separated by about 0.19 μm. For illumination with 546-nm green light, a properly aligned high-resolution VE-DIC system should readily resolve the rows of pores in *Amphipleura* (Fig. 9B), and the individual pores should be barely detectable as Eq. (1) predicts a resolution limit

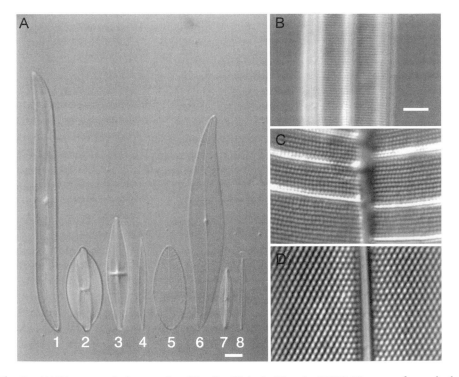

Fig. 9 (A) Diatom resolution test plate (Carolina Biological Supply, B25D). The rows of pores in the silica shell are spaced by about 0.25 μm in *Amphipleura pellucida* (A8, B), 0.41 μm in *Surrella gemma* (A5, C), and 0.62 μm in *Pleurosigma angulatum* (A6, C). Scale bar in (A) is 10 μm and in (B), (C), and (D) is 2.5 μm.

of $r = .546/(1.4 + 1.4) = .195 \, \mu m$ for $NA_{obj} = NA_{cond} = 1.4$. The pores can be seen distinctly by using blue light at 480 nm, where $r = .17$ from Eq. (1).

The diatoms are not low-contrast specimens. The pore lattice of each species if resolvable by the microscope optics is usually distinctly visible by eye. The main exception is visualizing the individual pores in the shell of *Amphipleura*. Because they are just at the limit of resolution for the highest-NA optics, their contrast is very low and contrast enhancement by the video methods is necessary.

An important use of the diatom test slide is to test the resolution of the video system. The eye usually has much better resolution than the video cameras for the same field of view. At low magnifications, it is common for the pore lattice of diatoms to be distinctly visible by eye but invisible by the video camera because of the poorer resolution of the video system. The diatom test slide is a convenient way to determine how much projection magnification is needed for the video camera so that it does not limit resolution. Magnification beyond this point deteriorates image quality because intensity drops off as $1/M^2$.

B. Squamous Cheek Cell

Another resolution test for the video camera and the alignment of the DIC optics are squamous epithelial cells scraped from your cheek (Fig. 10). The preparation is made by scraping the inside of your cheek with the tip of a plastic pipette or similar tool and spreading the cells and saliva on the center of a clean number 1.5 22 × 22-mm coverslip. The coverslip is quickly inverted on a clean slide and pressed down to spread the cell preparation into a thin layer. The edges of the coverslip are sealed with a thin layer of nail polish. As seen in the low-magnification

Fig. 10 Human cheek cell test specimen. (A) Low magnification of cheek cell preparation taken with 20 × objective. Scale = 20 μm. (B) High-resolution view of the surface of the cell at top of (A) using 60 ×/NA = 1.4 Plan Apochromat objective and matching condenser illumination. Ridges at cell surface are often diffraction limited in width. Scale = 5 μm.

view in Fig. 10A, the cheek cells are large and flat with the nucleus in the center. The upper and lower surfaces have fine ridges, which swirl around much like fingerprints. Many of the ridges are diffraction-limited in width and separated by about 0.5–1 μm. If the microscope is aligned properly, these ridges should be distinctly visible by eye and appear in high contrast by VE-DIC using high-resolution optics (Fig. 10B). The cheek cells are also a good test for the optical sectioning capabilities of the microscope as they are about 2–3 μm thick near the periphery.

C. Embedded Skeletal Muscle Thin Section

This specimen (Inoué, 1986) tests both the resolution and video contrast enhancement capabilities of the VE-DIC system and is available from the Microscope Facility (Marine Biological Laboratory, Woods Hole, MA).

Frog sartorious muscle is fixed and embedded in epon and 100- or 300-nm thin sections cut with a microtome. These sections are placed on the inner surface of a

Fig. 11 Embedded 100-nm thin section of frog sartorius skeletal muscle. (A) View by eye in DIC microscope. (B) VE-DIC image of same field as (A). See text for details. Scale = 5 μm.

clean number 1.5 coverslip in the center between two black India ink dots that are also on the inner surface of the coverslip. The coverslip is inverted onto a tiny drop of unpolymerized epon in the center of a clean glass slide, and the whole preparation is placed in an oven to polymerize the epon. In this process, the epon spreads into a thin layer and the muscle becomes embedded in a near-uniform layer of epon. The thin muscle sections are usually not visible by eye in the DIC microscope (Fig. 11A) because the refractive index of epon nearly matches the refractive index of the protein in the muscle. Sometimes, wrinkles in the sections are visible by eye, and this helps in finding the sections. The best way to find the sections is to first focus on the inner edge of one of the black dots. Then, using VE-DIC, scan the coverslip in a direction between the dots until the sections are found. When the DIC compensation, orientation of the specimen, and video-enhanced contrast are adjusted properly, you should be able to see clearly the sarcomere structure of skeletal muscle (Fig. 11B). The sarcomeres repeat at about 2.5-μm intervals (dependent on muscle stretch) along the length of the 1-μm-diameter myofibrils. In the middle of each sarcomere are the bipolar thick filaments, which appear thicker toward their ends because of the presence of the myosin heads. At the ends of the sarcomere are the z-disks. The actin thin filaments attach to the z-disks and extend into and interdigitate with the myosin thick filaments. There appears to be a gap between the z-disks and the ends of the myosin thick filaments because the actin thin filaments are lower in density than the myosin thick filaments.

References

Allen, R. D., and Allen, N. S. (1983). *J. Microsc.* **129,** 3–17.

Allen, R. D., Allen, N. S., and Travis, J. L. (1981a). *Cell Motil.* **1,** 291–302.

Allen, R. D., David, G. B., and Nomarski, G. (1969). *Z. Wiss. Mikf. Microtech.* **69,** 193–221.

Allen, R. D., Travis, J. L., Allen, N. S., and Yilmaz, H. (1981b). *Cell Motil.* **1,** 275–290.

Bennett, H. S. (1950). *In* "Handbook of Microscopical Technique" (C. E. McClung, ed.), pp. 591–677. Hoeber, New York.

Berg, H. C., and Block, S. M. (1984). *J. Gen. Microbiol.* **130,** 2915–2920.

Block, S. M., Blair, D. F., and Berg, H. C. (1991). *J. Bact.* **173,** 933–936.

Cassimeris, L. U., Pryer, N. K., and Salmon, E. D. (1989). *J. Cell Biol.* **107,** 2223–2231.

CLMIB Staff(1995). *Am. Lab.* **April,** 25–40.

Cole, R. W., Khodjakov, A., Wright, W. H., and Rieder, C. (1995). *J. Micros. Soc. Amer.* **1,** 203–215.

Ellis, G. W. (1985). *J. Cell Biol.* **101,** 83a.

Gelles, J., Schnapp, B. J., and Sheetz, M. P. (1988). *Nature* **331,** 450–453.

Gliksman, N. R., Parsons, S. F., and Salmon, E. D. (1992). *J. Cell Biol.* **5,** 1271–1276.

Inoué, S. (1981). *J. Cell Biol.* **89,** 346–356.

Inoué, S. (1986). "Video Microscopy." Plenum, New York.

Inoué, S. (1989). *Methods in Cell Biol.* **30,** 85–112.

Inoué, S., and Oldenbourg, R. (1993). *In* "Handbook of Optics" (Optical Society of America, ed.), 2nd Ed., McGraw Hill, New York.

Inoué, S., and Salmon, E. D. (1995). *Mol. Biol. Cell* **6,** 1619–1640.

Inoué, S., and Spring, K. (1997). "Video Microscopy." 2nd Ed., Plenum Press, New York.

Keller, H. E. (1995). *In* "Handbook of Biological Confocal Microscopy" (J. B. Pawley, ed.), pp. 111–126. Plenum, New York.

Kuo, S. C., and Sheetz, M. P. (1992). *Trends Cell Biol.* **2,** 116–118.

Kuo, S. C., and Sheetz, M. P. (1993). *Science* **260,** 232–234.

Pluta, M. (1989). "Advanced Light Microscopy; Vol. II: Specialized Methods." Elsevier, Amsterdam.

Salmon, E. D. (1995). *Trends Cell Biol.* **5,** 154–158.

Salmon, E. D., Walker, R. A., and Pryer, N. K. (1989). *Bio Techniques* **7,** 624–633.

Samuel, R. E., Salmon, E. D., and Briehl, R. W. (1990). *Nature* **345,** 833–835.

Schnapp, B. J. (1986). *Meth. Enzymol.* **134,** 561–573.

Scholey, J. M., (ed.) (1993). *Methods Cell Biol.* **39,** 1–292.

Schotten, D. (1993). "Electronic Light Microscopy." Wiley-Liss, New York.

Shaw, S. L., Salmon, E. D., and Quatrano, R. S. (1995). *Bio Techniques* **19,** 946–955.

Skibbens, R. V., Skeen, V. P., and Salmon, E. D. (1993). *J. Cell Biol.* **122,** 859–875.

Smith, F. H. (1995). *Research (London)* **8,** 385–395.

Spencer, M. (1982). "Fundamentals of Light Microscopy." Cambridge University Press, London.

Svoboda, K., and Block, S. M. (1994). *Cell* **77,** 773–784.

Svoboda, K., Schmidt, C. F., Schnapp, B. J., and Block, S. M. (1993). *Nature* **365,** 721–727.

Thomas, C., DeVries, P., Hardin, J., and White, J. (1996). *Science* **273,** 603–607.

Walker, R. A., Gliksman, N. R., and Salmon, E. D. (1990). *In* "Optical Microscopy for Biology" (B. Herman and K. Jacobson, eds.), pp. 395–407. Wiley-Liss, New York.

Walker, R. A., Inoué, S., and Salmon, E. D. (1989). *J. Cell Biol.* **108,** 931–937.

Walker, R. A., O'Brien, E. T., Pryer, N. K., Soboeiro, M., Voter, W. A., Erickson, H. P., and Salmon, E. D. (1988). *J. Cell Biol.* **107,** 1437–1448.

Waters, J. C., Mitchison, T. J., Rieder, C. L., and Salmon, E. D. (1996). *Mol. Biol. Cell* **7,** 1547–1558.

Waterman-Storer, C. M., Gregory, J., Parsons, S. F., and Salmon, E. D. (1995). *J. Cell Biol.* **5,** 1161–1169.

Weiss, D. G., Maile, W., and Wick, R. A. (1989). *In* "Light Microscopy in Biology: A Practical Approach" (A. J. Lacey, ed.), pp. 221–278.

White, J. (1996). *Science*.

Yeh, E., Skibbens, R. V, Cheng, J. W., Salmon, E. D., and Bloom, K. (1995). *J. Cell Biol.* **130,** 687–700.

CHAPTER 15

Quantitative Digital and Video Microscopy

David E. Wolf

Sensor Technologies LLC
Shrewsbury, Massachusetts 01545

XXXIII

There was the Door to which I found no Key:
There was the Veil through which I could not see:
Some little talk awhile of Me and Thee
There was—and then no more of Thee and Me.

XXXIV

Then to the rolling Heav'n itself I cried,
Asking, "What Lamp had Destiny to guide
Her little Children stumbling in the Dark?"
And—"A blind Understanding!" Heav'n replied.

The Rubyat of Omar Kayham, Charles Fitzgera

I. What Is an Image?

Several years ago I was presenting a lecture on the "Physical Optics of Image Formation" and one of the wise sages of microscopy asked me "What is my definition of an image?" This question has an answer that is at the core of the subject of quantitative video microscopy. My response was to go to the blackboard and draw something like what is shown in Fig. 1. "This is essentially the old engineering problem of the black box. The microscope and all of our fancy video imaging instrumentation form a black box. Into the black box we put a signal—reality. The black box transforms reality and out comes our image. So the image is the transformation of reality. If we call reality $R(x,y)$ with x and y the coordinates in object space, the transformation T, and the image $I(x',y')$ with x' and y' the coordinates in image space, then

$$I(x',y') = T * R(x,y)."$$ (1)

The reader will, perhaps, see a similarity between this and the problem of the Fourier transform discussed in Chapter 2, Appendix I. Indeed, as is the case of the Inverse Fourier Transform, our job is to determine the inverse transform T^{-1} such that

$$R(x,y) = T^{-1} * I(x',y').$$ (2)

What I was saying is that the goal is to determine how the optics and electronics distort important aspects of the true object and produce the image. We need to

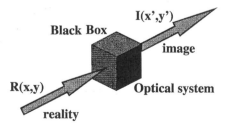

Fig. 1 Optical systems as block boxes. Optical systems can be treated as black boxes. Reality in this case is a two-dimensional set of intensities: $R(x,y)$ enters the optical system and is transformed or distorted to produce the image $I(x',y')$. The goal of the video microscopist is to understand the mathematical rules of the transformation so that one can go backward from $I(x',y')$ to $R(x,y)$.

know this so that we can digitally reverse the distortion and correctly define the properties of the object. When I say that we need to know how the distortion takes place, I do not mean that we need to follow mathematically the tortuous route of light through the system. Rather we need to empirically define the transformation. As a simple example, suppose that you are concerned about the intensity of objects. If you put a signal through the system with a given intensity and then double the intensity, does the intensity of the image also double?

You will also note that I have used a cryptic $*$ in defining the process of transformation in Eq. (1). This is because different properties transform in different ways. They are not always linear and, as anyone who has meditated upon transcendental functions for any length of time knows, not always analytically reversible. However, as my quantum mechanics professor once pointed out to me: "This is the age of computers!" That, after all, is what we are talking about here, taking an image and converting it digitally by computer processing to reality.

II. What Kind of Quantitative Information Do You Want?

The particular kind of quantitative information that you want obviously depends on the experiment you are doing. I have tried to list some of these out in Table I. Basically, these fall into two categories: those that require critical assessment of spatial relationships within an image and those that require critical assessment of intensity relationships.

III. Applications Requiring Spatial Corrections

A. Maximizing Resolution before You Start

Let's begin with the issue of obtaining accurate spatial information. In Table I we have distinguished between information above and information below the classical resolution of the microscope. A good place to begin is to discuss how

Table I
Categories of Quantitative Microscopy Applications

Applications requiring spatial corrections
 1. I need to accurately know the position of objects within the resolution limit.
 2. I need to accurately know the position of objects below the resolution limit.
 3. I need to extract from my image the finest resolution possible.
 4. I need to determine color coincidence within an image.

Applications requiring intensity corrections
 1. I need to know the relative intensity between points in an image.
 2. I need to know the absolute intensity at different points in an image.
 3. I need to know the spatial distribution of intensities at two or more wavelengths.

resolution is classically defined. A complete discussion of this subject is outside of the scope of this chapter, and I refer the reader to Chapter 2. For our purposes, let us first follow our intuition, which tells us that resolution, defined as the smallest distance, r, between which two self-luminous points would still be distinguishable, should be related to wavelength. We then define the Rayleigh diffraction limit r as

$$r = .61 \, \lambda/\mathrm{NA}_{\mathrm{obj}}, \tag{3}$$

where $\mathrm{NA}_{\mathrm{obj}}$ is the numerical aperture of your objective (you will find it written on the barrel of the objective). For a brightfield application, the NA of the condenser, $\mathrm{NA}_{\mathrm{cond}}$ also factors in, and Eq. (3) becomes

$$r = 1.22 \, \lambda/(\mathrm{NA}_{\mathrm{obj}} + \mathrm{NA}_{\mathrm{cond}}). \tag{4}$$

What this tells you is that for 500-nm light and for an objective with a NA $= 1.4$ objective at, say, 500 nm, the resolution is going to be around .2 μm.

A striking point is that resolution does not involve any eyepiece or camera projection lens. These contribute what is called "empty magnification." They make images bigger but do not contribute any added detail.

Empty magnification can, in fact, be really important in digital imaging applications. Digital detectors can be thought of as arrays of individual pixel detectors. These are separated by some distance. Recognize that at the detector surface the resolution limit r in the object plane maps to a distance R, where

$$R = r \times (\text{objective magnification}) \times (\text{empty magnifcation}). \tag{5}$$

It is critical that this R be significantly greater than the interpixel distance. If it isn't, your camera is going to reduce the resolution of your microscope.

What do we mean by the phrase "significantly greater?" This is actually a difficult question to answer. If resolution is the most critical thing in your application, then I might suggest that R be at least 10 times the interpixel distance. However, there are other considerations. First, image intensity scales as the inverse of the magnification squared. If you start with light in a single pixel and then spread it out over a square 10 pixels on a side, then each pixel is going to be 1/100th as bright. Second, if .2 μm is spread out over 10 pixels and you have a 1000×1000-pixel array, then the image is going to only cover a $20 \times 20 \, \mu$m area of your sample. This might not suit your application. The moral is that you have to make compromises between the need for greater intensity, the need for resolution, and the need to see your object.

B. Aspect Ratio

Before going any further, I want to warn you about aspect ratio. You are probably going to want to measure the magnification of your system. Take a stage reticule and image it through your system. Then determine the number of pixels between two points of known distance on the reticule's rulings. This tells you the

interpixel distance projected back down to object space. Now do the same calibration vertically. Do you get the same number? Sometimes you don't. This usually relates to whether your camera and video frameboard (this is the computer board where your image processor stores an image) are assuming the same aspect ratio. For instance, trouble arises if your camera has square pixels and the frameboard assumes they are rectangular. The image becomes elongated in one dimension. Circles become ellipses and squares become rectangles. This has become less of a problem with the modern generation of digital cameras, which transfer an array of digital data directly into computer memory.

Most often this problem arises when you are transforming from one system to another. For instance, your confocal microscope might assume square pixels and portray geometrically correct images on the computer screen display. But try to move this data digitally into a video printer, which assumes it is working with the standard rectangular aspect ratio of conventional video signals, and distortions arise.

Some of you will have a problem in performing the above calibration. You will find that horizontal in the microscope does not translate to horizontal in the video system. Moving along a horizontal line in the object plane also moves you vertically in the video plane. The simple solution to this is to rotate your camera until the video-plane horizontal and vertical match perfectly with the object-plane horizontal and vertical. If you can't manually rotate the system, read on. I describe below how to digitally rotate images.

Recognize also that in some systems, because the detector pixels are rectangular, the interpixel distance will be smaller in one direction. This results in the resolution being greater in that direction. If your structures of interest line up in a particular direction, then you can maximize resolution in that direction again by the simple expediency of rotating the camera.

C. Image Translation

Now that you have optimized resolution and been warned about aspect ratio, you are ready to look at all of the other nasty things your optical system can do to your image. Let's start off with something simple. Suppose that you image a submicron fluorescent bead that you have positioned dead center in your microscope. Will it be at the center of your image? Probably not.

This may or may not matter to you. When it tends to be a real problem is when you are concerned with issues like color coincidence. Different colors tend to be shifted by different amounts, and proper registration can only be achieved by making at least a relative correction for these shifts. In addition, as already noted, this represents a first simple example, which leads us into the more complicated issue of nonlinear distortions.

As a practical matter, you might take a two-color bead and measure its position with one filter set and then with another. This will give you the shifts for each filter set. The issue will be whether the shifts are the same for the two colors. They

are probably not. Armed with the relative shifts, you are in a position to shift one image relative to the other and therefore to bring them back into coincidence.

In general terms (see Fig. 2), if a bead is in position (x,y) in object space, its location will shift off in going to image space and will settle in at position (x',y'). Usually these shifts are small and can be described by a simple pair of linear equations, such as

$$x' = x + a, \tag{6}$$

and

$$y' = y + b, \tag{7}$$

where a and b are constants. As already noted, this kind of correction becomes really important in applications such as color registration. Typically the as and bs will be wavelength dependent, especially if you are changing wavelengths by shifting filter cubes. In addition, you cannot assume *a priori* that these shifts are independent of where in the object you are. The shifts may be greater at the edges of the image than at the center.

Equations (6) and (7) are easily inverted to obtain x and y. That, after all, is our goal: We want to know how a position in the image (x',y') translates to a position in the plane of the object. We have that

$$x = x' - a, \tag{8}$$

and

$$y = y' - b. \tag{9}$$

D. Image Rotation

Above, I described the situation in which the camera's horizontal and vertical did not match the object's horizontal and vertical. I suggested the simple solution of carefully rotating your camera. This might not always be convenient. Alternatively, you might have a specific need to rotate an image about the center

Fig. 2 Linear transformation. One form of transformation in an optical system is linear translation. Here, we show a hypothetical bead at coordinate (0,0) in the reality or object plane. The optical system translates the bead to coordinate (*a*,*b*) in the image.

of the field. This can be done using a very similar process to that described for point translation in Eqs. (4) to (7). We will again use the convention that (x,y) describes the position in the object space and (x',y') describes the position in the image space (see Fig. 3). If the image is rotated by an angle θ relative to the object, we have that

$$x' = x\cos\theta + y\sin\theta, \qquad (10)$$
$$y' = y\cos\theta - x\sin\theta. \qquad (11)$$

On inversion, Eqs. (10) and (11) become

$$x = x'\cos\theta + y'\sin\theta, \qquad (12)$$
$$y = x'\sin\theta - y'\cos\theta. \qquad (13)$$

Of course, in a real world, you are liable to find a combination of translation and rotation, so the inversion becomes slightly more involved.

E. Image Warping

We are now in a position to consider what happens when we image a rectilinear pattern like a hemacytometer grid through a microscope and video system. Typically, rectilinear patterns are not transmitted true through the "black box" of your optical system. Figure 4 illustrates the two most common results: pincushion and barrel distortion. These distortions are not really surprising as, despite the best efforts of microscope designers, optical systems tend to focus to curved rather than planar surfaces, and the detector of your digital camera is more or less flat. You may also note that the edges of the image are slightly out of focus. My calculus teacher taught me that "a sphere is not isomorphic to a plane." That means that if you cut a rubber ball in half and try to flatten it out perfectly you will never succeed. So you can't flatten a curved image surface to a flat detector surface without distortion.

Fig. 3 Rotational translation. Optical systems can also rotate. Here, the optical system rotates the object through an angle of θ so that a point with coordinates (x,y) in the object is located at (x',y') in the image.

Fig. 4 Pincushioning and barrel distortion. Because optical systems tend to focus to curved rather than to planar surfaces, rectilinear patterns in the object plane tend to produce "pincushioned" or "barrel-distorted" images. These can be corrected for as described in the text.

The implications of warping can be very disturbing. Implicit in warping is the fact that magnification changes with position in your image. Also, if warping is different for different wavelengths, then the magnification becomes wavelength or color dependent.

The bad news here is that we do not live in a linear world. The good news is that in a digital world we can easily deal with distortions like that of Fig. 4. So the next question is, How does one correct for this type of distortion?

1. Ignoring the Problem

First some practical advice: Be aware that in some cases you can ignore this kind of distortion. Determine over what area of the center of the field this distortion remains less than a pixel. If you stay within that area, you can safely ignore it for most purposes.

2. Dewarping Algorithms

Many image-processing software packages come with "canned" software to dewarp an image. You should always make the effort to understand what the algorithm is doing. In the end, you are the judge of the validity of a particular algorithm for your applications.

An example of a dewarping algorithm is polynomial dewarping. This is a logical step up from a linear transformation. The idea is to assume that the shape of the distorted pattern in image space is a generalized polynomial of the rectilinear pattern of the object. For most purpose, a second-order polynomial will suffice. Again following our convention, the image coordinates (x', y') that correspond to a point in the object plane are given by

$$x' = a + bx + cy + dx^2 + exy + fy^2, \qquad (14)$$

$$y' = A + Bx + Cy + Dx^2 + Exy + Fy^2, \qquad (15)$$

where a, b, c, d, e, f, A, B, C, D, E, and F are constants. Because each point in object space has two coordinates, these 12 constants are determined by choosing six points in object space and measuring the values of (x',y') in the image. Typically, these points are chosen to be major intersections of your rectilinear grid; Eqs. (14) and (15) then enable you to calculate the constants. For example, suppose you use the point you define as the origin in the object plane, that is, $(x,y) = (0,0)$, which maps to a point (x',y') in the image plane, then Eqs. (14) and (15) tell us that $a = x'$ and $A = y'$, respectively.

Once the constants are determined, you are ready to dewarp your image. As in the cases of translation and rotation, this requires inversion of Eqs. (14) and (15). This looks like an algebraic nightmare. This is because it is. However, the fact is that there are several readily available symbolic language software packages, such as Mathematica, that can do this for you. Not only will they solve this equation for you, but many of them will generate software in your favorite computer language to do the calculating for you. This is not meant to be facetious. Modern personal computers have gotten so fast that imaging calculations like this, which a few years ago required array processors to accomplish in reasonable time, can now be accomplished in the blink of an eye.

IV. Two-Camera and Two-Color Imaging

With the popularity of ratio imaging, one is often confronted by the problem of processing images from two cameras or two colors. In both of these cases the images are not in perfect registration, and there tend to be magnification differences. This is in fact a very similar situation to the warping problem. The same generalized polynomial dewarping algorithm can be used to map an image obtained with one camera onto that obtained with the other. This is, in fact, one of the most common uses of dewarping algorithms.

V. A Warning About Transformations—Don't Transform Away What You Are Trying to Measure!

My goal so far has been to introduce the concept of digitally correcting your images. I have tried to focus on some of the more critical types of transformation. For a much more in-depth discussion of image processing, I refer you to Chapters 11–19 in this volume and to several specialized texts (Baxes, 1984; Castleman, 1979; Pratt, 1991; Taylor and Wang, 1989; Wang and Taylor, 1989). Recognize that image processing represents a form of data processing. There are, of course, many other examples of data processing such as fitting your data to a theoretical

curve. I cannot overemphasize the admonition I made above that you should always be aware of the consequences of what you are doing.

Suppose you want to accurately determine the area under some curve. The data is noisy. So you choose to smooth it out using one of several conventional approaches before analyzing it. This smoothing represents a transformation. Does your transformation preserve the area under the curve, or does it systematically distort it in a particular direction? Obviously you want the area to be true, so choose your smoothing algorithm accordingly. Recognize that the problem of measuring area is analogous to that of measuring total intensity in a fluorescence measurement. So preserving area is analogous to preserving total intensity.

VI. The Point-Spread Function

I have tried here to separate spatial from intensity distortions. However, the two come together when we consider how an optical system treats a point of light. At a practical level one can achieve this by using fluorescent beads of a diameter of .1 to .2 μm. Figure 5A shows a pseudocolor image of such a bead. What one observes is that the light from a point source is spread out over neighboring pixels. This pattern is referred to as the point-spread function (PSF). It is not the result of bad optics. Indeed, a microscope will never create a perfect point from a point

Fig. 5 The three-dimensional point spread function. Pseudocolor images of the point spread function of a microscope. A Z-series was taken of a 0.2-mm bead in the microscope and then reconstructed with pseudocolor. (A) The view looking down the optical axis of the microscope; (B) 40 degrees to the axis; (C) 100 degrees; (D) 190 degrees; (E) 210 degrees; (F) 260 degrees; (G) 300 degrees; and (H) 360 degrees (images were prepared by Ted Inoue and Scott Blakely of Universal Imaging Corporation, Westchester, PA). (See Color Insert.)

because it cannot capture all of the high-order diffraction bands (see Chapter 2) (Inoué, 1986; Born and Wolf, 1980). The PSF represents what is referred to as a convolution. That is, all points in the object are distorted in the same way to create the image. Mathematically, we can write

$$I(x, y) = \int\limits_{-\infty}^{+\infty} \int\limits_{-\infty}^{+\infty} \rho(z - x, \, t - y) R(x, y) \, dz \, dt. \tag{16}$$

A more complete discussion of convolutions may be found in Chapter 5. For our purposes here, let's suppose that you have a noisy image. You would like to smooth it out and make it less noisy. One way to proceed is to replace the intensity at each pixel by the average of itself and its eight nearest neighbors. Performing such an operation leads to a quieter, but fuzzier, image. As a next level of correction, you might decide not to give equal weighting to all of the pixels. Maybe you would use the full intensity of the center pixel but only add in half of the intensity of the neighboring pixels in calculating your average. The PSF is performing such a convolution on the intensity distribution of the object $R(x,y)$. Because it tails off as one gets farther and farther away from the center, it is a weighted average.

Now, of course, as always, our task is the more daunting one of inverting Eq. (16). Suppose, for a moment, that the PSF was the equal-weighted averaging convolution described above. A reasonable inversion, referred to as deconvolution, could be achieved by replacing the intensity at each point in the image by itself less 1/8 of the intensity in each of the neighboring pixels. This is, in fact, the philosophy behind some of the simple sharpening algorithms employed in image processing.

There are a number of ways of deconvolving real PSFs. One direct approach is the method of Fourier transforms. This is discussed in Chapter 15. Furthermore, it is important to recognize that the PSF is three dimensional. This is illustrated clearly in Fig. 5, where we look at the PSF different angles relative to the optical axis. One sees that the distortion of the point source along the axis is even more extreme than in the plane perpendicular to the optical axis, so there really should be a third axis in Eq. (16). This is where the remarkable power of deconvolution lies. Three-dimensional deconvolution techniques enable one to remove signal from out-of-focus planes in the image. This is discussed in detail in Chapter 15.

VII. Positional Information Beyond the Resolution Limit of the Microscope

One might assume that one cannot determine position in the microscope to a greater resolution than that defined by Eq. (4). This is not really the case. The resolution defined by Eq. (4) describes the ability of the observer to distinguish between one and two points of light. As the points get closer and closer, they get lost in each other's PSFs. The question of how accurately you can determine position is quite a separate issue.

Recent work on the technique of single-particle tracking has demonstrated that position may be determined to an accuracy of 10 or 20 nm (Gelles *et al.*, 1988). The key to this is to accurately determine the image of a particle. This is typically done using differential interference microscopy (see Chapter 9). This image is in a sense equivalent to a PSF and is referred to as the kernel. The analysis algorithms then involve convolving the kernel around the image and using statistical correlation techniques to find the "best" position.

A. Applications Involving Intensity Corrections

We next turn our attention to the issue of applications that involve or require intensity correction. What I am going to assume is that it is your goal to be able to accurately compare intensities from different points on the image and then to follow and monitor the intensity at these points over time.

B. Take Control of Your Camera

Although there are no absolutes, it is probably the case that the first thing you are going to want to do is turn off your automatic gain control and your automatic black-level adjust. This puts you in charge of your camera. You can then, for instance, calibrate the response of your camera at a particular gain setting and know how it will respond in an experiment conducted at those settings.

C. Dynamic Range—Don't Waste It

In my experience the most common error in making intensity measurements, an error by no means confined to imaging applications, is not paying attention to dynamic range. In a typical imaging application an analog signal (i.e., voltage) comes out of a digital or video camera. In modern digital cameras this conversion is built in, but the issue of dynamic range remains central and critical. This signal is then digitized using some kind of analog-to-digital (AD) converter. The function of an AD converter is shown schematically in Fig. 6. In this example the AD converter will digitize a 1-V signal into 10 parts. A signal such as that shown in Fig. 6A, which ranges from 0.0 V to about 0.7 V, transmitted reasonably well through the AD converter. Here we have exaggerated the step nature of the digital output. Most real-life AD converters divide the signal into more than 10 parts. The trouble arises if all of your signal falls between 0 and 0.05 V, as in Fig. 6B. The AD converter will treat it as all black. If all of your signal falls between 0 and .15 V, the AD converter will treat it as either black for $V \leq .1$ or gray for $V > .1$. The obvious solution is to multiply your signal voltage, that is, apply gain to your signal, making the maximum 1.0 V so that you maximize the gray-level resolution known as dynamic range. In Fig. 7 we demonstrate this for a video image. Figure 7 shows a properly adjusted dynamic range giving a full 8-bit (256) gray-level image resolution. Successive images show the degradation associated with

Fig. 6 The importance of dynamic range. One should always maximize the dynamic range in image processing. Ultimately, the signal passes through an AD converter, which divides the signal into a finite number of discrete steps. By setting the output gain on the camera, one can adjust the voltage going into the converter. (A) We see a camera output gain reasonably well matched to the AD converter. The digital output of the converter does a good job of detecting the shape of the original object. (B) All of the signal falls within the first step on the converter and no output above zero is obtained.

improper setting of dynamic range to 4, 2, 1, and 0 bits respectively. We see progressive loss of detail and information. The 1-bit image is binary regions that are either black or white. In the 0-bit image, all information is lost.

Typically, cameras have a gain control that enables you to adjust the gain setting so that it totally fills the full range of the AD converter. Cameras that lack such flexibility are unsuited for quantitative microscopy. This will provide you with maximum dynamic range. In some systems, this control is provided by a computer setting rather than a manual switch. For a further discussion of this issue see Chapter 5.

Fig. 7 The importance of dynamic range. Here, we illustrate the value of dynamic range in resolving image detail. (8) Shows an 8-bit image of a rat seminiferous tubule labeled with eosin. The same image is shown successively at 4-, 2-, 1-, and 0-bit resolution. Progressive image detail is lost.

D. Correcting for Nonlinearity

As discussed in Chapter 7, certain types of video cameras do not have linear gain. That is, that if you plot camera output versus light input, the response is not a straight line (Fig. 8). The example in the plot is hypothetical so as to exaggerate nonlinearities, which more typically are only a few percentages. To generate such a plot for your camera system, place an intensity step wedge with a series of graded optical densities between the light source and the sample. In actuality you do not need a sample. You can just look at a blank slide and get a "homogeneous" image. You then systematically read the output from the camera as you change the intensity with the step wedge. This curve can then be used to digitally calibrate the camera's response. This is typically done using what is known as a look-up table, or LUT. Suppose you have an 8-bit video system; you get intensity values from 0 to 255. The LUT tells the system that a value of, say, 240 is underestimated and should be, say, 250. Every intensity value from 0 to 255 has a corresponding value in the LUT that corrects the intensities in the image.

Fig. 8 Camera linearity: output intensity versus input intensity. With certain cameras, one cannot assume that the output intensity is linear with the input intensity (figure courtesy of Ted Inoue courtesy of Universal Imaging Corporation, Westchester, PA).

A major complication here is that modern cameras have very broad dynamic range. You can change the sensitivity by changing the gain. Often there is more than one gain to change. For instance, a SIT camera will have the intensifier gain and the output gain. Linearity tends to depend on these settings, so you need to do calibrations for all possible settings.

E. Flat Field Correction

Now that your dynamic range is properly set and you have corrected for any nonlinearities in gain you are ready to analyze an image. Figure 9A shows a fluorescence image of a seminiferous tubule labeled with eosin. An obvious problem is going to be the background. For this experiment, we obtain a

Fig. 9 Flat field correction. To get a true representation of intensities over an image, it is necessary to perform flat field correction. (A) The original image of rat seminiferous tubules labeled with eosin; (B) the background, in this case an unlabeled no-cell region of the sample; (C) the image of a homogenous sample. One clearly sees that the illumination or detection is not homogeneous; (D) The flat field corrected image which is $(A - B)/(C - B)$. One additional point to note is that the dirt spots in the optics are clearly visible in both B and C. Although one can, by this flat field approach, correct for such blemishes, one should be aware that one may be seriously compromising dynamic range in those regions of the sample. It is always important to keep one's optics as clean as possible (images courtesy of Scott Blakely of Universal Imaging Corporation, Westchester, PA).

background by moving to a region of the sample where there is no cell and taking a background image (Fig. 9B). We then, pixel by pixel, subtract the background image from the image of the tubule. An obvious warning here is to watch your dynamic range. This is where you can lose it. If you examine Fig. 9A closely, you'll see a couple of disturbing points: first, there are what appear to be dirt blotches on the image, and second, there appears to be a general tendency of the intensity to fall off as one moves away from the center of the image. Background subtraction does not completely solve these problems.

To correct for these problems, one needs to perform a flat field correction, which corrects for inhomogeneities of illumination and detection. You create a sample that is a homogeneous fluorescent surface. You don't want this to be a thick solution. Some kind of a film is best. What we tend to do is to take solution of a protein labeled with the same fluorophore being used in the experiment and let a drop of this sit on a coverslip for 20 to 30 minutes. We do not allow this drop to dry. On gently washing away the drop, you will find that a film of fluorophore remains on the coverslip. You search out a region on the coverslip where the film is essentially homogeneous and then defocus very slightly to correct for any minor imperfections. We then take an image of this field (Fig. 9C). We then subtract a background image (again a region of no fluorescence) and measure the intensity of the center of the homogeneous image field. What we tend to do is to take the average intensity of the center nine pixels. We then divide the background-corrected homogeneous image by this value. This will create a matrix that, in general, is one at the center and falls off as you move away from the center. The final step is to divide the original background subtracted image by this matrix in point-by-point fashion, creating what is referred to as a flat field corrected image (Fig. 9D), where the intensity relationships are true.

In my description I am assuming that you are doing this calculation in floating point rather than integer arithmetic. With modern computers, this is generally doable and preferable. I do not assume that you can necessarily store such a large floating-point matrix. I will now repeat the sequence of events as a step-by-step algorithm in more mathematical terms. Because, in general, the flat field image will be prestored, I will start with the acquisition of this corrected image:

Step 1. Take an image of a homogeneous field: $H(x,y)$

Step 2. Take a background image in a region of no fluorescence: $B_H(x,y)$

Step 3. Background correct homogeneous field image: $H'(x,y) = H(x,y) - B_H(x,y)$

Step 4. Calculate average intensity of central nine pixels in $H'(x,y)$: H_o

Step 5. Take image of your sample: $I(x,y)$

Step 6. Take background image in a region of no fluorescence: $B_1(x,y)$

Step 7. Background correct your image: $I'(x,y) = I(x,y) - B_1(x,y)$

Step 8. Perform that flat field correction: $F(x,y) = I'(x,y) H_o/H'(x,y)$

VIII. Intensity Changes with Time

Taking a temporal series of images causes a few additional concerns. The two most common concerns are whether the intensity of the illuminator changes with time and whether the image bleaches with time. Source fluctuations can be corrected for by monitoring what should be a constant point in the image. You could, for instance, add some fluorescent beads to your sample. Alternatively you could add a photodiode to monitor lamp intensity and divide your images by the diode intensity. Photobleaching can also be dealt with using a constant region of your sample. If your experimental conditions are reproducible, you can do a precalibration for photobleaching.

A bigger problem would be if you determine that lamp flicker or wander are causing variations in the spatial intensity distribution of the source light in your image. Fortunately this is usually not a problem. Köhler illumination is designed to optimally confuse light coming from different regions of the source. Once again we stress the importance of proper Köhler illumination of the microscope (see Chapter 3).

IX. Summary

Obviously there are many variations and embellishments on the topic of quantitating your image. I have tried here to offer you a very practical guide that highlights some of the critical issues, paying particular attention to problems that can prevent or compromise your success. These include errors caused by aspect ratio, use of automatic camera settings, improper setting of dynamic range, and use of integer arithmetic. Further information can be found in several other chapters in this volume as well as in the references provided. In addition, you should not overlook the technical manuals that come with your imaging systems. The field of digital microscopy has evolved as a cooperative effort between academia and industry. As a result you will find that many of the technical support personnel from microscope, camera, and image-processing companies are well versed on the issue of digital imaging in biology and are more than willing to assist you.

Acknowledgments

I thank Christine A. Thompson and Scott Blakely for help in the preparation of figures for this manuscript. He would also like to acknowledge the support of the nittunded grants, R44 DK 57347 and R01 NS 28760.

References

Baxes, G. (1984). "Digital Image Processing." Prentice Hall, Englewood Cliffs, NJ.
Born, M., and Wolf, E. (1980). "Principles of Optics." Pergamon, New York.

Castleman, K. R. (1979). "Digital Image Processing." Prentice Hall, Englewood, NJ.

Gelles, J., Schnapp, B. J., and Sheetz, M. P. (1988). Tracking kinesin-driven movements with nanometer scale precision. *Nature* **331,** 450–453.

Inoué, S. (1986). "Video Microscopy." Plenum, New York.

Pratt, W. (1991). "Digital Image Processing." Wiley, New York.

Taylor, D. L., and Wang, Y.-L. (1989). "Fluorescence Microscopy of Living Cells in Culture," Part A, Vol. 29. Academic Press, San Diego, CA.

Wang, Y.-L., and Taylor, D. L. (1989). "Fluorescence Microscopy of Living Cells in Culture," Part B, Vol. 30. Academic Press, San Diego, CA.

CHAPTER 16

Computational Restoration of Fluorescence Images: Noise Reduction, Deconvolution, and Pattern Recognition

Yu-li Wang

Department of Physiology
University of Massachusetts Medical School
Worcester, Massachusetts 01605

I. Introduction

Optical microscopy is now performed extensively in conjunction with digital imaging. A number of factors contribute to the limitations of the overall performance of the instrument, including the aperture of the objective lens, the inclusion of light originating from out-of-focus planes, and the limited signal-to-noise ratio of the detector. Both hardware and software approaches have been developed to overcome these problems. The former include improved objective lenses, confocal scanning optics, total internal reflection optics, and high-performance cameras. The latter, generally referred to as computational image restoration, include a variety of algorithms designed to reverse the defects of the optical-electronic system. The purpose of this chapter is to introduce in an intuitive way the basic concept of several computational image-restoration techniques that are particularly useful for processing fluorescence images.

METHODS IN CELL BIOLOGY, VOL. 72

II. Adaptive Noise Filtration

Noise, defined as the uncertainty of intensity measurement, often represents the primary factor limiting the performance of both confocal microscopes and various computational approaches. Because of the statistical and accumulative nature of photon detection, noise may be reduced most effectively by increasing the time of image acquisition (Fig. 1A, B, G, H). However, this approach is often impractical for biological imaging because of the problems of sample movements, photobleaching, and radiation damage.

An optimal computational noise filter should aggressively remove random fluctuations in the image while preserving as much as possible the nonrandom features. Filters that apply a uniform algorithm across the image, such as low-pass convolution and median filters, usually lead to the degradation of image resolution or amplification of artifacts (Fig. 1). For example, low-pass filters cause both image features and noises to spread out over a defined area, whereas median filters replace every pixel with the median value of the neighborhood.

Better performance may be obtained using filters that adapt to the local characteristics of the image. In anisotropic diffusion filter (Black *et al.*, 1998; Tvarusko *et al.*, 1999), local intensity fluctuations are reduced through a simulated diffusion process by diffusing from pixels of high intensity toward neighboring pixels of low intensity. This process, when carried out in multiple iterations, effectively reduces intensity fluctuations by spreading the noise around a number of pixels. In one implementation (Black *et al.*, 1998), the change in intensity of a given pixel during a given iteration is calculated as

$$\lambda * \Sigma g(\Delta I)\Delta I, \tag{1}$$

where λ is a user-defined diffusion rate constant, ΔI is the difference in intensity from a neighboring pixel, and the sum Σ is taken over all eight neighbors. However, as diffusion without constraints would lead to homogenization of the entire image, it is critical to introduce the function $g(\Delta I)$ for the purpose of preserving structural features. In one of the algorithms, it is defined as $1/2[1 - (\Delta I/\sigma)^2]^2$ when $|\Delta I|$ is $\leq \sigma$ and 0 otherwise (Black *et al.*, 1998). The constant σ thus defines a threshold of intensity transitions to be preserved as structures. If the difference in intensity is larger than σ, then diffusion is inhibited [$g(\Delta I) = 0$].

Although this diffusion mechanism works well in removing a large fraction of the noise, the recognition of features based on ΔI is not ideal, as it also preserves outlying noise pixels. The resulting "salt and pepper"-type noise (Fig. 2A, B) may have to be removed subsequently with a median filter. In an improved algorithm, the diffusion is controlled not by intensity differences between neighboring pixels but by edge structures detected in the images. If an edge is detected across a pixel (e.g., using correlation-based pattern recognition), then diffusion is allowed only along the edge; otherwise, diffusion is allowed in all directions. In essence, this

Fig. 1 Fluorescence images either unprocessed (A, B; G, H) or processed with a standard median filter (C, D) or low-pass convolution filter (E, F). Mouse fibroblasts were stained with rhodamine phalloidin, and images collected with a cooled CCD camera at a short (20 ms, A, B) or long (200 ms, G, H) exposure. A region of the cell is magnified to show details of noise and structures. Median filter creates a peculiar pattern of noise (C, D), whereas low-pass convolution filter creates fuzzy dots and a slight degradation in resolution (E, F).

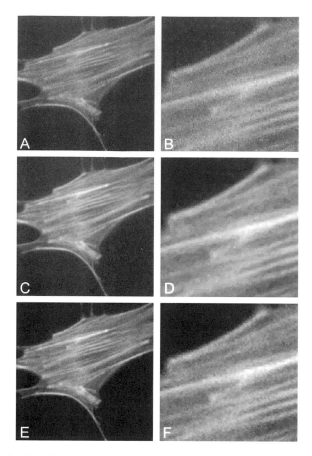

Fig. 2 Noise reduction with the original anisotropic diffusion filter according to Tukey (Black *et al.*, 1998; A, B), with a modified anisotropic diffusion filter that detects edges (C, D), and with an adaptive-window edge-detection filter (E, F). Images in (A–D) were processed by 10 iterations of diffusion. Residual noise outside the cell was easily noticeable in (A) and (B), whereas the noise was nearly completely removed in F without a noticeable penalty in resolution. The original image is shown in Fig. 1A and B.

algorithm treats structures in the image as a collection of iso-intensity lines that constrain the direction of diffusion (Fig. 2C, D).

An alternative approach is the adaptive-windowed edge-detection filter (Myler and Weeks, 1993). The basic concept is to remove the noise by averaging intensities within local regions, the size of which is adapted according to the local information content. In one implementation, the standard deviation of intensities is first calculated in a relatively large square region (e.g., 11×11) surrounding a pixel. If the standard deviation is lower than a defined threshold, indicating that no structure is present within the square, then the center intensity is replaced by the average value within the region and the calculation is moved to the next pixel.

Otherwise, the size of the square is reduced and the process is repeated. If the size of the square is eventually reduced to 3×3 and the standard deviation remains high, then the central pixel is likely located at a structural border. In this case an edge-detection operation is used to determine the orientation of the line, and the intensity of the central pixel is replaced by the average of the pixels that lie along the detected line. This procedure is repeated at each pixel of the image (Fig. 2E, F).

Both anisotropic diffusion and adaptive-window edge-detection methods can reduce the noise by up to an order of magnitude while preserving structural boundaries (Fig. 2). However, neither of them can restore lost resolution caused by high noise (cf Fig. 1G and H with Fig. 2). In addition, both of them preserve pseudofeatures formed by stochastic distribution of noise pixels. With anisotropic diffusion, areas of uniform signal may become populated with lumplike artifacts, whereas with adaptive-window edge-detection filters, straight bundle structures may show a jagged contour (Fig. 2). Despite these limitations, the reduction of noise alone can greatly improve the quality of noisy confocal images for three-dimensional reconstruction or for further processing (Tvarusko *et al.*, 1999).

III. Deconvolution

Mathematical reversal of systemic defects of the microscope is known as image "deconvolution." This is because the degradation effects of the microscope can be described mathematically as the "convolution" of input signals by the point-spread function of the optical system [Young, 1989; for a concise introduction of convolution, see the book by Russ (1994)]. The two-dimensional convolution operation is defined mathematically as

$$i(x, y) \otimes s(x, y) = \sum_{u,v} i(x - u, y - v)s(u, v). \tag{2}$$

This equation can be easily understood when one looks at the effects of convolving a matrix i with a 3×3 matrix:

$$
\begin{array}{ll}
\cdots\cdots\cdots\cdots\cdots & \\
\cdots\cdots i_1 i_2 i_3 \cdots\cdots & s_1 s_2 s_3 \\
\cdots\cdots i_4 i_5 i_6 \cdots\cdots \otimes & s_4 s_5 s_6 \\
\cdots\cdots i_7 i_8 i_9 \cdots\cdots & s_7 s_8 s_9. \\
\cdots\cdots\cdots\cdots\cdots &
\end{array}
$$

The calculation turns the element (pixel) i_5 into $(i_1 \times s_9) + (i_2 \times s_8) + (i_3 \times s_7) + (i_4 \times s_6) + (i_5 \times s_5) + (i_6 \times s_4) + (i_7 \times i_3) + (i_8 \times i_2) + (i_9 \times i_1)$. When calculated over the entire image, each pixel becomes "contaminated" by the surrounding pixels, to an extent specified by the values in the s matrix (the point-spread function). Thus, two-dimensional convolution operation mimics image degradation by the diffraction through a finite aperture. Three-dimensional convolution can be similarly expressed as

$$o(x, y, z) = i(x, y, z) \otimes s(x, y, z), \tag{3}$$

where $i(x,y,z)$ is three-dimensional matrix describing the signal originating from the sample, $s(x,y,z)$ is a matrix describing the three-dimensional point-spread function, which contains the information on image degradation caused by both diffraction and out-of-focus signals, and $o(x,y,z)$ is the stack of optical slices as detected with the microscope.

It should be noted that such precise mathematical description of signal degradation does not mean that original signal distribution can be restored unambiguously from the detected images and the point-spread function. Because of the loss of high-frequency information when light passes through the finite aperture of the objective lens, it is impossible to obtain predegraded images even under ideal conditions. The collected information instead allows a great number of potential "answers" to fit Eq. (3). This is because the calculation is plagued by a number of indeterminants as a result of "zero divided by zero." As a result, straightforward reversal of equation 3 (referred to as inverse filtering) typically leads to images that fit the mathematical criteria but contain unacceptable artifacts and amplified noise.

The challenge of computational deconvolution is to find strategies that identify the most likely answer. A number of deconvolution algorithms have been tested for restoring fluorescence images (for a detailed review, see Wallace et al., 2001). The two main approaches in use are constrained iterative deconvolution (Agard, 1984; Agard et al., 1989; Holmes and Liu, 1992) and nearest neighbor deconvolution (Castleman, 1979; Agard, 1984; Agard et al., 1989). Constrained iterative deconvolution uses a trial-and-error process to look for signal distribution $i(x,y,z)$, that satisfies Eq. (3). It usually starts with the assumption that $i(x,y,z)$ equals the measured stack of optical sections, $o(x,y,z)$. As expected, when $o(x,y,z)$ is placed on the right-hand side of Eq. (3) in place of $i(x,y,z)$, it generates a matrix $o'(x,y,z)$ that deviates from $o(x,y,z)$ on the left-hand side. To decrease this deviation, adjustment is made to the initial guess, voxel by voxel, based on the deviation of $o'(x,y,z)$ from $o(x,y,z)$ and on constraints such as nonnegativity of voxel values. The modified $o(x,y,z)$ is then placed back into the right-hand side of Eq. (3) to generate a new matrix, $o''(x,y,z)$, which should resemble more closely $o(x,y,z)$ if the adjustment is made properly. This process is repeated until there is no further improvement or until the calculated image matches closely the actual image.

Various approaches have been developed to determine the adjustments in calculated images between iterations (Agard et al., 1989; Holmes and Liu, 1992). Different algorithms differ with respect to the sensitivity to noise and artifact, speed to reach a stable answer, and resolution of the final image. Under ideal conditions, constrained iterative deconvolution can achieve a resolution that goes beyond what is predicted by the classical optical theory (Raleigh criterion) and provide three-dimensional intensity distribution of photometric accuracy (Carrington et al., 1995). The main drawback of constrained iterative

deconvolution is its computational demand, which typically takes minutes to hours to complete a stack. This delay makes troubleshooting particularly tedious. A second disadvantage is its requirement for a complete stack of images for deconvolution, even if the experiment requires only one optical slice. Iterative constrained deconvolution is also very sensitive to the condition of the imaging, including optical defects and signal-to-noise ratio.

The nearest-neighbor algorithm is based on the decomposition of three-dimensional convolution [Equation (2)] into a series of two-dimensional convolutions (Agard *et al.*, 1989):

$$o(x,y) = i_0(x,y) \otimes s_0(x,y) + i_{-1}(x,y) \otimes s_{-1}(x,y) + i_{+1}(x,y) \otimes s_{+1}(x,y)$$
$$+ i_{-2}(x,y) \otimes s_{-2}(x,y) + i_{+2}(x,y) \otimes s_{+2}(x,y) + \cdots, \tag{4}$$

where $i(x,y)$'s are two-dimensional matrices describing the signal originating from the plane of focus (i_0), and from the planes above (i_{+1}, i_{+2}, ...) and below (i_{-1}, i_{-2}, ...), $s(x,y)$ are matrices of two-dimensional point-spread functions that describe how point sources on the plane of focus (s_0) or planes above (s_{+1}, s_{+2}, ...) and below (s_{-1}, s_{-2}. ...) spread out when they reach the plane of focus. This equation is further simplified by introducing three assumptions: first, that out-of-focus light from planes other than those adjacent to the plane of focus is negligible; that is, terms containing s_{-2}, s_{+2}, and beyond are insignificant. Second, that light originating from planes immediately above or below the plane of focus can be approximated by images taken while focusing on these planes; i.e., $i_{-1} \approx o_{-1}$ and $i_{+1} \approx o_{+1}$. Third, that point-spread functions for planes immediately above and below the focal plane, s_{-1} and s_{+1}, are equivalent (hereafter denoted as s_1).

These approximations simplify Eq. (4) into

$$o = i_0 \otimes s_0 + (o_{-1} + o_{+1}) \otimes s_1. \tag{5}$$

Rearranging the equation and applying Fourier transformation, the equation turns into

$$i_0 = [o - (o_{-1} + o_{+1}) \otimes s_1] \otimes F^{-1}[1/F(s_0)], \tag{6}$$

where F and F^{-1} represents forward and reverse Fourier transformation, respectively. This equation can be understood in an intuitive way: It states that the unknown signal distribution, i_0, can be obtained by taking the in-focus image, o, subtracting out estimated contributions from planes above and below the plane of focus, $(o_{-1} + o_{+1}) \otimes s_1$, followed by the convolution with the matrix $F^{-1}[1/F(s_0)]$ to reverse diffraction-introduced spreading of signals on the plane of focus.

To address artifacts introduced by the approximations, nearest-neighbor deconvolution is typically performed with a modified form of Eq. (6):

$$i_0 = [o - (o_{-1} + o_{+1}) \otimes (c_1 * s_1)] \otimes F^{-1}[F(s_0)/(F(s_0)^2 + c_2)], \tag{7}$$

where constants c_1 and c_2 are empirical factors. c_1 is used to offset errors caused by oversubtraction, as described below. c_2 is required to deal with problems associated with the calculation of reciprocals, $1/F(s_0)$, at the end of Eq. (6). The constant c_2 keeps the reciprocal value from getting too large when the matrix element is small compared to c_2. In general, c_1 falls in the range of 0.45 to 0.50, depending on the separation between adjacent optical slices, whereas the value of c_2 is in the range of 0.0001 to 0.001, depending on the level of noise in the images. The optimal values for c_1 and c_2 should be determined through systematic trials.

The main concern of nearest-neighbor deconvolution is its accuracy because of the three approximations discussed above. In particular, as the neighboring optical sections include significant contributions of signals from the plane of focus, the use of these images leads to oversubtraction and erosion of structures, particularly when the optical section is performed at too small a spacing. However, the approximations also greatly simplify and accelerate the calculations. It requires the collection of only three images (the in-focus image and images immediately above and below), which reduces photobleaching during image acquisition. Unlike constrained iterative deconvolution, the computation is finished within seconds. In addition, it is relatively insensitive to the quality of the lens or the point-spread function, yielding visually satisfactory results with either actual or computer-calculated point-spread functions. When the constant c_1 is set small enough, even the image itself may be used as an approximation of the neighbors. The resulting "no-neighbor" deconvolution is in essence identical to "unsharp-masking" found in many graphics programs such as Photoshop. Nearest-neighbor deconvolution can serve as a quick-and-dirty means for qualitative deblurring. It is ideal for preliminary evaluation of samples and optical sections, which may then be processed with constrained iterative deconvolution.

There are cases where confocal microscopy would be more suitable than either deconvolution techniques. Both contrained iterative and nearest-neighbor deconvolution require images of relatively low noise. Although noise may be reduced before and during the calculation with filters, as discussed earlier, in photon-limited cases, this may not give acceptable results. In addition, laser confocal microscopy is more suitable for thick samples, where the decreasing penetration and scattering of light limit the performance of deconvolution. For applications with moderate demand in resolution and light penetration, but high demand in speed and convenience, spinning disk confocal microscopy serves a unique purpose. Finally, under ideal situations, the combination of confocal imaging and deconvolution should yield the highest performance.

IV. Pattern Recognition–Based Image Restoration

Deconvolution as discussed above is based on few assumptions about the image. However, in many cases the fluorescence image contains specific characteristics, which may be used as powerful preconditions for image restoration. One such

example is the detection of microtubules in immunofluorescence or GFP images. The prior knowledge, that all the features in these images consist of line structures, allows one to take an alternative approach based on the detection of linear features.

Pattern recognition is performed most easily with a correlation-based algorithm. The correlation operation,

$$i(x,y) + (x,y) = \sum_{u,v} i(x+u, y+v)s(u,v), \tag{8}$$

is similar to that of convolution except that the corresponding (instead of transposed) elements from the two matrices are multiplied together; that is, when a matrix i is correlated with a 3×3 matrix, s,

$$
\begin{array}{cc}
\cdots\cdots i_1 i_2 i_3 \cdots\cdots & s_1 s_2 s_3 \\
\cdots\cdots i_4 i_5 i_6 \cdots\cdots + & s_4 s_5 s_6 . \\
\cdots\cdots i_7 i_8 i_9 \cdots\cdots & s_7 s_8 s_9
\end{array}
$$

The element (pixel) i_5 turns into $(i_1 \times s_1) + (i_2 \times s_2) + (i_3 \times s_3) + (i_4 \times s_4) + (i_5 \times s_5) + (i_6 \times s_6) + (i_7 \times i_7) + (i_8 \times i_8) + (i_9 \times i_9)$.

It can be easily seen that this result is maximal when the two matrices contain an identical pattern of numbers, such that large numbers are multiplied by large numbers and small numbers multiplied by small numbers. The operation thus provides a quantitative map indicating the degree of match between the image (i) and the pattern (s) at each pixel. To make the calculation more useful, Eq. (8) is modified as

$$i(x,y) + (x,y) = \sum_{u,v} [i(x+u, y+v) - i_{avg}][s(u,v) - s_{avg}] \tag{9}$$

to generate both positive and negative results; negative values indicate that one matrix is the negative image of the other (i.e., bright regions correspond to dark regions, and vice versa).

Figure 3 shows the matrices $s(u,v)$ for detecting linear segments in eight different orientations. The operations generate eight correlation images, each one detecting segments of linear structures (microtubules) along a certain orientation. Negative correlation values are then clipped to zero, and the images are added together to generate the final image (Fig. 4). This is a much faster operation than iterative deconvolution, yet the results are substantially better than that provided by nearest neighbor deconvolution. However, despite the superb image quality, the method is not suitable for quantitative analysis of intensity distribution.

```
1.000 2.000 4.000 2.000 1.000
1.000 2.000 4.000 2.000 1.000
1.000 2.000 4.000 2.000 1.000
1.000 2.000 4.000 2.000 1.000
1.000 2.000 4.000 2.000 1.000

0.386 1.310 2.468 3.684 1.918
0.769 1.693 3.234 2.918 1.535
1.152 2.152 4.000 2.152 1.152
1.535 2.918 3.234 1.693 0.769
1.918 3.684 2.468 1.310 0.386

0.172 0.879 1.586 2.586 4.000
0.879 1.586 2.586 4.000 2.586
1.586 2.586 4.000 2.586 1.586
2.586 4.000 2.586 1.586 0.879
4.000 2.586 1.586 0.879 0.172

0.386 0.769 1.152 1.535 1.918
1.310 1.693 2.152 2.918 3.684
2.468 3.234 4.000 3.234 2.468
3.684 2.918 2.152 1.693 1.310
1.918 1.535 1.152 0.769 0.386

1.000 1.000 1.000 1.000 1.000
2.000 2.000 2.000 2.000 2.000
4.000 4.000 4.000 4.000 4.000
2.000 2.000 2.000 2.000 2.000
1.000 1.000 1.000 1.000 1.000

1.918 1.535 1.152 0.769 0.386
3.684 2.918 2.152 1.693 1.310
2.468 3.234 4.000 3.234 2.468
1.310 1.693 2.152 2.918 3.684
0.386 0.769 1.152 1.535 1.918

4.000 2.586 1.586 0.879 0.172
2.586 4.000 2.586 1.586 0.879
1.586 2.586 4.000 2.586 1.586
0.879 1.586 2.586 4.000 2.586
0.172 0.879 1.586 2.586 4.000

1.918 3.684 2.468 1.310 0.386
1.535 2.918 3.234 1.693 0.769
1.152 2.152 4.000 2.152 1.152
0.769 1.693 3.234 2.918 1.535
0.386 1.310 2.468 3.684 1.918
```

Fig. 3 Matrices for detecting linear structures lying along the directions of north–south, north–northeast, northeast, east–northeast, east–west, west–northwest, northwest, and north–northwest.

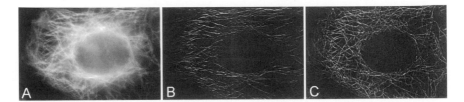

Fig. 4. Restoring of microtubules by feature recognition. An optical slice of a NRK cell stained for microtubules is shown in (A). The image is processed to detect linear segments lying along the east–west direction (B). A complete image, obtained by summing structures along all the eight directions, is shown in (C).

V. Prospectus

Image processing and restoration represent a rapidly advancing field of information science. However, not all the algorithms are equally suitable for fluorescence microscopic images, because of their special characteristics. As optical microscopy continues to push for maximal speed and minimal irradiation, overcoming the limitation in signal-to-noise ratio will likely remain a major challenge for both the retrieval of information from unprocessed images and the application of various restoration algorithms. Development of optimal noise-reduction algorithms represents one of the most urgent tasks for the years to come. Although this chapter explores several simple methods for noise reduction, new methods based on probability theories may be combined with deconvolution to overcome the resolution limit imposed by noise. In addition, as many biological structures contain characteristic features, the application of feature recognition and extraction will play an increasingly important role in both light and electron microscopy. The ultimate performance in microscopy will likely come from combined hardware and software approaches, for example, by spatial/ temporal modulation of light signals coupled with software decoding and processing (Gustafsson *et al.*, 1999; Lanni and Wilson, 2000).

References

Agard, D. A. (1984). *Ann. Rev. Biophys. Bioeng.* **13**, 191–219.

Agard, D. A., Hiraoka, Y., Shaw, P., and Sedat, J. W. (1989). *Methods Cell Biol.* **30**, 353–377.

Black, M. J., Sapiro, G., Marimont, D. H., and Heeger, D. (1998). *IEEE Trans. Image Process.* **7**, 421–432.

Carrington, W. A., Lynch, R. M., Moore, E. D., Isenberg, G., Fogarty, K. E., and Fay, F. S. (1995). *Science* **268**, 1483–1487.

Castleman, K. R. (1979). "Digital Image Processing" Prentice-Hall, Englewood Cliffs, NJ.

Gustafsson, M. G., Agard, D. A., and Sedat, J. W. (1999). *J. Microsc.* **195**, 10–16.

Holmes, T. J., and Liu, Y.-H. (1992). *In* "Visualization in Biomedical Microscopies" (A. Kriete ed.), pp. 283–327. VCH Press, New York.

Lanni, F., and Wilson, T. (2000). *In* "Neuron Imaging" (R. Yuster, A. Lanni, and A. Konnerth eds.), pp. 8.1–8.9. Cold Spring Harbor Laboratory Press, Cold Spring Harbor, NY.

Myler, H. R., and Weeks, A. R. (1993). "Computer Imaging Recipes in C." Prentice-Hall, Englewood Cliffs, NJ.

Russ, J. C. (1994). "The Image Processing Handbook." CRC Press, Boca Raton, FL.

Tvarusko, W., Bentele, M., Misteli, T., Rudolf, R., Kaether, C., Spector, D. L., Gerdes, H. H., and Eils, R. (1999). *Proc. Natl. Acad. Sci. USA* **96,** 7950–7955.

Wallace, W., Shaefer, L. H., and Swedlow, J. R. (2001). *BioTechniques* **31,** 1076–1097.

Young, I. T. (1989). *Methods Cell Biol.* **30,** 1–45.

CHAPTER 17

Quantitative Fluorescence Microscopy and Image Deconvolution

Jason R. Swedlow

Division of Gene Regulation and Expression
University of Dundee
Dundee, DD1 5EH, Scotland, United Kingdom

A major application of fluorescence microscopy is the quantitative measurement of the localization, dynamics, and interactions of cellular factors. The introduction of Green Fluorescent Protein (GFP) and its spectral variants has led to a significant increase in the use of fluorescence microscopy as a quantitative assay system. For quantitative imaging assays, it is critical to consider the nature of the image-acquisition system and to validate its response to known standards. Any image-processing algorithms used before quantitative analysis should preserve the relative signal levels in different parts of the image. A very common

image-processing algorithm, image deconvolution, is used to remove blurred signal from an image. There are two major types of deconvolution approaches, deblurring and restoration algorithms. Deblurring algorithms remove blur, but treat a series of optical sections as individual two-dimensional entities, and therefore sometimes mishandle blurred light. Restoration algorithms determine an object that, when convolved with the point-spread function of the microscope, could produce the image data. The advantages and disadvantages of these methods are discussed.

I. Introduction

Fluorescence microscopy has experienced a revolution in the last 10 years. This mode of imaging has been transformed by the labeling of proteins with GFP from a specialized technique into a standard assay for molecular function (Chalfie *et al.*, 1994; Stearns, 1995; Patterson *et al.*, 2001). In addition, the cost of imaging hardware has dropped and new imaging techniques have appeared for measuring molecular interactions and dynamics, often in living cells. The applications of these technologies has made quantitative analysis of digital microscope images a required part of the cell biologist's toolbox. In this chapter, I review some of the principles of quantitative imaging and then discuss one of the most common image-processing applications that depends on rigorous application of quantitative imaging: image deconvolution.

II. Quantitative Imaging of Biological Samples Using Fluorescence Microscopy

Quantitative imaging has long been a cornerstone of fluorescence microscopy. The use of small molecule fluorophores that preferentially localize to a cellular compartment or report the concentration of a specific cellular ion (Tsien and Waggoner, 1995), especially those appropriate for ratio imaging (Silver, 1998), have traditionally been the most quantitatively accurate probes for fluorescence microscopy. Antibody-based localization in indirect immunofluorescence faithfully reported the localization of the antibody but often suffered from variable antigen accessibility and differences in extraction or fixation. More recently, the use of genetically encoded fluorescence based on GFP and its spectral variants (Tsien, 1998) ensures that, assuming there is no proteolytic cleavage of the GFP fusion protein, each fluorophore molecule is spatially and quantitatively linked to a single molecule of the protein under study. This capability is now commonly used as the basis for the quantitative study of protein localization, dynamics, and interactions (Lippincott-Schwartz *et al.*, 2001).

A. Quantitative Fluorescence—Detectors

Detectors for fluorescence microscopy are now routinely provided on commercially available turnkey systems. Laser scanning confocal microscopes (LSCMs) and multiphoton microscopes (MPMs) use photomultiplier tubes (PMTs) to detect the small number of photons emanating from the in-focus image plane. Wide-field microscopes (WFMs) and spinning disk confocal microscopes (SDCMs) image a large field simultaneously and thus require the use of an array of detectors to record an image. Charge-coupled device (CCD) cameras have become the standard detector used in these microscope systems. Both PMTs and CCDs provide high sensitivity and linear response over their dynamic range and thus, when used appropriately, can form the basis of a linear fluorescence microscope-based detection system (Art, 1995; Inoué and Spring, 1997).

B. Quantitative Fluorescence—Limits on Linearity

It is one thing to design a microscope system for quantitative imaging; it is quite another thing to use it so that all measurements are, in fact, in the linear range of the detection system. First and foremost, the intrinsic sources of noise in the imaging system should be identified and minimized. In the author's experience, noise can derive from anywhere in the optical train, but is most commonly caused by illumination instabilities, the detector electronics, or mechanical or thermal fluctuations in the sample or microscope body. Any combination of these effects will add noise to any image measurement, thus decreasing its dynamic range and accuracy. It is critical that these sources not be ignored or taken for granted just because, for instance, a commercial supplier claims them to be "minimized."

1. Illumination Variations

In fluorescence microscopy, a major source of noise is the variation of light flux coming from either the lamp or the laser used as an illumination source. In WFMs, the lamps used as sources can suffer significant power deviations of up to 10% on timescales of milliseconds to seconds. These fluctuations become more dramatic as the lamp ages. For applications requiring repeated imaging (i.e., optical sectioning or time-lapse), these variations cause stochastic changes during the acquisition of each image. The result is that the total fluorescence excitation light varies between images, resulting in deviations in fluorescence signal derived from the imaging system, not the sample. Stabilized power supplies for these lamps are available, and these can partially suppress this problem. Preferably these deviations can be measured, either during data collection or subsequently from the image data, and then corrected by a software correction algorithm (Chen et al., 1995).

For laser scanning confocal microscopes, recent studies have identified power deviations of the order of 1%–10% in the standard gas lasers used in commercial turnkey systems, apparently caused by changes in the plasma discharge (Zucker

and Price, 2001; Swedlow *et al.*, 2002). They are significant because they occur on the microsecond timescale, which is on the order of the dwell time of the laser at each pixel in a scanning microscope. These variations cause pixel-to-pixel variations in illumination intensities. In principle, these can be corrected by measuring illumination variations with a rapid detector, although use of this approach failed to correct the observed deviations (Swedlow *et al.*, 2002). Regardless of their source, illumination power deviations can contribute a significant source of noise in fluorescence imaging and should therefore be assessed and corrected as much as possible.

2. Detector Noise

A second major source of noise in imaging systems derives from the detectors used to record the fluorescence signals. In PMTs this largely results from spurious electrons generated by the high voltages within the PMT (Pawley, 1994; Art, 1995). This problem grows as the PMT gain is increased. In addition, our recent work revealed a second source of detector noise that we were unable to unambiguously characterize, but that appeared to be associated with the amplifier circuitry associated with the PMT detector (Swedlow *et al.*, 2002). For CCDs, each time a pixel is "read," there is an uncertainty, usually expressed as the root-mean-square (RMS) number of electrons (e^-) that is added to the value measured at each pixel. This source of noise is stochastic and varies pixel by pixel and is therefore very hard to remove. In the authors' labs, we try to use CCDs with less than 6 e^- RMS, especially for low-light-level imaging. Regardless of the detector used, measurements made near the lower end of the dynamic range of the detector will have a significant noise content. Consequently, any attempts to make critical measurements at these signal levels will have significant noise deviations and thus not be "linear." The best solution is to either record higher signal levels, so that detector noise comprises less of the total signal, or to use a more sensitive, lower-noise detector (see Inoué and Spring, 1997, for a full description of detector types, performance, and limitation).

3. Photon Shot Noise

The detection of photons is inherently a statistical process, with the uncertainty in the detection being given by $(N)^{1/2}$, where N is the number of photons counted (Pawley, 1995a). As the number of photons counted increases, the relative uncertainty in the measurement decreases. This uncertainty is referred to as photon shot noise. To minimize this source of noise, it seems reasonable to try to collect as many photons as possible. In fluorescence imaging, especially when imaging photosensitive live cells, it is only possible to collect small numbers of photons, because only limited amounts of fluorescence excitation can be tolerated by the cell or tissue (Swedlow and Platani, 2002). For this reason, it is often the case that photon shot noise is a significant source of noise in fluorescent microscope images.

C. Quantitative Fluorescence—Characterizing the Performance of an Imaging System

Before proceeding with a quantitative measurement, it is critical that the imaging system be characterized and any sources of systematic noise be minimized. A number of helpful articles are available to aid in the characterization of different systems (Sheppard et al., 1995; Murray, 1998; Zucker and Price, 2001). In the author's lab, to characterize the overall performance of the detection system and characterize the linearity of an imaging system's response, we have also used a distribution of large beads (InSpeak 2.5-μm beads, Molecular Probes, Inc.) made up of beads with six different concentrations of a fluorophore spanning over two orders of magnitude. The beads are spread on a coverslip, and many hundreds of beads are imaged. The selection of fluorescence excitation and duration and detector settings must be chosen so that the whole range of beads can be visualized without saturating the detector. After imaging, the fluorescence in each bead is summed and the distribution of the measured bead fluorescence is plotted on a histogram (Fig. 1; Swedlow et al., 2002). This analysis reveals two aspects of the quantitative limits of the imaging system. First, the relative fluorophore concentrations of each bead population can be compared to those measured independently by FACS to test whether the microscope is working as a reasonably linear detector. Second, the coefficients of variation within each bead population reveal how the contributions of systematic and photon shot noise discussed above are contributing to each of the measurements. For the wide-field microscope shown analyzed in Fig. 1, we found that the coefficients of variation were essentially unchanged over the five brightest bead populations, covering over two orders of magnitude of the system's dynamic range (Table I). We observed a clear increase in the coefficient of variation for the weakest bead population. Although the median of this population appeared in an appropriate position (Fig. 1), the measurement clearly contained a higher uncertainty (Table I). Measurements made within this dynamic range of the detector would therefore contain significant noise.

D. Preprocessing of Images for Quantitative Analysis

Before performing quantitative analyses, digital image data often must be preprocessed, or filtered to minimize various types of systematic noise. One example of this is the flat-field correction of the CCD field used in wide-field imaging. This step corrects for illumination variation across the area of the CCD as well as any systematic differences in pixel response within the CCD array. This step is usually critical to prevent quantitative results from being affected by systematic errors in illumination or signal detection (Agard et al., 1989).

A second example of quantitative image preprocessing corrects the time-dependent illumination variation discussed above. In the WFM, illumination changes that occur between frames in a series of optical sections or a time-lapse movie must be corrected before further quantitative processing is performed. Direct measurement of the excitation flux in each frame is possible, but it can only

Fig. 1 WFM imaging of calibrated fluorescent standards. (A) Merged fluorescence and DIC image of a mixture of 2.5-μm polystyrene beads with seven different fluorophore densities. Fluorescence from the beads with the three highest fluorophore densities is bright enough to make them appear colored in this image, whereas beads with the lower fluorophore densities appear gray. Scale bar, 5 μm. (B) Quantitative analysis of fluorescent bead image. Total fluorescence in three-dimensional images of 290 beads was determined by summing an identical volume in each bead and normalized to put all

Table I
Statistical Analysis of Noise in Measurements of Fluorescent Beads

Beads[a]	WFM/Raw	WFM/Decon	FACS[b]
.3	.35	.24	.20
1	.09	.10	.10
3	.08	.08	.08
10	.09	.08	.07
30	.07	.08	.06
100	.06	.07	.06

Note. Values are coefficients of variation (standard deviation/arithmetic mean) for each of the bead populations measured in Fig. 1. The central 80% of each population was used to calculate the mean. Background was subtracted as described in Eq. (1). Between 30 and 45 beads were used for each bead population assayed by microscopy. From each population 1200–1500 beads were used for FACS assay. Table adapted from Swedlow *et al.* (2002). Copyright 2002 National Academy of Sciences, USA
[a]Nominal relative bead fluorophore density as specified by manufacturer.
[b]Coefficients of variation for beads used for WFM measured by FACS.

be made if the illumination system of the microscope includes suitable photon detectors. Alternatively, illumination changes can be measured and corrected by simply summing the fluorescence signal in each frame and then fitting the summed signals to a polynomial (Chen *et al.*, 1995).

E. Processing Data for Quantitative Analysis

Before performing any processing algorithms on image data, it is important to consider whether the operation will preserve the quantitative relationships in the data. In many cases, quantitative relationships will not be preserved. This is often desirable, as the resulting changes in contrast can help identify objects, edges, and so forth by visual inspection (Russ, 1992). However, if the interpretation of an image requires quantitative analysis, care must be taken to ensure that the algorithm used preserves quantitative relationships.

As an example of the effects of processing algorithms, consider the image in Fig. 2, recorded with a CCD camera with a wide-field microscope. This is a large bead that contains fluorescent dye on its surface, but not in its interior. The images shown in Fig. 2A show the same bead imaged under five different relative illumination levels. The LUT(look-up table) on each image is adjusted to show the minimum and maximum signal detected by the detector, a CCD camera. Each image is labeled with the relative level of illumination, expressed as a percentage.

measurements on the same scale. Relative bead fluorescence was also determined by FACS and similarly normalized. Arrows show the positions of the median fluorescence of each bead population measured by FACS. (C) Same dataset as (B) but after image restoration by iterative deconvolution. Figure adapted from Swedlow *et al.* (2002). Copyright 2002 National Academy of Sciences, USA. (See Color Insert.)

The line plots through the center of the bead reveal the relative differences between the background, the shell of fluorescence, and the unlabeled center of the bead. These same images are shown after processing with low-pass (Fig. 2B) and high-pass (Fig. 2C) convolution filters (Russ, 1992). Note that the low-pass filter improves the visibility of the bead, but also significantly changes the relative fluorescence measurements shown in the line plots. The relative intensities are apparently identical for the three brightest images (100, 50, 10); nearly the same for the next brightest image (1), but incorrect for the dimmest image (0.1). Use of the high-pass filter makes the bead invisible in the lowest signal image and also dramatically changes the relative intensities measured within the bead.

The convolution operations in Fig. 2 dramatically affected the relative intensities within the bead test image. At first glance, this may suggest that these and even more sophisticated processing and filtering schemes should not be used for quantitative image analysis. In fact, a common approach is to use the results of these methods as the basis for a mask that defines which pixels are to be included in an analysis and which are to be excluded. For example, although the 0.1% image in Fig. 2A is quite noisy, the result from the low-pass convolution in Fig. 2B might be used to define the area within Fig. 2A that was to be subjected to quantitative analyses. Such strategies are quite common and thus define a critical role for nonlinear image-processing methods within quantitative imaging.

F. Methodologies for Quantitative Imaging

The applications for quantitative analysis in fluorescence microscopy have exploded over the last few years (Lippincott-Schwartz et al., 2001). A large number of them depend on the determination of the fluorescence signal within a subregion of an image. As discussed above, as most digital microscopes are linear detectors and GFP fluorescence shows us the concentration of protein at specific sites (unlike antibody-based immunofluorescence), such measurements are now routine. Notable applications using summed fluorescence include

Fig. 2 Effects of standard image processing methods on relative fluorescence measurements. A 5-μm bead with fluorophore concentrated on its surface was imaged in a fluorescence microscope repeatedly while varying the neutral density filter placed between the excitation light beam and the sample (Transmittance = 100%, 50%, 10%, 1%, and 0.1%) while keeping all other imaging parameters the same. (A) Raw images from the microscope. (B) The images in (A) were processed with a low-pass convolution filter. (C) The images in (A) were processed with a high-pass convolution filter. Each image is shown alone and superimposed with a line plot through the center of the bead to indicate the relative intensities in the image and is presented using a LUT set to the individual images minimum and maximum signal. Each line plot is also scaled to the minimum and maximum signal in the individual image. J. R. S. thanks Paul Goodwin, Applied Precision, LLC, for recording this data at the 2002 Analytical and Quantitative Light Microscopy Course, Marine Biological Laboratory. (See Color Insert.)

fluorescence recovery after photobleaching (FRAP), fluorescence loss in photo-bleaching (FLIP), fluorescence resonance energy transfer (FRET), and fluorescence lifetime imaging (FLIM) as well as simple measurements of fluorescence change in different cellular compartments. The basic principles in measuring the fluorescence in an image involve five steps:

1. Identifying the object in two or three dimensions to be measured
2. Summing the fluorescence signal in the object
3. Measuring the area or volume in the object (number of pixels or voxels)
4. Identifying a second area considered to be representative of background
5. Measuring the summed fluorescence and area/volume in the background.

With these values, the background corrected fluorescence in the object can be calculated as follows:

$$F'_{obj} = \sum_{i=1}^{i=N_{obj}} F_{obj_i} - N_{obj} \frac{\sum_{j=1}^{j=N_{bkg}} F_{bkg_j}}{N_{bkg}}, \tag{1}$$

where F is the fluorescence signal measured at each pixel i or j, obj is the object area or volume, bkg is the selected background area or volume, and N is the number of pixels in the selected object or background. This equation sums the fluorescence in an object, calculates the background contribution per pixel, and then corrects the summed object fluorescence by the number of pixels in the object multiplied by background per pixel. This background correction is critical to help reveal subtle changes in fluorescence.

III. Image Blurring in Biological Samples

One of the major challenges facing the cell biologist using digital imaging is the intrinsic thickness of cells and tissues. In most fluorescence imaging (and especially when imaging live cells), it is critical to gather and measure as many photons as possible to reduce photon shot noise. Objective lenses with high numerical aperture or light-gathering power are therefore usually used (for the definition and description of basic microscope optics, see Inoué and Spring, 1997). They also tend to be the lenses with the greatest resolving power, so that small objects can be detected and resolved. Unfortunately these lenses have a relatively narrow depth of field, so they produce an image that combines in-focus information from the focal plane and blurred, out-of-focus information from elsewhere in the sample. The degradation of the in-focus signal by blurring decreases contrast and thus prevents individual objects from being resolved. The density of the blurred light increases linearly with the thickness of the sample. In practice, blurring becomes a significant problem in cells more than 10–20 μm thick (depending on the density of the fluorescence signal).

The blurring of a sample by an objective lens is represented by the point-spread function (PSF). The PSF can be either calculated by a variety of formulae (e.g., (Gibson and Lanni, 1991) or directly measured by imaging a subresolution fluorescent bead using the same optical setup as will be used for samples (Wallace *et al.*, 2001). The blurring of the bead by the objective lens can be described by a convolution operation where the PSF operates on every point in the image:

$$\text{image}(x, y, z) = \int_{-\infty}^{\infty} \int_{-\infty}^{\infty} \int_{-\infty}^{\infty} \text{psf}(x - x', y - y', z - z') * \text{object}(x', y', z') dx' dy' dz',$$

where the image is the recorded data, the object is the sample on the microscope, and (x,y,z) is the coordinate system of the microscope. Note that the PSF and this convolution are three-dimensional. The equation can be written more succinctly as

$$\text{image} = \text{object} \otimes \text{psf}, \tag{2}$$

where the symbol \otimes connotes a convolution. The equation means that every source of fluorescence in a sample is spread into the three-dimensional distribution that is the PSF (Fig. 3). To obtain these images, a small, 0.1-μm bead was imaged in a WFM and optical sections were collected from 4 μm below to 4 μm above the bead. Because the beads are significantly smaller than the resolution limit of the microscope (Inoué and Spring, 1997; Wallace *et al.*, 2001), they contain no structural information visible by the WFM [see Goodman (1996) for a thorough treatment of resolution in optics]. In the fluorescence microscope, these beads are essentially point sources and therefore reveal the PSF of the microscope. Figure 3 shows the PSF viewed from the side, so that the optical axis is running vertically through the center of the bead. The inverted cones above and below the in-focus bead are the blurred light emanating from the bead. It is clear that there is significant out-of-focus light even from a single bead. In a cell or tissue, with point sources spread throughout the sample volume, the density of blurred light can easily dominate the in-focus signal.

It is important to note that Fig. 3 shows a single bead in an optically clear medium. This highly idealized specimen is a far cry from the optical properties of a real specimen, especially an embryo or tissue. These samples contain significant amounts of material that can scatter light. Scattering is a random phenomenon and thus cannot be modeled using expressions similar to Eq. (2). For this reason, scattering can only be minimized or eliminated by changing aspects of the optical path, although there may be applications in the future where the refractive index heterogeneities that cause scattering can be measured *in situ* and corrected (Kam *et al.*, 2001).

It is possible to use either optical or computational methods to reduce the amount of blurred light in an image. The most common optical methods involve LSCMs and MPMs. LSCMs excite the sample point by point by scanning the sample with a diffracted-limited beam and remove blurred light by passing fluorescence emission through a pinhole confocal with the specimen plane of the microscope (Inoué,

Fig. 3 PSF of a high–numerical aperture lens. Optical sections of a 0.1-μm fluorescent bead were recorded with a 100 × 1.4 oil immersion lens. These were then rotated 90° to create an orthogonal (or so called "x–z" view) of the PSF. The images show a slice through the PSF where the vertical axis of the image is parallel to the optical axis of the microscope. (A) Image of PSF scaled so to show the minimum and maximum of the signal in the image. (B) The same image as (A), but scaled with a logarithmic gamut to highlight the lower-level out-of-focus information. Scale = 5 μm.

1995). MPMs also scan the sample with a diffraction-limited beam, but they limit the fluorophore excitation to a small volume by ensuring that fluorophore excitation can only occur where the excitation light flux is highest, just at the point of focus of the scanned beam (Denk and Svoboda, 1997). A large number of methods and configurations are available, and the interested reader should consult any number of texts for a full discussion of these methods (e.g., Pawley, 1995b).

An alternative strategy involves the use of the imaging equation [Eq. (2)] in sophisticated image processing methods to discern in-focus and out-of-focus signal. These methods attempt to reverse the effects of convolution of the PSF in the light microscope and are thus referred to as deconvolution methods. A large number of reviews on these methods have been produced (Agard, 1984; Agard *et al.*, 1989; Shaw, 1993; Swedlow *et al.*, 1997; McNally *et al.*, 1999; Wallace *et al.*, 2001). The interested reader should visit these texts as well for detailed descriptions of this methodology. In this section, I discuss the general design and use of these deconvolution algorithms and their use in wide-field and spinning disk confocal fluorescence microscopy.

A. Approaches for Image Deblurring by Deconvolution

1. Deblurring or Neighbor–Based Methods

There are two general families of deconvolution algorithms. The first are known as deblurring or neighbor-based algorithms. These methods are

fundamentally two-dimensional in nature: they seek to identify the contribution of out-of-focus fluorescence in each optical section and remove it. These algorithms deblur one section at a time by considering the image as a sum of the in-focus signal and the out-of-focus signal from neighboring sections. In their simplest form, they consider a given optical section and its immediate neighbors:

$$\text{image}_n = \text{object}_n \otimes \text{psf}_n + \text{object}_{n+1} \otimes \text{psf}_{n+1} + \text{object}_{n-1} \otimes \text{psf}_{n-1}, \qquad (3)$$

where n is the optical section number. In this treatment, each of these terms is a two-dimensional function at a specific focal plane. Given the PSF shown in Fig. 3, this is clearly an approximation, but it works surprisingly well, especially when a low numerical aperture lens or relatively large section spacings are used. In these cases the approximation that most of the out-of-focus signal in section n derives from section $n - 1$ and $n + 1$ is roughly correct.

To calculate object$_n$, Eq. (3) can be rearranged; however, it still depends on object$_{n-1}$, and object$_{n+1}$. Obviously these are not known, so to speed the calculation these values are substituted with the appropriate optical sections in the image data:

$$\text{image}_n = \text{object}_n \otimes \text{psf}_n + \text{image}_{n+1} \otimes \text{psf}_{n+1} + \text{image}_{n-1} \otimes \text{psf}_{n-1}.$$

This approximation and the limitation of the solution to only one optical section and its neighbors add error to the calculated solution for object$_n$. Nonetheless, neighbor-based solutions can be calculated rapidly, usually within a few seconds, and are used frequently to quickly assess an image. Because of the errors in the method, they should not be relied on to provide quantitatively accurate data. This is most easily seen if one considers the image model in Eq. (3) in a sample containing a bright object four sections away from n. Using Eq. (3), any blurred light in section n will be considered to be "signal," with blurred signal coming from $n + 1$ and $n - 1$. Clearly this would produce erroneous results. For these reasons, deblurring or neighbor-based methods should not be used for quantitative analysis.

A special case for these methods arises when one is deblurring single optical sections; that is a two-dimensional image. There are many implementations of this so-called "no neighbors" deconvolution. This processing is fundamentally two-dimensional, and all structure in the image, whether deriving from a real object or from blurred fluorescence will be enhanced by this method. Again, the results from this approach can produce images with improved contrast, but these data should not be subjected to quantitative analysis.

2. Restoration Methods

An alternative set of methods for deconvolving digital microscope images are known as restoration methods. These methods use the imaging equation [Eq. (2)]

to obtain an estimate of the object: If the object were known or could be estimated, convolution with the PSF would generate the image data:

$$\text{image} = \hat{o} \otimes \text{psf},$$

where \hat{o} represents an estimate or guess at the object. In general, these methods are iterative and progress through the following steps:

1. $\hat{i}^{(k)} = \hat{o}^{(k)} \otimes \text{psf}$

2. $\hat{o}^{(k+1)} = \hat{o}^{(k)} \dfrac{\text{image}}{\hat{i}^{(k)}}$

3. if $\hat{o}^{(k+1)} < 0,$ then $\hat{o}^{(k+1)} = 0$

4. $k = k + 1,$

where \hat{i} represents the guess after blurring with the psf and k is the iteration number. All of these functions are three-dimensional; the coordinate system (x, y, z) has been left out for simplicity.

In step 1, restoration methods start with a guess $\hat{o}^{(k)}$ at the object (usually the original data) and convolve this guess with the psf to give a blurred guess $\hat{i}^{(k)}$. In step 2, the blurred guess $\hat{i}^{(k)}$ is compared with the image data; this comparison is used to update the guess $\hat{o}^{(k)}$ to generate a new guess $\hat{o}^{(k+1)}$. The exact form of this update of $\hat{o}^{(k)}$ to $\hat{o}^{(k+1)}$ represents the major difference between different methods. Originally, a number of methods were developed, tested, and published (Agard, 1984; Agard et al., 1989; Carrington, 1990; Conchello, 1998; Schaefer et al., 2001). The form shown here in step 2 is based on the ratio of the image and $\hat{i}^{(k)}$ as suggested by Gold (1964) and implemented for digital microscope images by Agard (Agard et al., 1989). In step 3, the new guess is subjected to a nonnegativity constraint: Any values in $\hat{o}^{(k+1)}$ that are less than 0 are set equal to 0. This ad hoc constraint was added to help stabilize restoration methods during their early applications (Agard, 1984). More recent analysis indicates that this step is used infrequently in at least some methods and that eliminating it does not affect the quantitative nature of the final restored result (Swedlow et al., 2002). This is important because without the nonnegativity constraint, this restoration method becomes linear. Finally, in step 4, the iteration number is increased and the process is then repeated, starting at step 1, until a stable $\hat{o}^{(k+1)}$ is achieved.

One notable extension of this approach is known as blind deconvolution, where both the object and the PSF are not known and derived from the image data (Holmes, 1992; Holmes et al., 1995). The strategy in this approach is similar to that outlined above with three main differences. First, the convolution in step 1 is performed with a guess at the PSF, which initiates with a calculated PSF based on the known imaging parameters (numerical aperture, wavelength, etc.). The update, as in many nonblind methods, is then performed using a maximum liklihood method (Holmes et al., 1995). In step 3, the guess at the object is constrained by nonnegativity, as above, but the guess at the PSF is constrained to

lie within a volume described by a calculated PSF. With these constraints, blind deconvolution can be used for image restoration and is available as a commercial product from a number of vendors.

B. Image Deconvolution: Effects and Results

The major effect of deconvolution algorithms is an improvement in the contrast in an image by a reduction in blur. Deblurring algorithms accomplish this by estimating and removing blur. Restoration algorithms generate an estimate of the object and, in so doing, partially restore blurred signal to its in focus position. This allows blurred signal to be used, to some extent at least, as in focus signal. This results in an improvement in the signal-to-noise ratio, as shown by the decrease in the coefficients of variations measured after restoration in each of the bead populations in Table I. Note also that the relative intensities in an image are largely preserved after restoration (Fig. 1B, C), and thus, this approach preserves quantitative relationships and therefore may be used to improve image contrast in preparation for quantitative image analysis. An example of the improvement in image contrast after image restoration is shown in Fig. 4. There is a clear visual improvement in the contrast in the image (Fig. 4A, B) but also an improvement in the signal-to-noise, as shown by the line plots (Fig. 4 C, D).

C. Image Deconvolution: Practical Issues

Restoration is only sensibly applied to three-dimensional datasets, as they treat both the image and the PSF as a three-dimensional entity. In practice, the steps listed above are calculated by a series of Fourier transforms, as these represent a convenient and efficient way to calculate convolutions (Bracewell, 1986). The hardware requirements for these calculations, including fast CPUs and significant memory requirements (see Wallace et al., 2001) are now routinely available in desktop computers, so restoration can be used by most microscopists.

In the last few years, restoration algorithms have been extended and developed by a number of commercial software vendors (although see http://3dmicroscopy.wustl.edu/~xcosm/ and http://www.msg.ucsf.edu/IVE/ for notable exceptions). Most of these methods remain proprietary, so it has become difficult to definitively understand the differences between various algorithms. Besides the exact form of the update (step 2), there are many differences in the ways images are preprocessed and handled during the restoration calculation. There are a great number of implementation issues that, although not part of the actual algorithm discussed above, greatly affect the performance and speed of the algorithms (Agard et al., 1989; Swedlow et al., 1997; Wallace et al., 2001). As a user, the best strategy is to test different methods on images familiar to you and to assess the performance for yourself.

Fig. 4 Restoration of images of a mitotic HeLa cell. A metaphase HeLa cell stably expressing a fusion of the aurora-B kinase and GFP was fixed with 3.7% CH_2O and stained with a mouse monoclonal antitubulin antibody and DAPI. The antitubulin was detected with an anti-mouse IgG antibody conjugated to Texas Red. Optical sections covering the whole cell were recorded with a DeltaVision Restoration Microscope (Applied Precision, LLC, Issaquah, WA) and deconvolved using a constrained iterative restoration algorithm (Swedlow *et al.*, 1997). Images are projections through 2 μm of the data stack. (A) Image before restoration with constrained iterative deconvolution. (B) Image after restoration with constrained iterative deconvolution. (C) Line plot showing fluorescence signal values in image before deconvolution along line shown in (A). DAPI (blue), aurora-B-GFP kinase (yellow), and antitubulin (magenta) are plotted on a scale so that each graph is normalized to its maximum value. (D) Same as (C), but along identical line in deconvolved image. Note the dramatic increase in contrast. (See Color Insert.)

IV. Applications for Image Deconvolution

Image deconvolution in fluorescence microscopy has usually been applied to high-resolution imaging to improve contrast and thus detect small, dim objects that might otherwise be obscured (Dernburg *et al.*, 1996; Femino *et al.*, 1998;

Monks *et al.*, 1998). Because of their ability to at least partially use blurred light, restoration algorithms have been especially useful for low-light-level imaging in living cells (Swedlow *et al.*, 1993; Carrington *et al.*, 1995; Wilkie and Davis, 2001; Platani *et al.*, 2002; Swedlow *et al.*, 2002; Swedlow and Platani, 2002). Traditionally, these algorithms have been applied to images from WFMs, although there have been some efforts to use deconvolution algorithms on image data from LSCMs (Shaw and Rawlins, 1991; Highett *et al.*, 1993; Holmes *et al.*, 1995). Recently, spinning disk confocal microscopes (SDCMs) have been developed that scan the specimen with an array of beams generated by holes in a Nipkow disk (Inoué and Inoué, 2002). These microscopes generate a confocal image that can be directly viewed or projected onto a CCD camera and have recently found many applications in cell biology. Application of commercial restoration algorithms to SDCM data has proven quite effective in images from many different cell types (Boes *et al.*, 2002; Maddox *et al.*, 2002).

V. Concluding Remarks

Quantitative imaging and image deconvolution have become standard techniques for the modern cell biologist because they can form the basis of an increasing number of assays for molecular function in a cellular context. Their proper use demands some consideration of the imaging hardware, the acquisition process, fundamental aspects of photon detection, and image processing. This can prove daunting for some cell biologists, but the power of these techniques has been proven many times in the works cited in this article and elsewhere. Their usage is now well-defined, so they can be incorporated into the capabilities of most laboratories.

Acknowledgments

The work from my laboratory is supported by grants from the Wellcome Trust and Cancer Research UK. J. R. S. is a Wellcome Trust Senior Research Fellow.

References

Agard, D. A. (1984). Optical sectioning microscopy: cellular architecture in three dimensions. *Ann. Rev. Biophys. Bioeng.* **13**, 191–219.

Agard, D. A., Hiraoka, Y., Shaw, P., and Sedat, J. W. (1989). Fluorescence microscopy in three dimensions. *Methods Cell Biol.* **30**, 353–377.

Art, J. (1995). Photon detectors for confocal microscopy. *In* "Handbook of Biological Confocal Microscopy" (J. B. Pawley, ed.), pp. 183–196. Plenum, New York.

Boes, M., Cerny, J., Massol, R., Op den Brouw, M., Kirchhausen, T., Chen, J., and Ploegh, H. L. (2002). T-cell engagement of dendritic cells rapidly rearranges MHC class II transport. *Nature* **418**, 983–988.

Bracewell, R. N. (1986). "The Fourier Transform and its Applications." McGraw-Hill, New York.

Carrington, W. (1990). Image restoration in 3D microscopy with limited data. *Proc. SPIE (Int. Soc. Optical Eng.)* **1205**, 72–83.

Carrington, W. A., Lynch, R. M., Moore, E. D., Isenberg, G., Fogarty, K. E., and Fay, F. S. (1995). Superresolution three-dimensional images of fluorescence in cells with minimal light exposure. *Science* **268**, 1483–1487.

Chalfie, M., Tu, Y., Euskirchen, G., Ward, W. W., and Prasher, D. C. (1994). Green fluorescent protein as a marker for gene expression. *Science* **263**, 802–805.

Chen, H., Swedlow, J. R., Grote, M., Sedat, J. W., and Agard, D. A. (1995). The collection, processing, and display of digital three-dimensional images of biological specimens. *In* "Handbook of Biological Confocal Microscopy" (J. Pawley, ed.), pp. 197–210. Plenum Press, New York.

Conchello, J. A. (1998). Superresolution and convergence properties of the expectation-maximization algorithm for maximum-likelihood deconvolution of incoherent images. *J. Opt. Soc. Am. A.* **15**, 2609–2619.

Denk, W., and Svoboda, K. (1997). Photon upmanship: why multiphoton imaging is more than a gimmick. *Neuron* **18**, 351–357.

Dernburg, A. F., Broman, K. W., Fung, J. C., Marshall, W. F., Philips, J., Agard, D. A., and Sedat, J. W. (1996). Perturbation of nuclear architecture by long-distance chromosome interactions. *Cell* **85**, 745–759.

Femino, A. M., Fay, F. S., Fogarty, K., and Singer, R. H. (1998). Visualization of single RNA transcripts in situ. *Science* **280**, 585–590.

Gibson, S. F., and Lanni, F. (1991). Experimental test of an analytical model of aberration in an oil-immersion objective lens used in three-dimensional light microscopy. *J. Op. Soc. Am.* **8**, 1601–1613.

Gold, R. (1964). "An Iterative Unfolding Method for Response Matrices." Argonne National Laboratory. ANL-6984.

Goodman, J. W. (1996). "Introduction to Fourier Optics." McGraw-Hill, New York.

Highett, M. I., Beven, A. F., and Shaw, P. J. (1993). Localization of 5 S genes and transcripts in *Pisum sativum* nuclei. *J. Cell Sci.* **105**, 1151–1158.

Holmes, T. J. (1992). Blind deconvolution of quantum-limited imagery: maximum likelihood approach. *J. Opt. Soc. Am. A.* **9**, 1052–1061.

Holmes, T. J., Bhattacharya, S., Cooper, J. A., Hanzel, D., Krishnamurthi, V., Lin, W.-C., Roysam, B., Szarowski, D. H., and Turner, J. N. (1995). Light microscopic images reconstructed by maximum likelihood deconvolution. *In* "Handbook of Biological Confocal Microscopy" (J. Pawley, ed.), pp. 389–402 Plenum Press, New York.

Inoué, S. (1995). Foundations of confocal scanned imaging in light microscopy. *In* "Handbook of Biological Confocal Microscopy" (J. Pawley, ed.), pp. 1–17. Plenum Press, New York.

Inoue, S., and Inoué, T. (2002). Direct-view high-speed confocal scanner: the CSU-10. *Methods Cell Biol.* **70**, 87–127.

Inoué, S., and Spring, K. R. (1997). "Video Microscopy" Plenum Press, New York.

Kam, Z., Hanser, B., Gustafsson, M. G. L., Agard, D. A., and Sedat, J. W. (2001). Computational adaptive optics for live three-dimensional biological imaging. *Proc. Natl. Acad. Sci. USA* **98**, 3790–3795.

Lippincott-Schwartz, J., Snapp, E., and Kenworthy, A. (2001). Studying protein dynamics in living cells. *Nat. Rev. Mol. Cell Biol.* **2**, 444–456.

Maddox, P. S., Moree, B., Canman, J. C., and Salmon, E. D. (2002). A spinning disk confocal microscope system for rapid high resolution, multimode, fluorescence speckle microscopy and GFP imaging in living cells. *Methods Enzymol.* **360**, 597–617.

McNally, J. G., Karpova, T., Cooper, J., and Conchello, J. A. (1999). Three-dimensional imaging by deconvolution microscopy. *Methods* **19**, 373–385.

Monks, C. R., Freiberg, B. A., Kupfer, H., Sciaky, N., and Kupfer, A. (1998). Three-dimensional segregation of supramolecular activation clusters in T cells. *Nature* **395**, 82–86.

Murray, J. M. (1998). Evaluating the performance of fluorescence microscopes. *J. Microsc.* **191**, 128–134.

Patterson, G., Day, R. N., and Piston, D. (2001). Fluorescent protein spectra. *J. Cell Sci.* **114**, 837–838.

Pawley, J. (1995a). Fundamental limits in confocal microscopy. *In* "Handbook of Biological Confocal Microscopy" (J. Pawley, ed.), pp. 19–37. Plenum Press, New York.

Pawley, J. (1995b). "Handbook of Confocal Microscopy," 2nd Ed. Plenum Press, New York.

Pawley, J. B. (1994). The sources of noise in three-dimensional data sets. *In* "Three Dimensional Confocal Microscopy" (J. Stevens, ed.), pp. 47–94. Academic Press, New York.

Platani, M., Goldberg, I., Lamond, A. I., and Swedlow, J. R. (2002). Cajal body dynamics and association with chromatin are ATP-dependent. *Nature Cell Biol.* **4,** 502–508.

Russ, J. C. (1992). "The Image Processing Handbook." CRC Press, Boca Raton, FL.

Schaefer, L. H., Schuster, D., and Herz, H. (2001). Generalized approach for accelerated maximum likelihood based image restoration applied to three-dimensional fluorescence microscopy. *J. Microsc.* **204,** 99–107.

Shaw, P. J. (1993). Computer reconstruction in three-dimensional fluorescence microscopy. *In* "Electronic Light Microscopy" (D. Shotton, ed.), pp. 211–230 Wiley-Liss, New York.

Shaw, P. J., and Rawlins, D. J. (1991). The point-spread of a confocal microscope: its measurement and use in deconvolution of 3-D data. *J. Microsc.* **163,** 151–165.

Sheppard, C. J. R., Gan, X., Gu, M., and Roy, M. (1995). Signal-to-noise in confocal microscopes. *In* "Handbook of Biological Confocal Microscopy" (J. B. Pawley, ed.), pp. 363–402. Plenum, New York.

Silver, R. B. (1998). Ratio imaging: practical considerations for measuring intracellular calcium and pH in living tissue. *Methods Cell Biol.* **56,** 237–251.

Stearns, T. (1995). Green fluorescent protein. The green revolution. *Curr. Biol.* **5,** 262–264.

Swedlow, J. R., Hu, K., Andrews, P. D., Roos, D. S., and Murray, J. M. (2002). Measuring tubulin content in *Toxoplasma gondii*: a comparison of laser-scanning confocal and wide-field fluorescence microscopy. *Proc. Soc. Natl. Acad. USA* **99,** 2014–2019.

Swedlow, J. R., and Platani, M. (2002). Live cell imaging using wide-field microscopy and deconvolution. *Cell Struct. Funct.* **27,** 335–341.

Swedlow, J. R., Sedat, J. W., and Agard, D. A. (1993). Multiple chromosomal populations of topoisomerase II detected in vivo by time-lapse, three-dimensional wide field microscopy. *Cell* **73,** 97–108.

Swedlow, J. R., Sedat, J. W., and Agard, D. A. (1997). Deconvolution in optical microscopy. *In* "Deconvolution of Images and Spectra" (P. A. Jansson, ed.), pp. 284–309. Academic Press, New York.

Tsien, R. Y. (1998). The green fluorescent protein. *Annu. Rev. Biochem.* **67,** 509–544.

Tsien, R. Y., and Waggoner, A. (1995). Fluorophores for confocal microscopy: photophysics and photochemistry. *In* "Handbook of Biological Confocal Microscopy" (J. B. Pawley, ed.), pp. 267–280. Plenum, New York.

Wallace, W., Schaefer, L. H., and Swedlow, J. R. (2001). A working person's guide to deconvolution in light microscopy. *Biotechniques* **31,** 1076–1097.

Wilkie, G. S., and Davis, I. (2001). Drosophila wingless and pair-rule transcripts localize apically by dynein-mediated transport of RNA particles. *Cell* **105,** 209–219.

Zucker, R. M., and Price, O. (2001). Evaluation of confocal microscopy system performance. *Cytometry* **44,** 273–294.

CHAPTER 18

Ratio Imaging: Measuring Intracellular Ca^{++} and pH in Living Cells

Randi B. Silver

Department of Physiology and Biophysics
Weill Medical College of Cornell University
New York, New York 10021

I. Introduction

The development of sensitive and stable probes for monitoring intracellular pH (pH$_i$) and calcium (Ca$_i^{++}$) in living cells has provided scientists with invaluable tools for studying a multitude of cellular processes. This chapter focuses on the use of ratiometric fluorescent probes for measuring intracellular hydrogen (H$^+$) and calcium ion (Ca$_i^{++}$) activities at the single cell level. These probes afford a noninvasive and semiquantitative assessment of intracellular pH (pH$_i$) and Ca$_i^{++}$, eliminating the need to impale cells with microelectrodes. The development and availability of membrane-permeant Ca^{++}- and pH-specific fluorescent

probes coupled with major advances in the technology and design of low-light-level CCDs geared toward biological applications and improved microscope optics has made it possible to visualize a two-dimensional fluorescence signal that is related to Ca_i^{++} and pH_i. This chapter describes the basis for using dual-excitation ratio imaging and tries to provide a framework for understanding and developing the technique for investigating the roles of Ca_i^{++} and pH_i in cellular processes.

II. Why Ratio Imaging?

The fluorescence emission of a probe may be influenced by a variety of factors. The uncertainties associated with quantitating single-wavelength fluorescence emissions are apparent from the standard fluorescence equation:

$$F = f(\theta)g(\lambda)\Phi_F I_o \,\varepsilon b c$$

where fluorescence emission of the probe (F) is related to a geometric factor [$f(\theta)$], the quantum efficiency of the detector [$g(\lambda)$], fluorescence quantum yield of the probe (Φ_F), excitation intensity (I_o), extinction coefficient of the probe (ϵ), optical pathlength (b), and fluorophore concentration (c) (Bright *et al.*, 1989). Fluorescence emission of a probe can also be influenced by cellular factors, such as uneven loading of the dye or compartmentalization of the probe in intracellular organelles (Heiple and Taylor, 1981), as well as instrumentation noise, sample geometry, and intrinsic properties of the probe itself (Bright *et al.*, 1989). These factors can all lead to difficulties in interpreting changes in a single-wavelength fluorescent probe.

These limitations have been overcome through the development of dual-wavelength fluorescent probes. Dual-wavelength indicators have a high affinity for binding their parameter of interest, such as Ca^{++} or H^+, and contain fluorophores that fluoresce when the molecule is bound and unbound, but at two distinct and nonoverlapping wavelengths. The total fluorescence emitted from the probe represents two independent fluorescent forms of the dye originating from the same volume. The changes in fluorescence intensity of bound and unbound dye can be in the probe's excitation or emission spectrum. For the intracellular pH and Ca^{++} probes discussed in this chapter, the fluorophore on the dye molecule shifts its excitation intensity depending on whether the probe is bound or unbound to either H^+ or Ca^{++}, so that the fluorescence emitted from these two excitation wavelengths represents the total fluorescence of the probe in the cytosol. The fluorescence measurements obtained with dual-wavelength probes are independent of both pathlength and intracellular dye concentration (Heiple and Taylor, 1981). It is this principle that underlies the efficacy of two widely used dual-excitation ratiometric indicators for measuring pH_i and Ca_i^{++}. Both 2′, 7′-bis (carboxyethyl)-5(6)-carboxyfluorescein (BCECF) and Fura-2 shift their wavelength distribution of fluorescence excitation on binding H^+ and Ca_i^{++},

respectively. Understanding the use of these two intracellular fluorescent dyes for understanding the roles of pH$_i$ and Ca$_i^{++}$ in various cellular processes is the focus of this chapter.

III. Properties of the Indicators BCECF and Fura-2

A. Structure and Spectral Characteristics

Figure 1 shows the chemical structures of BCECF and Fura-2. BCECF is a derivative of fluorescein with three additional carboxylate groups; two are attached by short alkyl chains, which raises the pK from 6.4 (for fluorescein) to a more physiological pK of 7.0 (Rink *et al.*, 1982). Fura-2, developed from the Ca chelator BAPTA, is the double-aromatic analogue of EGTA with added fluorophores (Cobbold and Rink, 1987). Compared to its predecessor quin2, Fura-2 is a larger fluorophore with a much greater extinction coefficient and a higher quantum efficiency, translating to 30-fold higher brightness per molecule (Cobbold and Rink, 1987). As shown in Fig. 1, both dyes are penta-anions and, therefore, hydrophilic and membrane impermeable in this form.

Fig. 1 Chemical structures of BCECF and Fura-2. The free-acid and membrane-permeant forms of each dye are represented in the figure. Reprinted by kind permission from Molecular Probes, Inc.

The chemical structures of these dyes had to be modified to render them membrane permeable. Making these molecules neutral was accomplished by masking the negative charges on the structures with acetoxymethyl (AM) esters as shown in the right panel of Fig. 1 (BCECF AM and Fura-2 AM). The loading of the neutral AM forms of the dyes into cells is discussed in more detail in Section IIIB.

As discussed above, a fundamental requirement that must be met if an indicator is to be used for quantitative ratio imaging is a differential sensitivity to its ligand at one specific wavelength relative to another wavelength. The measured fluorescence signal at these two wavelengths would then result in a ratio of fluorescence intensity, reflecting the relative proportion of the bound form and unbound form of the indicator originating from the same volume. The excitation spectra in the following figures illustrate the wavelength specificity of BCECF for pH (Fig. 2) and Fura-2 for Ca^{++} (Fig. 3).

Excitation spectra of BCECF at various pH are shown in Fig. 2. To generate these curves, the free-acid form of BCECF ($2\,\mu M$) was added to aliquots of balanced Hepes buffered salt solutions titrated to a known pH. The samples ranged from pH 6.6 to 7.8. The BCECF in each sample of solution was excited by scanning the monochromater in the fluorimeter from 400 to 500 nm, as shown on the abscissa.

Fig. 2 Excitation spectra of $2\,\mu M$ BCECF at various pHs. The salt solution contained 130 mM KCl, 1 mM $MgCl_2$, 2 mM glucose, 2 mM $CaCl_2$, and 25 mM Hepes. The spectra (emission: 520) were generated with a fluorimeter (Photon Technology Incorporated–Deltascan) scanning at 1-nm intervals and interfaced to an inverted microscope (Zeiss IM35) equipped with a Hamamatsu photomultiplier tube. Individual dishes placed on the stage of the microscope and aligned in the epifluorescent light path contained $250\,\mu L$ of Hepes buffered salt solution with $2\,\mu M$ BCECF at the pHs indicated. The spectra have not been corrected for background noise. The peaks at 470 nm are the result of xenon lamp output.

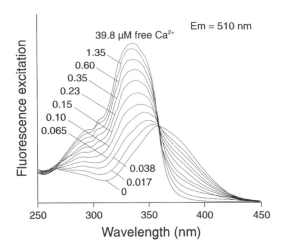

Fig. 3 Excitation spectra of Fura-2 in a range of solutions containing 0–39.8 μM free Ca. Emission is at 510 nm. Reprinted by kind permission from Molecular Probes, Inc.

The corresponding emitted fluorescence intensity for each wavelength, collected at 520 nm, is shown on the ordinate. Figure 2 shows that between 490 and 500 nm, BCECF displays strong pH sensitivity. At these wavelengths, the fluorescence intensity of BCECF increases as the pH of the solution becomes more alkaline. In contrast, at lower-excitation wavelengths, the fluorescence emitted from BCECF is pH independent. Therefore, in a given volume, alternately exciting the BCECF molecules at a pH-sensitive wavelength with exciting them at a pH-insensitive wavelength yields the relationship of the changes in BCECF fluorescence signal at each wavelength with respect to the other. In Fig. 2, for example, the ratio of the emission intensity at 490 nm excitation, the pH-dependent wavelength, to the emission intensity at 440 nm excitation, the pH-independent wavelength, increases as pH becomes more alkaline and decreases as pH becomes more acidic.

The spectral characteristics of Fura-2 are shown in Fig. 3. Fura-2, developed by Grynkiewicz and colleagues (Grynkiewicz *et al.*, 1985) exhibits properties that make it ideal for ratio imaging. These properties are illustrated by the spectra in Fig. 3, showing the shape of the excitation spectrum and the large dynamic range of the dye in a range of solutions containing varying concentrations of free Ca^{++}. For Fura-2, the fluorescence intensity at 340-nm excitation is directly proportional, and at 380-nm excitation inversely proportional, to the free Ca^{++} concentration. The ratio of the emitted intensities at 340- and 380-nm excitation can be used to determine the concentration of ionized Ca^{++} in a given volume.

The BCECF and Fura-2 spectra demonstrate that these probes possess properties that make them prime candidates for dual excitation ratio imaging. From the BCECF and Fura-2 spectra, it should be apparent that by choosing the appropriate excitation wavelengths it is possible to have adequate emitted

fluorescence intensity to generate a ratio of the fluorescent species of the dye bound and unbound in a given volume. Thus, with both BCECF and Fura-2, a fundamental requirement for ratio imaging is met.

Going back to the standard fluorescence equation presented in Section II, we are reminded of the many factors with the potential to influence the fluorescence signal yet be unrelated to actual changes in the parameter of interest. With dual-wavelength fluorescent probes such as Fura-2 and BCECF, interference from these factors is minimized. This principle is illustrated in Fig. 4, which shows the effect of changing the optical pathlength on the BCECF fluorescence signals. For this maneuver, BCECF free acid was dissolved in physiologically balanced salt solution buffered to a pH of 7.4. An aliquot of this solution was placed on a coverglass on the stage of an inverted epifluorescence microscope interfaced to an imaging system outfitted with the appropriate excitation and emission filters. The top panel of Fig. 4

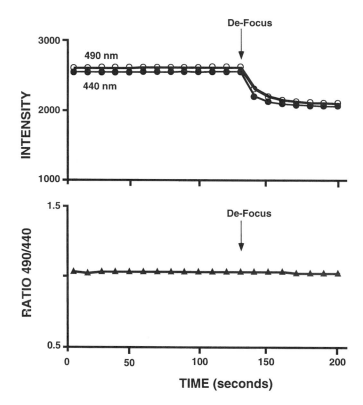

Fig. 4 The effect of changing focus on the fluorescence signal from BCECF. A dish containing $2\,\mu M$ BCECF free acid in $250\,\mu L$ salt solution was placed on the stage of an inverted microscope. The top graph shows the individual traces for the emitted fluorescence excitation intensities at 490 (open circles) and 440 nm (closed circles), and the bottom graph is the ratio of 490/440. The focus was changed at the arrow. As shown in the top graph, both the 490- and 440-nm signal decreased with the change in focus; however, the 490/440 ratio remained the same.

shows the emitted BCECF fluorescence intensity from the 490- and 440-nm excitation wavelengths, and the bottom panel is the ratio of the corresponding 490- and 440-nm signals. At the arrow, the focus or optical pathlength was changed. As shown in the top panel, both the 490- and 440-nm-excitation fluorescence signals originating from the same volume decreased proportionately in response to the change in the focus. The corresponding 490/440 ratio remained constant, as shown in the bottom panel. The changes in the fluorescence intensities were caused by a mechanical factor: a change in the microscope focus. This simple example illustrates how factors other than the parameter of interest can affect fluorescence emission of a probe, but with dual-wavelength probes, some of this interference can be minimized. It is also important to understand how a dye responds at its activated wavelength with respect to binding its parameter of interest. If the fluorescence intensity changes in a direction opposite from what is expected, there may be interference from an unrelated factor.

B. Incorporation into Intact Living Cells

As discussed in Section IIIA, the active forms of Fura-2 and BCECF are charged and not membrane permeable. The charged anionic forms of Fura-2 and BCECF can only be introduced into a cell with microinjection. To overcome the issue of membrane permeability, permeant, neutral forms of BCECF and Fura-2 were synthesized. This was a major accomplishment in dye chemistry, for it permits diffusive entry of these dyes into cells (Cobbold and Rink, 1987). The membrane-permeable analogs of BCECF and Fura-2 were created by replacing the negatively charged carboxylate groups of the molecule with neutral acetoxymethyl (AM) esters (see Fig. 1) (Tsien, 1989). In this formulation, the dye can diffuse across the cell without disruption of the cell membrane. Once the lipophilic form of the dye gets into the cytoplasm, esterases cleave off the hydrolyzable AM esters leaving the anionic form of the dye trapped inside the cell and free to bind its ligand (i.e., H^+ or Ca^{++}). This strategy is illustrated for BCECF in Fig. 5. Note that for every molecule of BCECF hydrolyzed in the cytosol, five molecules of formaldehyde, five molecules of acetate, and 10 protons are formed.

C. Signal-to-Noise Ratio

The loading concentration of the dye and the amount of time the cells need to be loaded will vary from cell type to cell type and needs to be determined empirically. A good starting point is to expose cells to micromolar concentration of the AM form of the dye dissolved in medium or balanced salt solution for about 60 minutes at room temperature. Once the extracellular dye is washed away, the loaded cells are ready to be used. The cells should be maintained in buffered salt solutions without phenol, amino acids, or vitamins, because these components can fluoresce at wavelengths used to excite Fura-2, thereby interfering with the Fura-2 signal. As a rule, the emitted fluorescence intensity

Fig. 5 Cartoon of BCECF/AM entering a cell and undergoing hydrolysis. The neutral molecule of BCECF is membrane permeable and readily diffuses into a cell. Once in the cytosol, endogenous esterases cleave the acetoxymethyl esters from the molecule, leaving the polyanion trapped inside the cell, where it will combine with free H^+. A similar strategy applies for Fura-2. The chemical reaction depicted in the figure shows that for every BCECF/AM molecule hydrolyzed to its penta-anionic free acid, five molecules of formaldehyde, five molecules of acetate, and 10 protons are formed.

of a probe should be at least two to three times greater than background noise. Tissue or cell autofluorescence should be measured before dye loading, with the imaging system configured exactly the way it will be used for the experiment. Optimal conditions for yielding a good fluorescence signal from cells will come from balancing loading of the dye into the cells with the appropriate combination of neutral density filters and excitation exposure time. It is important that the cells are not overloaded with the dyes, for this can result in toxic accumulation of the end products of hydrolysis described above and buffering of steady-state intracellular Ca^{++} and pH. At the beginning of an experiment, the intracellular pH_i and Ca_i^{++} values measured with BCECF and Fura-2 should be representative of a resting, unperturbed state. When analyzing the experimental data, the background and autofluorescence should be subtracted from each excitation wavelength before determining the final ratio.

D. Possible Problems

It has been reported in some tissues that hydrolysis of Fura-2 AM may be incomplete, leaving partially cleaved forms of the dye that fluoresce at 380 nm (Tsien, 1989). Overloading cells with indicator may also lead to excessive compartmentalization of the dye in intracellular organelles, so that the emitted fluorescence may not adequately reflect a contribution of all of the intracellular compartments, which include the cytosol and the organelles (Tsien, 1989). Another potential problem to be aware of if the cells are poorly loaded is the possibility that hydrolyzed dye is transported out of the cell. It has been shown in certain cell types that once the AM form of the dye is cleaved into a penta-anion by intracellular esterases, it can be extruded from the cell by anion transporters in the plasma membrane. This movement of dye out of the cell can be inhibited by blocking the anion transporter with probenecid (Cardone et al., 1996; Di Virgilio et al., 1990; Di Virgilio et al., 1988; Millard et al., 1989).

IV. Calibration of the Fluorescence Signal

To assign a numerical value to the experimentally determined ratios, it is necessary to calibrate the fluorescence signal. The easiest but most unreliable method for determining the pH_i and Ca_i^{++} is by generating calibration curves on solutions that are titrated to known pH and pCa values to which the free-acid form of the dye is added. Kits are commercially available for this purpose. The experimentally determined ratios generated on living cells are then extrapolated to fit these curves, and the free H^+ and Ca^{++} concentration can be generated. An underlying assumption of this technique is that the indicator acts in a similar fashion in salt solutions and cytoplasm, which may not be a valid assumption. This protocol often requires the use of viscosity correction factors to account for the difference in behavior of the dye inside the cell versus an external solution (Tsien, 1989).

A preferable method for calibrating the behavior of the dye inside the cell is to "clamp" the pH_i and Ca_i^{++} to known values and to measure the dye intensity at the corresponding wavelengths. Ideally this clamp is performed at the end of each experiment on the field of cells. Specific ionophores or carriers are incorporated into the plasma membrane of the cells, allowing one to set the Ca_i^{++} or pH_i to known values. Equilibrium between the external solution and internal environment of the cell is assumed. The corresponding fluorescence signals from the two excitation wavelengths at these known values are then used to calibrate the experimentally determined ratios.

One commonly used technique for calibrating BCECF in cells is the high potassium/nigericin clamp protocol of Thomas et al. (1979). With this protocol, pH_i is set to known values at the end of an experiment by exposing the cells to

the K^+/H^+ antiporter, nigericin, in the presence of potassium solutions titrated to known pH. With the nigericin present, K^+ and H^+ gradients across the cell membrane are collapsed so that $[K]_i/[K]_0$ is equal to $[H]_i/[H]_0$, BCECF, with a pK ~ 7.0, changes its fluorescence intensity at 490 nm proportionaly between pH 6.4 and 7.8. Clamping pH_i/pH_0 in the experimental cells with nigericin to values between 6.4 and 7.8 yields a linear relationship. The slope and y intercept of this relationship is then used to convert the experimentally determined ratios to pH_i values. Figure 6 shows how this calibration technique is done. Figure 6A–C show pseudocolor ratiometric images of a field of BCECF-loaded neuroblastoma SH-SY5Y cells excited at 490 and 440 nm at three different time points during an experiment. The pseudocolor ranges from red (alkaline) to blue (acid). Figure 6A shows the 490/440 fluorescence in a field of cells at the beginning of the experiment and represents basal pH_i values. Figure 6B and Figure 6C were generated at the end of the experiment during the nigericin clamp, at pH 7.8 (Fig. 6B) and pH 6.5 (Fig. 6C). With the appropriate software, each cell in the field can generate its own slope and intercept from the linear relationship generated by the nigericin clamp. The linear relationship derived from the nigericin clamp for one of the cells in this field is shown in Fig. 6D. By calculating the slope and y intercept of the relationship, the experimentally determined ratios can be converted to pH_i. An example of the conversion of the 490/440 ratio to pH_i is shown for the cell whose values were used to calculate the slope and y intercept (Fig. 6D). Figure 6E is the trace of pH_i versus time in and shows the Na^+-dependent pH_i recovery response of a cell acutely exposed to an NH_4Cl prepulse.

Intracellular calibration of Fura-2 can also be carried out in cells with the Ca^+ ionophore ionomycin. This procedure is done at the end of an experiment similar to the nigericin technique described for BCECF. Calibration of the Fura-2 signal is achieved by determining both the maximum 340/380 ratio and the minimum 340/380 ratio of Fura-2 in the field of cells being studied. The maximum Fura-2 ratio is achieved with saturating levels of Ca^{++} (2 mM), and the minimum Fura-2 ratio is attained in the presence of the Ca^{++} chelator EGTA with no added Ca^{++}, both in the presence of ionomycin. Intracellular Ca^{++} concentrations measured at intermediate ratios are calculated according to the relationship described for Fura-2 by Grynkiewicz et al. (1985):

$$[Ca_i^{++}] \, K_d \, \frac{R - R_{min}}{R_{max} - R} \frac{S_{f2}}{S_{b2}},$$

where K_d is the effective dissociation constant (224 nM) at 37 °C, S_{f2} is the free or unbound signal at 380 nm, and S_{b2} is the Ca^{++}-bound dye signal at 380 nm.

Figures 7I and 7II are examples of how Fura-2 is calibrated in cells. Figure 7I shows four pseudocolor ratiometric images of Fura-2-loaded neuroblastoma SH-SY5Y cells, excited at 340 and 380 nm, at four different time points during an experiment. The pseudocolor ranges from red (>1 μM Ca^{++}) to blue (<10 nM

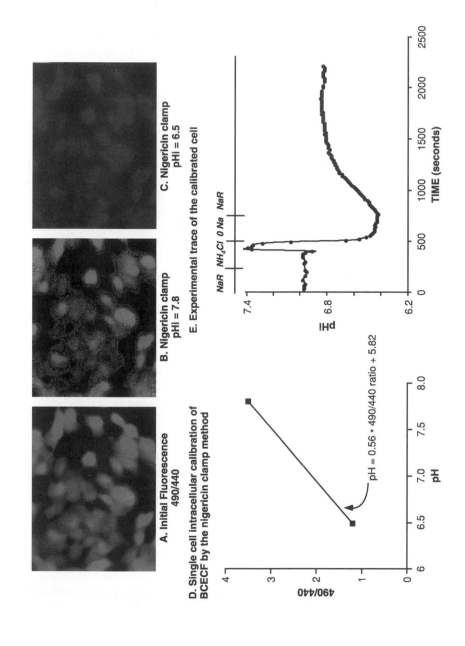

A. Initial Fluorescence 490/440

B. Nigericin clamp pHi = 7.8

C. Nigericin clamp pHi = 6.5

D. Single cell intracellular calibration of BCECF by the nigericin clamp method

pH = 0.56 * 490/440 ratio + 5.82

490/440

pH

E. Experimental trace of the calibrated cell

pHi

TIME (seconds)

NaR NH$_4$Cl 0 Na NaR

Ca^{++}). Panel A shows the 340/380 pseudocolor ratio of the cells at the beginning of the experiment and corresponds to a time point during interval A on the representative trace from a cell in this field (Fig. 7II). Panel B is a time point in which the cells were exposed to a depolarizing high-K^+ solution, thereby opening voltage-sensitive Ca^{++} channels in the cell membrane. The pseudocolor image has changed from dark green to bright green/yellow under this condition, which translates to an increase in Ca_i^{++}. This time point corresponds to point B on the trace in Figure 7II. Panels C and D represent images during the calibration of Fura-2 in the cells, with C being the R_{max}, also indicated by C in the trace of Fig. 7II, with D being the R_{min} indicated in Fig. 7II.

Figure 7II shows the 340- and 380-nm signals as well as the ratio and the calibrated Ca_i^{++} value for a single cell in the field of cells shown in Fig. 7I. The cells are initially bathed with a Hepes buffered solution. At the first arrow, the superfusate is changed to a high-K^+ solution. As mentioned above, depolarization by high extracellular K^+ leads to an influx of Ca^{++}, evidenced by a decrease in the 380-nm signal and an increase in the 340-nm signal, resulting in a transient increase in the 340/380 ratio. To convert the changes in the 340/380 ratio to Ca_i^{++} values, the intracellular Fura-2 was calibrated. As indicated on the trace, ionomycin was added to the superfusate in the presence and absence of extracellular Ca^{++}. Addition of ionomycin in the presence of extracellular Ca^{++} leads to a massive influx of Ca^{++} through the ionomycin pore and yields the R_{max}. This results in an increase in the 340-nm and a decrease in the 380-nm signals, resulting in a maximum 340/380 ratio of 3.2 from an initial ratio of 0.9. For generating an R_{min}, ionomycin remained present in the extracellular fluid, and extracellular Ca was replaced with EGTA. Under this condition, the 340 signal goes down and the 380 signal increases, resulting in the minimum 340/380 ratio (R_{min}), as shown in the trace. The values obtained from this intracellular calibration of Fura-2 are then plugged into the equation described above to convert the experimental 340/380 ratios to Ca_i^{++}. For this cell, the initial Ca_i^{++} started at 100 nM. With the K^+-induced depolarization, the Ca_i^{++} went up to 250 nM and was immediately regulated back down to basal levels.

The calibration of intracellular BCECF and Fura-2 shown in Figs. 6 and 7 demonstrates the utility of dual wavelength ratiometric imaging for measuring pH_i and Ca_i^{++}. It is important to monitor the behavior of the dye at the level of the individual wavelengths as well as with the ratio. To maximize the amount of

Fig. 6 Top: Three representative ratiometric pseudocolor images of neuroblastoma SH-SY5Y cells loaded with BCECF and excited at 490 and 440 nm, emission at 520 nm. The range of pseudocolor goes from red (alkaline) to dark blue (acid). (A) An image of the initial fluorescence in these cells at the beginning of an experiment, with the cells bathed in Hepes-buffered Ringer's solution. (B and C) Pseudocolor images of the same field of cells clamped to pH_i 7.8 (B) and pH_i 6.5 (C), with nigericin. Bottom: (D) The calibration of BCECF using the nigericin clamp protocol in one cell from the field above. Intracellular and extracellular pH were equilibrated with the H^+/K^+ exchanger, nigericin (10 μM) and K^+ solutions titrated to the indicated pH. The slope and intercept defined by the line was used to convert the experimentally determined 490/440 ratios to pH_i. (E) The experimental trace from this cell expressed as pH_i as a function of time. (See Color Insert.)

A. initial 340/380 B. K+−depolarization

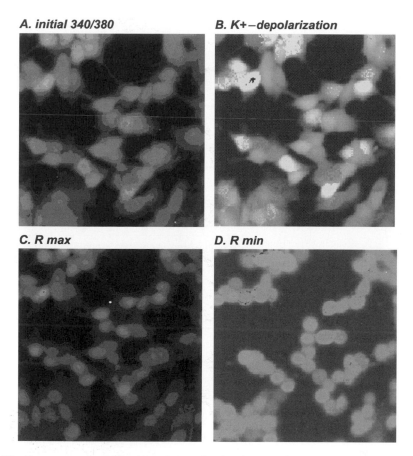

C. R max D. R min

Fig. 7I Four representative ratiometric pseudocolor images of cells neuroblastoma SH-SY5Y loaded with Fura-2 and excited at 340 and 380 nm, emission at 510 nm. The range of pseudocolor goes from blue (<10 nM Ca_i^{++}) to red (>1000 nM Ca_i^{++}). (A) is an image of the initial fluorescence in these cells at the beginning of an experiment, with the cells bathed in Hepes-buffered Ringer's solution and corresponds to a time point from (A) in the traces in Figure 7II. (B) An image from the experiment after the bathing solution was changed to a high-K^+ solution, which depolarized the cells. This image corresponds to a time point from (B) in the traces in Figure 7II. These cells express a voltage-sensitive Ca^{++} channel in the membrane. The switch to a K^+-depolarizing solution resulted in an opening of these channels and an influx of Ca^{++} from the extracellular fluid. The pseudocolor image is bright green/yellow indicating that the 340/380 ratio increased. (C) is an image from the experiment during the maneuver to calibrate the Fura-2 in the cell, specifically the R_{max} value, and corresponds to a time point during (C) in the trace in Figure 7II. Ionomycin ($10\,\mu$M) was added to the extracellular Ringer's solution, which resulted in a massive influx of Ca^{++} from the extracellular fluid. This caused a large increase in the 340/380 ratio. (D) An image from the experiment during the maneuver to calibrate the Fura-2 in the cell, specifically the R_{min} value, and corresponds to a time point during (D) in the trace in Figure 7II. Ionomycin ($10\,\mu$M) was added to the Ca^{++}-free extracellular solution, which also contained EGTA. This maneuver resulted in a massive efflux of Ca^{++} from the cell, resulting in a decrease in the 340/380 ratio. 7II represents the responses of a single cell in the field of cells shown in the pseudocolor images in 7I, showing the changes in the 340- and 380-nm intensities (top), the 340/380 ratio (middle), and the corresponding Ca_i^{++} values based on the Fura-2 calibration in this cell (bottom). (See Color Insert.)

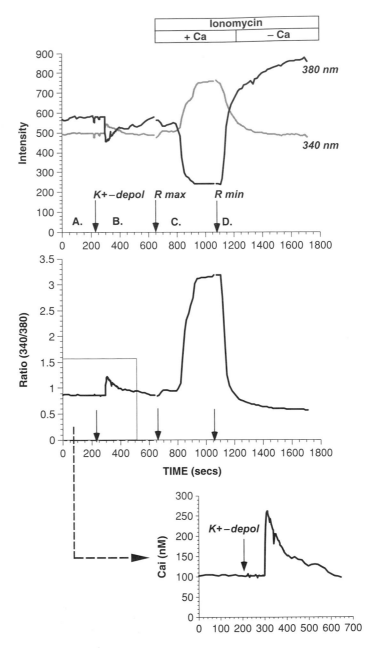

Fig. 7II (*Continued*).

useable data acquired from a field of cells and to monitor variability of responses on a cell-to-cell basis, it is imperative that each cell monitored during the experiment generate its own calibration curve based on the behavior of the dye in the cell. Imaging software is available for this purpose.

V. Components of an Imaging Workstation

Figure 8 is a schematic of an imaging workstation. The fluorescence light path begins with a high-energy xenon or mercury lamp (Fig. 8A) attached to the back of the microscope. Xenon lamps provide a continuous light output from 270 to 700 nm (Lakowicz, 1986) except around 450–485 nm, where one sees some sharp lines similar to those seen in the BCECF spectra in Fig. 1. Mercury lamps produce a higher intensity than xenon lamps, but this output is not continuous; rather, it is concentrated in lines, so these lamps are only suitable if the lines coincide with the peak excitation of the fluorophore. A high-energy light source providing the optimal output of intensity in the excitation range needed should be chosen. A 75-watt xenon lamp works well for both Fura-2 and BCECF measurements. It is also important that the lamp be focused and provide a flat and evenly illuminated field. Output from the lamp passes through the appropriate excitation filters housed in a shutter-controlled filter wheel (Fig. 8B). This device changes excitation wavelengths and controls the duration of the illuminating light. To minimize photobleaching and photodynamic damage to the cells, fluorescence excitation can be shuttered off, except during the brief periods required to record an image. In many filter wheels a neutral density filter can be inserted in the same slot as the excitation filter, adding additional protection against photobleaching. Neutral density filters can also be chosen for equalizing the two excitation wavelengths of light. The two alternating wavelengths of light enter the optical axis of the microscope and encounter a filter cube housing an appropriate dichroic mirror and emission filter (Fig. 8C). The dual-purpose dichroic mirror reflects the exciting light up through the objective to the sample sitting in the chamber on the stage of the microscope. The emitted fluorescence travels back down through the objective and is transmitted through the dichoric mirror and emission filter to the detector (Fig. 8D). An inverted epifluorescence microscope outfitted with high–numerical aperture oil- or glycerin-immersion objectives (>1.25) is best for low-light-level imaging. The light-collecting efficiency of an objective varies approximately with the square of the numerical aperture.

The basic requirements for a detector or camera used in low-light-level imaging are wide dynamic range and linear response within the range of detection. Intensified video cameras and frame-transfer CCDs can both be used for ratio imaging. An advantage of the frame-transfer CCD is its wide dynamic range— useful and sometimes the only option for performing quantitative ratio imaging on all of the cells viewed in the field. For example, at a given camera gain with a fixed grey-level scale of 0 to 255, a cell population may not have homogenous loading.

Fig. 8 Schematic of an imaging work station. The components include a high-energy lamp (A) connected to a shutter-controlled filter wheel (B) attached to the back of the microscope. The dichroic mirror and emission filter are housed in the base of the nosepiece (C). The low-light-level imaging device (D) is interfaced to a port on the microscope. The image processor and operating system are housed in the computer (E), which controls the entire work station.

This can be caused by a variety of reasons, such as differences in intrinsic esterase activity or differences in subcellular compartment volumes. In experimental situations of this nature, a frame-transfer camera with an expanded greyscale would be very helpful. For example, a frame-transfer camera containing a frame-transfer chip (EEV-37) with 12-bit readout has a greyscale 16 times greater than a standard digital camera and goes from 0 to 4095 grey levels. Another advantage of using the frame-transfer type of device for ratio imaging is the speed at which it records an image pair. This is possible because of the chip in the camera, which has half of the surface covered by an opaque mask. The first excitation wavelength

signal may be recorded on the unmasked side and electronically transferred to the masked side (Bright *et al.*, 1989). The second excitation wavelength is then recorded while the first is being read off the masked side of the chip, which allows the recording of two images in rapid succession with on-chip transfer of a 14-bit image taking less than two milliseconds (Bright *et al.*, 1989).

The best way to decide which detector is most suitable is to test various detection devices with your biological specimen. If possible, try to perform an intracellular calibration of the dye to see how the detection device performs at the maximum and minimum range of signals. A discussion of the properties of different types of low-light-level cameras may be found elsewhere in this volume.

A host computer (Fig. 8E) that includes the operating system and an image processor controls the entire workstation. The operating system controls the shutter and filter wheel and coordinates the acquisition and analysis of the ratio images. The image processor is required for data acquisition and decreases processing time over that of the computer, permitting readout of the experimentally acquired images in close to real time (Bright *et al.*, 1989).

VI. Experimental Chamber and Perfusion System—A Simple Approach

As important as choosing the right components of the imaging workstation is finding an experimental chamber and perfusion system that is easy to use and assemble. This section describes a simple chamber and a perfusion system routinely used in my laboratory, which may be useful to others.

Figure 9 is a diagram of a perfusion apparatus consisting of a Lucite rack from which glass syringes are suspended (Fig. 9A). Solutions are gravity fed into a six-port Hamilton valve with six individual inputs and one output (Fig. 9B). The solution exiting from the output port then goes directly into a miniature water-jacketed glass coil (Fig. 9C) (Radnotti Glass Technology, Monrovia, CA) for regulating solution temperature. The warmed solution (37 °C) then enters the experimental chamber (Fig. 9D), which fits on the stage of the inverted epifluorescence microscope. The experimental chamber, which was designed to fit on the stage of an inverted microscope, is diagrammed in more detail in the inset of Fig. 9. It consists of a piece of Lucite fitted on the bottom and top with interchangeable coverslips (number 1 thickness and 22 mm square) that are temporally attached to the chamber with Dow Corning high-vacuum grease. The specimen area of the chamber contains an entry port for accommodating the entering perfusate and an exit port to convey the perfusate to a reservoir sitting at a lower level. The chamber volume is roughly 600 μL exchanged at a rate of about 2 mL/minute. For an inverted microscope, the experimental cells must rest on the surface of the coverslip, which constitutes the bottom of the chamber. This is essential because of the small working distance of many of the high–numerical aperture objectives that are required for performing low-light-level imaging

Fig. 9 Diagram of experimental perfusion set-up and chamber. The perfusion apparatus consists of a ring stand with a rack holding glass syringes (A). Each syringe is attached to an input on a Hamilton valve (B) via tubing. The output from the Hamilton valve goes into a miniature water-jacketed glass coil (C) (Radnotti Glass Technology, Monrovia, CA) where it is warmed to 37 °C. Output from the coil enters the experimental chamber (D) mounted on the stage of an inverted microscope.

experiments. For example, the Nikon Fluor 40X oil-immersion objective with variable numerical aperture (0.8–1.3) has a working distance of 0.22 mm when used with a number 1 size coverslip of 0.17 mm thickness. With this combination of objective and coverslip there is enough working distance to view cells attached to the coverslip surface facing the chamber. A coverslip is also placed on the top of the chamber to maintain temperature, laminar flow, and optimal optical conditions for viewing the cells.

VII. Conclusion

In conclusion, the technique of quantitative ratio imaging for the measurement of pH_i and Ca_i^{++} has revolutionized the field of cell physiology. Using the proper equipment and choosing the right dyes for your experimental needs should provide reliable and reproducible results. More important, the amount of data produced from each experiment when analyzing pH_i and Ca_i^{++} on an individual cell basis

yields valuable information on the heterogeneity of cellular responses (Silver *et al.*, 2001; Silver *et al.*, 2002) and will open up new areas for understanding the roles of pH$_i$ and Ca$_i^{++}$ in signal transduction.

Acknowledgments

This work was generously supported by (NIDDK) Grant DK-060726. I acknowledge the contributions of Alicia C. Reid and Li Ma.

References

Bright, G. R., Fisher, G. W., Rogowska, J., and Taylor, D. L. (1989). Fluorescence ratio imaging microscopy. *In* "Methods in Cell Biology" (D. L. Taylor and Y. Wang, eds.), Vol. 30, pp. 157–192. Academic Press, San Diego.

Cardone, M. H., Smith, B. L., Mennitt, P. A., Mochly-Rosen, D., Silver, R. B., and Mostov, K. E. (1996). Signal transduction by the polymeric immunoglobulin receptor suggests a role in regulation of receptor transcytosis. *J. Cell Biol.* **133**, 997–1005.

Cobbold, P. H., and Rink, T. J. (1987). Fluorescence and bioluminescence measurement of cytoplasmic free calcium. *Biochem. J.* **248**, 313–328.

Di Virgilio, F., Steinberg, T. H., and Silverstein, S. C. (1990). Inhibition of Fura-2 sequestration and secretion with organic anion transporter blockers. *Cell Calcium* **11**, 57–62.

Di Virgilio, F., Steinberg, T. H., Swanson, J. A., and Silverstein, S. C. (1988). Fura-2 secretion and sequestration in macrophages. A blocker of organic anion transport reveals that these processes occur via a membrane transport system for organic anions. *J. Immunol.* **140**, 915–920.

Grynkiewicz, G. M., Poenie, M., and Tsien, R. Y. (1985). A new generation of Ca2+ indicators with greatly improved fluorescence properties. *J. Biol. Chem.* **260**, 3440–3450.

Heiple, J. M., and Taylor, D. L. (1981). An optical technique for measurement of intracellular pH in single living cells. *Kroc. Found. Ser.* **15**, 21–54.

Lackowicz, J. R. (1986). *Principles of Fluorescence Spectroscopy.* pp. 24, Plenum Press, New York.

Millard, P. J., Ryan, T. A., Webb, W. W., and Fewtrell, C. (1989). Immunoglobulin *E. coli* receptor cross-linking induces oscillations in intracellular free ionized calcium in individual tumor mast cells. *J. Biol. Chem.* **264**, 19730–19739.

Rink, T. J., Tsien, R. Y., and Pozzan, T. (1982). Cytoplasmic pH and free Mg^{2+} in lymphocytes. *J. Cell Biol.* **95**, 189–196.

Silver, R. B., Mackins, C. J., Smith, N. C. E., Koritchneva, I. L., Lefkowitz, K., Lovenberg, T., and Levi, R. (2001). Coupling of histamine H3 receptors to neuronal Na+/H+ exchange: a protective mechanism in myocardial ischemia. *Proc. Natl. Acad. Med.* **98**, 2855–2859.

Silver, R. B., Poonwasi, K. S., Seyedi, N., Wilson, S., Lovenberg, T. W., and Levi, R. (2002). Decreased intracellular calcium mediates the histamine H3-receptor induced attenuation of norepinephrine exocytosis from cardiac sympathetic nerve endings. *Proc. Natl. Acad. Med.* **99**, 501–506.

Thomas, J. A., Buchsbaum, R. N., Zimniak, A., and Racker, E. (1979). Intracellular pH measurements in Ehrlich ascites tumor cells utilizing spectroscopic probes generated in situ. *Biochem.* **18**, 2210–2218.

Tsien, R. Y. (1989). Fluorescent probes of cell signalling. *Ann. Rev. Neurosci.* **12**, 227–253.

CHAPTER 19

Ratio Imaging Instrumentation

Kenneth Dunn[1] and Frederick R. Maxfield[2]

[1]Department of Medicine
Indiana University Medical Center
Indianapolis, Indiana 46202-5116

[2]Department of Biochemistry
Weill Medical College of Cornell University
New York, New York 10021

Ratio imaging is a powerful method for obtaining quantitative information about the properties of cells. By measuring a ratio of fluorescence intensities, many of the difficulties that are inherent in quantitative microscope fluorometry can be reduced. For example, an excitation ratio with an ion-sensitive dye will

accurately report the ion concentration independent of the local concentration of the dye. Nevertheless, there are many limitations that are imposed by the microscopy instrumentation, and these can lead to serious errors of interpretation if not adequately controlled. In this chapter we discuss instrumentation considerations for excitation and emission ratio imaging. Special considerations that are applicable to wide-field and confocal fluorescence imaging are described, and the effects of properties of the optical system such as spherical aberration and chromatic aberration are discussed.

I. Introduction

With the continuing development of new fluorescent probes, sensitive microscope imaging equipment, and affordable image processing systems, the use of fluorescence microscopy in cell biology is flourishing. In addition to providing multiparameter characterizations of tissue organization and cellular structure, fluorescence microscopy is increasingly used as a quantitative tool in studies of cell physiology, genetics, and biochemistry.

The major technical difficulty in using fluorescence microscopy quantitatively is that the amount of fluorescence detected in a given microscopic volume is a function of several parameters. These include the amount of fluorophore in the volume, the molecular and physical environment of the fluorophore, the background fluorescence of the sample, the intensity and spectrum of illumination, the light collection properties of the objective and optical train, the optical corrections of the optical train, and the sensitivity of the detector to the fluorophore emission. The underlying principle of ratio microscopy is that the quantitation of fluorescence as a ratio has the effect of isolating the variable of interest by providing an internal control for many of the extraneous parameters.

For example, when an investigator uses BCECF fluorescence to measure cytosolic pH, although the fluorescence of BCECF excited by 490-nm illumination is sensitive to pH and to all of the other parameters listed above, the fluorescence excited at 450 nm illumination is relatively insensitive to pH while being similar to the fluorescence excited at 490 nm in its sensitivity to the extraneous parameters. By calculating the ratio of one to the other, one obtains a quotient that is sensitive to pH, but largely insensitive to other aspects of the physical environment, probe concentration, and optical path length. In a well-corrected digital microscopy system, these are the only parameters that are variable within and between fields, and so the other parameters comprise constants for the system, affecting absolute measurements of fluorescence power but not ratio measurements.

Ratio microscopy has been most widely used for ion measurements using special environment-sensitive dyes (see chapter 12 of this volume), but it is increasingly being applied to a variety of new applications (Dunn et al., 1994a). For example, relative amounts of two (or more) probes within the same volume

can be calculated to address questions of endocytic sorting (Mayor *et al.*, 1993; Brown *et al.*, 2000), cytosol permeability (Luby-Phelps and Taylor, 1988), localized actin polymerization (Giuliano and Taylor, 1994), genome mapping (Reid *et al.*, 1992), and genetic screening (Kallioniemi *et al.*, 1992). Fluorescence ratios can also be calculated between different regions of cells and have been used to characterize intracellular protein distributions (Adams *et al.*, 1996), drug distributions (de Lange *et al.*, 1992), calcium permeability of the nuclear membrane (O'Malley, 1994), and membrane potentials (Loew, 1993).

Fluorescence microscopy may also be used to analyze molecular interactions. For example, molecular concentration and intermolecular associations can be characterized from fluorophore–fluorophore self-interactions that shift the intensity or fluorescence spectrum of certain fluorophores at high concentrations. Ratios of shifted to unshifted fluorescence have been used to analyze lipid endocytosis (Chen *et al.*, 1997) and to reveal local differences in the structure of the plasma membrane (Terzaghi *et al.*, 1994).

Molecular associations can also be assessed on the basis of fluorescence resonance energy transfer (FRET), in which the ratio of acceptor to donor fluorescence provides a sensitive measure of proximity between the two fluorophores (see chapter on FRET and fluorescence microscopy). FRET has been applied to a number of diverse applications (Selvin, 2000; Truong and Ikura, 2001) addressing such questions such as lipid-protein sorting (Uster and Pagano, 1986), cAMP levels (Adams *et al.*, 1991), cytosolic free calcium concentrations (Miyawaki *et al.*, 1999), lipoprotein catabolism (Myers *et al.*, 1993), transmembrane electrical potentials (Gonzalez and Tsien, 1995), and various aspects of protein structure and interactions (Truong and Ikura, 2001). The utility of FRET has been facilitated by the development of methods for site-specific labeling of proteins with FRET probes, including Green Fluorescent Protein (GFP) color variants (Pollok and Heim, 1999), or reactive amino acids that can be labeled with conventional fluors (reviewed in Selvin, 2000).

FRET studies are complicated by the relatively low efficiency of energy transfer observed in most cases. These weak signals can be difficult to distinguish from the amount of donor fluorescence that bleeds through into the acceptor emission range and from the amount of direct excitation of the acceptor occurring at the wavelength used to excite the donor. Accordingly, these parameters must be established in a set of control studies that, as much as possible, must faithfully represent the experimental conditions (Herman *et al.*, 2001). One way of circumventing the problem of distinguishing sensitized emissions to detect FRET is to use the fact that FRET shortens the fluorescence lifetime of the donor fluorophore and to use fluorescence lifetime imaging to detect FRET (Bastiaens and Squire, 1999). This approach has the additional advantage that it is capable of detecting multiple degrees of FRET in a sample (Verveer *et al.*, 2001). As FRET is only one of many physical factors that influence fluorescence lifetimes, fluorescence lifetime imaging has been applied to studies of a variety of physiological parameters (Oida *et al.*, 1993; Bastiaens and Squire, 1999). Fluorescence lifetimes may be

measured either as a ratio of the emissions occurring during two time intervals following excitation or from changes in phase and modulation of fluorescence stimulated by a sinusoidally modulated illumination (Gadella *et al.*, 1994, Verveer *et al.*, 2001). For a more detailed description of fluorescence lifetime imaging, the reader is referred to Chapter 15 of this volume.

Intensity-based fluorescence ratio microscopy can be divided into several categories. These include excitation ratio microscopy, in which fluorescence ratio images are collected by sequentially exciting the sample with two different wavelengths of light and sequentially collecting two different images, emission ratio microscopy, in which the sample is illuminated with a single wavelength of light images formed from light of two different emission wavelengths are collected, and a combination of the two, in which the sample is illuminated with two wavelengths of illumination and images are formed from light of two different emission wavelengths.

II. Choosing an Instrument for Fluorescence Measurements

A. Microscope, Fluorometer, or Flow Cytometer?

The first question to consider when designing a fluorescence study is whether the experiment is best addressed by imaging microscopy, as opposed to flow cytometry or fluorometry in cuvettes or microplates. Even with advances in microscopy instrumentation and software, these latter techniques are often much easier to implement than a quantitative fluorescence microscopy study.

The obvious value of quantitative imaging microscopy is that it yields spatial information not available through the other approaches. Resolution of subcellular structures can only be achieved by imaging microscopy. In addition, certain indicator dyes may partition inappropriately; for example, cytosolic indicators may accumulate in endosomes. In these cases, imaging may be required to identify dye sequestration, and digital image analysis used to eliminate these sequestrations from quantification.

A less obvious reason to use imaging is that for studies of dynamic events in single cells, it provides enhanced temporal resolution and sensitivity when compared with fluorometric techniques. Unless a cell culture is synchronized with respect to the measured parameter, cell–cell variability has the effect of masking transient changes when using methods that do not measure single cells. For example, rises in intracellular free calcium Ca_i^{++} in response to a stimulus frequently occur asynchronously within a cell culture, and averaging over many cells can reduce the apparent size of the cellular response and prolong its apparent duration.

In many cases, subcellular resolution or time course information about single cells may not be required, and the nonimaging fluorescence techniques may be more appropriate. Flow cytometry can provide quantitative measurements on thousands of individual cells, allowing the distribution of fluorescence intensities

in a population to be measured conveninently. Flow cytometry cannot provide information about the time course of a response in a single cell (e.g., repetitive increases in Ca_i^{++}), but it can easily measure the time course of response in a population of cells. In many studies, the ability of flow cytometry to measure properties of thousands of cells may be more valuable than detailed information on a smaller number of cells obtained by microscopy.

Fluorometry, either in a cuvette or in a microplate reader, is usually the simplest type of fluorescence measurement to carry out. In a cuvette, cells can be either in suspension or attached to a coverslip held at an angle to the incident beam (Salzman and Maxfield, 1989). Average fluorescence intensity from thousands of cells can be measured rapidly by these methods. Some potential problems occur in fluorometry that are less serious for microscopy or flow cytometry studies. One such problem is that some cells may become extremely bright during fluorescent labeling (e.g., dead cells in some immunofluorescence experiments). These all are easily excluded in analyses of flow cytometry data or in selecting fields for analysis by microscopy, but they are included in fluorometer experiments. Such cells may dominate the total signal in some unfavorable cases. Also, extracellular fluorophore will contribute to the signal in fluorometer experiments. This is a serious problem with low–molecular weight indicator dyes, which can exit cells by diffusion or by active transport (Maxfield et al., 1989).

B. Whole-Cell or Subcellular Microscopy?

An important early consideration is to determine whether subcellular resolution is needed or whether measurements on whole cells will provide the desired information. For many studies such as changes in cytoplasmic pH or Ca_i^{++} whole-cell measurements are typically sufficient. Until recently, microfluorometry using a photometer mounted on the microscope was often used to quantify fluorescence from a region of the microscope field. This method is still useful if very fast response times are required or if repeated measurements with very short time intervals are to be made. However, if speed is less of a priority, cooled change-coupled device (CCD) detectors offer sensitivity equivalent to that of a microscope fluorometer, and image-processing software can be used to independently measure changes in fluorescence in scores of individual cells in a single field collected at low magnification. For several reasons, measurements of fluorescence power from whole cells are typically much easier than measurements of subcellular objects. First, the fluorescence power from the whole cell is greater, and this improves the signal-to-noise values of the measurements. Also, the identification of whole cells in the image is usually easily carried out automatically by image-analysis software.

As with fluorometry, indicator dye sequestration can confound microfluorometry, conducted either with a photometer or by low-magnification imaging onto a cooled CCD. In this case, subcellular imaging, which would allow such sequestrations to be eliminated from analysis, is the only solution.

C. Confocal or Wide-Field Ratio Microscopy?

To date, most ratio microscopy has been conducted using wide-field microscope systems. Confocal microscopy offers the potential for enhanced resolution, which is frequently necessary for data interpretation. Furthermore, the superior rejection of out-of-focus fluorescence provides the confocal microscope with the capacity to image specimens whose background fluorescence is so high that it prevents adequate imaging by conventional, wide-field microscopy. Such samples include cells immersed in fluorescent labels (Dunn *et al.*, 1994b), thick samples such as polarized epithelia, and ramifying systems such as nerve cells within tissues.

The process by which point-scanning confocal microscopes collect images, scanning the illumination and the detector over the field and sequentially constructing images in a raster scan, gives confocal microscopes an advantage for emission ratio microscopy. In a wide-field microscope, the simultaneous collection of ratio images requires imaging to two separate two-dimensional detectors, which can either be two different cameras or two different regions of the same camera. Even slight differences in the geometry of these two light paths will result in a lack of pixel-for-pixel registration between ratio images. This misregistration can cause problems for ratio calculations. Misregistration is avoided in confocal microscopes because the scanning process maps photons of each color of fluorescence from a particular position in the specimen to the same point in multiple images.

The price of building up an image by sequentially scanning a single point across the sample is that images are assembled relatively slowly; for most microscope designs, this means that image collection requires around a second. This compares poorly with wide-field ratio microscopy in which it is frequently possible to acquire pairs of images within fractions of a second. This slow image collection hampers imaging dynamic events and makes confocal systems susceptible to problems of sample movement and stage drift (either of which will yield spurious ratio measurements).

Although several designs of point-scanning confocal microscopes have been developed to provide very high scan rates that are capable of providing video-rate confocal images, the fluorescence of most samples is insufficient to provide a useable signal during the exceedingly brief pixel dwell time of these systems. Consequently, reasonable signal-to-noise is frequently obtained only after averaging several frames, and image collection still requires seconds rather than milliseconds. Acquisition times can be shortened by employing line-scanning rather than point-scanning detection, which sacrifices some resolution in exchange for video-rate acquisition rates.

Even in order to assemble an image in a few seconds, point-scanning confocal microscopes must scan the sample very rapidly, with pixel dwell times of only a few microseconds. Intense illumination is needed to generate sufficient fluorescence in the diffraction-limited spot during the exceedingly short period of time

that the spot is being imaged. Because of these high levels of illumination intensity, care must be taken to avoid fluorophore saturation (Sandison *et al.*, 1995), which can confound quantitative studies, such as ratio microscopy. (See discussion of saturation in Chapter 9 on Fluorescence.)

An alternative solution to point scanning or line scanning is to simultaneously scan multiple points in the sample. Scanning disk confocal systems can simultaneously scan hundreds of points of illumination onto the sample. Fluorescence emissions are filtered through confocal pinholes onto a cooled CCD or intensified video camera that, as the disk is spinning at high speed, results in the formation of a continuous two-dimensional image. These systems are capable of collecting high-quality images at video rate (30 frames per second) or higher. Because the laser illumination is split among hundreds of pinholes, the instantaneous illumination dose is much lower than in point-scanning confocal systems. In addition to preventing fluor saturation, low-illumination dosage may also result in the low rates of photobleaching observed in these systems (Inoué and Inoué, 2000). However, the relationship between photobleaching and illumination dosage is unclear; the low photobleaching of these systems may result from the fact that the use of efficient, low-noise cooled CCDs allows use of lower levels of illumination. One drawback to this system is that multiple colors of fluorescence must be collected sequentially or to separate two-dimensional detectors.

As will be discussed below, confocal microscopy places some special requirements on the optical train of the microscope that also must be considered when deciding between confocal and wide-field ratio microscopy.

III. Different Methodological Approaches to Ratio Imaging

A. Excitation Ratio Microscopy

This approach has been the most widely used method of ratio microscopy. A variety of fluorophores have been developed whose fluorescence excitation properties change in response to the presence of specific ions, allowing characterizations of the ionic environment of the cytosol, organelles, or extracellular space. The best known of these are Fura-2 and BCECF, which are used to characterize intracellular pH and Ca_i^{++} respectively. The specifics of the excitation ratio technique used to measure intracellular Ca_i^{++} are detailed in Chapter 12 of this volume.

A general problem with excitation ratio imaging of living cells is that the delay between collection of the two images in a ratio pair can result in a lack of correlation between the two images. Spurious ratios can result from collecting images from different time periods during a dynamic cellular process or from a sample that is moving. Small amounts of stage drift or movements in the sample can produce profound effects on ratio images, especially at the edges of objects.

The consequences of movement are more severe in confocal microscopy because of the enhanced vertical discrimination, which causes intensities to shift if an object moves into or out of focus.

Despite these difficulties, excitation ratio imaging has been used to measure properties such as local changes in Ca_i^{++} in rapidly moving leukocytes (Marks and Maxfield, 1990) or the pH of single endosomes and lysosomes (Yamashiro and Maxfield, 1987). The major obstacle to measuring localized Ca_i^{++} changes in moving cells is the change in cell thickness imaged to any given pixel as the cell moves. Especially at the edge of cells, the cytoplasmic thickness can change significantly within the time (typically about 1/4 second) required to obtain an image pair. There are various strategies to deal with this. One is to produce a series of ratio images in which the order of acquisition is reversed for each sequential pair. With Fura-2 excitation, wavelengths of 340 and 380 nm are used. The first ratio image can be produced from the first 340-nm image divided by the first 380-nm image. The second ratio would then be produced by the second 340-nm image divided by the first 380-nm image. If increasing thickness at the front of a moving cell was affecting the ratio, the 340/380 ratio at the front of the cell would be low in the first ratio image and high in the second ratio image. This type of alternation is a warning that movement is a major contributor to ratio differences at the cell edge, and appropriate changes in the experimental design need to be made. Another way to reduce the impact of edge effects is to take into account the reduced intensity at the edges in producing output images (Marks and Maxfield, 1990; Tsien and Harootunian, 1990). This can be done by blanking all pixels that fall below an arbitrary threshold above background. Alternatively, the intensity of each pixel in the ratio image can be weighted by the intensities in the underlying single-wavelength images. If this type of correction is not made, ratio images tend to overweigh the pixels with low intensity (and poor signal-to-noise).

Fluorescence excitation ratio measurements have been largely limited to images collected by wide-field microscopy rather than confocal microscopy. The white light sources used in wide-field microscopy allow flexible selection of optimal excitation wavelengths, and the rapid, sensitive image collection provided by these systems allows accurate characterization of dynamic events.

The number of illumination wavelengths available in a confocal microscope can be increased by combining multiple lasers to provide the illumination wavelengths appropriate for a particular excitation ratio dye. Kurtz and Emmons (1993) combined two separate lasers to provide the 488- and 442-nm excitation wavelengths used for confocal excitation ratio measurements of intracellular pH of cells loaded with BCECF. Alternatively, some dyes have been designed to be used with particular laser lines. For example, DM-NERF, a pH-sensitive dye whose fluorescence is such that it permits excitation ratio measurements using the 488- and 514-nm lines of the argon laser. Because of the low pKa of DM-NERF, it has been used to measure the pH of especially acidic compartments such as lysosomes (Dunn et al., 1991) and Xenopus yolk platelets (Fagotto and Maxfield, 1994).

The slow speed with which early confocal microscopes collected images largely precluded their use for excitation ratio microscopy. However, new designs select and attenuate laser lines by means of acousto-optical tunable filters (AOTFs). These devices are capable of switching excitation lines rapidly enough that, by synchronizing PMT collection with the illumination with one or the other wavelength, the two different excitation ratio images are alternately collected line by line, so that the two images are effectively collected nearly simultaneously.

B. Emission Ratio Microscopy

In emission ratio microscopy, the pair of images can be collected either sequentially with a single camera or simultaneously with two cameras or onto two regions of the same camera. For living cells, simultaneous image collection has the advantage of providing perfect temporal correlation between the two ratio images. For fixed cells, sequential or simultaneous image collection is a matter of convenience.

To collect different emission images, different optical filters or dichromatic reflectors are placed in the emission path for each image of a ratio pair. These optical filters can generate linear and nonlinear geometric differences between the images. When using an imaging detector in wide-field microscopy, this can lead to distortions and relative displacement of pixels. A major source of pixel misregistration has been slight differences in light path through different dichroic beam splitters. This problem can be avoided by using polychromatic mirrors that pass and reflect at multiple wavelengths and thus permit ratio images to be collected with a single reflector. The use of high-quality plane-parallel emission filters also reduces distortion and displacement of images. With improved machining and alignment of optical elements, the displacement of an object when switching between two reflecting dichroics can be almost undetectable in some recently manufactured microscopes.

When two imaging detectors are used to simultaneously collect ratio images, further misregistration can be generated by geometric differences between two detectors. This is especially true for tube-type cameras, which have inherently poor geometric linearity. The two detectors are also likely to show spatial differences in sensitivity, so although the ratio technique controls for spatial heterogeneity in the detector when using a single camera, this benefit is lost with two cameras. This heterogeneity may occur at the level of single pixels, or over a larger scale. To a large extent, differences in registration and spatial sensitivity between detectors can be characterized and corrected via image processing (as will be discussed later).

With most current systems, laser scanning confocal microscopy is better suited to fluorescence emission ratio microscopy than to fluorescence excitation ratio microscopy. First, as emission ratio images can be collected simultaneously with two photometers, the slow collection time of the confocal smears dynamic events, but it doesn't contribute to a lack of correlation between the images in a ratio

pair. Second, as for some applications only a single excitation wavelength is needed, the emission ratio technique is less affected by the limited number of laser wavelengths available. Unlike the excitation ratio method, the limited number of excitation wavelengths limits the efficiency of excitation, but it does not limit the dynamic range of the ratio, which is set by the optical division of light between the two detectors. Third, as discussed above, point-scanning systems avoid geometric distortion by digitally mapping photons collected from a particular volume in the sample to the equivalent location of two images. Lateral inhomogeneity is less of a problem with scanning systems than with two-dimensional detectors, as detector variability is not spatially correlated.

In many applications of emission ratio microscopy, the sample is illuminated with a single wavelength of light, and images from two different ranges of emission wavelengths are collected. This is the approach typically used in studies of fluorophore proximity as assessed by resonance energy transfer, in which the ratio of donor to acceptor fluorescence is measured, and by excimer formation, in which the ratio of excimer to monomer fluorescence is measured. This technique is also used to image certain fluorescent indicators whose emission spectrum is sensitive to the ionic environment of the fluorophore such as Indo-1 and SNARF (and related molecules), which are used to measure cytosolic $[Ca^{++}]$ and pH, respectively. In some cases, however, it is necessary to change both the excitation and emission wavelengths. By using polychromatic reflectors (or AOTFs to select laser lines), it is possible to illuminate a sample with two different excitation wavelengths and simultaneously collect two images in different emission wavelengths. This approach can be used to extend the dynamic range of ratio measurements of certain indicators whose excitation and emission spectra are both environmentally sensitive. For example, as both the excitation and emission spectra of SNAFL change with pH, it may be used in either an excitation or emission ratio mode. However, the most sensitive response is obtained by combining the two approaches: by exciting the dye with 488- and 568-nm light while collecting images centered at 530 and 620 nm, respectively. More generally, simultaneous multi-wavelength excitation and emission permits efficient simultaneous imaging of two different fluorophores.

Frequently, the aim of emission ratio microscopy is to characterize complex fluorescence spectra. For example, the emission spectrum of SNARF varies with pH. When we measure the fluorescence of SNAFL at 585 and 620 nm, we are essentially summarizing the pH-dependent spectrum of SNAFL in two spectral "windows." An alternative approach would be to collect the spectrum of emissions, as with the Zeiss Meta spectral detector system, which uses an optical grating to split fluorescence emissions into up to 32 different wavelength bands (Dickinson et al., 2001).

By measuring a complete emission spectrum in an image, this approach may more sensitively detect spectral responses and will also reveal any complex or unexpected changes in the spectrum. Such changes, if undetected, can confound certain ratiometric studies. For example, the emission spectrum of SNAFL

appears to shift position at different protein concentrations (Sanders *et al.*, 1995). These spectral shifts alter the relative amounts of fluorescence collected in each emission band in a conventional emission ratio microscopy system. Thus local differences in protein concentration could alter emission ratios in ways that cannot be distinguished from pH effects. Such shifts would be easily detected by systems collecting complete emission spectra.

C. Ratio Imaging with Multiple Fluorophores

In many cases it is necessary to obtain the ratio of fluorescence from two fluorescent dyes. For example, this can provide quantification of the relative abundance of molecules within an organelle (Mayor *et al.*, 1993). Ion levels can be measured using an ion-sensitive dye and an ion-insensitive dye both coupled to a macromolecule (e.g., Fluorescein–Rhodamine dextran for pH; Dunn *et al.*, 1994a, 1994b). Ratio quantitation of separate fluorophores incurs a unique set of difficulties not encountered with single fluorophores. A general problem with using more than one fluorophore is the susceptibility of the ratio to photobleaching. Because two fluorophores are unlikely to bleach at the same rate, a measured ratio will reflect not only the parameter of interest but also the illumination history of the sample. Meaningful data can be collected by scrupulously maintaining a consistent protocol for image collection (to make the effects of bleaching uniform in all samples) and by minimizing illumination intensity and duration. If necessary, it may be possible to correct for rates of photobleaching in a sample. However, it has been shown that rates of bleaching can vary within a cell, and this may affect the validity of the corrections (Benson *et al.*, 1985).

When the two fluorophores are not covalently linked, differential access of the probes to the imaged volume is also a potential problem. For example, in immunofluorescence, differences in the ability of two antibodies to access their epitopes in a given structure can complicate interpretations of the ratio with respect to the distributions of the two epitopes. Accessibility problems are difficult to control, and this has limited the effective use of quantitative immunofluorescence for measuring the relative abundance of molecules in cellular structures. A solution to this is to use directly labeled molecules or intrinsically fluorescent molecules such as constructs containing GFP. For example, using fluorescently labeled transferrin and LDL, endocytic trafficking parameters could be measured and an overall kinetic model for endocytosis could be developed (Dunn and Maxfield, 1992; Ghosh *et al.*, 1994; Mayor *et al.*, 1993). Size-dependent differences in permeability of macromolecules has been exploited to measure the regional properties of the cytoplasm (Luby-Phelps and Taylor, 1988).

Systems that collect spectra are capable of sensitively discriminating the fluorescence of multiple fluorophores, even those whose spectra overlap significantly. This is achieved through digital linear unmixing procedures (Dickinson *et al.*, 2001) in which the fluorescent contribution of multiple probes are discriminated on

the basis of reference spectra collected for each probe. Such capability is significant for studies comparing the relative distributions of probes and may also increase the dynamic range of measurements in ratiometric analyses of multiple probes. Although the potential of this technology is exciting, the results of linear unmixing of spectral images depend on the quality of the images and the degree to which the reference spectrum of each fluor is representative of its spectrum in the sample environment.

The final consideration for ratio studies of multiple probes is that of chromatic aberration, which can have a significant effect on ratio measurements, especially for fluorophores whose excitation or emission spectra fall outside the design parameters of the microscope optics. This issue is considered in depth below.

IV. Optical Considerations for Ratio Microscopy

The choice of an appropriate objective is essential for the success of a ratio imaging project. As with any aspect of fluorescence microscopy, efficient light collection is very important in ratio microscopy, so high-numerical aperture (NA) objectives are usually preferred. However, in some cases it may be preferable to image through a wide depth of focus (e.g., in making whole-cell ratio measurements), and a smaller numerical aperture may be beneficial. A limiting factor in many studies is the amount of light captured at one pixel in the imaging detector. This can be increased by increasing the numerical aperture of the objective. Because fluorescence power projected onto a given area of the detector decreases as the square of magnification, increased brightness can also be achieved by using the lowest power objective appropriate to the level of resolution needed. The number and quality of optical elements in an objective can also affect its light collection efficiency. For example, glass transmits ultraviolet light poorly, so efficient excitation of ultraviolet dyes requires the use of optics designed to be transparent to ultraviolet light.

As mentioned previously, the most widely practiced form of ratio microscopy is wide-field excitation ratio microscopy. Alternative forms of ratio microscopy include emission ratio microscopy and confocal ratio microscopy. It turns out that relative to these alternative approaches, wide-field excitation ratio microscopy is fairly forgiving of optical aberrations. Before conducting ratio microscopy experiments, particularly using one of these alternative approaches, it is important to appreciate the demands that they place on the microscope optical train.

A. Spherical Aberration

Spherical aberration in an objective results in the axial and peripheral rays being focused at different places, so that light is focused to a broad region rather than to a single point. The blurring that results generates images with poor

contrast and resolution. Although modern objectives are typically well corrected for spherical aberration, this correction applies to specific conditions. First, the correction is specific to particular wavelengths of light. Thus, some objectives may not be corrected for ultraviolet light or for far-red light. Second, the correction for spherical aberration is accurate only when the light path is carefully controlled. For high-NA oil immersion objectives this means that the light path will have a specific and more-or-less constant refractive index, which means either that the refractive index of the immersion and mounting media must match or that the object is imaged at the surface of the coverslip. This condition is frequently unobtainable in studies of live cells in a perfusion chamber or in studies of thick tissues. Recently, objective manufacturers have responded to this problem with new high-NA water immersion objectives that, in some cases, make it possible to collect images 220 μm into an aqueous medium, with negligible loss in contrast (Inoué, 1995). For water-immersion objectives designed for use with a glass coverslip, the thickness of the coverslip must be carefully controlled or the objective adjusted by means of an adjustment collar. Water-immersion objectives designed to be used without a coverslip avoid even this requirement.

Spherical aberration results in decreased sensitivity in confocal microscopy, which, in rejecting out-of-focus light, also rejects much of the signal from an object imaged with spherical aberration (Majlof and Forsgren, 1993). Sensitivity is also lost to spherical aberration as the illumination spot is spread beyond the ideal diffraction limited spot. Unfortunately, confocal microscopy is frequently applied to imaging thick samples in which spherical aberration is particularly manifest. With oil-immersion objectives, spherical aberration becomes increasingly pronounced as focus penetrates into an aqueous medium such that image contrast is reduced to inadequate levels within 15 to 20 μm of the coverslip (Hell and Stelzer, 1995; Keller, 1995). Careful matching of refractive index is clearly critical to exploit the potential for three-dimensional imaging by confocal microscopy. For studies of living cells or other aqueous samples, this requirement is nicely satisfied by the new generation of high-NA water-immersion objectives.

B. Chromatic Aberration

Although high-quality microscopic systems are largely corrected for chromatic aberration (apochromatic), residual chromatic aberration can still have profound effects in ratio microscopy where the quantitative imaging of two or more colors provides the most severe test. As described below, this is particularly true for ratio confocal microscopy and for any emission ratio microscopy.

Chromatic aberrations result in color-dependent distortions in the image both laterally and axially. Lateral chromatic aberrations result in different wavelengths of light being magnified to different degrees. As a consequence, a field of objects labeled with two fluorophores will produce a pair of images in which one color is offset relative to the other, with the offset increasing with distance away from the optical axis. In transillumination microscopy, such aberration is frequently

observed in objects that have colored edges. Axial chromatic aberration, in which different wavelengths of light are focused to different depths, has a less obvious effect in that the efficiency of collection of one or another wavelength of light is dependent on the vertical position of the object relative to the focal plane. For some objectives, lateral chromatic aberration is left uncorrected, being corrected at the microscope eyepiece. Thus it is critical to ensure that imaging systems use matched apochromatic optics. It should be obvious that either form of chromatic aberration can have a serious effect on quantitative ratio microscopy. The exact consequences depend on the nature of the ratio microscopy, as outlined below.

For conventional, wide-field excitation ratio microscopy, in which two wavelengths of light are used to excite a fluorophore that emits at a single wavelength, chromatic aberration will have minimal effect. The Koehler-illuminated light path of such a system ideally provides for parallel uniform illumination of the specimen plane, in which case chromatic aberration will have minimal consequence.

For wide-field emission ratio microscopy, in which one is collecting fluorescence emissions at two wavelengths, chromatic aberration will have a measurable effect on ratio measurements. In this case, chromatic aberration will result in the two sets of emissions assigned to a given point in the image being collected from different volumes in the sample. Lateral chromatic aberration will result in horizontal displacements, which may be easily recognized and perhaps corrected through nonlinear "warping" of images using digital image processing. Axial chromatic aberrations will result in different efficiencies of collection for the two wavelengths, depending on the vertical position of the sample volume relative to the objective. Ratios will thus reflect not only the relative amounts of fluorescence at each wavelength but also the vertical position of the imaged object. In fact, axial chromatic aberration has been used in reflection microscopy to measure surface contours at high resolution (Boyde, 1987). For fluorescence microscopy, this form of aberration is hard to recognize and difficult to correct in an image once collected. It should be possible to correct for this in a three-dimensional data set using deconvolution algorithms if three-dimensional point-spread functions have been obtained at multiple wavelengths. Aside from adding variance to fluorescence ratios, axial chromatic aberration will also decrease detection sensitivity, as a given structure will necessarily be defocused in one or the other color.

As might be expected, accurate confocal ratio microscopy is especially vulnerable to chromatic aberration. If chromatic aberration results in the two colors of fluorescence emissions attributed to a given point in an image arising from two different volumes in the sample, the problem is aggravated by the enhanced horizontal and vertical discrimination of the confocal microscope. Figure 1 illustrates the problem. Cells were incubated simultaneously with Fluorescein-transferrin (green) and Cy-5-transferrin (red). Both probes were endocytosed by the cells, and the intracellular distributions were imaged by dual-emission confocal microscopy with excitations at 488 and 647 nm. Single optical

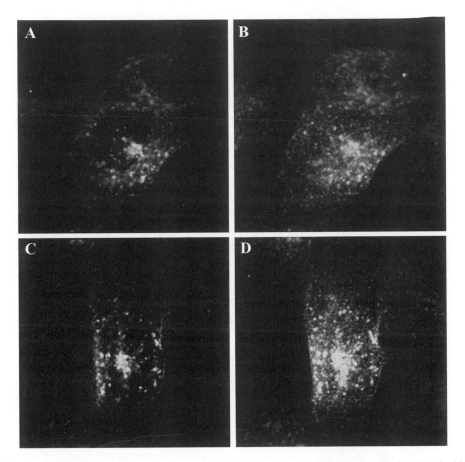

Fig. 1 Effects of axial chromatic aberration on ratio measurements. Living cells were incubated with mixture of transferrin conjugated to either fluorescein or to Cy-5 and then fixed and imaged by confocal microscopy. As the two conjugates are expected to proportionally label the same endocytic compartments, one would expect the ratio between the two to be constant in all labeled endosomes. Fluorescein fluorescence was excited by the 488-nm line and Cy-5 fluorescence excited by the 647 line of a Krypton-Argon laser. (A) An image of a single focal plane using an objective in which a disparity of $0.4\,\mu$ in the focal plane of the 488- and 647-nm excitation lines results in the production of variously colored endosomes ranging from green to red. That each endosome has the same ratio of fluorescein to Cy-5 fluorescence is shown when one combines the vertical series of images of this field (B) and one obtains a uniform brown color in the endosomes. (C) The same experiment using an objective with less than $0.1\,\mu$ of axial chromatic aberration between the 488- and 647-nm lines. In this image, the constant ratio between the two different transferrin conjugates in each endosome is apparent in the uniform yellow color of the endosomes. This same color is obtained when one combines all the images of a vertical series into a single projected image (D), indicating that both colors of fluorescence are accurately collected in each single focal plane. (See Color Insert.)

sections and projections through the cells are shown. One objective exhibited serious axial chromatic aberration in this specimen, and the second objective showed acceptable levels of axial chromatic aberration. Projection images obtained with both objectives show a uniform brown color, indicating that the two transferrin derivatives were trafficked similarly following internalization. However, in single optical sections obtained with one of the objectives there was an apparent lack of colocalization (i.e., separation of the red and green objects) because individual endosomes appeared in different focal positions for the red and green images. This aberration can result in misinterpretation of relative probe localizations and, in ratiometric studies, generates erroneous ratio measurements (Dunn and Wang, 2000).

A less obvious way that chromatic aberration affects ratio measurements in confocal microscopy is through the effect that it has on detection efficiency (Bliton and Lechleiter, 1995). Because of the Stokes shift (the difference in the wavelengths of fluorophore excitation and emission, see Chapter 9), the wavelengths of excitation and emission may not be focused to the same volume. Unlike a two-dimensional detector system, lateral chromatic aberration in a point-scanning system such as a confocal microscope can result in the illumination of one point in the object plane and the imaging of another, nonilluminated point. Because in a confocal microscope the focused spot moves away from the detector pinhole with increasing scan angle, fluorescence collection efficiency decreases with distance off axis (Sandison et al., 1995). Because each wavelength will have a different degree of aberration, a ratio of two wavelengths will likewise vary spuriously with distance off axis. For quantitative ratio imaging it is best to acquire images near the optical axis of the microscope even though "zoom and scroll" features in most scanning systems will allow the acquisition of data far from the optical axis. Axial chromatic aberration profoundly decreases detection efficiency because it causes excitation of a volume that is not parfocal with the detector aperture, and thus much of the excited fluorescence is rejected. Ratio measurements will be affected by how detection efficiency of each wavelength is affected by axial chromatic aberration. This will have a large, apparently random component for each individual object that is determined by the position of the object relative to the nominal focal plane.

The particular sensitivity of the confocal microscope to chromatic aberration is shown by the fact that levels of residual chromatic aberration in the ultraviolet that were tolerated for wide-field microscopy proved to be excessive for confocal microscopy. Solutions recently introduced to this problem include placement of an additional lens into the excitation light path and the development of new objectives that are chromatically corrected into the ultraviolet.

Another solution to chromatic aberration in the confocal microscope is the two-photon design, in which a high local density of long-wavelength photons is capable of exciting fluorescence typically associated with visible or ultraviolet excitation. Because the photon density outside a small region is insufficient to excite fluorescence, confocality is determined simply by the focal point of excitation.

Because no detector aperture is needed, differences in the focal plane of the excitation (which now are in the infrared) and emission wavelengths have no effect on sensitivity. This should be a valuable method for emission ratio applications (Denk *et al.*, 1995). Although recent designs of tunable laser systems allow automatic wavelength tuning, changes typically require several seconds, so that excitation ratio measurements are currently not feasible for two-photon systems.

V. Illumination and Emission Control

For wide-field microscopes, the intense illumination needed for epifluorescence is typically provided by either mercury or xenon arc lamps. The spectrum of illumination of a xenon arc lamp is relatively uniform from the ultraviolet into the visible spectrum, whereas that of a mercury arc lamp includes strong peaks at several wavelengths in the ultraviolet and visible wavelengths. Although it may seem that the uniform spectroscopic output of the xenon would make it a better choice, in fact several of the "mercury lines" correspond well to the excitation spectra of popular fluorophores and frequently yield better sensitivity.

For excitation ratio studies, temporal variation in lamp output generates variability in fluorescence, which can adversely affect ratio measurements. Because "flicker" increases with the age of the lamp, output variation can be minimized by frequent lamp replacement. Flicker resulting from movement of the arc ("arc wander") can be minimized by "scrambling" lamp output through a coiled fiber-optic (Kam *et al.*, 1993). These systems also provide for a more spatially homogeneous field of illumination than can be obtained with lenses alone.

For confocal microscopy, the range of illumination wavelengths available has been broadened by the development of multiline lasers and the combination of multiple lasers. The high-powered pulsed lasers used in two-photon systems are typically tunable over a wide range of wavelengths but provide only a single wavelength at a time.

Each of these systems must have some means of accurately controlling the duration and the spectrum for both sample illumination and image collection. Typically, these functions are controlled by special peripheral devices controlled with personal computers. High-speed filter wheels and shutters may be placed in either the excitation or emission light path to provide rapid, consistent image collection parameters. As mentioned previously, AOTFs can provide rapid selection of laser lines. These devices have the additional advantage that they permit separate and continuously variable levels of attenuation for each excitation wavelength.

The correct choice of optical filters can have a large effect on the quality of the data obtained in ratio-imaging experiments. Among the considerations are the wavelength, transmission, and bandwidth of the filters. In any ratio study, one seeks a sensitive ratio with a wide dynamic response. In emission ratio microscopy, bleed-through of signal between channels limits the upper and lower

bounds of the ratio. Narrower-bandwidth emission filters can improve selectivity, but this may reduce the signal to the point at which noise becomes limiting. In contrast, a large overlap in transmission through two emission filters will reduce the dynamic range of a ratio measurement.

In the case of dual excitation and emission ratio microscopy in which image pairs are collected simultaneously, some discrimination is lost because the sample is simultaneously illuminated at multiple wavelengths. Accordingly, discrimination of each fluorophore can be enhanced by sequential selective illumination at particular wavelengths and collection of the emissions at particular wavelengths. As discussed previously, dual excitation is not an option for ratiometric studies of FRET, in which donor and acceptor fluorescence are collected on stimulation at the donor excitation wavelength. In this case, filter selectivity is a prime concern, despite the frequently low levels of sensitized acceptor emissions. Typically, these trade-offs must be evaluated for each set of experiments.

Another factor to consider when specifying emission filters is the environmental sensitivity of the fluors to be imaged. As discussed previously, extraneous factors such as local protein concentration and local hydrophobicity may shift the position of emission spectra (Sanders *et al.*, 1995). Bright *et al.* (1989) and Carlsson and Mossberg (1992) give several examples of fluorophores that undergo shifts in their emission spectra inside cells, as a function of concentration, or in different solvents. To the degree that such spectral shifts occur within cells, they can alter the relative amounts of fluorescence collected in each emission band in a conventional emission ratio microscopy system and can potentially confound ratiometric studies. A way of avoiding this problem is to use barrier filters that encompass the range of emission spectra of such probes.

Recently, systems have been developed that employ prisms or optical gratings to discriminate different colors of fluorescence (e.g., Leica TCS SP and Zeiss LSM510 META confocal systems). As the bandwidth of each channel of collected fluorescence is adjustable, users can optimize color discrimination according to the needs of a particular experiment. Thus, these systems provide much greater flexibility than conventional, barrier-filter-based designs. The Leica AOBS system extends this to a design without glass interference filters of any kind, employing a tuneable "Acousto-optical beam splitter" system in place of a conventional dichroic beamsplitter. This system reflects very narrow bands of illumination ($<3\,$nm) while efficiently transmitting all other wavelengths, making it ideally suited to laser-scanning confocal microscopy. Freed from the constraints of multiple-cavity interference filters, the AOBS should offer higher sensitivity than is possible with conventional beamsplitters.

VI. Detector Systems

Discussion of detector systems may be found in chapters by Moomaw, Spring, and Jacobson. Although issues of sensitivity, signal-to-noise ratio, spectroscopic

sensitivity, and linearity are all important to ratio microscopy, in this chapter we will consider only those aspects of detectors that are uniquely pertinent to ratio microscopy.

For many studies, the speed of image collection is paramount, either because of the speed of the dynamic process being characterized or because a pair of images is expected to freeze a particular point in time. SIT cameras and intensified tube cameras, which were long the standard for low-light level microscopy, are particularly lacking in this respect because of the lag in their response time. Intensified CCDs show significantly less lag but with similar levels of sensitivity. Each of these systems is capable of collecting images at video rate, or 30 frames per second.

Cooled CCDs show no detector lag. Although once cooled, CCDs were limited to readout rates of around a frame per second, recent improvements in the design of interline-transfer CCDs have increased readout rates to beyond 8 full frames per second. However, CCDs are limited by readout noise that can become a significant fraction of the total intensity at low signals and short acquisition times. Still faster image collection can be accomplished by frame-transfer, in which an image is collected onto a portion of the CCD array and the charges are then rapidly transferred to another portion of the array. Additional images can then be collected and transferred on the chip. Using this technique, it is possible to rapidly collect multiple images, each of a restricted size, and then to read them out at a later time.

The second consideration for ratio imaging is that of dynamic range. For quantitative studies, the linear dynamic range of the detector must be sufficient to encompass not only the intrascene range of a single image but the entire range of images that are to be compared. For ion ratio studies, the range of response is frequently such that sensitivity in one experimental condition is compromised to avoid signal saturation in another condition. This limited dynamic range places an unnecessary limitation on data collection and may impose a bias on the results. SIT cameras typically have very limited dynamic range, and intensified CCDs and tube cameras show somewhat more. However, although images from these devices are typically digitized into 8 bits (256 gray levels), the images rarely contain more than 6 bits of data above the noise. At present, the best solution is provided by cooled CCDs, which are capable of linear detection at 12–14 bits with 8–11 bits of data above the instrument noise.

The limitations of 8-bit digitization for quantitative ratio imaging are illustrated in Fig. 2. Cells were incubated with dextran coupled to both fluorescein and rhodamine, and the dextran conjugates were delivered to lysosomes, which are acidic organelles. These conjugates are useful for ratiometric pH measurements of endosomes and lysosomes (Dunn *et al.*, 1994a, 1994b) because the fluorescein fluorescence decreases at low pH, whereas rhodamine is insensitive to pH changes. Figure 2A shows an image of live cells in which the fluorescein (green) emissions are quenched by the low pH of lysosomes so that, when combined with the rhodamine (red) emissions, the lysosomes appear yellow.

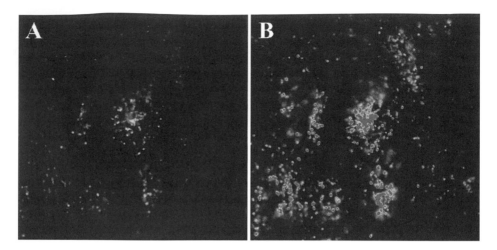

Fig. 2 Effects of limited dynamic range on ratio measurements. Living cells were incubated with dextran conjugated to both fluorescein and rhodamine, which is delivered to lysosomes. Because the fluorescence of fluorescein is quenched at low pH, but the fluorescence of rhodamine is pH insensitive, the ratio of red-to-green fluorescence can be used to sensitively measure the pH of lysosomes. (A) A field of living cells whose lysosomes appear yellow because of the quenched fluorescein fluorescence at the low pH of lysosomes. (B) The same field of cells after the lysosomes were alkalinized by the addition of an ionophore (B). In addition to the endosomes becoming greener, one also sees that many, if not most, of the detectable lysosomes in (A) now show saturating signal levels of green fluorescence (depicted in red). (See Color Insert.)

When the pH gradients were collapsed by addition of an ionophore (Fig. 2B), the fluorescein fluorescence of the lysosomal dextran increased to the extent that in many of the lysosomes it exceeded the 8-bit range, and saturated pixels are shown in red. Ratio data would be lost for all of these lysosomes. In effect, the 8-bit range of this system limits the range of lysosome pH values that can be measured by this technique.

Until recently, direct storage of digital images presented a problem when acquiring data on moving cells because of the large amounts of data that images contain. It was possible to store data in analog form on videotapes or videodisks, but images were typically limited in terms of signal-to-noise and resolution by the quality of the video recorders. With the increase in speed and decrease in cost of digital storage devices, direct digital storage is almost always used in new systems. If an analog-to-digital converter is used to digitize a video signal, it is important to use a scientific-quality digitizer to maximize the signal-to-noise ratio. Although the images require disk space, it is almost always advisable to store original images rather than processed ratio images. This will allow for later changes in the analysis such as improved algorithms used to correct for background.

VII. Digital Image Processing

Complete descriptions of image-processing software and hardware are given in chapters by Cardullo and Inoué, respectively. In this chapter we will consider only those aspects of image processing that are uniquely pertinent to ratio microscopy.

At a minimum, an image-analysis system must be capable of distinguishing an object from the image background (segmentation) and capable of correcting the amount of fluorescence in the object for the amount of background fluorescence in the image (background correction) and then measuring the integrated intensity within the bounds of the object in each of two ratio images.

Image segmentation may be conducted in a variety of ways. For images with few objects, it is sufficient for the user to designate regions of interest; for example, by drawing a region around the perimeter of a cell. For images with more objects, it may be preferable to use an automated segmentation procedure, which has the added advantage of minimizing potential user bias. Automated segmentation may be based on a threshold criterion or on more elaborate morphological criteria determined by the user.

The intention of background correction is to isolate the fluorescence arising in the region of interest from whatever stray light may exist in that region and to correct for spatial variations in detected fluorescence. Typically, stray light is eliminated from images by collecting an image from a empty field and subtracting this image from the image to be measured. Shading correction circuitry is included in certain detectors to compensate for large-scale spatial variability in detector sensitivity. In addition, both cooled CCDs and intensified CCDs show some degree of pixel variation. Spatial variation in detected fluorescence (which reflects spatial variability in both illumination and detection) can be compensated by using an image of a thin, uniform film of fluorophore as a calibration standard (Jericevic et al., 1989).

Because of image registration problems (from a variety of sources described above), measurement of the integrated fluorescence within the bounds of an object in two images may not be the same thing as measuring the fluorescence in the corresponding pixel loci of the two images. To some extent image registration can be accomplished using image-processing techniques capable of linear and nonlinear geometric transformations.

Image processing may be conducted either "off-line," at some time after image collection, or "on-line," in which case some minimal level of processing is conducted during image collection. For some studies, it is critical to be able to monitor the progress of the study, as displayed, for example, in the real-time display of ratio images. However, it can be argued that much of the subjective aspect of microscopy is avoided when the microscopist is unaware of the experimental outcome while collecting "representative" image fields.

VIII. Summary

Using ratio imaging to obtain quantitative information from microscope images is a powerful tool that has been used successfully in numerous studies. Although ratio imaging reduces the effects of many parameters that can interfere with accurate measurements, it is not a panacea. In designing a ratio imaging experiment, all of the potential problems discussed in this chapter must be considered. Undoubtedly, other problems that were not discussed can also interfere with accurate and meaningful measurements. Many of the problems discussed here were observed in the authors' laboratories. In our experience there are no standard routines or methods that can foresee every problem before it has been encountered. Good experimental design can minimize problems, but the investigator must continue to be alert.

Progress in instrumentation continues to overcome some of the difficulties encountered in ratio imaging. CCD cameras with 12- to 14-bit pixel depth are being used more frequently, and several confocal microscope manufacturers are now also using 12-bit digitization. The dramatic increase in the use of confocal microscopes over the past decade is now causing microscope manufacturers to more critically evaluate the effect of axial chromatic aberration in objectives, and recent designs to minimize this problem are being implemented. Other developments such as the use of AOTFs to attenuate laser lines extend the applicability of ratio imaging.

Ratio imaging is clearly applicable to a wide range of cell biological problems beyond its widespread use for measuring ion concentrations. Imaginative but careful use of this technique should continue to provide novel insights into the properties of cells.

References

Adams, C. L., Nelson, W. J., and Smith, S. J. (1996). Quantitative analysis of cadherin-catenin-actin reorganization during development of cell-cell adhesion. *J. Cell Biol.* **135,** 1899–1912.

Adams, S. R., Harootunian, A. T., Buechler, Y. J., Taylor, S. S., and Tsien, R. Y. (1991). Fluorescence ratio imaging of cyclic AMP in single cells. *Nature* **349,** 694–697.

Bastiaens, P. I. H., and Squire, A. (1999). Fluorescence lifetime imaging: spatial resolution of biochemical processes in the cell. *Trends in Cell Biol.* **9,** 48–52.

Benson, D. M., Bryan, J., Plant, A. L., Gotto, A. M., and Smith, L. C. (1985). Digital imaging fluorescence microscopy: spatial heterogeneity of photobleaching rate constants in individual cells. *J. Cell Biol.* **100,** 1309–1323.

Bliton, A. C., and Lechleitner, J. D. (1995). Optical considerations at ultraviolet wavelengths in confocal microscopy. *In* "Handbook of Biological Confocal Microscopy" (J. B. Pawley, ed.), 2nd Ed., pp. 431–444. Plenum, New York.

Boyde, A. (1987). Colour-coded stereo image from the tandem scanning reflected light microscope (TSRLM). *J. Microsc.* **146,** 137–142.

Bright, G. R., Fisher, G. W., Rogowska, J., and Taylor, D. L. (1989). Fluorescence ratio imaging microscopy. *In* "Methods in Cell Biology" Volume 29, Part B: "Fluorescence Microscopy of Living Cells in Culture" (Y.-L. Wang and D. L. Taylor, eds.), pp. 157–192. Academic Press, New York.

Brown, P. S., Wang, E., Aroeti, B., Chapin, S. J., Mostov, K. E., and Dunn, K. W. (2000). Definition of distinct compartments in polarized MDCK cells for membrane-volume sorting, polarized sorting and apical recycling. *Traffic* **1**, 124–140.

Carlsson, K., Aslund, N., Mossberg, K., and Philip, J. (1994). Simultaneous confocal recording of multiple fluorescent labels with improved channel separation. *J. Microsc.* **176**, 287–299.

Carlsson, K., and Mossberg, K. (1992). Reduction of cross-talk between fluorescent labels in scanning laser microscopy. *J. Microsc.* **167**, 23–37.

Chen, C.-S., Martin, O. C., and Pagano, R. E. (1997). Changes in spectral properties of a plasma membrane lipid analog during the first seconds of endocytosis in living cells. *Biophys. J.* **72**, 37–50.

de Lange, J. H., Schipper, N. W., Schuurhuis, G. J., ten Kate, T. K., van Heijningen, T. H., Pinedo, H. M., Lankelma, J., and Baak, J. P. (1992). Quantification by laser scan microscopy of intracellular doxorubicin distribution. *Cytometry* **13**, 571–576.

Denk, W., Piston, D. W., and Webb, W. W. (1995). Two-photon molecular excitation in laser-scanning microscopy. *In* "Handbook of Biological Confocal Microscopy" (J. B. Pawley, ed.), 2nd Ed., pp. 445–458. Plenum, New York.

Dickinson, M. E., Bearman, G., Tille, S., Lansford, R., and Fraser, S. E. (2001). Multi-spectral imaging and linear unmixing add a whole new dimension to laser scanning fluorescence microscopy. *BioImaging* **31**, 1272–1278.

Dunn, K. W., and Maxfield, F. R. (1992). Delivery of ligands from sorting endosomes to late endosomes occurs by maturation of sorting endosomes. *J. Cell Biol.* **117**, 301–310.

Dunn, K., Maxfield, F., Whitaker, J., Haugland, R., and Haugland, R. (1991). Fluorescence excitation ratio measurements of lysosomal pH using laser scanning confocal microscopy. *Biophys. J.* **59**, 345a.

Dunn, K., Mayor, S., Meyer, J., and Maxfield, F. R. (1994a). Applications of ratio fluorescence microscopy in the study of cell physiology. *FASEB J.* **8**, 573–582.

Dunn, K., Park, J., Semrad, C., Gelman, D., Shevell, T., and McGraw, T. E. (1994b). Regulation of endocytic trafficking and acidification are independent of the cystic fibrosis transmembrane regulator. *J. Biol. Chem.* **269**, 5336–5345.

Dunn, K. W., and Wang, E. (2000). Optical aberrations and objective choice in multi-color confocal microscopy. *Biotechniques* **28**, 542–550.

Fagotto, F., and Maxfield, F. R. (1994). Changes in yolk platelet pH during *Xenopus laevis* development correlate with yolk utilization. A quantitative confocal study. *J. Cell Sci.* **107**, 3325–3337.

Gadella, T. W. J., Jr., Clegg, R. M., and Jovin, T. M. (1994). Fluorescence lifetime imaging microscopy: pixel-by-pixel analysis of phase modulation data. *BioImaging* **2**, 139–159.

Ghosh, R. N., Gelman, D. L., and Maxfield, F. R. (1994). Quantification of low density lipoprotein and transferrin endocytic sorting in HEp2 cells using confocal microscopy. *J. Cell Sci.* **107**, 2177–2189.

Giuliano, K. A., and Taylor, D. L. (1994). Fluorescent actin analogs with a high affinity for profilin in vitro exhibit an enhanced gradient of assembly in living cells. *J. Cell Biol.* **124**, 971–983.

Gonzalez, J. E., and Tsien, R. Y. (1995). Voltage sensing by fluorescence resonance energy transfer in single cells. *Biophys. J.* **69**, 1272–1280.

Hell, S. W., and Stelzer, E. H. K. (1995). Lens aberrations in confocal fluorescence microscopy. *In* "Handbook of Biological Confocal Microscopy" (J. B. Pawley, ed.), 2nd Ed., pp. 347–354. Plenum, New York.

Herman, B., Gordon, G., Mahajan, N., and Centonze, V. (2001). Measurement of fluorescence resonance energy transfer in the optical microscope. *In* "Methods in Cellular Imaging" (A. Periasamy, ed.), pp. 257–272.

Inoué, S. (1995). Foundations of confocal scanned imaging in light microscopy. *In* "Handbook of Biological Confocal Microscopy" (J. B. Pawley, ed.), 2nd Ed., pp. 1–17. Plenum, New York.

Inoué, S., and Inoué, T. (2000). Direct-view high-speed confocal scanner—the CSU-10. *In* "Methods in Cell Biology: Cell Biological Applications of Confocal Microscopy" (B. Matsumoto, ed.), 2nd Ed., pp. 88–128. Academic Press, New York.

Jericevic, Z., Wiese, B., Bryan, J., and Smith, L. C. (1989). Validation of an imaging system: steps to evaluate and validate a microscope imaging system for quantitative studies. *In* "Methods in Cell Biology" Volume 29, Part B: "Fluorescence Microscopy of Living Cells in Culture" (Y.-L. Wang and D. L. Taylor, eds.), pp. 47–83. Academic Press, New York.

Kallioniemi, A., Kallioniemi, O.-P., Sudar, D., Rutowitz, D., Gray, J. W., Waldman, F., and Pinkel, D. (1992). Comparative genomic hybridization for molecular cytogenetic analysis of solid tumors. *Science* **258**, 818–821.

Kam, Z., Jones, M. O., Chen, H., Agard, D. A., and Sedat, J. W. (1993). Design and construction of an optimal illumination system for quantitative wide-field multi-dimensional microscopy. *Bioimaging* **1**, 71–81.

Keller, H. E. (1995). Objective lenses for confocal microscopy. *In* "Handbook of Biological Confocal Microscopy" (J. B. Pawley, ed.), 2nd ed., pp. 111–126. Plenum, New York.

Kurtz, I., and Emmons, C. (1993). Measurement of intracellular pH with a laser scanning confocal microscope. *In* "Methods in Cell Biology" Volume 28: "Cell Biological Applications of Confocal Microscopy" (B. Matsumoto, ed.), pp. 183–193. Academic Press, New York.

Loew, L. M. (1993). Confocal microscopy of potentiometric fluorescent dyes. *In* "Methods in Cell Biology" Volume 28: "Cell Biological Applications of Confocal Microscopy" (B. Matsumoto, ed.), pp. 195–209. Academic Press, New York.

Luby-Phelps, K., and Taylor, D. L. (1988). Subcellular compartmentalization by local differentiation of cytoplasmic structure. *Cell Motil. Cytoskeleton.* **10**, 28–37.

Majlof, L., and Forsgren, P. O. (1993). Confocal microscopy: important considerations for accurate imaging. *In* "Methods in Cell Biology" Volume 28: "Cell Biological Applications of Confocal Microscopy" (B. Matsumoto, ed.), pp. 79–95. Academic Press, New York.

Marks, P. W., and Maxfield, F. R. (1990). Ratio imaging of cytosolic free calcium in neutrophils undergoing chemotaxis and phagocytosis. *Cell Calcium* **11**, 181–190.

Maxfield, F. R., Bush, A., Marks, P., and Shelanski, M. L. (1989). Measurement of cytoplasmic free calcium in single motile cells. *Methodological Surveys Bioc. Anal.* **19**, 257–272.

Mayor, S., Presley, J., and Maxfield, F. R. (1993). Sorting of membrane components from endosomes and subsequent recycling to the cell surface occurs by a bulk flow process. *J. Cell Biol.* **121**, 1257–1269.

Miyawaki, A., Griesbeck, O., Heim, R., and Tsien, R. Y. (1999). Dynamic and quantitative Ca measurements using improved cameleons. *Proc. Natl. Acad. Sci. USA* **96**, 2135–2140.

Myers, J. N., Tabas, I., Jones, N. L., and Maxfield, F. R. (1993). ß-VLDL is sequestered in surface-connected tubules in mouse peritoneal macrophages. *J. Cell Biol.* **123**, 1389–1403.

Oida, T., Sako, Y., and Kusumi, A. (1993). Fluorescence lifetime imaging microscopy (flimscopy). Methodology development and application to studies of endosome fusion in single cells. *Biophys. J.* **64**, 676–685.

O'Malley, D. M. (1994). Calcium permeability of the neuronal nuclear envelope: evaluation using confocal volumes and intracellular perfusion. *J. Neuroscience* **14**, 5741–5758.

Pollok, B. A., and Heim, R. (1999). Using GFP in FRET-based applications. *Trends Cell Biol.* **9**, 57–60.

Reid, T., Baldini, A., Rand, T. C., and Ward, D. C. (1992). Simultaneous visualization of seven different DNA probes by in situ hybridization using combinatorial fluorescence and digital imaging microscopy. *Proc. Natl. Acad. Sci. USA* **89**, 1388–1392.

Salzman, N. H., and Maxfield, F. R. (1989). Fusion accessibility of endocytic compartments along the recycling and lysosomal endocytic pathways in intact cells. *J. Cell Biol.* **109**, 2097–2104.

Sanders, R., Draaijer, A., Gerritsen, H. C., Houpt, P. M., and Levine, Y. K. (1995). Quantitative pH imaging in cells using confocal fluorescence lifetime imaging microscopy. *Anal. Biochem.* **227**, 302–308.

Sandison, D. R., Williams, R. M., Wells, K. S., Strickler, J., and Webb, W. W. (1995). Quantitative fluorescence confocal laser scanning microscopy. *In* "Handbook of Biological Confocal Microscopy" (J. B. Pawley, ed.), 2nd edition, pp. 39–53. Plenum, New York.

Selvin, P. R. (2000). The renaissance of fluorescence resonance energy transfer. *Nat. Structural Biol.* **7,** 730–734.

Terzaghi, A., Tettamanti, G., Palestini, P., Acquotti, D., Bottiroli, G., and Masserini, M. (1994). Fluorescence excimer formation imaging: a new technique to investigate association to cells and membrane behavior of glycolipids. *Eur. J. Cell Biol.* **65,** 172–177.

Truong, K., and Ikura, M. (2001). The use of FRET imaging microscopy to detect protein-protein interactions and protein conformational changes in vivo. *Curr. Opin. Struct. Biol.* **11,** 573–578.

Tsien, R. Y., and Harootunian, A. T. (1990). Practical design criteria for a dynamic ratio imaging system. *Cell Calcium* **11,** 93–109.

Uster, S., and Pagano, R. E. (1986). Resonance energy transfer microscopy: observations of membrane-bound fluorescent probes in model membranes and in living cells. *J. Cell Biol.* **102,** 1221–1234.

Verveer, P. J., Squire, A., and Bastiaens, P. I. H. (2001). Frequency-domain fluorescence lifetime imaging microscopy: a window on the biochemical landscape of the cell. *In* "Methods in Cellular Imaging" (A. Periasamy, ed.), pp. 273–294. Oxford University Press, New York.

Yamashiro, D. J., and Maxfield, F. R. (1987). Acidification of morphologically distinct endocytic compartments in mutant and wild type Chinese hamster ovary cells. *J. Cell Biol.* **105,** 2723–2733.

CHAPTER 20

Fluorescence Resonance Energy Transfer Microscopy: Theory and Instrumentation

Richard A. Cardullo[1] and Vladimir Parpura[2]

[1]Department of Biology
The University of California
Riverside, California 92521

[2]Department of Cell Biology and Neuroscience
The University of California
Riverside, California 92521

I. Introduction

As discussed elsewhere in this book, the resolution of the light microscope is limited by diffraction (see Chapter 2) and is, at best, on the order of about 0.2 μm. On a molecular scale, this translates to a distance of 2000 Å (200 nm), which means that resolving molecular interactions is an impossible feat using a light microscope. However, using fluorescence intensity information, one is able to

quantitatively detect molecular interactions and motions. Perhaps the most powerful tool for this purpose is nonradiative fluorescence resonance energy transfer (FRET), which can quantitatively detect associations between molecules with Ångstrom resolution. Until recently, this methodology has been restricted to populations of molecules using steady-state fluorimeters or lifetime instruments. However, with recent technological advances in microscopes, light sources, and detectors, FRET is now possible within single cells.

In this chapter we will first outline the basic principles of FRET focusing on both steady-state and time-resolved methodologies. We will then turn our attention to developing different kinds of FRET microscopes, emphasizing the specific pieces of equipment that are required for making quantitative or qualitative determinations of molecular associations.

II. Principles and Basic Methods of FRET

Nonradiative FRET is a quantum mechanical phenomenon that occurs between two fluorescent molecules. The precise way in which these molecules interact allows distance measurements to be made on a molecular scale. In this section we introduce the basic concepts of FRET at a simple level. A more detailed treatment can be found elsewhere (Cardullo, 1992, 2002).

A. Basic Principles of Nonradiative FRET

The method of nonradiative FRET allows separation between fluorescent molecules to be made with Ångstrom resolution over distances between 10 and 100 Å. The technique was first conceived of by Förster (see 1959 for historical review) and has been used to measure intra- and intermolecular distances between, for instance, different reactive sites on a protein, proteins and lipids in a model system, or proteins on the cell surface. Because of its sensitivity over molecular distances, the technique has been dubbed "the spectroscopic ruler" (Stryer and Haugland, 1967). Although extremely useful for probing macromolecular interactions, FRET is a sophisticated technique that requires exact determination of critical spectroscopic parameters. To emphasize these parameters, it is critical to understand the mechanism of electronic energy transfer in fluorescence assays.

The principle of FRET is simple and is shown in Fig. 1. A donor molecule absorbs light at some frequency that temporarily places that molecule into a higher energetic electronic state. Before the electron can decay back down to its ground state, the close proximity of another molecule results in the nonradiative transfer of energy from the donor molecule to an acceptor molecule by a dipole-induced dipole interaction. The donor molecule has therefore given up its energy to an acceptor molecule, where it can now decay radiatively at its characteristic

No Transfer **Energy Transfer**

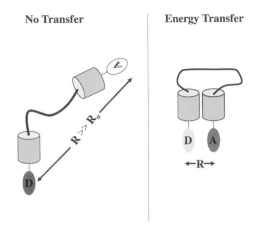

Fig. 1 Principle of FRET between a donor molecule, D, and an acceptor molecule, A. In this case, a single macromolecule (such as a protein) is labeled with both D and A. Initially, D and A are separated by a sufficiently large distance so that transfer does not occur and the fluorescence intensity of the donor, measured at the donor emission peak, is maximal. When the protein undergoes a conformational change leading to a separation of D and A that is typically on the order of tens of Ångstroms, then there is a nonradiative transfer of energy from the donor to the acceptor resulting in a quenching of donor and a sensitized emission of the acceptor.

fluorescence emission wavelength. In using FRET, only one of the two molecules needs to be fluorescent. However, most users of this technique employ both fluorescent donor and acceptor molecules whose spectrofluorometric properties become modulated when energy transfer occurs.

When designing molecules in which energy transfer will occur, three conditions must be met:

1. The donor emission spectrum must overlap the acceptor's absorbance spectrum.
2. The donor and acceptor fluorophores must be sufficiently aligned so that an acceptor dipole can be induced by the donor.
3. The donor and acceptor must be separated by some minimum distance so that the probability of energy transfer is high.

When these conditions are met, the probability of transfer, also known as the transfer efficiency, E_T for transfer between a single donor and single acceptor molecule is related by the Förster equation:

$$E_T = \frac{R_o^6}{R^6 + R_o^6} \tag{1}$$

where R is the separation distance between the donor and acceptor fluorophores and R_o is the separation distance for that particular donor/acceptor pair where

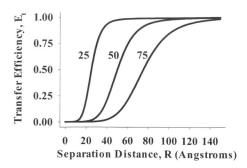

Fig. 2 Theoretical transfer efficiency curves as a function of the separation distance, R, between donor, D and acceptor, A. Numbers represent theoretical R_0 values of 25, 50, and 75 Å.

the transfer efficiency equals 0.5 (Fig. 2). It is because the transfer efficiency falls off inversely as the sixth power of the separation distance that FRET is a useful tool for measuring molecular distances both quantitatively and qualitatively. The transfer efficiency, and therefore the molecular separation distance, can be determined by either measuring donor lifetimes or steady-state methods.

Quantitative application of Eq. (1) is confined to the case in which one has a single donor transferring energy to a single acceptor. More complex situations, particularly those applicable to surface distributions in membranes are referred to in Chapter 9 on Fluorescence.

B. Methodologies for Measuring Transfer Efficiencies in Solutions

There are four major ways to measure the transfer efficiency caused by FRET when the donor is excited; they include

1. A decrease in the donor lifetime.
2. A decrease in the steady-state fluorescence emission intensity of the donor (donor quenching).
3. An increase in the steady-state fluorescence emission intensity of the acceptor (sensitized emission).
4. A change in the fluorescence polarization.

Of these four methods, 1 and 2 are the most widely used and the most amenable for measuring transfer efficiencies in microscopes. Therefore, we will focus on these two methods (Fig. 3).

As discussed in Chapter 9, a molecule can lose energy by a number of both radiative and nonradiative mechanisms:

$$k_t = k_r + k_{nr},$$

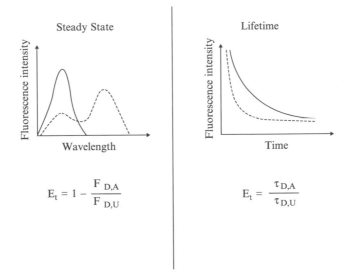

Fig. 3 FRET can be quantified using either steady-state or lifetime measurements. (A) In steady-state FRET there is a decrease in the fluorescence intensity of the donor along with the sensitized emission of the donor. Microscopes are designed to either measure fluorescence intensities at discrete wavelengths corresponding to the donor and acceptor emission peaks or by gathering emission spectra when the donor is excited. (B) In lifetime FRET there is a decrease in the lifetime of the donor fluorophore in the presence of acceptor. Solid lines represent the presence of the donor in the absence of acceptor and dashed lines in the presence of acceptor.

where k_t is the overall rate constant for radiative (k_r) and nonradiative (k_{nr}) processes. In the absence of nonradiative processes, the donor fluorophore will decay at some characteristic rate. However, when a competing nonradiative process occurs (e.g., FRET), there is a decrease in the lifetime of the donor. In general, the transfer efficiency, E_T, is given by

$$E_T = 1 - \frac{\tau_{D,A}}{\tau_{D,U}} \tag{2}$$

where $\tau_{D,A}$ is the excited-state lifetime of the donor in the presence of acceptor and $\tau_{D,U}$ is the excited-state lifetime in the absence of acceptor. Using a fluorescence-lifetime instrument, measurements of donor lifetimes in the presence and absence of acceptor can be made, and the transfer efficiency can be calculated directly from Eq. (2). The advantage of lifetime measurements is that they are extremely sensitive, so that accurate determinations of E_T can be made (Herman, 1989). In addition, the mathematics of complex transfer situations tends to be simpler in the excited state. However, few investigators have ready access to this equipment, as it is expensive and difficult to maintain.

As opposed to fluorescence-lifetime instrumentation, most investigators have access to a steady-state fluorimeter, and it is possible to make fairly accurate

determinations of transfer efficiency using such instrumentation (Gordon *et al.*, 1998). The degree of energy transfer can be quantified as a decrease in the donor's fluorescence emission intensity or by an increase in the fluorescence emission intensity of the acceptor (sensitized emission). The most common method is to quantify the transfer efficiency by measuring the amount of donor quenching in the presence and absence of acceptor. In this mode, the transfer efficiency is

$$E_T = 1 - \frac{F_{D,A}}{F_{D,U}} \tag{3}$$

where $F_{D,A}$ is the fluorescence intensity of the donor in the presence of acceptor (i.e., the transfer condition) and $F_{D,U}$ is the fluorescence intensity in the absence of acceptor. In the case of ligand–receptor interactions or nucleic acid hybridization, the measurement of $F_{D,U}$ (Fig. 2) must be made with an unlabeled complementary molecule. By measuring $F_{D,U}$ (or $\tau_{D,U}$) in this way, other donor-quenching mechanisms in addition to FRET are accounted for. Often it is more convenient to express the transfer efficiency using the degree of donor emission quenching rather than measuring the fluorescence intensities directly. In this case,

$$E_T = \frac{q_{D,A} - q_{D,U}}{1 - q_{D,U}}. \tag{4}$$

Whether one is making lifetime or steady-state measurements, an accurate determination of R_0 must be made. Measurements of R_0 are easily achieved if certain spectral parameters can be measured. In general, R_0 is given by

$$R_o = 9.765 \times 10^3 (\kappa^2 J(\lambda) Q_D n^{-4})^{1/6}, \tag{5}$$

where $J(\lambda)$ is the overlap integral (in $cm^3 M^{-1}$) between the donor emission spectrum and the acceptor absorbance spectrum, κ^2 is the orientation factor between donor and acceptor, Q_D is the quantum yield of the donor in the absence of acceptor, and n is the refractive index of the medium between donor and acceptor (Fig. 4). Quantitatively, the overlap integral can be calculated as

$$J(\lambda) = \int_0^\infty \varepsilon(\lambda) f(\lambda) \lambda^4 d\lambda, \tag{6}$$

where $\varepsilon(\lambda)$ is the molar extinction coefficient of the acceptor and $f(\lambda)$ is the normalized fluorescence spectrum of the donor, which is defined as

$$f(\lambda)d\lambda = \frac{F(\lambda)d\lambda}{\int_0^\infty F(\lambda)d\lambda}, \tag{7}$$

and $F(\lambda)$ is the fluorescence emission intensity of the donor. The orientation factor, κ^2 is perhaps the most troublesome factor, as its numerical value can vary anywhere between 0 and 4. In reality, the orientation between a population of donor and acceptor molecules are randomly oriented both spatially and temporally. It can also be shown that under randomizing conditions, the average

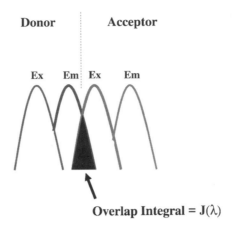

Donor **Acceptor**

Ex Em Ex Em

Overlap Integral = J(λ)

Fig. 4 FRET occurs only when there is a significant overlap between the donor emission and the acceptor excitation spectra. In general, the overall value of the transfer efficiency is dependent on R_o a value that includes the overlap integral and the relative orientation of the donor and acceptor molecules.

value of κ^2 ($<\kappa^2>$) is equal to 2/3 (Dale *et al.*, 1979). For most macromolecular interactions in solutions, using a value of κ^2 of 2/3 is entirely appropriate, and even minor polarizations of donor and acceptor molecules will not lead to major variations in the determination of R_o. However, in certain geometries, the investigator using energy transfer as a quantitative tool must be conscious of the possibility that certain molecular interactions may lead to extreme values in κ^2. In particular, energy transfer in highly polarizing situations such as biological membranes or in nucleic acids may lead to situations in which dipoles are either orthogonally aligned (leading to no possibility for a dipole-induced dipole interaction), with a resulting κ^2 value of zero, or aligned in parallel so that κ^2 is equal to 4.

C. Practical Considerations for All FRET Measurements

Whether using FRET for quantitatively detecting interactions between complementary molecules in solution or for designing experiments using a FRET microscope, described in the following section, a number of measurements and controls must always be performed to minimize artifacts and maximize signal-to-noise ratios to obtain the highest-quality images. These include, first, determining the background fluorescence of the sample. Measure the background fluorescence intensities of all samples in the absence of labeled molecules using the appropriate wavelengths for FRET measurements.

Second, determine the fluorescence intensity of the donor. Ideally, this should be in a range in which the fluorescence emission intensity varies linearly

with fluorophore concentration. (see discussion of saturation in Chapter 9). This reading will be the baseline value for determining the amount of quenching that occurs in the presence of a complementary molecule that contains the acceptor fluorophore.

Third, determine the fluorescence intensity of the donor in the presence of the unlabeled complementary molecule. In an ideal experiment, the unlabeled complementary molecule would not modulate the fluorescence intensity of the donor after binding. However, this is often not the case, and the fluorescence emission intensity of the donor generally changes on binding. In the case of polynucleic acids, hybridization of an unlabeled strand quenches the donor molecule on the labeled complementary strand (Cardullo et al., 1988). This degree of quenching [$Q_{D,U}$ in Eq. (4)] can depend on a number of different parameters, including the number of nucleotide pairs in the hybrid, the length of the hydrocarbon spacer between the terminal nucleotide and the fluorophore, the temperature, and the ionic strength of the solution. In some cases, especially those involving imaging, the best way to measure the donor fluorescence intensity in the absence of acceptor is to photobleach the acceptor fluorophore after the two labeled molecules associate with one another (Kenworthy, 2001).

Fourth, determine the fluorescence intensity of the donor in the presence of the acceptor-labeled complement. The amount of quenching in the presence of acceptor ($Q_{D,A}$) is used along with the amount of quenching in the absence of acceptor-labeled complement ($Q_{D,U}$) to determine the transfer efficiency using Eq. (4).

It is important to note that in the absence of these kinds of controls that modulation of fluorescence intensities or lifetimes using a microscope system may be the result of other factors than FRET.

III. FRET Microscopy

In theory, FRET should be readily achievable in an imaging microscope system if accurate detection of the donor and the acceptor fluorescence intensities, or lifetimes, can be made. In most cases, because of difficulties in accurately quantifying parameters such as R_0 and κ^2, a FRET microscope is not generally used for quantifying interactions between molecules but, rather, is best used for localizing those interactions within a cell. In this mode, all that is needed is sufficient signal-to-noise ratio to determine whether any increase in transfer efficiency can be mapped onto pixels. This requires either that fluorescence intensities can be accurately determined at both donor and acceptor wavelengths for steady state measurements or that accurate lifetime measurements can be made using a fluorescence-lifetime imaging microscope (FLIM) see chapter by Scatten). In either case, care must be taken to ensure that high-quality fluorescence images are obtained in the absence of artifacts resulting from differential response of optical or electronic elements at different wavelengths.

Consequently, all aspects of microscope design from the choice of objectives, light sources, and cameras must all be taken into account. In this section we will discuss the required instrumentation for FRET microscopy studies using either a steady-state or FLIM instrument.

A. The Microscope

FRET microscopes can either be upright or inverted, depending on the particular application and need for manipulating samples. In an upright microscope, cells can either be prepared and imaged through a coverslip or, alternatively can be attached to glass coverslips and imaged from above using high–numerical aperture (NA) long-working-distance objectives that may be immersed in a physiologically buffered solution that surrounds the sample. In contrast, inverted microscopes image cells from below using high-NA short-working-distance objectives and coverslips. In either case, one can have easy access to the cells of interest when microscopy is combined with patch-clamp recordings, pressure injections, amperometry, or similar experimental manipulations.

As discussed elsewhere in this book, although a microscope has many components that are responsible for the delivery of excitation light to the sample and emission light to the detector, the singularly most important part is the choice of objective or objectives. Magnification, NA, aberration, and spectral properties are some of the factors that need to be taken into account when choosing objectives for FRET. In cellular microscopy the majority of work is performed using magnifying powers greater than $40\times$ to allow for intracellular localization of donor-acceptor pairs. NA of the objective is important for two reasons. First, a high NA maximizes the resolution of the system, which is an especially important feature when donor-acceptor pairs may be localized within intracellular domains or organelles. Second, the NA dictates the efficiency of the objective to collect light, a feature especially important with fluorescence measurements, as selected multiple wavelengths of light are passing through the objective. As the magnification of the objective increases, more light needs to be gathered by the lens, which is readily available when using objectives with NAs greater than 1.3. Use of appropriate immersion fluids between the objectives and the sample in either upright (by immersing the lens in physiological saline) or inverted configurations (by immersing the lens in oil below the coverslip and the sample) increases the NA when compared with the air interface.

Although objectives should be devoid of spherical and spatial aberrations, this is usually a trade-off feature. In general, as the number of components that make up the objective lens decreases, the loss of light is decreased, but often at the expense of some spherical aberration. The transmittance of objectives is also important, and for FRET, differences in transmission can be a critical factor in the magnitude of the absolute signal in signal-to-noise ratios in both the donor and acceptor channels. This is especially true in the Ultraviolet (UV), when the investigator may be using intercalating dyes for detecting interactions with nucleic

acids or when using some other of the newer high-efficiency probes in the lower wavelengths. This has recently become an issue in FRET microscopy when Blue Fluorescence Protein (BFP) is used as a donor, as the objective must have excellent transmittance in near-UV range. Indeed, the best (albeit the most expensive) option would be to use an objective that contains quartz optical components. However, some companies offer more economical alternatives that have adequate transmittance down to 340 nm, such as Fluor and SuperFluor objectives.

The FRET microscope must also provide the appropriate transmission optics to locate and position the cell of interest and to correlate fluorescent signals within known cellular regions or organelles. In general, some form of contrast enhancement is desirable. A simple insertion of green interference filters in the path can be acceptable to observe some cell types (e.g., neurons), whereas for flatter cells (e.g., astrocytes or spermatozoa), additional contrast is often necessary. As discussed elsewhere in this book, the most commonly used methods for enhancing contrast are phase and differential interference contrast (DIC). Phase contrast reduces the amount of light caused by the presence of the phase ring in the objective but otherwise does not compromise fluorescence imaging. In DIC microscopy, polarizers are introduced into the light path, which not only reduces the intensity of fluorescence emission but also changes the polarization of light. Consequently, polarizers should be removed (usually they are mounted on a slider) to yield optimal fluorescence imaging.

Recently, the feasibility of using FRET below the diffraction limit of visible light has been demonstrated. In these experiments, Kirsch *et al.* (1999) used scanning near-field optical microscopy with uncoated glass fiber tips for light delivery to detect FRET between donor and acceptor molecules. Although not widely used, the use of near-field microscopy may ultimately offer distinct advantages over diffraction-limited methods that require the use of objectives.

B. Fluorescence Illumination

In a standard epifluorescence microscope, the light emitted from a source is directed by associated optics into the back aperture of the microscope and then through an objective. As in all elements of the microscope, the optical components in this path must be capable of transmission of the relevant light wavelengths (i.e., excitation and emission wavelengths for both the donor and acceptor fluorophores). Because the total transmittance depends on the number of individual components comprising the system, a reduction in the number of optical elements is advisable. Excitation wavelength selectors, dichroic mirrors, and emission selectors are all additional components in the delivery of the excitation wavelengths and recovery of emission wavelengths in the FRET microscope.

1. Light Sources

The most commonly used sources of light for fluorescence microscopy are mercury (Hg) and xenon (Xe) arc lamps. Although Hg lamps have some usable intensity maxima (e.g., as with fluorescein, rhodamine, and BFP excitation wavelengths), Xe arc lamps provide relatively even spectral radiance and, as with ratio imaging, are the light source of choice for FRET applications. When these lamps are combined with monochromators or appropriate filters, one can select the required excitation wavelengths to generate a complete spectrum for FRET. Because these lamps produce large amounts of emission in the infrared (IR), it is necessary to use a heat filter before the entry of light into the microscope. Such filters are most commonly mounted at the back aperture of the microscope. Alternatively, optical fibers or liquid light guides can be used to deliver the light to the back of the microscope or directly to the sample.

Lasers offer a source of coherent light at discrete wavelengths. Argon (Ar) and nitrogen (N_2) lasers can be used in conjunction with commercially available dye modules to generate light at a variety of different wavelengths. For example, a pulsed N_2 laser with a principal line at 337 nm can be used to cover the range from 360 to 950 nm when combined with appropriate dye modules. Although applicable for steady-state FRET, this pulsed laser is not a choice for FLIM applications because of a pulse time (~3 nanoseconds) on the order of the lifetime of most fluorophores. Instead, lasers that offer temporal resolution of approximately 100 ps are required for FRET using FLIM. One option is to use a laser-pumped Ti:sapphire-pulsed IR laser that is tunable between 700 and 1000 nm, with or without a frequency doubler, yielding 350–1000-nm excitation wavelengths. In addition, pulsed lasers can be used to "freeze" images, similar to a flash with a camera.

Finally, light-emitting diodes (LEDs) have shown promise in FLIM applications in cuvettes. However, at the present time, their light emission is not sufficient to combine them with complex optical systems that are used in imaging single cells.

2. Wavelength Selectors

When a broad-spectrum (multiwavelength) source of light is used, the wavelength of light is selected at three points: at the excitation selector, at the dichroic mirror, and at the emission selector. This is most commonly achieved using glass (fused silica) filters. Increasingly, however, various kinds of monochromators are used for selecting excitation and emission wavelengths for microscopic applications such as FRET. Further, acousto-optical tunable filters can be used for specific applications, such as blending wavelengths from different laser sources in confocal microscopy and in frequency-domain FLIM. Liquid-crystal tunable filters (LCTF) can also be used for selecting emission, but not excitation, wavelengths, although these filters will also polarize the light as well.

Two major filter types used in fluorescence microscopy are colored filter glass and thin-film coated filters. Color glass filters are relatively inexpensive, and their spectral characteristics are insensitive to their angle of incidence, but there is a limited selection, with their band-pass types having poor slopes and often low peak transmittance. Therefore, the most commonly used filters for FRET contain thin-film coatings—either metallic or interference coatings. Metallic coatings are used for mirrors or neutral-density filters. Interference coatings can be used to design almost any filter type, including band-pass exciters and emitters, long-pass and short-pass filters, and dichroic mirrors. This flexibility is inherent in the composition of stacked thin layers of material. Filters and filter sets ("cubes") commonly used for FRET applications are listed in Tables I and II.

Monochromators are frequently used in FRET applications. In essence, a monochromator produces a single spectral line from a broad spectrum source. The most common type is a Czerny-Tuner monochromator—which uses a grating to disperse light—whose wavelength is chosen using an exit slit. Monochromators can be tunable, and changing between two wavelengths requires speeds down to the millisecond range. In FRET applications in which, typically, a ratiometric approach is used, one can use a beam splitter with two static monochromators or use a single tunable monochromator at the emission end.

Acousto-optical tunable filters (AOTFs) are the filters most commonly used to filter laser light. They have found commercial applications in confocal microscopes (and FRET) and are used there to mix light emitted from different lasers. In these filters the light passes through a crystal (tellurium oxide), which acoustically vibrates when driven by radio frequencies. This basically creates a diffraction grating, and by varying the frequency of vibrations, one can quickly

Table I
Commonly Used Filter Sets for Fluorescent Proteins

Fluorescent protein (FP) filter sets	Exciter	Dichroic	Emitter
BFP	387RDF28	410DRLP	450RDF58
CFP	440DF21	455DRLP	480DF30
YFP	500RDF25	525DRLP	545RDF35
GFP	475RDF40	505DRLP	535RDF45

B = blue, C = cyan, Y = yellow, and G = green.

Table II
FRET Filter Sets Used for Two Different Donor/Acceptor Pairs

FRET filter sets	Exciter	Dichroic	Emitter 1	Emitter 2
CFP/YFP set	440 DF21	455DRLP	480DF30	535DF26
BFP/GFP set	365HT25	400DCLP	450DF65	535DF45

tune the filter to diffract out any wavelength of light at approximately 2 nm full width at half maximum (FWHM). These filters are used to modulate light frequencies in frequency-domain FLIM.

The LCTF is another electronically tunable optical filter, consisting of several horizontally stacked units. Each unit is composed of a liquid crystal sandwiched by sheet polarizers. With these filters one can electronically tune the wavelength within a few millseconds. These filters can be used for FRET only at the emission end, as they are thermally unstable and cannot receive direct light from either a Hg or Xe light source.

3. Detectors

Traditional FRET experiments use a single camera together with wavelength selectors at the emission end to capture a pair of emission images: one at the donor's emission wavelength and the other at the acceptor's emission wavelength because of excitation of the donor fluorophore. There are a number of ways to rapidly switch wavelengths, including rotating filter wheels, motorized sliders, LCTFs, and tunable monochromators. These methods are relatively inexpensive, with excellent spatial resolution, but all suffer in providing adequate temporal resolution (e.g., switching emission filters results in at least a 100 ms delay).

Ideally one should be able to simultaneously collect information for both the donor and acceptor fluorophores. This can be achieved by splitting the emission light into two spectral channels, one corresponding to the donor's emission and the other to the acceptor's emssion, that are then routed to individual detectors. This method greatly improves temporal resolution, although problems with registration between the two detectors are often difficult to achieve. Consequently, this type of system is relatively complex and expensive. An alternative is to use a single camera with an image splitter. In this system each light channel is routed to its own half of the imaging array. This gives excellent temporal resolution and reduces the cost at expense of reduction in spatial resolution.

To record planar information for fluorescent preparations, a camera is required (except for confocal configurations, described subscquently). Most cameras currently in use for FRET applications are either ICCDs (intensified charged-coupled devices) or CCCDs (cooled CCDs), which have analog and digital outputs, respectively. ICCDs have no lag time and show high sensitivity throughout a range required for imaging FRET emissions. Gen III intensifiers are mostly used today to amplify the light before delivering light to the CCD chip. The readout from the chip is synchronized to a standard analog video signal. The limiting factor in quality of images generated by an ICCD is the quality of the intensifier. A CCD is an imaging device whose sensor consists of semiconductor layers divided into electronic traps. Incident photons create electron-hole pairs, accumulating charge that is proportional to the arriving photon flux. The readout of a resulting potential from each pixel is then digitized for display and stored in a computer. Signals can be integrated for variable amounts of time until readout.

Because the noise is mainly the result from thermal generation of electrons, cooling of the detector increases signal-to-noise ratio.

Confocal microscopy as well as near-field microscopy have been employed in FRET imaging. Because in both cases spatial information is built up on a point-by-point basis, photo-multiplier tubes (PMT) can be used as fluorescent detectors to generate a two (or three)-dimensional image. PMTs can also be used for fast temporal detection in combination with wide-field fluorescence microscopes. In these kinds of photometry applications, an aperture can be inserted into a secondary imaging plane at the emission end of the microscope to define a region of interest such as a group of cells, a single cell, or a portion of a cell.

C. Typical FRET Systems

As shown previously, the most common way to monitor FRET is to use either a steady-state approach in which donor quenching of the presence of acceptor is used to calculate transfer efficiencies or a lifetime instrument is used to monitor decrease in donor lifetime in the presence of acceptor. Using the considerations described in these sections, we describe three systems for measuring FRET between a CFP-labeled donor and a YFP-labeled acceptor.

1. A Steady-State FRET System

The following is a description of a typical FRET system for CFP/YFP acceptor–donor pairs. A microscope equipped with a $40\times$ SuperFluor objective for maximum transmission of light is connected to a 100-W xenon (Xe) arc lamp used for sample excitation. The duration of the sample's exposure to light is controlled by an electronic shutter to minimize photobleaching. The light exiting the lamp housing, containing a focusing lens, is routed to the back aperture of the microscope. In the light path there is a holder containing three filter sets: CFP, YFP, and FRET filter sets (Tables I and II). The fluorescence emission is collected one filter at a time, and then the sample is imaged with an ICCD camera. When ratiometric imaging is used, a pair of images corresponding to emission wavelengths at 480 and 535 nm because of excitation at 440 nm reports donor and acceptor emission intensity values. To access the transfer efficiency, YFP (the acceptor) has to be bleached, as this will maintain the association between the two labeled molecules but will result in obtaining an unquenched value for the donor. This is accomplished by excitation of the YFP with a 525/40-nm band-pass filter to minimize bleaching of the donor CFP. Monitoring of bleaching success can be accomplished using a YFP filter set. The increase in fluorescence of CFP as recorded by looking at the CFP donor-emission channel is a direct measure of the transfer efficiency (E_t), which can be calculated using the following equation:

$$E_t = 1 - (\text{CFP intensity before YFP photobleach}/\text{CFP intensity after YFP photobleach}).$$

2. Fluorescence-Lifetime FRET Systems—Time versus Frequency Domains

In this configuration, a 440-nm laser line is used as the excitation wavelength. A laser (535 nm; Coherent Verdi, Santa Clara, CA) pumped pulsed (76 MHz; 150 fs) tititanum/sapphire IR laser that is tunable between 700- and 1000-nm wavelengths is used here to achieve the necessary wavelength and time resolution. The laser is tuned at 880 nm, and light exiting from the laser is passed through a frequency doubler, resulting in 440-nm light. This pulsed light is delivered to the back aperture of the microscope and used to illuminate living cells. The emitted light is filtered through a 480/30-nm filter and amplified at image intensifier and then integrated on a CCD chip coupled to an intensifier. This gated intensifier is synchronized to the laser. After laser pulse excitation, the image intensifier with the coupled camera acquires images at different time delays. Provided that integration times during acquisition of the individual images are the same, it is possible to make a comparison of the fluorescence lifetimes by acquiring two images at two different delay times with respect to the excitation pulse. For example, in this system, CFP lifetimes decrease from 2.2 to 1.6 ns in the presence of acceptor (Elangovan et al., 2002).

For frequency domain FLIM, the continuous excitation light originating from a laser is modulated at radio frequencies (typically at 10–100 MHz), using an AOTF. Two radio-frequency synthesizers whose phase settings are computer controlled are used to produce a repetitive signal (e.g., a sinusoidal wave). One frequency synthesizer drives the modulation of the AOTF, and the other drives the modulation of an image intensifier. The emission light is focused onto an image intensifier. Thus, fluorescence emission is demodulated, phase-shifted, and captured onto a CCD. Image acquisition and shutter control at the excitation are also computer interfaced and controlled.

IV. Conclusions

The first FRET microscope was constructed over a quarter of a century ago (Fernandez and Berlin, 1976) although recent advances in imaging technology and in the development of wavelength selection devices have only now made this powerful technique popular among investigators interested in studying the interactions between molecules in cells. Using steady-state methods, it is now possible to construct a relatively low-cost system that can detect molecules within cells. In contrast, lifetime measurements allow for the determination of more quantitative data to be obtained. Coupled with the advent of the development of new fluorescent probes such as the green fluorescent protein and other genetically engineered reporters (Zhang et al., 2002), the future of this technology is sure to reveal molecular associations both within cells and on cell surfaces that were previously detected only using nonmicroscopic methods (Nagy et al., 2002; Zimmermann et al., 2002).

References

Cardullo, R. A. (1992). Nonradiative fluorescence resonance energy transfer. *In* "Nonradioactive Labeling and Detection of Biomolecules" (C. Kessler Ed.), pp. 414–423. Springer-Verlag.

Cardullo, R. A. (2002). Principles of non-radiative FRET: the spectroscopic ruler. *Microscop. Anal.* **15,** 19–21.

Cardullo, R. A., Agrawal, S., Zamecnik, P., and Wolf, D. E. (1988). Detection of nucleic acid hybridization by nonradiative fluorescence resonance energy transfer. *Proc. Natl. Acad. Sci. USA* **85,** 8790–8794.

Cardullo, R. A., Mungovan, R., and Wolf, D. E. (1991). Imaging membrane organization and dynamics. *In* "Biophysical and Biochemical Aspects of Fluorescence Microscopy" (G. Dewey Ed.), pp. 231–260. Plenum Press, New York.

Dale, R. E. (1979). The orientation factor in intramolecular energy transfer. *Biophs. J.* **26,** 161–194.

Elangovan, M., Day, R. N., and Periasamy, A. (2002). Nanosecond flurorescence resonance energy transfer: fluorescence lifetime imaging microscopy to localize the protein interactions in a single living cell. *J. Microsc.* **205,** 3–14.

Fernandez, R. M., and Berlin, R. D. (1976). Cell surface distribution of lectin receptors determined by resonance energy transfer. *Nature* **264,** 411–415.

Förster, T. (1959). Transfer mechanisms of electronic excitation. *Discuss. Faraday Soc.* **264,** 7–17.

Gordon, G. W., Berry, G., Liang, X. H., Levine, B., and Herman, B. (1998). Quantitative fluorescence resonance energy transfer measurements using fluorescence microscopy. *Biophys. J.* **74,** 2702–2713.

Herman, B. (1989). Resonance energy transfer microscopy. *Meth. Cell Biol.* **30,** 219–243.

Kenworthy, A. K. (2001). Imaging protein-protein interactions using fluorescence resonance energy transfer microscopy. *Methods* **24,** 289–296.

Kirsch, A. K., Subramanian, V., Jenei, A., and Jovin, T. M (1999). Fluorescence resonance energy transfer detected by scanning near-field optical microscopy. *J. Microsc.* **194,** 448–454.

Nagy, P., Vereb, G., Sebestyen, Z., Horvath, G., Lockett, S. J., Damjanovich, S., Park, J. W., Jovin, T. M., and Szöllosi, J. (2002). Lipid rafts and the local density of ErbB proteins influence the biological role of homo- and heteroassociations of ErbB2. *J. Cell Sci.* **115,** 4251–4262.

Stryer, L., and Haugland, R. P. (1967). Energy transfer: a spectroscopic ruler. *Proc. Natl. Acad. Sci. USA* **58,** 719–726.

Zhang, J., Campbell, R. E., Ting, A. Y., and Tsien, R. Y. (2002). Creating new fluorescent probes for cell biology. *Nat. Rev. Mol. Cell Biol.* **3,** 906–918.

Zimmerman, T., Rietdorf, J., Girod, A., Georget, V., and Pepperkok, R. (2002). Spectral imaging and linear un-mixing enables improved FRET efficiency with a novel GFP2-YFP FRET pair. *FEBS Lett.* **531,** 245–249.

CHAPTER 21

Fluorescence–Lifetime Imaging Techniques for Microscopy

Chen Y. Dong,[1] Todd French,[2] Peter T. C. So,[1] C. Buehler,[1] Keith M. Berland,[3] and Enrico Gratton[1]

[1]Laboratory for Fluorescence Dynamics
Department of Physics
University of Illinois at Urbana-Champaign
Urbana, Illinois 61801

[2]Molecular Devices Corporation
Sunnyvale, California 94089

[3]Physics Department
Emory University
Atlanta, Georgia 30322

Three different methods of fluorescence-lifetime imaging for microscopy are presented along with some examples of their use. All three methods use the frequency-domain heterodyning technique to collect lifetime data. Because of the nature of the data collection technique, these instruments can measure the correct lifetime even when the sample undergoes strong photobleaching. Each instrument has unique capabilities that complement the others.

The first microscopic-lifetime imaging technique uses a fast charge-coupled device (CCD) camera and a gated image intensifier. The camera system collects an entire lifetime image in parallel in only a few seconds. This microscope is well suited to kinetic studies of intracellular lifetime changes. The other two techniques use scanned laser source to collect sequential lifetime information pixel by pixel. One microscope uses two-photon excitation to achieve three-dimensional, confocal-like imaging without using detection pinholes. Two-photon excitation also limits the effects of out-of-plane photodamage of the sample. The second laser-scanning microscope uses a pump-probe technique for fluorescence-lifetime imaging. By measuring the cross-correlation frequency, high-frequency harmonic imaging can be achieved without high-speed detectors. The cross-correlation volume also results in three-dimensional spatial resolution equal to a confocal microscope and time resolution limited only by the laser light source.

I. Introduction

Fluorescence is a sensitive technique useful as a vital contrast-enhancement mechanism for microscopic imaging. Labeling at high specificity, fluorescence microscopy has excellent background rejection. It provides the high contrast needed to spatially resolve microscopic structures such as cellular organelles. Although the spatial relationship of the organelles is important, the functional properties of the organelles also are vital in the understanding of cellular physiology. Local physiological parameters such as the pH or molecular concentration may be revealed by fluorescence microscopic imaging. Fluorescent probes can also act as sensitive probes to local cellular environment. For example, some probes are fluorescent only in a particular pH or polarity condition. In most applications, fluorescence intensity measurements are used to monitor various processes in cells and tissues. However, intensity imaging may not be suitable for quantitative work. The measured intensity depends not only on the fluorophore environment but also on the local probe concentration, which cannot be easily determined. Quantitative measurements using concentration-independent parameters may bypass probe concentration–related artifacts. Spectra and fluorescence lifetime of a fluorescent probe are two parameters independent of the probe concentration. Techniques that exploit either spectral- or lifetime-sensitive probes can be used as environmental probes in measuring quantitatively environmental factors that affect the excited state. Consequently, ratiometric (spectral) and fluorescence-lifetime (temporal) techniques coupled to fluorescence microscopy can provide localized quantitative information of the cellular and tissue environments.

Fluorescence techniques reveal information of the molecular state of a chromophore. Spectral and polarization changes in the emitted light reveal the excited-state properties and the orientation of the transition dipole moments. To form a more complete investigation of the nature of the excited state, time-resolved measurements are required. For example, fluorescence quenching may occur because of a ground-state reaction or an excited-state reaction. Only by measuring the probe's fluorescence lifetime can one determine the nature of molecular interaction. The excited state also can be affected by the molecular environment through processes such as solvent relaxation, energy transfer, and conformational changes. This sensitivity makes fluorescent probes excellent monitors of cellular factors such as pH, viscosity, molecular concentration, and local order.

The sensitivity of fluorescence lifetime to the microenvironment has been used to measure pH (Sanders et al., 1995a), metal ion concentration (Piston et al., 1994; Lakowicz et al., 1994a), fluorescence resonance energy transfer (Oida et al., 1993; Gadella and Jovin, 1995), cellular photostress (König et al., 1996), and antigen processing (French et al., 1997). Other quantities such as molecular oxygen concentration, environmental polarity, and local order also may be measured using lifetime imaging techniques. Lifetime can also be used as a contrast-enhancing mechanism. Different fluorophore species with different lifetimes can be imaged in one picture, and the fraction of each fluorophore can be resolved within a single image element (So et al., 1995; Sanders et al., 1995b).

Time-resolved fluorescence microscopy has advanced greatly from the first single-pixel measurements (Dix and Verkman, 1990; Keating and Wensel, 1990). These first experiments deduced important cellular information such as calcium concentration or cytoplasm matrix viscosity at selected points inside a cell. Further development in fluorescence-lifetime-resolved microscopy resulted in the extension of the single-point measurements to obtain lifetime information across the entire cell. Two different approaches have been applied. The first method uses CCD cameras equipped with gain-modulated image intensifiers to collect data simultaneously across the entire image. The other approach modifies traditional confocal laser scanning microscopes and obtains time-resolved information on a point-by-point basis.

The laser scanning microscope uses a single-point detector to acquire images one point at a time. Serial acquisition systems consist of a single-point detector and a scanning mechanism to move the sample or the excitation light. Fluorescence-lifetime imaging can be achieved by adapting normal lifetime-resolved detectors and electronics to the new optical setup. Laser scanning microscopy has been used to measure three-dimensionally resolved lifetime images with confocal detection (Buurman et al., 1992; Morgan et al., 1992), two-photon excitation (Piston et al., 1992; So et al., 1995) and time-dependent optical mixing (Dong et al., 1995; Müller et al., 1995). In addition, near-field scanning optical microscopy has been used to image surface fluorescent lifetimes (Ambrose et al., 1994; Xie and Dunn, 1994).

Time-resolved imaging of the full field simultaneously is harder to implement. Full-field imaging generally employs a two-dimensional array detector (such as a CCD) to capture all points in an image in parallel (rather than one at a time). The problem associated with this approach is in achieving nanosecond time resolution (required for fluorescence) across a large spatial area. The basic approaches are to use a gated image intensifier coupled to a camera or a position-sensitive photomultiplier. Both frequency-domain (Wang *et al.*, 1989; Marriott *et al.*, 1991; Lakowicz and Berndt, 1991; So *et al.*, 1994; Morgan *et al.*, 1995) and time-domain (Wang *et al.*, 1991; Oida *et al.*, 1993; McLoskey *et al.*, 1996) techniques have been developed.

In this chapter, we describe the development and applications of fluorescence-lifetime imaging microscopy. Three different fluorescent-lifetime imaging microscopes that use the frequency-domain heterodyning technique are described: a CCD-based system, a two-photon laser scanning system, and a laser scanning, pump-probe (stimulated emission) technique.

II. Time-Resolved Fluorescence Methods

A. Time-Domain and Frequency-Domain Measurements

Time-resolved fluorescence measurements can be performed in two functionally equivalent ways: the time-domain or the frequency-domain approach (for further discussion, see Chapter 9). In the time domain, the impulse response of a system is probed. A fluorescent sample is illuminated with a narrow pulse of light, and the resulting fluorescence emission decay is captured with a fast recorder. A common method for reconstructing the decay profile is time-correlated single-photon counting. With this method, the time delay between the emitted photon and the excitation pulse is recorded. For a low enough emission rate (fewer than 10^5 photons per second), every photon's delay can be recorded. An entire decay curve can be reconstructed by plotting the number of photons as a function of the delay times. To properly reconstruct the decay curve, the excitation profile must also be measured so that it may be used to deconvolve the finite width of the excitation pulse from the emission profile.

The frequency-domain method measures the harmonic response of the system. The sample is excited by a sinusoidally modulated source. An arbitrarily complex modulation waveform can be decomposed into sinusoidal components such that only sinusoidal modulation needs to be discussed. The emission signal appears as a sine wave that is demodulated and phase shifted from the source (Fig. 1). The phase shift and modulation are used to obtain the lifetime of the fluorophore. For a single exponential decay, the phase (ϕ) and modulation (M) are related to the excited state lifetime (τ) by Eqs. (1) and (2), in which ω is the angular modulation frequency, or 2π times the modulation frequency. For maximum sensitivity, the angular modulation frequency should be roughly the inverse of the lifetime. Because typical lifetimes are 1–10 ns, the corresponding modulation frequencies are 20–200 MHz.

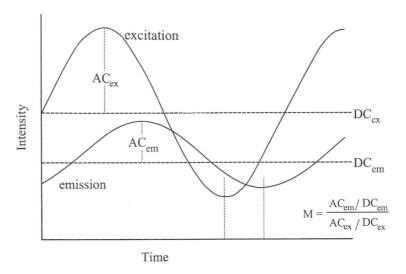

Fig. 1 Definitions of phase (ϕ) and modulation (M) in frequency domain measurements.

$$\omega\tau = \tan(\phi) \tag{1}$$

$$\omega\tau = \sqrt{\frac{1}{M^2} - 1}. \tag{2}$$

Because the emission signal is too fast to be sampled continuously, the high-frequency signal is often converted to a lower frequency. In this process of heterodyning, the frequency conversion is accomplished using a gain-modulated detector. The detector is modulated at a frequency close to the frequency of the excitation source. The result is a beating of the emission and detector modulation signals that yields a cross-correlation frequency signal that is at the difference of the frequencies.

If the source and detector frequencies are the same, the frequency-mixing process is called homodyning. Homodyning, by definition, results in a DC signal whose amplitude is proportional to the sine of the difference of the phase between the detector and the emission. To acquire the entire phase and modulation information of the emission signal, it is necessary to systematically step the phase difference between the source and detector modulation signals. Homodyning is commonly used with a fixed phase difference to collect phase-resolved data. By properly choosing the phase of the detector, one can suppress or enhance certain lifetimes. A disadvantage of homodyning is that it is more sensitive than heterodyning to spurious DC components such as stray light. Heterodyning recovers all of the high-frequency phase and modulation information in each cross-correlation period (typically 10–100 ms) and can be used for acquiring phase-resolved data as well.

For the three different time-resolved techniques, the concept of heterodyned data acquisition is used. First, we apply a synchronous averaging filter. Several cross-correlation waveforms are collected and combined to form an average waveform. This filter removes random noise by rejecting signals that are not at the cross-correlation frequency or its harmonics. The reduction of the bandwidth along with the averaging causes the signal-to-noise ratio to increase linearly with the number of waveforms averaged (Feddersen *et al.*, 1989). The next step in data reduction involved fast Fourier transform (FFT). The cross-correlation signal is uniformly sampled in time such that FFT can be used to calculate the phase and modulation. The manner in which we apply FFT is equivalent to (but simpler than) a least-squares fit of multiple sine waves to the data. Additional averaging of the sequential phase and modulation images is sometimes used in the scanning microscopes to further reduce the noise. This is a less-efficient filter, and the noise is reduced as expected from Poisson statistics.

The sampling frequency is generally chosen such that four samples are collected in one cross-correlation period (Fig. 2). To measure a signal at a given frequency,

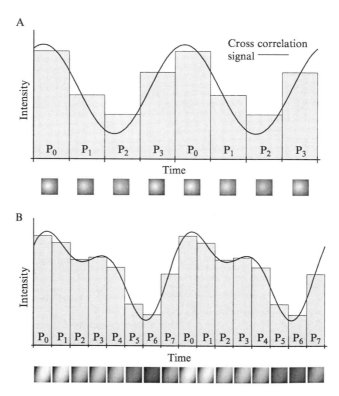

Fig. 2 Sampling of the cross-correlation signal. (A) Four images collected per cross-correlation period. (B) Eight images can reduce the error in the measurement (harmonic distortion).

the signal must be sampled at least at twice that frequency (Nyquist theorem). If noise appears as a high-frequency signal, it is better to sample at a higher rate to produce a more accurate measurement. More points sampled results in better discrimination of the various harmonics. Thus, by increasing the number of samples per cross-correlation period, higher-frequency signals (generally noise) can be more easily separated from the fundamental.

B. Simultaneous Multiple-Lifetime-Component Measurement

To discriminate more harmonics and achieve better noise rejection, more points can be sampled per period. For the first-generation microscope instruments presented in this chapter, we chose to use four points per cross-correlation period because it was faster and the higher harmonics were small compared to the fundamental frequency. However, there are situations that can benefit from measuring higher harmonics.

One such case is the simultaneous measurement of two probes with dissimilar lifetimes. To measure the two lifetimes, the phase and modulation would have to be collected in separate measurements at each of the frequencies appropriate for the given fluorophore. However, it is possible to map the two modulation frequencies to two different cross-correlation frequencies and collect the phase and modulation in one measurement. If the two cross-correlation frequencies are related by an integer multiple, they can be separated by FFT.

Consider the case of a sample consisting of two probes whose lifetimes are 1 and 1000 ns. Two appropriate modulation frequencies are 100 MHz and 100 kHz, respectively. If the laser is modulated at a mixture of 100 MHz and 100 kHz and the detector is modulated at a mixture of 100 MHz + 10 Hz and 100 kHz + 20 Hz, the two signals can be separated. The result of the heterodyning is two signals at 10 and 20 Hz that correspond to the fluorescence decay at 100 MHz and 100 kHz, respectively.

To achieve the mixing of the 100-MHz and 100-kHz signals and still produce a strong fluorescence signal, the two signals should both be sine waves. When combined with a high-frequency mixer, the result is the high-frequency signal enclosed in an envelope of the intermediate frequency signal (Fig. 3A). On heterodyning, the resultant low-frequency signal will be composed mainly of the two cross-correlation frequencies (Fig. 3B).

After measuring the phase and modulation at each frequency, it is still necessary to separate the lifetime components. The most common approach is to fit a decay scheme to the acquired data. For the example outlined in this section, it is possible to use algebraic methods to separate the two components. The algebraic method is possible whenever the two lifetimes are known to be different by several orders of magnitude.

To describe the example system, the following conventions are used. The shorter lifetime component (1 ns) will be referred to with the subscript 1. The longer component (1000 ns) will have the subscript 2. The fractional intensity

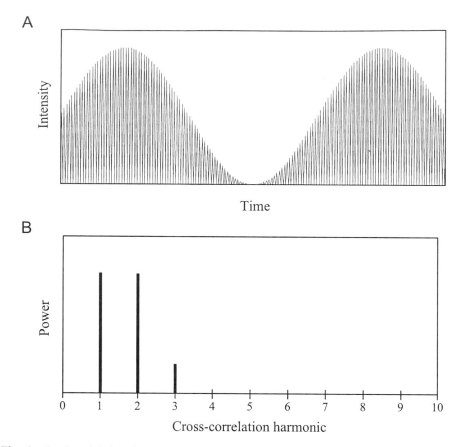

Fig. 3 Dual modulation signal. (A) The source or detector signal. (B) The low-frequency power spectrum of the heterodyned signal.

of the fluorescence contributed by the short lifetime probe is indicated by f. $(1 - f)$ will be contributed by the other component.

In the frequency domain, lifetime components add as vectors. The vector sum of the phase and modulation times the fractional intensity of each component results in the measured phase and modulation of a multiple-component system. The Cartesian components of the resultant lifetime vector for a two-component system are given in Eqs. (3) and (4):

$$M_r(\omega)\cos[\phi_r(\omega)] = fM_1(\omega)\cos[\phi_1(\omega)] + (1 - f)M_2(\omega)\cos[\phi_2(\omega)], \qquad (3)$$

$$M_r(\omega)\sin[\phi_r(\omega)] = fM_1(\omega)\sin[\phi_1(\omega)] + (1 - f)M_2(\omega)\sin[\phi_2(\omega)]. \qquad (4)$$

By measuring the phase and modulation at the two frequencies appropriate for the two components ($\omega_1 \approx 1/\tau_1$, $\omega_2 \approx 1/\tau_2$), Eqs. (3) and (4) can be rearranged and

combined with Eqs. (1) and (2) to solve for each of the lifetime values and the fractional intensity:

$$f = \frac{M_r(\omega_1)}{\cos[\phi_r(\omega_1)]}, \tag{5}$$

$$\tau_1 = \frac{\tan[\phi_r(\omega_1)]}{\omega_1}, \tag{6}$$

$$\tau_2 = \frac{M_r(\omega_2)\sin[\phi_r(\omega_2)]}{\omega_2[M_r(\omega_2)\cos[\phi_r(\omega_2)] - f]}. \tag{7}$$

Table I lists the values that would be measured in three different two-component systems. The first system consists of 20% of the short component, the second 50%, and the third 80%. These three configurations demonstrate the ability of the algebraic method. As can be seen in Table II, there is some error involved in using this technique. The error, however, is less than the typical error of the fluorescence-lifetime imaging systems presented in this chapter. For an integration time of several seconds, an error of 0.4° in phase and 0.005 in modulation is normal. This magnitude of error results in about a 1% error in the lifetime at the appropriate frequency. If smaller errors are required, the algebraic method could be performed interatively, or the measured phase and modulation could be fitted to a two-component model using standard fitting routines.

C. Photobleaching Effects

Fluorescence photobleaching (photon-induced destruction of the fluorophore) is a major problem in fluorescence microscopy. This can make quantitatively reproducible intensity measurements next to impossible. Lifetime measurements, however, should be insensitive to such a loss of fluorophores. However, a problem can still arise if the concentration changes significantly during a lifetime measurement. In this section, lifetime-measurement errors caused by photo-bleaching are compared for three frequency-domain data acquisition methods.

Table I

Phase and Modulation Values of Three Two-Component Systems at Two Sample Frequencies

		$\phi_r(\omega_1)$	$M_r(\omega_1)$	$\phi_r(\omega_2)$	$M_r(\omega_2)$
20% short	80% long	32.5°	0.170	25.0°	0.853
50%	50%	32.2°	0.424	14.7°	0.888
80%	20%	32.1°	0.678	5.5°	0.948

Note. $\omega_1 = 2\pi \cdot 100\,\text{MHz}$, $\omega_2 = 2\pi \cdot 100\,\text{kHz}$.

Table II
Results of the Numerical Separation of Different Lifetime Components in the Three Sample Systems

value	20% τ_1		50% τ_1		80% τ_1	
	result	error	result	error	result	error
f	0.2016	0.8% ·	0.5011	0.2%	0.8004	0.05%
τ_1	1.014 ns	1%	1.002 ns	0.2%	0.998 ns	0.2%
τ_2	1.004 μs	0.4%	1.002 μs	0.2%	1.010 μs	1%

In the comparison, each method was given the same amount of time to observe the sample, and all methods collected four phase samples per integration cycle.

The first method investigated is heterodyning. The cross-correlation frequency was 32 Hz, and integration was performed by synchronous averaging. The second method is normal homodyning. The detector was modulated at the four phase angles 0°, 90°, 180°, and 270°. Each phase was integrated for one-quarter of the total integration time. The third method is modified homodyning. For this method, the detector was modulated at the same four phase angles, but the phase was first stepped up and then back to counteract trends caused by photobleaching. The phase steps and order were 0°, 90°, 180°, 270° and then 270°, 180°, 90°, and 0°. Each phase step was integrated one-eighth of the total time and intensities at corresponding phase angles were averaged.

To compare the three acquisition methods, two samples were produced: one that exhibited strong photobleaching and one that had insignificant photobleaching. For both samples, DAPI (4,6-diamidino-2-phenylindole; Sigma Chemical, St. Louis, MO), a common fluorescent probe, was chosen. This probe is quite easily photobleached. The nonphotobleaching sample was a solution of DAPI loaded into a hanging drop slide. The bleaching in this sample was negligible because of the diffusion of fresh DAPI molecules from outside the excitation volume. For the photobleaching sample, the effects of diffusion were limited by using a polyacrylimide gel commonly used for gel chromatography (Bio-Gel P6, exclusion limit 6 kD; Bio-Rad, Richmond, CA). When a sample volume of the gel was photobleached, no return of the fluorescence intensity to its original value was observed even after several minutes. The lifetime and photobleaching rate were constant in these samples.

Figure 4 shows a representative photobleaching decay in the photobleaching-sensitive system. The intensity decrease was fitted to a double exponential model that resulted in a short photobleaching time of 9 seconds and a long photobleaching time of 140 seconds. The double exponential fit suggests a dual rate process. The origin of the processes is not known. To avoid the effects of the fast component, all of the photobleaching samples were illuminated for at least 30 seconds before lifetime data was acquired.

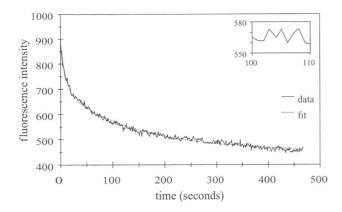

Fig. 4 Fluorescence intensity of DAPI as a function of time showing photobleaching. The bleaching effects were fit to a double exponential decay with decay times of 9 and 140 seconds.

Phase and modulation errors of the three data collection methods are shown in Fig. 5. For the bleaching measurements, the errors for the various integration times were calculated by comparing the longer integration measurements to the average of reference measurements. As a reference for each method, the phase and modulation were measured for 10 seconds repeatedly. During this short integration time, photobleaching caused little change in average intensity (as shown in the inset of Fig. 4). Consequently, photobleaching should have little effect on the phase and modulation during the reference measurements using any method. The errors presented are the average errors of four to eight different samples at each integration time. The graph clearly shows that the heterodyning acquisition method is the least affected by photobleaching. This is an important factor in our choice of the heterodyning acquisition method for fluorescence-lifetime imaging microscopy.

III. Fluorescence-Lifetime-Resolved Camera

The fluorescence-lifetime-resolved camera uses a CCD detector to collect nanosecond time-resolved data in parallel. The camera system can simultaneously measure fluorescence lifetime at every point in a microscopic image. It uses a high-speed CCD camera modified to collect lifetime data. The heterodyning technique coupled with a fast camera yields several unique advantages over previously reported camera systems (Lakowicz and Berndt, 1991; Wang *et al.*, 1991; Gadella *et al.*, 1993; Oida *et al.*, 1993; Morgan *et al.*, 1995; McLoskey *et al.*, 1996). First, this instrument is capable of generating lifetime images in a few seconds. Second, it minimizes the effect of photobleaching, a common problem in microscopy.

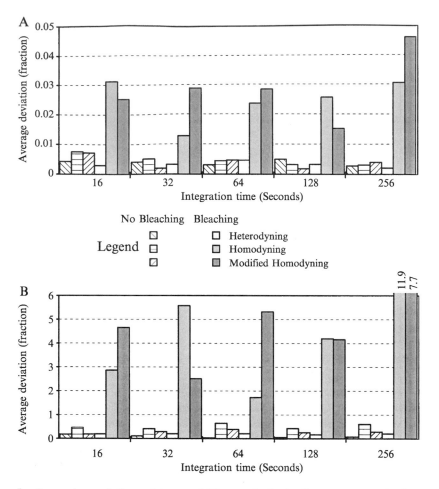

Fig. 5 Comparison of three data acquisition methods in the presence and absence of photobleaching. The average deviation is the average of the magnitude of the error of several measurements. (A) Modulation; (B) phase.

This system can operate in the presence of high background fluorescence and can quantitatively measure lifetimes of microscopic samples. Time-resolved imaging can not only effectively and selectively enhance the contrast of microscope fluorescence images but also quantitatively measure lifetimes within cellular compartments to monitor their microenvironment. With an acquisition rate as short as a few seconds, kinetic studies of lifetime changes are also possible with this camera.

A. Instrumentation

Our first camera system was constructed using a CCD camera coupled to an image intensifier (So *et al.*, 1994). Subsequently, a second-generation lifetime-resolved camera was constructed of a scientific-grade high-speed CCD and a custom image intensifier. The second-generation instrument addressed problems with the CCD, frame rate, modulation frequency, and other troubles. Throughout the development, the optics and data acquisition remained essentially the same. A general schematic of the instrument is illustrated in Fig. 6.

1. Camera and Image Intensifier

The two most important components of the lifetime-resolved camera system are the CCD and the microchannel plate image intensifier. The second-generation camera includes a scientific-grade CCD (CA-D1-256, Dalsa, Waterloo, Ontario). This CCD operates in the progressive-scan mode as opposed to the interlaced mode. Its frame rate is variable (derived from an external signal) and can be as high as 200 Hz. The new CCD also has a signal-to-noise ratio of 70 dB. The resolution is 256×256 pixels, each with an area of $16 \times 16 \, \mu m^2$. Although we could have chosen a camera with higher resolution, we chose one that has a lesser resolution but that can operate at a faster frame rate. The microchannel plate is coupled via fiber-optics to the CCD. It was custom built by Hamamatsu (model V6390U, Bridgewater, NJ) for high-speed modulation. It has a double-stage

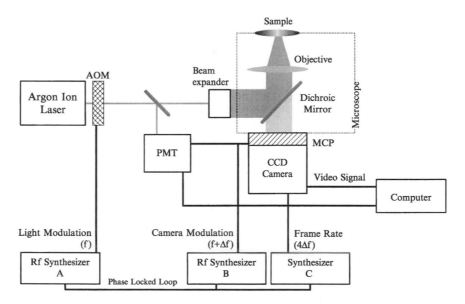

Fig. 6 Camera-based fluorescence-lifetime imaging microscope schematic.

design with a gain of approximately 10^5. The camera is gain modulated by modulating the cathode of the microchannel plate (So *et al.*, 1994). We have tested the modulation to 500 MHz.

2. Light Source and Optics

To illuminate the sample, a laser is directed into an epifluorescence microscope (Axiovert 35, Zeiss Inc., Thornwood, NY). The laser beam is coupled via fiber-optic to a beam expander and then delivered to the microscope for wide-field illumination. Shown in Fig. 6 is an argon ion laser (model 2025, Spectra Physics, Mountain View, CA) modulated by an acousto-optical modulator (AOM; Intra-Action, Belwood, IL). The argon ion laser can provide illumination at several selected blue-green wavelengths, most notably 514 and 488 nm. The acousto-optical modulator can optically modulate light at discrete frequencies from 30 to 120 MHz. One particular benefit of an AOM is its high throughput (up to 50%). As an alternative to the AOM, a Pockels cell (ISS Inc., Champaign, IL) was also used. The Pockels cell has the advantage of modulating at any frequency from 0 to 300 MHz. The advantage of continuous wide-band modulation is offset by the relatively poor throughput (~5%). Another alternative modulated light source used in our experiments was a cavity-dumped DCM dye laser (model 700, Coherent Inc., Palo Alto, CA) synchronously pumped by a Nd:YAG laser (Antares, Coherent Inc.). The dye laser produces 10-ps pulses at a range of frequencies. The frequency can be chosen by the cavity dumper to be any integer divisor (4–256) of the Nd:YAG fundamental frequency (76.2 MHz). The narrow pulse width insures that there will be harmonics measurable to many gigahertz. The dye laser provides a tunable source in the near UV region (300–340 nm).

3. Data Acquisition

The data acquisition scheme plays an important part in the performance of the camera system. The hardware determines the sensitivity and time response of the system, whereas the software provides a user interface and noise/artifact reduction. The camera has an 8-bit digital output. The output signal is sent to an Image-1280 digitizer (MATROX Electronic Systems Ltd., Dorval, Quebec). Four frames are collected per cross-correlation period. The cross-correlation frequency of the system is from 1–50 Hz. Each frame is synchronously averaged with the corresponding frame of the previous cross-correlation period. The Image-1280 can average the frames and transfer the averaged frames to the host computer without interrupting image acquisition. Hence there is no limit on the number of cross-correlation periods that can be averaged. After collecting the average cross-correlation images, the phase and modulation are independently calculated for each point in the image. Measurements of typical fluorescence probes generally result in an uncertainty of about 200 ps, which can be achieved in about 300 cross-correlation periods (30 seconds at 10 Hz).

Although the camera can record internally consistent phase and modulation images, there is no guarantee that the values in different images are comparable. In general, the high-frequency modulation signals change slightly between measurements. Slow phase and modulation drifts are common in acousto-optical and electro-optical modulators. To account for these small variations, a second detector is used to monitor the laser light source. All values calculated for an image are referenced to the monitor values. The detector that monitors the laser is a photo-multiplier tube (PMT; R928, Hamamatsu, Bridgewater, NJ), and data from the PMT are digitized with a second digitizer (A2D-160, DRA Laboratories, Sterling, VA).

B. Camera-Based Microscope Examples

Lifetime images of some simple microscopic systems were obtained to test the performance of this fluorescence-lifetime imaging microscope. The following examples demonstrate the ability of our microscope to selectively enhance image contrast and to quantitatively measure fluorescence lifetime.

One of the most important features of the lifetime microscope is its ability to measure minute differences in cellular microenvironments in which fluorescence-intensity measurements do not have sufficient sensitivity. As a demonstration, we imaged a string of live spirogyra cells (Fig. 7). Spirogyra cells organize as long strands, with cells connected end to end. The most prominent features in each of these cells are the large, double-helical chloroplasts. The chlorophyll in these organelles is brightly fluorescent when illuminated at 514 nm. The string of cells was imaged with the time-resolved microscope at a modulation frequency of 81 MHz.

This image was taken at the junction between two distinct spirogyra cells. The break in the helical structures corresponds to the separating cell walls between the two cells. The cell walls (which have been drawn for clarity) are not visible, as they are not fluorescent. Judging from the fluorescence-intensity picture alone, these two cells appear to be identical. However, a significant difference in chlorophyll lifetimes in these two cells can be observed in the phase-resolved picture (Fig. 7B). Note that the chloroplast within each individual cell has a uniform lifetime that is distinct from the other. This observation shows that the nonuniformity in the phase-resolved picture reflects the environment of the chloroplast in the cells and is not caused by experimental artifacts of the lifetime camera. In the phase-resolved picture, the cell at the upper-right-hand corner has a higher phase value (and is more demodulated), whereas the other cell has a lower phase value (and is better modulated). This is consistent with the hypothesis that the chlorophyll of the cell at the upper-right corner has a longer lifetime. Because the growth of these cells was not controlled, the cause of the lifetime difference is unknown. This example demonstrates the promise of the time-resolved microscopy technique in quantitatively monitoring cellular functions.

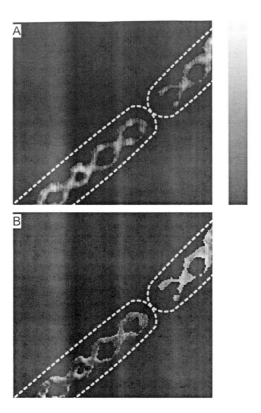

Fig. 7 Frequency domain pictures of chloroplast fluorescence of two spirogyra cells. (A) DC intensity (arbitrary units). (B) phase (0°–90°) at 81 MHz. The gray scale is linear from the minimum (black) to the maximum (white). The dotted line illustrates the cell walls.

As another demonstration of lifetime imaging, a two-layer fluorescent sample was imaged. In this sample, the well of a hanging drop slide was filled with a POPOP-ethanol solution and sealed with a coverslip. The second layer, placed on top of the fist, consisted of 15-μm blue fluorescent spheres (Molecular Probes, Inc., Eugene, OR) in water and was sealed with another coverslip. POPOP exhibits a single exponential decay in ethanol of 1.3 ns and served as an internal fluorescence lifetime reference. The two solutions were not allowed to mix together because different solvents were required for each probe. Frequency-domain pictures were taken at multiple frequencies from 8 to 140 MHz using the DCM dye laser. The phase differences and modulation ratios between the sphere and the dye background were measured at each frequency. Using the known lifetime of the POPOP background, the absolute phase shift and modulation of the sphere fluorescence were determined (Fig. 8).

The absolute phase shift and modulation values were analyzed using GLOBALS Unlimited (University of Illinois, Urbana, IL). As expected for a

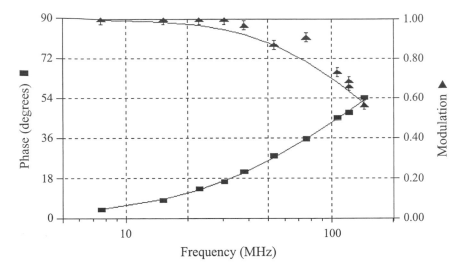

Fig. 8 Phase shift and demodulation of 15-μm fluospheres as a function of frequency. The data are the average value of all of the spheres in one image. The fit (solid line) is a double exponential fit. The phase error was 0.4° (error bars are smaller than the symbols), and the modulation error was 0.05.

two-species system, the data obtained fits best to a double exponential decay. One component was fixed to have the lifetime of POPOP, and the other was allowed to vary. From the intensity images, the POPOP was expected to contribute about 0.7 of the total intensity. The calculated fractions were 76% for POPOP and 24% (±3%) for the sphere in close agreement with the intensity estimate. The lifetime of the spheres was calculated to be 2.5 ns (±0.3 ns).

IV. Two-Photon Fluorescence Lifetime Microscopy

The second fluorescence-lifetime microscope design uses two-photon excitation and laser scanning to produce three-dimensional fluorescence-lifetime images. Two-photon excitation was first introduced to microscopy by Denk *et al.* (1990). In this technique, chromophores are excited by the simultaneous absorption of two photons, each having half the energy needed for the excitation transition (Friedrich, 1982; Birge, 1983; Birge, 1985). Because two photons are involved in the absorption process, the corresponding excitation probability is proportional to the square of the excitation power. The key for efficient two-photon excitation is a high temporal and spatial concentration of photons. Only in the region of a high photon density will there be appreciable two-photon excitation. The high spatial concentration of photons can be achieved by the diffraction-limited focusing of laser light using a high–numerical aperture objective. The high temporal concentration of photons is best accomplished using high-peak-power-mode-locked lasers.

Depth discrimination is the most important advantage of two-photon excitation microscopy. For one photon excitation in a spatially uniform fluorescent sample, equal fluorescence intensities are contributed from each z-section above and below the focal plane (assuming negligible excitation attenuation). This is a result of the conservation of energy (Wilson and Sheppard, 1984). In contrast, in two-photon excitation using objectives with a numerical aperture of 1.25, over 80% of the total fluorescence intensity comes from a 1-μm-thick region about the focal point (So *et al.*, 1995).

The spatial resolution and depth discrimination of the two-photon microscope are comparable to conventional confocal systems. For excitation of the same chromophore, the resolution is roughly half of that obtained under one-photon confocal microscopy (Sheppard and Gu, 1990). This reduction in spatial resolution is the result of the larger diffraction-limited spot achieved in focusing the longer-wavelength, two-photon excitation source (double the wavelength of the one-photon source). For our microscope, 960-nm excitation results in a FWHM (full width at half maximum) of the point-spread function 0.3 μm along the radial axis and 0.9 μm along the axial direction (So *et al.*, 1995).

Two-photon excitation also has the unique advantage that photobleaching and photodamage are localized to a submicron region at the focal point. In contrast, a conventional scanning confocal microscope causes photobleaching and photo-damage anywhere within the illumination volume. In addition, no detection pinhole is required with a two-photon microscope to achieve axial depth discrimination. Because more fluorescence photons are required to generate high-quality time-resolved images than intensity imaging, the light-gathering efficiency is an important factor in the successful implementation of a time-resolved microscope. This requirement is critical in three-dimensional imaging in which the sample is exposed to a long period of laser excitation. Therefore, maximizing microscope detector efficiency and minimizing sample photobleaching are important design considerations.

Our instrument operates at a high cross-correlation frequency that provides lifetime information on a per pixel basis. The temporal resolution of this system is about 400 ps, which is slightly inferior to standard fluorometers, which have a resolution of about 25 ps. This result is expected given that the data acquisition time at each pixel is typically a million times shorter than the time used by a conventional fluorometer. Because of the heterogeneous nature of the cellular environment, it is seldom necessary to determine specimen lifetime to an accuracy comparable to the standard fluorometer.

A. Instrumentation

Presented in Fig. 9 is the schematic of the two-photon, time-resolved microscope. It consists of a laser scanning microscope and a high-peak-power laser. This system operates efficiently at the normal light levels of microscopy. It also can operate at very low light levels. The system can detect low-photon events

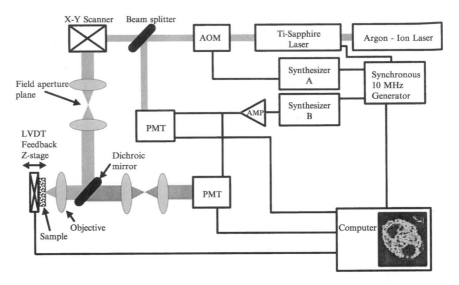

Fig. 9 Two-photon fluorescence-lifetime imaging microscope schematic.

(two to three photons) and has single-molecule detection capabilities. At the highest sensitivity, the background noise is equivalent to about one photon per pixel per frame.

1. Light Source

The laser used in this microscope was a mode-locked titanium sapphire (Ti-Sapphire) laser (Mira 900, Coherent Inc., Palo Alto, CA) pumped by an argon-ion laser (Innova 310, Coherent Inc., Palo Alto, CA). The features of this laser system are a high average power of up to 1 W, a high pulse repetition rate of 80 MHz, and a short pulse width of 150 fs. In addition, the intensity output of this laser is very stable, with typical fluctuations of less than 0.5%. Such stability is important for uniform excitation in the scanning system. The Ti-Sapphire laser has a tuning range from 720 to 1000 nm corresponding to one-photon excitation wavelengths of 360 to 500 nm. This wide tuning range allows most common near-ultraviolet, blue, and green fluorescent probes to be excited.

As a frequency-domain light source, the pulse train of the Ti-Sapphire laser has a modulation frequency content of 80 MHz and its harmonics. The harmonic content of the femtosecond pulse extends to terahertz. The lifetime determination of many common fluorescent probes requires the availability of modulation frequencies below 80 MHz. An acousto-optical modulator (Intra-Action, Belwood, IL) driven by the amplified signal of a phase-locked

synthesizer is used to generate these additional frequencies not available directly from the laser. This AOM has the desirable properties of low-pulse-width dispersion and high-intensity transmittance (typically 50%). Additional modulation frequencies can be generated by beating the AOM modulation with the 80-MHz laser pulse train and its harmonics. The mixing between the laser repetition frequency and the AOM modulation frequency generates new components at the sum and difference frequencies. This scheme allows one to generate intensity modulation from kilohertz to tens of terahertz (Piston *et al.*, 1989).

2. Optics and Scanner

An *x-y* scanner (Cambridge Technology, Watertown, MA) directs the laser light into the microscope. A low-cost single-board computer (New Micros, Inc., Dallas, TX) is the synchronization and interface circuit between the scanner and the master data acquisition computer. The master computer synchronizes the scan steps by delivering a TTL trigger pulse to the interface circuit, which outputs the required 16-bit number to move the scanner to the next pixel position. The normal region is a square of 256×256 scanned in a raster fashion. The scanner can scan over its full range with a maximum scan rate of 500 Hz. This rate limits the scan time needed for a typical 256×256-pixel region to be about 0.5 seconds, which corresponds to a pixel residence time of $8 \mu s$. For normal operation, the pixel spacing in the images was $0.14 \mu m$ but could be adjusted as needed.

The excitation light enters the microscope (Axiovert 35, Zeiss Inc., Thronwood, NY) via a modified epiluminescence light path. The light is reflected by the dichroic mirror to the objective. The dichroic mirror is a custom-made short-pass filter (Chroma Technology Inc., Brattleboro, VT) that maximizes reflection in the infrared and transmission in the blue-green region of the spectrum. Because tight focusing increases the photon density, a high–numerical aperture objective is critical to obtain efficient two-photon excitation. The objective normally used is a well-corrected Zeiss $63\times$ Plan-Neofluar lens with a numerical aperture of 1.25. The objective delivers the excitation light and collects the fluorescence signal. The fluorescence signal is transmitted through the dichroic mirror and refocused onto the detector. Because two-photon excitation has the advantage that the excitation and emission wavelengths are well separated (by 300–400 nm), suitable short-pass filters eliminate most of the residual scatter with a minimum attenuation of the fluorescence signal. In the excitation region of 900–1000 nm, we use 3 mm of BG39 Schott filter glass. It has an optical density of over 15 for the excitation wavelength while retaining over 80% of the transmittance in the fluorescence wavelength.

The *z*-axis position of the microscope stage is controlled by a second single-board computer (Iota System Inc., Incline Village, NV). The distance between the objective and the sample is monitored by a linear variable differential transformer (LVDT; Schaevitz Engineering, Camden, NJ). The LVDT output is digitized, and the single-board computer compares the measured position with the preset

position. The position of the objective is dynamically maintained by the computer, which drives a geared stepper motor coupled to the standard manual height-adjustment mechanism of the microscope. This control system is designed to have a position resolution of 0.1 μm over a total range of 200 μm. This dynamic feedback control system has a bandwidth of about 10 Hz.

3. Detector and Data Acquisition

A gain-modulated photomultiplier tube (model R3896, Hamamatsu, Bridgewater, NJ) detects the fluorescence signal from each position. A second gain-modulated photomultiplier tube (model R928, Hamamatsu, Bridgewater, NJ) monitors the laser beam to correct for frequency and modulation drift of the laser pulse train. The analog outputs of the two PMTs are digitized by the data acquisition computer.

One unique feature of this microscope is its high cross-correlation frequency. A high frequency ensures that complete cross-correlation waveforms can be collected within a minimum pixel residence time. A short pixel residence time is essential to achieve an acceptable frame refresh rate. The absolute minimum pixel residence time is limited by the mechanical response of the scanner to about 8 μs. However, the minimum residence time is actually limited by the digitizer and the number of photons available. The digitizer used in this instrument can operate at 60 kHz in simultaneous dual channel mode (12-bit resolution; A2D-160, DRA Laboratories, Sterling, VA). Data is acquired at four points per cross-correlation period. Thus, the digitizer limit is 70 μs per pixel (15 kHz). To make the timing easier, the actual maximum frequency is chosen to be 12.5 kHz (80 μs per pixel). At this rate an entire 256×256 frame can be acquired in just over 6 seconds. For fluorescence photon fluxes less than 10^7 per second, the pixel residence time should be increased to reduce statistical noise. As has been discussed, the most efficient way to reduce noise is to average over a few waveforms at each pixel. In this instrument, at least two waveforms are averaged, which brings the pixel residence time to 160 μs, which corresponds to a frame rate of about 13 seconds.

B. Two-Photon Microscopy Examples

The time resolution of this microscope was studied by imaging latex spheres labeled with chromophores of different lifetimes (Molecular Probes, Eugene, OR). Orange fluorescent latex spheres (2.3 μm in diameter) were mixed with Nile red fluorescent latex spheres (1.0 μm in diameter). The lifetime of these spheres was independently measured in a conventional cuvette lifetime fluorometer (ISS, Champaign, IL). The orange and red spheres each show a single exponential decay with a lifetime of 4.3 and 2.9 ns, respectively.

An image of two orange spheres (the larger ones) and three red spheres (the smaller ones) is presented in Fig. 10. Note that the small red sphere at the right edge of the picture has the same intensity as that of the larger orange spheres and

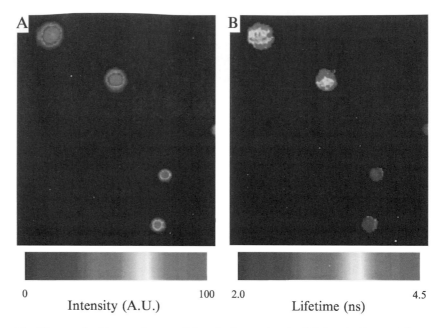

Fig. 10 Time-resolved image of orange (2.3 μm in diameter) and red (1.0 μm in diameter) fluorescent latex spheres. (A) Intensity; (B) lifetime. (See Color Insert.)

is significantly less intense than the other red spheres. This observation stresses the fact that intensity is a poor parameter for discerning the property of the specimen in a fluorescence image. Intensity differences can be the result of differences in concentration and many experimental artifacts such as the uniformity of the illumination and detector response. In contrast, the lifetime picture shows lifetime values of 4.0 ± 0.2 and 2.6 ± 0.2 ns, in good agreement with the data obtained in the conventional fluorometer. The sphere on the right is correctly identified only in the lifetime picture.

Fluorescence-lifetime imaging is most valuable in cellular systems. As an example, FITC-dextran (FITC, fluorescein-5-isothiocyanate isomer I) was used to observe the pH in the vacuoles of mouse macrophages. The three-dimensional resolution of the two-photon microscope proved to be crucial in distinguishing closely packed vacuoles. Out-of-focus vacuoles contributed minimal fluorescence to the measured lifetime images.

Macrophages were incubated with 1 mg/mL FITC-dextran (Sigma Chemical; 50.7 kD, 1.2 mol FITC per mol dextran) for 24 hours before observation. The cells were not washed before examination. Fluorescence was observed only in vacuoles and in the extracellular media (Fig. 11). The average lifetime measured in the extracellular fluid was 3.9 ns, corresponding to a neutral pH, whereas the lifetime measured in the vacuoles was 3.1 ns on average, indicating an average intravacuolar

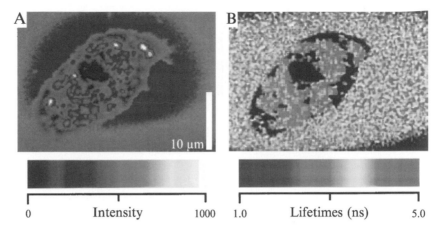

Fig. 11 Unwashed macrophages incubated 24 hours with FITC-dextran. Cells were provided by the laboratory of Dr. E. W. Voss, Department of Microbiology, University of Illinois. (See Color Insert.)

pH of 4.0, consistent with previous reports (Ohkuma and Poole, 1978; Tycko and Maxfield, 1982; Murphy *et al.*, 1984; Straubinger *et al.*, 1990; Aubry *et al.*, 1993). All vacuoles have roughly the same lifetime, indicating that the vacuoles are at the same pH even though the intensity varied dramatically within individual cells.

V. Pump–Probe Microscopy

The third example of a fluorescence-lifetime imaging microscope uses an asynchronous pump-probe technique. We have adapted a frequency-domain, pump-probe technique (Elzinga *et al.*, 1987) for use in microscopy. Pump-probe spectroscopy uses a pump pulse of light to promote the sample to the excited state and a probe pulse to monitor the relaxation back to the ground state. The most common implementation is transient absorption (Fleming, 1986). Recently, applications using pump-probe spectroscopy with stimulated emission have also been reported (Lakowicz *et al.*, 1994b; Kusba *et al.*, 1994). With stimulated emission, one can either measure the stimulated emission directly or the resulting change in fluorescence emission intensity. In our microscope, we measure the modulation in fluorescence emission from chromophores excited by a pump laser source and stimulated to emit by a probe laser.

In microscopy, the asynchronous pump-probe technique offers spatial resolution equal to confocal microscopy and provides high-frequency response of a fluorescence system without a fast photodetector. The principle of this technique is illustrated in Fig. 12. Two pulsed laser beams overlap at the sample. Their wavelengths are chosen such that one beam (pump) is used to excite the molecules

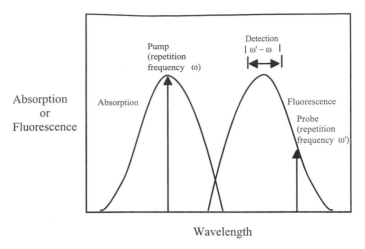

Absorption
or
Fluorescence

Wavelength

Fig. 12 Principles of the pump-probe (stimulated emission) technique.

under study and another beam (probe) is used to stimulate emission from the excited-state chromophores. The two laser pulse trains are offset in frequency by a small amount. This arrangement generates a fluorescence signal at the cross-correlation frequency and corresponding harmonics. Because the cross-correlation signal depends strongly on the efficient overlap of the two laser sources (Dong *et al.*, 1995; Dong *et al.*, 1997), superior spatial resolution and improved depth discrimination can be obtained by detecting the fluorescence at the beat frequency or its harmonics. Furthermore, pulsed laser systems can have high harmonic content. The low-frequency, cross-correlation signal harmonics correspond to the high-frequency laser harmonics. Therefore, a high-speed detector is not required to record the high-frequency components of the fluorescence signal.

A. Instrumentation

The experimental arrangement for our pump-probe fluorescence microscope is shown in Fig. 13. The design is quite similar to the two-photon microscope. The differences are mainly the result of the use of two laser beams instead of one. For example, the light sources are different, along with the excitation and emission filters. Also, the detector does not need to be gain modulated because the pump-probe signal is not at high frequency. Otherwise, the majority of the components are the same (such as the microscope, the *x-y* scanner, *z* (focus) positioner, and data acquisition software and hardware).

1. Light Sources

A master synthesizer that generates a 10-MHz reference signal is used to synchronize two mode-locked neodymium-YAG (Nd-YAG, Antares, Coherent

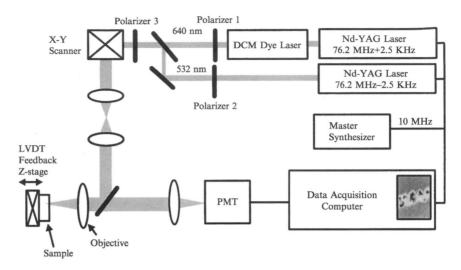

Fig. 13 Pump-probe fluorescence-lifetime imaging microscope schematic.

Inc., Santa Clara, CA) lasers and to generate a clock for the digitizer and scanner. The 532-nm output of the one Nd-YAG laser is used for excitation. The probe Nd-YAG laser pumps a DCM dye laser (Model 700, Coherent Inc., Santa Clara, CA) tuned to 640 nm and is used to induce stimulated emission. The pulse width (FWHM) of the pump laser is 150 ps, and the DCM probe laser has a pulse width of 10 ps. Combinations of polarizers are used to control the laser power reaching the sample. The average power of the pump and probe beams, at the sample, are about 10 μW and 7 mW, respectively. For time-resolved fluorescence microscopy, the pump source is operated at from 76.2 MHz to 2.5 kHz, and the probe laser's repetition frequency is 5 kHz away at 76.2 MHz + 2.5 kHz.

2. Optics

The two lasers are combined at a dichroic mirror (Chroma Technology Inc., Brattleboro, VT) before reaching the x-y scanner (Cambridge Technology, Watertown, MA). As with the two-photon system, the images are typically 256 × 256 pixels with a 0.14-μm pixel spacing. The beams are reflected into the microscope objective by a second dichroic mirror. To align the pump and probe lasers, we found it convenient to overlap their projections on the laboratory's ceiling.

Because tight focusing increases the photon density and localizes the pump-probe effect, a high–numerical aperture objective is used. The objective used in these studies is a well-corrected Zeiss 63× Plan-Neofluar with a numerical aperture of 1.25. With this objective, the optical point-spread function has a FWHM of 0.2 μm radially and 0.5 μm axially for excitation at 532 nm (Dong *et al.*,

1995). The fluorescence signal is collected by the same objective, transmitted through the second dichroic mirror and two 600 ± 20-nm band-pass filters.

3. Detector and Data Acquisition

A PMT (model R928 or R1104, Hamamatsu, Bridgewater, NJ) detects the fluorescence signal from each position. The analog PMT signal is electronically filtered by a preamplifier (Stanford Research, Sunnyvale, CA) to isolate the 5-kHz, cross-correlation signal before being delivered to the data acquisition hardware and software. Typically we use a pixel dwell time of 800 μs, with a resulting frame acquisition time of 65 seconds.

4. Pump–Probe Polarization Microscopy and Laser Diode–Based Systems

There have been two technical developments in the pump-probe methodologies. First, it has been demonstrated that by varying the pump and probe orientation from the parallel/parallel to the parallel/perpendicular orientation, polarization microscopy can be achieved. As Fig. 14 shows, as the probe beam polarization samples the excited-state population, polarization measurements can be measured by rotating the probe beam orientation from parallel and perpendicular to the pump beam (Buehler *et al.*, 2000). This exciting development extends pump-probe microscopy to include polarization imaging capabilities. The second development in the pump-probe technique involves using intensity-modulated diode lasers as the pump and probe laser sources. Instead of using mode-locked pulse laser systems, economical intensity-modulated laser sources

Fig. 14 Implementation of pump-probe polarization measurements. Polarization experiments can be performed by changing the relative orientations of the pump-probe beams from the ‖/‖ (parallel-parallel) to ‖/⊥ (parallel-perpendicular) configurations.

Fig. 15 Pump-probe fluorescence imaging using intensity-modulated laser diodes.

represent attractive alternatives and can contribute to popularizing the pump-probe methodology. A laser-diode-based pump-probe system is shown in Fig. 15. In this example, a sinusoidally modulated laser operating at 635 nm [Model APM 08(635-08), Power Technology Inc., Maybelvale, AR] is used as the excitation source. Another intensity-modulated laser diode at 680 nm [Model APM 08(690-40), Power Technology Inc., Maybelvale, AR] was used as the probe beam. The pump and probe beam modulation frequencies were 80 MHz and 80 MHz + 5 KHz, respectively (Dong *et al.*, 2001). For laser diodes operating in this range of wavelengths, the number of fluorescent species that can be used for pump-probe studies is rather limited. However, as the costs for the green and blue laser diodes drop, one can expect standard fluorescent molecules such as fluorescein or rhodamine to be used in laser diode–based pump-probe systems.

B. Pump–Probe Microscopy Examples

We obtained lifetime-resolved images of a mixture of 2.3 μm orange and 1.1 μm Nile-red (absorption maximum: 520 nm, emission maximum: 580 nm) fluorescent latex spheres (Molecular Probes, Eugene, OR). The two types of spheres were

Fig. 16 Fluorescent lifetime images of 1.1-μm Nile-red (τ_p = 3.20 ± 1.0 ns) and 2.3-μm orange (τ_p = 4.19 ± 1.4 ns) fluorescent latex spheres. (A) First harmonic amplitude, (B) phase. (See Color Insert.)

known to have different lifetimes. The measured lifetimes using a standard frequency-domain phase fluorometer are 2.70 ns for 1.1-μm spheres and 4.28 ns for 2.3-μm spheres. In our images, the first harmonic amplitude and phase are measured (Fig. 16). The phase image was referenced to that of a 4.16-mM rhodamine B slide for the purpose of lifetime calculations. From the histograms of lifetime values, the lifetimes of the spheres were determined to be 3.2 ± 1.0 ns (1.1 μm) and 4.2 ± 1.4 ns (2.3 μm). These values agree within error to the results from frequency-domain phase fluorometry.

We also examined mouse fibroblast cells doubly labeled with the nucleic acid stain ethidium bromide and the membrane stain rhodamine DHPE (Molecular Probes, Eugene, OR). The pump-probe image is shown in Fig. 17. These cells were grown on a coverslip and then fixed with acetone. The cells were stained first with ethidium bromide (1 mM in PBS, 0.1% Triton X-100) for 30 minutes and then stained by rhodamine DHPE (10 μg/ml in PBS, 0.1% Triton X-100) for another 30 minutes before it was rinsed twice in PBS and mounted for viewing. The lifetimes of the cytoplasmic and nuclear region were determined from the phase image. The reference phase was obtained from a slide of 4.16 mM rhodamine B in water. It was found that the average of lifetime histograms in the cytoplasm and nucleus are 2.0 ± 0.5 s and 6.6 ± 4.8 ns, respectively. For comparison, the lifetime of rhodamine B in water was determined in a standard frequency-domain phase fluorometer to be 1.44 ns. Furthermore, the lifetimes of the unbound ethidium bromide and bound ethidium bromide to nucleic acid are known to be 1.7 and 24 ns, respectively (So *et al.*, 1995). Our measurements of lifetime in cytoplasm show that there was significant staining of cytoplasmic structures by rhodamine DHPE. The average lifetime in the

0 100 0 90

First harmonic Phase (degrees)
amplitude (A.U.)

Fig. 17 Fluorescent-lifetime images of a mouse fibroblast cell labeled with rhodamine DHPE and ethidium bromide (membrane and cytoplasm: $\tau_p = 2.00 \pm 0.54$ ns, nucleus: $\tau_p = 6.62 \pm 4.8$ ns). (A) First harmonic amplitude; (B) phase. Cells were provided by the laboratory of Dr. M. Wheeler, Department of Animal Sciences, University of Illinois. (See Color Insert.)

nucleus is between that of bound and unbound ethidium bromide, indicative of the fact that both populations of the chromophores exist in the nucleus. Nonetheless, the lifetime contribution from bound ethidium bromide is sufficient to distinguish the different lifetimes in the nucleus and cytoplasm as demonstrated by the phase image.

This example demonstrates one advantage of lifetime-resolved imaging. From intensity imaging, it is difficult to distinguish the cytoplasmic and nuclear regions, as these chromophores have similar emission spectra. With lifetime imaging, sharp contrast between the two species of chromophores can be generated.

As discussed, by rotating the pump and probe beam orientations, the pump-probe technique can also be used for polarization microscopy studies. Shown in Figs. 18 and 19 are examples of time-resolved, pump-probe images using this approach. In Fig. 18, the lifetime of a 15-μm orange fluorescent sphere (Molecular Probes, Eugene, OR) was determined to be 9.15 ns. In addition, one sees that the phase difference between the parallel/parallel (pump beam/probe beam) and parallel/perpendicular orientations is $\Delta\phi = \phi_{\parallel/\parallel} - \phi_{\parallel/\perp} = 5.8°$. In this case, energy transfer most likely is the mechanism responsible for the depolarization. Another example of pump-probe polarization imaging is one in which a mouse fibroblast cell labeled with CellTracker CMTMR (Molecular Probes). As Fig. 19 shows, lifetimes of four different regions (I to IV) were determined to be 1.93, 2.75, 1.75, and 2.85 ns, respectively. As in the case of the 15-μm orange fluorescent sphere, by varying the relative pump and probe polarizations, the rotational correlation times for the four regions can also be determined. They are 27, 104, 107, and 151 ps for regions I to IV, respectively.

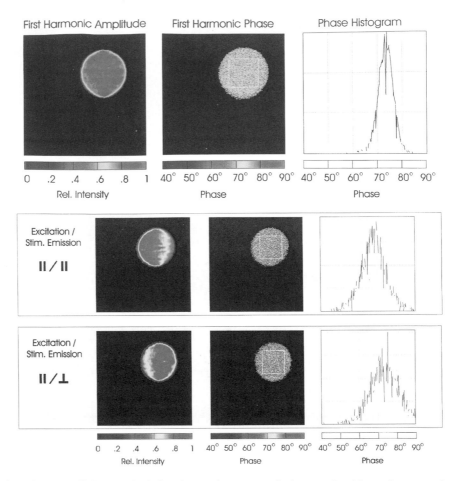

Fig. 18 Top: lifetime-resolved, first harmonic, pump-probe images of a 15-mm fluorescent latex sphere (lifetime 15 ns). Middle and bottom: lifetime-resolved, pump-probe polarization images of the same sphere in the $\|/\|$ and $\|/\perp$ configurations. $\Delta\phi = \phi_{\|/\|} - \phi_{\|/\perp} = 6°$. (See Color Insert.)

As the final example of pump-probe microscopy, an image of mouse STO cells labeled with TOTO-3 (Molecular Probes) is shown in Fig. 20. As the figure shows, the lifetime of the TOTO-3 labeled region is 1.81 ns. This example demonstrates that feasibility of using intensity-modulated laser diodes in pump-probe fluorescence imaging.

VI. Conclusion

Fluorescence-lifetime imaging provides the unique opportunity to study functional structures of living cellular systems. The three implementations of

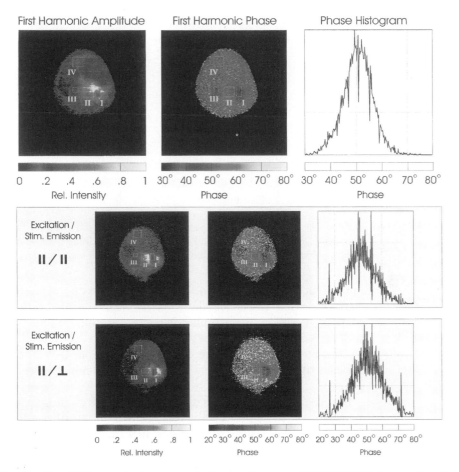

First Harmonic Amplitude First Harmonic Phase Phase Histogram

Fig. 19 Top: lifetime-resolved, pump-probe images of an orange CMTMR-labeled mouse fibroblast cell. Lifetimes in four regions were determined. In regions I to IV, the measured lifetimes were 1.93, 2.75, 1.75, and 2.85 ns, respectively. Bottom: lifetime-resolved, pump-probe polarization images of the same sphere in the ∥/∥ and ∥/⊥ configurations. The rotational correlation times obtained from regions I to IV are 27, 104, 107, and 151 ps, respectively. The displayed histogram also demonstrates the global phase shift from the ∥/∥ to ∥/⊥ orientations.

the lifetime-resolved microscope described in this chapter offer complimentary ways to solve similar problems. The lifetime camera captures all points in an image simultaneously, which is better for fast events and phosphorescence imaging. The laser scanning systems can image arbitrarily shaped regions of interest. Three-dimensional resolution is inherently part of both the two-photon and pump-probe implementations. The lifetime camera images, however, must be mathematically deconvolved to achieve three-dimensional resolution.

Each microscope presented has unique beneficial features. All three microscopes benefit from the frequency-domain heterodyning technique. The lifetime

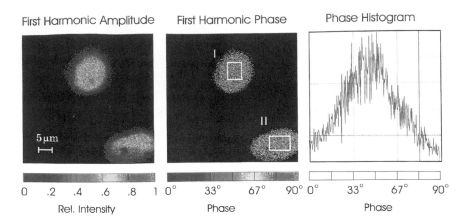

Fig. 20 Time-resolved, pump-probe image of mouse fibroblast cells labeled with TOTO-3. The average phase from regions I and II is $43°$, corresponding to a fluorescence lifetime of 1.73 ns.

camera achieves high-speed imaging, high temporal resolution, and greater photobleaching resistance than existing camera alternatives. Compared with confocal detection, the two-photon microscope has better separation of excitation and emission light, better spatial confinement of photodamage, and similar resolution. The pump-probe microscope provides equal spatial resolution and effective off-focal background rejection while eliminating the need for high-speed detectors.

Fluorescence-lifetime imaging is a powerful technique that has far-ranging applications. Some projects that may be explored further are microscopic thermal imaging, multiple structure labeling of cells, and imaging and fluorescence in highly scattering media. Any process that needs nanosecond temporal resolution across an extended object is a good candidate. Fluorescence-lifetime imaging microscopy has the potential to dramatically enhance the field of fluorescence microscopy.

Acknowledgments

We thank Dr. Matt Wheeler, Dr. Laurie Rund, Ms. Linda Grum, and Ms. Melissa Izard in the Department of Animal Sciences, University of Illinois, for providing us with mouse fibroblast cells. We also thank Dr. Edward Voss, Dr. Jenny Carrero, Ms. Anu Cherukuri, and Mr. Donald Weaver in the Department of Microbiology, University of Illinois, for providing us with mouse macrophage cells. This work was supported by the National Institutes of Health grant RR03155.

References

Ambrose, W. P., Goodwin, P. M., Martin, J. C., and Keller, R. A. (1994). Alterations of single molecule fluorescence lifetimes in near-field optical microscopy. *Science* **265**, 364–367.
Aubry, L., Klein, G., Martiel, J.-L., and Satre, M. (1993). Kinetics of endosomal pH evolution in *Dictyostelium discoideum* amoebae. *J. Cell Sci.* **105**, 861–866.

Birge, R. R. (1985). Two-photon spectroscopy of protein-bound chromophores. *Acc. Chem. Res.* **19**, 138–146.

Birge, R. R. (1983). One-photon and two-photon excitation spectroscopy. *In* "Ultrasensitive Laser Spectroscopy" pp. 109–174. Academic Press, New York.

Buehler, C., Dong, C. Y., Dong, So, P. T. C., French, T., and Gratton, E. (2000). Time-resolved polarization imaging by pump-probe (stimulated emission) fluorescence microscopy. *Biophys. J.* **79**, 536–549.

Buurman, E. P., Sanders, R., Draaijer, A., Gerritsen, H. C., van Veen, J. J. F., Houpt, P. M., and Levine, Y. K. (1992). Fluorescence lifetime imaging using a confocal laser scanning microscope. *Scanning* **14**, 155–159.

Denk, W., Strickler, J. H., and Webb, W. W. (1990). Two-photon laser scanning fluorescence microscopy. *Science* **248**, 73–76.

Dix, J. A., and Verkman, A. S. (1990). Pyrene eximer mapping in cultured fibroblasts by ratio imaging and time-resolved microscopy. *Biochemstry* **29**, 1949–1953.

Dong, C. Y., Buehler, C., So, P. T. C., French, T., and Gratton, E. (2001). Implementation of intensity modulated laser diodes in time-resolved, pump-probe fluorescence microscopy. *Applied Optics* **40**, 1109–1115.

Dong, C. Y., So, P. T. C., Buehler, C., and Gratton, E. (1997). Spatial resolution in pump-probe microscopy. *Optik* **106**, 7–14.

Dong, C. Y., So, P. T. C., French, T., and Gratton, E. (1995). Fluorescence lifetime imaging by asynchronous pump-probe microscopy. *Biophys. J.* **69**, 2234–2242.

Elzinga, P. A., Kneisler, R. J., Lytle, F. E., King, G. B., and Laurendeau, N. M. (1987). Pump/probe method for fast analysis of visible spectral signatures utilizing asynchronous optical sampling. *Appl. Opt.* **26**, 4303–4309.

Feddersen, B. A., Piston, D. W., and Gratton, E. (1989). Digital parallel acquisition in frequency domain fluorimetry. *Rev. Sci. Instrum.* **60**, 2929–2936.

Fleming, G. R. (1986). "Chemical Applications of Ultrafast Spectroscopy" Oxford University Press, New York.

French, T., So, P. T. C., Weaver, Jr., D. J., Coelho-Sampaio, T., Gratton, E., Voss, Jr, E. W., and Carrero, J. (1997). Two-photon fluorescence lifetime imaging microscopy of macrophage mediated antigen processing. *J. Microsc.*

Friedrich, D. M. (1982). Two-photon molecular spectroscopy. *J. Chem. Education* **59**, 472–481.

Gadella, Jr, T. W. J., and Jovin, T. M. (1995). Oligomerization of epidermal growth factor receptors on A431 cells studied by time-resolved fluorescence imaging microscopy. A stereochemical model for tyrosine kinase receptor activation. *J. Cell Biol.* **129**, 1543–1548.

Gadella, Jr., T. W. J., Jovin, T. M., and Clegg, R. M. (1993). Fluorescence lifetime imaging microscopy (FLIM): spatial resolution of microstructures on the nanosecond time scale. *Biophys. Chem.* **48**, 221–239.

Keating, S. M., and Wensel, T. G. (1990). Nanosecond fluorescence microscopy: emission kinetics of Fura-2 in single cells. *Biophys. J.* **59**, 186–202.

König, K., So, P. T. C., Mantulin, W. W., Tromberg, B. J., and Gratton, E. (1996). Two-photon excited lifetime imaging of autofluorescence in cells during UVA and NIR photostress. *J. Microsc.* **183**, 197–204.

Kusba, J., Bogdanov, V., Gryczynski, I., and Lakowicz, J. R. (1994). Theory of light quenching: effects on fluorescence polarization, intensity, and anisotropy decays. *Biophys. J.* **67**, 2024–2040.

Lakowicz, J. R., Szmacinski, H., Lederer, W. J., Kirby, M. S., Johnson, M. L., and Nowaczyk, K. (1994a). Fluorescence lifetime imaging of intracellular calcium in COS cells using QUIN-2. *Cell Calcium* **15**, 7–27.

Lakowicz, J. R., Gryczynski, I., Bogdanov, V., and Kusba, J. (1994b). Light quenching and fluorescence depolarization of rhodamine B. *J. Phys. Chem.* **98**, 334–342.

Lakowicz, J. R., and Berndt, K. W. (1991). Lifetime-selective fluorescence imaging using an RF phase-sensitive camera. *Rev. Sci. Instrum.* **62**, 1727–1734.

Marriott, G., Clegg, R. M., Arndt-Jovin, D. J., and Jovin, T. M. (1991). Time resolved imaging microscopy. *Biophys. J.* **60**, 1374–1387.

McLoskey, D., Birch, D. J. S., Sanderson, A., Suhling, K., Welch, E., and Hicks, P. J. (1996). Multiplexed single-photon counting. 1. A time correlated fluorescence lifetime camera. *Rev. Sci. Instrum.* **67**, 2228–2237.

Morgan, C. G., Murray, J. G., and Mitchell, A. C. (1995). Photon correlation system for fluorescence lifetime measurements. *Rev. Sci. Instrum.* **66**, 3744–3749.

Morgan, C. G., Mitchell, A. C., and Murray, J. G. (1992). Prospects for confocal imaging based on nanosecond fluorescence decay time. *J. Microsc.* **165**, 49–60.

Müller, M., Ghauharali, R., Visscher, K., and Brakenhoff, G. (1995). Double pulse fluorescence lifetime imaging in confocal microscopy. *J. Microsc.* **177**, 171–179.

Murphy, R. F., Powers, S., and Cantor, C. R. (1984). Endosome pH measured in single cells by dual fluorescence flow cytometry: rapid acidification of insulin to pH 6. *J. Cell Biol.* **98**, 1757–1762.

Oida, T., Sako, Y., and Kusumi, A. (1993). Fluorescence lifetime imaging microscopy (flimscopy). *Biophys. J.* **64**, 676–685.

Ohkuma, S., and Poole, B. (1978). Fluorescence probe measurement of the intralysosomal pH in living cells and the perturbation of pH in various agents. *Proc. Natl. Acad. Sci. USA* **75**, 3327–3331.

Piston, D. W., Kirby, M. S., Cheng, H., Lederer, W. J., and Webb, W. W. (1994). Two photon excitation fluorescence imaging of three-dimensional calcium ion activity. *Appl. Optics* **33**, 662–669.

Piston, D. W., Sandison, D. R., and Webb, W. W. (1992). Time-resolved fluorescence imaging and background rejection by two-photon excitation in laser scanning microscopy. *Proc. SPIE* **1640**, 379–389.

Piston, D. W., Marriott, G., Radivoyevich, T., Clegg, R. M., Jovin, T. M., and Gratton, E. (1989). Wide-band acousto-optic light modulator for frequency domain fluorometry and phosphorimetry. *Rev. Sci. Instrum.* **60**, 2506–2600.

Sanders, R., Draaijer, A., Gerritsen, H. C., Houpt, P. M., and Levine, Y. K. (1995a). Quantitative pH imaging in cells using confocal fluorescence lifetime imaging microscopy. *Analytical Biochem.* **227**, 302–308.

Sanders, R., Draaijer, A., Gerritsen, H. C., and Levine, Y. K. (1995b). Selective imaging of multiple probes using fluorescence lifetime contrast. *Zoological Studies* **34**, 173–174.

Sheppard, C. J. R., and Gu, M. (1990). Image formation in two-photon fluorescence microscopy. *Optik* **86**, 104–106.

So, P. T. C., French, T., Yu, W. M., Berland, K. M., Dong, C. Y., and Gratton, E. (1995). Time-resolved fluorescence microscopy using two-photon excitation. *Bioimaging* **3**, 49–63.

So, P. T. C., French, T., and Gratton, E. (1994). A frequency domain time-resolved microscope using a fast-scan CCD camera. *Proc. SPIE* **2137**, 83–92.

Straubinger, R. M., Papahadjopoulos, D., and Hong, K. (1990). Endocytosis and intracellular fate of liposomes using pyranine as a probe. *Biochem* **29**, 4929–4939.

Tycko, B., and Maxfield, F. R. (1982). Rapid acidification of endocytic vesicles containing α_2-macroglobulin. *Cell* **28**, 643–651.

Wang, X. F., Uchida, T., Coleman, D. M., and Minami, S. (1991). A two-dimensional fluorescence lifetime imaging system using a gated image intensifier. *Appl. Spect.* **45**, 360–366.

Wang, X. F., Uchida, T., and Minami, S. (1989). A fluorescence lifetime distribution measurement system based on phase-resolved detection using an image dissector tube. *Appl. Spect.* **43**, 840–845.

Wilson, T., and Sheppard, C. (1984). "Theory and Practice of Scanning Optical Microscopy" Academic Press, New York.

Xie, X. S., and Dunn, R. C. (1994). Probing single molecule dynamics. *Science* **265**, 361–364.

CHAPTER 22

Fluorescence Correlation Spectroscopy: Molecular Complexing in Solution and in Living Cells

Dylan A. Bulseco and David E. Wolf

Sensor Technologies LLC
Shrewsbury, Massachusetts 01545

I. Introduction

In this chapter we will discuss how the microscope can be used to measure a fluorescence signal from a small, confined volume of the sample, the confocal volume, and how these measurements are used to quantitate the dynamics and complexing of molecules, the technique of Fluorescence Correlation Spectroscopy (FCS). Beyond being an important technique in the arsenal of modern biophysics, biochemistry, and cell biology, FCS represents a significant example of how the microscope can be used to extract information beyond the resolution limit of classical optics. FCS enables us to study events at the level of single molecules. With FCS, one can measure the diffusion times and the interaction of macromolecules, the absolute concentration of fluorescently labeled particles, and the kinetics of chemical reactions. Practical applications of FCS include studies on ligand–receptor binding, protein–protein and protein–DNA interactions, and the aggregation of fluorescently labeled particles. For comprehensive reviews on the theory and applications of FCS, see Rigler (1995), Schwille (2001), and Hess *et al.* (2002).

This chapter is divided into two sections. In the first, we discuss the principles of FCS, demonstrate how FCS is used to study macromolecular interactions in solution and in living cells, and examine critical experimental parameters that must be considered. In the second section, we discuss the minimum requirements for building a microscope-based FCS instrument and illustrate key criteria for both instrument sensitivity and analysis of FCS data.

II. Studying Biological Systems with FCS

A. First Principles

Suppose that you have a solution of some solute in a beaker. Suppose that we have precisely V liters of this solution and that it is at a molar concentration, C. How many molecules (N) of solute are in the beaker? The answer is, of course, $N = CVA$, where A is Avogadro's Number. A key point to realize is that this is a closed system. If you take care not to let the system evaporate, that is, if you keep it closed, you will always find N molecules in the beaker. However, suppose you had a way of looking at a subvolume within the beaker, call this v where $v < V$ (Fig. 1). How many molecules will you find in this subvolume? Your first answer is likely to be $n = CvA$. However, you need to be careful. Suppose, for instance, that v is a small subvolume ($v \ll V$) whose diameter is less than the average distance between solute molecules? In this case, there is a reasonably high probability that the volume will contain zero molecules, a similar probability that it will contain one molecule, and progressively lower probabilities that there are two, three, and so on molecules in the volume (Fig. 1). It is only on average that you get the number n. The longer the time over which the sample is averaged, the

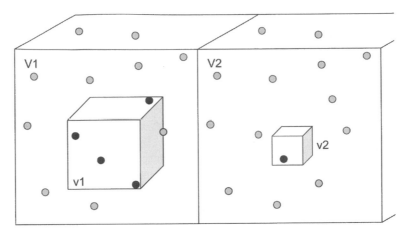

Fig. 1 Illustration of volume (V1 and V2) and subvolume (v1 and v2) when detection volume is larger (v1) and smaller (v2) than the average distance between diffusing particles.

more likely the average will be **n**. If we call the probabilities respectively P_i, then

$$n = 0P_0 + 1P_1 + 2P_2 + 3P_3 + \cdots NP_N, \qquad (1)$$

where **N** is again the total number of molecules in the beaker and where

$$1 = P_0 + P_1 + P_2 + P_3 + \cdots P_N. \qquad (2)$$

Now suppose that you did this measurement **M** times. You would have **M** values of n_k. You could then calculate the standard deviation of your measurements about the mean value n in the usual way:

$$SD = \sum_{K=1}^{M} \frac{(n_K - n)^2}{(M-1)}. \qquad (3)$$

It is actually rather straightforward to calculate the SD provided you know the probabilities P_i. The reader is referred to Howard Berg's wonderful book, "Random Walks in Biology" (Berg, 1993) for this derivation. It turns out that

$$SD = \sqrt{n}. \qquad (4)$$

Therefore, just as in radioactive decay, another random process, we get

$$n \pm \sqrt{n}. \qquad (5)$$

It is important to note that these equations are fully generalizable and therefore apply to any volume **v**. We see that the percentage variation of the measurement SD over mean is given by $(1/\sqrt{n})^*100$. For an average value of **n** = 100, the percentage variation therefore is 10%, and for **n** = 10,000, it is 1%.

It is also important to recognize that in a solution in which molecules are free to diffuse, you can actually focus on a single subvolume and let the random diffusion of molecules into and out of this volume replace scanning from subvolume to subvolume. In this case, the stochastic fluctuation occurs over time but the same equations apply. The timescale of the fluctuations is defined by the characteristic diffusion time. If the volume is a sphere with radius ω, then this time is given as $\omega^2/2D$, $\omega^2/4D$, $\omega^2/6D$ for one-, two-, and three-dimensional diffusion, respectively. If we anticipate our later discussion and assume that we are studying a cylindrical rather than a spherical volume, then we have two time constants for diffusion $\omega_1^2/4D$ and $h^2/2D$, where ω is the radius of the cylinder and h is the length. Again we refer the reader to Howard Berg's book for a discussion of the random walk of molecules in solution (Berg, 1993). The reader is further referred to Charles L. Dodgson's description of the dance of the molecules, referred to as the Dodo's Caucus-Race, in his *Alice's Adventures in Wonderland* (Carroll, 2000).

(And as you might like to try the thing yourself, some winter day. I will tell you how the Dodo managed it.)

First it marked out a racecourse, in a sort of circle ('the exact shape doesn't matter' it said), and there all the party were placed along the course, here and there. There was no 'One, two, three and away' but they began running when they liked, and left off when they liked, so it was not easy to know when the race was over. However, when they had been running half an hour or so, and were quite dry again, the Dodo suddenly called out, 'The race is over!' and they all crowded round it, panting, and asking, 'But who has won?'

B. Defining a Small Sample Volume—The Confocal Principle

FCS takes advantage of confocal optics and improved electronics to increase signal and to reduce noise. Figure 2 illustrates the formation of a confocal volume with a focused light source, such as a monochromatic laser. In Chapter 1, the concept of conjugate focal planes in the microscope is described. In a confocal microscope, apertures at the conjugate image planes are used to confine the interrogated region of the sample to a small diffraction-limited volume. Optics are designed to reduce out-of-focus light and to limit image detection to the desired focal plane of in-focus light (the sample plane), which increases contrast and effective resolution. This is achieved by first minimizing the detection volume by illumination with a laser beam focused to the limit of resolution with a high–numerical aperture (NA) objective. Second, out-of-focus light is eliminated by introducing a field pinhole or aperture in the conjugate image plane and before the detector. This serves to limit detection to the plane in which the object is focused, which is depicted in Fig. 2 by the box at beam waist of the illumination volume. Signal from planes either above or below the object plane are focused either above or below the conjugate image plane and are therefore collected inefficiently. That is, fluorescence signals from these out-of-focus planes are excluded by the field aperture and are therefore not recorded by the detector. It is therefore clear that only those fluorescently labeled particles that diffuse into

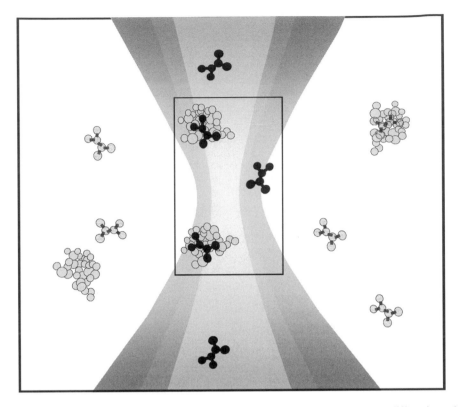

Fig. 2 Confocal illumination and detection volumes. Only those particles that diffuse into the confocal volume will be detected by the photon counter.

the laser-excitation volume emit fluorescence and that only those precisely at the object plane will be "visible" to the photon detector. In this way, FCS takes advantage of the confocal principle to improve the signal-to-noise ratio, which enables one to realize single-molecule detection limits.

C. What Exactly is FCS?

When optimal confocal optics and electronics are used, FCS is a single-molecule detection method that can be carried out in small (femtoliter) volumes. As described above, a tightly focused laser beam defines this confocal volume, and the diffusion of fluorescently labeled particles into and out of this illuminated volume determines the pattern of fluorescence intensity fluctuation. From these data, one can extract both qualitative (presence or absence of interaction) and quantitative (diffusion times, stoichiometry of interactions, concentration of interacting particles, and kinetics of this interaction) information about the macromolecules being studied.

The concept of FCS evolved from work on dynamic light scattering [for a comprehensive review of dynamic light scattering, see Berne and Pecora (2000)]. FCS was first proposed in the early 1970s (Elson and Magde, 1974; Magde et al., 1974) but was not a practical technique for biological samples because of high noise and low sensitivity. Despite these technical limitations, pioneering work of this period used FCS to study diffusion in lipid bilayers (Fahey et al., 1977), lateral transport on cell membranes (Elson et al., 1976), chemical kinetics (Magde 1976; Magde 1977), and the molecular weight of DNA (Weissman et al., 1976). In the 1980s FCS was coupled with the technique of total internal reflection and became a powerful tool for studying surface-solution interactions (Axelrod et al., 1983) and antibody–hapten interaction at surfaces (Thompson and Axelrod, 1983). Advances in autocorrelation electronics, detectors, and confocal microscopy have improved detection limits, shortened measurement times, and increased our ability to resolve multiple correlation times (Rigler, 1995; Widengren and Rigler, 1998). This has led to a renaissance in the application of FCS to biological systems (Rigler, 1995; Schwille, 2001; Hess et al., 2002).

FCS can be implemented in two ways—autocorrelation and cross correlation. Autocorrelation measures the persistence of a single fluorescent particle in the confocal volume. It temporally correlates fluorescence intensity fluctuations (Fig. 3A) as labeled particles diffuse into and out of the detection volume. Statistical analysis of fluorescence-intensity fluctuations results in an autocorrelation curve (Fig. 3B) which shows the decay of temporal correlation in fluorescence intensity over time. The autocorrelation function is given by

$$G(\tau) = 1 + \frac{< \delta I(t) * \delta I(t + \tau) >}{< I >^2},$$

(1)

where the δI's refer to the deviations of the intensity about the mean. Cross correlation extends standard autocorrelation FCS by introducing two different fluorescent labels with distinct excitation and emission properties that can be detected in the same confocal volume. It temporally correlates the intensity fluctuations of two distinguishable labels. Coincidence of these fluorescent labels on the same macromolecule is detected as a change in amplitude, R, at short time points, τ, and the amplitude of the crosscorrelation function is directly proportional to the concentration of dual-labeled fluorescent particles. The crosscorrelation function is given by

$$r(\tau) = \frac{< \delta I_i(t) * \delta I_j(t + \tau) >}{SD_i * SD_j}.$$

(2)

The correlation function of Eq. (2) is the form commonly used in statistics, which goes to 1 for perfect cross correlation and to 0 for no cross correlation. Instrumentally, it is simpler to define the cross-correlation function in a manner

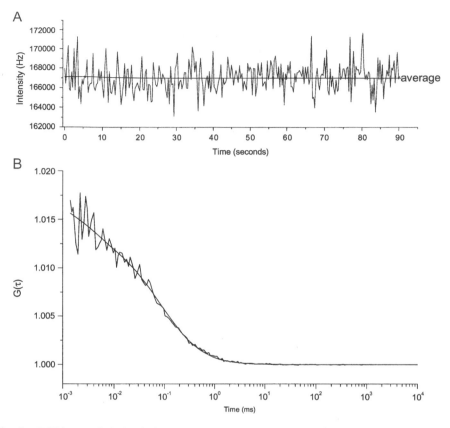

Fig. 3 FCS is a statistical technique that temporally correlates fluorescence intensity fluctuations. (A) Fluorescence intensity fluctuates over time around an average intensity. (B) Autocorrelation curve shows the decay of temporal correlation over time.

analogous to Eq. (1) for the autocorrelation function.

$$R(\tau) = 1 + \frac{< \delta I_i(t) * \delta I_j(t + \tau) >}{I_i * I_j}. \tag{3}$$

This form is simpler to calculate in real time from an ongoing data stream and has the further advantage that when $I_i = I_j$, then $R(\tau) = G(\tau)$.

The relaxation time for correlation relates to stochastic processes of randomization such as diffusion, whereas the size of these fluctuations relates to the number of molecules or particles involved in the stochastic process. Autocorrelation functions are used to analyze these fluctuations and yield information on diffusion coefficients, aggregation state chemical concentration, chemical reaction kinetics, and stoichiometry of macromolecules (Elson and

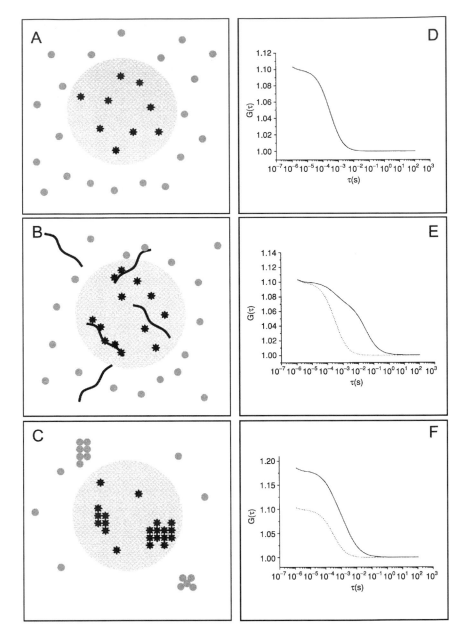

Fig. 4 Illustration of FCS detection. Only those labeled particles that diffuse into and out of the laser-illuminated volume (stars) and are precisely in the object plane defined by the confocal optics will be detected by the photon counter. (A) Single-labeled particles, rhodamine-labeled Fab fragments, for example, emitting fluorescence when in the illumination volume. (B) Binding of labeled particles to a large binding protein such as whole IgG. (C) Aggregation of labeled particles to form large complexes.

Magde 1974; Magde *et al.*, 1974), in solution as well as in the plasma membrane of living cells (Elson *et al.*, 1976; Brock and Jovin, 1998; Widengren and Rigler, 1998). FCS, in either autocorrelation or cross-correlation mode, is an ideal method to study the interactions of macromolecules.

Figure 4A illustrates the diffusion of a labeled particle, such as a rhodamine-conjugated Fab fragment, through a confocal volume. Only those particles in the illumination volume fluoresce, and detection is further limited to particles precisely within the defined confocal object plane. It is important to note here that FCS is sensitive to both the number and size of the particles that diffuse through the confocal volume. When fluorescently labeled particles bind to large macromolecular targets such as whole IgG (Fig. 4B) or self-aggregate to form complexes (Fig. 4C), the autocorrelation curves reflect the appearance of these large, slow-diffusing complexes.

Nonlinear regression is used to fit data to the three-dimensional autocorrelation function (Eq. [4]) for samples in solution. Parameter estimates are calculated for particle number (N), triplet state fraction (T), triplet state correlation time (τ_T), particle fraction (F_i), and diffusion time (τ_{D_i}) for diffusing particle species i. The structure parameter, K^2 where $K = \omega_2/\omega_1$ [ω_2 and ω_1 being the $\exp(-2)$ beam radii in the z and x directions, respectively], is determined separately and held constant for each fit.

$$G(\tau) = 1 + \left(\frac{1}{N}\right)(1 - T + T\exp\left(-\tau/\tau_T\right))\left(\sum_i \frac{F_i}{(1 + \tau/\tau_{D_i})(1 + \tau/K^2\tau_{D_i})^{1/2}}\right).$$

$$(4)$$

D. What Can We Study with FCS?

FCS can be used to study any fluorescently labeled molecule with single-molecule detection limits either in solution or in living cells. In other words, FCS can be used to monitor the interaction of labeled molecules with unlabeled or labeled targets, using autocorrelation or cross-correlation, respectively. FCS experiments conducted in solution are simpler, which results in unambigous experiments and simplified instrument design. Sample volumes may be as small as 1 μL (although confocal detection volumes are actually a few femtoliters), limited only by potential evaporation during the measurement. If the sample volume is large enough, precise positioning of the confocal detection volume is not critical, although laser power, buffer autofluorescence, and experimental or data analysis artifacts must still be addressed. Finally, when working with low concentrations in small volumes, one must mitigate adsorption of macromolecules to the coverglass by inclusion

(D) Sample autocorrelation curve for the particles detected in (A). (E) Sample autocorrelation curve for particles detected in (B) (solid). Autocorrelation curve from (D) included for comparison (dotted). (F) Sample autocorrelation curve for the particles detected in (C) (solid). Autocorrelation curve from (D) included for comparison (dotted).

of NP-40 or Pluronic acid. Using FCS to study living cells requires special consideration. Cells are highly compartmentalized, with intracellular structures interspersed within an aqueous, cytosolic volume that is on the order of a few picoliters. Diffusion of soluble proteins may be affected by modulating binding proteins, increased cytosolic viscosity, and interfering structural proteins. In addition to precise positioning within the cell, researchers must be careful to use low laser power, consider the effects of background autofluorescence and photobleaching, and critically evaluate the results obtained.

Two features of FCS make it a useful tool for studying macromolecular interactions: FCS can resolve multiple diffusing components, and FCS is sensitive to changes in aggregation state of the fluorophore. Figure 5A shows how an autocorrelation curve can be used to discriminate fast- and slow-diffusing particles. Nonlinear curve fitting results in parameter estimates for two diffusing fractions with distinctly different diffusion times. Binding of small, fast-diffusing particles, to a large macromolecule (as illustrated in Fig. 4B), results in formation of a new, slower-diffusing component that can be used to monitor binding events. This is depicted in Fig. 4E, which shows the curve from Fig. 4D superimposed (dotted line) on results obtained for samples shown in Fig. 4B (solid line). This is further illustrated by the rightward shift in the autocorrelation curve as diffusion time is increased (Fig. 5B). The intercept of the correlation function at time $\tau = 0$ is the reciprocal of the average number of fluorescent particles in the sample and can be used as a measure of receptor complexing or aggregation (as illustrated in Fig. 4C). If the number of fluorescent particles in the detection volume is decreased, or if these fluorescent particles aggregate to form fewer, large complexes, the intercept at time $\tau = 0$ is increased. This is depicted in Fig. 4F, which shows the curve from Fig. 4D superimposed (dotted line) on results obtained for samples shown in Fig. 4C (solid line). This is further illustrated by the increased intercept of the correlation curve as time τ approaches 0, as the number of particles in the confocal detection volume is decreased (Fig. 5C). These two principles can therefore be used to monitor macromolecular interactions in small volumes and form the basis of many screening applications for protein–protein, protein–DNA, and DNA–DNA interactions.

A brief list of selected published applications of FCS follows. These include studies on translational diffusion and transport (Fahey et al., 1977), chemical kinetics (Magde, 1976), molecular aggregation (Palmer and Thompson, 1987; Meyer and Schindler, 1988; Palmer and Thompson, 1989; Berland, 1997; Brown and Royer, 1997), ligand binding (Matayoshi and Swift, 2001; Pramanik et al., 2001; Pramanik and Rigler, 2001; Rudiger et al., 2001; Zhong et al., 2001), enzymatic activity (Clair, 1997; Moore et al., 1999; Meyer-Almes and Auer, 2000), nucleic acid interactions in vivo and in vitro (Kinjo and Rigler, 1995; Schwille et al., 1996; Politz et al., 1998), monitoring PCR reactions (Walter et al., 1996), screening phage display results (Lagerkvist et al., 2001), active transport velocity in plants (Kohler et al., 2000), and single-molecule detection (Foldes-Papp et al., 2001; Foldes-Papp et al., 2002). FCS, therefore, enables one to study single macromolecules as well as large, labeled particles such

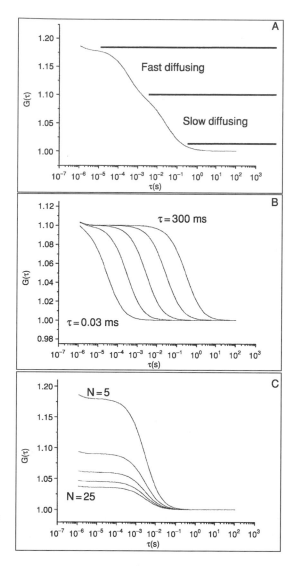

Fig. 5 Features of FCS that are used to detect the interaction of macromolecules. (A) FCS can be used to detect multiple diffusing components. This curve illustrates detection of fast- and slow-diffusing particles. (B) The FCS autocorrelation curve shifts to the right as diffusion time (and hence particle size) increases. (C) The intercept as τ approaches 0 is increased as the number of particles in the confocal detection volume is decreased.

as proteins binding to beads or bacteria expressing human receptors (Van Craenenbroeck *et al.*, 2001).

E. Molecular Complexing in Solution

FCS is ideally suited for the study of protein–protein interactions in solution. In addition to single-molecule detection limits, it can be run in homogenous assay format, which eliminates the need to separate bound from free label and it requires small sample volumes (μL), which reduce reagent requirements. To illustrate this, we have quantified molecular complexing and stoichiometry of interacting macromolecules using the binding of Rh-Fab to rabbit IgG. Figure 6A shows representative curves Rh-Fab in solution either alone (solid line) or in the presence of $4\,\mu$M IgG (dotted line). This figure clearly illustrates how the key principles previously discussed can be used to monitor binding: the binding of Rh-Fab to IgG results in a predominately slower diffusing fraction, as indicated by the rightward shift in the autocorrelation curve; and as Rh-Fab/IgG aggregates are formed, the particle number (N) is decreased as is indicated by the increased intercept as τ approaches 0.

The formation of a large Rh-Fab/IgG complex results in the appearance of a slow-diffusing component. Figure 6B shows that the slow-diffusing fraction is increased at higher IgG concentrations and saturates when IgG is greater than $1\,\mu$M. To quantify this interaction, we must first revisit the 3D autocorrelation function [Eq. (4)] presented above.

FCS is based on statistical analysis of fluorescence intensity fluctuations. It is important to recognize that there are two major sources of stochastic fluctuations in the fluorescence signal in FCS experiments. The first occurs on the microsecond time scale and results from intersystem crossing of the fluorophores between the singlet and triplet states. The second occurs on the millisecond time scale and results from diffusion of the macromolecules into and out of the confocal volume. This observation has two ramifications: First, the fluctuations observed between singlet and triplet states are governed by the number of fluorophores in the confocal volume, whereas diffusional fluctuations are governed by the number of particles, and second, fluctuations resulting from intersystem crossing and particle diffusion are completely independent. For these reasons, we restate the three-dimensional autocorrelation function as

$$G(\tau) = 1 + \frac{T}{N_M}\exp\left(-\tau/\tau_T\right) + \frac{1-T}{N_P}\left(\sum_i \frac{F_i}{(1+\tau/\tau_{D_i})(1+\tau/K^2\tau_{D_i})^{1/2}}\right), \quad (5)$$

where N_M and N_P are the average number of fluorophore molecules and average number of particles in the sample volume respectively. It should be noted that in the case where $N_M = N_P = N$, Eq. (5) reduces to Eq. (4), which has been derived elsewhere (Elson and Qian, 1989).

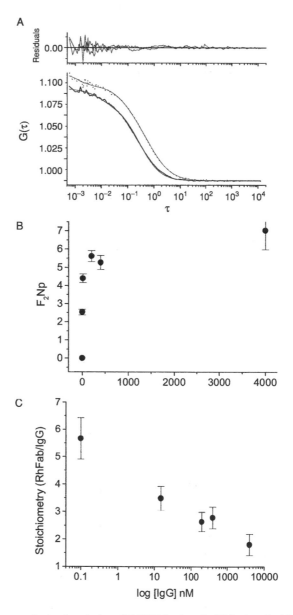

Fig. 6 Molecular complexing in solution. (A) RhFab alone (solid line) and with $4\,\mu$M IgG (dotted line). Residuals (top panel) were obtained after fitting the data to Eq. (6). (B) Fraction of slow-diffusing particles saturates as IgG concentration is increased. (C) Stoichiometry of RhFab binding to IgG in solution.

To further simplify this relationship, we assume that T is constant in our measurements. Our findings indicate that this is a valid assumption as long as laser power is held constant and samples are subjected to low laser illumination (25–40 μW). This results in Eq. (6)

$$G(\tau) = 1 + \frac{1}{N'_M} \exp\left(-\tau/\tau_T\right) + \frac{1}{N_P}\left(\sum_i \frac{F_i}{(1+\tau/\tau_{D_i})(1+\tau/K^2\tau_{D_i})^{1/2}}\right), \qquad (6)$$

which is identical to Eq. (5) when $N_M = N'_M T$ and $N_P = N'_P(1-T)$.

Fitted parameters for particle number (N'_P) and diffusion time (τ_{D_i}) were obtained for Rh-Fab/IgG data presented in Fig. 6A by fitting to Eq. (6). Data for Rh-Fab alone were best fit to a single fast-diffusing component ($i = 1$), whereas Rh-Fab + IgG was best fit to two diffusing components ($i = 2$; fast and slow). Analysis of Rh-Fab alone resulted in $N'_P = 11.3$, and $\tau_{D1} = 189\,\mu$s, whereas in the presence of $4\,\mu$M IgG, $N'_P = 9.0$ with diffusion times of $\tau_{D_1} = 130\,\mu$s and $\tau_{D_2} = 884\,\mu$s.

Molecular stoichiometry was determined by titrating Rh-Fab (10 nM) with increasing concentrations of IgG. The autocorrelation curves were analyzed with Eq. (6), and parameters used to calculate stoichiometry as described below. First, a calibration factor, r, which is the number of fluorophores per Fab, is calculated using parameters obtained for Rh-Fab measurements alone and Eq. (7):

$$r = \frac{N'_M}{N'_P}. \qquad (7)$$

We can then define stoichiometry (S) conceptually as

$$S = \frac{\text{Number of Fabs in slow complex}}{\text{Number of complexes}},$$

where S is given by

$$S = \frac{\text{Total Fabs} - \text{fast-diffusing Fabs}}{\text{Number of complexes}}.$$

Using the parameters defined in Eq. (6) and (7), a general relationship for stoichiometry can be written as

$$S = \frac{N'_M/r - F_1 N'_P}{F_2 N'_P}, \qquad (8)$$

where N'_M is the number of fluorophore molecules, N'_P is the number of diffusing particles distributed between slow (F_1) and fast (F_2) diffusing classes, and $F_2 N'_P$ defines the total number of slow-diffusing complexes formed.

Figure 6C shows the stoichiometry (S) of RhFab bound per IgG as IgG concentration is increased. This indicates that there are about six Fab binding

sites per IgG, when multiple Fabs are bound at the lowest IgG concentration. As more IgG is added, the number of bound Rh-Fab per IgG is decreased, as binding is distributed over all available binding sites. These findings show that FCS can be used to measure molecular stoichiometry in solution by analysis of multiple autocorrelation curves. We next implemented this analysis in living cells expressing gp75, the low-affinity nerve growth-factor receptor.

F. FCS Measurements in Living Cells

The first successful FCS measurements made on cell membranes were reported in the mid-1970s (Elson *et al.*, 1976). This pioneering work demonstrated the feasibility of using FCS to study dynamic cellular events, in this case, lateral diffusion in the plasma membrane, in living cells. With the genomes of many organisms now well characterized, an increasing emphasis is being placed on understanding protein function. Furthermore, it is critical to understand how this function is modulated by interactions with other proteins in the context of a cell. For these reasons, FCS is an important technique to consider when investigating dynamic interactions in living cells.

As a result, the application of FCS to the study of intracellular proteins *in vivo* has grown in recent years, and the critical factors that govern successful measurements have been more clearly defined. The fundamental issues to consider are the precise location of the confocal volume in a cell, the effect of autofluorescence on FCS measurements, and the effect of laser power on apparent diffusion times (Brock, Hink *et al.*, 1998; Brock and Jovin, 1998; Widengren and Rigler, 1998). Positioning of the confocal detection volume will affect the nature and quality of *in vivo* FCS data. Cell compartmentalization, cytoskeletal elements, internal membranes, and organelles result in microdomains that will be sampled differently as the position of the confocal detection volume is changed (Brock and Jovin, 1998). Figure 7 illustrates how the relative fractions of fast and slow-diffusing particles will change as the position of the detection volume is moved relative to the plasma membrane. For detection volume A (Fig. 7), only slow-diffusing membrane receptors will be detected. If the detection volume is slightly displaced, it is clear how one might detect both fast- and slow-diffusing particles (Fig. 7B) or only fast-diffusing particles (Fig. 7C). A related and perhaps more difficult problem to solve is the process of membrane ruffling over time in response to perturbation of the signaling systems being studied (Ridley, 1994).

Measurement artifacts present potential problems when using FCS to study living cells. Both photobleaching and autofluorescence results in reduced signal quality but can be overcome with diligent selection of experimental conditions. First, specific fluorescent signal should be at least tenfold higher than background autofluorescence. Second, fluorophores such as Alexa (Molecular Probes) can be used that show reduced photobleaching. Finally, when studying living cells, low laser power is essential to avoid cell damage and to minimize photobleaching and fluorophore depletion in cellular compartments.

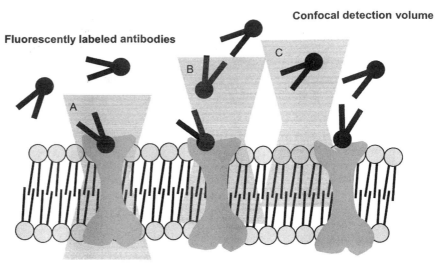

Fig. 7 Precise positioning of the confocal volume affects reproducible FCS measurements of receptors in the plasma membrane.

The choice of fluorophore is critical when using FCS to study protein interactions in living cells. As mentioned previously, Alexa dyes (Molecular Probes) are especially useful because of reduced photobleaching. GFP and spectral-shifted GFP mutants are effective tags for any *in vivo* study using fluorescence microscopy, as these are expressed as fusion proteins, which creates targeted cellular markers. When used with FCS, though, additional care must be taken when evaluating results because of potential artifacts related to GFP "blinking" (Haupts *et al.*, 1998; Dittrich *et al.*, 2001; Malvezzi-Campeggi *et al.*, 2001) or proteolytic cleavage of GFP from the fusion protein. Although beyond the scope of this chapter, it is important to point out that the application of two-photon excitation for cross-correlation FCS provides an excellent approach to studying live cells [for review, see Schwille *et al.* (1999) and Schwille (2001)].

G. Molecular Complexing in Living Cells

Application of FCS to living cells requires diligent experimental approaches as well as sensible evaluation of data. First, we made FCS measurements of lipophilic dye, $DiIC_{16}$, both in solution and in the plasma membranes of living A875 human melanoma cells. $DiIC_{16}$ is ideal for FCS measurements in plasma membranes of living cells for two reasons: First, the quantum yield of $DiIC_{16}$, which forms micelles in solution, is very low compared to $DiIC_{16}$ in cell membranes, and second, $DiIC_{16}$ remains in the plasma membrane after extensive

washing of free dye from the sample chamber. FCS measurements made on DiIC$_{16}$ in the cell membrane are easily distinguished from DiC$_{16}$ in solution (Fig. 8). In general, membrane measurements are characterized by longer correlation times but may exhibit both fast- and slow-diffusing components, which in part, depend on the precise placement of the confocal detection volume. We next combined FCS measurements of a membrane receptor in living cells with stoichiometry calculations, as described above.

The same rationale presented above for the three-dimensional autocorrelation function also applies to the two-dimensional autocorrelation function. Separation of N attributed to intersystem crossing and particle diffusion for the two-dimensional autocorrelation function is presented in Eq. (9)

$$G(\tau) = 1 + \frac{1}{N'_M} \exp\left(-\tau/\tau_T\right) + \frac{1}{N'_P}\left(\sum_i \frac{F_i}{(1+\tau/\tau_{D_i})}\right). \qquad (9)$$

The low-affinity NGFR gp75, is endogenously expressed by the human melanoma cell line, A875. FCS measurements were made with an Alexa-488 conjugated Fab fragment specific for gp75 on A875 cells before (Fig. 9, dotted line) and after (Fig. 9, solid line) exposure to 180 nM nerve growth factor (NGF) for 5 minutes. The data were fit to Eq. (9), using nonlinear regression, and the resulting parameters used to calculate stoichiometry. First, the calibration factor, r, was determined using measurements ($n = 20$) of Alexa-Fab alone ($r = 1.74 \pm 0.14$). Next, we made FCS measurements on different locations on 16 unique A875 cells both before and after treatment with NGF. Average fitted values were used to calculate S using Eq. (8). The stoichiometry of Alexa-Fab bound per gp75 particle was determined to be (1.12 ± 0.12) for untreated and (0.94 ± 0.10) for NGF-treated cells. These calculated molecular stoichiometries

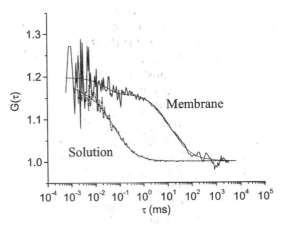

Fig. 8 FCS measurements of DiC$_{16}$ in solution and in the plasma membrane of a living cell.

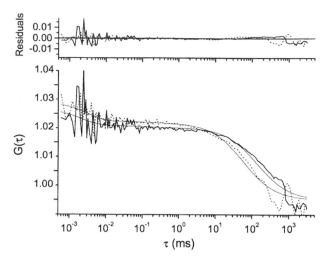

Fig. 9 FCS measurements of the low-affinity nerve growth-factor receptor, gp75, in the presence (solid) and absence of NGF. Residuals (top panel) were obtained after fitting to Eq. (9).

do not significantly differ from 1.0 for untreated (student's two-tailed t-test, $p \leq .41$) and NGF-treated (student's two-tailed t-test, $p \leq .55$) cells, indicating that gp75 is a monomer in A875 cells.

The astute reader will realize that our estimation of stoichiometry is dependent on several experimental factors. First, according to this approach, theoretical values for monomers, dimers, trimers and tetramers must be 1, 2, 3, and 4, respectively, if and only if 100% of all available binding sites are filled (e.g., 100% fractional occupancy) with the labeled probe used in the study and if all receptor complexes are composed of receptors that have one bound labeled probe per receptor. Unlabeled receptors are therefore "invisible" to FCS but may still participate in the formation of receptor oligomers. We know that gp75 has a single antigenic epitope for the Alexa-Fab used in this study. Because the number of observed Fabs/particle is dependent on the fractional occupancy of these binding sites, we must take this into consideration when calculating receptor stoichiometry. Fractional occupancy (p) is dependent both on the affinity (K_D) of the Fab for its binding site and the concentration of Fab ($[L]$) used in each experiment and can be calculated by $p = [L]/([L] + K_D)$. Our experiments were conducted with Alexa-Fab at a concentration of 320 nM. Because the affinity of Alexa-Fab for gp75 was independently determined to be 313 ± 98 nM (data not shown), we assume a fractional occupancy (p) of 0.51.

Figure 10A shows the probability relationships that predict the number of measured Fabs per receptor particle for fractional occupancy, p. In deriving these relationships it is again important to recognize that FCS only measures receptors with at least one Fab bound to them. Unoccupied receptors are not detected.

A

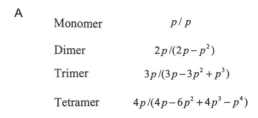

Monomer p/p

Dimer $2p/(2p - p^2)$

Trimer $3p/(3p - 3p^2 + p^3)$

Tetramer $4p/(4p - 6p^2 + 4p^3 - p^4)$

B

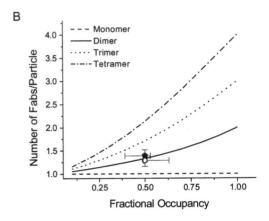

Fig. 10 Calculated stoichiometry values are dependent on fractional occupancy. (A) Probability relationships used to predict the number of measured Fabs per receptor particle, which is dependent on fractional occupancy, p. (B) Theoretical curves for monomers, dimers, trimers, and tetramers as a function of fractional occupancy (p).

Theoretical curves for monomers, dimers, trimers, and tetramers as a function of p are shown in Fig. 10B. Note that for monomers, the number of measured Fabs/particle is independent of fractional occupancy and equals 1.0. As discussed above, we found that the number of Fabs/particle for gp75 did not significantly deviate from 1.0 for untreated and NGF-treated cells. Furthermore, Fabs/particle for untreated (1.12 ± 0.12) and NGF-treated (0.94 ± 0.10) cells were significantly lower (student's one-tailed t-test, $p \leq .02$ and $p \leq .0001$ for untreated and NGF-treated cells, respectively) than the value predicted for a dimer (1.34) when receptor fractional occupancy is 0.51. Therefore, our findings demonstrate that gp75 receptors are monomers before NGF treatment and that NGF does not result in receptor complexing.

This study demonstrates that FCS can be used to quantify the interactions of membrane receptors *in vivo*. Furthermore, it shows the additional complexity that is introduced when studying macromolecules in living cells. Our studies were routinely conducted at low laser power ($<25 \mu$W) but were only successful when the Fab was conjugated to Alexa-488. The same study was attempted with the

fluorescein-conjugated form of the Fab without success, mostly because of problems associated with rapid photobleaching.

III. Designing and Building an FCS Instrument

A. Overview—The Experimental Setup

The remainder of this chapter is focused on describing the factors to consider when building a microscope-based FCS instrument. A schematic of the FCS experimental setup is shown in Fig. 11, and a photograph (Fig. 12A) of the final

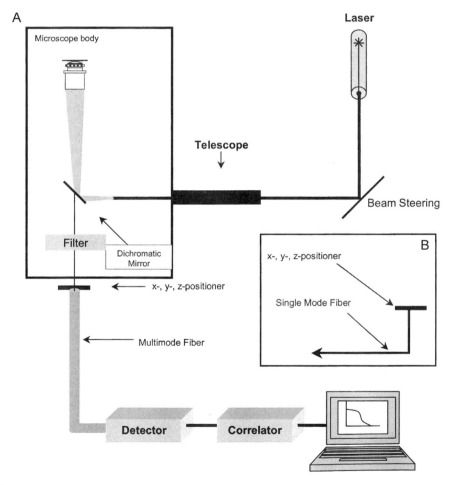

Fig. 11 Schematic of FCS instrument built on a Zeiss Axiovert 35 microscope in our laboratory with beam steering (A) and fiber coupling (B).

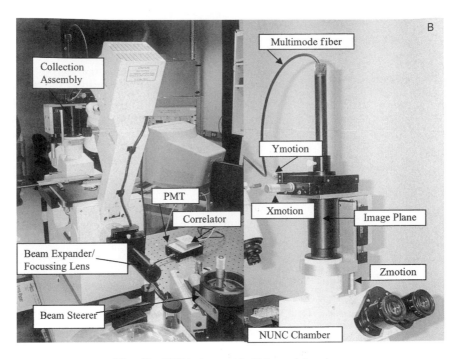

Fig. 12 FCS instrument built in our laboratory.

instrument built in our laboratory on a Zeiss Axiovert 35 is also shown. The illumination source was a CW Ar laser (Lexel Laser, Model 95-2Ar), which was focused through the epiillumination port of a Zeiss Axiovert 35. The laser was coupled to the microscope in two different ways: using a wavelength-optimized single-mode fiber aligned through a FiberPort micropositioning device (Optics for Research), which provides both focusing as well as alignment for optimal laser to fiber launch, or using mirrors to steer the beam. When fiber coupling was used, a snap-on lens was used to collimate the laser light. For both fiber-coupled and beam steering, the laser light was focused through a lens in a telescope device attached to the epiillumination port of the microscope. Incoming light was aligned with x-y positioners, and focus on the back aperture of the objective adjusted with the telescope. A Zeiss 63X, 1.2-NA water-immersion objective was used to refocus the laser onto the sample to be studied. The emitted fluorescent light was collected through the same objective and passed through a 50- or 100-μm multimode fiber, placed at the conjugate image plane, which served both as the pinhole and the collection fiber. The pinhole served to reject out-of-focus light, and the multimode fiber carried the emitted fluorescence light to a PMT (Correlator.com, using a Hamamatsu HC120-08 PMT module) for photon counting. Positive TTL pulses from the PMT were sent to the digital correlator (Correlator.com, Flex2K-12Dx2 multiple tau) via coaxial cables with BNC

connectors. The digital correlator was connected to a desktop or laptop computer via a USB port.

Laser power output was regulated in light control mode and attenuated using neutral density filters. Samples were characteristically exposed to 20–50 μW of laser power after optical attenuation, as measured at the object plane. Regulation of laser power was a critical consideration for the FCS experimental setup to ensure optimal laser stability and to minimize photobleaching of cell membrane samples. Laser instability may be observed as systematic oscillations in photon counts, and is therefore correlated.

B. Primary Components of an FCS Instrument

Five primary components are necessary to build an FCS instrument. Although each component is essential, one can choose from a wide variety of commercially available hardware solutions. We, therefore, discuss the key factors to consider when selecting these components:

- Laser illumination
- Optics
- Photon detection
- Correlator
- Data acquisition and analysis.

The laser selected must meet stability, power, and excitation wavelength requirements. Optics between the laser (input) and photon detector (output) determine the beam diameter, confocal volume and ultimately, photon detection efficiency. A multimode fiber (100 μm diameter) was positioned in the conjugate image plane and simultaneously served both as pinhole before the detector and to carry the light signal to the photon detector. The photon detector selected must have low dark count rates and output positive TTL pulses, which are counted and processed by the digital correlator. The digital correlator, which was connected to a computer via USB port, was used to acquire photon counts, dual autocorrelation, or cross-correlation data. Relevant data processing and analysis was conducted using OriginLab. Visit our Web site, (www.biosensorgroup.com/fcs) for more details on the software developed in our laboratory as well as the hardware used to build our FCS instrument.

C. Laser Illumination

The laser selected for an FCS machine must meet stability, power, and excitation wavelength criteria. We must first assume that the laser beam intensity profile is Gaussian, or TEM_{00} mode. It is important to attain the correct mode structure, otherwise, data analysis routines developed for FCS are not applicable. For our FCS instrument, we used a water-cooled, 2-W, argon ion laser (Lexel Laser Model 95-2Ar). The laser was tuned to ensure TEM_{00} mode structure. Laser light input

was coupled to a Zeiss Axiovert 35 microscope by direct beam steering or via single-mode, wavelength-optimized fiber-optics. Although fiber-optic coupling resulted in greater than 50% light loss, both techniques required further attenuation and worked adequately for the illumination of biological samples.

1. Laser Power

FCS instruments do not require high-power lasers. The output of a 5-mW laser is adequate to illuminate biological samples whether coupled by beam steering or fiber optics and often requires additional attenuation. To minimize interconversion between singlet and triplet states, laser power should be kept as low as possible for the sample being studied. We typically exposed our samples to 20–50 μW of laser power after total attenuation. Note that the power per unit area is the critical parameter to control.

2. Wavelengths Available

One of the most important factors when selecting a laser is excitation wavelength. Available wavelengths will depend on the type of laser selected. Ion lasers (Argon or Argon/Krypton) produce multiple laser lines in wavelengths from around 457–568 nm. Ion lasers can be single-line, tunable multiline, or simultaneous multiline, with power levels from 20–30 mW to 10 W. If single wavelengths are to be used, helium-neon (HeNe) lasers provide lines at either 543 or 635 nm. In addition, solid-state diode lasers are available from ultraviolet through infrared wavelengths, including visible laser lines at 430, 473, 488, 490, 532, 633 or 658 nm at a variety of power levels from a few milliwatts to tens of milliwatts. The final criteria to determine is the stability of the laser selected.

3. Laser Stability

In addition to desired wavelength, laser stability is the most important property to consider. Because FCS requires temporal correlation of fluorescent intensity fluctuations, any systematic noise in laser output in the measurement time domain will be correlated and reflected in the autocorrelation curve. We have evaluated a number of HeNe and diode lasers with inherent instability, which made their use in FCS problematic. Although the level of background noise that can be tolerated in an FCS instrument is dependent on collection efficiency and the assay application to be implemented, minimizing systematic laser output fluctuations should be a high priority and will provide you with the greatest degree of flexibility and sensitivity.

4. Fiber-Optic Coupling of Laser

The laser light source may be coupled to the epiillumination port of the microscope through single-mode fiber optics. Although polarization-maintaining (PM) fibers are often used for this coupling, we have found that wavelength-optimized (e.g., 488/

514-nm) single-mode fibers that are not PM fibers work adequately. The critical parameter is the efficient launching of the input laser light into the fiber, which requires both focusing the laser and alignment with micropositioners.

Alignment of the laser launch into the fiber is a critical step in building a fiber-coupled FCS instrument. Selection of the fiber launch coupling port, therefore, is critical. We chose to use the Optics for Research FiberPort miniature micropositioner, outfitted with optics designed to focus the input laser beam into the single-mode fiber. Alignment is accomplished using two xy adjustment and three z/tilt/yaw screws, which enables both translational and tilt adjustment. We have been able to attain less than 50% coupling efficiency with this fiber port, which is sufficient for illumination of biological samples. In fact, further attenuation of the laser input before the fiber port is necessary to keep laser power within the single-mode fiber specifications. Improper laser-to-fiber launch alignment will result in damage to the fiber and alteration of the laser beam intensity profile.

Other fiber coupling hardware is available from a variety of other manufacturers. The Point Source kineFLEX kinematic single-mode fiber delivery system uses polarization-maintaining fibers and includes alignment hardware to optimize fiber launch. OZ Optics sells a variety of component-level laser-to-fiber delivery systems that can be customized for specific needs. Contact one of these product manufacturers for more details.

The primary advantage of fiber-coupling laser input is the benefit of modularity. This enables one to easily switch laser sources without difficult realignment tasks and without increasing the complexity of the input light path by the addition of dichroics and mirrors. We have also successfully used beam steering to direct laser input to the epiillumination port of the microscope.

5. Beam Steering

Laser beam steering was accomplished using the beam steerer setup shown in Fig. 12A. It consists of two mirrors with positional controls that enables one to direct the laser beam to enter the microscope along the optical axis. Pinholes were placed in the light path between the laser and beam steerer and the beam steerer and microscope. This facilitated alignment of the input laser light in the correct plane and along the optical axis. Correct input alignment was verified by focusing on an image of the spot on fluorescent tape. When the input beam was on the optical axis, the image appeared symmetrical above and below the plane of focus. If not aligned on the optical axis, the image appeared as an ellipse and was skewed on either side of the spot's center as we focused above and below the focal plane.

6. System Alignment

Overall alignment of the FCS system is critical to optimize signal collection efficiency and to ensure Gaussian laser beam intensity profiles. Alignment is required between the laser output and input into the microscope and between the

pinhole/collection fiber-optic and the conjugate image plane. If the laser is fiber
coupled to the microscope, then launching of the laser beam into the fiber is
critical (as described above). If the laser is directed into the microscope with a
beam steerer, then alignment using pinholes and mirror adjustment is required (as
described above).

Positioning the multimode fiber pinhole and collection fiber is critical to
optimize efficient collection of photons. Collection efficiency is greatly reduced
when the detector is not aligned correctly in the conjugate image plane. We have
used differential drive micrometers in the x-y dimensions with a 0.5–25-μm/
revolution precision (Thorlabs). We found that this level of precision in the z-axis
was not necessary and have used a micrometer with 500-μm/revolution precision.
To test collection efficiency, we have characterized autocorrelation curves
obtained with HPLC purified water, 1 nM R6G, and 10 nM R6G. The goals
were to minimize counts obtained with water (no fluorophore) and maximize
counts obtained in the presence of low fluorophore concentrations (Fig. 13). The
final counts per particle (CPP) obtained for R6G was used as a general measure of
instrument efficiency.

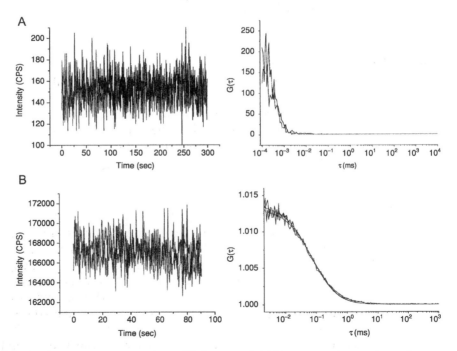

Fig. 13 FCS measurements made on HPLC water and R6G in water to characterize our instrument.
(A) Fluorescence intensity fluctuations (left panel) and autocorrelation curve (right panel) of
measurements made on HPLC water. (B) Fluorescence intensity fluctuations (left panel) and
autocorrelation curve (right panel) of measurements made on R6G in water.

D. Optics

The optical requirements for laser illumination depends on your microscope. The minimum lenses required are a high–NA objective and those required to build the telescoping beam expander. Ideally, minimizing optical components between the object plane and photon detector will improve collection efficiency and reduce potential reflection and autofluorescence artifacts.

1. Telescoping Beam Expander

To minimize the confocal volume, it was necessary not only to focus the beam at the object plane but also to fill the back focal plane of the objective. To accomplish this, we used a telescoping lens and beam expander to focus the laser beam on the back focal plane of the objective. Because it is difficult to obtain a comprehensive schematic of the Zeiss Axiovert 35, we empirically determined the optimal position of the telescoping beam expander to minimize focused laser beam diameter. The assumption of Gaussian beam intensity profile appears to be valid, as determined by analysis of R6G diffusion times in water (Fig. 13B). For a comprehensive evaluation of Gaussian beam profiles and the effect on FCS, see Hess and Webb (2002).

2. Selecting Dichromatic Mirrors and Filters

The emission filters and dichromatic mirrors used for FCS will depend on the fluorophore being used. Specific excitation and the emission properties of the fluorophore probe will determine what filter sets are required for the microscope. More than likely, the appropriate filter sets already exist for your microscope, and one must only consider whether or not the properties are optimal for the FCS experiments being considered.

3. High-NA Objective

A number of excellent water-immersion objectives with high NAs are available. We have chosen to use a Zeiss 63X water-immersion 1.2-N A objective in our FCS system, which includes a selection collar for coverslip thickness. Water immersion offers the advantage that the path through aqueous media is constant regardless of how deeply into the sample one is focused. The only factors that affect the precise position of the image and of the confocal volume are the thickness and the angle relative to the optical axis of the coverslip. Subtle variations caused by these factors are compensated for by the micropositioners at the image planes, enabling precise alignment of the confocal aperture in the image plane.

E. Photon Counting

Low-noise photon counting is essential for optimal FCS instrumentation. Signal-to-noise ratios are affected by the nature of the photon-counting device used. There are two primary options available—a photon-counting APD from Perkin-Elmer or a PMT such as the one used on our FCS instrument. Although APD and PMT modules with low dark counts (25–100 cps) can be obtained, the spectral response of APDs and PMTs differ somewhat. Optimal detection at longer (red) wavelengths requires use of an APD, as the efficiency of PMTs drops off dramatically as one approaches 600 nm.

1. PMT

The photon counter used in our system was purchased from Correlator.com. It is based on the Hamamatsu HC120-08 PMT, with an amplifier/discriminator module and additional circuitry to prevent damage caused by high-intensity input. It uses an FC fiber optic connector for optical input and BNC cable to take positive TTL pulse output to the digital correlator. The PMT has low noise (\leq50 cps) with 20-ns pulse-pair resolution and a pulse width of 10 ns.

2. APD

Perkin-Elmer produces a photon-counting APD that is essentially the EG&G Model (model SPCM-100) described in many papers. Model numbers SPCM-AQR-14, SPCM-AQR-15, and SPCM-AQR-16 are photon-counting APD modules with dark counts of 100, 50, and 25 cps, respectively. Models typically used in FCS instruments exhibited dark current counts of 100 or fewer cps.

F. Digital Correlator

We have selected a digital hardware correlator from Correlator.com for our FCS system. Although hardware performance is excellent, the data acquisition and analysis software is not designed for FCS, but rather quasielastic light-scattering experiments, and there is no built-in data analysis features for FCS experiments. Because of this, we have developed, with the assistance of Correlator.com and OriginLab, data acquistion and analysis software that uses the graphical capabilities and data analysis tools of OriginLab (www.originlab.com).

1. Correlator.com

The Flex2K-12 × 2 multiple tau external digital correlator (www.correlator.com) was used to acquire photon-count data and for autocorrelation curves. It is a real-time, highly stable correlator that is easy to use and set up. It has a theoretical

sampling time of 12.5 ns, and accepts two TTL inputs from PMT modules via BNC connectors for dual autocorrelation or cross-correlation data acquisition. Correlation data is transferred to computer via USB port. In addition, the digital correlator can be run in photon-counting mode (in two channels) to enable PCH or FIDA analysis but requires processing of the incoming data before analysis.

2. ALV

ALV (www.alvgmbh.de) digital correlators are available as an ISA bus card or an external model that is interfaced with a PCI bus card in a desktop computer. The original Zeiss Confocor was built with the ALV-5000/E, as were many laboratory-built instruments. The primary advantage offered by the ALV correlator is that it currently provides superior software.

G. Data Acquisition and Analysis

Correlator.com provides basic data acquisition software with the external digital correlator to collect photon counts, dual autocorrelation, or cross-correlation data. Although acquisition is sufficient, it is not ideal for FCS data visualization and analysis. We have therefore written integrated data acquisition and analysis modules using OriginLab. Visit our Web site, (*www.biosensor-group.com/fcs*) for more details on the data processing and analysis software developed in our laboratory.

1. Random Noise and Optimized Signals

Reliable FCS measurements require an instrument that achieves high signal-to-noise ratios. There are two primary sources of random errors in any fluorescence measurement. The first is background noise that originates from instrinsic fluorescence of optics or sample preparations, back-reflections in fiber optics, and stray light from out-of-focus fluorescence. The second source is electronic noise, which is an intrinsic property of the detector used and includes the limitations imposed by photon-counting statistics. Although the first source of background noise can be minimized by careful selection of components and instrument alignment, the second is integral to the measured signal and is reflected in the signal-to-noise ratio that can be achieved in any measurement.

Shot noise is generated by random variation in emission from the PMT photocathode. Contributions from shot noise is present in all FCS autocorrelation measurements, which further complicates fluctuation analysis. Figure 13A, right panel, is the autocorrelation curve of HPLC water that shows the contribution of shot noise at short correlation times. The relative signal error caused by shot noise can be reduced with long sample measurement times or with high photon-count rates. Shot noise is dependent on the detected fluorescence intensity—it increases as the square root of signal intensity. Therefore, signal-to-noise ratio

is effectively increased at sufficiently high photon count rates. See the following references for detailed discussions on signal-to-noise-ratio, the sources of random errors, and shot noise (Magde *et al.*, 1974; Qian and Elson, 1990; Hess *et al.*, 2002).

Our goal was to optimize FCS measurements in solution using two criteria. First, FCS measurements of HPLC-purified water were made to characterize the overall background noise of our instrument. We typically observed between 100 and 200 cps for these measurements (Fig. 13A, left panel), whereas R6G were typically on the order of 160,000–180,000 cps (Fig. 13B, left panel). Second, we characterized CPP for R6G measurements. The values that we typically observed varied from around 30 to around 100 CPP. Before conducting experiments, we optimized the FCS system for detection of around 100 CPP for R6G in water and for low background counts.

2. Autocorrelation Analysis

Analysis of FCS data is a difficult yet critical step in obtaining biologically relevant information from experiments conducted in solution or in living cells. Parameters obtained by nonlinear curvefitting to the three-dimensional auto-correlation function [Eq. (4)] provides information on the average number of particles in the confocal volume (N), the time (τ_T) and fraction (T) of triplet state, and the diffusion time (τ_{D_i}) and fraction (F_i) of i diffusing particles under examination.

These results may then be used to calculate the Diffusion Coefficient (D), stoichiometry as described above (S), confocal volume, and concentration of fluorescently labeled particle. In addition, validation of the FCS system using the reference standard, R6G, enables one to calculate laser beam diameter and confocal volume for the system.

The diffusion coefficient is converted from diffusion time (τ) using the relationship:

$$D_i = \frac{\omega_1^2}{4\tau_{D_i}},$$

where ω_1 is the illumination volume waist radius and is a constant property of the FCS instrument. Several steps involving the analysis of R6G in water are required to determine K^2 and ω_1. First, autocorrelation curves of R6G in water are obtained and analyzed to determine the structure parameter (SP), K^2, where $K = \omega_2/\omega_1$, using a fixed diffusion coefficent value for R6G ($D = 2.8 \times 10^{-10}$ m^2 sec^{-1}). This value of K^2 is then fixed for all subsequent analysis of three-dimensional autocorrelation data using Eq. (4). ω_1 is determined using the following equation:

$$\omega_i = \sqrt{4D\tau_D},$$

assuming the diffusion coefficient for R6G as above and the best fit value for diffusion time, τ, obtained by curve fitting. The value for $\omega_2 = K^2 \omega_1$, which is then used to calculate confocal volume with the relationship, is volume $= 2\pi\omega_1^2\omega_2$ (in units m^3).

3. Fitting Correlation Curves

Nonlinear curve fitting is used to extract parameter information from FCS data using biologically relevant models. One selects the model to apply for the analysis and chooses the degree of complexity or number of distinct components for the fit. Often, selection of more complicated models results in "better fits," as additional parameters are introduced that can be "squeezed" independently to produce further minimization of the sum-of-squares of the residuals. Although one can visually inspect the residuals to determine whether the selected model results in a better fit, an F-test should be applied to compare results. It is important to note that the F-test is limited to the analysis of more complex forms of the same model; for example, one and two or two and three diffusing components of the three-dimensional model presented in Eq. (4) but it is not intended to compare different models [e.gs. Eq. (4) and (6)].

4. Measuring Stoichiometry

Stoichiometry of interacting macromolecules is an important parameter to characterize for dynamic systems. FCS is readily used to qualitatively detect macromolecular interactions using either autocorrelation or cross–correlation. Quantitative measure of these interactions require more stringent experimental conditions as well as additional computational steps, as described above.

Distribution analysis of photon counts have been recently introduced as a new method of fluorescence fluctuation analysis. Photon-counting histograms (PCH), also known as fluorescence intensity distribution analysis (FIDA), is the most widely accepted method to quantitatively characterize macromolecular interactions. PCH and FIDA were introduced at about the same time by two independent laboratories (Chen et al., 1999; Palo et al., 2000) but are based on similar principles. Although autocorrelation measures the temporal decay of correlation, PCH and FIDA measures the probability distribution of fluctuations. It has the advantage of analyzing photon intensity streams and is not dependent on the autocorrelation function and the ability to distinguish between fast- and slow-diffusing components. These techniques provide information on number and relationship between interacting classes or species of particles and can be used to measure ligand-receptor binding and the formation of oligomeric species (Kask et al., 2000; Rudiger et al., 2001; Chen et al., 2002; Palo et al., 2002). The technique used in our laboratory determines molecular stoichiometry by autocorrelation function analysis when two distinct diffusing components can be distinguished, as described above.

5. Calculation of Beam Diameter and Confocal Volume

R6G was used as the standard to characterize our FCS system. R6G (5 nM) was used to determine structure parameter (K^2) as described above. For the data shown in Fig. 13B, the structure parameter was determined to be 11.73. This value was fixed for all subsequent data collected on that particular day. We have found this value to vary between experiments, usually in the range of 3 to 20. Analysis of R6G data resulted in an average diffusion time of 73.6 μs for R6G in our FCS system. Using these data and the relationships described above, we determined the illumination beam diameter to be 0.6 μm and the confocal volume to be approximately 0.5 fL. This value should be borne in mind when considering power levels described in this chapter.

IV. What are the Current Commercial Sources of FCS?

FCS instruments are available from two primary commercial sources, ISS (www.iss.com) and Carl Zeiss (www.zeiss.com). Both systems share similar features—can function in autocorrelation and cross-correlation modes, can be configured for either single-photon or multiphoton excitation, can collect photon counts for PCH analysis or FIDA, and can work well for both solution and cellular systems. The ISS Alba Fluorescence Correlation Spectroscopy System can additionally be upgraded for steady-state and lifetime measurements, and the user can choose to use an Olympus or Nikon epifluorescence microscope. The Zeiss Confocor II is limited to Zeiss microscopes and optics but can be equipped with a laser scanning module that creates a full-featured confocal microscope. In addition, the Zeiss Confocor II offers software that enables researchers to visualize cells and select the specific location at which to collect correlation data.

A third commercial source of FCS instrumentation is Sensor Technologies, Inc. The FCS instrument produced by Sensor is optimized for measurements made in solution using both autocorrelation and cross-correlation modes. The unique feature of this instrument is its portability. It is based on a simplified design and is a small-footprint, benchtop instrument that is self-contained and easily transported. In addition to data acquisition and analysis software, Sensor Technologies also offers FCS-optimized reagent kits for rapid development of FCS-based assays. Visit the Sensor Technologies Web site at www.biosensorgroup.com/fcs for more details.

V. Summary

FCS is an important technique for biophysicists, biochemists, and cell biologists. FCS represents an example of how one can make use of the microscope and electronics to extract information beyond the resolution limit of classical optics. It can be used to study single-molecules both in solution and in

living cells and can be used to monitor a wide variety of macromolecular interactions. When used as an *in vitro* technique, FCS measurements are easy to conduct and can be made on simplified instrumentation. When used *in vivo* on living cells, many additional factors must be considered when evaluating experimental data. Despite these concerns, FCS represents a new approach that has broad applicability for the determination of molecular stoichiometry both *in vivo* and *in vitro* for a variety of membrane and soluble receptor systems.

Acknowledgments

We thank Christine Thompson and Alonzo Ross for providing experimental assistance and gp75 clones and Leya Bergquist and Roxanne Wellman for their assistance in preparing figures for this manuscript. D. A. B. completed portions of this work while supported by NIH Training Grant NS-07366. D. E. W. was supported by a grant from the National Institutes of Health (NS28760). The content of this publication is solely the responsibility of the authors and does not represent the views of these funding agencies.

References

Axelrod, D., Thompson, N. L., *et al.* (1983). Total internal inflection fluorescent microscopy. *J. Microsc.* **129**, 19–28.

Berg, H. C. (1993). "Random Walks in Biology." Princeton University Press.

Berland, K. M. (1997). Fluorescence correlation spectroscopy: new methods for detecting molecular associations. *Biophys. J.* **72**, 1487–1488.

Berne, B. J., and Pecora, R. (2000). "Dynamic Light Scattering: With Applications to Chemistry, Biology and Physics." Dover Publications, Inc., Mineola, New York.

Brock, R., Hink, M. A., *et al.* (1998). Fluorescence correlation microscopy of cells in the presence of autofluorescence. *Biophys. J.* **75**, 2547–2557.

Brock, R., and Jovin, T. M. (1998). Fluorescence correlation microscopy (FCM)—fluorescence correlation spectroscopy (FCS) taken into the cell. *Cell Mol. Biol. (Noisy-le-grand)* **44**, 847–856.

Brown, M. P., and Royer, C. (1997). Fluorescence spectroscopy as a tool to investigate protein interactions. *Curr. Opin. Biotechnol.* **8**, 45–49.

Caroll, Lewis. *Alice's Adventures in Wonderland.* Penguin Publishing, Inc., New York, New York. pp. 35, 239, (2000).

Chen, Y., Muller, J. D., *et al.* (1999). The photon counting histogram in fluorescence fluctuation spectroscopy. *Biophys. J.* **77**, 553–567.

Chen, Y., Muller, J. D., *et al.* (2002). Molecular brightness characterization of EGFP in vivo by fluorescence fluctuation spectroscopy. *Biophys. J.* **82**, 133–144.

Clair, J. J. (1997). Analysis of highly disfavored processes through pathway-specific correlated fluorescence. *Prod. Natl. Acad. Sci. USA* **94**, 1623–1628.

Dittrich, P., Malvezzi-Campeggi, F., *et al.* (2001). "Accessing molecular dynamics in cells by fluorescence correlation spectroscopy." *Biol. Chem.* **382**, 491–494.

Elson, E. L., and Magde, D. (1974). Fluorescence correlation spectoscopy. I. conceptual basis and theory. *Biopolymers* **13**, 1–27.

Elson, E. L., and Qian, H. (1989). Interpretation of fluorescence correlation spectroscopy and photobleaching recovery in terms of molecular interactions. *Methods Cell Biol.* **30**, 307–332.

Elson, E. L., Schlessinger, J., *et al.* (1976). "Measurement of lateral transport on cell surfaces." *Prog. Clin. Biol. Res.* **9**, 137–147.

Fahey, P. F., Koppel, D. E., *et al.* (1977). Lateral diffusion in planar lipid bilayers. *Science* **195**, 305–306.

Foldes-Papp, Z., Demel, U., *et al.* (2001). Ultrasensitive detection and identification of fluorescent molecules by FCS: impact for immunobiology. *Proc. Natl. Acad. Sci. USA* **98,** 11509–11514.

Foldes-Papp, Z., Demel, U., *et al.* (2002). Detection of single molecules: solution-phase single-molecule fluorescence correlation spectroscopy as an ultrasensitive, rapid and reliable system for immunological investigation. *J. Immunol. Methods* **260,** 117–124.

Haupts, U., Maiti, S., *et al.* (1998). Dynamics of fluorescence fluctuations in green fluorescent protein observed by fluorescence correlation spectroscopy. *Proc. Natl. Acad. Sci. USA* **95,** 13573–13578.

Hess, S. T., Huang, S., *et al.* (2002). Biological and chemical applications of fluorescence correlation spectroscopy: a review. *Biochemistry* **41,** 697–705.

Hess, S. T., and Webb, W. W. (2002). Focal volume optics and experimental artifacts in confocal fluorescence correlation spectroscopy. *Biophys. J.* **83,** 2300–2317.

Kask, P., Palo, K., *et al.* (2000). Two-dimensional fluorescence intensity distribution analysis: theory and applications. *Biophys. J.* **78,** 1703–1713.

Kinjo, M., and Rigler, R. (1995). Ultrasensitive hybridization analysis using fluorescence correlation spectroscopy. *Nucleic Acids Res.* **23,** 1795–1799.

Kohler, R. H., Schwille, P., *et al.* (2000). Active protein transport through plastid tubules: velocity quantified by fluorescence correlation spectroscopy. *J. Cell Sci.* **113,** 3921–3930.

Lagerkvist, A. C., Foldes-Papp, Z., *et al.* (2001). Fluorescence correlation spectroscopy as a method for assessment of interactions between phage displaying antibodies and soluble antigen. *Protein Sci.* **10,** 1522–1528.

Magde, D. (1976). Chemical Kinetics and Fluorescence Correlation Spectroscopy. *Q. Rev. Biophys.* **9,** 35–47.

Magde, D. (1977). Concentration correlation analysis and chemical kinetics. *Mol. Biol. Biochem. Biophys.* **24,** 43–83.

Magde, D., Elson, E. L., *et al.* (1974). Fluorescence correlation spectroscopy. II. An experimental realization. *Biopolymers* **13,** 29–61.

Malvezzi-Campeggi, F., Jahnz, M., *et al.* (2001). Light-induced flickering of DsRed provides evidence for distinct and interconvertible fluorescent states. *Biophys. J.* **81,** 1776–1785.

Matayoshi, E., and Swift, K. (2001). "Applications of FCS to Protein-Ligand Interactions: Comparison with Fluorescence Polarization." Springer-Verlag, Berlin.

Meyer, T., and Schindler, H. (1988). Particle counting by fluorescence correlation spectroscopy. Simultaneous measurement of aggregation and diffusion of molecules in solutions and in membranes. *Biophys. J.* **54,** 983–993.

Meyer-Almes, F. J., and Auer, M. (2000). Enzyme inhibition assays using fluorescence correlation spectroscopy: a new algorithm for the derivation of kcat/KM and Ki values at substrate concentrations much lower than the Michaelis constant. *Biochemistry* **39,** 13261–13268.

Moore, K. J., Turconi, S., *et al.* (1999). Single molecule detection technologies in miniaturized high throughout screening: fluorescence correlation spectroscopy. *J. Biomol. Screen* **4,** 335–354.

Palmer, A. G., 3rd, and Thompson, N. L. (1987). Molecular aggregation characterized by high order autocorrelation in fluorescence correlation spectroscopy. *Biophys. J.* **52,** 257–270.

Palmer, A. G., 3rd, and Thompson, N. L. (1989). Fluorescence correlation spectroscopy for detecting submicroscopic clusters of fluorescent molecules in membranes. *Phys. Lipids* **50,** 253–270.

Palo, K., Brand, L., *et al.* (2002). Fluorescence intensity and lifetime distribution analysis: toward higher accuracy in fluorescence fluctuation spectroscopy. *Biophys. J.* **83,** 605–618.

Palo, K., Mets, U., *et al.* (2000). Fluorescence intensity multiple distributions analysis: concurrent determination of diffusion times and molecular brightness. *Biophys. J.* **79,** 2858–2866.

Politz, J. C., Browne, E. S., *et al.* (1998). Intranuclear diffusion and hybridization state of oligonucleotides measured by fluorescence correlation spectroscopy in living cells. *Proc. Natl. Acad. Sci. USA* **95,** 6043–6048.

Pramanik, A., and Ekberg, K. (2001). C-peptide binding to human cell membranes: importance of Glu27. *Biochem. Biophys. Res. Commun.* **284,** 94–98.

Pramanik, A., and Rigler, R. (2001). Ligand-receptor interactions in the membrane of cultured cells monitored by fluorescence correlation spectroscopy. *Biol. Chem.* **382,** 371–378.

Qian, H., Elson, E. L., *et al.* (1990). On the analysis of high order moments of fluorescence fluctuations. *Biophys. J.* **57,** 375–380.

Ridley, A. J. (1994). Membrane ruffling and signal transduction. *Bioessays* **16,** 321–327.

Rigler, R. (1995). Fluorescence correlations, single molecule detection and large number screening. Applications in biotechnology. *J. Biotechnol.* **41,** 177–186.

Rudiger, M., Haupts, U., *et al.* (2001). Single-molecule detection technologies in miniaturized high throughput screening: binding assays for g protein-coupled receptors using fluorescence intensity distribution analysis and fluorescence anisotropy. *J. Biomol. Screen* **6,** 29–37.

Schwille, P. (2001). Fluorescence correlation spectroscopy and its potential for intracellular applications. *Cell Biochem. Biophys.* **34,** 383–408.

Schwille, P., Haupts, U., *et al.* (1999). Molecular dynamics in living cells observed by fluorescence correlation spectroscopy with one- and two-photon excitation. *Biophys. J.* **77,** 2251–2265.

Schwille, P., Oehlenschlager, F., *et al.* (1996). Quantitative hybridization kinetics of DNA probes to RNA in solution followed by diffusional fluorescence correlation analysis. *Biochemistry* **35,** 10182–10193.

Thompson, N. L., and Axelrod, D. (1983). Immunoglobulin surface-binding kinetics studied by total internal reflection with fluorescence correlation spectroscopy. *Biophys. J.* **43,** 103–114.

Van Craenenbroeck, E., Vercammen, J., *et al.* (2001). Heuristic statistical analysis of fluorescence fluctuation data with bright spikes: application to ligand binding to the human serotonin receptor expressed in *Escherichia coli* cells. *Biol. Chem.* **382,** 355–361.

Walter, N. G., Schwille, P., *et al.* (1996). Fluorescence correlation analysis of probe diffusion simplifies quantitative pathogen detection by PCR. *Proc. Natl. Acad. Sci. USA* **93,** 12805–12810.

Weissman, M., Schindler, H., *et al.* (1976). Determination of molecular weights by fluctuation spectroscopy: application to DNA. *Proc. Natl. Acad. Sci. USA* **73,** 2776–2780.

Widengren, J., and Rigler, R. (1998). Fluorescence correlation spectroscopy as a tool to investigate chemical reactions in solutions and on cell surfaces. *Cell Mol. Biol. (Noisy le grand)* **44,** 857–879.

Zhong, Z. H., Pramanik, A., *et al.* (2001). Insulin binding monitored by fluorescence correlation spectroscopy. *Diabetologia* **44,** 1184–1188.

INDEX

Boldface numerals indicate volume number.

VOLUMES IN SERIES

Founding Series Editor
DAVID M. PRESCOTT

Volume 1 (1964)
Methods in Cell Physiology
Edited by David M. Prescott

Volume 2 (1966)
Methods in Cell Physiology
Edited by David M. Prescott

Volume 3 (1968)
Methods in Cell Physiology
Edited by David M. Prescott

Volume 4 (1970)
Methods in Cell Physiology
Edited by David M. Prescott

Volume 5 (1972)
Methods in Cell Physiology
Edited by David M. Prescott

Volume 6 (1973)
Methods in Cell Physiology
Edited by David M. Prescott

Volume 7 (1973)
Methods in Cell Biology
Edited by David M. Prescott

Volume 8 (1974)
Methods in Cell Biology
Edited by David M. Prescott

Volume 9 (1975)
Methods in Cell Biology
Edited by David M. Prescott

Volume 10 (1975)
Methods in Cell Biology
Edited by David M. Prescott

Volume 11 (1975)
Yeast Cells
Edited by David M. Prescott

Volume 12 (1975)
Yeast Cells
Edited by David M. Prescott

Volume 13 (1976)
Methods in Cell Biology
Edited by David M. Prescott

Volume 14 (1976)
Methods in Cell Biology
Edited by David M. Prescott

Volume 15 (1977)
Methods in Cell Biology
Edited by David M. Prescott

Volume 16 (1977)
Chromatin and Chromosomal Protein Research I
Edited by Gary Stein, Janet Stein, and Lewis J. Kleinsmith

Volume 17 (1978)
Chromatin and Chromosomal Protein Research II
Edited by Gary Stein, Janet Stein, and Lewis J. Kleinsmith

Volume 18 (1978)
Chromatin and Chromosomal Protein Research III
Edited by Gary Stein, Janet Stein, and Lewis J. Kleinsmith

Volume 19 (1978)
Chromatin and Chromosomal Protein Research IV
Edited by Gary Stein, Janet Stein, and Lewis J. Kleinsmith

Volume 20 (1978)
Methods in Cell Biology
Edited by David M. Prescott

Advisory Board Chairman
KEITH R. PORTER

Volume 21A (1980)
Normal Human Tissue and Cell Culture, Part A: Respiratory, Cardiovascular, and Integumentary Systems
Edited by Curtis C. Harris, Benjamin F. Trump, and Gary D. Stoner

Volume 21B (1980)
Normal Human Tissue and Cell Culture, Part B: Endocrine, Urogenital, and Gastrointestinal Systems
Edited by Curtis C. Harris, Benjamin F. Trump, and Gray D. Stoner

Volume 22 (1981)
Three-Dimensional Ultrastructure in Biology
Edited by James N. Turner

Volume 23 (1981)
Basic Mechanisms of Cellular Secretion
Edited by Arthur R. Hand and Constance Oliver

Volume 24 (1982)
The Cytoskeleton, Part A: Cytoskeletal Proteins, Isolation and Characterization
Edited by Leslie Wilson

Volume 25 (1982)
The Cytoskeleton, Part B: Biological Systems and *in Vitro* Models
Edited by Leslie Wilson

Volume 26 (1982)
Prenatal Diagnosis: Cell Biological Approaches
Edited by Samuel A. Latt and Gretchen J. Darlington

Series Editor
LESLIE WILSON

Volume 27 (1986)
Echinoderm Gametes and Embryos
Edited by Thomas E. Schroeder

Volume 28 (1987)
***Dictyostelium discoideum:* Molecular Approaches to Cell Biology**
Edited by James A. Spudich

Series Editors
LESLIE WILSON AND PAUL MATSUDAIRA

Volume 38 (1993)
Cell Biological Applications of Confocal Microscopy
Edited by Brian Matsumoto

Volume 39 (1993)
Motility Assays for Motor Proteins
Edited by Jonathan M. Scholey

Volume 40 (1994)
A Practical Guide to the Study of Calcium in Living Cells
Edited by Richard Nuccitelli

Volume 41 (1994)
Flow Cytometry, Second Edition, Part A
Edited by Zbigniew Darzynkiewicz, J. Paul Robinson, and Harry A. Crissman

Volume 42 (1994)
Flow Cytometry, Second Edition, Part B
Edited by Zbigniew Darzynkiewicz, J. Paul Robinson, and Harry A. Crissman

Volume 43 (1994)
Protein Expression in Animal Cells
Edited by Michael G. Roth

Volume 44 (1994)
***Drosophila melanogaster:* Practical Uses in Cell and Molecular Biology**
Edited by Lawrence S. B. Goldstein and Eric A. Fyrberg

Volume 45 (1994)
Microbes as Tools for Cell Biology
Edited by David G. Russell

Volume 46 (1995) (in preparation)
Cell Death
Edited by Lawrence M. Schwartz and Barbara A. Osborne

Volume 47 (1995)
Cilia and Flagella
Edited by William Dentler and George Witman

Volume 48 (1995)
***Caenorhabditis elegans:* Modern Biological Analysis of an Organism**
Edited by Henry F. Epstein and Diane C. Shakes

Volume 49 (1995)
Methods in Plant Cell Biology, Part A
Edited by David W. Galbraith, Hans J. Bohnert, and Don P. Bourque

Volume 50 (1995)
Methods in Plant Cell Biology, Part B
Edited by David W. Galbraith, Don P. Bourque, and Hans J. Bohnert

Volume 51 (1996)
Methods in Avian Embryology
Edited by Marianne Bronner-Fraser

Volume 52 (1997)
Methods in Muscle Biology
Edited by Charles P. Emerson, Jr. and H. Lee Sweeney

Volume 53 (1997)
Nuclear Structure and Function
Edited by Miguel Berrios

Volume 54 (1997)
Cumulative Index

Volume 55 (1997)
Laser Tweezers in Cell Biology
Edited by Michael P. Sheez

Volume 56 (1998)
Video Microscopy
Edited by Greenfield Sluder and David E. Wolf

Volume 57 (1998)
Animal Cell Culture Methods
Edited by Jennie P. Mather and David Barnes

Volume 58 (1998)
Green Fluorescent Protein
Edited by Kevin F. Sullivan and Steve A. Kay

Volume 59 (1998)
The Zebrafish: Biology
Edited by H. William Detrich III, Monte Westerfield, and Leonard I. Zon

Volume 60 (1998)
The Zebrafish: Genetics and Genomics
Edited by H. William Detrich III, Monte Westerfield, and Leonard I. Zon

Volume 61 (1998)
Mitosis and Meiosis
Edited by Conly L. Rieder

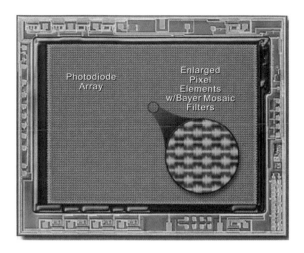

Fig. 6.3 A Bayer mosaic filter CCD for color imaging.

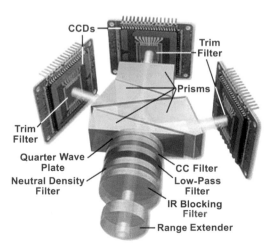

Fig. 6.4 A three-CCD color camera.

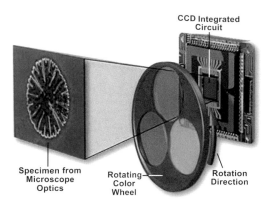

Fig. 6.5 A frame-sequential color camera using a filter wheel.

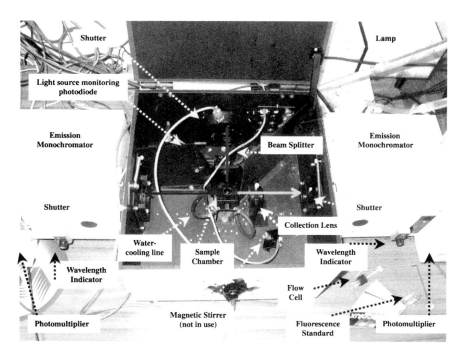

Fig. 9.10 Typical fluorescence spectrofluorimeter. The instrument (from Photon Technologies, Inc.) shown is set up in the so-called "T configuration," where there is a single excitation monochromator and two emission monochromators.

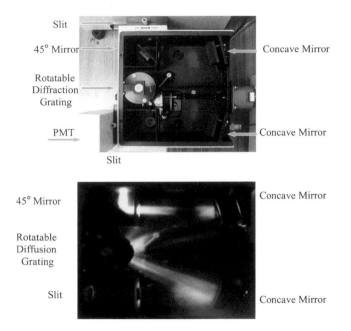

Fig. 9.11 Design of a monochromator for fluorescence spectroscopy (from Photon Technology Inc.)

Fig. 10.11 Anaphase recorded for mitotic spindles assembled in the test tube from *Xenopus* egg extracts as described (Murray *et al.*, 1996). At 30-second intervals, an X-rhodamine-tubulin image and a DA PI-stained chromosome image were recorded. Red and blue image stacks were overlaid with MetaMorph and printed in Adobe Photoshop. Time in minutes is indicated on each frame taken from the time-lapse sequence.

Fig. 10.12 Multimode imaging and local fluorescence photoactivation to see the dynamics of kinetochore fiber microtubules in metaphase newt lung epithelial cells. Cells were injected in early mitosis with X-rhodamine-labeled tubulin and C2CF caged-fluorescein-labeled tubulin. At each time point, a phase image showed chromosome position, an X-rhodamine image showed spindle microtubule assembly, and the C2CF fluorescein image recorded the poleward flux and turnover of photoactivated fluorescent tubulin within the kinetochore fiber microtubules. In the color frames, the green photoactivated C2CF fluorescein fluorescence is overlaid on the red image of the X-rhodamine tubulin in the spindle fiber microtubules. Time is given in minutes after photoactivation. See Waters *et al.* (1996) for details. Scale = 10 μm.

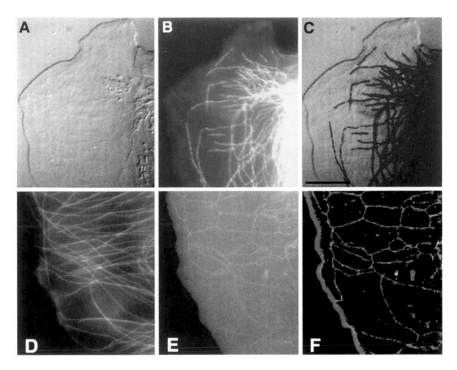

Fig. 10.13 Microtubules in the lamella of a live migrating newt lung epithelial cells. Microtubules are fluorescently labeled by microinjection of X-rhodamine-labeled tubulin into the cytoplasm and ER-labeled with $DiOC_6$. (A) DIC image of leading edge of lamella. (B) X-rhodamine microtubule image. (C) RGB color overlay of A and B. (D) X-rhodamine tubulin image of another cell. (E) $DiOC_6$ image of the ER. (F) RGB color overlay of E and F. See text for details.

Fig. 10.15 The mitotic arrest protein MAD2 localizes to kinetochores on chromosomes in mitotic PtK1 cells when they are unattached from spindle microtubules. The cell was treated with nocodazole to induce spindle microtubule disassembly and then lysed and fixed for immunofluorescence staining with antibodies to the MAD2 protein (Chen *et al.*, 1996). (A) A single optical fluorescence section. (B) The corresponding DIC image. (C) The fluorescent MAD2 image and the DIC image combined in an RGB image to show the localization of MAD2 on either side of the centomeric constriction of the chromosomes where the sister kinetochore are located. Some kinetochores are above or below the plane of focus and not visible.

Fig. 11.11 Different LUTS applied to the image of a cheek cell. (A) No filter; (B) reverse contrast LUT, (C) square root LUT, and (D) pseudocolor LUT.

Fig. 15.5 The three-dimensional point spread function. Pseudocolor images of the point spread function of a microscope. A Z-series was taken of a 0.2-mm bead in the microscope and then reconstructed with pseudocolor. (A) The view looking down the optical axis of the microscope; (B) 40 degrees to the axis; (C) 100 degrees; (D) 190 degrees; (E) 210 degrees; (F) 260 degrees; (G) 300 degrees; and (H) 360 degrees (images were prepared by Ted Inoue and Scott Blakely of Universal Imaging Corporation, Westchester, PA).

Fig. 17.1 WFM imaging of calibrated fluorescent standards. (A) Merged fluorescence and DIC image of a mixture of 2.5-μm polystyrene beads with seven different fluorophore densities. Fluorescence from the beads with the three highest fluorophore densities is bright enough to make them appear colored in this image, whereas beads with the lower fluorophore densities appear gray. Scale bar, 5 μm. (B) Quantitative analysis of fluorescent bead image. Total fluorescence in three-dimensional images of 290 beads was determined by summing an identical volume in each bead and normalized to put all measurements on the same scale. Relative bead fluorescence was also determined by FACS and similarly normalized. Arrows show the positions of the median fluorescence of each bead population measured by FACS. (C) Same dataset as (B) but after image restoration by iterative deconvolution. Figure adapted from Swedlow *et al.* (2002). Copyright 2002 National Academy of Sciences, USA.

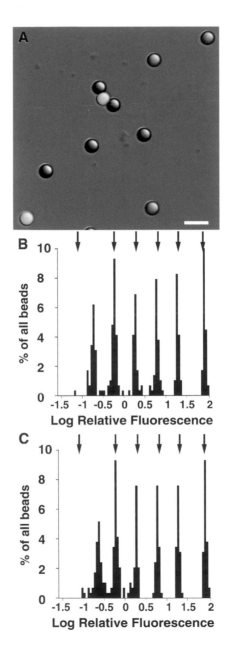

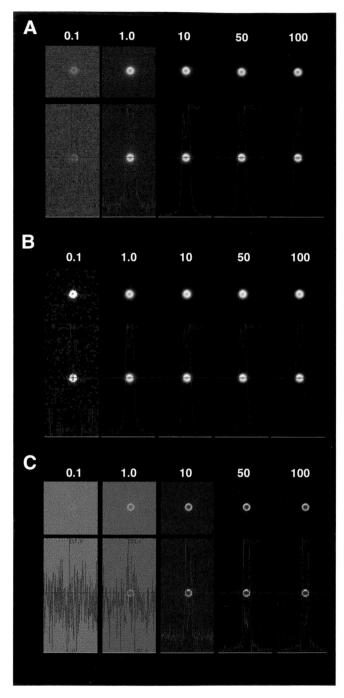

Fig. 17.2 Effects of standard image processing methods on relative fluorescence measurements. A 5-μm bead with fluorophore concentrated on its surface was imaged in a fluorescence microscope

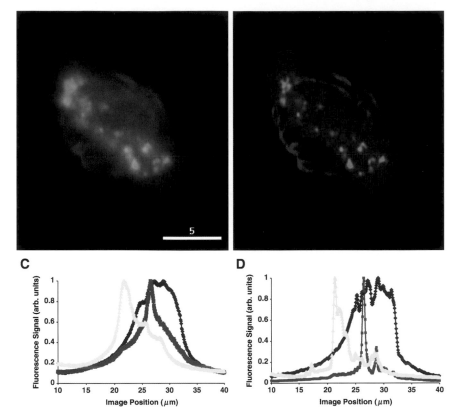

Fig. 17.4 Restoration of images of a mitotic HeLa cell. A metaphase HeLa cell stably expressing a fusion of the aurora-B kinase and GFP was fixed with 3.7% CH_2O and stained with a mouse monoclonal antitubulin antibody and DAPI. The antitubulin was detected with an anti-mouse IgG antibody conjugated to Texas Red. Optical sections covering the whole cell were recorded with a DeltaVision Restoration Microscope (Applied Precision, LLC, Issaquah, WA) and deconvolved using a constrained iterative restoration algorithm (Swedlow *et al.*, 1997). Images are projections through $2\,\mu$m of the data stack. (A) Image before restoration with constrained iterative deconvolution. (B) Image after restoration with constrained iterative deconvolution. (C) Line plot showing fluorescence signal values in image before deconvolution along line shown in (A) DAPI (blue), aurora-B-GFP kinase (yellow), and antitubulin (magenta) are plotted on a scale so that each graph is normalized to its maximum value. (D) Same as (D), but along identical line in deconvolved image. Note the dramatic increase in contrast.

Fig. 17.2 (*continued*) repeatedly while varying the neutral density filter placed between the excitation light beam and the sample (Transmittance = 100%, 50%, 10%, 1%, and 0.1%) while keeping all other imaging parameters the same. (A) Raw images from the microscope. (B) The images in (A) were processed with a low-pass convolution filter. (C) The images in (A) were processed with a high-pass convolution filter. Each image is shown alone and superimposed with a line plot through the center of the bead to indicate the relative intensities in the image and is presented using a LUT set to the individual images minimum and maximum signal. Each line plot is also scaled to the minimum and maximum signal in the individual image. J. R. S. thanks Paul Goodwin, Applied Precision, LLC, for recording this data at the 2002 Analytical and Quantitative Light Microscopy Course, Marine Biological Laboratory.

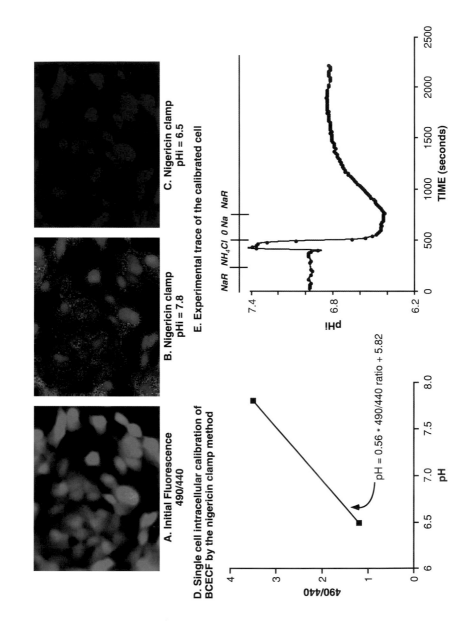

A. Initial Fluorescence 490/440

B. Nigericin clamp pHi = 7.8

C. Nigericin clamp pHi = 6.5

D. Single cell intracellular calibration of BCECF by the nigericin clamp method

pH = 0.56 * 490/440 ratio + 5.82

E. Experimental trace of the calibrated cell

Fig. 18.6 Top: Three representative ratiometric pseudocolor images of neuroblastoma SH-SY5Y cells loaded with BCECF and excited at 490 and 440 nm, emission at 520 nm. The range of pseudocolor goes from red (alkaline) to dark blue (acid). (A) An image of the initial fluorescence in these cells at the beginning of an experiment, with the cells bathed in Hepes-buffered Ringer's solution. (B and C) Pseudocolor images of the same field of cells clamped to pH_i 7.8 (B) and pH_i 6.5 (C), with nigericin. Bottom: (D) The calibration of BCECF using the nigericin clamp protocol in one cell from the field above. Intracellular and extracellular pH were equilibrated with the H^+/K^+ exchanger, nigericin $(10\,\mu M)$ and K^+ solutions titrated to the indicated pH. The slope and intercept defined by the line was used to convert the experimentally determined 490/440 ratios to pH_i. (E) The experimental trace from this cell expressed as pH_i as a function of time.

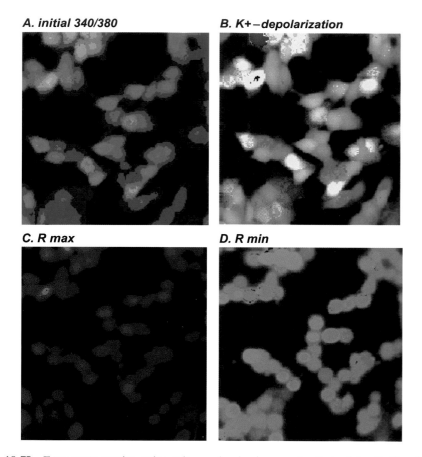

A. *initial 340/380* **B.** *K+−depolarization*

C. *R max* **D.** *R min*

Fig. 18.7I Four representative ratiometric pseudocolor images of cells loaded with Fura-2 and excited at 340 and 380 nm, emission at 510 nm. The range of pseudocolor goes from blue ($<10\,\text{nM}$ Ca_i^{++}) to red ($>1000\,\text{nM}\ Ca_i^{++}$). (A) is an image of the initial fluorescence in these cells at the beginning of an experiment, with the cells bathed in Hepes-buffered Ringer's solution and corresponds to a time point from (A) in the traces in Figure 7II. (B) An image from the experiment after the bathing solution was changed to a high-K^+ solution, which depolarized the cells. This image corresponds to a time point from (B) in the traces in Figure 7II. These cells express a voltage-sensitive Ca^{++} channel in the membrane. The switch to a K^+-depolarizing solution resulted in an opening of these channels and an influx of Ca^{++} from the extracellular fluid. The pseudocolor image is bright green/yellow indicating that the 340/380 ratio increased. (C) is an image from the experiment during the maneuver to calibrate the Fura-2 in the cell, specifically the R_{max} value, and corresponds to a time point during (C) in the trace in Figure 7II. Ionomycin ($10\,\mu\text{M}$) was added to the extracellular Ringer's solution, which resulted in a massive influx of Ca^{++} from the extracellular fluid. This caused a large increase in the 340/380 ratio. (D) An image from the experiment during the maneuver to calibrate the Fura-2 in the cell, specifically the R_{min} value, and corresponds to a time point during (D) in the trace in Figure 7II. Ionomycin ($10\,\mu\text{M}$) was added to the Ca^{++}-free extracellular solution, which also contained EGTA. This maneuver resulted in a massive efflux of Ca^{++} from the cell, resulting in a decrease in the 340/380 ratio. 7II represents the responses of a single cell in the field of cells shown in the pseudocolor images in 7I, showing the changes in the 340- and 380-nm intensities (top), the 340/380 ratio (middle), and the corresponding Ca_i^{++} values based on the Fura-2 calibration in this cell (bottom).

Fig. 19.1 Effects of axial chromatic aberration on ratio measurements. Living cells were incubated with mixture of transferrin conjugated to either fluorescein or to Cy-5 and then fixed and imaged by confocal microscopy. As the two conjugates are expected to proportionally label the same endocytic compartments, one would expect the ratio between the two to be constant in all labeled endosomes. Fluorescein fluorescence was excited by the 488-nm line and Cy-5 fluorescence excited by the 647 line of a Krypton-Argon laser. (A) An image of a single focal plane using an objective in which a disparity of $0.4\,\mu$ in the focal plane of the 488- and 647-nm excitation lines results in the production of variously colored endosomes ranging from green to red. That each endosome has the same ratio of fluorescein to Cy-5 fluorescence is shown when one combines the vertical series of images of this field (B) and one obtains a uniform brown color in the endosomes. (C) The same experiment using an objective with less than $0.1\,\mu$ of axial chromatic aberration between the 488- and 647-nm lines. In this image, the constant ratio between the two different transferrin conjugates in each endosome is apparent in the uniform yellow color of the endosomes. This same color is obtained when one combines all the images of a vertical series into a single projected image (D), indicating that both colors of fluorescence are accurately collected in each single focal plane.

Fig. 19.2 Effects of limited dynamic range on ratio measurements. Living cells were incubated with dextran conjugated to both fluorescein and rhodamine, which is delivered to lysosomes. Because the fluorescence of fluorescein is quenched at low pH, but the fluorescence of rhodamine is pH insensitive, the ratio of red-to-green fluorescence can be used to sensitively measure the pH of lysosomes. (A) A field of living cells whose lysosomes appear yellow because of the quenched fluorescein fluorescence at the low pH of lysosomes. (B) The same field of cells after the lysosomes were alkalinized by the addition of an ionophore (B). In addition to the endosomes becoming greener, one also sees that many, if not most, of the detectable lysosomes in (A) now show saturating signal levels of green fluorescence (depicted in red).

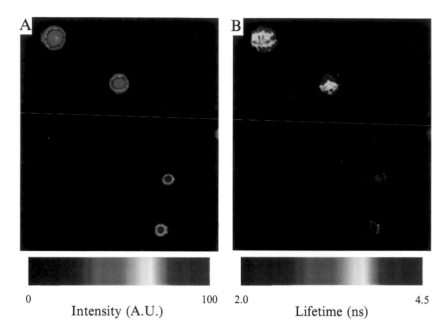

Fig. 21.10 Time-resolved image of orange (2.3 μm in diameter) and red (1.0 μm in diameter) fluorescent latex spheres. (A) Intensity; (B) lifetime.

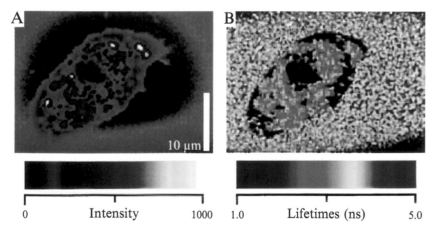

Fig. 21.11 Unwashed macrophages incubated 24 hours with FITC-dextran. Cells were provided by the laboratory of Dr. E. W. Voss, Department of Microbiology, University of Illinois.

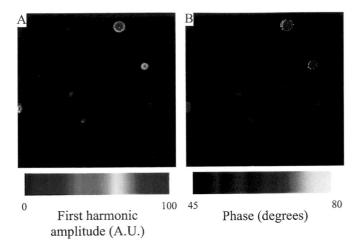

0 First harmonic 100 45 Phase (degrees) 80
 amplitude (A.U.)

Fig. 21.16 Fluorescent lifetime images of 1.1-μm Nile-red (τ_p = 3.20 \pm 1.0 ns) and 2.3-μm orange (τ_p = 4.19 \pm 1.4 ns) fluorescent latex spheres. (A) First harmonic amplitude, (B) phase.

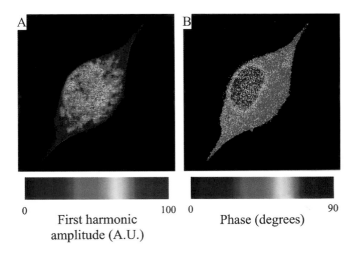

0 First harmonic 100 0 Phase (degrees) 90
 amplitude (A.U.)

Fig. 21.17 Fluorescent-lifetime images of a mouse fibroblast cell labeled with rhodamine DHPE and ethidium bromide (membrane and cytoplasm: τ_p = 2.00 \pm 0.54 ns, nucleus: τ_p = 6.62 \pm 4.8 ns). (A) First harmonic amplitude; (B) phase. Cells were provided by the laboratory of Dr. M. Wheeler, Department of Animal Sciences, University of Illinois.

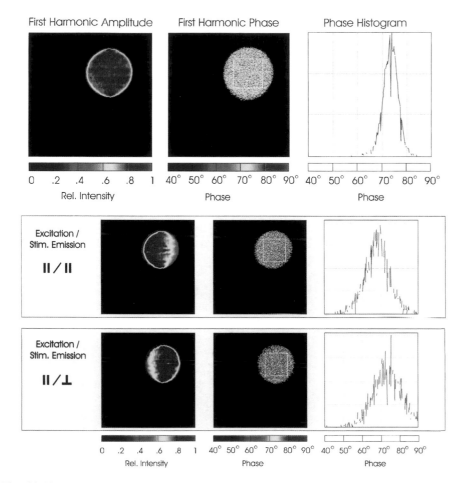

Fig. 21.18 Top: lifetime-resolved, first harmonic, pump-probe images of a 15-mm fluorescent latex sphere (lifetime 15 ns). Middle and bottom: lifetime-resolved, pump-probe polarization images of the same sphere in the $\|/\|$ and $\|/\perp$ configurations. $\Delta\phi = \phi_{\|/\|} - \phi_{\|/\perp} = 6°$.

ISBN 0-12-564169-9

9 780125 641692

90038